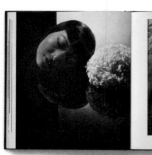

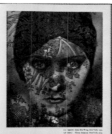

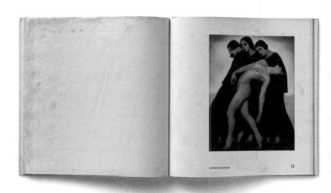

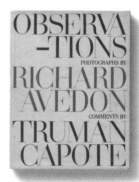

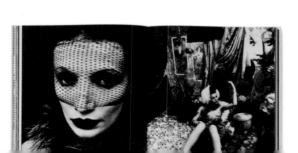

Photographers
A–Z

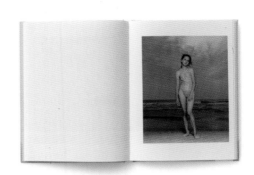

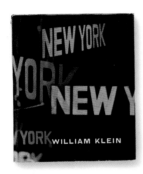

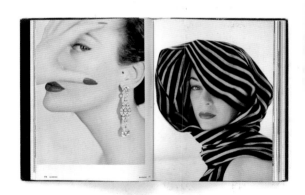

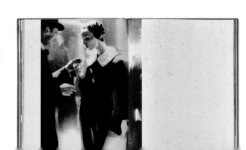

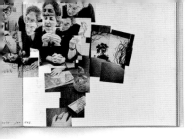

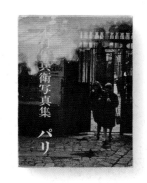

Photographers
A–Z

Hans-Michael Koetzle

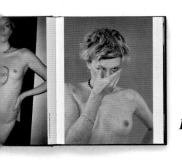

TASCHEN

Bibliotheca Universalis

Foreword and Acknowledgments

Hans-Michael Koetzle

There's no question – photography is the medium of our age. Despite all the competition from various (especially flickering) media – the "great still" (Norbert Bolz) remains in first place. Not only when it's a matter of the visual arts. On the market as well – in galleries and auction houses – the "fine art print" is well established, with photographic prints being seen as works of art and thus as investments. If you are going to talk, argue, negotiate about photography, you need sound data and facts – not least on the artists behind the works. Information that is succinct and authoritative, clear and factual, forms the basis of this new book. Yet the title quite intentionally bridges two worlds, for the book is both a lexicon and a volume of prints, a useful reference book and a feast for the eyes. The aim is to provide those interested in photography with reliable information in a convenient form that they can also browse, rummage through, "surf" freely – a book that will surprise and inspire.

Its clear structure, alphabetical order, and fact-rich entries relate to the idea of an encyclopedia. But completeness, however defined – something in any case unattainable – was never the intention. The book's strength lies in its precise selection, in its restriction to a sort of pantheon. Thus the photographers to be found in these pages are those whose contribution to the culture of the photographic image is beyond question, whose work is internationally recognized, presented, and discussed – even if controversial. Those included are mostly photographers from Europe and the United States. African and Latin American photographers are also prominently represented, as are those from Japan, whose photo scene is gaining international respect. Taken together, this selection provides a history of photography in the 20th century through succinct biographies of artists whose works reflect an eventful century.

Photography has always been both art and business, aesthetics and communication. Our book therefore reflects as many of the medium's various applications as possible. True photo artists have been included, along with fashion and advertising photographers, photojournalists, science and sports photographers, as well as interpreters of landscapes and architecture. The alphabetical order creates its own serendipitous logic. Classics of the medium find themselves next to the latest shooting stars, dedicated artists beside well-known contract photographers. This can lead to unexpected insights, but also quite naturally erases the border – in any case questionable – between "independent" and

"applied". Career-related biographical data, a bibliography, and a list of exhibitions form the core of the entries. Each entry also features a quotation highlighting the photographer's starting point, his/her artistic significance, and perhaps his/her personality as well, taking the reader beyond the positivism of a simple collection of facts. A hand symbol points out the source of the quotation in the literature listed. This, of course, is a selected biography, just as the list of exhibitions – which are classified as solo (SE), joint (JE), or group exhibitions (GE) – takes into account only the most important. Books, journals, and magazines accompanied photography in the 20th century. Photographic images were and are first and foremost printed images, whether they are made expressly for publication in a magazine or book, or are later included in a retrospective monograph in order to reach a larger public. Facsimiles of important books and magazines, prominent for their ideas and finish, concept and design – including rare art magazines, programmatic periodicals, and icons of the recent photobook culture – therefore accompany the biographies. This, in effect, provides a brief survey of printed images, a history of the art of bookmaking in photography, typology, and design.

Many people have contributed to the success of the project. First, thanks go to Hans Christian Adam, Roland Angst, Irène Attinger, Michaela Baer, Ferdinand Brüggemann, Norbert Bunge, Henri Coudoux, Renate Gruber, F. C. Gundlach, Dieter Hinrichs, Klaus Kinold, Helmut Kummer, Jean-Marc Lacabe, Ulrich Pohlmann, Jasmin Seck, Markus Schaden, Christoph Schifferli, Dietmar Siegert, Niklas Weiß, Michael Wiedemann, and Thomas Wiegand. Hans Döring succeeded brilliantly in reproducing the often fragile printed materials. Andy Disl found an appealing and functional, not to mention flexible, design solution for the theme. Thanks are also due to the staff of the TASCHEN Verlag, especially Simone Philippi, Frank Goerhardt and Horst Neuzner for their commitment to this demanding project. And special thanks are due to Benedikt Taschen himself. This work will more than live up to his passion for books.

Slim *(George Allen)* Aarons

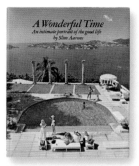

Slim Aarons: **A Wonderful Time: An Intimate Portrait of the Good Life.**
New York (Harper and Row) 1974

29.10.1916 New York (USA) — 29.5.2006 Montrose (New York, USA)
Photojournalist with a focus on people, notably portraits of countless personalities for prominent magazines in the USA. Chronicles of an upmarket lifestyle in America during the 1950s and 60s. At 18 joins the US Army. Works as photographer at West Point. Active service in WW II. Awarded the Purple Heart. After 1945 moves to California, where he specializes in photos of prominent people for illustrated magazines with the motto "photographing attractive people who were doing attractive things in attractive places". Numerous publications in magazines such as *Life, Town & Country, Holiday Magazine, Travel and Leisure*, and other holiday magazines. His best-known work a group photo from New Year's Eve 1957, *Kings of Hollywood* with Clark Gable, Gary Cooper, Van Heflin, and James Stewart in formal dress in the relaxed atmosphere at Romanoff's restaurant in Los Angeles. His apartment has a place in film history as it inspired the set design for Alfred Hitchcock's film *Rear Window* (with James Stewart in the leading roll). 1974 publication of a book with the programmatic title *A Wonderful Life: An Intimate Portrait of the Good Life* looking back at his career. In 2005 participates in the major group exhibition *Kriegsende und Neuanfang* in the Westfälischen Landesmuseum für Kunst und Kulturgeschichte in Münster.

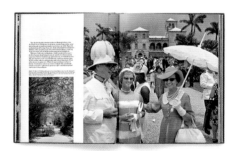

BIBLIOGRAPHY (Selected) — **A Wonderful Time: An Intimate Portrait of the Good Life.** New York 1974 // **Once Upon a Time.** New York 2003 // **A Place in the Sun.** New York 2005 // Martin Parr and Gerry Badger: **The Photobook: A History Volume II.** London 2004 ⚏ // **1945 – Im Blick der Fotografie. Kriegsende und Neuanfang.** Münster 2005 (cat. Westfälisches Landesmuseum für Kunst und Kulturgeschichte) // **Poolside with S.A.** New York 2007

"Although Aarons' book [*A Wonderful Time*] might seem superficially similar to the 'lifestyles of the rich and famous' genre, as seen in publications like *Hello!*, he wields a sharp camera. He has the happy knack of picking up little details, small but vital touches that serve to lift his work above such hagiographies. That is not to say that this is a deliberately subversive exposé of the privileged lifestyle; indeed, it is difficult to know for certain whether Aarons deliberately digs at the super-rich. His view seems neither flattering nor unflattering, neither fawning nor bitchy, but there is a dedicated air of satire about the book." — Gerry Badger

Berenice *(Bernice)* Abbott

17.6.1898 Springfield (Ohio, USA) — 9.12.1991 Monson (Maine, USA) Discoverer and lifelong champion of Atget's works, her own documentary photographs of New York being influenced by him. Also portraits and scientific photography. After high school and Ohio State University, moves to New York in 1918. Sculptor, various jobs. Meets > Man Ray and Marcel Duchamp. Spring 1921, moves to Paris. Changes her first name to Berenice. To earn a living she does darkroom work for Man Ray. Takes up photography. Successful especially with portraits: Jean Cocteau, Max Ernst, Peggy Guggenheim, James Joyce, among others. 1926 successful solo exhibition in Paris. Afterwards, opens her own studio. 1928, participates in the celebrated Salon Indépendent de la Photographie in the Théâtre des Champs-Élysées, initiated by Florent Fels (with > Hoyningen-Huene, > Kertész, > Krull, > Man Ray, > Outerbridge). Meets > Atget. After his death (1927), she acquires 1,400 glass negatives and 7,800 prints (since 1968 in the collection of the Museum of Modern Art, New York) from the estate with the support of Julien Levy. 1929, returns to New York. Unsuccessful search for sponsors to document New York (inspired by Atget). 1935–1958 teaches at the New York School for Social Research. Begins working on her New York project, at first out of her own pocket then from 1935 with the financial support of the Federal Art Project (FAP). 1938 finishes series. 1939 publishes the book *Changing New York*. 1930 and 1964 publishes two books on Atget. From 1940, above all scientific photography. 1981, honorary doctorate from the New School. 1987 ICP Infinity Award for Master of Photography.

"With a spirit of adventure, in love with freedom and perfectly in tune with her times, the American Berenice Abbott produced a photographic oeuvre influenced by two men: Man Ray and Eugène Atget. […] As part of the Art Project of the Works Progress Administration […], she intensively photographed a 1930s New York undergoing rapid transformation, in particular, the building of the Rockefeller Center. She had, she said, an 'instinct for the city' and an urban archaeological aspect was ever present in her images of the creation of the architecture of the future. She was not at all interested in art for art's sake and her photographic vision was 'straight, no holds barred'." — Annick Lionel-Marie ✍

EXHIBITIONS (Selected) — **1926** Paris (Galerie Sacre du Printemps) SE // **1928** Paris (Salon Indépendant de la Photographie) GE // **1932** New York (Julien Levy Gallery) SE // **1934** New York (Museum of the City of New York: 1937, 1997) SE // **1941** Cambridge (Massachusetts) (Massachusetts Institute of Technology — 1959, 1990) SE // **1951** Chicago (Art Institute) SE // **1970** New York (Museum of Modern Art) SE // **1982** New York (International Center of Photography) SE // **1982** Paris (Centre Pompidou: 1996) GE // **2008** Berlin (Kicken Berlin) JE (with Fritz Henle) // **2009** Hamburg (Flo Peters Gallery) GE

BIBLIOGRAPHY (Selected) — **Atget**. Paris 1930 // **Changing New York**. New York 1939 // **A Guide to Better Photography**. New York 1941 // **The World of Atget**. New York 1964 // **The 20s and the 30s**. New York 1982 (cat. International Center of Photography) // Atelier Man Ray: **B.A., Jacques-André Boiffard, Bill Brandt, Lee Miller, 1920–1935**. Paris 1982 (cat. Centre Pompidou) // Hank O'Neil: **B.A.: American Photographer**. New York 1985 // Julia Van Haaften (ed.): **B.A., Photographer: A Modern Vision**. New York 1989 // **B.A.: Changing New York**. New York 1997 (cat. Museum of the City of New York) // **Collection de photographies**. Paris 1996 (cat. Centre Pompidou) ✍ // Ron Kurtz and Natalie Evans (eds): **B.A.** Göttingen 2008

Berenice Abbott, from:
Album, August 1970

Ansel *(Easton)* Adams

Ansel Adams. Hastings-on-Hudson (Morgan & Morgan) 1972

20.2.1902 San Francisco (USA) — 22.4.1984 Carmel (California, USA)
Main exponent of heroic interpretations of landscapes celebrating unspoiled (American) nature. Also prominent as a campaigning environmentalist. The great earthquake in San Francisco (1906) and the collapse of his father's timber company (1907) are the defining events in the life of this multi-talented child. From 1914 piano lessons. 1916 first photographs during vacation with his parents in Yosemite National Park. From this time on interested both in photography and nature. 1920 first of four summer jobs as a "keeper" in Yosemite. During this period more intensive preoccupation with photography as a serious artistic activity. 1925 buys a concert piano (still considering a professional career as pianist). 1927 *Monolith, the Face of Half Dome*, his first successful photograph (in respect of the visualization of his pictorial ideas). In the same year, his first portfolio: *Parmelian Prints of the High Sierras.* 1928 first solo exhibition at the Sierra Club. 1930 meets > Strand and decides definitively to become a professional photographer. In the same year, opens a studio in San Francisco. 1932 founding member of the group f/64. 1933 meets > Stieglitz in New York. 1935 *Making a Photograph*, the first of his many technical books. 1936 beginning of his political activism for the

"In the course of a life from 1902 to 1984, Ansel Adams created some of the most influential photographs ever made, contributing more than any other photographer to the public acceptance of the medium as fine art. Perhaps his greatest legacy, however, was his role as one of the twentieth century's leading exponents of environmental values. His photographs have become icons of the conservation movement, conveying to millions a vision of an ideal America where nature's grand scenes and gentle details live on in undiminished glory." — Jonathan Spaulding ✍

EXHIBITIONS (Selected) — **1928** San Francisco (Sierra Club) SE // **1933** New York (Delphic Studio) SE // **1936** New York (An American Place) SE // **1939** San Francisco (Museum of Modern Art – 1965, 1972, 1981, 1982, 2001) SE // **1944** New York (Museum of Modern Art – 1979) SE // **1951** Chicago (Art Institute) SE // **1956** Cologne (photokina) SE // **1963** San Francisco (M.H. de Young Memorial Museum) SE // **1974** New York (Metropolitan Museum) SE // **1976** Tucson (Arizona) (Center for Creative Photography) SE // **1986** Venice (Palazzo Fortuny) SE // **2001** San Francisco (San Francisco Museum of Modern Art) SE // **2002** Chicago (Art Institute) SE // **2003** New York (Museum of Modern Art) SE // **2007** Rochester (George Eastman House) SE // **2008** Washington, DC (The Corcoran Gallery of Art) SE

BIBLIOGRAPHY (Selected) — **Making a Photograph.** London/ New York 1935 // **My Camera in Yosemite Valley.** Boston 1949 // **My Camera in the National Parks.** Boston 1950 // Liliane DeCock (ed.): **A.A.** Hastings-on-Hudson. 1972 // **A.A.: Images 1923–1974.** Boston 1974 // **The Portfolios of A.A.** Boston 1977 // **A.A.: An Autobiography.** Boston 1986 // **A.A. in Color.** Boston/London 1993 // **A.A.: Classic Images.** Boston 1995 // Jonathan Spaulding: **A.A. and the American Landscape: A Biography.** Los Angeles, 1995 ✍ // John Szarkowski: **Ansel Adams at 100.** Boston 2001 (cat. San Francisco Museum of Modern Art) // Andrea G. Stillman (ed.): **A.A. – 400 Photographs.** New York 2007

idea of national parks. 1940 co-initiator of a photography department at the Museum of Modern Art. 1941 develops his "zone system". 1946 first of three Guggenheim Fellowships (1948, 1958). From 1949 consultant for Polaroid Corporation. 1952, participates in the founding of the journal *Aperture*. 1962 builds a studio over the Pacific in Carmel Highlands. 1967 founder and president (later chairman of the board of trustees) The Friends of Photography. 1974 first trip to Europe. Guest of honor at the Rencontres d'Arles. 1975 co-initiates the Center for Creative Photography, Tucson (Arizona). 1981: 71,500 dollars for a (mural-sized) print of *Moonrise, Hernandez, New Mexico*, the highest price ever paid for the work of a living photographer. Awards incl. 1980 Presidential Medal of Freedom (as highest civilian honor) as well as 1981 Hasselblad Award, 2001 major retrospective on his 100th birthday with stops in San Francisco, Chicago, London, Berlin, Los Angeles, and New York.

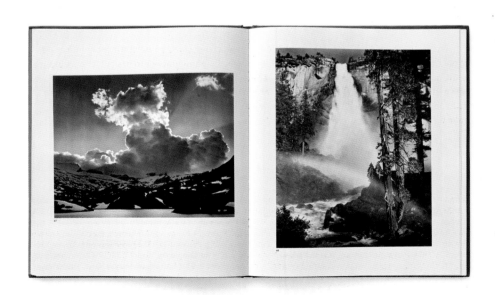

Robert *(Hickman)* Adams

White Churches of the Plains EXAMPLES FROM COLORADO

Robert Hickman Adams: **White Churches of the Plains.** Boulder (Colorado Associated University Press) 1970

8.5.1937 Orange (New Jersey, USA) — Lives in Longmont (Colorado, USA) "Man-altered landscapes." Main exponent of a new, critical view of the American landscape. In general, larger series in b/w. Wheat Ridge High School, Colorado (1952–1955). University of Redlands, California (1955–1959). B.A. in English. Ph.D. University of Southern California, Los Angeles (1965). 1962–1970 teacher and assistant professor at Colorado College, Colorado Springs. Freelance photographer and writer since 1967. Numerous awards incl. Guggenheim Fellowship (1973–1980), NEA (National Endowment for the Arts) Fellowships (1973, 1978), Charles Pratt Memorial Award (1987), Spectrum International Prize for Photography (1995). Participates in programmatic group exhibitions such as *New Topographics* (George Eastman House, 1975), *American Landscapes* (Museum of Modern Art, 1981), *Critical Landscapes* (Tokyo Metropolitan Museum, 1993). 2009 Hasselblad Foundation International Award in Photography.

EXHIBITIONS (Selected) — **1971** New York (Museum of Modern Art) JE (with Emmet Gowin) // **1975** Rochester (New York) (George Eastman House) GE // **1976** New York (Castelli Graphics – 1979, 1981) SE // **1978** Denver (Art Museum – 1986, 1993) SE // **1979** New York (Museum of Modern Art) SE // Berlin (Werkstatt für Photographie der VHS Kreuzberg) SE // **1980** San Francisco (Fraenkel Gallery – 1985, 1987, 1994, 2000, 2003, 2005, 2007) SE // **1981** Philadelphia (Museum of Art – 1989) SE // **1986** Riverside (California Museum of Photography) SE // **1991** Tokyo (Photo Gallery International) SE // **1994** Hannover (Sprengel Museum) SE // **2003** New York (Matthew Marks Gallery – 2006, 2007) SE // **2004** Bottrop (Germany) (Josef Albers Museum) SE // **2005** Munich (Haus der Kunst) SE // San Francisco (San Francisco Museum of Modern Art) SE // **2006** Los Angeles (J. Paul Getty Museum) SE // Tucson (Center for Creative Photography) SE // Houston (Museum of Fine Arts) SE // **2007** Paris (Fondation Cartier pour l'art contemporain) SE // **2008** Washington, DC (National Gallery of Art) SE // **2009** Cologne (Galerie Thomas Zander) SE // **2009** Rochester (George Eastman House) GE// **2013** Bottrop (Quadrat Bottrop) SE

BIBLIOGRAPHY (Selected) — **White Churches of the Plains.** Boulder (Colorado) 1970 // **The New West: Landscapes Along the Colorado Front Range.** Colorado 1974 (facsimile reprint: 2008) // **New Topographics: Photographs of a Man-altered Landscape.** Rochester 1975 (cat. International Museum of Photography) // **Denver: A Photographic Survey of the Metropolitan Area.** Boulder (Colorado) 1977 // **Prairie.** Denver 1978 (cat. Denver Art Museum) // **From the Missouri West.** New York 1980 // **Beauty in Photography: Essays in Defense of Traditional Values.** New York 1981 // **Our Lives and Our Children: Photographs Taken Near the Rocky Flats Nuclear Weapons Plant.** New York 1983 // Jonathan Green: **American Photography.** New York 1984 ⟋ // **Summer Nights.** New York 1985 // **R.A.: Photographs 1965–1985.** New York 1988 // **To Make it Home: Photographs of the American West.** New York 1989 // **Listening to the River: Seasons in the American West.** New York 1994 // **West from the Columbia.** New York 1995 // **California. Views by R.A. of the Los Angeles Basins, 1978–1983.** San Francisco 2000 (cat. Fraenkel Gallery) // **No Small Journeys.** New York 2003 (cat. Matthew Marks Gallery) // **Commercial Residential.** New York 2003 // **Pine Valley.** Tucson 2005 // **Interiors 1973–74.** Tucson 2006 // **Along Some Rivers.** New York 2006 // **Questions For an Overcast Day.** Los Angeles 2007 (cat. Fraenkel Gallery) // **R.A.: Time passes.** Paris 2007 (cat. Fondation Cartier pour l'art contemporain) // **Gone?** Göttingen 2009 // **Tree line. The Hasselblad Award 2009.** Göttingen 2009 // Britt Salvesen (ed.): **New Topographics.** Göttingen 2009 (cat. George Eastman House)

"In the work of the two major photographers of the new American frontier, Baltz and Robert Adams, art, nature, and industrial form become inextricably tangled. Both photograph the meeting point of land and settlement in such a way that the landscape and the buildings assume qualities traditionally associated with one another. […] The landscape takes on attributes of industrial regularity, urban brutality, and artificiality. It too is both sacred and profane. In this ambiguous world mechanized facts come to stand for natural facts, while nature takes on the characteristics of culture." — Jonathan Green ✑

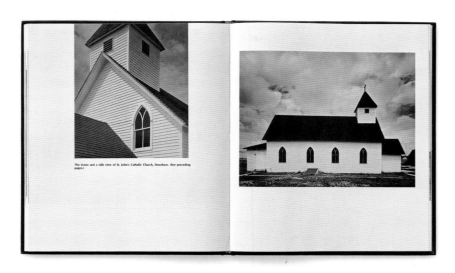

The tower and a side view of St. John's Catholic Church, Stoneham. (See preceding pages.)

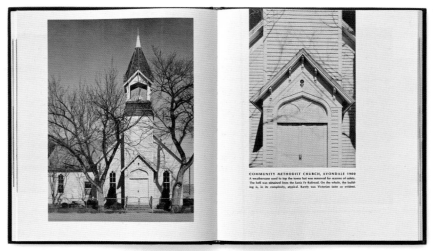

COMMUNITY METHODIST CHURCH, AVONDALE 1900
A weathervane used to top the tower but was removed for reasons of safety. The bell was obtained from the Santa Fe Railroad. On the whole, the building is, in its complexity, atypical. Rarely was Victorian taste so evident.

Manuel Álvarez Bravo

4.2.1902 Mexico City (Mexico) — 19.10.2002 Mexico City Portraits, nudes, landscapes, especially street scenes and still lifes, intellectually close to Surrealism. Important early works around 1930 part of the development of photographic modernism. Father teacher and amateur photographer. Fifth of eight children. 1915 (for financial reasons) leaves school. Learns the basics of photography from a school friend and his father. Various jobs incl. in a textile factory. From 1917 evening classes (literature and music) at the Academia San Carlos. From 1922 works for Hugo Conway, director of the Mexican Light and Power Company and himself a photo enthusiast. Through him, discovers magazines such as *The Amateur Photographer*, *Camera Craft*, and *El Progresso fotográfico*. 1923 formative meeting with > Brehme as well as works of > Modotti and Edward Weston. 1924 a Century Master 25 for his first own camera and beginning of independent photographing, at first influenced by Pictorialism. Marries Dolores Martínez de Anda (divorced 1934) and moves to Oaxaca. 1927 returns to Mexico City. There he opens a gallery with works by Tamayo, Orozco, Rivera, and Frida Kahlo. 1928 participates in the *Primer Salón Mexicano de Fotografía*, beginning of intensive exhibition work. Influenced by > Renger-Patzsch (*Die Welt ist schön*), turns to a stricter pictorial language. First platinum prints using a method from Modotti. From the end of the 1920s publishes works in avant-garde magazines such as *Dyn*, *Contemporáneos*, and *Mexican Folkways*. 1930 discovers the works of > Atget. The next year, gives up his job at the Mexican Treasury Department and dedicates himself fully to photography. 1932 first solo exhibition. Meets > Strand (1933) and > Cartier-Bresson (1934). With him 1935 joint exhibition at the Palacio de Bellas Artes (Mexico City). 1939 meets André Breton and participates in the Surrealist exhibition *Mexique* in the Galerie Renou et Colle (Paris). Photographs in *Minotaure*. 1942 the Museum of Modern Art (New York) acquires nine of his works. 1943–1959 filmmaker and still photographer with the Sindicato de

Susan Kismaric: **Manuel Álvarez Bravo.** New York (Museum of Modern Art) 1997

EXHIBITIONS (Selected) — **1932** Mexico City (Galería Posada) SE // **1942** New York (Photo League Gallery) SE // **1968** Mexico City (Palacio de Bellas Artes – 1972, 1989) SE // **1971** Pasadena (Pasadena Art Museum) SE // **1972** New York (Witkin Gallery – 1975, 1981, 1989, 1992, 1995) SE // **1978** Washington, DC (Corcoran Gallery of Art) SE // **1983** Jerusalem (Israel Museum) SE // **1986** Paris (Musée d'art moderne de la Ville de Paris) SE // **1990** San Diego (Museum of Photographic Arts) SE // **1992** Malibu (J. Paul Getty Museum) SE // **1997** New York (Museum of Modern Art) SE // **2004** Paris (Fondation Henri Cartier-Bresson) JE (with Henri Cartier-Bresson and Walker Evans) // **2007** Santa Monica (Rose Gallery) SE // **2008** New York (Throckmorton Fine Art) SE

BIBLIOGRAPHY (Selected) — Fred Parker: **M.Á.B.** Pasadena 1971 (cat. Pasadena Art Museum) // Jane Livingston and Alex Cas-

tro: **M.Á.B.** Washington, DC, 1978 (cat. Corcoran Gallery of Art) // **M.Á.B.: 303 photographies 1920–1986.** Paris 1986 (cat. Musée d'art moderne de la Ville de Paris) // Arthur Ollman and Nissan N. Perez: **Revelaciones: The Art of M.Á.B.** San Diego 1990 (cat. Museum of Photographic Arts) // Elena Poniatowska: **M.Á.B. El artista, su obra, sus tiempos.** Mexico City 1991 // Erika Billeter: **Canto a la realidad. Fotografía Latinoamericana 1860–1993.** Barcelona 1993 // Susan Kismaric: **M.Á.B.** New York 1997 (cat. Museum of Modern Art) *▱* // **Documentary and Anti-Graphic Photographs. M.Á.B., Henri Cartier-Bresson, Walker Evans.** Göttingen 2004 (cat. Fondation Henri Cartier-Bresson, Paris) // **M.Á.B. – The Eyes in His Eyes/Ojos en los ojos.** Santa Monica 2007 (cat. RoseGallery) // Leonard Folgarit: **Seeing Mexico Photographed. The Work of Horne, Casasola, Modotti, and Á.B.** New Haven/London 2008 // **M.Á.B. Photopoésie.** Arles 2008

Trabajadores de la Producción Cinematográfica de México. There works for Luis Bruñel among others. An exhibition (1971) in Pasadena Art Museum with stops in New York (Museum of Modern Art), San Francisco (Museum of Modern Art), and Rochester (George Eastman House) marks the beginning of his international reputation. Another important retrospective in Washington in 1978. Important group exhibitions incl. *La fotografía como arte* (1945), *The Family of Man* (1955), and *The Photographer's Eye* (1964). Numerous awards, incl. National Arts Prize (1975), Hasselblad Award (1984), Hugo Erfurth Award (1991). Last years of his life in Coyoacán near Mexico City.

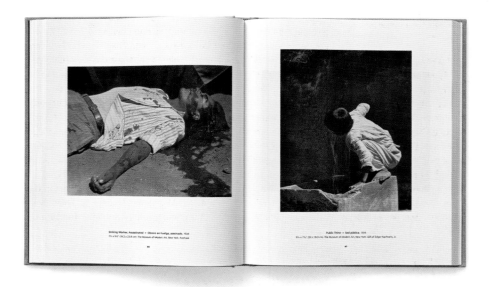

Striking Worker, Assassinated • Obrero en huelga, asesinado, 1934
7½ x 9½" (19.2 x 23.8 cm). The Museum of Modern Art, New York. Purchase

Public Thirst • Sed pública, 1934
9½ x 7½" (24 x 18.9 cm). The Museum of Modern Art, New York. Gift of Edgar Kaufmann, Jr.

"Manuel Álvarez Bravo enjoys an international reputation as one of the most important photographers in the history of the medium. Between the two world wars, he was one of the inventors of the modern vocabulary of photography. By 1928, when his photographs were shown in an exhibition of Mexican photography, his reputation as Mexico's leading photographer of the modern movement was secured. In 1939 André Breton, the leader of the Surrealist movement, featured Álvarez Bravo's work in an exhibition of Surrealist art in Paris, bringing it into the world's artistic center and identifying him as an artist of international stature." — Susan Kismaric

Nobuyoshi Araki

Nobuyoshi Araki: **Erotos.**
Tokyo (Libro Port Publishing Co.)
1993

25.5.1940 Tokyo (Japan) — Lives in Tokyo The staging of sexual fantasies is central to an oeuvre that also includes urban scenes, plants, and animals. Photography as visual diary. With over 250 books, the most prolific, internationally known Japanese photographer. Son of a shoe salesman. Fifth of seven children. Father an enthusiastic amateur photographer, who in 1952 gives Araki his first camera, a Baby Pearl. First photographs during a school trip. 1959 begins studies (photography and film major) at Chiba University (engineering department). 1963 graduates with a b/w film (*Children Living in Apartments*). Begins as advertising photographer for the Dentsu agency. 1964 prize in a photo competition sponsored by the magazine *The Sun*. 1965 *Satchin and His Brother Mabo*, his first solo exhibition in Tokyo. 1970 self-publishes 25 *Xeroxed Photo Albums* (70 copies), sent to friends, to art critics, and to addresses taken at random from a telephone book. 1971 marries Yoko Aoki. A pictorial record of their honeymoon trip (*Sentimental Journey*) is perhaps his best, and most personal ("purest") book. 1972 leaves Dentsu. 1974, together with > Tōmatsu, > Moriyama, > Hosoe, Masahisa Fukase, and Noriaki Yokosuka founds the Photo Workshop School. 1979 travels to New York for the opening of the exhibition *Japan: A Self-Portrait* at the International Center of Photography. First series of bondage shots for the magazine *SM Sniper*. 1981 sets up his own company, the Araki Company Limited. In the same year, travels with Yoko to Paris, Madrid, and Buenos Aires. 1986 first slide projection (*Arakinema*). 1988 first accusations of pornography with a publication in *Shashin Jidai* (Photo Age). 1990

EXHIBITIONS (Selected) — **1992** Graz (Forum Stadtpark/**Akt-Tokyo**) // **1995** Paris (Fondation Cartier pour l'art contemporain) SE // Wolfsburg (Kunstmuseum – 2007) SE // **1997** Vienna (Secession) SE // **1999** Tokyo (Museum of Contemporary Art) SE // **2000** Paris (Galerie Kamel Mennour) SE // Prato (Centro per l'Arte Contemporanea Luigi Pecci) SE // **2003** Houston (Museum of Fine Arts/**The History of Japanese Photography**) GE // Tokyo (Tokyo Metropolitan Museum of Photography) SE // Paris (Galerie Kamel Mennour – 2007) SE // **2004** Madrid (La Fábrica Galería – 2006) SE // **2005** London (Barbican Art Gallery/**Self.Life.Death**) SE // London (Michael Hoppen Gallery – 2008) SE // Paris (Palais de Tokyo) SE // **2006** Munich (Pinakothek der Moderne) SE // Charleroi (Musée de la Photographie) SE // **2007** Stockholm (Kulturhuset) SE // **2008** Hannover (kestnergesellschaft) SE // Salzburg (Museum der Moderne/Rupertinum) SE // **2009** Vienna (Galerie Johannes Faber) SE

BIBLIOGRAPHY (Selected) — **Zerokkusu Shashincho 24 – Nihonjin Nanayu 15/8/70 (Xeroxed Photo Album 24 – Seventy Japanese 15/8/70).** Tokyo 1970 // **Senchimentaru na Tabi** (A Sentimental Journey). Tokyo 1971 (facsimile reprint: Göttingen 2001) // **Tokyo Lucky Hole 1983–1985 Shinjuku Kabukico district.** Tokyo 1990 // **Akt-Tokyo. N.A.** 1971–1991. Graz 1992 (cat. Forum Stadtpark) // **Shokuji** (The Banquet). 1993 // **Erotos.** Tokyo 1993 // N.A. and Nan Goldin: **Tokyo Love.** Zurich 1995 // **N.A. à la Fondation Cartier pour l'art contemporain.** Paris 1995 // **The Works of N.A. – 16, Erotos.** Tokyo 1997 // **Tokyo Comedy.** Vienna 1997 (cat. Wiener Secession) // **A.** Paris 2000 (= Photo Poche no. 86) // **Tokyomania.** Paris 2000 // A. Cologne 2002 // Willfried Baatz: **50 Klassiker. Photographen.** Hildesheim 2003 ✍◻ // Anne Wilkes Tucker, Dana Friis-Hansen, Ryu ̄ichi Kaneko, and Takeba Joe: **The History of Japanese Photography.** New Haven/London 2003 (cat. Museum of Fine Arts, Houston) // **Dirty Pretty Things.** Tokyo 2006 // A. Cologne 2007 (with extensive bibliography) // Philippe Forest: **A. enfin. L'homme qui ne vécut que pour aimer.** Paris 2008 // **N.A.** Hamburg 2009 (= Stern Portfolio no. 56) // **N.A. Bondage.** Cologne 2012 // **Tokyo Lucky Hole.** Cologne 2015

death of his wife. 1992 opening of the exhibition *Akt-Tokyo* in Graz (Forum Stadtpark) as the start of a major European tour with ten stops (to 1995). 1994 first solo exhibition in the USA. 1999 first solo exhibition in a Japanese museum (Museum of Contemporary Art, Tokyo).

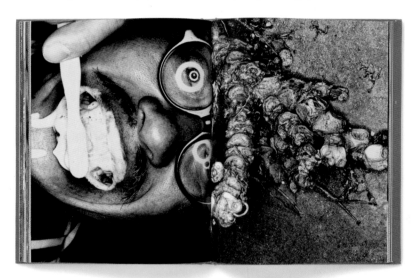

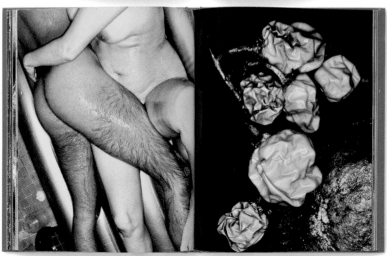

Nobuyoshi Araki: **Dirty Pretty Things**.
Tokyo (IBC Publishing) 2006

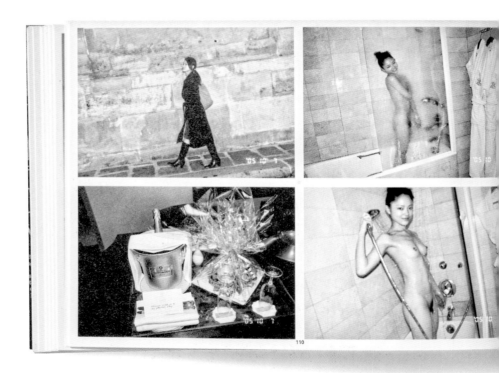

"Like a driven man, he hurries from one shot to the next, from image to image. Cloudy sky, view of the bathtub, cats, cityscapes, again and again flowers and naturally nudes – it's as if the restless collector of images would like to capture every moment in a photo. For Nobuyoshi Araki, the countless photos that he makes every day are a sort of diary that 'contains the past as well as projections on the future'. It is not unusual for him to shoot 80 rolls of film a day, because the more images he takes from his surroundings, the more his work attains for him a 'cosmic dimension' and becomes a sort of 'Buddhist mandala'." — Willfried Baatz

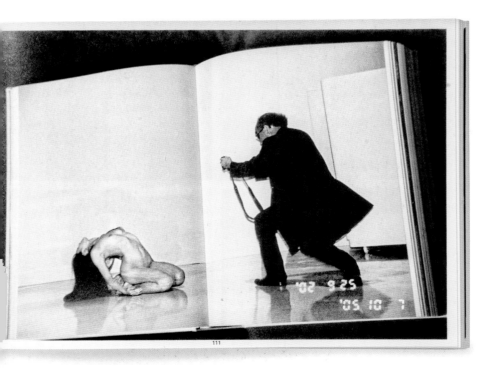

111

Diane Arbus *(Diane Nemerov)*

Diane Arbus. New York/Frankfurt am Main (Aperture/Zweitausendeins) 1972/1984

14.3.1923 New York (USA) — 26.7.1971 New York Fashion and portraits. Sought a typology, *pace* Sander, of the abnormal. In general, greatly influenced the photography of the 1960s and 70s. Grandparents Polish-Jewish immigrants. 1930–1940, attends school in New York (Ethical Culture School and Feldston School). Meets the future photographer Allan Arbus, whom she marries 1941. Takes up photography. Mostly self-taught. From 1946 first photo experiments with a Speed Graphic camera. In this phase short study under > Abbott. Together with Allan A. (commissioned by her grandfather's fur company) first fashion photos. From 1947 regular fashion photography for *Glamour*, *Vogue*, and *Seventeen*. Also advertising contract work for Young & Rubicam, for Greyhound and Maxwell House Coffee. Workshop with > Brodovitch, in 1958 with > Model. Subsequently abandons fashion for her own projects, quickly developing an affinity for those on the margins of society. Divorces Allan A. 1959. Beginning in the 1960s, publication of her always-controversial oeuvre in magazines such as *Esquire*, *Harper's Bazaar*, *Nova*. In this period also portraits (e.g. Lucas Samaras, Frank Stella, James Rosenquist, Jorge Luis Borges, and Marcel Duchamp), her "home visits", and photo essays that caricature "normality" (e.g. the seemingly ideal world of the middle class in a nudist camp). 1965–1966 teaches at Parsons School of Design, New York, at the Cooper Union, New York (1968–1969) and Rhode Island School of Design, Providence (1970–1971). Guggenheim Fellowship 1963 and 1966. Robert Leavitt Award 1970. 1967 part of *New Documents*, an important MoMA exhibition. Although both highly praised and also strongly criticized during her lifetime (see Susan Sonntag's accusation of her "anti-humanist message"), D.A. becomes a cult figure in the world of photography after her suicide and a major retrospective at the Museum of Modern Art (1972).

EXHIBITIONS (Selected) — **1967** New York (Museum of Modern Art/**New Documents**) GE // **1972** New York (Museum of Modern Art) SE // Venice (Biennale) SE // **1978** Frankfurt am Main (Fotografie Forum) SE // **1980** Paris (Centre Pompidou) SE // **1987** New York (Robert Miller Gallery – 2005) SE // **1991** Chicago (Edwynn Houk Gallery) SE // **2001** Berlin (Kicken Berlin) SE // **2003** San Francisco (San Francisco Museum of Modern Art/**Revelations**) SE // **2004** Los Angeles (Los Angeles County Museum of Art/**Revelations**) SE // Houston (Museum of Fine Arts/**Revelations**) SE // **2005** New York (Metropolitan Museum of Art/**Revelations**) SE // Essen (Museum Folkwang/**Revelations**) SE // London (Victoria and Albert Museum/**Revelations**) SE // **2006** Barcelona (Caixa Forum/**Revelations**) SE // Minneapolis (Walker Art Center/**Revelations**) SE // **2007** Los Angeles (Fraenkel Gallery) SE // **2008** Paris (Kadist Art Foundation/**Rétrospective imprimée** 1960–1971) SE // **2011** Paris (Jeu de Paume) SE // **2012** Berlin (Martin-Gropius-Bau) SE

BIBLIOGRAPHY (Selected) — **D.A.** New York 1972/Frankfurt am Main 1984 // **D.A. Magazine Work 1960–1971.** New York 1984 (cat. Spencer Museum of Art) // Patricia Bosworth: **D.A.: A Biography.** New York 1984 ✍ // Jane Livingston: **The New York School.** New York 1992 // **D.A.: Revelations.** Munich 2003 // **D.A.: Family Albums.** New Haven 2003 // **D.A.: The Libraries.** San Francisco 2005 (cat. Fraenkel Gallery) // Violaine Binet: **D.A.** Paris 2009

"Diane Arbus's disturbing photographs of freaks and eccentrics were already well known in the international art world when she took her life in 1971. A year after her death, ten of her photos of her bizarre people (midgets, transvestites, nudists) were shown at the Venice Biennale, monumentally enlarged. They were the 'overwhelming sensation of the American Pavilion' […] It is quite possible that Diane Arbus would never have attained such a level of fame had she not died, although it is widely recognized that her austere, almost brutal style […] greatly influenced other photographers. She radically altered our perception of what was permitted in photography, extending the spectrum of acceptable subjects. She also deliberately explored the visual ambiguity of marginal groups as well as of people well integrated in society."

— Patricia Bosworth ✍

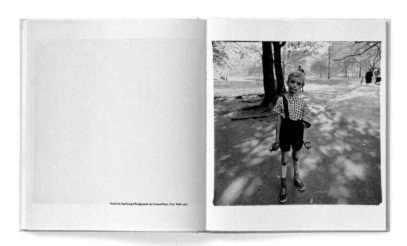

Kind mit Spielzeug-Handgranate im Central Park, New York 1962

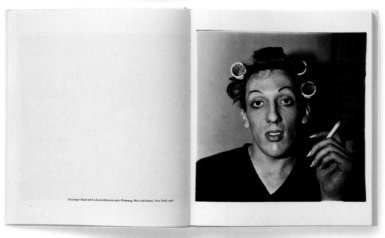

Ein junger Mann mit Lockenwicklern in seiner Wohnung, West 20th Street, New York 1966

Eve Arnold

Eve Arnold, from: **Camera**, no. 5.
May 1954

21.4.1912 Philadelphia (Pennsylvania, USA) — 4.1.2012 London (England) Intimate portraits of Marilyn Monroe and an extensive color essay on China are the best-known works of this prominent Magnum photographer. Daughter of Russian immigrants. At first interested above all in literature and dance. Mid 1940s, takes first photographs. 1948 six-week photography course at the New School for Social Research under > Brodovitch. Photos of fashion show in Harlem her first published work (in *Picture Post*). Turns professional. Numerous publications, incl. in *Life*, *Look*, *Stern*, *Paris Match*, *Vogue*, *The Sunday Times*. In the 1960s and 70s, photo reports on black Muslims, Malcolm X, and the civil rights movement in the USA. 1976 series on women in the world (*The Unretouched Woman*). 1979 two trips to China followed by a widely admired book. 1983 essay on contemporary America. *Marilyn Monroe: An Appreciation* is still her most admired publication. Further photo essays on James Cagney, Joan Crawford, Clark Gable, Paul Newman. Associate member of Magnum from 1951, full member from 1957. Travels, to South America, India, the Soviet Union, Afghanistan, Egypt, and South Africa among others. Moves to London in 1962. Many awards, incl. Kraszna-Krausz Book Award for *In Retrospect* (1996) and the Order of the British Empire (2003).

EXHIBITIONS (Selected) — **1980** New York (Brooklyn Museum) SE // **1991** London (National Portrait Gallery) SE // **1995** New York (International Center of Photography) SE // **1999** Edinburgh (Scottish National Portrait Gallery) GE // **2002** London (Zelda Cheatle Gallery – 2003) SE // **2004** Los Angeles (Apex Fine Art – 2005) SE // **2005** London (Halcyon Gallery) SE // **2007** London (Atlas Gallery) SE // **2008** Amsterdam (Stedelijk Museum Post CS/**MAGNUM** Photos 60 Years) GE // **2012** Munich (Kunstfoyer der Versicherungskammer Bayern) SE

BIBLIOGRAPHY (Selected) — **The Unretouched Woman**. New York 1976 // **Flashback! The 1950's**. New York 1978 // **In China**. New York 1981 // **In America**. New York 1983 // **Marilyn Monroe: An Appreciation**. New York 1987 // **Private View: Inside Baryshnikov's American Ballet Theatre**. New York 1988 // **All in a Day's Work**. New York 1989 // **In Britain**. London 1996 // **In Retrospect**. New York 1996 // **Die Magnum-Fotografinnen**. Munich 1999 // **Film Journal**. London 2002 // **Handbook**. London 2004 // **Marilyn Monroe by E.A.** New York 2005 // Brigitte Lardinois: **Magnum Magnum**. Munich 2007 ✍ // **All About Eve. The Photography of E.A.** Kempen 2011 // **E.A. Hommage**. Munich 2012 (cat. Kunstfoyer der Versicherungskammer Bayern)

"In all of Eve's work, as with her personality, her special ability has been getting close to her subjects — often becoming a trusted friend, regardless of their caste or fame, while always maintaining the dignity that permeates her, a principal characteristic of her charisma. Eve Arnold's legacy is as varied as it is fascinating. It is hard to fathom that one person's work can be so diverse. It covers the humblest to the most exalted, the meanest to the kindest and everything in between. The subjects are all there in Eve Arnold's photographs and they are treated with intelligence, consideration and sympathy. The most important factor is Eve's ability to visually communicate her ideas inconspicuously and unpretentiously in the best humanist tradition." — Elliott Erwitt ✍

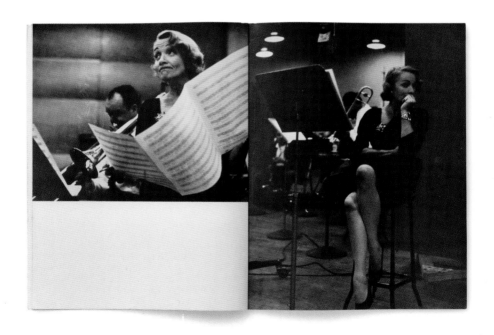

Jean-Eugène-Auguste Atget

Atget. Photographe de Paris.
Paris (Henri Jonquières) 1930

12.2.1857 Libourne (France) — 4.8.1927 Paris (France) Over three decades, on his own initiative, broad documentation of old Paris. Initially discovered by the Surrealists for the world of art. Now a model for countless documentary photographers. Loses both his parents at an early age. From 1862 lives with his mother's parents. After finishing school, becomes a cabin boy in the merchant marine. From 1878 in Paris. Drama school. Military service: 1881 released after the death of his grandparents. Traveling actor. 1887 gives up acting (because of vocal chord infection). Paints, without success. From 1888, takes up photography. Makes artists' studies for painters ("documents for artists"). 1897 begins a systematic exploration of old Paris: "petty tradesmen", courtyards and facades, elements of facades (doors, balconies), shop windows, interiors. 1898 first sale to public institutions (incl. Musée Carnavalet). Meets > Man Ray (like A. living in Montparnasse, Rue Campagne-Première, since 1922). 1926 four photographs (uncredited) in the magazine *La Révolution surréaliste*. 1927 – through Man Ray – portrait sitting for > Abbott (three photographs). After A.'s death, his estate acquired by Archives Photographiques d'Art et d'Histoire (2,000 negatives) as well as – with the support of gallery owner Julien Levy – by Abbott (7,800 glass negatives, 1,400 prints). 1929 presentation of 11 photographs at the Werkbund exhibition *Film und Foto*. The monograph *Atget: Photographe de Paris* (1930), brought out by Abbott is the beginning of his international reputation. 1968 acquisition of Abbott collection by the Museum of Modern Art, New York. For the 150th anniversary of his birth, a major retrospective with stops in Paris, Berlin, and Winterthur.

EXHIBITIONS [Selected] — **1928** Paris (1er Salon indépendant de la photographie/**Salon de l'Escalier**) GE // **1929** Stuttgart (**Film und Foto**) GE // **1930** New York (Erhard Weyhe Bookstore and Gallery) SE // **1931** New York (Julien Levy Gallery – 1936) JE (with Nadar) SE // **1952** New York (Metropolitan Museum) SE // **1972** New York (Museum of Modern Art – 1981, 1982, 1983, 1985, 1987) SE // **1982** Paris (Musée Carnavalet – 1992) SE // **2000** Paris (Hôtel de Sully) SE // Los Angeles (J. Paul Getty Museum) SE // **2007** Paris (Bibliothèque nationale de France) SE // Berlin (Martin-Gropius-Bau) SE // **2008** Winterthur (Fotomuseum) SE // Cologne (Galerie Thomas Zander) JE (with Lee Friedlander) // **2011** Madrid (Fundación Mapfre) SE

BIBLIOGRAPHY [Selected] — Berenice Abbott (ed.): **A.: Photographe de Paris**. New York 1930 // Berenice Abbott: **The World of Atget**. New York 1964 // Jean Leroy: **A.: Magicien du vieux Paris en son époque**. Paris 1975 // John Szarkowski and Maria Morris Hambourg (eds): **The Work of A.**, 4 vols. New York 1981–1985 // Laure Beaumont-Maillet (ed.): **A.: Paris**. Paris 1992 // Wilfried Wiegand: **E.A.: Paris**. Munich 1998 ∠ // Atget, le pionnier. Paris 2000 (cat. Hôtel de Sully) // **E.A.: Paris**. Cologne 2000 // **A.: Une Retrospective**. Paris 2007 (cat. Bibliothèque nationale de France) // **E.A.: Photographe de Paris**. New York 2008 (= **Books on Books** no. 1)

"The history of photography is short, but it is long enough for us to divide it into the epoch of the old masters and a modern epoch. As with painters, among photographers we most admire a few old masters who inexplicably seem modern, as if they were strangers in their own times and created their work for future generations. The best-known examples of such artists, strange and at the same time familiar, are Vermeer amongst painters and Atget for the photographers."

— Wilfried Wiegand

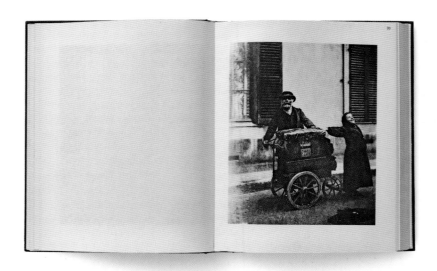

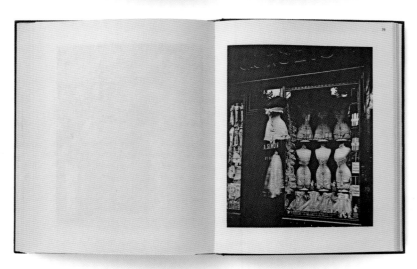

Richard Avedon

Richard Avedon: **Observations.**
New York (Simon & Schuster)
1959

15.5.1923 New York (USA) — 1.10.2004 San Antonio (Texas, USA)
Talented crossover between independent and commissioned photo-
graphy. Fashion and portraits are the focus of his creative interests.
Brodovitch student. Together with Irving Penn, unquestionably the
best-known 20th-century American art photographer. 1937–1941
DeWitt Clinton High School in New York. 1941–1942 studies at Colum-
bia University. 1942–1944 serves in the merchant marine. 1944–
1950 studies under > Brodovitch at the New School for Social Re-
search. Own studio from 1946. 1945–1947 contract photographer for
Junior Bazaar under Brodovitch and Carmel Snow (with Henry Wolf,
Marvin Israel, Ruth Ansel, and Bea Feitler as later art directors). 1957
consultant for Stanley Donen's film *Funny Face*. 1958 voted one of
the ten most important photographers by *Popular Photography*. 1962
first museum exhibition (arranged by Marvin Israel). 1966 switches
to *Vogue* under Diana Vreeland and > Liberman. 1985–1992 publish-
es exclusively in *Egoïste*. 1994 staff photographer for the *The New
Yorker*. > Munkácsi as model for this fashion photography innovator (outdoor and in the studio) al-
ways interested in typography and layout. In addition, independent series: street photography, espe-
cially portraits, generally against a neutral (white) background. Best known are his portraits of his
father (at the end marked by his impending death), Jacob Israel A., and anonymous people from the
American west. 1970 brings out his first monograph on > Lartigue: *Diary of a Century*. Also TV com-
mercials, campaigns for Chanel, Dior, Versace, and Calvin Klein. Numerous awards, incl. Hasselblad
Award (1991), Berlin Photography Prize (2000).

EXHIBITIONS (Selected) — **1962** Washington, DC (Smithsonian Institution – 1972) SE // **1970** Minneapolis (Minnesota) (Institute of Arts) SE // **1974** New York (Museum of Modern Art) SE // **1975** New York (Marlborough Gallery) SE // **1978** New York (Metropolitan Museum of Art – 2003) SE // **1980** Berkeley (California) (University of California) SE // **1985** Fort Worth (Texas) (Amon Carter Museum) SE // **2001** Wolfsburg (Kunstmuseum) SE // **2007** Berlin (Camera Work) SE // Humlebæk (Denmark) (Museum of Modern Art) SE // **2008** Milan (Forma) SE // Paris (Jeu de Paume) SE // Berlin (Martin-Gropius-Bau) SE // **2009** Amsterdam (Fotografiemuseum Amsterdam) SE // San Francisco (Museum of Modern Art) SE // New York (International Center of Photography) SE // **2011** Cologne (Museum Ludwig) GE // **2014** Munich (Museum Brandhorst) SE

BIBLIOGRAPHY (Selected) — **Observations**. New York 1959 // **Nothing Personal**. New York 1964 // **Portraits**. New York 1976 // **Photographs 1947–1977**. New York 1978 // **In the American West 1979–1984**. New York 1985 // Jane Livingston: **The New York School**. New York 1992 ✍ // **An Autobiography**. New York 1993 // **Evidence 1944–1994**. New York 1994 (cat. Whitney Museum of American Art) // R.A. and Doon Arbus: **The Sixties**. New York 1999 // **Woman in the Mirror**. New York 2005 // **The Kennedys – Portrait of a Family**. New York 2007 // Michael Juul Holm (ed.): **R.A.: Photographs 1946–2004**. Ostfildern 2007 (cat. Museum of Modern Art, Humlebæk) // **R.A.: Fashion 1944–2000**. New York 2009 (cat. International Center of Photography) // **Ichundichundich. Picasso im Fotoporträt**. Cologne 2011 (cat. Museum Ludwig)

T
he only front-rank artists
that have been exclusively developed by the movie me-
dium are, all too obviously, Garbo, Chaplin, a couple
of cameramen, several directors, and the Italian screen-
writer Cesare Zavattini.

An amiable hysteric with jutting chipmunk teeth, left-
minded and a would-be hermit, Zavattini is the single
original literary figure for which films can assume credit:
if the form had gone uninvented, it is not likely that his
writing would have amounted to much—pictorial plays
are his true means of expression and, living in the hills
beyond Rome far from the Via Veneto parade, he works
on them with that isolated intensity one associates with
the more dedicated poets; in result, he is in good measure
responsible for the successes of De Sica, for whom he
composed, among others, The Bicycle Thief, Shoe Shine,
Miracle in Milan, Umberto D., and, lately, The Roof.
It is interesting that De Sica has never made a first-rate
film not derived from Zavattini's work; after reading a
half dozen of his scripts, the reason would seem to be:

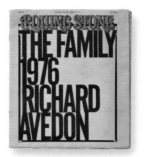

"For much of his life, Richard Avedon has set the pace in various genres within American photography, while simultaneously teasing them and testing their limits. As a portraitist and fashion and advertising photographer, Avedon has virtually invented a series of photographic styles. As is now being revealed, he also made a substantial body of reportorial documentary work during the late 1940s, 1950s, and 1960s." — Jane Livingston ✍

Richard Avedon: **The Family 1976,** from: **Rolling Stone,** no. 224, 1976

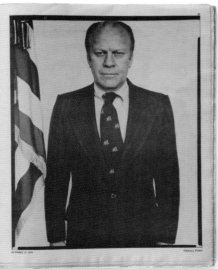

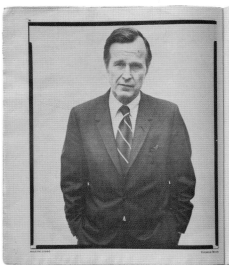

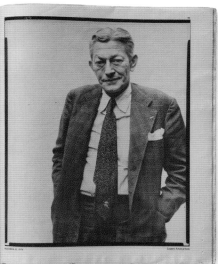

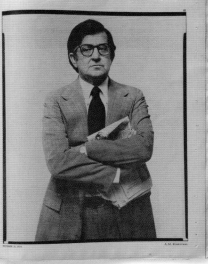

David *(Royston)* Bailey

David Bailey: **Bailey's Democracy.**
Göttingen (Steidl Verlag) 2005

2.1.1938 London (England) — **Lives in London** British 1960s cult photographer. Together with Brian Duffy and Terence Donovan, the most prominent interpreter of fashion at the time. Initially also street photography. Later, landscapes, still lifes, nudes, and portraits. Model for the restlessly obsessive photographer in Antonioni's film *Blow-Up* (1967). Schooling in London (1944–1956). Self-taught photographer. Serves in the Royal Air Force in Malaysia (1957–1958). 1959 assistant in John French's studio. From 1960 contract photographer for *Vogue*. In addition, freelance work for *Daily Express*, *Sunday Times*, *Daily Telegraph*, *Elle*, and *Glamour*. 1963 publication of his first book *The Truth About Modelling*. From 1966 also TV commercials. Documentary on > Beaton (1971) and > Warhol (1973). Member of the Royal Photographic Society (from 1972), as well as the Society of Industrial Artists and Designers (from 1975). Marries Rosemary Bramble (divorced), Catherine Deneuve (divorced), Marie Helvin (divorced), and Catherine Dyer. Also works as a painter and farmer.

"The identification of Bailey as central to pop culture in the 1960s is based more on his social milieu, and the subjects of his portraits, than an expression inherent in his photography. He consciously distanced himself from the image of 'swinging' London sanctioned by the USA [...]. By late 1964 Bailey's attitude to fashion photography was changing; boredom and disenchantment were creeping in. He was preparing the portraits which would be published the following year as *David Bailey's Box of Pin-ups*, and which heralded the diversification in his career that would be fully realized in the 1970s." — Martin Harrison ✍

EXHIBITIONS (Selected) — **1971** London (National Portrait Gallery – 2002) SE // **1972** Paris (Nikon Galerie) SE // **1973** London (The Photographers' Gallery) SE // **1980** London (Olympus Gallery – 1981, 1982) SE // **1983** London (Victoria and Albert Museum – 1991) SE /GE // **1998** Bradford (England) (National Museum of Photography, Film and Television) GE // **2002** London (Hamiltons) SE // **2003** London (Proud Central) JE (with [John] Rankin) // **2005** London (Faggionato Fine Art) SE // **2006** New York (Faggionato Fine Art) SE // **2014** London (National Portrait Gallery) SE

and White Memories: Photographs 1948–69.** London 1983 (cat. Victoria and Albert Museum) // **Nudes.** London 1984 // Martin Harrison: **Appearances: Fashion Photography Since 1945.** London 1991 (cat. Victoria and Albert Museum) ✍ // **If we shadows.** London 1992 // **The Lady is a Tramp. Portraits of Catherine Bailey.** London 1995 // Martin Harrison: **Young Meteors. British Photojournalism: 1957–1965.** London 1998 (cat. National Museum of Photography, Film and Television, Bradford) // **Archive One 1957–1969.** London 1999 // **Chasing Rainbows.** London 2001 // D.B.: **Locations.** London 2003 // **B.'s Democracy.** Göttingen 2005 // **Havana.** Göttingen 2006 // **NY JS DB 62.** Göttingen 2007 // **Eye.** Göttingen 2009 **Bailey's Delhi Dilemma.** Göttingen 2010 // **D.B.'s Stardust.** Munich 2014 (cat. National Portrait Gallery, London)

BIBLIOGRAPHY (Selected) — **D.B.'s Box of Pin-ups.** London 1964 // **Goodbye Baby and Amen.** London 1969 // **Beady Minces.** London 1974 // **D.B.'s Trouble and Strife.** London 1980 // **Black**

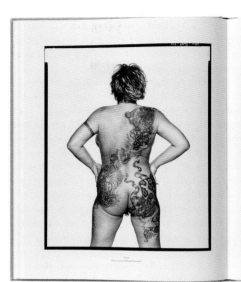

Dmitri *(Nikolajevich)* Baltermants
Dmitri Grigoryevich Stolovitskij

Dmitri Baltermants: **Selected Photographs.** Moscow (Planeta Publishers) 1977

13.5.1912 Warsaw (Poland) — 11.6.1990 Moscow (Soviet Union) Photojournalist, war photographer. Widely regarded as a giant of Soviet photography. Father, Grigori Stolovitski, officer in the Tsarist army. 1915, parents divorce. Adopted by stepfather Nikolai B. Apprenticeship as a printer and typesetter at *Izvestya*. 1935–1938 studies mathematics at Moscow University. Takes up photography (self-taught). 1936 first small-format camera. 1939 (under contract from *Izvestya*) photos of the occupation of Ukraine and Poland (Molotov-Ribbentrop Pact). First publications in the magazine *Ogonyok*, among others. 1940 photographs Stalin and his close circle. War reporter. 1942 series *Grief* (on a battlefield covered with bodies near Kerch in the Crimea) his most shocking (not published, however, until 1962) work of the period. 1942 Stalingrad. Wounded in battle. To 1943 convalescence. From 1944 works for the army journal *Narasgrom vraga*. With the Red Army to Berlin. From 1945 works for *Ogonyok*, from 1964 as chief photographer. In this post virtual chronicler of Soviet foreign and domestic policy. Numerous portraits of influential contemporaries (Castro, Nixon, Tito, Thatcher, and all party chairmen from Stalin to Gorbachev). From 1980 often on the World Press Photo Prize jury. Articles on D.B. incl. in *Photo* (July 1989) and *Life* (July 1992).

EXHIBITIONS (Selected) — **1962** Moscow (House of Journalists) SE // **1964** London (Ceylon Tea Hall Centre) SE // Hamburg (**Weltausstellung der Fotografie** – 1968) GE // **1987** Perpignan (France) (Visa pour l'Image) SE // **1990** New York (International Center of Photography – 1992) SE // Paris (Mois de la Photo) SE // **1991** Santa Monica (California) (G. Ray Hawkins Gallery) SE // Washington, DC (Corcoran Gallery of Art) GE // **1998** London (Elizabeth Hall) SE // **2005** Paris (Maison européenne de la photographie) SE // **2009** Barcelona (Kowasa Gallery/**The Vision of the Other**) GE

BIBLIOGRAPHY (Selected) — **100 Days in China**. Moscow 1955 // **D.B.: Selected Photographs**. Moscow 1977 // **D.B.** Leipzig 1981 // **The Russian Century**. New York 1994 // **Faces of a Nation: The Rise and Fall of the Soviet Union, 1917–1991**. Golden 1996 // **D.B.** Paris 1997 (= Photo Poche no. 70) ✍

"Nicknamed 'the eye of the nation', Dmitri Baltermants was the principal author (producer and censor) of the majority of images shown to the Soviet people for almost a half a century. Photographer, photojournalist and later photo editor for the magazine *Ogonyok*, the most widely distributed news magazine of the time, Baltermants had a considerable influence on the way Russians viewed their world. His numerous works, expositions and contributions in public of course served the state, but also provided the peoples of all the republics of the empire with a visual heritage synonymous with national pride, founded on the accomplishments of everyday life, international action, development of resources and ethnic diversity." — Paul Harbaugh ✍

Gian Paolo Barbieri

Gian Paolo Barbieri: **Madagascar.** Cologne (TASCHEN) 1997

1938 Milan (Italy) — Lives in Milan and the Seychelles Fashion and beauty for editorial and advertising. Since the late 1960s one of the most sought after representatives of his field. Also independent themes around the way of life, and the cult of the body, in the South Seas. Child of a well-off Milan family. His father works in wholesale textiles, so he is familiar with the world of fashion early on. Studies economics at Cattolica University. Also strong interest in theater and cinema. 1961 moves to Rome with the hope of a career in Cinecittà. There works in darkroom, developing and printing photos of rising stars. 1962 moves to Paris. Assistant to Tom Kublin "an excruciating two-month experience", which at least opens the door to the world of professional photography. 1965 photographer under contract to the Italian *Vogue*, whose first cover he designs. Subsequently also works for the French, American, and German *Vogue*. Parallel to editorial, also increasing advertising work, for example for Valentino, Armani, Yves Saint Laurent, Ferré, Versace, Dolce & Gabbana. Also publications in *Look*, *Town & Country*, *Harper's Bazaar*, and *Stern*. The latter ranked him among the 14 top fashion photographers in 1978. Participates in important exhibitions on fashion photography in London (Victoria and Albert Museum, National Portrait Gallery) and Vienna (Kunstforum Länderbank).

"He fills the sumptuous elegance of his portraits of women as well as scenes in poor neighborhoods with the same spirit, the same love. A secret that is his alone. As soon as I met him through Gustav Zumsteg, I was very dazzled by his work. The face of a young woman impressed me as a face of startling intensity that I did not hesitate to make the image of the latest perfume that I launched at the time. I deeply admire Gian Paolo Barbieri. I think he is sensitive, human, capable of tenderness and nobility. A painter of the everyday world and that of mysterious dream." — Yves Saint Laurent ✍

EXHIBITIONS (Selected) — **1984** Milan (La Rinascente) GE // **1990** Vienna (Kunstforum Länderbank/**Modefotografie von 1900 bis heute**) GE // **1991** Milan (Il Diaframma) SE // **1995** Milan (Photology — 1998, 2002, 2004, 2007) SE/GE // **1996** New York (The Landon Gallery) SE // **2000** Milan (Galleria Gio Marconi GQ) SE // **2004** Milan (Palazzo della Triennale) SE // **2007** Naples (Studio Trisorio) SE // Milan (Palazzo Reale) SE // **2008** Lugano (Museo d'Arte/**Photo20esimo**) GE // **2009** Bologna (Galleria Stefano Forni) GE //**2010** New York (Clic Bookstore & Gallery) SE

BIBLIOGRAPHY (Selected) — **I Grandi Fotografi: G.B.** Milan 1982 // **Artificial.** Veniano 1982 // **Silent Portraits.** Modena 1984 // **G.B.** Milan 1988 // **Tahiti Tattoos.** Milan 1989 // Ingried Brugger (ed.): **Modefotgrafie von 1900 bis heute.** Vienna 1990 (cat. Kunstforum Länderbank) // **Madagascar.** Cologne 1997 // **Tahiti Tattoos.** Cologne 1998 // **Equator.** Cologne 1999 // **A History of Fashion.** Milan 2001 // **Innatural.** Rome 2004 // **Sud.** Milan 2006 // **Body Haiku.** Milan 2007 // **G.P.B.** Milan 2007

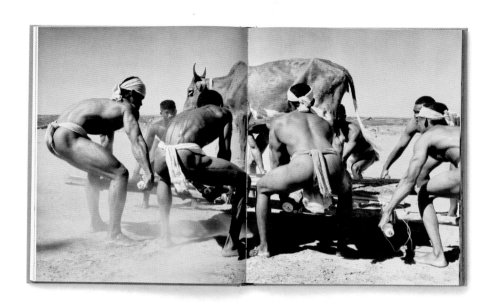

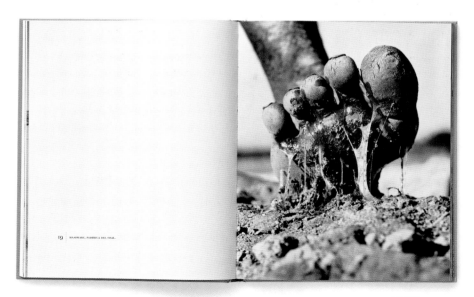

19 HAADWARI, FABRICA DEL SISAL.

Lillian Bassman *(Lillian Himmel)*

Lillian Bassman. Kilchberg/
Zurich (Edition Stemmle) 1997

15.6.1917 New York (USA) — 13.2.2012 New York Important fashion photographer in the 1940s and 50s, with numerous publications, especially in *Harper's Bazaar*. Daughter of Russian immigrants. Attends school in New York — Textile High School, and City College in Manhattan. At the time also nude model at the Art Students League. 1934 – 1939 WPA fellowship. Works as "assistant painter". 1935 marries the photographer and later psychoanalyst Paul Himmel (1914– 2009). Takes up textile design and attends evening classes at the Pratt Institute, Brooklyn. 1940 presents her fashion illustrations to > Brodovitch, who accepts her for one of his classes at the New School for Social Research. 1941 Brodovitch's assistant at *Harper's Bazaar*. Moves to the cosmetic firm Elizabeth Arden as Betty Godfrey's assistant. Returns to *Harper's Bazaar*. 1945–1948 art director for the magazine *Junior Bazaar*. Works with young photographers such as > Avedon, > Faurer, > Frank, > Neuman, Herman Landshoff, and Himmel. Also produces her own fashion photography for the first time for *Junior Bazaar* (May 1948 – the magazine's last issue). Works more as photographer for *Harper's Bazaar*. 1951 opens a studio in New York with Himmel. From 1962 mostly advertising. 1971 retires from commercial photography and works on independent art projects. 1984–1988 her own fashion line under the label L.B. Rediscovery of her early fashion photos as part of *Shots of Style* exhibition, curated by > Bailey. 1985–1995 teaches at the Parsons School of Design. 1996 once again fashion photos for the *New York Times Magazine*. In the same year Graphis/ Agfa Lifetime Achievement Award, as well as Directors Club Award. Homage to L.B. at the Rencontres d'Arles 1999 (*Les Dames de Bazaar*). 2009 major retrospective with Paul Himmel at the Haus der Photographie/Deichtorhallen Hamburg.

EXHIBITIONS (Selected) — **1978** New York (Staempfli Gallery) SE // **1989** London (Victoria and Albert Museum/**Shots of Style**) GE // **1992** New York (Howard Greenberg Gallery – 1997) SE // **1993** London (Hamilton's Gallery) SE // Paris (Palais de Tokyo/**Vanités**) GE // **1994** Paris (Cinquième Festival International de la Photo de Mode) SE // Atlanta (Georgia) (Jackson Fine Art) SE // **1997** New York (Fashion Institute of Technology) SE // Los Angeles (Peter Fetterman Gallery – 2006, 2008) SE // New York (Gallery 292) SE // **2000** Toronto (Tatar/Alexander Gallery) SE // **2001** Moscow (House of Photography) SE // New York (Ricco Maresa Gallery) SE // **2002** Madrid (PHotoEspaña) SE // London (Michael Hoppen Gallery) SE // **2003** Munich (Galerie f5,6 – 2009) SE // **2004** New York (Staley Wise Gallery – 2006, 2008, 2009) SE // **2005** Hamburg (Monika Mohr Galerie) SE // **2007** La Jolla (California)

(Joseph Bellows Gallery) SE // **2008** New York (Hearst Tower) SE // **2009** Hamburg (Deichtorhallen/Haus der Photographie) JE (with Paul Himmel) // **2012** Leipzig (Grassi Museum) SE // **2014** Vienna (Kunst Haus Wien) SE

BIBLIOGRAPHY (Selected) — Martin Harrison: **Appearances: Fashion Photography Since 1945**. London 1991 ⬈ //**Vanités**. Paris 1993 (cat. Palais de Tokyo) // **L.B.** Boston/New York/ Toronto/London 1997 // "Layout, was ist denn das?" In: **Leica World**, no. 1, 2000 // **Diccionario de Fotógrafos/A Dictionary of Photographers 1998–2007**. Madrid 2007 (cat. PHotoEspaña) // **Women**. New York 2009 // **L.B. & Paul Himmel: Die erste Retrospektive/The First Retrospective**. Heidelberg 2009 (cat. Deichtorhallen/Haus der Photographie)

"Bassman's atmospheric photographs succinctly expressed mood or emotion, before describing detailed fashion information. Brodovitch would appear to have supported this impressionistic approach in the late 1940s, but it was basically at odds with Carmel Snow's insistence on showing 'the buttons and bows'. The most oblique of Bassman's experiments were published in *Harper's Bazaar*, December 1949 and March 1950, and involved an almost total elimination of detail. The negatives were printed through a tiny hole cut in card, exposing only those areas which she selected. […] This was about as far as anti-realism could go, and very rarely was Bassman permitted to be as radical again." — Martin Harrison ✎⊐

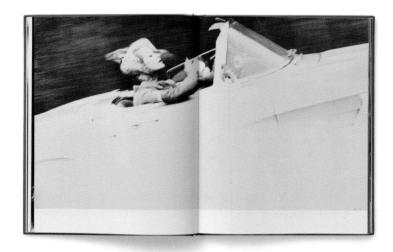

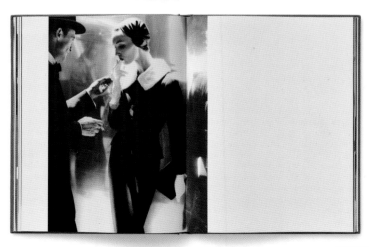

John Batho

John Batho. Toulouse (cat. Galerie municipale du Château d'Eau) 1980

4.3.1939 Beuzeville dans l'Eure (France) — Lives in Paris (France) Important French exponent of artistically intentioned color photography. Since the mid 1970s, well known for his work produced using the Fresson process. Son of a French mother and English father. 1954–1957 apprentice in book and art restoration, and works in the national archives. 1959–1961 military service in Algeria. 1961 begins his self-taught exploration of photography. 1963 marries Claude Bodier (1935–1981), who as a photographer is known under the name Claude Batho. End of the 1960s, takes up color photography definitively and develops a specific pictorial language — at first unpublished experiments, which only attract attention with his discovery of the Fresson process (1976). First exhibition of his work 1977. Subsequently a number of photo series such as *Manèges* (1980–1983), *Deauville* (1977–1986), *Giverny* (1980–1983), *Burano* (1983–1985). From 1981 also some prints in Cibachrome. Workshops on the theme of color, for example at Rencontres d'Arles. Publishes in *Photo Ciné Magazine*, *Professional Camera*, *Photo Revue, Photo Magazine*. 1986 participates in the important group exhibition *50 Jahre moderne Farbfotografie/50 Years Modern Color Photography 1936–1986* and photokina in Cologne.

"We must congratulate John Batho for having settled on the concentrated warmth, rich and dense velour of clean surfaces, matte and soft, of the Fresson process. John Batho's color fields, thus brought to their richest expression, easily compensate for their lack of precision relative to reality that some nit-pickers might criticize." — Jean Dieuzaide ✎

EXHIBITIONS (Selected) — **1977** Paris (Musée d'art moderne de la Ville de Paris) GE // **1978** New York (Zabriskie Gallery – 1981) SE/GE // Paris (Galerie Zabriskie – 1980, 1981, 1982) SE/GE // Chalon-sur Saône (France) (Musée Nicéphore Niépce) SE // **1979** London (The Photographers' Gallery) SE // **1980** Toulouse (Galerie municipale du Château d'Eau) SE // Lausanne (Galerie Portfolio) SE // **1982** Nuremberg (Galerie Profoto) SE // Cologne (photokina – 1986) GE // **1983** Washington, DC (Galerie Addison Ripley) SE // Le Mans (Palais de la Culture) SE // **1984** Mulhouse (France) (Galerie A.M.C.) SE // **1987** Florence (Fratelli Alinari) SE // **2003** Chalon-sur-Saône GE // **2006** Mulhouse (France) (La Galerie de La Filature) GE

BIBLIOGRAPHY (Selected) — Sue Davies, Michael Langford, and Bryn Campbell: **European Colour Photography**. London 1978 (cat. Photographers' Gallery) // Toulouse 1980 (cat. Galerie municipale du Château d'Eau) ✎ // **La couleur et son lieu**. Mulhouse 1984 (cat. Galerie A.M.C.) // **Giverny comme une peinture déjà faite.** Aurillac 1984 // **Photocolore.** Paris 1985 // **50 Jahre moderne Farbfotografie/50 Years Modern Color Photography 1936–1986**. Cologne 1986 (cat. photokina) // **At the Still Point: Photographs from the Manfred Hewiting Collection at the Museum of Fine Arts, Houston. Volume III.** Amsterdam/Houston 2010

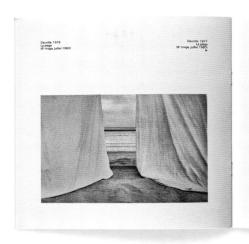

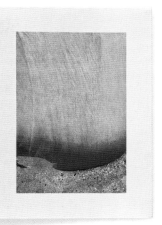

Herbert Bayer

5.4.1900 Haag (Austria) — 30.9.1985 Montecito (California, USA) Painter, typographer, designer, architect, and photographer. Bauhaus graduate. Pioneer of modern communications design in Germany and the USA. 1919–1920 apprentice at a graphics studio in Linz. 1921 moves to Darmstadt. Typographical designs for Emmanual Margold. 1921–1925 studies at Bauhaus (under Oskar Schlemmer, Wassily Kandinsky, among others). First photographs, photomontages around 1925. 1925–1928 heads Bauhaus workshop for print and advertising. Design of school's printed matter. 1928 in Berlin artistic consultant for the (short-lived) first German *Vogue* as well as (to 1938) head of the advertising agency studio Dorland's Berlin office. In addition still lifes and collages influenced by > Heartfield and Hannah Höch. 1929 prominent part in Werkbund exhibition in Stuttgart. 1933 designs catalogue for the exhibition *Die Kamera* (Berlin). 1936 catalogue design for *Germany* (a show for the Olympic Games in Berlin). 1938 emigrates to the USA. In the same year designs the Museum of Modern Art catalogue *Bauhaus 1919–1928*. 1942 designs the propaganda exhibition *Road to Victory* as well as (1943) *Airways to Peace*. From 1946 design consultant for the Aspen (Colorado) cultural center. 1946–1956 artistic consultant for Container Corporation of America. From 1966 consultant for Atlantic Richfield Corporation. 1968 global concept *50 Jahre Bauhaus* (in the Württemburgischen Kunstverein). From 1975 in Montecito (California). 1969 Kulturpreis of the DGPh (Deutsche Gesellschaft für Photographie: German Photographic Association).

"While the graphic artist and painter Bayer was always true to himself in his photography as well, it would be erroneous to see this work, like Cohen, as simply a 'backroad' of his output. Contradicting such a view is an oeuvre of over 250 photographs. In spite of all qualifications (a tendency towards the decorative and all too slick – for example *Denkmal* and *Nature morte* – as well as a tendency to myth-making) Bayer's significance is to be seen in his merging of different media, an integration of photography with other forms of design: photomontage, photo sculpture, typography and advertising." — Jeannine Fiedler ✎

EXHIBITIONS (Selected) — **1929** Stuttgart (*Film und Foto*) GE // **1931** New York (**Foreign Advertising**) GE // **1956** Nuremberg (Germanisches Nationalmuseum – 1970) SE // **1971** Munich (Die Neue Sammlung) SE // **1973** Denver (Art Museum) SE // **1977** Los Angeles (Arco Center for Visual Art) SE // **1981** Paris (Centre Pompidou) SE // **1982** Berlin (Bauhaus-Archiv – 1990, 2007) SE /GE // **1997** Bonn (Rheinisches Landesmuseum) GE // **2000** Essen (Museum Folkwang) GE // **2003** New York (Kent Gallery) SE // **2005** Berlin (Kunstbibliothek) GE // **2007** Washington, DC (National Gallery of Art) GE // **2013** Berlin (Bauhaus-Archiv) SE // **2013** Salzburg (Museum der Moderne) GE

BIBLIOGRAPHY (Selected) — **H.B.: Photographic Works**. Los Angeles 1977 (cat. Arco Center for Visual Art) // **H.B.: Das künstlerische Werk 1918–1938**. Berlin 1982 (cat. Bauhaus-Archiv) // Arthur A. Cohen: **H.B.: The Complete Work**. Cambridge (Mass.)/London 1984 // **H.B.: Kunst und Design in Amerika 1938–1985**. Berlin 1986 (cat. Bauhaus-Archiv) // Jeannine Fiedler: **Fotografie am Bauhaus**. Berlin 1990 (cat. Bauhaus-Archiv) ✎ // Klaus Honnef and Frank Weyers: **Und sie haben Deutschland verlassen ... müssen**. Bonn 1997 (cat. Rheinisches Landesmuseum) // **Bauhaus: Dessau > Chicago > New York**. Cologne 2000 (cat. Museum Folkwang, Essen) // Christine Kühn: **Neues Sehen in Berlin. Fotografie der Zwanziger Jahre**. Berlin 2005 (cat. Kunstbibliothek) // Patrick Rössler: **die neue linie 1919–1943. Das Bauhaus am Kiosk**. Bielefeld 2007 (cat. Bauhaus-Archiv, Berlin) // Matthew S. Witkovsky: **Foto: Modernity in Central Europe, 1918–1945**. Washington, DC, 2007 (cat. National Gallery of Art) // **Focus on Photography**. Munich 2013 (cat. Museum der Moderne, Salzburg)

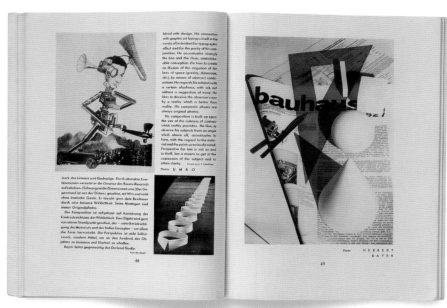

Herbert Bayer: **Umbo – Herbert Bayer,** from: **Gebrauchsgraphik,** July 1930

Peter *(Hill)* Beard

Peter Beard: **The End of the Game.**
San Francisco (Chronicle Books)
1988

22.1.1938 New York (USA) — Lives in Montauk (New York, USA) Painter, draftsman, writer, conceptual artist with a special affinity for Africa. Own photography (hunting scenes, landscapes, portraits) since the 1960s as a starting point for being over-painted, for collages and large-scale installations that include various objets trouvés. Schooling in New York and Vermont (1945–1954). Felsted College, Essex, England (1956–1957), followed by art studies under Josef Albers at Yale University, New Haven (Connecticut) (1958–1961). Graduates with B.A. Works as photographer and diary author from 1950. First visit to Africa in 1955. 1961 moves to Kenya ("Hog Ranch" at the foot of the Ngong Mountains). In the same year first meets the author Karen Blixen (*Out of Africa*). From the mid 1960s, together with wildlife protection organizations, photographs nature in various national parks in Kenya. Since 1973 second home in Montauk (Long Island).

Author of a number of highly acclaimed photobooks on animals of Africa. *End of the Game* is, according to Maren Stange, "a moving view of Kenya as it may have been at the time of the first European explorers, hunters and settlers." Especially well known in Germany through a number of large and lavish publications in *twen* (nos. 1/64, 3/65, and 4/66). 1996 large exhibition in Centre national de la photographie curated by Robert Delpire.

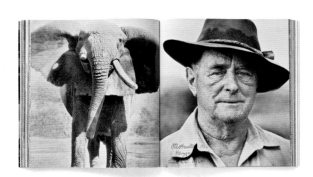

EXHIBITIONS (Selected) — **1975** New York (Blum-Helman Gallery) SE // New York (International Center of Photography) SE // **1979** Tokyo (Seibu Museum) SE // **1996** Paris (Centre national de la photographie) SE // **1998** Berlin (Galerie Camera Work) SE // **1999** Madrid (Museo Nacional de Ciencias Naturales) SE // Vienna (KunstHaus) SE // **2003** Paris (Galerie Kamel Mennour) SE // **2004** Los Angeles (Fahey/Klein Gallery) SE // London (Michael Hoppen Gallery – 2006) SE // **2006** Berlin (Camera Work) SE

BIBLIOGRAPHY (Selected) — **The End of the Game.** New York 1965 // **Carnets Africains. A Retrospective.** Paris 1996 ⚹D.// **Fifty Years of Portraits.** Santa Fe 1999 // **Stress & Density.** Vienna 1999 (cat. KunstHaus) // **Zara's Tales. Perilous Escapades in Equatorial Africa.** New York 2004 // Steven M. L. Aronson, Owen Edwards: **Peter Beard.** Cologne 2006 // **Die letzte Jagd.** Cologne 2008

"Since 1961, Peter Beard's life has been definitively tied to Africa and animals. Elephants, of course, but also crocodiles, zebras, buffalo, lions, rhinoceroses, and antelope populate a world in which men and women have a natural place. Without glossing over the violence of the natural world, Peter Beard asks questions about man's suicidal folly, which we call progress, which is based on the pathetic religion of commerce and profit, of falsehood and pretence."
— Christian Caujolle

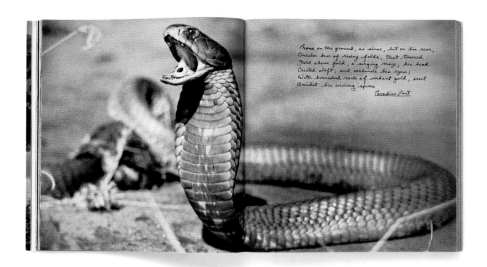

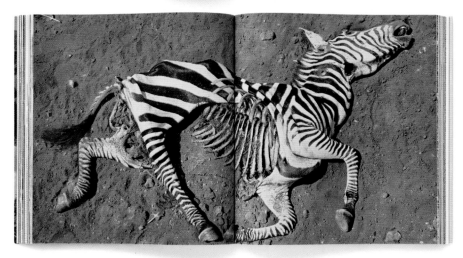

Cecil Beaton *(Walter Hardy)*

Cecil Beaton: **The Face of the World: An international Scrapbook.** New York (John Day Company) 1957

14.1.1904 Hampstead (London, England) — 18.1.1980 Broad Chalke (England) Fashion photography and portraits of celebrities taken over more than five decades. Doyen of British fashion photography. Also active as a writer and set designer. 1916 St Cyprian's boarding school with George Orwell, among others. From 1918 Harrow. There W.E. Hine encourages his artistic leanings. From 1922 studies at Cambridge. Theater work, caricatures. 1925 drops out of university. In London part of the young art scene. First photos, incl. Edith Sitwell. 1927 first contribution for British *Vogue*. First exhibition. From 1928 works for American *Vogue*. 1929 (the only Englishman) to take part of the *Film und Foto* exhibition in Stuttgart. 1933 in Paris. Contact with Jean Cocteau and others. Trip to North Africa with > Hoyningen-Huene. From 1935 regular set design and costume design work as well as from 1937 portraits of English nobility. 1938 (because of anti-Semitic statements) forced to leave *Vogue* (re-hired in 1940). 1940 documents historic London buildings destroyed in bombing raids. 1942 as RAF photographer in the Middle East. 1944 in battle zones in India and China for the Ministry of Information. 1953 official coronation portrait of Queen Elizabeth II. 1955 designer for the musical *My Fair Lady*. 1956 moves to *Harper's Bazaar*. Portraits of Marilyn Monroe, Grace Kelly, Joan Crawford. End of the 1960s, Twiggy, Keith Richards, Mick Jagger. 1971 organizes the show *Fashion — An Anthology*. Author of a history of photography, *The Magic Image*, with Gail Buckland. 1972 knighted by Queen Elizabeth II. The year before his death again in Paris for *Vogue*.

EXHIBITIONS (Selected) — **1927** London (Cooling Galleries) SE // **1929** Stuttgart (**Film und Foto**) GE // **1936** London (Redfern Gallery — 1958, 64) SE // **1968** London (National Portrait Gallery — 2004) SE // **1969** New York (Museum of the City) SE // **1971** London (Victoria and Albert Museum — 1991, 2003) SE/ GE // **1981** London (Imperial War Museum) SE // **1985** London (Barbican Art Gallery) SE // **2005** Vienna (KunstHaus) SE // Amsterdam (Fotografiemuseum Amsterdam) SE // **2006** Christchurch (New Zealand) (Christchurch Art Gallery) SE

BIBLIOGRAPHY (Selected) — **The Book of Beauty**. London 1930 // **C.B.'s Scrapbook**. London 1937 // **C.B.'s New York**. London 1938 // **History under Fire**. London 1941 // **Time Exposure**. London 1941 // **Winged Squadrons**. London 1942 // **Chinese Album**. London 1946 // **Indian Album**. London 1946 // **Photobiography**. London 1951 // **The Face of the World: An International Scrapbook**. New York 1957 // **The Best of B.** London 1968 // **C.B.: War Photographs 1939–45**. London 1981 // Martin Harrison: **Appearances**. London, 1991 (cat. Victoria and Albert Museum) // Philippe Garner and David Alan Mellor: **C.B.: Photographien 1920–1970**. Munich 1994 // **The Unexpurgated Beaton. The C.B. Diaries as He Wrote Them 1970–1980**. New York 2002 // **C.B.** Hamburg 2005 (= **Stern** Portfolio no. 40) ✐

"In this, as it were, 'fanaticism', he was 'many artists in one', as the art historian Peter Conrad has said. He photographed, but he also wrote, painted, designed and acted. But as extensive as his work was – his photographs were his most mature legacy. With his camera, Beaton became a pioneer of a completely new portrait photography that, staged and retouched with a mania for details, not only depicted its subject but also artfully weaved itself into the subject's world. His best photographs were successful not only because of his technical play with light and shadow, but also through his play with himself as photographer."
— Jochen Siemens ✍

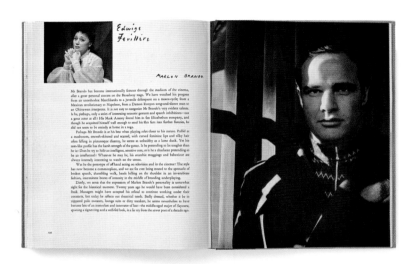

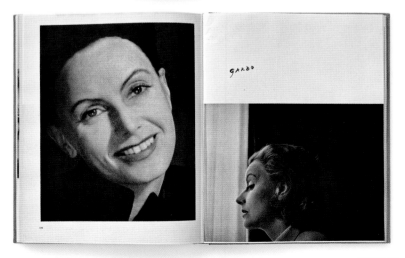

Bern_(har)d Becher / Hilla Becher

(Hilla Wobeser)

Bernhard and Hilla Becher:
Anonyme Skulpturen.
Düsseldorf (Kunst-Zeitung no. 2 /
Verlag Michelpresse) 1970

20.8.1931 Siegen (Germany) — 22.6.2007 Rostock (Germany) — 2.9.1934 Potsdam (Germany) — 10.10.2015 Düsseldorf (Germany) Since the 1960s, extensive documentation of industrial architecture. Residues of an industrial age form the center of a conceptually viewed pictorial aesthetic. B.B.: 1947 apprenticeship as decoration painter. 1953–1956 studies painting and lithography at the Staatliche Kunstakademie Stuttgart under Karl Rössing. 1957–1961 studies typography at the Staatliche Kunstakademie Düsseldorf. From 1959 works together with H.B., a photographer who trained in Potsdam under Walter Eichgrün. H.B.: 1958–1961 studies in Düsseldorf. Later establishes a photo department in the Academy there. 1961 marries B.B. Influenced by the works of > Blossfeldt and > Sander, but also Concept and Minimal Art (e.g. Ed Ruscha) at the beginning of the 1960s, they take up photographic documentation of industrial buildings. Using a stringent concept (b/w photographs, orthogonal approach, diffuse light) precise depictions of "historic" gas tanks, winding towers, water towers. Later they organize their photographs in the form of multi-part (ordered) series. First solo exhibition 1963. First museum presentation 1967 in the Neue Sammlung in Munich. A review by Carl Andre (in *Artforum*, no. 12, 1972) establishes their international reputation. B.B., as professor for artistic photography in Düsseldorf (from 1976) of major influence on a number of generations of conceptual documentary photographers (> Gursky, > Ruff, > Struth). Numerous awards, incl. Golden Lion at the XLIV Venice Biennale (1990), Erasmus Prize (2002), Hasselblad Award (2004).

EXHIBITIONS (Selected) — **1963** Siegen (Germany) (Galerie Ruth Nohl) SE // **1967** Munich (Die Neue Sammlung) SE // **1972** Kassel (documenta 5 – 1977/76, 1982/87, 2002/11) SE // **1975** New York (Museum of Modern Art) SE // **1985** Essen (Museum Folkwang) SE // **1989** Brussels (Palais des Beaux-Arts) SE // **1990** Venice (Biennale) GE // **1991** Cleveland (Ohio) (Cleveland Center for Contemporary Art) SE // **1994** Bochum (Germany) (Kunstsammlungen der Ruhr-Universität) SE // **1998** Berlin (Berlinische Galerie) SE // **1999** Cologne (SK Stiftung Kultur) SE // **2004** Düsseldorf (Kunstsammlung Nordrhein-Westfalen K21) SE // **2005** Berlin (Hamburger Bahnhof) SE // **2006** Cologne (Die Photographische Sammlung/SK Stiftung Kultur) SE // **2008** New York (Museum of Modern Art) SE // **2009** Bologna (Museo Morandi) SE // **2012** Paris (Paris Photo) SE

BIBLIOGRAPHY (Selected) — **Industriebauten 1830–1930.** Munich 1967 (cat. Die Neue Sammlung) // **Anonyme Skulpturen. Eine Typologie technischer Bauten.** Düsseldorf 1970 // **Fachwerkhäuser des Siegener Industriegebietes.** Munich 1977 // **Fördertürme.** Essen 1985 (cat. Museum Folkwang) // **Tipologie, Typologien, Typologies.** Venice 1990 (cat. Biennale) // **Hochöfen.** Munich 1990 // **Pennsylvania Coal Mine Tipples.** Munich 1991 // **Fabrikhallen.** Munich 1994 // **Zeche Hannibal.** Munich, 2000 // **Industrielandschaften.** Munich 2001 // **Grundformen Industrieller Bauten.** Munich 2004 // Susanne Lange: **Was wir tun, ist letztlich Geschichten erzählen.** Munich 2005 // **Getreidesilos.** Munich 2006 // Stefan Gronert: **Die Düsseldorfer Photoschule. Photographien von 1961–2008.** Munich 2009 // **Printed Matter 1964/2013.** Paris 2014

"An artistic couple that worked together for more than thirty years [...] they created an astounding archive of documentary photography virtually by themselves, far from academic discourse: Workers' housing, water towers and gas tanks, lime kilns and blast furnaces, coal bunkers and cooling towers [...]. The instruments of industrial production sites, seen as sculpture, seem isolated, without working people, complete also in respect of their functional context, monuments to themselves and, equally, symbols of a society organized for functionality and efficiency." — Klaus Bussmann ✍🏻

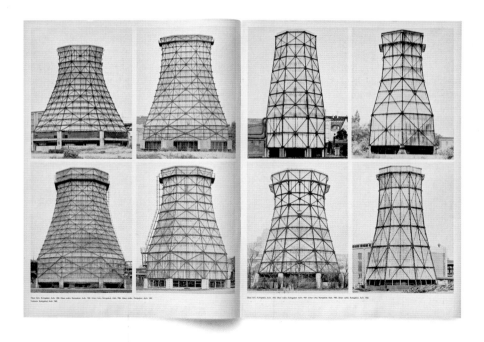

Hans Bellmer

Hans Bellmer: **Die Puppe.**
Berlin (Gerhardt Verlag) 1962

**13.3.1902 Kattowitz (Germany, today Katowice, Poland) — 23.2.1975
Paris (France)** Author of an oeuvre as idiosyncratic as it is comprehensible, centering around sexually charged images of large, self-made dolls of girls. Usually discussed in the context of Surrealism. Father a mining engineer. Following his father's wishes, studies at the Technischen Hochschule (Institute of Technology) Berlin. 1924 drops out and turns to art. Meets Otto Dix, George Grosz, > Heartfield. Applied graphics for the Malik-Verlag. From 1926 his own advertising agency in Berlin. 1933 (year of the Nazi seizure of power) constructs his first, almost life-sized, articulated dolls as a medium of artistic exploration, to be understood not least as a conscious "break with society and rationalism" and a "flight into childish unreality" (Alain Sayag). At the same time first photos of his creation. 1934 *Die Puppe*, a generally ignored first, self-printed, publication. 1935 visits Paris. Contact with Surrealism. Autumn 1935 publishes a selection of photos in the magazine *Minotaure* (no. 6). 1936 French book publication with the title *La Poupée*. Takes part in the most important Surrealist art exhibitions in the 1930s (Tenerife 1935, London 1936, Tokyo 1937, Paris 1938). 1938 moves permanently to Paris. Constructs a second puppet. 6 x 6 photos with the aim of "presenting credible gruesomeness from 'everyday life' and the 'fourth dimension'". Also hand-colored prints at the end of the 1930s (see *Les Jeux de la Poupée*). 1953–1970 lives with the writer Unica Zürn. "Obscene" nude photos featuring her (Unica series). During his lifetime only limited interest in his work. 1983 major retrospective at the Centre Pompidou. 1985 many of his photographs shown at the important show *Explosante-fixe: photographie & surrealism*, also in the Centre Pompidou. April 2008 unveiling of a memorial plaque in B.'s former apartment house in Berlin-Lichtenberg (Ehrenfelsstrasse 8 A).

EXHIBITIONS (Selected) — **1944** Toulouse (Librairie Silvio Trentin) SE // **1966** Ulm (Ulmer Museum) SE // **1967** Hannover (kestnergesellschaft — 1984) SE // **1971** Paris (Centre national d'art contemporain) SE // **1983** Paris (Centre Pompidou – 2006) SE // **1984** Vienna (Österreichisches Fotoarchiv im Museum Moderner Kunst) SE // **1985** Paris (Centre Pompidou – 2002, 2009) GE // Washington, DC (Corcoran Gallery of Art) GE // **1995** New York (Ubu Gallery – 1999, 2006) SE // **1999** Düsseldorf (Kunstsammlung Nordrhein-Westfalen) GE // **2006** Paris (Galerie 1900–2000) SE // Munich (Pinakothek der Moderne) SE // London (Whitechapel Art Gallery) SE // **2007** Berlin (Galerie Berinson) SE // **2009** Paris (Jeu de Paume – Site Sully/**Collection Christian Bouqueret**) GE

BIBLIOGRAPHY (Selected) — **La Poupée**. Paris 1936 // **Les Jeux de la Poupée**. Paris 1949 // **Die Puppe**. Berlin 1962 // Alain Sayag: **H.B. photographe**. Paris 1983 (cat. Centre Pompidou) // **L'Amour fou: photography and surrealism**. Washington, DC, 1985 (cat. Corcoran Gallery of Art) // **Collection de photographies**. Paris 1996 (cat. Centre Pompidou) // **Puppen, Körper, Automaten – Phantasmen der Moderne**. Cologne 1999 (cat. Kunstsammlung Nordrhein-Westfalen) // **La Révolution surréaliste**. Paris 2002 (cat. Centre Pompidou) // Agnès de Beaumelle (ed.): **H.B.: Anatomie du désir**. Paris 2006 (cat. Centre Pompidou) // Michael Semff and Anthony Spira (eds): **H.B.** Ostfildern 2006 (cat. Staatliche Graphische Sammlung München) ✐ // **H.B.** Paris 2006 (cat. Galerie 1900–2000) // **Paris. Capitale photographique. 1920/1940. Collection Christian Bouqueret**. Paris 2009 (cat. Jeu de Paume – Site Sully) // **La subversion des images**. Paris 2009 (cat. Centre Pompidou)

"Bellmer, born in 1902, worked in Berlin until 1938. He is, without doubt, one of the least well-known German artists of classic modernism, and at the same time the most shrouded in secrecy and tainted with taboos. His role as an outsider is based on the lasting power of his rebellion against the ruling ideology. [...] It is with this in mind that his first puppet, which was made in 1933 at the same time as Hitler's takeover of power and the beginning of the 'Third Reich', can be seen as an instrument for a critique of society. All Bellmer's energy was directed at the exploration of this artificial being – a life-sized, plaster-covered skeleton of wood and metal – on which he could project his suppressed needs like on a fetish object. Instead of treating this puppet as a sculptural object, he let it exist only in the medium of photography."
— Michael Semff and Anthony Spira ✍

Im Kinderschrank sind Zauberlichter, eine schreckenerregende geladene Pistole, ein durchsichtiger Springbrunnen, ein Steinbassin, das sich übervoll auf ein Bett von Opalen ergießt, ein Jäger ohne Schuh, ein Mädchen ohne Haar, ein Schiff auf dem Meer und der Seemann singt, ein damastseidenes Pferd, ein Wandertheater, eine Grille, weiße Federn vom Turteltaubennest, herzförmige hohle Körbchen mit rosa Creme gefüllt, eine Guitarre, die Funken schlägt, und ein Kleid, das immer neu bleibt.

74

E.J. Bellocq (John Ernest Joseph Bellocq)

E.J. Bellocq: **Storyville Portraits: Photographs from the New Orleans Red-Light District, circa 1912.** New York (The Museum of Modern Art) 1970

1873 New York (USA) — 1949 New Orleans (Louisiana, USA) Studio photographer in New Orleans after 1900. Discovered posthumously (mostly through Lee Friedlander) and published as a photographer of nudes and chronicler of the city's red-light district. Exact birth and death dates unknown. Born into a well-off family with Creole roots in the French Quarter of New Orleans. In his lifetime probably a loner and dandy. Interested in photography from an early age, at first as an amateur, from 1912 to 1938 as a studio and commercial photographer with a focus on urban landscapes and photography for local industry (ships, plants, machines). Also landscapes and (relatively conventional) portraits. In addition, takes photos on his own initiative, especially in opium dens in Chinatown and nudes and semi-nudes in the town's red-light district, known as Storyville. A (probably small) part of his archive was discovered after his death, printed by > Friedlander (in full format) and has since been published as a successful book. 1970, first major exhibition in Museum of Modern Art as starting point for his posthumous international reputation. Leaves a small oeuvre with, however, an enormous influence on literature, photography, and film (*Pretty Baby* [1978] with Keith Carradine and Brooke Shields). Several postmodern art photographers (> Witkin) have been inspired by his nude studies of local prostitutes that have been reworked to make the subjects anonymous, their faces scratched out while the emulsion was still wet. Destruction of most of his negatives after E.J.B.'s death. Buried in the Saint Louis Cemetery in New Orleans.

EXHIBITIONS (Selected) — **1970** New York (Museum of Modern Art/**E.J. Bellocq: Storyville Portraits**) SE // **1977** Kassel (documenta 6) GE // **1985** Munich (Münchner Stadtmuseum) GE // **1998** Barcelona (Fundació Joan Miró) GE // **2001** New York (Julie Saul Gallery) SE // **2003** San Francisco (Fraenkel Gallery) GE // **2004** Toulouse (Frac Midi-Pyrénées/**Collection Agnès B**) GE // New York (International Center of Photography/ **The Mysterious Monsieur Bellocq**) SE // **2005** New Orleans (Louisiana) (New Orleans Museum of Art) GE // Cologne (Galerie Thomas Zander/**The Red-Light District of New Orleans**) SE // **2006** Monaco (Salle d'exposition du quai Antoine 1er) GE // **2008** Lucca (Italy) (Fondazione Ragghianti) GE // **2013** Salzburg (Museum der Moderne) GE

BIBLIOGRAPHY (Selected) — **E.J.B.: Storyville Portraits: Photographs from the New Orleans Red-Light District, circa 1912.** New York 1970 (cat. Museum of Modern Art) // John Szarkowski (ed.): **E.J.B.: Storyville Porträts.** Cologne 1978 // Michael Köhler and Gisela Barche (eds): **Das Aktfoto. Ansichten vom Körper im fotografischen Zeitalter.** Munich 1985 (cat. Münchner Stadtmuseum) // **B.: Photography from Storyville.** New York 1996 // **Focus on Photography.** Munich 2013 (cat. Museum der Moderne, Salzburg)

"E.J. Bellocq was a commercial photographer who worked in New Orleans before and after the First World War. A plausible guess might be that his working life reached from about 1895 through the first four decades of this century. The thirty-four pictures reproduced here are selected from a group of eighty-nine plates – portraits of Storyville prostitutes – which were discovered in Bellocq's desk after his death. These negatives were made about 1912. As far as it is known, they constitute the only fragment of his work to have survived."

— John Szarkowski

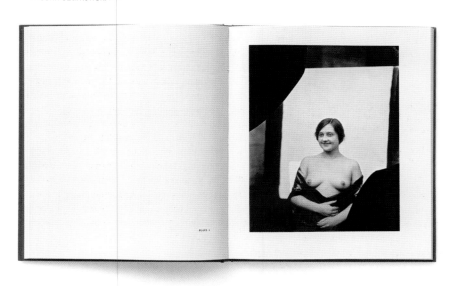

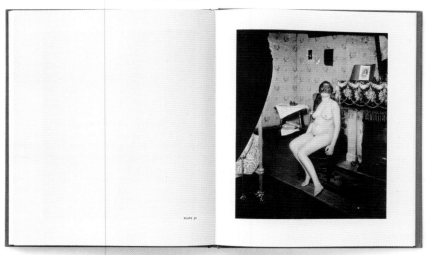

Ferenc Berko

FERENC BERKO

Ferenc Berko: **60 Jahre Fotografie.**
"**The Discovering Eye**".
Schaffhausen (Edition Stemmle)
1991

28.1.1916 Nagyvárad (Hungary) — 18.3.2000 Aspen (Colorado, USA)
From the 1930s photo reportage and portraits. Known especially for his nudes. In the 1940s and 50s much admired studies in color. Also documentary films as contract work. Early death of mother. 1921 with father (a doctor of nervous disorders) moves to Dresden. School in Dresden and Frankfurt am Main. First Leica. Photographs influenced by Hein Gorny and > Wolff. 1933 grammar school in England. Meets Emil Otto Hoppé. Contact with Marcel Lajos Breuer, György Kepes, > Moholy-Nagy. First prize in a photography contest. Subsequently takes up photography definitively. First documentary film. Stay in Paris. First nudes, published in *Paris-Magazine* and *The Naturalist*. 1938 (anticipating the coming war) moves to India. Works as cameraman in the film industry. Own photo studio in Bombay — industry photography, advertising, reportage and portraits. 1944—1947 documentary film director for the British Army. 1947 returns to Europe. First solo exhibition. Portfolio in *Du*. 1947—1948 teaches at the New Bauhaus in Chicago. Intensive exploration of color photography. 1948—1949 half-year contract with London Films. Returns to the USA at the invitation of the industrialist Walter Paepcke. Documents cultural activities initiated by Paepcke in Aspen (Colorado). From then on works in Aspen as independent filmmaker and photographer.

"**The group of great masters of 20th-century photography contains a surprisingly large number of immigrants who came from Hungary between the wars: Lucien Aigner, Robert and Cornell Capa, André Kertész, Brassaï, László Moholy-Nagy, Martin Munkácsi, Nickolas Muray. The name Ferenc Berko must now be added to this list, not least because of the stunning quality of his black and white photojournalistic work.**" — Colin Ford ✍

EXHIBITIONS (Selected) — **1947** London (Victoria and Albert Museum) SE // **1967** Cincinnati (Ohio) (Cincinnati Museum of Art) SE // **1971** Aspen (Colorado) (Institute for Humanistic Studies – 1979, 1984) SE // **1972** Fort Worth (Texas) (Amon Carter Museum – 1976) SE // **1978** Cologne (photokina) JE (with Keld Helmer-Petersen) // **1980** Tucson (Arizona) (Center for Creative Photography) SE // **1986** Cologne (photokina/ **50 Jahre moderne Farbfotografie 1936–1986**) GE // **1988** Frankfurt am Main (Fotografie Forum – 1991) SE // **1991** Arles (Rencontres internationales de la photographie) SE // **2002** Helmond (Netherlands) (Gemeentmuseum) GE // **2007** Barcelona (Kowasa Gallery) GE // **2009** Munich (Stadtmuseum) GE

BIBLIOGRAPHY (Selected) — **Aspen Portraits 1949–1983.** Aspen 1984 (cat. Institute for Humanistic Studies) // **50 Jahre moderne Farbfotografie/50 Years Modern Color Photography 1936–1986.** Cologne 1986 (cat. photokina) // **60 Jahre Fotografie.** Schaffhausen 1991 ✍ // **Nude Visions. 150 Jahre Körperbilder in der Fotografie.** Heidelberg 2009 (cat. Münchner Stadtmuseum)

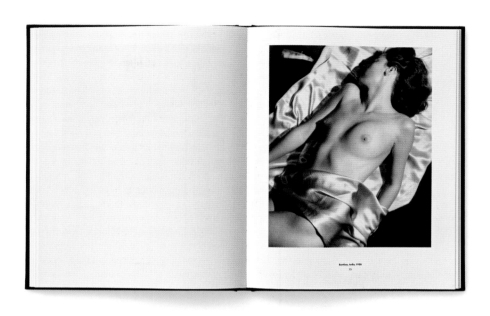

Bombay, India, 1938

Fire Escapes, Chicago, USA, 1947

Tramlines, New York, USA, 1949

Mario De Biasi

I grandi della fotografia: Mario De Biasi. Milan (Editioni Aprile) 1982

2.6.1923 Sois (Italy) — 27.3.2013 Milan (Italy) Doyen of post-war photojournalism in Italy. Begins with independent street photography akin to Neorealism. 1938 moves to Milan. After an apprenticeship at the Istituto Radiotechnico works at first as electrical engineer. 1944 imprisoned by the Germans. Labor camp in Nuremberg. After his release in spring 1945, while still in Nuremberg, buys a camera and a photography manual. From 1946 takes up photography, at first as amateur. Photographic exploration of his adopted home town of Milan: streets, squares, people. From 1948 member of the group Circolo Fotografico Milanese (Ezio Croci, Pietro Donzelli, > Monti). Partici-pates in photo competitions. 1952 first solo exhibition as part of 5th *Salone Internazionale della Fotografia alla Triennale di Milano*, his breakthrough. In the same year, contact with *Epoca*. Staff photographer from 1953. After publications on local topics 1954, first major reportages: President Nasser in Egypt, Aristotle Onassis in New York. International recognition for his photo reports of the Hungarian Uprising of 1956. Subsequently, intensive travels. Especially in the 1960s, sometimes called the *decennio d'oro* (Goldern Decade) of photojournalism, reportages from almost everywhere in the world. 1972, with Jack Garofalo, > McCullin, and > Lebeck, presentation at photo-kina entitled *Univeralisten*. The next year gets Dr Erich-Salomon award from the DGPh (Deutsche Ge-sellschaft für Photographie: German Photographic Association). Since the 1980s, mostly conception of photobooks. Altogether over 50 titles. 2000 major retrospective in Milan (catalogue).

EXHIBITIONS (Selected) — **1948** Milan (Circolo Fotografico Mila-nese — 1962) SE // **1952** Milan (Triennale di Milano) SE // **1961** Cologne (Studio Heinz Held) SE // **1967** Milan (II Diaframma — 1971) SE // **1972** Cologne (photokina) JE (with Jack Garofalo, Robert Lebeck, Don McCullin) // **1976** London (The Photogra-phers' Gallery) SE // **1977** Tokyo (Istituto italiano di Cultura) GE // **1993** Bologna (Galleria Comunale d'Arte Moderna) JE (with Paolo Gioli) // **1995** New York (Howard Schickler Gallery) SE // **1998** Rome (Galleria Borgognona) SE // **1999** Madrid (PHotoEspaña — 2007) GE // **2000** Milan (Palazzo Reale — Arengario) SE // **2003** Milan (Galleria Carla Sozzani) SE // **2004** Cagliari (Italy) (Centro Comunale d'Arte e Cultura Il Ghetto) SE // **2007** Milan (Galleria 70 — 2008) SE // Madrid (PHotoEspaña/**NeoRealismo**) GE // Winterthur (Fotomuse-um/**NeoRealismo**) GE

BIBLIOGRAPHY (Selected) — **I grandi della fotografia: M.D.B.** Milan 1982 // **Milano, una città e il suo fascino.** Bergamo 1993 // **Neorealismo e realtà.** Milan 1994 // **Milano. 50 anni di foto-grafia.** Bergamo 1995 // **New York 1955.** Milan 1995 // **El neor-realismo en la fotografía italiana.** Madrid 1999 (cat. PHo-toEspaña) // **M.D.B.: Fotografia professione e passione.** Milan 2000 (cat. Palazzo Reale) // Enrica Viganò: **NeoRealismo. La nueva imagen en Italia. 1932–1960.** Madrid 2007 (cat. PHo-toEspaña)

"He has borne witness to half a century of Italian life and international events. His photographs have surprised, touched, exalted millions of people. He has created the image of the years of struggle and the mythology of the people of the economic miracle. [...] A giant of Italian photography and an internationally recognized master, Mario De Biasi is a person difficult to define, easily escaping every attempt at categorization. We speak of the reckless reporter who climbs the tallest flagpole of Amerigo Vespucci, and then we have the gentle poet who delights at a blade of grass. We focus on the cosmopolitan traveler voyaging around the world, and we find out about old taverns and explore the courtyards of the Brianza in Milan. We have the rash photographer that officers struggle to hold back from the battle, and we find ourselves confronted by Franciscan chants of the changing seasons." — Attilo Colombo ✍

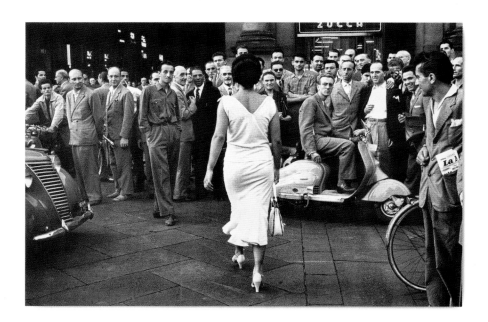

Aenne Biermann (Anna Sibilla Sternefeld)

Franz Roh: **Aenne Biermann.**
60 Fotos. Berlin (Klinkhardt &
Biermann) 1930

3.3.1898 Goch (Germany) — 14.1.1933 Gera (Germany) Self-taught.
Important exponent of avant-garde photography around 1930.
Daughter of a well-off industrial family. Initially very interested in
music. 1920 marries Herbert Joseph Biermann and moves to Gera.
Bears two children (Helga and Gerd). First photos are of family mem-
bers. At the end of the 1920s "attempts at very sharp stone photo-
graphs" for the geologist Rudolf Hundt. At the same time, beginning of
professional photography. Plant photos, object photos, close-up pho-
tos at the center of an oeuvre that attracts attention from 1928. Pub-
lishes in well-known avant-garde photography magazines (*Das Kun-
stblatt*, *Variétés*, *Arts et Métiers Graphiques*). Altogether around
3,000 photographs, of which about 400 have been traced to date.
1930 published by Franz Roh; only monograph during her lifetime.
Her works appear in important interwar exhibitions such as *Foto-
grafie der Gegenwart* (Essen, 1929), *Film und Foto* (Stuttgart, 1929),
Das Lichtbild (Munich, 1930). 1933 dies of a liver disease before the
family could be persecuted by the Nazis.

"**Aenne Biermann belongs to the new generation of photographers in the 1920s, oriented
towards New Objectivity, who propagated photography as an independent means of artistic
expression. […] The principal themes of her work are the objects of everyday life, things from
her personal surroundings as well as family and friends that she impressively staged photo-
graphically. Her images are marked by clear structures, supported by a creative use of light
and a concentration on unusual framing which emphasizes details.**" — Anne Schulte ✎⟩

EXHIBITIONS (Selected) — **1928** Munich (Kunstkabinett) SE //
1930 Gera (Kunstverein) SE // **1949** Gera (Stadthalle) GE //
1970 Essen (Museum Folkwang — 1994) GE // **1987** Essen
(Museum Folkwang) SE // **1998** Gera (Museum für Ange-
wandte Kunst) SE // **1999** Hannover (Sprengel Museum) GE //
2004 Cologne (Alfred-Ehrhardt-Stiftung) GE // **2005** New York
(Neue Galerie/**Portraits of an Age**) GE // Vienna (Albertina/
Portrait im Aufbruch) GE // Berlin (Kunstbibliothek) GE

BIBLIOGRAPHY (Selected) — Franz Roh: **A.B. 60 Fotos.** Berlin
1930 (= Fototek. Bücher der Neuen Fotografie 2) // **Foto-
grafien 1925–33.** Berlin 1987 (cat. Museum Folkwang Essen)
// **Fotografieren hieß teilnehmen. Fotografinnen der Weimar-**
er Republik. Düsseldorf 1994 (cat. Museum Folkwang) // **A.B.
1898–1933: Fotografie.** Gera 1998 (cat. Museum für Ange-
wandte Kunst) // **Mechanismus und Ausdruck. Sammlung
Wilde.** Munich 1999 (cat. Sprengel Museum Hannover) ✎⟩ //
Christiane Stahl (ed.): **Lebendiger Kristall. Die Kristallfoto-
grafie der Neuen Sachlichkeit zwischen Ästhetik, Weltan-
schauung und Wissenschaft.** Ostfildern-Ruit 2004 (cat.
Alfred-Ehrhardt-Stiftung, Cologne) // Monika Faber and Janos
Frecot (eds): **Portrait im Aufbruch. Photographie in Deutsch-
land und Österreich 1900–1938.** Ostfildern-Ruit 2005 (cat.
Albertina, Vienna) // Christine Kühn: **Neues Sehen in Berlin.
Fotografie der Zwanziger Jahre.** Berlin 2005 (cat. Kunstbiblio-
thek)

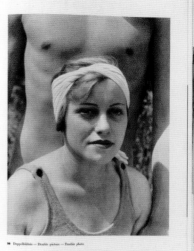

25 Schatten — Shadow — Ombre

26 Doppelbildnis — Double picture — Double photo

11

12

Ilse Bing

Ilse Bing: **Femmes, de l'enfance à la vieillesse.** Paris (Éditions des femmes) 1982

23.3.1899 Frankfurt am Main (Germany) — 10.3.1998 New York (USA)
Fashion and dance photography, Paris streets scenes, portraits and reportages influenced by the "New Photography" of the 1930s. After finishing school, studies mathematics and then art history at the University of Frankfurt 1920–1929. First photographs to illustrate her final paper. Self-taught photographer. 1930 moves to Paris. Dance photography, portraits, photojournalism. *Selbstporträt mit Spiegel* (1931, Self-Portrait with Mirror) her best known work. Meets Julien Levy and (1932) participates in the group exhibition *Modern European Photography* in his gallery in New York. 1933–1935 fashion photographer (accessories) for *Harper's*. Publishes in *AMG Photographie* and *VU*, among others. 1937 marries the pianist Konrad Wolff. In the same year participates in the exhibition *Photography 1839–1937*, curated by Beaumont Newhall. 1940 imprisoned in the Gurs internment camp. 1941 emigrates to the USA. In New York begins anew with her photographic work. 1959 gives up photography: poems, drawings, collages. Dog grooming (to earn a living). Rediscovery of her early oeuvre in 1976 after a group exhibition in New York (Museum of Modern Art) and Chicago (Art Institute).

"She was never interested in a repetitive, recognizable style. Instead Ilse Bing experimented, constantly exploring new techniques and themes. During her lifetime her inner independence was more important than anything else. In Paris, the German Jew could not escape internment in the notorious Gurs camp, but in the end she succeeded in escaping with her husband, the noted piano teacher Konrad Wolff. She emigrated to America. There her photographic work was rediscovered in the 70s […]." — Wilfried Wiegand ✍

EXHIBITIONS (Selected) — **1931** Paris (Galerie de la Pléiade – 1932, 1933, 1934, 1938) GE // **1932** New York (Julien Levy Gallery) GE // **1937** New York (Museum of Modern Art/**Photography** 1839–1937) GE // **1985** New Orleans (Museum of Art) SE // **1987** Paris (Musée Carnavalet) SE // **1989** Chicago (Edwynn Houk Gallery) SE // **1992** New York (Houk Friedman Gallery – 1994) SE // **1994** Essen (Museum Folkwang) GE // **1996** Aachen (Suermondt-Ludwig-Museum) SE // **1998** New York (Edwynn Houk Gallery) SE // **2000** Paris (Goethe Institut) SE // **2004** London (Victoria and Albert Museum) SE // **2005** New York (Neue Galerie/**Portraits of an Age**) GE // Vienna (Albertina/**Portrait im Aufbruch**) GE // **2007** Paris (Galerie Karsten Greve) SE // **2009** Barcelona (Kowasa Gallery/**The Vision of the Other**) GE // **2014** Hamburg (Haus der Photographie/Deichtorhallen) GE

BIBLIOGRAPHY (Selected) — **Photographs from the Julien Levy Collection.** Chicago 1976 (cat. Art Institute) // **Femme, de l'enfance à la vieillesse, 1929/1955.** Paris 1982 // Nancy C. Barrett: **I.B.: Three Decades of Photography.** New Orleans 1985 (cat. Museum of Art) // **I.B.: Paris 1931–1952.** Paris 1987 (cat. Musée Carnavalet) // **Fotografieren hieß teilnehmen. Fotografinnen der Weimarer Republik.** Düsseldorf 1994 (cat. Museum Folkwang) // **I.B.: Fotografien 1929–1956.** Aachen 1996 (cat. Suermondt-Ludwig-Museum) // **I.B.: Vision of a Century.** New York 1998 (cat. Edwynn Houk Gallery) // Wilfried Wiegand: "Kinderaugen: Zum Tod von I.B." In: **Frankfurter Allgemeine Zeitung,** 14.3.1998 ✍ // Monika Faber and Janos Frecot (eds): **Portrait im Aufbruch. Photographie in Deutschland und Österreich 1900–1938.** Ostfildern-Ruit 2005 (cat. Albertina, Vienna) // Larisa Dryansky: **Through the Looking Glass.** New York 2006 // **Augen auf! 100 Jahre Leica.** Heidelberg 2014 (cat. Haus der Photographie/Deichtorhallen Hamburg)

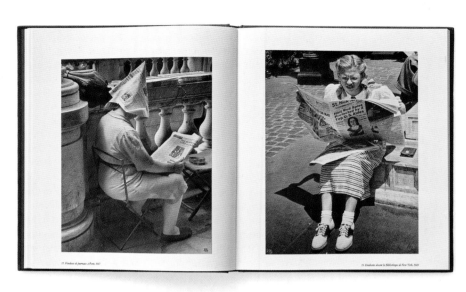

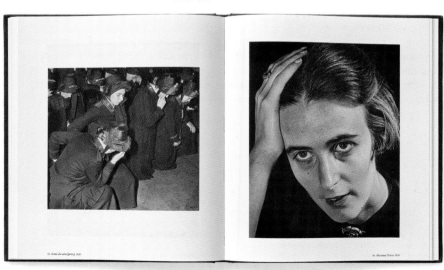

Werner Bischof

Werner Bischof: **Carnet de Route.**
Paris (Delpire Éditeur) 1957

24.6.1916 Zurich (Switzerland) — 16.5.1954 Peruvian Andes Magnum member. Exponent of a humanist photojournalism with an iconography marked by artistic ambitions, i.e. clear tendency towards aestheticization. Together with René Burri, he is the best-known post-war Swiss photographer. Childhood in Zurich, Kilchberg, and Waldshut. Father employee in a pharmaceutical company and also enthusiastic amateur photographer. 1932–1936 studies at the Kunstgewerbeschule Zürich under > Finsler. After graduating opens a studio for Foto-Grafik in Zurich. June 1939 goes to Paris. With outbreak of WW II returns to Switzerland. Active service in the Swiss army 1940–1945. December 1941, first publication in *Du*. From February 1942 "permanent photographic collaborator" for *Impressum*. 1945 bicycles through France, Germany, Holland (*Du* special issue, May 1946). 1946–1948 travels for the charity Switzerlander Spende in Austria, Italy, Greece, and Eastern Europe. Works for *Picture Post*, *Illustrated*, and *Observer*. 1948 joins Magnum. 1951 with Walter Läubli, > Schuh, Paul Senn, and Jakob Tuggener founds the Kollegiums Switzerlanderischer Photographen. 1951, for *Life*, *Hunger in India* (no. 22, 1951), his international breakthrough. 1952 Japan. Travels for *Paris Match* to Asia (Korean War). 1953 *Du* special issue (*Menschen im Fernen Osten*). September 1953 New York and South America. Dies in a road accident in the Andes during an inspection tour to Amazonia.

"Bischof's lovely photography was not just pure aesthetics, but also corresponded to his credo of an ideal world. But what it showed, from war-torn Europe and famine in India to war in Indochina and Korea, gave witness to a world of disasters. Thus also a part of Bischof is a determination to confront the disasters of the world with a camera and to overcome them."
— Hugo Loetscher ✎⌐

EXHIBITIONS (Selected) — **1953** Zurich (St. Annahof) SE // **1955** Chicago (Art Institute) SE // **1957** Zurich (Kunstgewerbemuseum) SE // **1961** Washington, DC (Smithsonian Institution) SE // **1967** New York (Riverside Museum/**The Concerned Photographer**) GE // **1977** Kassel (documenta 6) GE // **1984** Toulouse (Galerie municipale du Château d'Eau) SE // **1986** Zurich (Kunsthaus) SE // **1990** New York (International Center of Photography – 1998) SE // **1999** London (Barbican Centre) GE // **2006** Zurich (Helmhaus) SE // Berlin (C/O Berlin) SE // **2007** Iserlohn (Germany) (Städtische Galerie) SE // Aachen (Suermondt-Ludwig-Museum) SE // **2008** Vienna (WestLicht) GE // Paris (Galerie Fait & Cause) SE // **2009** London (Magnum Print Room) SE

BIBLIOGRAPHY (Selected) — **W.B.: 24 Photos**. Bern 1946 // **Japan**. Paris 1954 // **Indiens pas morts** (with Robert Frank and Pierre Verger). Paris 1956 // **W.B.: Carnet de Route**. Paris 1957 // **W.B.: Querschnitt**. Zurich 1961 // **W.B.** Lucerne 1973 // **W.B.: 1916–1954. Leben und Werk**. Bern 1990 ✎⌐ // Dieter Bachmann and Daniel Schwarz: **Der geduldige Planet**. Zurich 1996 // Marco Bischof (ed.): **Questions to My Father: A Tribute to W.B.** London 2004 // **W.B.: Bilder**. Bern 2006 // Peter Coeln, Achim Heine, and Andrea Holzherr (eds): **MAGNUM's first**. Ostfildern 2008 (cat. WestLicht, Vienna) // **W.B.: Carnets de Route 1932–1954**. Paris 2008

Karl Blossfeldt

Karl Blossfeldt: **Urformen der Kunst.** 4th edition, Berlin (Ernst Wasmuth) 1948

13.6.1865 Schielo (Germany) — 9.12.1932 Berlin (Germany) Crafts teacher, professor, and self-taught photographer. B/w plant studies, the focus of an oeuvre which anticipates New Objectivity. Elementary school, secondary school, apprenticeship as sculptor and modeler. 1884–1889 grant for an undergraduate drawing course at the Unterrichtsanstalt des Königlichen Kunstgewerbemuseums, Berlin. 1889 moves to Rome with a group under Prof. Moritz Meurer. There collects and prepares plants for later use in crafts teaching. From Rome, travels through the rest of Italy, to Greece, and North Africa. In this period begins systematic photographic plant documentation. 1898 returns to Berlin. Teaches at the Kunstgewerbemuseum school ("modelling using plants"). 1921 named professor. 1926 first exhibition in Karl Nierendorf's Berlin art gallery. Beginning of international reputation for his photographs of plants originally intended only for art teaching. Discussion of his work in the context of New Objectivity. Two highly appreciated books during his lifetime. His works included in the Stuttgart exhibition *Film und Foto* (1929). 1974 beginning of acquisition of his estate by Ann and Jürgen Wilde (Zülpich) and creation of an archive. Since 2001 part of the Stiftung Fotografie und Kunstwissenschaft Ann und Jürgen Wilde (Ann and Jürgen Wilde Photography and Art Research Foundation), based in Munich (Pinakothek der Moderne). *www.karl-blossfeldt-archiv.de*

"In the history of photography, Karl Blossfeldt is seen as one of the most important exponents of New Objectivity. Blossfeldt's close-ups of plants correspond to New Objectivity aesthetics in their strict, centered and often symmetrical structure and their neutral backgrounds. They present an inventory of plant forms which, in their formal consistency, became a model for photographic projects, one that Bernd and Hilla Becher follow still today in their typology of industrial buildings." — Ulrike Meyer Stump ✍

EXHIBITIONS (Selected) — **1926** Berlin (Galerie Neumann-Nierendorf) SE // **1929** Dessau (Germany) (Staatliches Bauhaus) SE // **1930** Halle (Germany) (Städtisches Museum in der Moritzburg) SE // **1976** Bonn (Rheinisches Landesmuseum) SE // **1978** Cologne (Galerie Wilde – 1983) SE // **1994** Bonn (Kunstmuseum) SE // **1997** Paris (Maison européenne de la photographie) SE // **2003** Cologne (Stiftung Fotografie und Kunstwissenschaft) SE // Munich (Pinakothek der Moderne) SE // **2004** Cologne (Art Cologne) SE // **2005** Oberhausen (Ludwig Galerie Schloss Oberhausen) SE // Cologne (Rautenstrauch-Joest-Museum) SE // **2006** Madrid (PHotoEspaña) SE // Cologne (Alfred Ehrhardt Stiftung) JE (with Alfred Ehrhardt) // **2010** Amsterdam (Foam/Fotografiemuseum Amsterdam) SE // **2013** Salzburg (Museum der Moderne) GE

BIBLIOGRAPHY (Selected) — **Urformen der Kunst**. Berlin 1928 // **Wundergarten der Natur**. Berlin 1932 // **Wunder in der Natur**. Leipzig 1942 // **Fotografien 1900–1932**. Bonn 1976 (cat. Rheinisches Landesmuseum) // **Das fotografische Werk**. Munich 1981 // **K.B. Fotografie**. Ostfildern, 1994 // **K.B. 1865–1932**. Cologne 1999 // **Mechanismus und Ausdruck. Die Slg. Ann und Jürgen Wilde**. Munich 1999 (cat. Sprengel Museum Hannover) ✍ // **Arbeitscollagen**. Munich 2000 // **Urformen der Kunst aus Pflanzenreich und fremden Welten**. Zülpich/Cologne 2004 (cat. Art Cologne) // Bernhard Mensch and Peter Pachnicke (eds): **Die Wunder der Natur. Romanische Kapitelle – Alte Pflanzenbücher – Blossfeldts Fotografien**. Oberhausen 2005 (cat. Ludwig Galerie Schloss Oberhausen) // **Focus on Photography**. Munich 2013 (cat. Museum der Moderne, Salzburg)

42

43

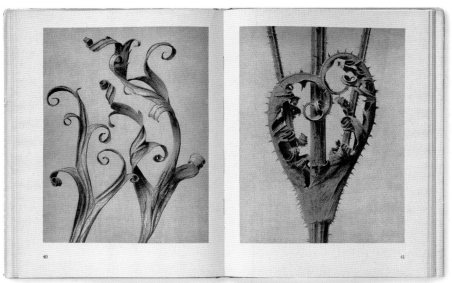

40

41

Erwin Blumenfeld

26.1.1897 Berlin (Germany) — 4.7.1969 Rome (Italy) Collages influenced by Dadaism in Berlin. Nude studies, portraits, and above all fashion photography. In this area one of the most imaginative photographers from the 1930s to the 60s. Secondary school in Berlin. School friend of the photographer Paul Citroen. 1907 first camera. 1913 death of his father. Family goes bankrupt. Apprenticeship in ladies' wear. Meets George Grosz, among others. Military service 1917–1918. End of 1918 moves to Amsterdam. Bookseller, independent artist, then enters the leather trade. At the same time photography (studio portraits and nudes). 1935 insolvency of the Fox Leather Company. 1936 moves to Paris and takes up photography definitively. First publications in *AMG Photographie*, *Votre Beauté*, *Verve*, *Coronet*, *Modern Photography*. 1938 through > Beaton makes contract with *Vogue*. From 1938 works for *Harper's Bazaar*. Interned at the outbreak of war. 1941 flees to the USA. December first color cover for *Harper's Bazaar*. Also publishes in *Life*, *Look*, *Lilliput* and *Picture Post*. 1943 his Hitler collage (from 1933) as flyer with a print run in the millions. In the same year opens a studio in New York. 1944 collaborator with *Vogue* (more than 100 fashion features). Also film work, i.e. advertising (incl. L'Oréal). 1955–1969 works on his autobiography, published in Paris after his death.

Erwin Blumenfeld
(right-hand page):
Untitled, from: **Verve,**
no. 1, 1937

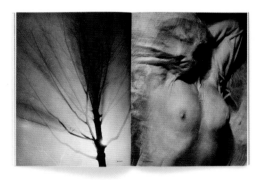

EXHIBITIONS (Selected) — **1929** Stuttgart (**Film und Foto**) GE // **1932** Amsterdam (Kunstzaal) SE // **1936** Paris (Galerie Billiet) SE // **1975** Paris (Fnac-Montparnasse) SE // **1978** New York (Witkin Gallery) SE // **1980** London (The Photographers' Gallery – 1993) SE /GE // **1981** Hamburg (PPS Galerie) SE // **1982** Paris (Centre Pompidou) SE // **1987** Essen (Museum Folkwang) SE // **1996** London (Barbican Centre) SE // **1998** Paris (Maison européenne de la photographie) SE // **1999** Berlin (Galerie Bodo Niemann) SE // **2001** London (Michael Hoppen Photography) SE // **2006** The Hague (Fotomuseum Den Haag) SE // **2008** Paris (Galerie Esther Woerdehoff) SE // **2009** Berlin (Berlinische Galerie) SE // **2013** Paris (Jeu de Paume) SE

BIBLIOGRAPHY (Selected) — **Jadis et Daguerre**. Paris 1975 (**Eye to I**. London 1999) // **Meine 100 besten Fotos**. Bern 1979 // E.B. Essen 1987 (cat. Museum Folkwang) // Martin Harrison: **Appearances: Fashion Photography Since 1945**. London 1991 // **Paul Citroen and E.B. 1919–1939**. London 1993 (cat. The Photographers' Gallery) // **Collection de photographies**. Paris 1996 (cat. Centre Pompidou) // William A. Ewing: **B. 1897–1969: A Fetish for Beauty**. Zurich 1996 // **E.B.: Einbildungsroman**. Frankfurt am Main 1998 // **The Naked and the Veiled: The Photographic Nudes of E.B.** London 1999 // Michel Métayer: E.B. London 2004 ✍ // **E.B.: His Dutch Years 1918–1936.** Rotterdam 2006 (cat. Fotomuseum Den Haag) // Helen Adkins: **E.B.: In Wahrheit war ich nur Berliner. Dada-Montagen 1916–1933.** Ostfildern 2008 (cat. Berlinische Galerie, Berlin)

"Blumenfeld resolutely embraced experimentation from the 1930s onwards. Though fashion photography was still in its infancy as a genre and offered many opportunities, it was not only this form of photography that captured his interest. His curiosity tended towards an artistic environment in which expressive languages were in constant renewal. Edward Steichen, Martin Munkácsi, Man Ray, Bauhaus, light and easily manipulated materials – each contributed to a blossoming of artistic ideas that encouraged Blumenfeld to make his photography compatible with both his financial requirements and his need to experiment with nudes and with portraiture."
— Michel Métayer ✍

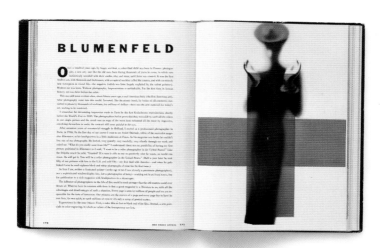

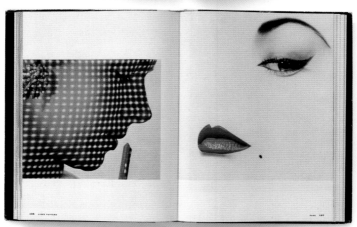

Erwin Blumenfeld, from: **The Art and Technique of Color Photography.** New York (Simon & Schuster) 1951

Édouard Boubat

Édouard Boubat: **Mes chers enfants.** Paris (Édition Phébus) 1991

13.9.1923 Paris (France) — 30.6.1999 Paris Photo essays, reportages, poetic individual photographs. Generally discussed in the context of "Photographie humainste". One of the most popular post-war photographers in France. 1938–1942 apprenticeship in collotype at the École Estienne, Paris. 1943 taken to Germany as forced laborer. 1945 returns to Paris. 1946 a Rolleicord his first camera. 1947 marries Lella. In the same year participates in the *Salon international de la Photographie de la Bibliothèque nationale de France* and a Premier Prix Kodak for *The Little Girl with Dead Leaves* (La Petit Fille au Feuilles Mortes) (1946), one of his first photos. Meets > Brassaï, > Cartier-Bresson, and > Frank. 1950 beginning of friendship with > Smith. Publishes in *US Camera* and *Camera*. 1951 buys his first Leica. In the same year important group exhibition in the Paris bookstore La Hune with Brassaï, > Doisneau, Paul Facchetti, and > Izis. Through this meets Albert Gilou, art director of the monthly *Réalités*. First reportage 1951 (*Les artisans de Paris*). 1952–1967 permanent collaborator with *Réalités*. Afterwards independent photographer. Separates from Lella (1957) and marries Sophie. Numerous trips for *Réalités*. Many books. 1973 David-Octavius-Hill-Medaille. 1977 Grand Prix du Livre for *La Survivance* at the Rencontres d'Arles. 1984 Grand Prix National de la Photographie. 1985 Officier de l'Ordre des Arts et des Lettres. 1988 Prize from the Hasselblad Foundation. 1990 *Le Paris de Boubat* in Musée Carnavalet. Participates in the important group exhibition *Weltausstellung der Photographie* (1964), *Photographie als Kunst* (1979) and *subjektive fotografie* at the San Francisco Museum of Modern Art (1984).

EXHIBITIONS (Selected) — **1949** Paris (Bibliothèque nationale/Salon international – 1949) GE // **1951** Paris (La Hune) GE // **1967** Stockholm (Moderna Museet) SE // **1971** Paris (Galerie Rencontre) SE // **1973** Paris (Bibliothèque nationale) SE // Toulouse (Galerie municipale du Château d'Eau – 1975) SE // **1974** Paris (Galerie Agathe Gaillard – 1985, 2004) SE // **1976** Chicago (Art Institute) SE // **1978** London (The Photographers' Gallery) SE // **1979** Lyon (Fondation nationale de la Photographie) SE // **1980** Paris (Musée d'art moderne de la Ville de Paris) SE // **1984** Rio de Janeiro (Museo de arte moderna) SE // **1990** Paris (Musée Carnavalet) SE // **1995** Paris (Centre Pompidou) SE // **1996** Charleroi (Belgium) (Musée de la Photographie) SE // **1998** Paris (Maison européenne de la photographie – 2004, 2008) SE /GE // **2000** Biarritz (Terres d'images) SE // **2002** Aveyron (France) (Château de Belcastel) SE // **2005** Padua (Italy) (Museo Civico di Piazza del Santo) SE // Brest (Centre atlantique de la Photographie) SE // **2006** Paris (Bibliothèque nationale de France – Site Richelieu/**La photographie humaine 1945–1968**) GE // **2008** Paris (Maison européenne de la photographie/**Réalités**) GE // Moscow (Moscow House of Photography) SE // **2014** Hamburg (Haus der Photographie/Deichtorhallen) GE

BIBLIOGRAPHY (Selected) — **Femmes**. Paris 1972 // **Grosse Photographen unserer Zeit: E.B.** Lucerne 1972 // **Miroirs: autoportraits**. Paris 1973 // **Anges**. Paris 1974 // **La Survivance**. Paris 1976 // **L'Ombre de l'autre**. Paris 1979 // **Préférées**. Paris 1980 // **Au Pays du Cheval d'Orgueil**. Paris 1980 // Jean-Luc Mercié: **E.B.** Paris 1982 // **Les Boubat de Boubat**. Paris 1989 // **Le Paris de Boubat**. Paris 1991 (cat. Musée Carnavalet) // **Donne-moi quelque chose qui ne meure pas**. Paris 1996 // **La vie est belle**. Paris 1996 // **La Bible de B.** Paris 1998 // **Collection de photographies**. Paris 1996 (cat. Centre Pompidou) ✍ // Bernard Boubat and Geneviève Anhoury: **E.B.** Munich 2005 // Laure Beaumont-Maillet and Dominique Versavel: **La photographie humaine. Autour d'Izis, Boubat, Brassaï, Doisneau, Ronis et les autres**. Paris 2006 (cat. Bibliothèque nationale de France) // Anne de Mondenard and Michel Guerrin: **Réalités. Un mensuel français illustré (1946–1978)**. Arles 2008 (cat. Maison européenne de la photographie) // **Augen auf! 100 Jahre Leica**. Heidelberg 2014 (cat. Haus der Photographie/Deichtorhallen, Hamburg)

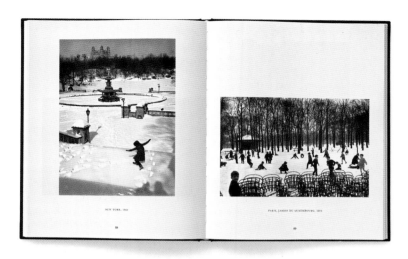

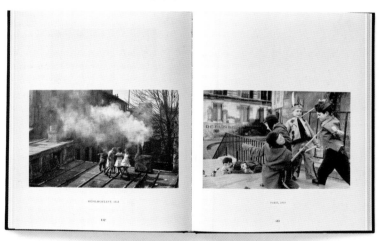

"Without being a classic reporter rushing after the news [Édouard Boubat] traveled around the world: France and Europe, the United States, Canada, Algeria, Guadeloupe, Mexico, Iran, Côte d'Ivoire, Guinea, Brazil, Peru, India, China, Japan, bringing back images taken 'point-blank'. But rather than showing us war, famine and unhappiness in general, he captured moments of peace and equilibrium, without any mawkishness or sentimentality. Jacques Prévert said of him in 1971: 'Boubat, in the neighboring villages, like in the farthest corners of the earth or the large deserts of boredom, looks for and finds an oasis. He is a correspondent of peace.'"
— Emmanuelle de l'Écotais ✍

Pierre Boucher

29.2.1908 Paris (France) — 27.11.2000 Faremoutiers (France) Pioneer of a modern advertising schooled in Constructivism. In addition photograms, montage, solarization, nude studies, photojournalism, sport. Especially versatile camera artist in France of the 1930s to 60s. 1922–1925 studies at the École des Arts Appliqués in Paris. Internship with the firm Draeger. 1926–1927 in the advertising department of the Printemps department store. Takes up photography during his time in the Air Force (1928–1930). 1932 internship with Deberny & Peignot. Meets > Matter, Maurice Cloche, Roger Parry, Maurice Tabard, Maximilien Vox, and René Zuber. Joins Zuber's studio. From 1932 numerous publications in *AMG Photographie*. Through André Lejard (editor-in-chief of AMG) meets Maria Eisner. 1934 founds the Alliance Photo agency (with Eisner, Zuber, Emeric Feher, and Denise Bellon). Apart from reportages (incl. from Spain, Morocco and Egypt) intensive work with all forms of experimental camera art (photomontage, photograms etc.). Publishes in *Art et Médecine*, *Regards*, and *VU*. 1933 takes part in the first *Salon international du Nu photographique*, initiated by Daniel Masclet, as well as (1935) the *Affiches/Photos* exhibition in the Galerie Billiet-Vorms. 1940 moves to the Vichy zone. 1945 a member of the Agence de Diffusion et d'Édition Photographiques (A.D.E.P.). 1948–1953 publicity work for the Marshall Plan. 1952 founds Mulitphoto, an advertising agency. From 1961 extensive trips (incl. to Moscow, Latin America, New York). Appears in *Photo-France*, *Camera*, *Graphis*, and *Camera International*. 1972 abandons photography.

Pierre Boucher (and the 4 images on the right), from: **Nus**. Paris (Premier Salon international du Nu photographique) 1933

"More 'photo-graphic artist' than photographer, he used all the techniques at his disposal: photomontage, solarisation, superimposition. He retained the notion of applied art from his studies and considered photography as a tool." — Emmanuelle de l'Écotais ✍

EXHIBITIONS (Selected) — **1935** Paris (Galerie Billiet-Vorms) GE // **1937** Paris (Maison de la Culture/**Affiche Photo Typo**) GE // **1941** Lyon (Couvent des Carmélites) SE // **1975** Biot (Maison de la Culture) SE // **1978** Paris (Galerie Zabriskie) GE // **1984** Dijon (Salle du Consortium) SE // **1988** Paris (Bibliothèque historique de la Ville de Paris) GE // **1996** Paris (Centre Pompidou) GE // **2003** Poitiers (Musée Sainte-Croix) SE // **2004** Chalon-sur-Saône (Musée Nicéphore Niépce) SE // **2005** Paris (Mairie du 3ème) SE // **2009** Paris (Jeu de Paume – Site Sully/ Collection Christian Bouqueret) GE

BIBLIOGRAPHY (Selected) — **B.: Photo Graphiste**. Paris 1988 // Alliance Photo. Agence photographique 1934–1940. Paris 1988 (cat. Bibliothèque historique de la Ville de Paris) // **Collection de photographies**. Paris 1996 (cat. Centre Pompidou) ✍ // Christian Bouqueret: **Des années folles aux années noires**. Paris 1997 // **Paris. Capitale photographique. 1920/1940. Collection Christian Bouqueret**. Paris 2009 (cat. Jeu de Paume – Site Sully) // Michel Frizot and Cédric de Veigy: **VU. Le magazine photographique 1928–1940**. Paris 2009

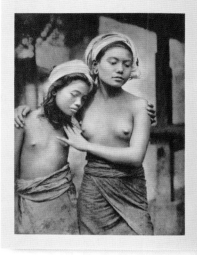

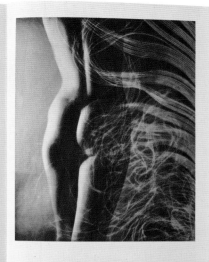

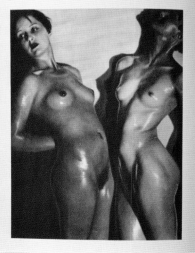

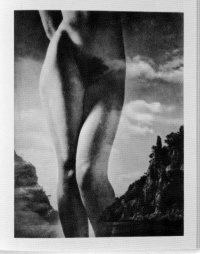

Guy Bourdin *(Guy Louis Banarès)*

2.12.1928 Paris (France) — **29.3.1991 Paris** Painter and photographer. Fashion, beauty, advertising with a deliberately provocative aesthetic schooled in Surrealism. In the 1960s and 70s one of the most discussed fashion photographers. 1948–1949 army photographer in Dakar (Senegal). 1951–1953 works as sales clerk, reproduction photographer, messenger in the American embassy in Paris. At the same time intensive study of drawing and painting. First (independent) photographs influenced by > Meatyard, > Sommer, Edward Weston, and especially > Man Ray's Surrealist photographic work. Meets Jacques Fath and Leonor Fini. 1952 first solo exhibition (with an encouraging text by an admiring Man Ray). 1954 meets Edmonde Charles-Roux, editor-in-chief of the French *Vogue*. The next year first fashion photos (*Chapeau-Choc*) in the French *Vogue*. To 1987 numerous style-setting fashion features for *Vogue* (France) under Francine Crescent. In addition, works for *Harper's Bazaar* (1967–1971), the American, Italian and English *Vogue*, *Vogue Hommes*, *Linea Italiana*, *Egoïste*, and *The Best* (1987–1991). 1967–1981 his work with Charles Jourdan (shoes) attracts considerable attention. Other campaigns for Issey Miyake, Gianfranco Ferré, Complice, Loewe, Madame Grès, Claude Montana, Lancetti, and Emanuel Ungaro. Generally perfectly staged "full of references and ambiguities […] often charged with sex and vulgarity, with models often appearing defenseless and lost and sometimes literally followed in these staged fantasies and nightmares." He is seen, together with > Newton and Chris von Wangenheim, as an innovator of a fashion advertising "close to the limits of erotic photography" (Freddy Langer). 1985 awarded the Grand Prix national de la photographie (refused). 1988 Infinity award from the International Center of Photography, New York. 2001 (after years of disputes among his heirs) publication of a first monograph, by his son Samuel Bourdin. 2003 first retrospective with stops in London (Victoria and Albert Museum), Melbourne (National Gallery of Victoria), and Paris (Jeu de Paume).

EXHIBITIONS (Selected) — **1952** Paris (Galerie 29) SE // **1953** Paris (Galerie Huit) SE // **1969** Paris (Galerie Delpire) SE // **1978** Cologne (photokina – 1986) GE // **1981** Arles (Rencontres internationales de la photographie) SE // **1990** Vienna (Kunstforum Länderbank) GE // **1991** London (Victoria and Albert Museum) GE // **1993** Paris (Centre national de la photographie) GE // **1999** New York (PaceWildensteinMacGill) SE // **2003** London (Victoria and Albert Museum) SE // **2004** Paris (Jeu de Paume) SE // Amsterdam (Fotografiemuseum Amsterdam) SE // **2005** Shanghai (Shanghai Art Museum) SE // **2006** Tokyo (Tokyo Metropolitan Museum of Photography) SE // **2008** Vienna (KunstHaus) SE // **2013** Hamburg (Haus der Photographie/Deichtorhallen) SE

BIBLIOGRAPHY (Selected) — **Vier Meister der erotischen Photographie**. Munich 1972 // Michael Köhler: **Das Aktfoto**. Munich 1985 (cat. Stadtmuseum) // Ingried Brugger (ed.): **Modefotografie von 1900 bis heute**. Vienna 1990 (cat. Kunstforum Länderbank) // Martin Harrison: **Appearances**. Munich 1991 (cat. Victoria and Albert Museum) // Freddy Langer: "Grand Hotel in Flammen, Museum überschwemmt". In: **Frankfurter Allgemeine Zeitung**, 5.4.1991 // **Vanités**. Paris 1993 (cat. Centre national de la photographie) // **G.B.: Exhibit A. Photographien**. Munich 2001 ✍ // Gabriel Bauret: **Color Photography**. Paris 2001 // **G.B.** London 2003 (cat. Victoria and Albert Museum) // **G.B.: 67 Polaroids**. Paris 2004 // **G.B.: A Message for you**. Paris 2006 // Alison M. Gingeras: **G.B.** London 2006 // **G.B.** Arles 2008 (= Photo Poche no. 109) // **Polaroids**. Paris 2009 (cat. Le Bon Marché Rive Gauche) // **In Between.** Göttingen 2010 // **G.B.** Hamburg 2013. (cat. Haus der Photographie/Deichtorhallen)

"With the idea that the image was more powerful than its motif, Bourdin constructed an optical morality that allowed him to blast open the limits of the affected, glamorous and decorative. He only had to use the ideas that he was full of in his younger years. He became the creator of cleverly thought out tableaux that also suggest a story or narrative of rare complexity. […] Guy Bourdin never speaks, moreover, of taking photos, but of realizing them. And he experiments with 'paintings' that together form a series of images like in an opera."
— Michel Guerrin ✑

Guy Bourdin: **Le Juste Milieu de la Mode,** from: **Vogue** (Paris), February 1981

Guy Bourdin: **Beauté,** from: **Vogue** (Paris), May 1979

Margaret Bourke-White *(Margaret White)*

14.6.1904 New York (USA) — 27.8.1971 Stamford (Connecticut, USA) Industrial photographer, war reporter, reportages. As *Life*'s chief photographer, the most prominent exponent of her trade in America of the 1930s to the 50s. Both innovator and "star" of the print media at the high point of the illustrated press. Daughter of an engineer. Interested in technology early on. 1922 begins studying at Columbia College, New York. Photography course at the Clarence H. White School of Photography. After various changes 1927 B.A. from Cornell University, Ithaca (New York). Moves to Cleveland. Takes the name Bourke-White. To 1936 works successfully as advertising and industry photographer. 1930 moves to New York. Begins working with the magazine *Fortune*. 1931 and 1932 trips to the USSR. From 1936 full-time journalist for *Life* (first cover). With the writer Erskine Caldwell (her husband 1939–1942), explores social injustice in the American south (*You Have Seen Their Faces*). 1941 Moscow: documents German attack on the city. 1942 first female photographer for the American Air Force. 1943–1944 in Italy. 1945 photographs of the liberation of Buchenwald concentration camp. 1946–1948 Reportages on the liberation process in India and Pakistan. 1950 South Africa. 1952 war reporter in Korea. 1957 beginning of Parkinson's disease. 1969 gives up photography. 1963 autobiography *Portrait of Myself*.

"Margaret Bourke-White was one of the great chroniclers of the Machine Age. In the late 1920s and early 1930s, the first decade of her career, she photographed implements, processes, and industrial output in ways that captured beauty in a world not usually perceived as beautiful. Hers were not merely documentary photographs. Romanticizing the awesome power of industry and machines through close-ups, dramatic cross-lighting, and unusual perspectives, she presented industrial environments as artful compositions. These tour-de-force images, showing her grasp of modern design and aesthetics, soon caught the eye of corporate executives and magazine publishers and propelled Bourke-White to the forefront of photography and journalism in the twentieth century." — Stephen Bennett Phillips ✎⊐

EXHIBITIONS (Selected) — **1931** New York (John Becker Gallery) SE // **1956** New York (Art Institute of Chicago) SE // New York (Syracuse University – 1975, 78) SE // **1974** Santa Clara (California) (University of California) SE // York (Neikrug Galleries) SE // **1988** New York (International Center of Photography) SE (then Detroit, Kansas City, Hartford, Washington, DC, Fort Worth, Cleveland, Milan, Paris, Bonn, Munich, Frankfurt am Main) // **2003** Washington, DC (The Phillips Collection) SE // Sarasota (Florida) (John and Mable Ringling Museum of Art) SE // **2004** Charlotte (North Carolina) (Mint Museum of Art) SE // Fort Wayne (Indiana) (Fort Wayne Museum of Art) SE // **2005** Portland (Maine) (Portland Museum of Art) SE // **2013** Salzburg (Museum der Moderne) GE // Munich (Versicherungskammer Kulturstiftung) SE

BIBLIOGRAPHY (Selected) — **The Story of Steel**. New York 1928 // **Eyes on Russia**. New York 1931 // **U.S.S.R. Photographs**. Albany 1934 // **You Have Seen Their Faces**. New York 1937 // **Dear Fatherland, Rest Quietly**. New York 1946 // **Halfway to Freedom**. New York 1949 // **Portrait of Myself**. New York 1963 // **The Photographs of M.B.-W.** Greenwich 1972 // Vicki Goldberg: **B.-W.** New York 1988 (cat. International Center of Photography) // Stephen Bennett Phillips: **M.B.-W.: The Photography of Design 1927–1936**. New York 2003 (cat. The Phillips Collection, Washington, DC) ✎⊐ // **M.B.-W.: The Early Work, 1922–1930.** Boston 2005 // **Focus on Photography**. Munich 2013 (cat. Museum der Moderne, Salzburg)

Margaret Bourke-White:
A New Way to Look at the U.S.,
from: **Life** (International Edition),
Vol. 12, no. 9, 5.5.1952

Bill Brandt *(Hermann Wilhelm Brandt)*

Bill Brandt: **Shadow of Light.**
London (The Bodley Head) 1966

3.5.1904 Hamburg (Germany) — 20.12.1983 London (England)
Portraits, landscapes, socially committed reportages. Independent imagery schooled on Surrealism with a pointedly dark pictorial language. In later years intensive work with nudes. Most important 20th-century British photographer. Father heads an import-export business. His mother from a prominent Hamburg family. 1920–1927 tuberculosis therapy in Davos. 1927 Vienna, where he makes contact with artists and Dr Eugenie Schwarzwald. At her instigation he develops an interest in photography. 1929 through Ezra Pound three months in > Man Ray's Paris studio. Meets Surrealist writer René Crevel. 1931 moves to England. Trips to Spain, Hungary, Austria. A photograph in *Minotaure* (with a text by Crevel) his first important publication. 1936 his first book *The English at Home*. 1937 begins his collaboration with the magazine *Lilliput*, founded in the same year. 1938 contributions in *Picture Post*. 1940 documents life in wartime London (*Blitz*) for the Ministry of War Information. From 1943 works for the British *Harper's Bazaar*. 1948 *Camera in London* as his retrospective in book form. From 1941 occupied with nudes. Generally outdoor. In the 1960s growing international reputation. Included among "The World's Greatest Photographers" by the *Observer* (14 June 1968). 1969 solo exhibition at the Museum of Modern Art. In the 1970s continues with portraits of notables, incl. for the *New York Times Magazine*. 1999 major retrospective in the International Center of Photography, Midtown. His influence on the self-image and confidence of British author photographers in the 20th century cannot be overestimated (e.g. Chris Killip, > Parr, > Ray-Jones).

EXHIBITIONS (Selected) — **1948** New York (Museum of Modern Art – 1969) SE // **1974** London (The Photographers' Gallery – 1983) SE // **1976** Arles (France) (Rencontres internationales de la photographie) SE // **1978** Stockholm (Moderna Museet) SE // **1981** Bath (Royal Photographic Society) SE // **1983** New York (International Center of Photography – 1999) SE // **1993** London (Barbican Art Gallery) SE // **1994** Paris (Centre national de la photographie) SE // **1999** New York (International Center of Photography Midtown) // **2005** Paris (Fondation Henri Cartier-Bresson) SE // **2004** London (Victoria and Albert Museum) SE // **2008** Houston (Museum of Fine Arts) SE // Madrid (PHotoEspaña/BBVA/Sala de exposiciones de AZCA) SE // **2013** New York (Museum of Modern Art) SE

BIBLIOGRAPHY (Selected) — **The English at Home**. London 1936 // **A Night in London**. London/Paris/New York 1938 // **Camera in London**. London 1948 // **Literary Britain**. London 1951 // **Perspective of Nudes**. London 1961 // **Shadow of Light**. London/New York 1966 // **B.B.: Photographs**. London 1970 (cat. Arts Council) // **B.B.: Nudes 1945–1980**. London/New York 1980 // **B.B.: A Retrospective Exhibition**. Bath 1981 (cat. Royal Photographic Society) // **B.B.: War Work**. London 1983 (cat. The Photographers' Gallery) // Patrick Roegiers: **B.B. Paris** 1990 // **B.B.: Photographs 1928–1983**. London 1993 (cat. Barbican Art Gallery) // **The Photography of B.B.** New York 1999 (cat. International Center of Photography) // Martin Parr and Gerry Badger: **The Photobook: A History Volume I**. London 2004 // Paul Delany: **B.B.: A Life**. London 2004 ✍

"Bill Brandt, the greatest of British photographers, who visually defined the English identity in the mid-twentieth century, was an enigma. In fact, despite his assertions to the contrary, he was not in fact English at all. His life, like much of his work, was an elaborate construction. England was his adopted homeland and the English his chosen subject." — Paul Delany ✍

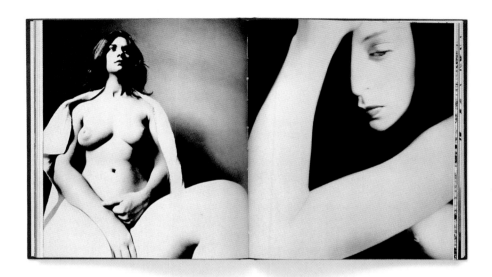

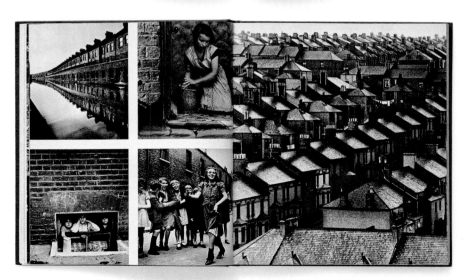

Brassaï (Gyula Halász)

Brassaï: **Paris de nuit.**
Paris (Édition Arts et Métiers
Graphiques) 1933

**9.9.1899 Brassó (Hungary, today Brašov, Romania) — 7.7.1984
Beaulieu-sur-Mer (France)** Drawings, sculptures, prose, set design,
film. Important artist, close to Surrealism, with multimedia interests.
Paris by Night the best-known work of this versatile photographer.
1903–1904 in Paris with his parents for the first time. Schooling in
Brassó and Budapest. 1918–1919 studies in the academy of fine
arts in Budapest. 1920 moves to Berlin. Meets Wassily Kandinsky,
Oskar Kokoschka, > Moholy-Nagy. Kunstakademie Berlin-Charlotten-
burg, diploma 1924. 1924 moves to Paris (French citizen from 1947).
Works as journalist and painter. Meets > Kertész. 1929 acquires his
first own camera, street photography at first, from 1932 under the
pseudonym "Brassaï" (after his hometown). December 1932 *Paris
de nuit* (with a text by Paul Morand) his first book – breakthrough for
the photographer, little known until then. Thereafter numerous publi-
cations in *Verve*, *Vu*, *Picture Post*, *Lilliput*, *Coronet*, and *Réalités*, as
well as the Surrealist magazine *Minotaure*. 1933 his first "sculptures involontaires" (photographs of
everyday objects). Meets André Breton, Paul Éluard, > Man Ray and, through the publisher Tériade,
Pablo Picasso. From 1934 close friendship with > Brandt. First graffiti photos. Series on people in big
cities (book *Le Paris secret des années 30*). 1937 contact with > Brodovitch. Beginning of collabora-
tion with *Harper's Bazaar*. Artist portraits (Pierre Bonnard, Samuel Beckett, Georges Braque, Aristide
Maillol, and others) as well as (1949–1960) travel photography (Greece, Ireland, Italy, Spain, Turkey,
Brazil, Sweden, Morocco, USA). 1940 moves to Vichy zone. 1944 returns, photos of the liberation of
Paris. Designs for stage sets (Jean Cocteau, Raymond Queneau, Elsa Troilet), film work (*Conversa-
tions with Picasso*), tapestries, drawings, sculpture. In old age numerous awards and prizes, incl.
1971 first Grand Prix national de la photographie. Buried in Montparnasse Cemetery (Paris).

EXHIBITIONS (Selected) — **1932** New York (Julien Levy Gallery)
GE // **1933** Paris (Galerie Arts et Métiers Graphiques) SE //
1936 Paris (**Exposition Internationale de la photographie**) GE
// **1951** Saarbrücken (Germany) (**subjektive fotografie**) GE //
1956 New York (Museum of Modern Art — 1968) SE // **1963**
Paris (Bibliothèque nationale de France) SE // **1974** Arles
(France) (Rencontres internationales de la photographie) SE
// **1977** Kassel (documenta 6) GE // **1979** London (The Photog-
raphers' Gallery) SE // **1988** Paris (Musée Carnavalet) //
1993 Barcelona (Fundació Antoni Tàpies) SE // **1998** Houston
(Museum of Fine Arts) SE // **2000** Paris (Centre Pompidou) SE
// **2007** Berlin (Martin-Gropius-Bau) SE // **2009** Paris (Jeu de
Paume – Site Sully/**Collection Christian Bouqueret**) GE //
2013 Paris (Hôtel de Ville) SE

BIBLIOGRAPHY (Selected) — **Paris de nuit.** Paris 1932 // **Les
sculptures de Picasso.** Paris 1949 // **Camera in Paris**. London
1949 // **B.** Paris 1952 // **Graffiti**. Paris 1961 // **Conversations
avec Picasso**. Paris 1964 // **Le Paris secret des années 30**.
Paris 1976 // **The Artists of My Life**. New York 1982 // **B.** Paris
1987 // **B.: Paris le jour, Paris la nuit**. Paris 1988 (cat. Musée
Carnavalet) // **B.: Del surrealismo al informalismo**. Barcelona
1993 (cat. Fundació Antoni Tàpies) // Anne Wilkes Tucker: **B.
The Eye of Paris**. Houston 1998 (cat. Museum of Fine Arts) //
Alain Sayag and Annick Lionel-Marie: **B.** Paris 2000 (cat. Cen-
tre Pompidou) // Martin Parr and Gerry Badger: **The Photo-
book: A History Volume I**. London 2004 // Jean-Claude Gau-
trand: **B. 1899–1984**. Cologne 2004 ⏎ // Herbert Molderings:
Die Moderne der Fotografie. Hamburg 2008 // **Paris. Capitale
photographique. 1920/1940. Collection Christian Bou-
queret**. Paris 2009 (cat. Jeu de Paume – Site Sully) // Sylvie
Aubenas/Quentin Bajac: **B. – Flaneur durch das nächtliche
Paris**. Munich 2013.

CAMERA IN PARIS
by BRASSAI

Brassaï: **Camera in Paris.**
London (The Focal Press) 1949

"Artist, sculptor, writer, journalist and friend of all artists, that was Brassaï, the eye of Paris, photographer of the night and tenderness, who was given all the talents, especially the ability to trace the most delicate echo and react to vibrations, always available, always in action. John Szarkowski, the former director of the Museum of Modern Art in New York, once wrote that European photography around 1935 was dominated by two figures: Cartier-Bresson, the classic and measured, and Brassaï, the moving spirit of the bizarre. No one better captured and described the phenomenon that was Brassaï than Henry Miller, his brother of the night: 'Brassaï is a living eye, his gaze penetrates into the heart of things. Like a falcon or a shark we see him tremble before attacking reality.' – 'This man, who has more than two eyes', wrote Jean Paulhan, had above all a vision, an insatiable vision that swallowed things and people. This natural talent of seeing everything, indeed seeing even more, is certainly the origin of his versatility, the universality of an artist who plays on a thousand pianos."

— Jean-Claude Gautrand

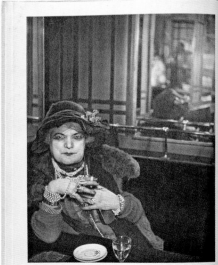

" Bijou " of Montmartre. Lady of fashion.

54 55

76 Market porter. Lady of the town. 77

78 Shop window. Something to look at. 79

Hugo Brehme *(Ernst Hugo Brehme Wick)*

Hugo Brehme: **Mexico Pintoresco.**
Mexico (H.B. Ave. 5 de Mayo 27)
1923

3.12.1882 Eisenach (Germany) — 13.6.1954 Mexico City (Mexico)
Mexico: the country and its people are the center of an oeuvre on the threshold of Pictorialism to modernism, much published after 1900, also incl. reportage-like images. Oldest of three children. Father a shoemaker. Moves to Erfurt at 16. Photography apprenticeship in Weimar. 1900–1901 trip to the German colonies: Cameroon, Togo, Southwest Africa (Namibia), and German East Africa (Tanzania). Perhaps 1903, certainly 1905 first trip to Mexico. First photo publication (uncredited) in the magazine *El Mundo Illustrado*. 1908 returns to Germany. Marries Augusta Carolina Hartmann. Returns to Mexico City, working at first as assistant to the German-born photographers Brinckmann and Waldemar Meldrert. 1910–1913 together with Agustin Victor Casasola documents the Mexican revolution. 1914 famous portrait (full figure in uniform) of the revolutionary Emiliano Zapata. In the same year, opens a studio in Mexico City. Numerous publications of his urban landscapes, landscapes and photos of Mexicans in the *National Geographic Magazine*, *Tricolor*, *Revista de Revistas*, *Mapa*, *L'art vivant*. His work appears in books such as *Guide and Handbook for Travellers to Mexico City and Vicinity* (1924), *Colonial Residences of Mexico* (1928), *Los Caminos de Mexico* (1931), *Mexico through Time* (1945), *The Aqueducts of Mexico in History and Art* (1949), *Taxco the Enchanted City* (1950), and *¿Cómo nace un Volcán?* (1950). 1923 in Germany to oversee the printing of his important book, *México pintoresco. 50 excursiones por los pintorescos alredededores de la ciudad de México*, which appeared in Spanish, English, German, and French. 1928 takes over Emilio Lange's studio in calle de Madero I. In the same year (August), together with > Álvarez Bravo and > Modotti, participates in the pioneering exhibition *Exposition of Mexican Photographers*. Awards for his works *Una calle de Guanajuato* and *El Mercado de Taxco*. 1931, together with the avant-garde photographers Álvarez Bravo, Augustin Jiménez, Eugenia Latapi, and Lola Álvarez Bravo, award in the Concurso Tolteca. The award is also a signal for the end of Pictorialism. 1935 his first Leica. Subsequently works increasingly with small-format camera. 1951 Mexican citizenship. Buried in the German cemetery (Panteón Alemán) in Mexico City. Major lot (359 original prints) held at the Ibero-Amerikanischen Institut in Berlin.

EXHIBITIONS (Selected) — **1928** Mexico City (**Exposition of Mexican Photographers**) GE // **1929** Sevilla (**Exposition of Mexican Photographers**) GE // **1995** Mexico City (Instituto Nacional de Bellas Artes) SE // **2004** Berlin (Martin-Gropius-Bau) SE // **2010** Barcelona (Fundació Foto Colectania) GE

BIBLIOGRAPHY (Selected) — **Mexico Pintoresco**. Mexico 1923 // **Mexiko: Baukunst, Landschaft, Volksleben**. Berlin 1925 // Erika Billeter: **Canto a la realidad. Fotografá Latinoamericana 1860–1993**. Barcelona 1993 // **México: una nación persistent E.H.B.: Fotografías**. Mexico 1995 (cat. Instituto Nacional de Bellas Artes) ✐ // Michael Nungesser (ed.): **H.B.: Fotograf. Mexiko zwischen Revolution und Romantik**. Berlin 2004 (cat. Martin-Gropius-Bau)

"The history of photography in Mexico includes among its pioneers exceptional artists who upon arriving from Europe took on the task of rediscovering the many faces of our country. Hugo Brehme was one of them. His unquestionable talent and creative vocation led him through pathways that with every step taken, revealed incomparable natural landscapes and simultaneously, the wealth of native popular cultures. All this fascinated the artist, who lived for over forty years in Mexico, ultimately his chosen home. […] His great human quality and professionalism merited the acknowledgement of his collaborators and students, especially after publication in 1923, of his *Picturesque Mexico*, a book that presents the best of his extensive artistic efforts and is still regarded as a classic in photography." — Rafael Tovar 🖉

Pirámide de la Luna Pyramid of the Moon

Mondpyramide
San Juan Teotihuacán
Estado de México

Hilera de Basamentos piramidales de la "Ciudadela" Series of Pyramid basements of the "Citadel"
(restaurados por Gamio) (restored by Gamio)
Reihe pyramidenförmiger Unterbauten der "Citadelle" (restauriert von Gamio)
San Juan Teotihuacán
Estado de México

Marianne Breslauer *(Marianne Feilchenfeldt)*

**Retrospektive Fotografie:
Marianne Breslauer.**
Düsseldorf (Edition Marzona) 1979

20.11.1909 Berlin (Germany) — 7.2.2001 Zollikerberg (Switzerland)
Portrait studies, travel photography and experimental street views the center of an oeuvre made principally between 1926 and 1937. Granddaughter of Julius Lessin, the first director of the Berlin Kunstgewerbemusem, built by the architect Martin Gropius, and daughter of the villa architect Alfred Breslauer. Inspired by the work of the Berlin photographer Frieda Reiss. Trains in the photo class of the Lette-Verein. Friendship with Paul Citroen. Meets Annamarie Schwarzenbach and (after 1933 in Switzerland) Therese Giehse. 1929 in Paris. Meets > Man Ray. Street Photography artistically close to > Kertész. To 1934 numerous publications in *Frankfurter Illustrierte*, *Querschnitt*, *Das Magazin*, *Gebrauchsgraphik*, *Uhu*, *Die Dame*, among others. 1930–1932 works for Ullstein Verlag. 1931 travels to Palestine. 1932 Paris. 1933 travels to Spain with Annemarie Schwarzenbach. From 1933 press work under the fictive agency names "Ippkind" and "Academia" as working under her own name is no longer possible. 1936 emigrates to Amsterdam. Marries Walter Feilchenfeldt. From 1939 (forced) residency in Switzerland, where she finds herself at the outbreak of the war, no longer able to return to Amsterdam. After stays in St Gallen and Tessin, from 1948 in Zurich. Her husband opens the Feilchenfeldt art dealership. Photography now especially for the art trade (documenting art works) and in the family. Carries on with the art trade after the death of Walter Feilchenfeldt (1953). 1999 Hannah Höch Award from the State of Berlin.

EXHIBITIONS (Selected) — **1929** Stuttgart (**Film und Foto**) GE // **1930** Munich (**Das Lichtbild**) GE // **1932** Berlin (Haus der Juryfreien/**Das Meisterphoto**) GE // **1982** Zurich (Kunsthaus) SE // **1987** Berlin (Das Verborgene Museum) SE // **1989** Berlin (Nationalgalerie) SE // **1994** Essen (Museum Folkwang) GE // **1997** Bonn (Rheinisches Landesmuseum) GE // **1999** Berlin (Museum Ephraim-Palais) SE // **2005** New York (Neue Galerie/**Portraits of an Age**) GE // Vienna (Albertina/**Portrait im Aufbruch**) GE // **2009** Paris (Jeu de Paume – Site Sully/Collection Christian Bouqueret) GE // Paris (Galerie Esther Woerdehoff) SE // **2010** Winterthur (Switzerland) (Fotostiftung Schweiz) SE // Berlin (Berlinische Galerie) SE

BIBLIOGRAPHY (Selected) — **Retrospektive Fotografie: M.B.** Düsseldorf 1979 // M.B.: **Photographien 1927–1937**. Berlin 1989 (cat. Nationalgalerie) // **Fotografieren hieß teilnehmen. Foto-**grafinnen der Weimarer Republik. Düsseldorf 1994 (cat. Museum Folkwang) // Christian Bouqueret: **Des années folles aux années noires**. Paris 1997 // Klaus Honnef and Frank Weyers: **Und sie haben Deutschland verlassen ... müssen. Fotografen und ihre Bilder 1928–1997**. Bonn 1997 (cat. Rheinisches Landesmuseum) 🖉 // **M.B.:Photographien 1927–1936**. Berlin 1999 // Dominik Bartmann: **M.B. in: Museumsjournal**, no. IV, 1999 // Monika Faber and Janos Frecot (eds): **Portrait im Aufbruch. Photographie in Deutschland und Österreich 1900–1938**. Ostfildern-Ruit 2005 (cat. Albertina, Vienna) // Paris. **Capitale photographique. 1920/1940. Collection Christian Bouqueret**. Paris 2009 (cat. Jeu de Paume – Site Sully) // **Bilder meines Lebens**. Wädenswil 2009 // Kathrin Beer and Christina Feilchenfeldt (eds): **M.B. – Fotografien**, Wädenswil 2010

"The photographer Marianne Breslauer often chose distant, elevated standpoints to oversee landscapes or squares and the people in them. In doing so, her photographic eye concentrated on structural details, the oscillation of the quay on the banks of the Seine or the zigzag of a set of stairs. She gave her photos a formal order. An often dramatic light and shadow contrast, the influence of Man Ray, strengthened this effect." — Frank Weyers ✍

Alexey Brodovitch

Alexey Brodovitch: **Ballet.**
New York (J.J. Augustin) 1945

1898 Ogolitchi (Russia) — 15.4.1971 Le Thor (France) Graphic artist, art director, photographer, influential teacher. Without doubt the most important graphic designer in America from the 1930s to the 50s. Child of an upper-middle-class family. Childhood in Moscow and St Petersburg. 1914 instead of planned art studies, joins White Russian Army. Battlefield service in Romania, Odessa, and Caucasus. 1920 moves to Paris. Set designer of Sergei Diaghilev's Ballets Russes. Layouts for *Arts et Métiers Graphiques* and *Cahiers d'Art*. From 1924 poster and exhibition design. Wins awards and begins to establish a reputation. 1930 moves to Philadelphia and sets up a class for advertising design at the Pennsylvania Museum School of Industrial Art. 1934 moves to New York. Art director for *Harper's Bazaar* (to 1958). 1941 sets up a design laboratory at the New School for Social Research. Students include > Bassman, > Faurer, > Namuth, > Penn, and especially > Avedon, who once called him "his only teacher". 1945 publication of his book *Ballet*, with his own experimental stage photography. Book design for > Kertész (*Day of Paris*, 1945), > Munkácsi (*Nudes*, 1959), and Avedon (*Observations*, 1959), among others. 1949–1951 design for the graphics magazine *Portfolio* (three issues). 1966 gives up teaching due to illness. Moves to France. Posthumous (1972) inclusion in the Hall of Fame of the ADC (Art Directors Club) New York. 1982 major exhibition *Hommage à A.B.* in Arles and Paris.

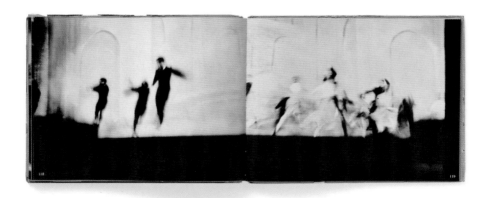

EXHIBITIONS (Selected) — **1972** Philadelphia (College of Art) SE // **1982** Arles (France) (Rencontres internationales de la photographie) SE // Paris (Grand Palais) SE // **1998** Paris (Maison européenne de la photographie) SE

BIBLIOGRAPHY (Selected) — **Ballet**. New York 1945 // Michel Maingrois: "Hommage à Alexey Brodovitch." In: **Zoom**, no. 9, 1971 // George R. Bunker: **A.B. and his Influence**. Philadelphia 1972 // Georges Tourdjman: **A.B.** Paris 1982 // Andy Grundberg: **A.B.** New York 1989 ✎ // Jane Livingston: **The New York School**. New York 1992 // Gabriel Bauret: **Portfolio A.B.** Paris 1998 // Kerry William Purcell: **A.B.** London 2002 // Martin Parr and Gerry Badger: **The Photobook: A History Volume I**. London 2004 // **Books on Books #11: Ballet**. New York 2011

"Brodovitch was a tireless advocate of photography's powers of communication. Fascinated with the medium's potential to go beyond everyday reality, he made it the backbone of his design technique, using photographs to cue his layout decisions. Seeking new ways of depicting clothes, he prominently featured the innovative fashion photographs of Martin Munkácsi, Man Ray, and Richard Avedon, among many others." — Andy Grundberg ✍

Anton Bruehl

Modern Photography 1937–38.
The Studio Annual of Camera Art.
London (The Studio Limited) 1938

11.3.1900 Hawker (Australia) — 10.8.1982 San Francisco (USA) Fashion photographer for Condé Nast, advertising photography akin to New Vision (Neues Sehen). In the 1930s, as pioneer of color photography, one of the most prominent art photographers in the USA. First photographs at the age of ten. Studies engineering in Melbourne. At the same time very active as amateur photographer. 1919 moves to New York. There works for Western Electric. 1923 visits an exhibition of students of the Clarence H. White School of Photography (probably > Outerbridge, Wynn Richards, Ralph Steiner, Margaret Watkins). Subsequently takes up professional photography and (1926) opens a studio on 47th Street. First advertising contracts in a visual language clearly schooled on Outerbridge. Works together with Ralph Steiner. 1927 first publications (advertising) in the *The New Yorker*. 1928 ADC (Art Directors Club) medal for his *Fabric Group* campaign; subtle light, elegant staging, spiced with dry humor from then on a speciality of his advertising work. From 1928 works more frequently for Condé Nast (*Vogue, Vanity Fair, House & Garden*). Together with M.F. Agha (art direction) and Fernand Bourges (technique), introduces color photography in fashion and beauty there. On 1 May 1932 first color photographs in *Vogue*. Exploration and refinement of (before the introduction of Kodachrome, 1935) complicated color process. 1931, together with Agha, develops a dummy (rejected) for an illustrated magazine entitled *Life* (taken up later by Henry Luce). In addition independent works, with ten shown at the *Film und Foto* exhibition in Stuttgart (1929). 1933 publishes his much admired photobook *Mexico*. Numerous publications in *U.S. Camera*. After 1945 returns to advertising contracts. 1966 retires from the business. End of the 1970s, rediscovery of his works by a growing art and photography market.

EXHIBITIONS (Selected) — **1929** Stuttgart (**Film und Foto**) GE // **1931** New York (Delphic Studios – 1933) SE // **1932** New York (Julien Levy Gallery) GE // **1937** New York (Museum of Modern Art) GE // **1976** Chicago (Art Institute) GE // **1980** Tucson (Arizona) (Center for Creative Photography) SE // **1986** Cologne (photokina/**50 Jahre moderne Farbfotografie 1936–1986**) GE // **1998** New York (Howard Greenberg Gallery) SE // **2008** London (National Portrait Gallery) GE // **2009** Stuttgart (Staatsgalerie/ **Film und Foto: Eine Hommage**) GE

BIBLIOGRAPHY (Selected) — **Photographs of Mexico**. New York 1933 // **Tropic Patterns**. Hollywood 1970 // Polly Devlin: **The Vogue Book of Fashion Photography**. London 1979 // **50 Jahre moderne Farbfotografie/50 Years Modern Color Photography 1936–1986**. Cologne 1986 (cat. photokina) // Bonny Yochelson: **Pictorialism into Modernism: The Clarence H. White School of Photography**. New York 1996 // **A.B.** New York 1998 (cat. Howard Greenberg Gallery) ✎ // **Geschichte der Photographie 1839 bis heute**. Cologne 2000 // **Vanity Fair Portraits. Photographs 1913–2008**. London 2008 (cat. National Portrait Gallery)

"More than any other Clarence White protégé, Bruehl fulfilled White's vision of an artist sustaining a career by making beautiful photographs for the printed page. Even when hampered by the demands of his clients, Bruehl never wavered in his commitment to creative expression and technical excellence. His elaborate studio fictions have a glamour, vibrancy, and wit that distinguish him from his contemporaries and illuminate the yearning of Americans in the decades between the world wars." — Bonnie Yochelson ✍

Anton Bruehl (right-hand page): **Still-Life,**
from: **Modern Photography 1937–38**
London (The Studio Limited) 1938

John Bulmer

John Bulmer: **We're not so crowded here,** from: **The Sunday Times Magazine,** 28.3.1965

28.2.1938 Hereford (England) — Lives in London (England) Style-setting color essays and reportages. In the 1960s works especially for *The Sunday Times Magazine*. Today active exclusively as a documentary filmmaker. Studies engineering at Cambridge. Photo editor of the student newspaper *Varsity*. At the same time first works for *Queen* and *Paris Match*, as well as dailies such as the *Daily Express*. Sent down from the university (six weeks before exams) after a publication in *Life* (*Night Climbers of Cambridge*). Subsequently works as freelance photographer for *Town* (under Art Director Tom Wolsey) and *Queen* (under Mark Boxer). 1962 begins work for the *Sunday Times Colour Section* (from 1963 *Sunday Times Colour Magazine* then *The Sunday Times Magazine*). Collaborator from the first issue. Guaranteed 60 pages annually, especially foreign reports. Reports from war zones such as Cyprus, Congo, Beirut, and Borneo, as well as British themes in color. Thus without doubt greatly influences the rising generation of British color photographers (> Parr, > Waplington, Tom Wood). After the supplement's editorial reorientation, takes up film. As director and/or cameraman, numerous documentaries, especially for the BBC (incl. *Dances with Llamas*, *Empty Quarter*, *Bull Magic*). Today director of the John Bulmer George & Dragon Studios in London. 1998 rediscovery of his most important color contributions as part of the exhibition *Young Meteors* (with > Bailey, > Deakin, > Donovan, Robert Freeman, > Griffiths, Nigel Henderson, David Hurn, > McCullin, > Mayne).

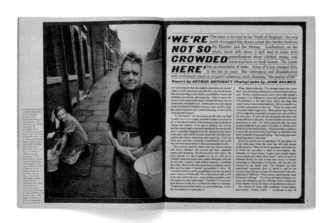

"John Bulmer was recognized immediately for having made the necessary adjustment and thinking specifically in terms of colour, and became one of the most prolific contributors of colour reportages to the *Sunday Times Colour Section*. Many of Bulmer's most important assignments were abroad, but he was also acknowledged as an adroit recorder of provincial Britain. His reputation as a photographer of the industrial cityscape was probably gained at *Town*, where he was responsible for stories on Nelson, Lancashire, the Black Country, and 'The North is Dead'." — Martin Harrison ✍

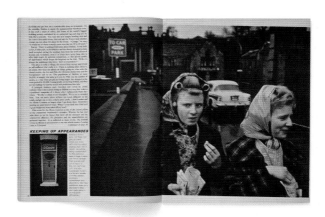

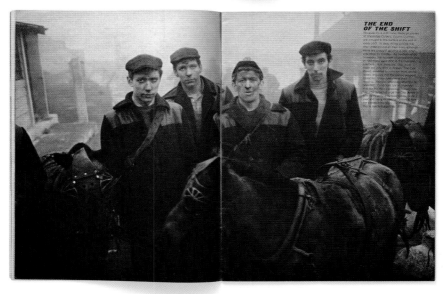

René Burri

9.4.1933 Zurich (Switzerland) — **20.10.2014** Zurich Documentary films and collages. As a photojournalist and member of Magnum he is especially well known for his reportages schooled in the ideals of an humane photojournalism. 1940–1949 attends primary school in Zurich. Begins studying at the Zürcher Kunstgewerbeschule. Foundation course under Johannes Itten. 1950 switches to photography major under > Finsler and Alfred Willimann. Graduates 1953. School grant for a film on his school. Studio with Walter Binder for a short time. As cameraman works on the Walt Disney Film *Switzerland*, directed by Ernst A. Heiniger. A reportage on young Americans in Switzerland (*13 sehen unser Land in 7 Tagen* for *Die Woche*, no. 39, 1953) his first major publication. 1954–1955 recruit school. Photographer in the graphic artist Josef Müller-Brockmann's Zurich studio. 1955 photo publication in the French journal *Science & Vie*, somewhat later in *Life*, on the Zurich music teacher Mimi Scheiblauer's work with deaf children. 1955 travels to Paris and first contact with the photographers' cooperative Magnum. 1956 associate member of Magnum, full member from 1959. In the 1950s and 60s numerous photo essays and reportages of Eastern and Western Europe, the Middle East, Latin America, and Africa. 1962 Robert Delpire encourages and then publishes his first book, entitled *Die Deutschen*. 1963 travels to Cuba for *Look*. Meets Fidel Castro and Ernesto "Che" Guevara. Portrays Guevara, the Minister of Industry, in his office during an interview lasting a number of hours. 1964 first trip to China. Many admired publications of the material in *Life*. In addition photo reports for journals and magazines such as *Fortune*, *Bunte*, *Stern*, *Paris Match*, *Switzerlander Illustrierte*, and *Du*. 1969 begins a long-standing series *Modern Architecture* for the *Daily Telegraph Magazine*. At the same time portraits and portrait series of well-known architects, painters, musicians, writers and directors such as Pablo Casals, Le Corbusier, Alberto Giacometti, Patricia Highsmith, Yves Klein, Oscar Niemeyer, Pablo Picasso, Jean Renoir, and Jean Tinguely. Numerous exhibitions. 1984 *One World*, his first major retrospective, with stops in Zurich, Paris, Lausanne.

EXHIBITIONS (Selected) — **1965** Zurich (Galerie Form) SE // **1980** Essen (Museum Folkwang) SE // **1981** Cologne (Galerie Rudolf Kicken) SE // **1984** Zurich (Kunsthaus) SE // Paris (Centre national de la photographie) SE // **1985** Lausanne (Musée des Arts décoratifs) SE // **1998** Cologne (photokina) SE // Frankfurt am Main (Fotografie Forum) SE // **2004** Paris (Maison européenne de la photographie) SE (Touring exhibition visiting Berlin, Lausanne, Milan, Zurich, Manchester, Havana, Mexico City, Buenos Aires, Caracas, Bogota and Luxemburg) // **2005** Basel (Museum Tinguely) SE // **2009** Arles (France) (Rencontres internationales de la photographie) GE // **2014** Vienna (OstLicht)SE

BIBLIOGRAPHY (Selected) — **Die Deutschen**. Zurich 1962 (new editions: Munich 1986, 90, 99) // **The Gaucho**. Buenos Aires 1968 // **I Grandi Fotografi. R.B.** Milan 1983 // **Ein amerikanischer Traum. Photographien aus der Welt der NASA und des Pentagon.** Nördlingen 1986 // **Gauchos.** New York 1994 // **Che Guevara.** Paris 1997 // **77 Strange Sensations.** Zurich 1998 // **R.B.** Paris 1998 (= Photo Poche no. 79) ✏ // **Le Corbusier.** Basel 1999 // **Luis Barragán.** London 2000 // **Berner Blitz.** Zurich 2002 // Hans-Michael Koetzle (ed.): **R.B. Photographs.** London 2004 // **Jean Tinguely. Face à face.** Bern/Basel 2005 (cat. Museum Tinguely) // **Un Mundo.** Havana 2007 (cat. Museo Nacional de Bellas Artes) // **On est treize à table.** Zurich 2008 // **Blackout New York.** Munich 2009 // **Impossible Reminiscences.** London 2013

A number of documentaries incl. *The Two Faces of China* (1966), *Jean Tinguely* (1972), and *Indian Summer* (1973). Together with > Bischof without doubt the best-known post-war Swiss photojournalist. 1988 Dr Erich-Salomon Prize from the DGPh (Deutsche Gesellschaft für Photographie: German Photographic Association). 1999 cultural prize from the Zurich Canton. 2004 major exhibition of his works in Paris (Maison européenne de la photographie) with stops in Berlin, Lausanne, Milan, Zurich, Manchester, Havana, and Mexico City, as well as (2008) Buenos Aires, Caracas, and Bogota.

(Henry Frank Leslie) Larry Burrows

Larry Burrows: **One Ride with Yankee Papa 13,** from: **Life,** Vol. 58, no. 15, 16.4.1965

29.5.1926 London (England) — 10.2.1971 Laos Photojournalist, war reporter. As such, the best-known exponent of his profession in the 1960s, with numerous cover stories, especially for *Life*. Son of a railway worker. Leaves school at 13. Subsequently art department at the *Daily Express* and at Keystone. At 16 in the *Life* photo lab in London. 1943 alternative service in a coal mine in Yorkshire. Returns to *Life*. First photo report of local events as well as art reproductions. After WW II, photographer for *Time*. First war reportage during the Anglo-French invasion of Egypt in 1956 (Suez Crisis). Subsequently in Congo. From 1961 lives in Hong Kong. From there, from 1962 (and until his death) photo reports on the Vietnam War. As war reporter quickly becomes one of the best known of his profession. Numerous publications especially in *Time* and *Life*. Author of numerous key images on the war. *One Ride with Yankee Papa 13* (published 16 April 1965 in *Life*) is considered one of his best reportages, sometimes compared with > Smith's *Country Doctor*. 1971, together with the photographers Henri Huet, Kent Potter, and Keisaburo Shimamoto, as well as seven Vietnamese soldiers, killed in a helicopter crash in Laos. Numerous awards, incl. Robert Capa Prize from the Overseas Press Club (1964, 1966), Magazine Photographer of the Year (1967), British Press Picture of the Year (1967). Further (posthumous) honors at the opening of the Newseum, a Museum of News & Journalism in Washington, DC, in 2008.

"**Burrows was well known for his color work also. Much of it was reproduced in the pages of *Life* at a time when war photographs in color were rare. He was an early master of the medium, setting a standard still hard to match. If the pictures were in color, they didn't work well in black and white. The subtlety of skin hues on wounded and dying men, red bandages against the earth's muck, make the four-color images melancholy masterpieces.**" — Marianne Fulton ✍

EXHIBITIONS (Selected) — **1967** London (British Press Awards) GE // **1971** London (Royal Photographic Society) SE // **1972** Rochester (Institute of Technology) SE // London (The Photographers' Gallery) SE // **2003** Bradford (England) (National Museum of Photography, Film and Television) GE // New York (Laurence Miller Gallery — 2009) GE // **2004** Amherst (Massachusetts) (Mead Art Museum/**The Pain of War**) GE // **2005** New York (Laurence Miller Gallery/**War and Peace**) SE

BIBLIOGRAPHY (Selected) — **L.B.: Compassionate Photographer.** New York 1972 // Rainer Fabian and Hans Christian Adam: **Bilder vom Krieg. 130 Jahre Kriegsfotografie – eine Anklage.** Hamburg 1983 // Marianne Fulton: **Eyes of Time. Photojournalism in America.** Boston/Toronto/London 1988 ✍ // John G. Morris: **Get the Picture: A Personal History of Photojournalism.** Chicago/London 2002 // **L.B.: Vietnam.** New York 2002 // **The Great LIFE Photographers.** New York 2004

Mission Over but Not for a
Long, Long Time Forgotten

Strike—Farley Cuts
Loose at the Tree Line

Harry Callahan

Harry Callahan: **Color 1941–1980.**
Providence (Matrix Publications)
1980

22.10.1912 Detroit (Michigan, USA) — 15.3.1999 Atlanta (Georgia, USA) Prominent art photographer in America from the 1940s to the 80s. Formally interested in nature studies, nudes (his wife), portraits, street scenes, landscapes, urban landscapes, experiments (in b/w, and color) at the center of an oeuvre oscillating between Bauhaus and American photography. 1934 studies at Michigan State University (chemical engineering). 1936 to Chrysler Motor Company. In the same year marries Eleanor Knapp. 1938 first camera. Member of Chrysler Camera Club and the Detroit Photo Guild. Meets Todd Webb and Arthur Siegel. 1941 workshop with > Ansel Adams. 1943 minimalist photographs of grass in snow. First color experiments (long exposure time on slide film). 1945 leaves his job at Chrysler. Moves to New York, where he meets > Abbott, > Levitt, > Model, and > Strand, among others, and discovers the work of > Atget. After failing to get a MoMA fellowship, returns to Detroit. 1946 at > Moholy-Nagy's invitation, teaches at the Institute of Design, Chicago. 1948 beginning of friendship with > Steichen. Contributes six works to the important exhibition *In and Out of Focus*. Friendship with > Siskind. 1949 head of the Department of Photography, Institute of Design, Chicago. Nudes, portraits of his wife as well as "snapshots" of her and his daughter, Barbara. 1958 longer stay in south of France. 1961 associate professor of photography, Rhode Island School of Design, Providence (tenured from 1964). 1963 extensive travels, incl. in Latin America, Europe, North Africa, and Asia. 1964 *Photographs: H.C.*, his first book. 1975 sells his archive to the Center for Creative Photography. 1977 retires from teaching. Concentrates on his artistic work (in color). In the same year guest of honor at the Rencontres d'Arles. 1983 moves to Atlanta. Numerous honors and awards, incl. 1996 National Medal of Arts.

EXHIBITIONS (Selected) — **1947** Chicago (750 Studio Gallery) SE // **1951** Chicago (Art Institute – 1984) SE // New York (Museum of Modern Art – 1962, 1968, 1976) SE // **1958** Rochester (New York) (George Eastman House – 1971) SE // **1968** Cambridge (Massachusetts) (Massachusetts Institute of Technology – 1975) SE // **1977** Arles (France) (Rencontres internationales de la photographie) SE // **1978** Venice (38 Biennale) SE // **1983** Tokyo (Seibu Museum of Art) SE // **1984** Tucson (Arizona) (Center for Creative Photography – 2006) SE // **1990** Paris (Musée national d'art moderne) SE // **1996** Washington, DC (National Gallery of Art) SE // **2000** Madrid (PHotoEspaña/Fundación "la Caixa") SE // **2002** New York (Howard Greenberg Gallery) SE // **2003** New York (Pace/MacGill Gallery – 2006) SE // Hamburg (Deichtorhallen) GE // **2004** Los Angeles (Peter Fetterman Gallery) SE // **2006** Chicago (Art Institute) SE // **2007** San Diego (California) (Museum of Photographic Arts) SE // Atlanta (High Museum of Art) SE // **2008** Rhode Island (School of Design) SE // **2013** Hamburg (Haus der Photographie/Deichtorhallen) SE

BIBLIOGRAPHY (Selected) — **Photographs: H.C.** Santa Barbara 1964 // **Color 1941–1980.** Providence 1980 // **The Photography of H.C.** Tokyo 1983 (cat. Seibu Museum) // **Eleanor: Photography by H.C.** Carmel 1984 // Sarah Greenough: **H.C.** Boston 1996 (cat. National Gallery of Art, Washington, DC) // **H.C.** Madrid, 2000 (cat. Fundación "la Caixa") 🖾 // **Taken by Design: Photographs from the Institute of Design 1937–1971.** Chicago 2002 // **A Clear Vision. Photographische Werke aus der Sammlung F.C. Gundlach.** Hamburg 2003 (cat. Deichtorhallen) // **Nature.** Göttingen 2007 // **Eleanor.** Göttingen 2007 // **H.C. Retrospektive.** Heidelberg 2013 (Haus der Photographie, Deichtorhallen Hamburg)

"Harry Callahan's significance to modern photography can hardly be overestimated. As a photographer and teacher he has touched thousands of lives, immeasurably enriching our visual heritage. His work has been admired for its precision and purity of means, as well as for its deep respect for the world, and for life. Callahan's vision charges the commonplace with a formal eloquence and timeless significance." — Keith F. Davis

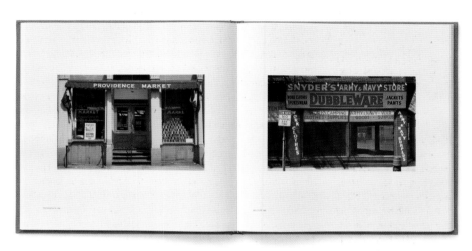

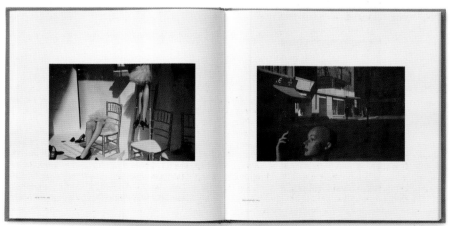

Robert Capa *(Endre Ernö Friedmann)*

Robert Capa: **Death in Spain,**
from: **Life,** 12. 7. 1937

22.10.1913 Pest/Budapest (Hungary) — 25.5.1954 Tai-Binh (North Vietnam) Photojournalist, war photographer. In 1938 already celebrated by *Picture Post* as the "Greatest War Photographer in the World". Also plays a central role in founding Magnum. 1923–1931 secondary school in Budapest. Friendship with the young Eva Besnyö. Meets the left-wing intellectual Lajos Kassák. Subsequently decides to become journalist. 1931 moves to Berlin. Studies at the liberal Deutsche Hochschule für Politik (German Academy for Politics). Contact with György Kepes. From him first (second-hand) camera. 1932–1933 lab technician at the Dephot agency. End of 1932 candid photos of Leon Trotsky agitating (in Copenhagen) taken with his Leica – his first major publication (in *Weltspiegel*). 1933 moves to Paris via Vienna. Meets > Freund, > Namuth, especially > Seymour ("Chim"), and > Cartier-Bresson. 1934 friendship with Gerda Taro. Works for Alliance Photo. Publishes under the name "André", "Fried", and finally "Capa". From 1936 reportages on the Spanish Civil War for *VU* and *Regards*. On 23 September 1936 his best-known photo: *Death of a Loyalist Soldier*. 1938 war reporter in China. 1939 moves to the USA. Works for *Collier's* and *Life*. At first American themes. Later much admired reportages from war zones in Europe (incl. *D-Day*, 1944). End of 1944 Paris correspondent for *Life*. 1947 founding member of Magnum. In the same year with John Steinbeck in the Soviet Union (*A Russian Journal*). 1948 first trip to Israel. 1954 (replacing the *Life* photographer Howard Sochurek) to Vietnam. There killed by a landmine. End of 2007 spectacular rediscovery of a case with around 3,500 negatives (photos by R.C., Taro, and Chim) from the Spanish Civil War period (see *Le Monde* 2, no. 208, 2008). Today in the International Center of Photography, New York.

EXHIBITIONS (Selected) — **1955** New York (**The Family of Man**) GE // **1956** Cologne (photokina – 1963, 1980) GE // **1960** Washington, DC (Smithsonian Institution – 1964) SE // **1986** Paris (Centre national de la photographie) SE // **1995** Berlin (Deutsches Historisches Museum) GE // **1997** Bonn (Rheinisches Landesmuseum) GE // **2001** Lausanne (Musée de l'Élysée) SE // **2007** New York (International Center of Photography) SE // **2008** Vienna (WestLicht) GE // **2010** New York (ICP) SE

BIBLIOGRAPHY (Selected) — **Death in the Making**. New York 1938 // **The Battle of Waterloo Road**. New York 1941 // **Slightly out of Focus**. New York 1947 // **Report on Israel**. New York 1950 // **Images of War**. New York 1964 // Cronell Capa and Richard Whelan: **R.C.: Photographs**. New York 1985 // Richard Whelan: **R.C.: A Biography**. New York 1985 // **Ende und Anfang. Photographien in Deutschland um 1945**. Berlin 1995 (cat. Deutsches Historisches Museum) ✎ // Klaus Honnef and Frank Weyers: **Und sie haben Deutschland verlassen … müssen**. Bonn 1997 (cat. Rheinisches Landesmuseum) // **Heart of Spain. R.C.'s Photographs of the Spanish Civil War**. New York 1999 // Richard Whelan: **R.C.: The Definitive Collection**. London 2001 // Richard Whelan: **This is War! Robert Capa at Work**. Göttingen 2007 (cat. International Center of Photography) // Peter Coeln, Achim Heine, and Andrea Holzherr (eds): **MAGNUM's first**. Ostfildern 2008 (cat. WestLicht, Vienna) // Cynthia Young (ed.): **The Mexican Suitcase**. New York 2010 (cat. ICP) // Bernard Lebrun/Michel Lefèbvre: **R.C.: Traces d'une legende**. Paris 2011 // Cynthia Young (ed.): **Capa in Color**. Munich 2014

"Robert Capa was already a legend during his lifetime and thanks to his photos, now classics, and his life, worthy of a film, he is still the 'most famous war reporter in the world'. […] In Spain, Capa developed his own style – he succeeded like no one before in depicting military action with a camera, capturing the horrors and tragedy of war in a specific moment."
— Katharina Menzel ✎

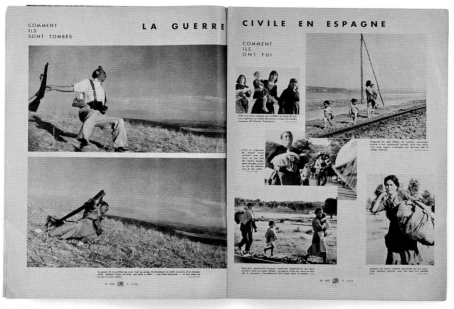

Robert Capa: **La Guerre Civile en Espagne,** from: **VU,** no. 445, 23.9.1936

Robert Capa: **Slightly out of Focus.** New York (Henry Holt and Company) 1947

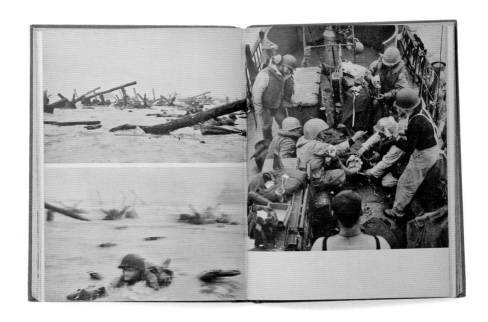

Henri Cartier-Bresson

Henri Cartier-Bresson: **Images à la Sauvette.** Paris (Verve) 1952

22.8.1908 Chanteloup (France) — 2.8.2004 Céreste (France) Artist, filmmaker. Photographer influenced by the fine arts (Cubism), literature (Surrealism), and philosophy (Zen). Sometimes celebrated as "the greatest photographer of modernism" and a "giant in the history of photography". Son of a wealthy family. Father is a textile manufacturer. Interested in art and literature from an early age. Schooling at the École Fénelon and Lycée Condorcet. Takes up painting influenced by Cubism. 1927–1928 trains with André Lhote. 1928–1929 studies at Cambridge (literature and painting). 1930 military service. 1931 visits Africa (Côte D'Ivoire). Subsequently takes up photography (due not least to one of > Munkácsi's photos: *Negro Boys at Lake Tanganyika*, 1930). First Leica. 1933 first exhibition of his imagery clearly drawing on Surrealism at Julien Levy's. 1934–1935 takes part in an ethnographic expedition in Mexico. 1935 a year in New York. Film training under > Strand. 1936–1939 works with the film director Jean Renoir (*La Vie est à Nous*, *La Règle du Jeu*). 1940–1943 prisoner of war in Germany. Escape and Resistance. 1945 documentary film *Le Retour*. 1946 ("posthumous") solo exhibition at the Museum of Modern Art as the beginning of his international reputation. 1947 founding member of Magnum. 1948–1959 India, Burma, Pakistan, China, Indonesia. 1954 Soviet Union. 1958–1959 China. 1960 Cuba, Mexico, Canada. 1965 India and Japan. 1952 *Images à la Sauvette* (*The Decisive Moment*) as his most important book with a programmatic text. 1970 marries > Franck. From the mid 1970s returns more and more to drawing. Numerous awards, incl. 1967 the Kulturpreis from the DGPh (Deutsche Gesellschaft für Photographie: German Photographic Association). Estate part of the Foundation Henri Cartier-Bresson, founded in May 2003 in Paris (Montparnasse).

EXHIBITIONS (Selected) — **1933** New York (Julien Levy Gallery) SE // **1946** New York (Museum of Modern Art – 1968) SE // **1954** Chicago (Art Institute) SE // **1970** Paris (Grand Palais) SE // **1974** New York (International Center of Photography – 1979, 1994) SE // **1981** Zurich (Kunsthaus) SE // **1984** Paris (Musée Carnavalet) SE // **1992** Bonn (Kunst- und Ausstellungshalle der BRD) GE // **1997** Paris (Maison européenne de la photographie – 2009) SE // **2003** Paris (Bibliothèque nationale de France) SE // **2004** Berlin (Martin-Gropius-Bau) SE // **2004** Paris (Fondation Henri Cartier-Bresson) JE (with Manuel Alvarez Bravo, Walker Evans) // **2006** Paris (Fondation Henri Cartier-Bresson) SE // **2007** New York (International Center of Photography) SE // **2008** Vienna (WestLicht) GE // **2010** New York (Museum of Modern Art) SE// **2014** Paris (Centre Pompidou) SE // **2014** Paris (Centre Pompidou) SE

BIBLIOGRAPHY (Selected) — **The Photographs of H.C.-B.** New York 1947 (cat. Museum of Modern Art) // **Images à la Sau-** vette. Paris 1952 (**The Decisive Moment.** New York 1952) // **D'une Chine à l'autre.** Paris 1954 // **Les Européens.** Paris 1955 // **Moscou, vu par H.C.-B.** Paris 1955 // **H.C.-B. photograph.** Paris 1979 // **H.C.-B.: Photoportraits.** Paris 1985 // **Line by Line: The Drawings of H.C.-B.** New York/London 1989 // Klaus Honnef: **Pantheon der Photographie im XX. Jahrhundert.** Bonn 1992 (cat. Kunst- und Ausstellungshalle der BRD) ✍ // Jean-Pierre Montier: **L'Art sans art d'H.C.-B.** Paris 1995 // Pierre Assouline: **C.-B.: L'œil du siècle.** Paris 1999 // **De qui s'agit-il?** Paris 2003 (cat. Bibliothèque nationale de France) // **Documentary and antigraphic photographs.** Göttingen 2004 (cat. Fondation Henri Cartier-Bresson, Paris) // **Scrap Book.** Göttingen 2006 (cat. Fondation Henri Cartier-Bresson, Paris) // **MAGNUM's first.** Ostfildern 2008 (cat. WestLicht, Vienna) // Michel Guerrin: **H.C.-B. et Le Monde.** Paris 2008 // **H.C.-B. – The Modern Century.** New York 2010 (cat. Museum of Modern Art) // Clément Chéroux: **H.C.-B.** Paris 2014 (cat. Centre Pompidou)

"No photographer reflected more intensely on the aesthetics of photography than Cartier-Bresson. No other photographer fused theory and practice to the extent that all of his photographic images are expressions of a determined aesthetic conception, without losing their immediate persuasiveness. No other photographer showed such mastery at capturing the 'decisive moment', that fleeting moment when all the moving elements of a motif are in harmony." — Klaus Honnef

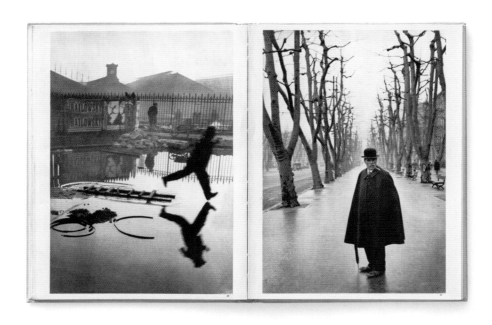

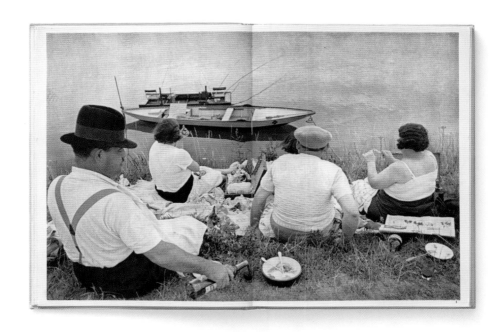

Yevgeny Chaldei *(Khaldei)*

Yevgeny Chaldei: **Von Moskau nach Berlin.** Berlin (Parthas Verlag) 1999

10.3.1916 Yuzovka (later Stalino, today Donetsk, Ukraine) — 6.10.1997 Moscow (Russia) Photojournalist, as chronicler of WW II one of the most important Soviet war photographers. Sometimes called the "Robert Capa of Russia". At the age of one, loses his mother in a pogrom in his home town. Difficult childhood with hunger and illness. 1929 first photographs with a camera obscura he builds himself (using his grandmother's glasses). 1934 photographer for a local work's newspaper, then for the magazine *Stalin's Worker*. 1935, at the invitation of the Soviet news agency TASS, photography course in Moscow. 1936 moves to the capital. Beginning of his professional career (at first for TASS). For *Soyuz Photo,* reportages on construction of the Moscow subway. Photo reports on the country's industrialization (Magnitka, Dneprostroi) and popular working class heroes (Pasha Angelina, Alexei Stakhanov). Contract photographer for *USSR in Construction*, works with > Rodchenko. From 1941, as photographer and lieutenant in the navy, present at nearly all the battle sites from Murmansk to Berlin. In addition photo reports from Bulgaria, Hungary, Romania, Yugoslavia, and Austria. Group photos from the Potsdam Conference. Photos of the Moscow victory parade (22 June 1945). Report from Nuremberg Trials (1946). His war photography appears in a special issue of *USSR in Construction*. 1948 dismissed from TASS (because of a new wave of anti-Semitism in the Soviet Union). Continues his work as journalist, more social themes and portraits of notables (Anna Akhmatova, Dmitri Shostakovich, Mstislav Rostropovich, Gina Lollobrigida). 1971 loses his post at *Pravda*, again because of anti-Semitic currents. Finishes his career working for *Sovestskaya Kultura*. 2008 major retrospective in the Martin-Gropius-Bau, Berlin.

EXHIBITIONS (Selected) — **1994** Berlin (Kunstamt Neukölln/ Galerie Körnerpark) SE // **1995** Berlin (Deutsches Historisches Museum) GE // Perpignan (Visa pour l'image) SE // Milan (Fondazione Antonio Mazzotta) GE // **1996** Skopelos (Greece) (International Festival of Photography) SE // Paris (Hôtel de Sully) GE // **1997** Moscow (Tretyakov Gallery) SE // New York (Jewish Museum) SE // San Francisco (Jewish Museum) SE // **2002** New York (Leica Gallery) SE // **2008** Berlin (Martin-Gropius-Bau) SE

BIBLIOGRAPHY (Selected) — **From Murmansk to Berlin**. Murmansk 1975 // Klaus Honnef and Ursula Breymayer (eds): **Ende und Anfang. Photographen in Deutschland um 1945**. Berlin 1995 (cat. Deutsches Historisches Museum) // Giuliana Scimé: **Fotografia della libertà e delle dittature da Sander a Cartier-Bresson 1922–1946**. Milan 1995 (cat. Fondazione Antonio Mazzotta) // Alexander and Alice Nakhimovsky: **Witness to History: The Photographs of Yevgeny Khaldei.** New York 1997 ⟋ // Ernst Volland and Heinz Krimmer (eds): **J.C. Von Moskau nach Berlin**. Berlin 1995 // Ernst Volland and Heinz Krimmer (eds): **J.C.: Der bedeutende Augenblick.** Leipzig 2008 (cat. Martin-Gropius-Bau, Berlin)

"His early photographs reflected popular beliefs and styles. It was the Second World War, paradoxically, that brought him artistic freedom. Khaldei covered the war from Murmansk to Sevastopol, from Moscow to Berlin. He decided what he would photograph and, to a surprising degree, where he would go. His photographs attained an iconographic power: his were the images that shaped how people remembered history. But particularly in the West, where Khaldei's work was attributed to an anonymous 'Sovfoto', few people knew who he was. At the end of the Soviet era, Khaldei was living in poverty in Moscow, in a room crammed with enlargers and a priceless archive." — Alexander and Alice Nakhimovsky ✎

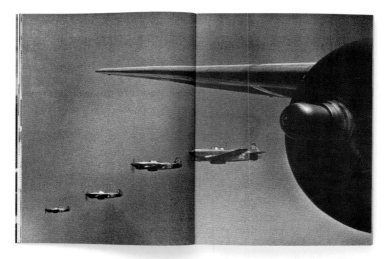

Martín Jiménez Chambi

Martín Chambi: **Fotografía del Perú 1920–1950.** Buenos Aires (La Azotea Editorial Fotografica) 1985

5.11.1891 Coaza bei Carabaya (Peru) — 13.9.1973 Cusco (Peru) Most important Latin American photographer with indigenous roots. Equally, the most important art photographer of his continent, who dealt pictorially with his own people. Discussion of his oeuvre as art since the 1980s. Child of a simple family, with a childhood in the country's poorest region. Father works as a miner. With him, first visit to the Mining Corporation Santo Domingo gold mines. Here meets an English photographer contracted by the company to photograph the mine. At his side, first steps towards photography. 1908 moves to Arequipa in southern Peru. There begins a photography apprenticeship under Max T. Vargas, whose studio is said to be the best equipped in the country. Marries Vargas's daughter. 1917 first exhibition in the Centro Archivo de Arequipa and first prize for his work. In the same year, sets off for Cuzco with the aim of becoming self-employed. In Sicuani (120 kilometers from Cuzco), suspends his trip, begins with documentary photography (landscapes and people). 1920 arrives in Cuzco and opens a photography studio. Apart from portraits, intensive photographic exploration of remains of Inca culture and the cultural inheritance of his country among the peasantry. Photographs with an IKA for glass negatives with a 10 x 15 format, later plates with an 18 x 24 format. His son Víctor a talented and enthusiastic assistant from 1933. 1938 introduction of photo postcards in Peru. 1950 earthquake in Cuzco, slowly gives up photography. Numerous honors and awards even in his lifetime. 1976 documentary film by José Carlos Huayhuaca entitled *El arte fotográfico de Martín Chambi*. From 1977, with the support of the Earthwatch Foundation (Belmont, Massachusetts), his oeuvre catalogued and restored (around 18,000 negatives) and the beginning of his international reputation. 1979 major retrospective in the Museum of Modern Art (New York).

EXHIBITIONS (Selected) — **1978** Lima (Peru) (Secuencia Fotogalería) SE // **1979** New York (Museum of Modern Art) SE // **1981** Zurich (Kunsthaus) GE // **1982** Madrid (Museo Español de Arte Contemporáneo) SE // **1986** Paris (Mois de la photo/Espace latinoaméricain) SE // **1988** Bogotá (Colombia) (Banco de la República/Biblioteca) SE // **1990** Madrid (Círculo de Bellas Artes) SE // **1991** Arles (Rencontres internationales de la photographie) SE // **1998** Houston (Texas) (FotoFest) GE // **2003** Paris (Jeu de Paume – Site Sully/**ALTER EGO Anthropologies involontaires)** GE // **2004** Beijing (Today Art Gallery) SE // **2006** Madrid (Sala de exposiciones Fundación Telefónica) SE // New York (Throckmorton Fine Art, Inc.) SE

BIBLIOGRAPHY (Selected) — **M.C.** Lima 1978 (cat. Secuencia Fotogalería) // Erika Billeter: **Fotografie Lateinamerika von 1860 bis heute.** Bern 1981 (cat. Kunsthaus Zürich) // Erika Billeter: **Fotografía Latinoamericana: desde 1860 hasta nuestros días.** Madrid 1982 (cat. Museo Español de Arte Contemporáneo) // **M.C.: Fotografías del Peru (1920–1950).** Buenos Aires 1985 // **M.C.** Bogotá 1988 (cat. Banco de la República) // Fernando Castro: **M.C.: De Coaza al Moma.** Lima 1989 // José Carlos Huayhuaca: **M.C.: Fotógrafo.** Lima 1991 // Erika Billeter: **Canto a la realidad. Fotografía Latinoamericana 1860–1993.** Barcelona 1993 // **M.C. 1920–1950.** Madrid 1991 // Erika Billeter: **Fotografie Lateinanmerika 1860–1993.** Wabern-Bern 1994 ✒ // **Image and Memory: Photography from Latin America, 1866–1994.** Houston 1998 (cat. Houston FotoFest) // **M.C.** Paris 2002 (= Photo Poche no. 95)

"**Martín Chambi was the creator of** *his* **light. He made pioneering experiments with the intensity of light. He was addicted to this playing with light. This is true for sunlight with its strong contrasts as much as for diffuse light that gently strokes the object. He made portraits is his studio with** *available light*, **there able to achieve quadruple lighting. He continually made self-portraits, using them for experiments and tests of new forms of lighting. Here he was guided by Rembrandt, his model. He drew on Rembrandt's masterly play of light and shadow. Martín Chambi was a conglomerate of natural talent, hard work, and stamina. He was a gifted observer of expression and light.**" — Víctor Chambi ✍

Chargesheimer *(Karl-Heinz Hargesheimer)*

Chargesheimer: **Unter Krahnen-
bäumen.** Cologne (Greven Verlag)
1958

19.5.1924 Cologne (Germany) — 31.12.1971 Cologne Multimedia interests; much-respected artist in Cologne in the 1950s and 60s. Numerous books akin to conceptual documentaries. Mother, Amalie Land, from a wealthy Cologne family, his father a tax official. First photos as a pupil. Secondary school, then business school. From summer of 1942 four semesters at the Cologne Werkkunstschule. 1943–1944 attends the Bayerischen Staatslehranstalt für Lichtbildwesen (Bavarian State School for Photography) in Munich. 1947–1950 freelance theater photographer for theaters in Hamburg-Harburg, Hannover, Cologne, and Essen. Also first works as set designer in Cologne and Hamburg. 1948 major reportage in *Stern* (and first use of pseudonym "Chargesheimer"). 1950–1955 teaches photo-graphics, advertising film and photography at the Düsseldorf Bi-Kla-Schule. From 1952 also collaborator for the *Neuen Post* in Düsseldorf. End of the 1950s a number of much admired books, incl. *Cologne intime* and *Unter Krahnenbäumen* (introduction by Heinrich Böll). In addition advertising, incl. for Siemens, Esso, Ford, Volkswagen. A portrait of German statesman Konrad Adenauer as a controversial *Der Spiegel* cover (11 September 1957), C.'s best-known work. 1960–1967 works mostly as a set designer and also director. From 1967 mostly kinetic objects ("Meditationsmühlen"). Takes part in exhibitions, incl. photokina, *subjektive fotografie* I and II, and World Exhibition of Photography. 1968 Kulturpreis from the DGPh (Deutsche Gesellschaft für Photographie: German Photographic Association). Commits suicide on New Year's Eve of 1971. Part of his estate in the Museum Ludwig, Cologne. There at the end of 2007 a major retrospective following his most significant book projects. Altogether a multifaceted oeuvre between experiment and conceptual reportage.

EXHIBITIONS (Selected) — **1952** Saarbrücken (Germany) (Staatliche Schule für Kunst und Handwerk – 1954) GE // **1954** Cologne (Französisches Kulturinstitut) SE // **1956** Cologne (Kölnischer Kunstverein – 1971, 1972) SE // **1980** Essen (Museum Folkwang) SE // **1983** Cologne (Museum Ludwig – 1989, 2007) SE // **1997** Aachen (Suermondt-Ludwig-Museum) SE // **2009** Cologne (Galerie Priska Pasquer) SE // **2010** Cologne (Kölnisches Stadtmuseum) GE

BIBLIOGRAPHY (Selected) — **Cologne intime.** Cologne 1957 // **Unter Krahnenbäumen.** Cologne 1958 (facsimile reprint: Cologne 1998) // **Im Ruhrgebiet.** Cologne 1958 // **Romanik am Rhein.** Cologne 1959 // **Menschen am Rhein.** Cologne 1960 //

Theater Theater. Velbert 1967 // **Köln 5 Uhr 30.** Cologne 1970 // **C. 1924–1972.** Munich 1981 (cat. Goethe-Institut) ✍ // **Photographien 1949–1970.** Cologne 1983 (cat. Museum Ludwig) // **C. persönlich.** Cologne 1989 (cat. Museum Ludwig) // **C. 1924–1970.** Cologne 1990 // **Schöne Ruinen.** Cologne 1994 // **C.: Photographien aus den 50er Jahren.** Aachen 1997 (cat. Suermondt-Ludwig-Museum) // Bodo von Dewitz (ed.): **C. 1924–1971. Bohemien aus Köln.** Cologne 2007 (cat. Museum Ludwig) // Jörn Glasenapp: **Die deutsche Nachkriegsfotografie. Eine Mentalitätsgeschichte in Bildern.** Paderborn 2008 // Werner Schäfke/Roman Heuberger (ed.): **Köln und seine Fotobücher.** Cologne 2010 (cat. Kölnisches Stadtmuseum)

"He was an enigmatic, contradictory artist; temperamental in conversation, full of ideas and turmoil in his creative work; during his short life he was successively, and sometimes simultaneously, a painter, sculptor, 'light-graphic artist', photogram maker, inventor of kinetic machines, set designer, director, and photographer. His photographic work, in its range and perfection remains his greatest artistic production — and not only within his own oeuvre: As a photographer, Chargesheimer wrote one of the most important chapters in the history of German photography after 1945." — Evelyn Weiss ✍ᴅ

Hermann Claasen

Hermann Claasen: **Gesang im Feuerofen.** Düsseldorf (Schwann Verlag) 1947

20.12.1899 Cologne (Germany) — 19.12.1987 Cologne Architectural photography, (studio) portraits, experimental photography. Known especially as chronicler of war-torn Cologne. First photography at age 14. 1918–1921 apprentice in his father's fabric shop. Active in sport and youth movement. 1929 father's business goes bankrupt. Takes up photography. Advertising (incl. for Mülhens, Cologne), architecture, portrait, and industrial photography. 1934 internship under Willy Otto Zielke during the filming of *Das Stahltier*. 1936 master certificate. Meets Ria Dietz, who becomes his wife. Destruction of his studio in the "1,000-bomber raid" (30/31 May 1942). Subsequently documents war damage in Cologne on his own initiative. Sporadic collaboration in color on Führerbefehl zur Dokumentation ortsfester Kunstwerke (a project to record works of art). After 1945 documentation contracts in Jülich and Düren. 1946 founds an advertising agency with Werner Labbé and Ria C. Participates in preparation for the first Cologne *Photo-Kino-Ausstellung*. From 1947 international interest for his photos of wartime destruction through exhibitions and publications. 1949 appointed to the GDL (Gesellschaft Deutscher Lichtbildner: German Photographic Academy), and in 1953 to the DGPh (Deutsche Gesellschaft für Photographie: German Photographic Association). 1970 gives up photography due to age.

"Claasen, too, was included among the 'old masters' of photography by Steinert and younger photographers. The collection of his most important 'rubble shots' in the photobook *Gesang im Feuerofen*, brought out by Josef Rick in 1949, is regarded as an exceptional document, showing the devastation of German cities as a result of Hitler's war." — J.A. Schmoll gen. Eisenwerth ✐

EXHIBITIONS (Selected) — **1947** Cologne (Eigelsteintorburg) SE // **1951** Saarbrücken (Germany) (**subjektive fotografie**) GE // **1955** New York (Museum of Modern Art/**The Family of Man**) GE // **1983** Bonn (Rheinisches Landesmuseum) SE // **1987** Cologne (Museum Ludwig) GE // **1997** Bonn (Kunst- und Ausstellungshalle der BRD) GE // **1999** Cologne (Kölnisches Stadtmuseum) SE // **2003** Cologne (Galerie Lichtblick/**images against war**) GE // **2004** Brno (Czech Republic) (The Brno House of Art/**Subjective Photography** 1948–1963) GE // **2005** Münster (Westfälisches Landesmuseum) GE // **2007** Cologne (Die Photographische Sammlung/SK Stiftung Kultur) GE // **2010** Cologne (Kölnisches Stadtmuseum) GE

BIBLIOGRAPHY (Selected) — **Der Kölner Dom**. Cologne 1939 // **Gesang im Feuerofen**. Düsseldorf 1947 // Hans J. Scheurer and Jan Thorn-Prikker: **Nichts erinnert mehr an Frieden**. Cologne 1985 // **subjektive fotografie. Der deutsche Beitrag 1948–1963**. Stuttgart 1989 (cat. Institut für Auslandsbeziehungen) ✐ // **H.C.: Werkverzeichnis** (5 Vol.). Cologne 1993–1999 // **Ende und Anfang**. Berlin 1995 (cat. Deutsches Historisches Museum) // Ludger Derenthal: **Bilder der Trümmer- und Aufbaujahre. Fotografie im sich teilenden Deutschland**. Marburg 1999 // Rudolf Wakonigg and Hermann Arnhold: **1945 — im Blick der Fotografie: Kriegsende und Neuanfang**. Münster 2005 (cat. Westfälisches Landesmuseum) // Wolfgang Vollmer (ed.): **Stadt|Bild|Köln. Photographien von 1880 bis heute**. Göttingen 2007 (cat. Die Photographische Sammlung/SK Stiftung Kultur, Cologne) // Jörn Glasenapp: **Die Deutsche Nachkriegsfotografie. Eine Mentalitätsgeschichte in Bildern**. Paderborn 2008 // Werner Schäfke/Roman Heuberger (ed.): **Köln und seine Fotobücher**. Cologne 2010 (cat. Kölnisches Stadtmuseum)

Larry Clark

Larry Clark: **Tulsa.**
New York (Lustrum Press) 1971

19.1.1943 Tulsa (Oklahoma, USA) — Lives in Los Angeles and New York (USA) Author of a comparatively small oeuvre associated with his experiences of sex and drugs. Mother a professional photographer of children. To 1961 works in his parents' shop. 1961–1963 studies photography under Walter Sheffer at Layton School of Art, Milwaukee. 1964–1966 military service in Vietnam. From 1966 independent photographer in New York, since 1970 in Tulsa and New York. Breakthrough comes with his first and to date most important book, *Tulsa* (compared by critics to > Frank's *Les Américains*), brought out by Lustrum Press (by > Gibson). Quickly seen and recognized as a complete break with the tradition of "humanistic" reportage aestheticizing misery (> Smith). As a radical description of the milieu of young junkies, taboo up to then, from the perspective of an "insider" (using the simplest photographic means), to a certain extent a precursor of autobiographically tinged essays of > Goldin to Richard Billingham. Continued interest in youth and youth culture (using older material) in his next books *Teenage Lust* and *The Perfect Child*. 1973 NEA (National Endowment for the Arts) Fellowship. Teaches incl. at the Pratt Institute, Massachusetts Institute of Technology and Rutgers University.

EXHIBITIONS (Selected) — **1971** San Francisco (Art Institute) SE // **1975** Rochester (New York) (George Eastman House) SE // **1976** Boston (New England School of Photography) SE // **1981** Paris (Galerie Agathe Gaillard) SE // **1982** Basel (Kunsthalle) JE (with Peter Hujar and Robert Frank) // **1986** Stockholm (Fotografiska Museet) SE // **1991** Graz (Austria) (Grazer Kunstverein) SE // **1992** Paris (Espace Photographique) SE // **1994** Munich (Galerie Rüdiger Schöttle) JE (with Robert Frank) // **2000** Paris (Galerie Kamel Mennour) SE // **2002** Munich (Galerie Pfefferle – 2008) SE // **2005** Groningen (Netherlands) (Groninger Museum) SE // New York (International Center of Photography) SE // **2007** Horten (Preus fotomuseum) SE // Berlin (Helmut Newton Stiftung) JE (with Helmut Newton and Ralph Gibson) // Hamburg (Haus der Photographie/Deichtorhallen) GE // Paris (Maison européenne de la photographie) SE // New York (Luhring Augustine) SE // **2008** London (Simon Lee Gallery) SE // **2010** Paris (Musée d'Art Moderne de la Ville de Paris) SE

BIBLIOGRAPHY (Selected) — **Tulsa**. New York 1971 (facsimile reprint: New York 2000) // **Teenage Lust**. Millerton 1982 // Jonathan Green: **American Photography: A Critical History 1945 to the Present**. New York 1984 ✍ // **L.C. 1992**. New York/Cologne 1992 // **The Perfect Childhood**. Zurich 1993 // **Punk Picasso**. New York 2003 // Martin Parr and Gerry Badger: **The Photobook: A History Volume I**. London 2004 ✍ // **Los Angeles 2003–2006**. New York/London 2007 (cat. Luhring Augustine)

"If Danny Lyon pushed the door ajar on the renegade social document with *The Bikeriders*, Larry Clark opened it wide with his book *Tulsa* in 1971. Lyon had shown youthful rebellion on an acceptable level, represented by the kind of kids who whooped it up on the weekends, but usually turned up for work (albeit wrecked) on a Monday morning. Clark, on the other hand, showed youthful alienation as a full-time way of life, with little or no way back into society. His documentation of communes in Tulsa, where serious drug-taking rated higher than casual sex on the activities list, extended the boundaries of acceptable subject matter for photographers, and made *Tulsa* one of the most talked about and important books of the decade." — Gerry Badger ✍

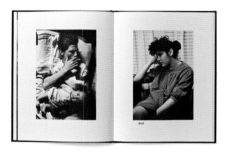

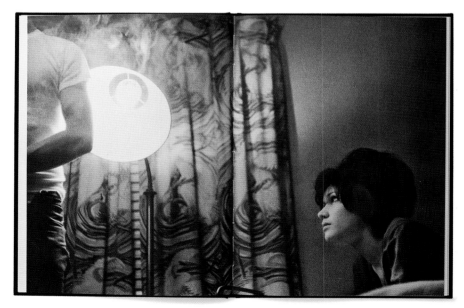

William Claxton

William Claxton: **Jazzlife**.
Offenburg (Burda Verlag) 1961

12.10.1927 Pasadena (California, USA) — 11.10.2008 Los Angeles (USA) Music, portrait, and fashion photographer. Best known as a chronicler of 1950s and 60s jazz. Begins as a hobby photographer. Studies psychology at the University of California, Los Angeles. First photographs in jazz clubs. 1952 meets music producer Richard Bock and first photos for his new label, Pacific Jazz. Subsequently numerous record covers with photos of nearly all major jazz musicians of the time, including — and doubtless the best known — his portraits of the young Chet Baker. In addition fashion photography and portraits of various Hollywood stars (incl. Steve McQueen). 1961 publication of his most important book, *Jazzlife*, the result of an extensive tour through the USA with the well-known jazz critic Joachim Ernst Berendt. Numerous magazine contributions, incl. in *Vogue*, *Life*, and *Paris Match*. From 1960 married to the former photo model Peggy Moffitt. *www.williamclaxton.com*

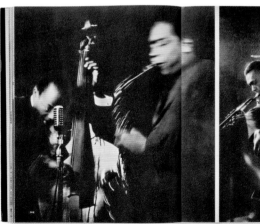

EXHIBITIONS (Selected) — **2003** Milan (Galleria Carla Sozzani/ **Invito alla Fotografia**) GE // **2004** London (Michael Hoppen Gallery) SE // Los Angeles (Fahey/Klein Gallery — 2007) SE // **2007** New York (Whitney Museum of American Art/**Summer of Love: Art of the Psychedelic Era**) GE // **2009** Portland (Maine) (Portland Museum of Art/**Backstage Pass: Rock & Roll Photography**) GE

BIBLIOGRAPHY (Selected) — Joachim-Ernst Berendt and W.C.: **Jazzlife**. Offenburg 1961 // **Young Chet. Der junge Chet Baker photographiert von William Claxton**. Munich 1993 // **Claxography. The Art of Jazz Photography.** Kiel 1995 ✑ // **Jazz**. San Francisco 1996 // **Jazz Seen**. Cologne 1999 // **Photographic Memory**. New York 2002 // **Jazzlife. A Journey Across America.** Cologne 2005 // **Steve McQueen.** Cologne 2005

"Growing up in California, William Claxton spent his time collecting 78s by Duke Ellington, Lena Horne, Count Basie, and Tommy Dorsey. As he pasted their pictures into scrapbooks, Claxton yearned to become a part of their world. By the time he started photographing musicians himself, he looked for ways to define them as people, not just as performers. He wanted to capture the innate drama in their lives, the fun, the anxiety, the eternal youthfulness. He learned to do all this and more in the 1950s, when his album covers for Pacific Jazz Records reflected a sound born of beachside jazz clubs and balmy California nights. Today, after decades of award-winning jacket photos, magazine layouts, books and exhibitions, it is safe to call William Claxton the most celebrated photographer in jazz history." — James Gavin ✍

Lucien Clergue

Lucien Clergue: **El Cordobès.**
Paris (La Jeune Parque) 1965

14.8.1934 Arles (France) — 15.11.2014 Nîmes (France) Nudes, photos of the world of bullfighting, photos of his friend Pablo Picasso the center of his internationally respected oeuvre (in b/w and color). Child of a merchant family. 1949 first photographs as amateur. 1952 leaves school. Works in a factory. 1953 meets Pablo Picasso. Beginning of his life-long friendship with the artist. First publishes in the daily *Le Provençal*. 1954 begins his series *Les Saltimbanques* in the ruins of Arles. 1956 first nude photos on the beaches of Camargue. 1957 publishes his book *Corps memorable*, the first of more than 80 independent publications. 1959 quits his job. Since then has worked as independent photographer. 1961 first trip to New York. There meets Marcel Lajos Breuer, > Brodovitch, > Frank, and > Smith. 1965 *Le drame du taureau* his first of many short and long films. 1969 co-initiator of the Rencontres d'Arles. 1975 first nudes in an urban setting (Paris, New York). In the same year first color photographs. 1976 first essay on the Camargue. 1980 first nudes in the American desert. 1981 first Polaroids. In addition numerous workshops, teaching posts (also international). 2006 with Yann Arthus-Bertrand first photographer named to the Académie des Beaux-Arts (Paris).

EXHIBITIONS (Selected) — **1958** Zurich (Kunstgewerbemuseum – 1963) SE // **1961** New York (Museum of Modern Art) JE (with Bill Brandt and Yashuhiro Ishimoto) // **1962** Essen (Germany) (Museum Folkwang) SE // **1964** Munich (Stadtmuseum) SE // **1969** Stockholm (Moderna Museet) SE // **1974** Brussels (Musée des Beaux-Arts) SE // **1980** Paris (Centre Pompidou) SE // **1984** Paris (Musée d'Art Moderne de la Ville de Paris) SE // **1985** Rochester (New York) (George Eastman House) SE // **1986** New York (International Center of Photography – 1989) SE // **1987** Helsinki (Amoas Anderson Museum) SE // **1989** Arles (France) (Rencontres internationales de la photographie – 2000, 2009) SE // **1999** Dortmund (Museum für Kunst und Kulturgeschichte) SE // **2007** Vienna (Kunst-Haus) SE // **2008** Münster (Graphikmuseum Pablo Picasso) SE // Erlangen (Germany) (Städtische Galerie) SE // **2009** Munich (Bernheimer Fine Art Photography) SE // **2011** Cologne (Museum Ludwig) GE // **2014** Arles (Musée Réattu) GE

BIBLIOGRAPHY (Selected) — **Corps mémorable.** Paris 1957 // **Naissance d'Aphrodite.** Paris 1963 // **L.C.: photographe.** Zurich 1964 // **El Cordobès.** Paris 1965 // **Née de la vague.** Paris 1968 // **Le quart d'heure du taureau.** Paris 1976 // **Camargue secrète.** Paris 1976 // **La Camargue est au bout des chemins.** Marseille 1978 // **Visions sur le nu/Nude Workshop.** New York/Paris 1982 // **Eros and Thanatos.** Boston 1985 // **Tauromachies.** Paris 1991 // **Picasso mon ami.** Paris 1993 // **La corrida en 1200 images.** Paris 1998 // **Grands Nus.** Paris 1999 // Eva-Monika Turck: **L.C.: Poésie photographique.** Munich 2003 ✍ // **Magie und Mythos – L.C.** Vienna 2007 (cat. KunstHaus) // **Ichundichundich. Picasso im Fotoporträt.** Cologne 2011 (cat. Museum Ludwig) // **Brasilia.** Ostfildern 2013

"For more than fifty years Lucien Clergue has been photographing everything that has impressed him and influenced his life: the Camargue – his homeland, beautiful women – his passion, the bullring and the theater, his memories of Picasso and his great admiration for twentieth-century art. Lucien Clergue is not only a romantic aesthete and a photographic poet; through his tireless commitment as founder, organizer and – for decades – artistic director of the Rencontres de la photographie in Arles, and through his work as an exhibition organizer and inspiring teacher, he has been an inspiration to the growing international photography scene since the seventies." — Manfred Heiting ✐⊐

Alvin Langdon Coburn

Alvin Langdon Coburn: **New York.**
London (Duckworth & Co) 1910

11.6.1882 Boston (Massachusetts, USA) — 23.11.1966 Rhos-on-Sea (Wales) Artist portraits, nature, urban and industrial landscapes akin to Pictorialism, as well as "abstract" "Vortographs" influenced by Futurism and Cubism. 1890 a Kodak 4 x 5 his first camera. 1897 first exhibition in Boston. 1899 with his mother and Fred Holland Day (1864–1933), a distant relative, travels to London. There (1900) nine of his works included in a Royal Photographic Society exhibition. 1902 returns to the USA and sets up a studio (384 Fifth Avenue). Elected to Photo-Secession (1902) and Linked Ring (1903). 1904 first portraits of George Bernard Shaw. Further portraits, among others of G.K. Chesterton, Henry James, Ezra Pound, Mark Twain, H.G. Wells, William Butler Yeats. 1906 learns the technique of photogravure at the London County School of Photoengraving. Photographs in autochrome for a special issue of *The Studio*. 1910 industrial landscapes around Pittsburgh (Pennsylvania). 1912 New York from above (incl. *The Octopus*). In the same year settles permanently in Great Britain. 1913 publication of *Men of Mark*. 1922: *More Men of Mark*. 1930 part of his collection donated to the Royal Photographic Society. 1932 British citizen. 1962 retrospective at the University of Reading. In the same year: *A.L.C.: A Portfolio of Sixteen Photographs*, published by George Eastman House, Rochester — the beginning of a rediscovery of an artist occupied with Freemasonry and religious studies from the 1920s.

"Influenced by Cubist vision, Alvin Langdon Coburn began to develop techniques which made photography useful for this avant-garde [...]; he worked with mirrors and prisms to break space up cubically. Among his best-known works are a series of portraits of Ezra Pound from 1917, which frame his shadowy profile in a pattern of horizontal, vertical and diagonal beams."
— Reinhold Misselbeck ✎◻

EXHIBITIONS (Selected) — **1900** London (Royal Photographic Society/**The New School of American Photography**) GE // **1903** New York (Camera Club) SE // **1906** London (Royal Photographic Society – 1924, 1957) SE // **1909** New York (Photo Secession Gallery) SE // **1913** London (Goupil Gallery) SE // **1962** Reading (England) (University of Reading) SE // **1985** Paris (Centre national de la photographie) SE // **1998** Cologne (Römisch-Germanisches Museum) SE (then Rochester, Madrid) // **2004** Vigo (Spain) (Museo de Arte Contemporánea de Vigo/**Fotografía et Arte**) GE // London (Atlas Gallery) SE // Madrid (PHotoEspaña/**Historias**) GE // **2005** San Francisco (San Francisco Museum of Modern Art) GE // **2006** Bradford (England) (National Museum of Photography Film and Television) GE // **2007** Barcelona (Kowasa Gallery/**Fotografía Abstracta 1920–1970**) GE

BIBLIOGRAPHY (Selected) — **London**. London 1909 // **New York.** London 1910 // **Men of Mark.** London 1913 // **More Men of Mark.** London 1922 // **Photography and the Quest of Beauty.** London 1924 // **A.L.C.: Photographer: An Autobiography.** London 1966 // **A.L.C.: Fotografie 1900–1924.** Zurich 1998 (cat. Römisch-Germanisches Museum, Cologne) ✎◻

Clifford Coffin

18.6.1913 Chicago (USA) — 2.3.1972 Pasadena (California, USA) Fashion photography. One of the most innovative fashion interpreters after 1945. Also photographs of notables as well as homoerotic male nudes. Father a salesman. With him (formative) trips to Paris and Rome. Diploma from Pasadena High School. Course at Art Institute. At his father's insistence, studies business management at the University of California, Los Angeles. Various jobs as night porter and accountant. 1938 moves to New York. Employee of Texaco in accounting. Influenced by contemporary magazines (especially *Vogue*) takes up photography. Self-taught. Contact with > Liberman. Around 1940 gets first contracts as well as probationary employment. At the same time evening classes under > Lynes. In February 1946 moves to Europe. At first London, from 1948 works for *Vogue* France. 1949 returns to New York. Autumn fashion 1954 using "ring-lights" introduced by C., the high point of his career (with 48 photos in the US *Vogue* and honors from the Art Directors Club). In addition numerous portraits, incl. of Christian Dior, Jean Marais, Arthur Miller (b/w and 6 x 6). 1961 last publication (in *Harper's Bazaar*). Increasing drug problems. Retires from photography. 1965 his archive is lost in a fire. Moves to Pasadena (California). There dies from throat cancer unnoticed by doctors. 1997 retrospective (posthumous) in the National Portrait Gallery.

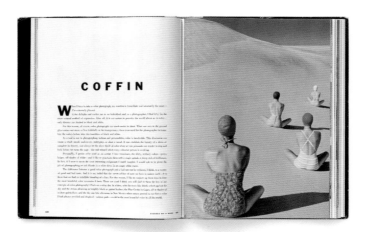

EXHIBITIONS (Selected) — **1986** Cologne (photokina/**50 Jahre moderne Farbfotografie 1936–1986**) GE // **1990** Vienna (Kunstforum Länderbank) GE // **1991** London (Victoria and Albert Museum) GE // **1997** London (National Portrait Gallery) SE

BIBLIOGRAPHY (Selected) — Alexander Liberman: **The Art and Technique of Color Photography**. New York 1951 // **50 Jahre moderne Farbfotografie/50 Years Modern Color Photography** **1936–1986.** Cologne 1986 (cat. photokina) // Ingried Brugger (ed.): **Modefotografie von 1900 bis heute**. Vienna 1990 (cat. Kunstforum Länderbank) // Martin Harrison: **Appearances: Fashion Photography Since 1945**. London 1991 (cat. Victoria and Albert Museum) // Lisa Fonssagrives: **Trente ans de classiques de la photo de mode**. Munich 1996 // **C.C.: Photographs from Vogue, 1945 to 1955**. Munich 1997 // **The Fashion Book**. London 1998.

"Coffin was a fashion personality whose early ambition was to be a dancer. He was also an 'out' homosexual, who was close to society writer Truman Capote. His work for American, British and French *Vogue* secured his own position in that society and he was described as 'the first photographer to actually think fashion, sometimes more than fashion editors'."

— *The Fashion Book* ✍

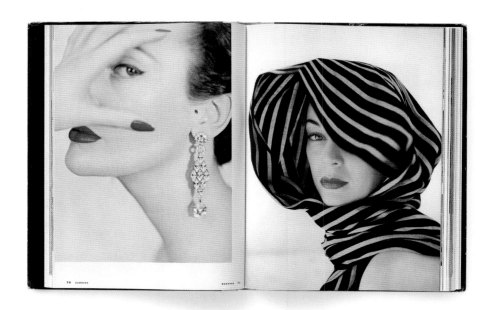

Clifford Coffin, from: **The Art and Technique of Color Photography.**
New York (Simon & Schuster)
1951

Anton Corbijn

Anton Corbijn: **Innocence.**
Hamburg (**Stern** Fotografie no. 37)
2004

20.5.1955 Strijen (Netherlands) — Lives in London (England) Portraits of international artists from film, theater, fashion, literature and especially music. Well-respected chronicler of pop culture in the 1980s and 90s. 1972 first photos: rock music (events on stage) and portraits of musicians. 1979 moves to London (center of music scene). There photos (35 mm, b/w) incl. David Bowie, Miles Davis, Sinead O'Connor, Tom Waits (see *Famouz*). In view of next project (*Star Trek*) moves to Los Angeles. With a 6 x 6 camera portrays actors, directors, writers, musicians. Publications in *Rolling Stone*, *W*, *Details*, *Stern*. Since 1984 also music videos. In the meantime over 70 clips (Johnny Cash, Depeche Mode, U2) as well as a short film with Captain Beefheart. Also designs record covers (Depeche Mode, Herbert Grönemeyer) as well as photographs for over 100 albums (Rolling Stones, Bryan Ferry, Tricky). 2007 much admired film on the short life of the musician Ian Curtis (*In Control*). Altogether a remarkable rise from musician photographer for the love of it to artist of museum quality.

"In the mixture of private sphere and self-depiction staged by Corbijn, the stars seem 'closer', you might say even 'more human', than on stage, but also more fragile and tragic. To realize his ideas, Corbijn employs a multifaceted photographic repertoire. [...] Thus in the course of two decades, a large gallery of photographic portraits has arisen in which a large number of famous rock musicians appear like in a Who's Who of popular culture." — Zdenek Felix ✍

EXHIBITIONS (Selected) — **1989** Amsterdam (Torch Gallery – 1996, 2000) SE // **1992** Esslingen (Germany) (Fototriennale) GE // **1993** Leverkusen (Germany) (Museum Morsbroich) SE // **1994** Amsterdam (Stedelijk Museum) SE // **1996** Hamburg (Deichtorhallen) SE // **1999** Frankfurt am Main (Galerie Anita Beckers) SE // **2000** Groningen (Netherlands) (Groninger Museum) SE // **2001** Munich (Stadtmuseum) SE // **2002** Berlin (Camera Work) JE (with Guy Bourdin) // The Hague (Fotomuseum) GE // **2003** Hannover (kestnergesellschaft) SE // **2004** Venice (Museo Fortuny) SE // Cologne (Visual Gallery/photokina) SE // **2005** Antwerp (Museum voor Fotografie) SE // Berlin (C/O Berlin) SE // **2007** Rotterdam (Nederlands Fotomuseum/**Dutch Eyes**) GE

BIBLIOGRAPHY (Selected) — **Famouz. Photographs 1976–88.** Munich 1989 // **Star Trak**. Munich 1996 ✍ // **33 Still Lives.** Munich 1999 // **A.C. – 25 jaar WERK/25 Years WORK.** Groningen 2000 (cat. Groninger Museum) // Wim van Sinderen: **Fotografen in Nederland. Een Anthologie 1852–2002.** The Hague 2002 (cat. Fotomuseum Den Haag) // **Innocence.** Hamburg 2004 (**Stern** Fotografie no. 37) // **U2 & I. The Photographs 1982–2004.** Munich 2005 // **In Control.** Munich 2007 // **Dutch Eyes: A Critical History of Photography in the Netherlands.** Zwolle 2007 (cat. Nederlands Fotomuseum, Rotterdam) // **Inside The American.** Munich 2010 // **Waits/Corbijn '77–'11.** Munich 2013

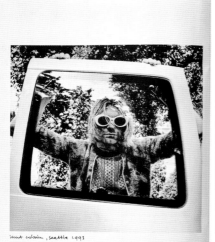

kurt cobain, seattle 1993

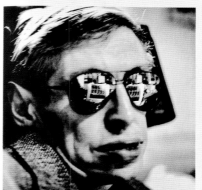

stephen hawkings, cambridge 1999

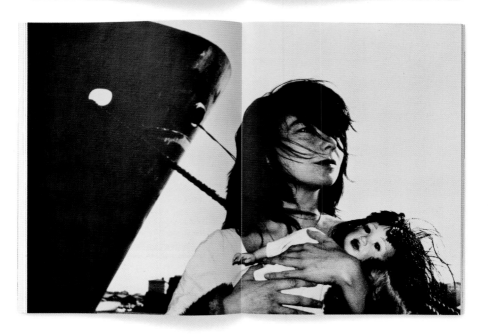

John Cowan

22.4.1929 Gillingham (England) — 26.9.1979 East Hagbourne (England) Leading fashion interpreter in England in the 1960s. Fashion photos in the spirit of the "Swinging Sixties". Exponent of a dynamic style of fashion photography outside the studio. Various schools. 1945 briefly in the Royal Air Force. Thereafter various jobs. From 1950 in father's rental automobile agency. 1954 job in the advertising department of a large company. First photos for advertising. From 1958 works independently. His first studio. First publications, incl. *Lilliput*. 1959 first well-received exhibition. A year later first portraits for *Vogue*. Subsequently works more and more in fashion. 1962 first photos with Jill Kennington, who becomes his favorite model. Photographs incl. *Vogue*, *Elle*, *Queen*, *Harper's Bazaar*, *The Sunday Times*, and the *Observer*. 1964 with > Bailey, > Donovan, Brian Duffy, Len Fulford, Donald Silverstein, group photo of leading contract photographers for *Daily Express*. 1966: Studio at 39 Princes Place, site for filming of Michelangelo Antonioni's (later cult film) *Blow-up*. Rising debts, so 1968 moves to Milan. With Oliviero Toscani conception of magazine *Senta* (only one issue). Photo shoots in the USA, Spain, France, and Israel. 1971 nude series with Erica Creer. In the 1970s magazines lose interest in his form of fashion interpretation. Industrial and object photography.

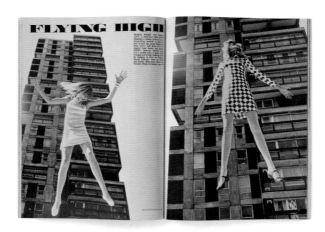

EXHIBITIONS (Selected) — **1959** London (Mac's Camera Shops) SE // **1964** London (Gordon's Cameras) SE // **1967** London (**modphot one**) GE // **1970** Cookham (England) (31 High Street) SE // **1974** Wallingford (England) (Flint House) SE // **1976** London (Heron Gallery) SE // **1983** London (The Photographers' Gallery) GE // **1999** London (Canon Photography Gallery/Victoria and Albert Museum) JE (with Michael Cooper and Ronald Traeger) // **2003** Granollers (Spain) (Centre Cultural/**Aqells anys 60**) GE // **2004** London (Tate Britain/Art and the 60s) GE // Birmingham (Birmingham Museum and Art Gallery/**Art and the 60s**) GE // **2006** Auckland (New Zealand) (Auckland Art Gallery/**Art and the 60s**) GE

BIBLIOGRAPHY (Selected) — **modphot one**. London 1967 (cat. **modphot one**) // **British Photography 1955–65: The master craftsmen in print**. London 1983 (cat. The Photographers' Gallery) // Philippe Garner: **J.C.: Through the Light Barrier**. Munich 1999 (cat. Victoria and Albert Museum) ✎

"He loved the unpredictable aspect of working on location. He loved risk, generating electricity from the danger which he courted. He had found a highly personal way of working, his own natural recklessness in tune with the iconoclastic buzz of popular culture. Just as the sombre, claustrophobic dramas of Bill Brandt's interiors, or the grandiose aristocratic pageants of Cecil Beaton's fashion and theater studies, had so well expressed the mood of a previous era, so Cowan's wide-horizon freshness, energy and vitality reflected the up-beat climate imposed by the new cultural consumers, the young 'pop' generation." — Philippe Garner ✍

ABOVE LEFT: a pale green cotton-knit dress, short and narrow with deep, square armholes, and vertical band down the centre. By Rosalind Yehuda. White tights flowered in pink and green by Martha Hill. Shoes from Kurt Geiger. ABOVE RIGHT: yellow cotton-knit dress with purple on hem and bodice. By Rosalind Yehuda. Bangles from Dickins and Jones. White shoes from Kurt Geiger. Shops and prices, page 112

ABOVE LEFT: crazily striped play-suit in tough, flexible towelling. The top is cut like a lanky boy's shirt, with a breast pocket and narrow three sleeves. Short shorts expose long brown legs and have front fly fastening. From Roberts. ABOVE RIGHT: sugar-sweet smock vividly patterned in sea-greens and sugar-pinks, with pink smocking. Worn over matching bikini. By Wallis. Shops and prices, page 112

John Cowan: **Flying High,**
from: **Queen,** 8.6.1966

Gregory Crewdson

Gregory Crewdson 1985–2005.
Ostfildern (Hatje Cantz Verlag)
2005

26.9.1962 Brooklyn (New York, USA) — Lives in New York (USA) Has staged photography since the 1980s. Elaborately staged small-town American life akin to Hollywood movies. Image world on the border between dream and nightmare, everyday life and fantasy. 1985 begins studying at State University of New York, Purchase, New York (B.A.). From 1988 studies at Yale School of Art, Yale University, New Haven, Connecticut (M.F.A.). Various teaching posts, incl. SUNY Purchase, Purchase (1988–1993), Sarah Lawrence College, Bronxville (1990), Cooper Union, New York (1990–1993), Vassar College, Poughkeepsie (1993), Yale University, New Haven (1993 to today). From mid 1980s works on large series of "staged photography": *Early Work* (1986–1988), *Natural Wonder* (1992–1997), *Hover* (1996–1997), *Twilight* (1998–2002), *Dream House* (2002), *Beneath the Roses* (2003–2007). International breakthrough with his series *Twilight*, a word that could serve as motto for his entire work, according to Stephan Berg, "as all of his works are really about messages from the Twilight Zone". Regularly discussed with reference to Edward Hopper, Stephen Spielberg's films, Wes Anderson, David Lynch, or compared to > Sherman's or > Wall's camera work. First solo exhibition 1988 at Yale University. 2005 major retrospective with stops in Hannover, Krefeld, Winterthur, and Linz. 2004 Skowhegan Medal for Photography, Skowhegan School of Painting and Sculpture, New York.

EXHIBITIONS (Selected) — **1988** New Haven (Connecticut) (Yale University) SE // **1991** Los Angeles (Ruth Bloom Gallery – 1995) SE // **1992** Houston (Houston Center for Photography) SE // **1995** London (White Cube – 2005) SE // New York (Luhring Augustine Gallery – 1997, 2000, 2002, 2005, 2008) SE // **1996** Tokyo (Ginza Art Space, Shiseido Co. – 1999) SE // **1997** Cleveland (Cleveland Center for Contemporary Art) SE // **1998** Madrid (Museo Nacional Centro de Arte Reina Sofía) SE // **2001** Santa Fe (SITE Santa Fe) SE // **2002** Beverly Hills (California) (Gagosian Gallery – 2005, 2008) SE // Aspen (Colorado) (Aspen Art Museum) SE // **2003** San Francisco (John Berggruen Gallery) SE // **2004** Paris (Galerie Daniel Templon) SE // **2005** Hannover (Kunstverein/**Retrospective** 1985– 2005) SE (Touring exhibition visiting Krefeld, Winterthur, Linz, and The Hague) // **2006** Williamstown (Massachusetts) SE // **2007** Salamanca (Spain) (Domus Artium) SE // Gothenburg (Hasselblad Center) SE // Rome (Palazzo delle Esposizioni) SE // **2008** Prague (Galerie Rudolfinum) SE // Milan (Photology s.r.l.) SE

BIBLIOGRAPHY (Selected) — David Campany: **Art and Photography.** London 2003 // Stephan Berg (ed.): **G.C. 1985–2005.** Ostfildern 2005 (cat. Kunstverein Hannover) 🖾 // **Vitamin Ph: New Perspectives in Photography.** London 2006 // **Beneath the Roses. Werke 2003–2007.** Ostfildern 2008 // **In a Lonely Place.** Ostfildern 2011

"Gregory Crewdson's photography revolves around a single theme: the intrusion of the suppressed, eerie and inexplicable into the seemingly idyllic, normal world. With an almost obsessive energy, he works on creating an imaginary world whose carefully painted idyll, rich in detail, is permanently and irreversibly subverted. In view of Crewdson's preference for elaborate stagings with the supernatural playing a central role it might seem surprising that he sees himself as an 'American realist landscape photographer', placing himself in the tradition of great chroniclers of everyday life in America from Walker Evans via Gary Winogrand to William Eggleston. But this self-description isn't as teasing and far-fetched as it seems. At a fundamental level, the works of this photographer, who lives in New York, always deal with a precise and credible survey of rural, small town America outside the major urban centers."

— Stephan Berg ✍️

Imogen Cunningham

Imogen Cunningham,
from: **Album,** June 1970

12.4.1883 Portland (Oregon, USA) — 23.6.1976 San Francisco (USA)
Early work akin to Pictorialism. Later takes up "straight photography".
Especially plant studies and portraits. Also (controversial) nudes of
her husband. Member of the informal group f/64. 1903–1907 studies
at the University of Washington, Seattle. 1907–1909 works in > Cur-
tis's portrait studio (retouching negatives and making platinum
prints). 1909 scholarship for postgraduate work in Dresden (photo
chemistry under Dr Robert Luther). 1910 publishes her doctoral the-
sis "Über Selbstherstellung von Platinpapieren für braune Töne" (On
the Self-creation of Platinum Papers for Brown Tones) in *Photogra-
phische Rundschau* and *Photographisches Centralblatt*. Returns to
Seattle and opens her own photo studio. 1914 first solo exhibition.
1915 marries Roi Partridge (divorced 1934). 1917 moves to San Fran-
cisco. There (1918) she meets Maynard Dixon, > Lange, and Francis
Bruguière. 1920 moves to Oakland (California). Meets Edward
Weston and Johan Hagemeyer. 1922 member of the Pictorial Photographers of America. 1920 ten
works in the *Film und Foto* exhibition. 1932 participates in the programmatic Group f/64 exhibition.
Continues portrait work. In addition plant studies, "industrial still lifes", magazine photographs. 1934
at *Vanity Fair's* invitation works in New York. Street photography. Portraits of the photographer
> Stieglitz. From 1947 studio in San Francisco. 1964 first experiments with Polaroid. In same year
honorary member American Society of Media Photographers. 1970 Guggenheim fellowship (to recon-
dition her earlier work). Takes portraits when over 90 – her last major work. 1975 establishment of the
Immogen Cunningham Trust to care for and catalogue her oeuvre.

EXHIBITIONS (Selected) — **1914** Brooklyn (Institute of Arts and
Sciences) SE // **1929** Stuttgart (**Film und Foto**) SE // **1931** San
Francisco (M.H. de Young Memorial Museum – 1970) SE //
1932 San Francisco (M.H. de Young Memorial Museum/**Group
f/64**) GE // **1937** New York (Museum of Modern Art/**Photogra-
phy 1839–1937**) GE // **1951** San Francisco (Museum of Art)
SE // **1961** Rochester (George Eastman House) SE // **1964**
Chicago (Art Institute) SE // **1971** San Francisco (Art Institute
– 1983) SE // **1973** New York (Metropolitan Museum) SE //
1974 Washington, DC (Henry Art Gallery) SE // **1984** Paris
(Galerie des Femmes) SE // **1993** Frankfurt am Main (Foto-
grafie Forum) SE // **2003** London (Zelda Cheatle Gallery) SE //
2004 New York (John Stevenson Gallery – 2005, 2006) SE //
2006 Zurich (ArteF Fine Art Photography Gallery) SE // **2007**
Atlanta (Fay Gold Gallery) SE // **2008** Lugano (Museo d'Arte/

Maestri della fotografia del XX secolo) GE // **2009** Stuttgart
(Staatsgalerie/**Film und Foto: Eine Hommage**) GE // **2012** Ma-
drid (Fundación Mapfre) SE

BIBLIOGRAPHY (Selected) — **I.C.: Photographs**. Seattle 1970 //
Imogen! I.C. Photographs 1910–1973. Seattle 1974 (cat.
Henry Art Gallery) // **After Ninety**. Seattle 1977 // Richard Lo-
renz: **I.C.: Ideas without End. A Life in Photographs**. San Fran-
cisco 1993 // **I.C.: The Poetry of Form**. Schaffhausen 1993
(cat. Fotografie Forum Frankfurt) // Richard Lorenz: **I.C.: Flora**.
Boston 1996 // Richard Lorenz: **I.C.: Portraiture**. Boston 1997
// Richard Lorenz: **I.C.: On the Body**. Boston 1998 // Manfred
Heiting (ed.): **I.C. 1883–1976**. Cologne 2001 //
I.C. Heidelberg 2012 (cat. Fundación Mapfre)

"With her fusion of art and science – her unique synthesis of form and poetry – Cunningham produced some of the most gripping and remarkable icons of the history of photography. During her lifetime, Cunningham showed an astonishing ability to capture, interpret, understand and persevere, allowing her to become the most important woman photographer on the American west coast." — Richard Lorenz

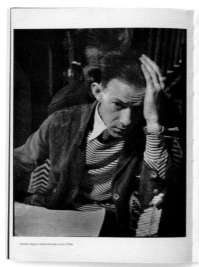

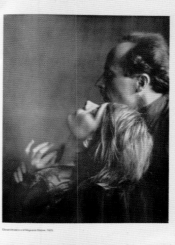

Edward S.*(heriff)* Curtis

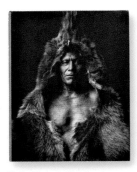

Native Nations. First Americans as seen by Edward S. Curtis.
Boston/New York/Toronto/London (Bulfinch Press) 1993

16.2.1868 Cold Spring (Wisconsin, USA) — 19.10.1952 Whittier (California, USA) Originally a studio photographer. From about 1900 large-scale photographic inventory of a disappearing Native American culture. Photography on the border between Pictorialism and scientific documentation. His father is the Reverend Johnson Asahel Curtis, with whom he takes long trips to isolated villages. Attends a one-room school. No more schooling after six. Early interest in photography. First photographs with a self-made camera, a popular manual (*Wilson's Photographics*) as technical guide. 1887 family moves to Minnesota. Apprenticeship in a photo studio in St John. 1887 family moves to Seattle. There partner in studio with Rasmus Rothi at first. Separates from partner. Works with Thomas Gupill, later opens his own studio on Second Avenue. 1892 marries Clara J. Philipps. Four children. Also works as mountain guide, and as such meets a team of scientists who are in distress. Through them named official photographer for the Harriman expedition in Alaska. Develops an interest in Native American culture. First stay with Prairie Indians. First photographs before 1900. Around 1903 first plans for an extensive documentation of the traditional life of disappearing Indian tribes. To 1904, studies for his major work. Political support for his project from Theodore Roosevelt. Financial support from the railway magnate John Pierpont Morgan. About 40,000 negatives (of around 80 tribes), plus interviews, linguistic studies, voice recordings (using a wax drum recorder) as basis for the 20-volume work *The North American Indian*, published between 1907 and 1920. At times up to 17 collaborators. High point of his career between 1903 and 1913. When the final volume appears, it is only known to a few specialists. Only a short obituary (1952) in the *New York Times*.

EXHIBITIONS (Selected) — **2000** Paris (Hôtel de Sully) SE // **2003** San Diego (California) (Museum of Photographic Arts – 2009) SE // The Hague (Fotomuseum) SE // **2004** Madrid (Museo de América) SE // Stockholm (Kungliga Biblioteket) SE // **2005** Berlin (Camera Work) SE // **2006** Gothenburg (Hasselblad Center) SE // Odense (Denmark) (Brandts Museet for Fotokunst) SE // Dublin (Gallery of Photography) SE // **2008** Hong Kong (University Museum and Art Gallery) SE

BIBLIOGRAPHY (Selected) — A.D. Coleman and T.C. McLuhan: **C.: His Work. Introduction to Portraits from the North American Indian by E.S.C.** New York 1972 // Victor Boesen and Florence Curtis Graybill: **E.S.C: Photographer of the North American In-** dian. New York 1977 // Christopher M. Lyman: **The Vanishing Race and Other Illusions: Photographs by E.S.C.** New York 1982 // Barbara A. Davis: **E.S.C.: The Life and Times of a Shadow Catcher**. San Francisco 1985 // Christopher Cardozo: **Native Nations: First Americans as Seen by E.S.C.** Boston/New York/Toronto/London 1993 // Barry Pritzker: **E.S.C.** New York 1993 // Gerald Hausman and Bob Kapoun: **Prayer to the Great Mystery: The Uncollected Writings and Photography of E.S.C.** New York 1995 // Hans Christian Adam: **E.S.C. Die Indianer Nord-Amerikas. Die kompletten Portfolios**. Cologne 1997 ✍□ // Hans Christian Adam: **E.S.C.** Cologne 1999 // Martin Parr and Gerry Badger: **The Photobook: A History Volume I.** London 2004

"It would be a mistake to judge Curtis's work as a photographer only on his carefully arranged, now expensively traded photos which have long since become icons. The feathered rider, the peaceful water carriers, the often wrinkled, expressive faces which fill the frame in fact recall the romanticism of the 19th century more than Curtis's time, when the first cars were coming off the production lines. Ethnologists have accused Curtis of making photos that are too artistic to accurately describe a tribe. Perhaps Curtis wanted, with his depictions, to undo the injustice done to Native Americans by members of his own race." — Hans Christian Adam ✎

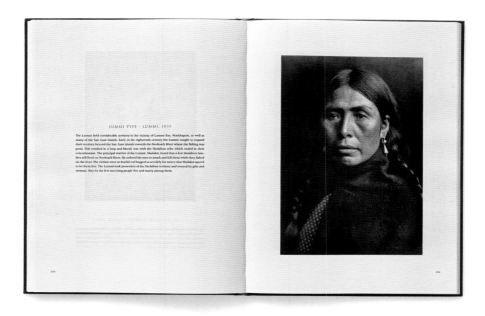

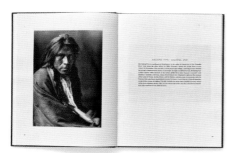

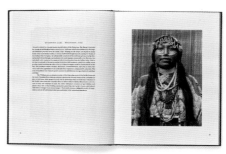

Louise (Emma Augusta) Dahl-Wolfe

Louise Dahl-Wolfe,
from: **Harper's Bazaar,** April 1958

19.11.1895 Alameda (California, USA) — 11.12.1989 Allendale (New Jersey, USA) Fashion photography and portraits. In the 1940s and 50s a pioneer in the field of elegant fashion interpretation in color (outdoor and studio). Daughter of Norwegian immigrants. 1914 begins studying at San Francisco Institute of Art. After father's death (1919) at first works as designer of illuminated advertising. 1921, encouraged by the photographer Annie W. Brigman (1869–1950), takes up photography. 1923 studies interior design in New York. 1928 in Tunisia, meets the sculptor Meyer "Milke" Wolfe. Marries 1928 in New York. 1930 returns to San Francisco. Meets > Lange and Edward Weston. Takes up professional photography definitively. From 1933 again in New York. *Tennessee Mountain Woman* in *Vanity Fair* (1933) her first photo publication. 1936 contract photographer with *Harper's Bazaar* under Carmel Snow (editor), Diana Vreeland (fashion editor) and > Brodovitch (art director). To 1958 in *Harper's Bazaar,* altogether 86 covers, more than 600 color pages as well as countless publications in b/w (fashion and portraits). Locations in North and South America, Europe, Africa, Hawaii and the Caribbean. From 1957 also works for *Sports Illustrated.* 1958 (after the end of the Snow/Brodovitch era) leaves *Harper's Bazaar.* 1958–1959 *Vogue.* 1961 moves to Frenchtown (New Jersey). 1976 a large part of her color archive to Fashion Institute of Technology. 1999 soirée (*Les Dames de Bazaar*) at the Rencontres d'Arles (together with > Bassman).

"**Dahl-Wolfe freed color from convention and timidity, wedding the American ideal of natural wholeness to a European standard of elegance. Today her pictures continue to seem just a little ahead of their time.**" — Vicki Goldberg ✍

EXHIBITIONS (Selected) — **1937** New York (Museum of Modern Art/**Photography** 1839–1937) GE // **1955** Manchester (Vermont) (Southern Vermont Art Center) JE (with Meyer Wolfe) // **1965** Westbury (New York) (Country Art Gallery) JE (with Meyer Wolfe) // **1975** San Francisco (Museum of Modern Art/**Women of Photography**) GE // **1983** New York (Staley-Wise Gallery – 1984, 1992) SE // New York (Grey Art Gallery) SE // **1985** Chicago (Museum of Contemporary Photography at Columbia College) SE // Washington, DC (National Museum of Women in the Arts) SE // **1986** Tucson (Arizona) (Center for Creative Photography – 2000) SE // **1991** London (Victoria and Albert Museum) GE // **1994** Palm Beach (Florida) (Society of the Four Arts) SE // **2000** New York (The Museum at FIT) SE // **2004** New York (Keith de Lellis Gallery) SE // **2007** Hamburg (Haus der Photographie/Deichtorhallen) GE

BIBLIOGRAPHY (Selected) — **L.D.-W.: A Photographer's Scrapbook**. New York 1984 // Sally Eauclaire: **L.D.-W.: A Retrospective Exhibition**. Washington, DC, 1985 (cat. National Museum of Women in the Arts) // Martin Harrison: **Appearances: Fashion Photography Since 1945**. London 1991 (cat. Victoria and Albert Museum) // **L.D.-W.** New York 2000 (cat. The Museum at FIT) ✍ // Gabriel Bauret: **Color Photography**. Paris 2001 // **The heartbeat of fashion. Sammlung F.C. Gundlach**. Bielefeld 2006 (cat. Haus der Photographie/Deichtorhallen Hamburg)

147

Cosmetic Color: Vibrant Violet

• Opposite: Vibrant violet, new radiant-complexion lighting, applied here in a vivid chic chemise dress that descends to a narrowing low from a cowl collar and a back-plunging décolletage. By Cristofoli-Enterre, in Oriental Textiles raw silk. About $36. Miss Bergdorf of Bergdorf Goodman, Dayton's, Minneapolis; Joseph Magnin. Hat by Lilly Daché; Kayser's "Plum Pink" stockings.
• Above: The breathing grey of a violet linen suit, cut along straight lines, is heightened by a white silk dimmity shirt. Suit (by Harry Frechtel, in Moygashel Irish linen, about $90) and shirt (2c Marschoff) at Lord and Taylor. Suit, also at Montaldo's; I. Magnin. Mr. John hat. Extra lighting effects, both pages. Tiffany jewels; Clarins of the Ritz "Mum Rose" lipstick.

Cosmetic Color: Mimosa Yellow

• Opposite: Mimosa yellow is a mélange with tender green—an effective beauty potion for the woman who combines her fashion with a sprinkling of pure pertinence. A double seasoner, here: one part overblouse, elasticized at the waist; one part easy skirt. By Nelly de Grab, in cotton by Fallex Fabrics. About $23. Miss Bergdorf of Bergdorf Goodman; Burdine's, Miami; Frederick and Nelson, Seattle; Mr. John's intense stripe hat.
• Right: Mimosa yellow, en-passant—a slenderer shift in flowy silk drops placid in a "drawstring" flounce. It's knitted (by Mr. John) in yellow blousette. Dress by Larry Aldrich. About $90. Bonwit Teller; Harzfeld's, Kansas City; Sakowitz, Houston; "Buttercup" stockings by Christian Dior; mimosa sheen: Amelli, "Fancy Red" lipstick by Beauty Counselor, both pages.

149

Josef Heinrich *(Jupp)* Darchinger

Josef Heinrich Darchinger:
**Die Bonner Republik. Bilder,
Menschen, Ereignisse.** Bonn
(Rheinisches Landesmuseum)
1997

6.8.1925 Bonn (Germany) — **28.7.2013 Bonn** Photojournalist, over more than three decades a much-published German press photographer. Chronicler of the Bonn Republic. 1932–1940 secondary school. 1940–1942 agriculture apprenticeship. 1942 called up for military service. 1945 badly wounded. American and then French prisoner of war. 1947 successful escape (at third attempt). Trains as photo lab technician at the Umkehrentwicklungsanstalt Tempo GmbH, Bonn. There meets his future wife, Frau Ruth Hofedank. From 1952 freelance photojournalist. Works at first especially for the Social Decoratic Party (SPD), the Friedrich-Ebert-Stiftung, Inter Nationes, trade unions and various newspapers and weeklies (incl. *Neuer Vorwärts*). 1964 begins intensive collaboration with *Der Spiegel* and *Die Zeit* (focus on federal politics). Observer of important conferences such as the Commission on Security and Cooperation in Europe (CSCE) (Helsinki, 1974). Travels to the German Democratic Republic (GDR), Poland, the Soviet Union, China, Israel, and Arab countries. Published in almost all major West German newspapers, as well as international magazines such as *Newsweek*, *L'Express*, *Weltwoche*. Also works for companies such as Friedrich Krupp, Volkswagen, Mercedes-Benz. "Full-time freelance" for *Der Spiegel* in Bonn for over three decades. As such accompanies more than 2,000 interviews. A number of honors and awards, incl. Bundesverdienstkreuz am Bande (1974), Dr Erich-Salomon Prize from the DGPh (Deutsche Gesellschaft für Photographie: German Photographic Association) (1987), Bundesverdienstkreuz (first class) (1989). 1997 major retrospective in the Rheinisches Landesmuseum, Bonn.

Josef Heinrich Darchinger: **Willy Brandt.
Bilder aus dem Leben eines großen
Europäers.** Munich (Droemer Knaur) 1993

EXHIBITIONS (Selected) — **1997** Bonn (Rheinisches Landesmuseum) SE // **2001** Berlin (Willy-Brandt-Haus) SE // **2006** Berlin (EADS-Atrium) SE // Hamburg (Haus der Photographie/Deichtorhallen) GE

BIBLIOGRAPHY (Selected) — **Heinrich Böll. Fotografiert von Chargesheimer, J.D., Gerd Sander.** Bad Godesberg 1968 // Ulrich Blank and J.D.: **Helmut Schmidt, Bundeskanzler.** Hamburg 1974 // J.D.: **Richard von Weizsäcker. Porträt einer Präsi-** dentschaft. Düsseldorf/Vienna/New York/Moscow 1993 // **Willy Brandt. Bilder aus dem Leben eines grossen Europäers.** Munich 1993 // Klaus Honnef (ed.): **J.H.D.: Die Bonner Republik. Bilder, Menschen, Ereignisse.** Bonn 1997 (cat. Rheinisches Landesmuseum) // **The heartbeat of fashion. Sammlung F.C. Gundlach.** Bielefeld 2006 (cat. Haus der Photographie/Deichtorhallen Hamburg) // Frank Darchinger (ed.): **J.H.D.: Wirtschaftswunder. Deutschland nach dem Krieg 1952–1967/Germany after the war.** Cologne 2008 ✍

"The view that this photographer had of events in the 1950s and 60s was that of a carefully and exactly observing contemporary. His aim was to effectively transmit the scenes he observed. This aim of factuality did not mean denying his own point of view. His interest in social 'outrages' is patent. He visualized misery with unvarnished directness, for example, the pitiful state of numerous refugee camps, not to gloss over the deprivation, but to underline their temporary nature. In the mid 1960s they were removed. With tangible commitment, Darchinger broached the fate of pensioners who had too little to live on and too much to die from, veterans who at first profited little or not at all from the economic miracle, and who a few years earlier had been politically persecuted. Very early on the social divide opened up and a 'two-thirds society' was already emerging. Sometimes a hidden tendency towards romanticism showed through in his work, for example when he photographed a tug pumping out thick smoke in Rheingau against a glowing sky, and there was always an air of slight amazement in his view of the things he depicted." — Klaus Honnef ✍

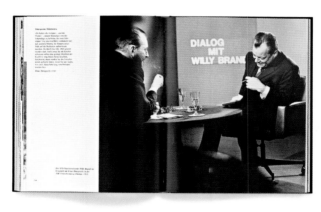

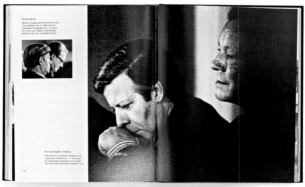

Bruce Davidson

Bruce Davidson: **Photographs.**
New York (Agrinde Publications
Ltd) 1978

5.9.1933 Oak Park (Illinois, USA) — Lives in New York (USA) Magnum photographer with socially critical focus. Essays on minorities in the USA. In the 1960s also fashion photographer for *Vogue*. Child of Polish immigrants. Childhood in Oak Park. First photographs at ten. High school in Oak Park. 1951–1954 studies at Rochester Institute of Technology. There encounters the works of > Smith and > Cartier-Bresson. Lab technician at Eastman Kodak. 1955 studies at Yale University School of Design under Josef Albers, courses with > Brodovitch and > Matter. Photo essay on the Yale football team published in *Life* (18/1955) his first publication. 1955–1957 military service in the USA and France, where he makes, among others, a photo essay on the widow of the Impressionist Léon Fauché. In Paris first contact with Magnum. Associate member from 1958, full member from 1959.

End of the 1950s photographic examination of youth street gangs in Brooklyn. 1961 at > Liberman's invitation, fashion photography for *Vogue*. Growing interest in civil rights movement in the USA. Long stays in Virginia, Mississippi, South Carolina, and Alabama. 1966 begins his long-term project *East 100th Street*, described by *Du* (no. 3, 1969) as "the most important photographic document of this past decade". 1968 stills for Michelangelo Antonioni's *Zabriskie Point*. Subsequently also works as filmmaker, incl. *Living off the Land* (1969), *Zoo Doctor* (1971), *Isaac Singer's Nightmare* (1972). 1980 much admired essay on the New York subway. Numerous fellowships and awards, incl. Guggenheim Fellowship (1962), National Endowment for the Arts (1966, 1967), Open Society Institute Individual Fellowship (1998), Lucie Award (2004), Gold Medal Visual Arts/National Arts Club (2007) for his socially conscious documentation, generally in large series, in b/w and color.

EXHIBITIONS (Selected) — **1965** Chicago (Art Institute) SE // **1966** Rochester (New York) (George Eastman House/**Toward a Social Landscape**) GE // **1970** New York (Museum of Modern Art) SE // **1979** Paris (Galerie Delpire) SE // **1983** Arles (Musée Réattu) SE // **1984** Paris (Centre national de la photographie) SE // **1998** New York (International Center of Photography – 2002) SE // **2000** New York (Historical Museum Society) SE // **2003** New York (Howard Greenberg Gallery – 2004, 2009) SE // **2004** New York (Museum of the City of New York) SE // **2007** Paris (Fondation Henri Cartier-Bresson) SE // Paris (Maison européenne de la photographie) SE // New York (Jewish Museum) SE // **2008** Amsterdam (Stedelijk Museum Post CS/ **MAGNUM Photos 60 Years**) GE // **2012** Berlin (C/O Berlin) SE

BIBLIOGRAPHY (Selected) — **The Bridge**. New York 1964 // **The Negro American**. New York 1966 // Nathan Lyons (ed.): **Contemporary Photographers: Toward a Social Landscape.** New York 1966 (cat. George Eastman House, Rochester) // **East 100th Street**. Cambridge, Mass., 1970 // **Photographs.** New York 1978 // **Subway**. New York 1984 // **B.D.** Paris 1984 (= Photo Poche no. 14) // **Central Park**. New York 1995 // **Brooklyn Gang**. Santa Fe 1998 // **Portraits**. New York, 1999 // **Time of Change. Civil Rights Photography 1961–1965**. Los Angeles 2002 // **Subway**. Los Angeles 2003 // **East 100th Street**. Los Angeles 2003 // **England/Scotland 1960**. Göttingen 2005 // **Circus**. Göttingen 2007 // **Journey of Consciousness.** Göttingen 2009

"Bruce Davidson's sympathies are wide. His typical subjects are the disadvantaged, the humbled, the wounded, living in proud acceptance of their circumstances. The black woman holding her baby in the brightly lit doorway of her collaged and decorated shack; the father and his sons amid the detritus of the Jersey Meadows; the Brooklyn gang defiantly creating a communal style from a poverty of role models — we enter worlds formerly closed to us, worlds opened up by Bruce Davidson's talent for being accepted." — Henry Geldzahler ✍

Brooklyn Gang

John Deakin

John Deakin: **London – Paris – Rom. Strassenfotografie.** Göttingen (Steidl Verlag) 2002

8.5.1912 Bebington (England) — 25.5.1972 Brighton (England) Active around 1950. Street photography. Fashion photography (contracted) and especially portraits. Graphic portrait studies of his artist friends. Son of working-class family. At 16 leaves grammar school. 1930 moves to Dublin. Various jobs (incl. display window dresser). Stay in Spain. Returns to England in the early 1930s. Meets the American art collector and patron Arthur Jeffress. Travels with him to the USA, Mexico, and Tahiti. Takes up painting. 1938 in the Mayor Gallery in London first exhibition of his works, which are compared to those of Georges Rouault or Chaim Soutine. 1939 separates from Jeffress. Short time in Paris. There first photographs with a cheap camera (found at a party). Military service as sergeant in Film and Photography Corps, incl. in Malta, Palestine, Lebanon. 1947 (through Michel de Brunhoff) contacts British *Vogue*. Fashion and portraits. 1948 dismissed (for notorious unreliability). Opens a studio. Works with *Tatler*, *Picture Post*, and (1950) the short-lived magazine *Flair*. 1949 *London Today* his first book (schooled in > Atget). Second chance at *Vogue* (with Audrey Withers' support). Now above all portraits of leading artists of the time: W.H. Auden, Lucian Freud, Eduardo Paolozzi, and especially Francis Bacon, who often uses J.D.'s photos as basis for his paintings. 1954 dismissed again from *Vogue*. Alcoholism, unemployment. 1956: *John Deakin's Paris* and *John Deakin's Rome* much admired exhibitions of his documentary work made in parallel to *Vogue*. 1971 with Bacon to Paris for his show at the Grand Palace. International recognition of his oeuvre 1996 following a retrospective in the National Portrait Gallery.

"Deakin's radical angles, his frontal view and a flagrant lack of 'style' anticipate by almost ten years the works of the American photographer Diane Arbus, whose portraits have especially one thing in common with Deakin's: an uncompromising, almost brutal veracity." — Robin Muir ✏

EXHIBITIONS (Selected) — **1938** London (Mayor Gallery) SE (paintings) // **1956** London (Buchhandlung David Archer) SE // **1984** London (Victoria and Albert Museum) SE // **1996** London (National Portrait Gallery) SE // Munich (Fotomuseum) SE // **1998** Bradford (England) (National Museum of Photography, Film and Television) GE // **2002** Edinburgh (Dean Gallery – National Galleries of Scotland) SE

BIBLIOGRAPHY (Selected) — **J.D.'s Paris**. London 1956 (cat. Buchhandlung David Archer) // **The Salvage of a Photographer**. London 1984 (cat. Victoria and Albert Museum) // Robin Muir ✏ // Martin Harrison: **Young Meteors: British Photojournalism: 1957–1965**. London 1998 (cat. National Museum of Photography, Film and Television, Bradford) // **London – Paris – Rom. Strassenfotografie**. Göttingen 2002.

Dmitri *(Georgiyevich)* Debabov

4.11.1899 Kontcheyevo (Russia) — 1949 Siberia (Soviet Union) Important photojournalist of the 1930s. Apart from industrial photography, photographic exploration of northern Russia. Regarded as a pioneer of expedition photography. At first, turner in a metalworking company. Active in workers' theater. At beginning of the 1920s takes up painting. Theater and film studies at the VGIK (Russian State Institute of Cinematography). There meets Sergei Eisenstein. With his encouragement, takes up photography. First publications in *Sovetskoe foto*. Reportages for *Isvestia* and *Komsomolskaya Pravda*. 1928 joins October Group led by > Rodchenko. From 1930 (by train, ship, automobile, and dogsled) extensive reportage trip to follow major industrial projects (keyword: first Five Year Plan). Photos of mines and factories (incl. construction of Magnitogorsk steel plant). From 1934 expeditions to the outlying regions of the USSR, to Siberia (Chukotka, 1936–1937) and Lake Baikal (1938). Reportages on the peoples living there and exploration of Northern Passage, published in special issues of *USSR in Construction*. 1936–1937 also in the magazine *Stroim* (mostly designed by > Zhitomirsky). 1934–1937 photo series on whale hunting in the Arctic and the first large Soviet icebreakers (Krasin, Sedov, Stalin). 1949 during a trip to Siberia suddenly taken ill and dies soon thereafter.

"Debabov succeeded in uniting the qualities of a Constructivist artist with the curiosity and drive of an adventurer and ethnographer. At first portraying everyday life and documenting a Socialist society in transformation, Debabov developed a new photographic genre in the form of extensive photo reports on the peoples of central Asia and northeast Siberia. His innovative, multifaceted landscape pictures of the far north are carefully composed, lively, atmospheric and bathed in the pathos of early Arctic exploration." — Tatiana Salzirn ✎

EXHIBITIONS (Selected) — **1928** Moscow/Leningrad (**Ten Years of Soviet Photography**) GE // **1930** Moscow (October Group) GE // **1932** London (Royal Photographic Society) GE (Touring exhibition Great Britain) // **1935** Moscow (**Meister sowjetischer Fotokunst**) GE // **1999** Washington, DC (Corcoran Gallery of Art) GE // **2000** Columbus (Ohio) (Columbus Museum of Art) GE // New York (International Center of Photography) GE // **2009** Cologne (Museum Ludwig) GE

BIBLIOGRAPHY (Selected) — **Sowjetische Fotografen 1917– 1940**. Leipzig 1980 // **Sowjet Photographie 1919–1939**. Zurich 1986 // **20 Sowjetische Photographen**. Amsterdam 1990 (cat. Touring exhibition) // **Politische Bilder. Sowjetische Fotografien 1918–1941. Die Sammlung Daniela Mrázková**. Göttingen 2009 (cat. Museum Ludwig, Cologne)

Dmitri Debabov (left-hand page),
from: Nikolai Troschin: **Principles
of Composition in Photography.**
Moscow (Ogonyok) 1929

Patrick Demarchelier

Kathryn E. Livingston: **Patrick Demarchelier: Fashion Photography.** Toronto/London (Bulfinch Press) 1989

21.8.1943 Le Havre (France) — Lives in New York (USA) Fashion, beauty and portraits. As fashion photographer one of the greats of his metier with countless publications in international magazines. Well known to the general public, especially for his portraits of Princess Diana. Childhood and youth with mother and four brothers in Le Havre. First camera at 17, a present from his step-father. Self-taught photographer. First contracts from magazines such as *Elle*, *Marie Claire*, *20 Ans Magazine*. 1975 moves to the USA and becomes one of the most sought after photographers in fashion and beauty, editorial, and advertising. 1989 invited for portrait photographs of Princess Diana, among his internationally best-known works. Thus also the first non-British court photographer. Pirelli Calendar 2005 and 2008. Numerous publications in *Harper's Bazaar*, *Vogue* (USA, France, Italy, Great Britain), *Cosmopolitan*, *Numero*, *Citizen K*, *Flair*, *Allure*, *Vanity Fair*, *Glamour*, and *Rolling Stone*. Advertising for Dior, Calvin Klein, Giorgio, Armani, Chanel, GAP, Gianni Versace, L'Oréal, Lacoste, Elizabeth Arden, Revlon, Lancôme, Gianfranco Ferré. Also record covers e.g. for Britney Spears, Elton John, and Janet Jackson. 2002 part of the important group exhibition *Archaeology of Elegance. 20 Jahre Modephotographie*. Chevalier in the Ordre des Arts et des Lettres (2007). *www.demarchelier.net*

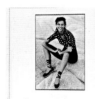 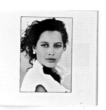 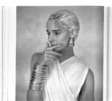

EXHIBITIONS (Selected) — **1995** New York (Tony Shafrazi Gallery – 1999, 2005) SE // **1996** Biarritz (Festival International de la Photo de Mode) GE // **1997** Monterrey (Mexico) (Museu de Arte Contemporaneo) GE // **2000** Milan (Padiglione d'Art Contemporanea) SE // **2002** Hamburg (Deichtorhallen) GE // **2005** Brussels (Young Gallery) SE // **2006** Berlin (Berlinische Galerie/**Der Pirelli-Kalender**) GE // **2008** New York (Staley-Wise Gallery) GE // Paris (Petit Palais) SE // Lugano (Switzerland) (Museo d'Arte/**Photo20esimo**) GE // Los Angeles (Fahey/Klein Gallery) SE // **2014** Berlin (Camera Work) SE

BIBLIOGRAPHY (Selected) — **P.D.: Fashion Photography.** New York 1989 // **Forms.** Milan 1998 // **Photographs.** New York 1995 // **P.D.: Fotografien.** Zurich 1996 // **Exposing Elegance.** Monterrey 1997 (cat. Museu de Arte Contemporaneo) // **Azzedine Alaïa.** Göttingen 1998 // **P.D.** Hamburg 1999 (= **Stern** Portfolio no. 17) // **Giorgio Armani: Twenty-Five Photographs.** New York 2000 (cat. Guggenheim Museum) // Marion de Beaupré (ed.): **Archeology of Elegance. 20 Jahre Modephotographie.** Munich 2002 (cat. Deichtorhallen Hamburg) // **P.D.** Göttingen 2009

"A photographer is someone sensitive. You always have to renew yourself. For me, every job is a new challenge. What I did before is behind me." — Patrick Demarchelier ✎

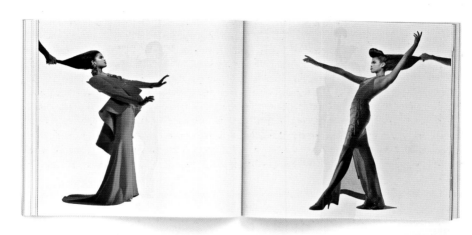

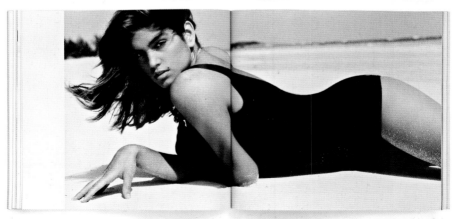

Raymond Depardon

Raymond Depardon: **Détours**.
Paris (Maison européenne de la photographie) 2000

6.7.1942 Villefranche-sur-Saône (France) — Lives in Paris (France)
Photo reporter. Magnum member, author of an oeuvre of reports often extending into the conceptual. Also documentary and feature films. Father a farmer. 1954 first photos of parents' farm. 1956 school-leaving certificate. Six-month apprenticeship at local optician and photo shop. Correspondence course in photography. 1958 moves to Paris, where he becomes assistant to Louis Foucherand. 1960 photo reporter fur Dalmas agency: notables, foreign reportages, war reports (incl. Algeria). 1968, with Hubert Henrotte, Hugues Vassal, and Léonard de Raemy founds the Gamma agency. 1969 first documentary film (*Jan Palach*). 1970, with Gilles Caron and Robert Pledge, first trip to Chad. 1973 head of Gamma. Robert Capa Gold Medal for his book *Chili* (with David Burnett and Chas Gerretsen). 1974 international attention for his reports (films, photos) on Françoise Claustre, kidnapped in Chad. First feature length film (*50.81 %, 1974, une partie de campagne*, on Giscard d'Estaing's election campaign). 1978 moves to Magnum. Reportages from Lebanon and Afghanistan. 1981 César and Academy Award nomination (Oscar) for his film *Reporters*. Photo exhibition *Correspondance new-yorkaise* for *Libération*. 1984 for DATAR (a project to photograph France's natural and built environment). Photo essays on parents' farm. 1989–1990 reports on the fall of the Berlin Wall. 1991 Grand Prix nationale de la photographie. César and Prix Joris Ivens for *Délits flagrants*. Also Prix Nadar (2000) and Gold Medal at the Chicago International Film Festival (2004). Altogether 18 feature length films and around 50 books. 2000 major retrospective in Maison européen de la photographie (Paris). 2006 artistic director of the Rencontres d'Arles.

EXHIBITIONS (Selected) — **1981** Paris (Fnac – 1983, 1999) SE // **1985** Paris (Centre national de la photographie) SE // **1989** Villefranche (France) (Centre d'Arts plastiques) SE // **1992** Chambéry (France) (Maison de la Culture) SE // **1996** Gap (France) (Théâtre de la Passerelle) SE // **1998** Marseille (Centre de la Vieille-Charité) SE // **2000** Paris (Maison européenne de la photographie – 2006) SE // **2002** Valladolid (Spain) (Fundación Municipal de Cultura) SE // **2004** Paris (Fondation Cartier pour l'art contemporain) SE // Paris (Hôtel de Ville) SE // **2005** Rotterdam/Amsterdam (Nederlands Fotomuseum/ Filmmuseum) SE // **2006** Strasbourg (Hôtel de région) SE // **2007** Vevey (Switzerland) (Musée Suisse de L'Appareil Photographique) SE // Madrid (PHotoEspaña) SE // **2013** Paris (Grand Palais) SE

BIBLIOGRAPHY (Selected) — David Burnett, R.D., and Chas Gerretsen: **Chili**. Paris 1974 // **Tchad**. Paris 1978 // **Notes**. Paris 1979 // **Correspondance new-yorkaise**. Paris 1981 // **Le désert américain**. Paris 1983 // **San Clemente**. Paris 1984 (cat. Centre national de la photographie) // **Les fiancées de Saigon**. Paris 1986 // **Hivers**. Paris 1987 // **D.: Cinéma**. Paris 1993 // **La ferme du Garet**. Paris 1995 // **En Afrique**. Paris 1996 // **D. Voyages**. Paris 1998 // **Silence rompu**. Paris 1998 // **Errance**. Paris 2000 // **Détours**. Paris 2000 (cat. Maison européenne de la photographie) // **Paroles prisonnières**. Paris 2004 // **Jeux Olympiques**. Paris 2004 // **Paris Journal**. Paris 2004 // **Afriques**. Paris 2005 // **R.D.: Photographer and Filmmaker**. Rotterdam/Amsterdam 2005 (cat.Fotomuseum/Filmmuseum) // **Photographies de personnalités politiques**. Paris 2006 // **Villes / Cities / Städte**. Göttingen 2007 // Chris Boot (ed.): **Magnum Stories**. London 2004

"As a photographer, I became a storyteller: I'm not in the 'decisive moment' school. I worked through the press agencies, and felt closer to photographers like Robert Capa, Larry Burrows and Don McCullin. At Gamma I was working with Gilles Caron and we were more responsive to McCullin's work in *The Sunday Times Magazine* than to the founding fathers of Magnum, whom we found a bit abstract. The French school, with its Cartier-Bresson influence, didn't affect us much, as it did the young French photographers working with the Viva agency, for example. I was working in the sphere of journalism and I wasn't too bothered by the search for the perfect photograph – a good photo, yes, but not a performance."

— Raymond Depardon ✎

Philip-Lorca diCorcia

Philip-Lorca diCorcia: **Streetwork.**
Hannover (Sprengel Museum)
2000

1953 Hartford (Connecticut, USA) — Lives in New York (USA) Street photography in color. Combination of daylight and flash. Big city scenes of intentional artificiality. Much discussed since the 1990s. Studies in Boston (School of the Museum of Fine Arts) with > Goldin and Jack Pierson as well as at Yale University, New Haven (Connecticut) (M.F.A., 1979). At the beginning of the 1990s (influenced by the works of > Meyerowitz and Tod Papageorge) takes up a postmodern form of street photography. Formal aesthetic extension of the genre by using a medium-format camera, color film, artificial light and (at least at the beginning) paid models (staging). Conscious intensification of banal everyday situations into absurdity. More recently, random photographs in crowded squares in New York, Berlin, Paris, Tokyo, and Rome. Series *Hollywood* (1990–1992), *Streetwork* (1993–1998). Also advertising. Solo exhibition in Museum of Modern Art, New York (*Strangers*, 1993) beginning of his international reputation. NEA (National Endowment for the Arts)Fellowship (1980, 1986, 1989), Guggenheim Fellowship (1987).

"Philip-Lorca diCorcia sets his sights on people in the streets of big cities, captures their faces with camera and flash and delivers them to the fantasies of the viewer. [...] diCorcia carefully prepares himself for the moment when views meet, but he does not stage anything. Quite unlike his Canadian colleague Jeff Wall, who carefully arranges his 'documentary' scenes, the American looks down the street to capture an unknown extra in a snapshot in the natural light of day, not to mystify him but to make recognizable this unknown actor in a biographical narrative in a transition from reality to fiction." — Günther Engelhard

EXHIBITIONS (Selected) — **1993** New York (Museum of Modern Art) SE // **1995** Cologne (Galerie Klemens Gasser – 1996, 1997) SE // Esslingen (Germany) (Triennale) GE // **1996** New York (PaceWildensteinMacGill – 1999) SE // **1998** Madrid (Museo Nacional Centro de Arte Reina Sofía) SE // Hamburg (Hamburger Kunsthalle) GE // **1999** Groningen (Netherlands) (Noorderlicht Photofestival) GE // **2000** Hannover (Sprengel Museum) SE // **2001** Munich (Monika Sprüth/Philomene Magers – 2006) SE // **2003** Madrid (Fundación Telefónica) SE // **2004** Paris (Centre national de la photographie – Jeu de Paume) SE // Essen (Museum Folkwang) SE // **2006** Amsterdam (Fotografiemuseum Amsterdam) SE // **2007** Boston (Institute of Contemporary Art) SE // **2008** Los Angeles (Los Angeles County Museum) SE // **2013** Frankfurt am Main (Schirn Kunsthalle) SE

BIBLIOGRAPHY (Selected) — **Pleasures and Terrors of Domestic Comfort**. New York 1991 (cat. Museum of Modern Art) // **Family Matters**. Tempe 1993 (cat. Northlight Gallery) // **After Art: Rethinking 150 Years of Photography**. Seattle 1994 (cat. Henry Art Gallery) // **P.-L.diC**. New York 1995 (cat. Museum of Modern Art) // **Emotions & Relations**. Cologne 1998 (cat. Hamburger Kunsthalle) // **Das Versprechen der Fotografie. Die Sammlung der DG Bank**. Munich 1998 // **Streetwork**. Salamanca 1998 (cat. Center of Photography) // **Streetwork**. Hannover 2000 (cat. Sprengel Museum) // **Heads**. New York 2001 // **A Storybook Life**. Santa Fe 2003 // **All one thousand polaroids**. New York/Göttingen 2007

New York (Chinatown), 1993. Courtesy Pace/MacGill, New York

Los Angeles, 1993, *Something Beneil F Xprrne*, Courtesy Pace/MacGill, New York

New York, 1998. Courtesy Pace/MacGill, New York

Mexico City, 1998. Courtesy Pace/MacGill, New York

André de Diénes (Ikafalvi Diénes Andor)

André de Diénes: **Marilyn.**
Cologne (TASCHEN) 2002

1913 Turia (today Romania) — 1985 USA Nudes, erotic photography, and portraits. In the 1950s one of the most internationally known pin-up photographers. Also known as the discoverer of Marilyn Monroe. Child of a wealthy merchant family. The family's wealth disappears after the war and inflation. Flees with mother to the countryside. Father and older siblings to Budapest. 1925 mother dies. Grows up with his grandmother. Moves to Budapest at 15. Various jobs (incl. as messenger boy and textile salesman). Spends time in Tunisia. Buys his first camera. 1933 moves to Paris, at first intending to study art. With a Rolleiflex he buys there, first photos for newspapers (*L'Humanité*) and news agencies (Associated Press). First fashion photographs at the encouragement of the Paris couturier Edward Molyneux from mid 1930s. 1938 moves to USA. In New York works for *Esquire*, *Vogue*, and *Life*. 1944 moves to Hollywood and takes up nude photography. International success with studies of the body on the border between outdoor nudes and pin-ups. In addition star portraits for Hollywood studios of actors such as Fred Astaire, Ingrid Bergman, Marlon Brando, Henry Fonda, Zsa Zsa Gabor, Elizabeth Taylor, Shirley Temple. 1945 meets 19-year old Marilyn Monroe (1926—1962). First photographs. After a short affair to 1960 close to the actress. Around two-dozen book publications during his lifetime. Internationally known especially due to his popular nude photography.

EXHIBITIONS (Selected) — **1985** Munich (Münchner Stadtmuseum) GE // **2002** New York (Tony Shafrazi Gallery) SE // London (Michael Hoppen Gallery) SE // **2004** New York (Staley-Wise Gallery – 2006) SE // Tel Aviv (Tel Aviv Museum of Art) GE // Denver (Colorado) (Camera Obscura – 2006) SE // Brooklyn (New York) (Brooklyn Museum of Art) GE // **2005** London (Atlas Gallery – 2007) SE // **2006** Atlanta (Georgia) (Fay Gold Gallery) SE // **2007** Paris (Maison européenne de la photographie) GE

BIBLIOGRAPHY (Selected) — **Nus.** Paris 1951 // **The Nude.** London 1956 // **Nude Pattern.** London 1958 // **Impression.** Kiel/ Frankfurt am Main 1961 // **Schönheit im Bild.** Thielle 1965 // **Best Nudes.** New York 1966 // **Natural Nudes.** New York 1966 // **The Glory of de Dienes Women.** Los Angeles 1967 // **Naked Women.** New York 1968 // **Western Nudes.** New York 1968 // **Die 64 besten Sexfotos.** Flensburg 1970 // **Nude Variations.** Garden City 1977 // Michael Köhler and Gisela Barche (eds): **Das Aktfoto.** Munich 1985 (cat. Münchner Stadtmuseum) // **Marilyn mon amour: the private album of A.deD., her preferred photographer.** New York 1985 // **Marilyn.** Cologne 2002 // **Studies of the Female Nude.** Santa Fe 2005 // Alessandro Bertolotti: **Livres de nus.** Paris 2007 (cat. Maison européenne de la photographie) 🖉

"In the 1950s, construction of the pin-up image tried to become simpler. You see it in volumes of *Nus* and collections of photobooks with highly-colored covers, made by an American of Hungarian origin, André de Diénes – the one who discovered Marilyn Monroe while working for fashion magazines. The shots were generally taken outside. The faces of the models are smiling, sometimes thoughtful; when placed on their breasts or pubic area, their hands seem to cover rather than to accent them. The profile of the body is accentuated by the framing of the breasts and the buttocks; the atmosphere is happy and relaxed, but the pubis is always hidden or airbrushed " — Alessandro Bertolotti ✍

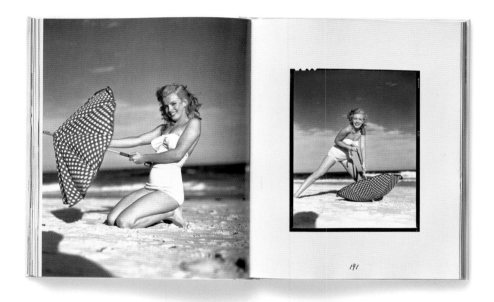

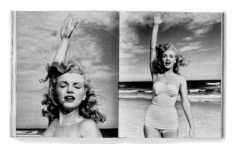

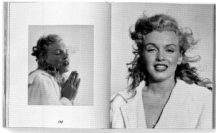

Rineke Dijkstra

Rineke Dijkstra: **Portraits.**
Ostfildern (Hatje Cantz Verlag)
2001

2.6.1959 Sittard (Netherlands) — Lives in Amsterdam (Netherlands)
Since the 1990s internationally recognized photo and video artist.
Portraits of young people, generally series following a concept that
breaks with the rules of conventional portrait photography. 1981–
1986 studies at the Gerrit Reitveld Akademie, Amsterdam. At first
magazine work and (contract) portraits of painters, writers, business
people (in b/w). *Beach Portraits* (1992–1996) her first independent
work (in color with large-format camera) and international break-
through. Also subsequently exploration of bodies, body language and
forms of youth self-presentation. More recently has also produced
"moving portraits" (Thomas Weski) using a video camera. A number
of awards, incl. Kodak Award Nederland (1987), Werner Mantz Prijs
(1994), Citibank Photography Prize (1999). Numerous solo exhibi-
tions since the mid 1990s. Participates in important group exhibi-
tions, incl. *Prospect 96* (Frankfurter Kunstverein/Schirn, 1996), *New
Photography 13* (Museum of Modern Art, 1997), *Wounds* (Moderna Museet, 1998), *Remix* (Musée
des Beaux-Arts, Nantes, 1998).

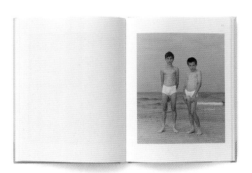

EXHIBITIONS (Selected) — **1984** Amsterdam (de Moor – 1988)
SE // **1994** Amstelveen (Netherlands) (**Kunstaanmoediging-
sprijs**) SE // **1995** Amsterdam (Stedelijk Museum Bureau) SE
// **1996** Cologne (Galerie Sabine Schmidt) SE // Cahors
(France) (Le Printemps de Cahors) SE // **1997** London (The
Photographers' Gallery) SE // **1998** Essen (Museum Folk-
wang) SE // Hannover (Sprengel Museum) SE // **1999** Berlin
(DAAD Galerie) SE // **2001** Chicago (Art Institute) SE // Boston
(The Institute of Contemporary Art) SE // **2003** Kiel (Germany)
(Stadtgalerie Kiel) SE // **2004** Madrid (PHotoEspaña) SE //
Paris (Jeu de Paume – Site Concorde) SE // **2005** Winterthur
(Switzerland) (Fotomuseum) SE // Amsterdam (Stedelijk Mu-
seum Post CS) SE // **2006** Prague (Galerie Rudolfinum) SE //
2007 Rotterdam (Nederlands Fotomuseum) SE // **2012** New
York (Solomon R. Guggenheim Museum) SE // **2013** Frankfurt
am Main (Museum für Moderne Kunst) SE

BIBLIOGRAPHY (Selected) — **Beaches**. Zurich 1996 // **R.D.** Lon-
don 1997 (cat. The Photographers' Gallery) // **Menschen-
bilder**. Essen 1998 (cat. Museum Folkwang) // **The Buzzclub,
Liverpool, UK/Mysteryworld, Zaandam, NL**. Hannover 1998
(cat. Sprengel Museum) // **Portraits**. Ostfildern 2001 (cat.
Institute of Contemporary Art, Boston) // **Portraits**. Munich
2004 // **Dutch Eyes: A Critical History of Photography in the
Netherlands**. Zwolle 2007 (cat. Nederlands Fotomuseum, Rot-
terdam)

"The depiction of people is Rineke Dijkstra's only theme up to today. The Dutch photographer became internationally known in the course of the 1990s with a series of portraits taken at the beach. This extensive work consists of color photographs that show children and youths in swimsuits on various beaches in Europe and the USA. Alone, in pairs or in groups […] they pose seriously against the background of the soft colors of the sea they seem just to have left. Without their normal clothing they have recourse only to a sort of self-presentation that allows no possibility of hiding. Almost naked and lacking the external signs of a certain social class, the people in the photographs seem to fall back on themselves." — Thomas Weski ✍

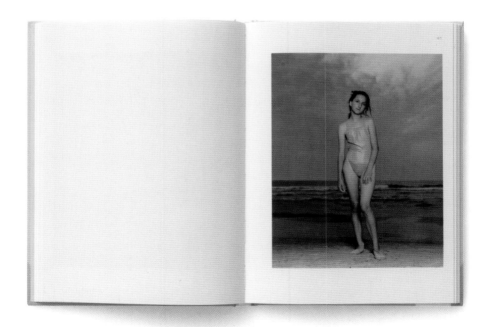

Robert Doisneau

Blaise Cendrars and Robert Doisneau: **La Banlieue de Paris. 130 Photographies de Robert Doisneau.** Paris (Pierre Seghers) 1949

14.4.1912 Gentilly (France) — 1.4.1994 Montrouge (France) Most popular exponent of "Photographie humaniste". Apart from portraits and reportages, especially tragi-comic snapshots of everyday life in Paris. Schooling in Gentilly. 1925–1929 studies at the École Estienne (École supérieure des arts et industries graphiques) in Paris. 1929 diploma as engraver and lithographer. 1930 graphic artist and advertising photographer for Ullmann studio. 1931 assistant to > Vigneau. 1932 publishes first photos: reportage on the flea market, in the illustrated daily *Excelsior*. 1934–1939 advertising and industry photography at the Renault factory in Billancourt. 1940 serves in the French Army. To 1945 active in the Resistance. 1946 member of Rapho, a photo agency founded by Charles Rado in 1933, which represents > Brassaï, Noras Dumas, Ergy Landau, and Lucien Chauffard, among others. 1947 Prix Kodak. In the same year first group exhibition at the Bibliothèque nationale de France in Paris. 1949 fashion photography for French *Vogue*. Also in 1949 *La Banlieue de Paris* as first book (text by Blaise Cendrars). 1951 first solo exhibition in Paris. Also 1952 (together with Brassaï, > Izis, > Ronis) group exhibition at the Museum of Modern Art, New York. 1952 leaves *Vogue*. Subsequently freelance photographer in Montrouge, near Paris. Known especially for his sly, ironic form of street photography, both humorist and melancholy (only b/w). With > Cartier-Bresson without doubt the best-known photographer in post-war France. From 1988 in reference to his most famous picture *Le Baiser de l'Hotel de Ville* (1950) various lawsuits concerning personal rights and royalties. Major retrospective 1992 in Oxford (Museum of Modern Art). In year of his death exhibitions and projects at the Rencontres d'Arles.

EXHIBITIONS (Selected) — **1960** Chicago (Art Institute) SE // **1968** Paris (Bibliothèque nationale de France) SE // **1972** Rochester (George Eastman House) SE // **1975** Arles (Musée Réattu) SE // **1979** Paris (Musée d'art moderne de la Ville de Paris) SE // **1989** Paris (Grande Halle de la Villette) SE // **1992** Oxford (Museum of Modern Art) SE // **1995** Paris (Musée Carnavalet) SE // **2002** London (Michael Hoppen Gallery) SE // **2003** Madrid (Escuela de Fotografía y Centro de Imagen) SE // **2005** Kyoto (Kahitsukan Kyoto Museum of Contemporary Art) SE // Milan (Palazzo Reale) SE // **2006** Paris (Hôtel de Ville) SE // **2007** Helsinki (Helsingin taidemuseo) SE // **2010** Paris (Fondation Henri Cartier-Bresson) SE // **2011** Cologne (Museum Ludwig) GE

BIBLIOGRAPHY (Selected) — **La Banlieue de Paris.** Paris 1949 // **Les Parisiens tels qu'ils sont.** Paris 1954 // **Instantanés de Paris.** Paris 1955 // **Trois secondes d'éternité.** Paris 1979 // **À l'Imparfait de l'objectif. Souvenirs et portraits.** Paris 1989 // **Doisneau-Renault.** Paris 1990 // Peter Hamilton: **R.D. Retrospective.** London 1992 (cat. Museum of Modern Art, Oxford) // Peter Hamilton: **R.D.** Paris 1995 // Daniel Girardin/Christian Pirker: **Controverses. Une histoire juridique et éthique de la photographie.** Arles 2008 // **From Craft to Art.** Göttingen 2010 (cat. Fondation Henri Cartier-Bresson) // **Du métier à l'œuvre.** Göttingen 2010 (cat. Fondation Henri Cartier-Bresson) // **Ichundichundich. Picasso im Fotoporträt.** Cologne 2011 (cat. Museum Ludwig) // Guy Mandery: **Un photographe et ses livres.** Fontainebleau 2013 // Jean Claude Gautrand: **R.D.** Cologne 2014

"The work of Robert Doisneau represents one of the most impressive achievements of the photographic perspective known as humanistic reportage. His files contain in excess of 325,000 negatives, made over a period of more than sixty years beginning in 1929, which cover almost every imaginable subject. The majority were made within a relatively small area of Paris and its banlieu, while the rest were mostly produced in other parts of France […] Doisneau's photographs are the result of patience, reflection, complicity, involvement. Yet in their largely urban subject-matter they also encapsulate a key element of modernity." — Peter Hamilton ✍

Ken Domon

Ken Domon: **The Children of Chikuhō.** Tokyo (Patoria Shoten) 1960

25.10.1909 Sakata (Japan) — 15.9.1990 Tokyo (Japan) Important representative of a documentary photography committed to political issues in the Japan of the 1950s and 60s. Also the author of pioneering book publications (*The Children of Chikuhō*, 1960). Shows an early interest in art and history. From 1930 takes evening classes at the law faculty at Nihon University in Tokyo. Expelled owing to repeated absence. 1933–1935 trains to be a photographer under Kotarō Miyauchi in Tokyo, after which he takes up the profession. 1935 moves to the Nippon Kōbō photo agency (Japan Workshop). In the same year he begins working for *Nippon* magazine, published in English (and intended for sale abroad). 1938 first report in *Life*. 1939 end of his collaboration with Nippon Kōbō. Works freelance for the Association for the Promotion of International Cultural relations. 1940 establishment of the "Japan News Photographers' Association". In the following year, he begins his photographic work on the culture of Japanese puppet theater (*Bunraku*). Increasingly involved in a documentary photography interested in social issues. In the 1950s, systematically explores social reality. His monthly column in *Camera* magazine (propagating a realism interested in social issues) particularly influential. *Hiroshima*, published in book form in 1958, marks the culmination of his humanist orientation. At the same time he devotes himself to traditional Japanese art and architecture. His work has a considerable impact on amateur photography. Numerous awards, among others Mainichi Award for his photobook on the Murōji temple (1955), Mainichi Award for *Hiroshima* (1958), Award of the Japanese Journalists' Conference for *The Children of Chikuhō* (1960), Grand Prix award for *Kamera Geijutsu* (1962), Medal of Honor with Purple Ribbon (1973), Honorary Citizenship of his home town Sakata (1974). 1960 first stroke. After a third cerebral haemorrhage he remains in a coma until his

EXHIBITIONS (Selected) — **1955** Tokyo (Takashima Department Store) SE // **1960** Tokyo (Fuji Photo Salon) SE // **1968** Tokyo (Nikon Salon) SE // **1972** Tokyo (Odakyu Department Store) SE // **1974** New York (Museum of Modern Art/**New Japanese Photography**) GE // **1973** Tokyo (Wako Gallery) SE // **1981** Tokyo (Shadai Gallery) SE // **1990** Frankfurt am Main (Fotografie Forum) SE // **2003** Houston (Museum of Fine Arts/**The History of Japanese Photography**) GE // **2005** Tokyo (Bunkamura Museum of Art) GE // **2008** Cologne (Japan Foundation) GE

BIBLIOGRAPHY (Selected) — **Japanese Statues**. Tokyo 1952 // **Fubo**. Tokyo 1953 // **The Moro-ji**. Tokyo 1954 // **Hiroshima**. Tokyo 1958 // **The Children of Chikuhō**. Tokyo 1960 // **Rumie's Daddy is Dead**. Tokyo 1960 // **Hiroshima Nagasaki Document 1961**. With Shomei Tomatsu and others, Tokyo 1961 // **Pilgrimages to Ancient Temples**. 5 vols. Tokyo 1963–1971 // **Taishino-Midera: The To-ji**. Tokyo 1965 // **Yakushi-ji Temple**. Tokyo 1971 // **Bunraku**. Osaka 1972 // **The Todai-ji**. Tokyo 1973 // **Selected Works of K.D.** 3 vols. Tokyo 1977 // **Living Hiroshima**. Tokyo 1978 // **The Complete Works of K.D.** 13 vols. Tokyo 1983 // **La Recherche Photographique: Japon**. Paris 1990 // Anne Tucker, Dana Friis-Hansen, and Ryūichi Kaneko: **The History of Japanese Photography**. Houston 2003 (cat. The Museum of Fine Arts) // Martin Parr and Gerry Badger: **The Photobook: A History Volume I**. London 2004 // Ryūichi Kaneko and Ivan Vartanian: **Japanese Photobooks of the 1960s and '70s**. New York 2009 ✐

death in September 1979. 1982 first Domon Ken Award from the *Asahi Shimbun* newspaper. 1983 opening of the Ken Domon Photography Museum, the first exhibition space dedicated to one single photographer. The same year sees the beginning of the publication of *The Complete Works of K.D.* (completed in 1985).

"In the 1960s, *The Children of Chikuhō* instigated a spate of similarly formatted social issue books, which became an emblem of the growing momentum of grassroots political movements. Domon demonstrated that a one-hundred-yen photobook was not only possible but an attractive alternative to expensive productions, especially in an era when numerous publications were focusing on social issues. Thus this volume established a new business model that continued until the early 1970s, and helped fuel a further expanse of realist photography, of which Domon was the most vocal proponent in Japan." — Ryūichi Kaneko

Terence Donovan

Terence Donovan: **It's going to be wet**, from: **Queen**, 25.9.1963

14.9.1936 London (England) — 22.11.1996 London Fashion, portraits, advertising and sorties into documentary photography. *Vogue* photographer 1961–1966. Also television commercials and music videos. Honorary Professor at Central St Martin's College of Art, London. Studies at the London School of Photo-Engraving & Lithography 1951–1954, then teaches (lithography and printing) at Fleet Street's London School of Engraving and Lithography. 1954–1955 assistant to the photographer Michael Williams at *Fleet Illustrated*. 1955–1957 military service as photographer in the Ordnance Corps. 1957–1958 assistant to photographers Adrian Flowers and John Adriaan in John French's studio, London. 1959 opens his own studio (moves several times, and closes only on T.D.'s death). 1961 first contract for *Vogue*. In addition (between 1959 and 1996) publishes in *Vogue* (UK, USA, France, Italy, Germany), *Vanity Fair*, *Harper's & Queen*, *Harper's Bazaar* (USA, Italy, France), *Elle*, *Marie Claire*, *Town*, *Nova*, *Queen*, *Cosmopolitan*, *Brides*, *Country Life*, *Tatler*, *Ritz*, *House & Garden*, as well as the newspapers *The Times*, *The Sunday Times*, *Daily Express*, *The Independent*, *The Financial Times*, the *Daily Mail*, the *Observer*, the *Mail on Sunday*. Also numerous advertising contracts. 1975 *Yellow Dog* his first feature film. 1980–1996 promotional videos for Robert Palmer, Liza Minnelli, Toyah Wilcox, Malcolm McLaren, Julio Iglesias, Rod Stewart, and Marianne Faithfull. Director of a number of Royal National Theatre productions for CBS. Two documentaries on Paris fashion shows for British television. Member of the Royal Photographic Society, Royal Society of Arts, British Institute of Incorporated Photographers. Trustee of the Arts Foundation, London.

EXHIBITIONS (Selected) — **1991** London (Victoria and Albert Museum) GE // **1992** London (Albemarle Gallery) SE (Painting) // **1994** London (Saatchi Gallery) GE // **1998** Bradford (England) (National Museum of Photography, Film and Television) GE // **1999** London (Museum of London) SE // **2001** Oxford (Museum of Modern Art) GE // **2004** Wadebridge (England) (Tristan's Gallery) GE // **2005** Moscow (Moscow House of Photography) SE // **2008** London (The Photographers' Gallery/**Fashion in the Mirror**) GE

BIBLIOGRAPHY (Selected) — **Women Through the Eyes of Smudger T.D.** London 1966 // **Glances**. London 1983 // **Fighting Judo**. London 1985 // Martin Harrison: **Appearances: Fashion Photography Since 1945**. London 1991 (cat. Victoria and Albert Museum) // Martin Harrison: **Young Meteors: British Photojournalism: 1957–1965**. London 1998 (cat. National Museum of Photography, Film and Television, Bradford) // **London Photographs**. London 1999 (cat. Museum of London) // **T.D.: The Photographs**. London 2000 // **Open City**. Ostfildern 2001 (cat. Museum of Modern Art, Oxford)

"Terence Donovan, too, at the outset of his career, was employed by *Town* magazine as much for his social reportages as for his notably revisionist depictions of men's fashions; the latter were often conceived around a loosely structured narrative and laid out by Tom Wolsey in the manner of a news-journal story. Donovan's work for *Vogue* and *Queen* was largely restricted to fashion and portraits, but the range of his contributions to *Town* was wider. He was seldom comfortable in relinquishing his directorial role, but in remarkable essays such as 'The Lay About Life' (*Man About Town*, December 1960) and 'Strippers' (*About Town*, July 1961) he came close to photojournalism." — Martin Harrison ✍

Terence Donovan: **Shoes go egg-shell light for Spring,** from: **Queen,** 25.3.1964

František *(Ferdinand)* Drtikol

3.3.1883 Příbram (Bohemia, today Czech Republic) — 13.1.1961 Prag (Czechoslovakia) Painter, drafts-
man, photographer, especially nudes influenced by Art Déco and Symbolism. Internationally best-
known Czech photographer around 1920. 1898–1901 photography apprentice under Antonín Mattas
in Príbram. 1901–1903 studies at the Lehr- und Versuchsanstalt für Photographie (Graphic Arts
Teaching and Research Institute) in Munich. 1907–1910 own studio Príbram. 1910–1935 portrait
studio in Prague with Jaroslav Rössler as second apprentice and assistant. Publishes two photo-
books: *Les nus de Drtikol* (1929) and *Zena ve svetle* (1930), the high point of his art photography
tending more and more towards Expressionism, Cubism, and Art Déco at the end of the 1920s. 1935
gives up photography. Takes up painting, yoga, and Buddhism as well as various Tibetan and Indian
teachings. Also documentary and landscape photography (see his album *Aus Prager Hinterhöfen*,
1911, made with Augustin Skarda). Numerous publications in international magazines (incl. *Arts et
Métiers Graphiques*). Many honors and awards. 1942 his archive housed in the Prague Crafts Muse-
um and the Czech National Museum. Only at the beginning of the 1970s is it rediscovered there and
edited by Anna Fárová. Beginning of a new recognition of this creative individualist between art pho-
tography and avant-garde.

EXHIBITIONS (Selected) — **1924** London (Royal Photographic
Society) GE // **1925** Paris (Exposition Internationale des Arts
décoratifs) GE // **1972** Prague (Museum für Kunsthandwerk)
SE // **1974** London (The Photographers' Gallery) SE // **1984** Es-
sen (Germany) (Museum Folkwang) GE // **1991** New York
(Howard Greenberg Gallery — 1997, 2007) SE // Bremen (Ger-
many) (Forum Böttcherstrasse) SE // **1999** Munich (Die Neue
Sammlung) GE // **2007** Berlin (Kicken Berlin) GE // **2008** Vi-
enna (Tschechisches Zentrum) JE (with Jaroslav Rössler and
Eugen Wiskovsky) // **2009** Munich (Stadtmuseum) GE // **2013**
Madrid (Real Academia de Bellas Artes) SE

BIBLIOGRAPHY (Selected) — **Les nus de Drtikol**. Paris 1929 //
Zena ve svetle. Prague 1930 // **Fotograf** F.D. Prague 1972 (cat.
Museum für Kunsthandwerk) // **Photographes tchèques**.
Paris 1983 (cat. Centre Pompidou) // Anna Fárová: **F.D.: Photo-
graph des Art Déco**. Munich 1986 // Vladimír Birgus: **Fotograf
F.D.** Prague 1994 // Vladimír Birgus: **Tschechische Avant-
garde-Fotografie 1918–1948**. Stuttgart/Munich 1999 (cat.
Die Neue Sammlung) 🔎 // Vladimír Birgus: **The Photographer
F.D.** Prague 2000 // Manfred Heiting: **At the Still Point**. Los An-
geles/Amsterdam 2000 // **Czech Vision. Avant-Garde Photog-
raphy in Czechoslovakia**. Ostfildern 2007 (cat. Kicken Berlin/
Howard Greenberg Gallery, New York) // **Nude Visions. 150
Jahre Körperbilder in der Fotografie**. Heidelberg 2009 (cat.
Münchner Stadtmuseum)

František Drtikol: **Nue,** from: **Nus.**
Paris (Premier Salon international
du Nu photographique) 1933

"It must seem paradoxical that among those who went farthest along the road from secessionist Pictorialism to the avant-garde is František Drtikol, who in the 1920s was often seen as a conservative exponent of Symbolism and Secession. Today we can see that Drtikol, although the radicalism and left-wing utopianism of most of the avant-garde artists was as foreign to him as their tendency to experimentation, was closer to the avant-garde in many of his works than most of its exponents were prepared to admit." — Vladimír Birgus ✐

David Douglas Duncan

David Douglas Duncan:
Le Petit Monde de Pablo Picasso.
Paris (Hachette) 1959

23.1.1916 Kansas City (Missouri, USA) — Lives in Mouans-Sartoux (France) Photojournalist. International recognition for his war reportages (Korea) as well as a long-term portrait of his friend Pablo Picasso. Studies archaeology at the University of Arizona, Tucson (1935), as well as ocean fauna at the University of Miami (1935–1938). B.A. 1938. Self-taught photographer. 1940–1941 participates in an archaeological expedition in Chile. Photographs for the American Museum of Natural History. 1943–1946 serves in the United States Marine Corps. War reporter in the South Pacific. 1946–1956 as *Life* staff photographer in Palestine, Greece, Indochina. 1951 book *This Is War!* a result of his observations of Korean War. From 1966 works freelance for *Collier's*, *Life*, NBC, and ABC TV. A number of awards, incl. Robert Capa Gold Medal (1968), and Photographer of the Year Award from the American Society of Media Photographers (1968).

EXHIBITIONS (Selected) — **1971** Kansas City (Missouri) (William Rockhill Nelson Gallery) SE // **1972** New York (Whitney Museum) SE // **1977** Kassel (Germany) (documenta 6) GE // **1981** New York (Sidney Janis Gallery) SE // **2000** New York (Mitchell-Innes & Nash) SE // **2001** Cologne (Museum Ludwig/Agfa Foto-Historama) GE // **2003** Mougins (France) (Musée de la Photographie André Villers/**Les Ateliers de Picasso**) GE // **2004** Paris (Galerie Nicole et Léon Herschtritt) GE // **2007** Vienna (WestLicht/**Picasso**) SE // **2011** Cologne (Museum Ludwig) GE

BIBLIOGRAPHY (Selected) — **This is War!** New York/London 1951 // **The Private World of Pablo Picasso**. New York 1958 (**Le Petit Monde de Pablo Picasso.** Paris 1959) // **The Kremlin**. London 1960 // **Picasso's Picassos**. London 1961 // **Yankee Nomad: A Photographic Odyssey.** London 1966 // Robert E. Hood: **12 At War. Great Photographers Under Fire**. New York 1967 📖 // **War Without Heroes**. New York 1970 // **Picasso malt ein Portrait**. Bern 1996 // **D.D. Photographs Picasso**. New York 2000 (cat. Mitchell-Innes & Nash) // **Faceless. The Most Famous Photographer in the World**. New York 2000 // **Ichundichundich. Picasso im Fotoporträt**. Cologne 2011 (cat. Museum Ludwig)

"David Douglas Duncan, who hails from the heartland of America, is the cheerful nomad of photojournalism. For the past thirty years, he has been in global pursuit of pictures, ranging with relentless goodwill from the Americas to Asia and Europe, and back again. [...] He has seen death close up many times, in the Second World War, and in Korea and Palestine; his book *This Is War!* is one of the most intense photographic documents of combat ever produced. An 'old-fashioned' rugged individualist, he is a one-man corporation who produces his handsome, expensive books — *The Private World of Pablo Picasso*, *The Kremlin*, *Picasso's Picassos*, *Yankee Nomad* — from idea to printed page and then sells the distribution rights. This 'corporate individualism' requires steely determination and the ability to work like a Missouri mule, the two prime characteristics of this Midwestern vagabond." — Robert E. Hood ✍️

Harold E. *(ugene)* Edgerton

Stopping Time. Die Fotografie von Harold Edgerton. Schaffhausen (Edition Stemmle) 1988

6.4.1903 Fremont (Nebraska, USA) — 4.1.1990 Cambridge (Massachusetts, USA) Principally an electrical engineer with a special interest in photography. Important as the inventor of high-speed or stroboscope flash as well as the author of an oeuvre interested in rapid movement in the tradition of Muybridge and Marey. First of three children. 1915–1921 attends junior high and high school in Aurora, Nebraska. First photographs with the help of his uncle. Gets his first darkroom. 1921–1925 studies at University of Nebraska in Lincoln. B.A. in electrical engineering. 1926 studies at MIT (Massachusetts Institute of Technology). First uses a stroboscope to visualize turning rotor blades. 1927 M.Sc. in electrical engineering. Until retirement (1968) member of MIT faculty, first as research assistant, from 1928 as teacher, assistant professor (1932), associate professor (1938), full professor (1948), institute professor (1966), and finally institute professor emeritus (1968). From 1931 perfection of stroboscope both in ultra-high-speed and in stop-motion photography. From 1932 high-speed photographs of processes too fast for human sight. 1933 first exhibition of his work in London. First publications in specialist and popular journals. 1937 begins working with > Mili, for whom he developed his own flash. First multi-flash photos of athletes in motion. 1940 in Hollywood, high-speed photography for films. 1944 technical consultant for the US Air Force in Italy, England, and France. Air reconnaissance using a stroboscope. 1947 first of numerous publications in *National Geographic*. 1952 documents nuclear tests on the Eniwetok atoll in the Pacific. From 1953 works on underwater photography, incl. with Jacques-Eve Cousteau. In this context also experiments with sonar. 1976 with echo sounder and

EXHIBITIONS (Selected) — **1933** London (Annual Exhibition of the Royal Photographic Society of Great Britain – 1934) GE // **1937** New York (Museum of Modern Art) GE // **1949** New York (Museum of Modern Art/**The Exact Instant**) SE // **1965** Boston (Museum of Science – 1974) SE // **1967** New York (Museum of Modern Art/**Once Invisible**) GE // **1975** Washington, DC (National Academy of Sciences) SE // Boston (Massachusetts College of Art) SE // **1977** Tucson (Arizona) (Center for Creative Photography) SE // **1978** Stockholm (Fotografiska Museet) SE // **1986** Lawrence (Kansas) (Spencer Museum of Art) SE // **1987** New York (International Center of Photography) SE // **2001** Toronto (Canada) (Corkin Gallery – 2008) SE // **2003** Seattle (Washington) (Photographic Center Northwest) SE // **2005** Cambridge (Massachusetts) (Massachusetts Institute of Technology) SE // Oklahoma City (Oklahoma) (International Photography Hall of Fame and Museum) SE // Amherst (Massachusetts) (Mead Art Museum/Amherst College) SE // Pittsburgh (Pennsylvania) (Silver Eye Center for Photography) SE // **2006** Boston (Gallery Kayafas) SE // **2007** London (Michael Hoppen Gallery) SE // **2010** Madrid (Fundación BBVA) SE

BIBLIOGRAPHY (Selected) — **Flash! Seeing the Unseen by Ultra-High-Speed Photography.** Boston 1939 // **Electronic Flash, Strobe.** New York 1970 // **Moments of Vision: The Stroboscopic Revolution in Photography.** Cambridge 1979 // **Sonar Images.** Englewood Cliffs 1986 // **Stopping Time.** New York 1987 (Schaffhausen 1988) ✒ // **Anatomía de Momento/The Anatomy of Movement.** Madrid 2010 (cat. Fundación BBVA)

underwater camera, searches for the Loch Ness Monster. Use of Edgerton Benthos underwater camera to locate the *Titanic*. Numerous honors and awards, incl. Kulturpreis from the DGPh (Deutsche Gesellschaft für Photographie: German Photographic Association) (1981), the New England Inventor of the Year (1982), Eastman Kodak Gold Medal (1983), admission to the National Inventors Hall of Fame (1986), Lifetime Achievement Award from the International Center of Photography (1987).

"An apple split by a bullet, a crown formed by a drop of milk, a football kick, a crystallized column of tap water and multi-flash shots of tennis players, golfers, fencers and divers, all captured in action, call to mind depictions of movement in futurist paintings. These remarkable Edgerton pictures made in the first decade – the 1930s- of the strobe flash reflect a cerebral, masterly scientific realism. Often published in *Life*, in major histories of photography, in scientific textbooks, in ads and in posters, they have become part of the history of our day."
— Estelle Jussim

William Eggleston

William Eggleston:
William Eggleston's Guide.
New York (MoMA) 1976

27.7.1939 Memphis (Tennessee, USA) — Lives in Memphis Pioneer of a postmodern color aesthetic. Since the 1970s intensive artistic exploration of everyday and popular culture, especially in the USA. Studies at Vanderbilt University, Nashville (Tennessee), at Delta State College, Cleveland (Mississippi), and the University of Mississippi, Oxford. 1957 first camera. 1958 first Leica. 1959 encounters the works of Cartier-Bresson (*The Decisive Moment*) and > Evans (*American Photographs*), which provide most important orientation at this time. 1965 begins to explore color film, at first reversal and from 1957 color negative. In the same year meets > Winogrand, > Friedlander, and > Arbus as well as the Director of the Museum of Modern Art at the time, John Szarkowski. There much admired and controversial solo exhibition (*Photographs by W.E.*), which can justifiably be seen as his breakthrough as well as pioneering for new color aesthetics. Numerous awards and fellowships, incl. Guggenheim Fellowship (1974), NEA (National Endowment for the Arts) Fellowship (1976), Hasselblad Award (1998). 1983 contract photography of Elvis Presley's mansion (*Graceland*), among his best-known works still today. Since the 1980s a number of travels, incl. in Africa, Europe (Berlin, Salzburg, Graz), the Near East, and Asia. A good dozen portfolios and books with glued-in prints (mostly in dye transfer process). Numerous exhibitions. A number of monographs, whose influence on a new generation of artistically intentioned color photographers cannot be overestimated (> Parr, Manfred Willmann). End of 2008, with the title *Democratic Camera, Photographs and Video 1958–2008*, major retrospective in New York with further stops in Munich, Washington, DC, Chicago and Los Angeles. 2013 Sony World Photography Award.

EXHIBITIONS (Selected) — **1974** Washington, DC (Jefferson Place Gallery) SE // **1976** New York (Museum of Modern Art) SE // **1979** Berlin (VHS – 1983) SE // **1983** Graz (Forum Stadtpark) SE // **1985** London (Victoria and Albert Museum) SE // **1992** London (Barbican Art Gallery) SE // **1999** Gothenburg (Sweden) (Hasselblad Center) SE // **2001** Paris (Fondation Cartier pour l'art contemporain) SE // **2003** Cologne (Museum Ludwig) SE // **2004** Oslo (Museum of Contemporary Art) SE // Humlebæk (Denmark) (Louisiana Museum of Contemporary Art) SE // **2005** Vienna (Albertina) SE // **2006** Berlin (Camera Work) SE // **2007** Munich (Pinakothek der Moderne) SE // **2008** New York (Whitney Museum of American Art) SE // **2009** Munich (Haus der Kunst) SE // Washington, DC (Corcoran Gal-lery of Art) SE // **2010** Chicago (Art Institute) SE // Los Angeles (Los Angeles County Museum of Art) SE

BIBLIOGRAPHY (Selected) — **W.E.'s Guide.** New York 1976 (cat. Museum of Modern Art) // **The Democratic Forest.** London 1989 // **Faulkner's Mississippi.** Alabama 1990 // **Ancient and Modern.** New York 1992 // **Horses and Dogs.** Washington, DC/London 1994 // **The Hasselblad Award 1998: W.E.** Zurich 1999 ⊿ // **2 1/4.** Santa Fe 1999 // **W.E.** Arles 2001 (cat. Fondation Cartier, Paris) // **Los Alamos.** Zurich 2003 // Gilles Mora: **The Last Photographic Heroes: American Photographers of the Sixties and Seventies.** New York 2007 // **Democratic Camera, Photographs and Video, 1961–2008.** New York 2008 (cat. Whitney Museum of American Art)

"William Eggleston has been one of the most important pioneers of color photography since the 1970s. His personal approach towards the everyday and the banal, combined with his break from formal photographic conventions, resulted in the deceptively 'accidental' quality of his picture making. Eggleston introduced a new aesthetic, a new 'democratic' way of seeing through which the ordinary and banal became extraordinary and engrossing. Like Robert Frank in the Fifties, William Eggleston radically re-invented the photography of the real world."

— Gunilla Knape ✎

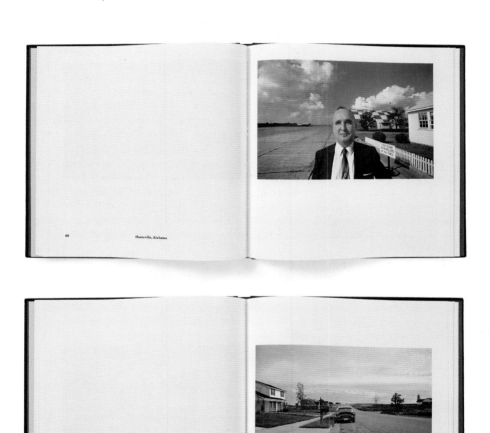

68 Huntsville, Alabama

74 Southern environs of Memphis

Alfred Eisenstaedt

Alfred Eisenstaedt: **The Eye of Eisenstaedt.** New York (The Viking Press) 1969

6.12.1898 Dirschau (West Prussia, today Tczew, Poland) — 23.8.1995 Long Island (New York, USA) Pioneer of modern photojournalism. Beginnings in interwar Germany. Later works for *Life* for over three decades. One of the 20th century's most productive documentary photographers. 1906 moves with family to Berlin. Secondary school and school-leaving exam. First camera at 14. 1916–1918 military service. Subsequently to 1925 in haberdashery trade. Death of father; rampant inflation. Thereafter takes up photojournalism. First publication 1927 in *Der Weltspiegel*. 1928 freelance collaborator with Associated Press. 1930–1934 reportages of political circles (conferences in Geneva, The Hague, Lausanne, the first Hitler-Mussolini meeting) or cultural events (Nobel Prize for Thomas Mann). 1931 first Leica. 1935 in Ethiopia for the first time. In the same year emigrates to the USA. 1936–1972 works exclusively for the recently founded *Life*. Photo reports on politics (Churchill, Kennedy, Khrushchev, McCarthy, Nixon, Haile Selassie), science (Einstein, Oppenheimer) and culture (> Bourke-White, Vladimir Horowitz, the Bolshoi Ballet). 1954 first solo exhibition (in George Eastman House, Rochester). 1958 voted one of the "ten best photographers in the world" by *Popular Photography*. 1962 Kulturpreis from the DGPh (Deutsche Gesellschaft für Photographie: German Photographic Association). From 1997 Alfred Eisenstaedt Award of Magazine Photography sponsored by *Life*.

"After arriving in the USA in 1935, he was one of four staff photographers for *Life*, just being set up at that time and a year later in full operation. In the following years he photographed almost 100 covers and more than 2,000 reportages for the magazine. […] Portraying the big names from politics, economics and culture was his specialty. In doing so, he opened himself completely to their character. […] Thus in more than 50 years on the job, he produced an exceptional 'Who's Who': a history of the world in portraits." — Enno Kaufhold ✐

EXHIBITIONS (Selected) — **1954** Rochester (New York) (International Museum of Photography) SE // **1966** New York (Time-Life Building) SE // **1976** New York (Knoedler Gallery) SE // **1980** Washington, DC (Smithsonian Institution) SE // **1981** New York (International Center of Photography) SE // **1997** Bonn (Rheinisches Landesmuseum) GE // **2001** Berlin (Altes Postfuhramt) SE // New York (Howard Greenberg Gallery) SE // Cologne (Museum Ludwig/Agfa Foto-Historama) GE // **2007** London (Michael Hoppen Gallery) SE // **2008** Munich (Galerie Stephen Hoffman) SE // **2009** Hamburg (Flo Peters Gallery) GE

BIBLIOGRAPHY (Selected) — **Witness to Our Time**. New York 1966 // **The Eye of E.** New York 1969 // **Witness to Nature**. New York 1971 // **E.: People**. New York 1973 // **E.'s Album**. New York 1976 // **E.'s Guide to Photography**. New York 1978 // **E.: Germany**. Washington, DC, 1981 // **E. on E.** New York 1985 // Enno Kaufhold: "Zum Tod von Alfred Eisenstaedt." In: **Photonews**, no. 10, 1995 ✐ // Klaus Honnef and Frank Weyers: **Und sie haben Deutschland verlassen … müssen**. Bonn 1997 (cat. Rheinisches Landesmuseum) // Bodo von Dewitz and Robert Lebeck: **Kiosk. Eine Geschichte der Fotoreportage/A History of Photojournalism**. Göttingen 2001 (cat. Museum Ludwig/Agfa Foto-Historama, Cologne)

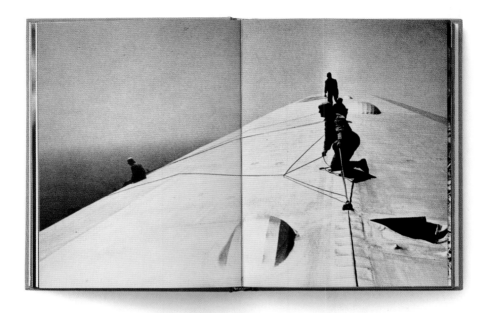

A SENSE OF TIMING

A photographer needs a short-circuit between his brain and his fingertips. Things happen: sometimes expected, more often unexpected. You must be ready to catch the right split second, because if you miss, the picture may be gone forever.

Fast reflexes are partly inborn, but they can be developed through practice and experience. You must know your equipment thoroughly, of course. You must be able to operate your camera quickly, automatically, without stopping to think. Life moves swiftly and unexpectedly; it won't wait for you to fumble with your focusing control or film advance.

On these pages are reproduced a number of my pictures where split-second timing was important. With some I've also included a few frames from the contact sheet, so you can see the near misses as well as the hits.

There's another element involved here, too, which I've already mentioned—luck. Often I think I've had more luck than brains as a photographer. The photograph on the facing page certainly is a good example of luck, as well as timing. I was walking through the crowds on V-J Day, looking for pictures. I noticed a sailor coming my way. He was grabbing every female he could find and kissing them all—young girls and old ladies alike. Then I noticed the nurse, standing in that enormous crowd. I focused on her, and just as I'd hoped, the sailor came along, grabbed the nurse, and bent down to kiss her. Now if this girl hadn't been a nurse, if she'd been dressed in dark clothes, I wouldn't have had a picture. The contrast between her white dress and the sailor's dark uniform gives the photograph its extra impact. Luck. But you do have to keep your eyes open, too!

56

Arthur Elgort

1940 New York (USA) — Lives in New York Fashion and beauty the focus of an oeuvre already in museums from the mid 1980s. Numerous editorials for Condé Nast International. Also works as a director. Childhood and youth in New York. Studies at Hunter College (The City University of New York). Takes up photography. From 1960 works as professional photographer with focus on fashion, beauty, and portraits. Numerous publications in *Vogue* and other Condé Nast magazines. Participates in important overview exhibitions on fashion photography in the 1980s and 90s.

Arthur Elgort's Models Manual.
New York (Grand Street Press)
1993

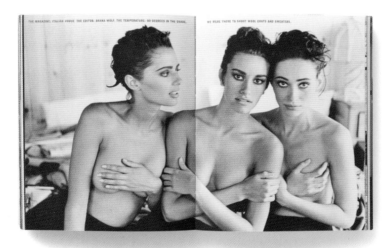

EXHIBITIONS (Selected) — **1985** London (Victoria and Albert Museum/**Photographing Women**) GE // **1992** New York (Fashion Institute of Technology/**Picture of Peace**) GE // **1993** New York (Staley/Wise Gallery – 1994) SE // **1996** Milan (Galleria Carla Sozzani) GE // **1997** Los Angeles (Fahey/Klein) GE // **2002** Tokyo (Gallery Tokyo) GE // **2003** London (Omega Watches) GE // **2004** Hamburg (Monika Mohr Galerie – 2008) Watches) GE // **2004** Hamburg (Monika Mohr Galerie – 2008) SE/GE // Amsterdam (Galerie Wouter van Leeuwen – 2005, 2006) SE/GE // **2005** Moscow (Moscow House of Photography) GE // New York (Steven Kasher Gallery) GE // **2006** Berlin (Berlinische Galerie/**Der Pirelli-Kalender**) GE // **2008** Berlin (Camera Work/**Fashion – 9 decades of fashion photography**) GE // Hamburg (Haus der Photographie/Deichtorhallen) GE

BIBLIOGRAPHY (Selected) — **Personal Fashion Pictures.** [Self-published] 1983 // **Swan Prince: Featuring Mikhail Baryshnikov.** New York 1987 // **A.E.'s Models Manual.** New York 1994 // **Camera Ready: How to Shoot Your Kids.** Milan 1997 // **Azzedine Alaia.** Göttingen 1998 // **Camera Crazy.** Göttingen 2004 // Nadine Barth (ed.): **Traumfrauen. Starfotografen zeigen ihre Vision von Schönheit.** Cologne 2008 (cat. Haus der Photographie/Deichtorhallen Hamburg) ✍

"My favorite photos are usually those taken with what I call a 'constant camera'. That means that I'm paying close attention the whole time and am always ready to capture a certain moment — between two shots on the job or when I'm walking down the street. [...] Sometimes the image that results is better than the 'shot' and really captures the aura of a certain model."
— Arthur Elgort ✐

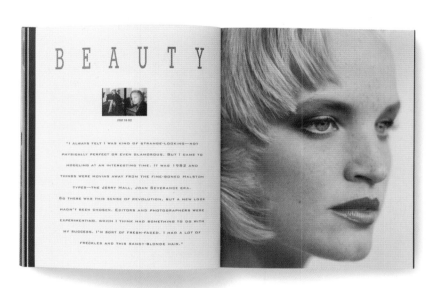

BEAUTY

"I ALWAYS FELT I WAS KIND OF STRANGE-LOOKING—NOT PHYSICALLY PERFECT OR EVEN GLAMOROUS. BUT I CAME TO MODELING AT AN INTERESTING TIME. IT WAS 1982 AND THINGS WERE MOVING AWAY FROM THE FINE-BONED HALSTON TYPES—THE JERRY HALL, JOAN SEVERANCE ERA. SO THERE WAS THIS SENSE OF REVOLUTION, BUT A NEW LOOK HADN'T BEEN CHOSEN. EDITORS AND PHOTOGRAPHERS WERE EXPERIMENTING, WHICH I THINK HAD SOMETHING TO DO WITH MY SUCCESS. I'M SORT OF FRESH-FACED. I HAD A LOT OF FRECKLES AND THIS SANDY-BLONDE HAIR."

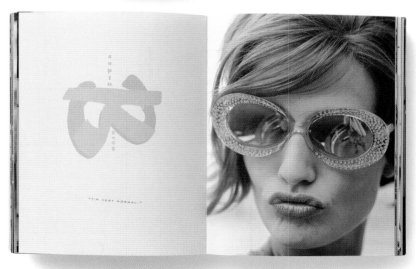

"I'M VERY NORMAL."

Ed*(ward)* van der Elsken

Ed van der Elsken: **Liebe in Saint Germain des Prés.**
Hamburg (Rowohlt Verlag) 1956

10.3.1925 Amsterdam (Netherlands) — 28.12.1990 Edam (Netherlands) Reportages and photo essays influenced by 1950s Existentialism. Best-known Dutch post-war art photographer. Interested in art and photography early on. Studies sculpting in Amsterdam (does not finish). 1944 flees to liberated Holland (to avoid forced labor in Germany). There works as translator and mine clearer. In this period discovers the magazine *Picture Post*, which leaves a lasting impression. After 1945 takes up photography definitively. Freelance photographer, at first in Amsterdam, from 1950 in Paris. 1954 returns to Amsterdam. 1956 publishes first book (*Liebe in Saint Germain des Prés*), which attracts international attention. Participates in pioneering, though contrasting, exhibitions *subjektive fotografie 2* (1954) and *The Family of Man* (1955). Travels the world 1959–1960. Subsequently a number of films and another much admired book *Sweet Life* (1966). From 1969 to his death, independent filmmaker and photographer in Edam. 1971 Dutch State Prize for Film. As photographer exponent of a socially committed photography (mostly in b/w) whose aesthetic premise (small format, available light, hard prints) is clearly steeped in the spirit of the 1950s. *Bye* (1989–1990), a film on the cancer that would kill him, is the last work of this internationally recognized artist. Estate held by the Netherlands Photo Archives Foundation (nfa), Rotterdam.

EXHIBITIONS (Selected) — **1960** Amsterdam (Stedelijk Museum – 1966, 1977, 1983, 1988, 1991, 1999) SE // **1986** Paris (Institut néerlandais – 1996) SE // **1993** New York (Howard Greenberg Gallery – 1998) SE // **1994** Winterthur (Switzerland) (Fotomuseum) SE // **1996** Rotterdam (Kunsthal) SE // **1998** New York (Gallery 292) SE // **2000** Wolfsburg (Germany) (Kunstmuseum) SE // **2001** Berlin (Kicken Berlin) SE // **2003** The Hague (Fotomuseum) GE // **2005** Paris (Galerie Agathe Gaillard) SE // Amsterdam (Fotografiemuseum Amsterdam) SE // **2006** Antwerp (Museum voor Fotografie) SE // **2007** Rotterdam (Nederlands Fotomuseum/**Dutch Eyes**) GE // **2008** Munich (Galerie f5,6) SE // **2012** Rotterdam (Nederlands Fotomuseum) GE

BIBLIOGRAPHY (Selected) — **Een liefdesgeschiedenis in Saint-Germain-des-Prés.** Amsterdam 1956 (facsimile reprint: Cologne 1999) // **Bagara**. Amsterdam 1958 // **Jazz**. Amsterdam, 1959 (facsimile reprint: Göttingen 2007) // **Sweet Life.** Amsterdam 1966 // **Eye love you.** Amsterdam 1977 // **Parijs! Foto's 1950–1954.** Amsterdam 1981 // **Once upon a time.** Amsterdam 1992 // **L'Amour**. Amsterdam 1995 // Thomas Honickel: "Ed van der Elsken – der Bohémien der Fotografie." In: **Photonews**, no. 12/1, 1999/2000 ✐ // **E v.d.E.: Fotografie + Film 1949–1990.** Wolfsburg 2000 (cat. Kunstmuseum) // Wim van Sinderen: **Fotografen in Nederland. Een Anthologie 1852–2002.** The Hague 2002 (cat. Fotomuseum Den Haag) // **Dutch Eyes: A Critical History of Photography in the Netherlands.** Zwolle 2007 (cat. Nederlands Fotomuseum, Rotterdam) // **The Dutch Photobook**. Rotterdam 2012 (cat. Nederlands Fotomuseum) GE

"Suddenly his work is 'in' again. People remember him, his photos that were raw and direct, sometimes lurid, vulgar, even obscene, and sometimes even hopelessly romantic: photos full of emotion and drama, full of a lust for life and the pleasure of the moment. In the 1950s, 60s and 70s, van der Elsken was seen as one of the great street and reportage photographers. You could call him a chronicler of the youth culture of the day, a zeitgeist photographer before and after Woodstock: a bohemian of photography." — Thomas Honickel ✎

Hugo Erfurth

Otto Steinert (ed.): **Hugo Erfurth: Bildnisse.** Gütersloh (Sigbert Mohn Verlag) 1961

14.10.1874 Halle, Saale (Germany) — 14.2.1948 Gaienhofen (Germany) Theater, expressive dance, portraits. Photographer "between tradition and modernism". Leading portrait interpreter in the period after 1900. Creator of an (informal) pantheon of some 500 names from art, culture, science, and politics. Secondary school, trade school in Dresden. Already in 1893 three photos at the first *Internationale Ausstellung von Amateur-Photographien* (International Exhibition of Amateur Photography) in the Kunsthalle Hamburg, the beginning of (life-long) frequent involvement in exhibitions. 1894–1895 apprentice under W. Höffert, Dresden. 1896 takes over the studio of the Dresden court photographer J.S. Schröder. 1906 buys the Palais Lüttichau. There he sets up a prestigious photo studio. Pioneer of dance photography (Isadora Duncan, Greta Wiesenthal, Mary Wigman, Clotilde von Derp-Sakharoff) from 1908. 1913–1919 theater photography. 1908 member of the Deutsche Werkbund (the first photographer). 1919 founding member of the GDL (Gesellschaft Deutscher Lichtbildner: German Photographic Academy). From 1920 close contacts with Paul Klee, Oskar Kokoschka, Ernst Haeckl, and especially Otto Dix. Numerous portraits of local as well as international artists, incl. Archipenko, Beckmann, Chagall, Corinth, Gropius, Kokoschka, Liebermann, > Moholy-Nagy, Pechstein, Schlemmer, Schwitters, van de Velde. 1922 opens a "Graphics Cabinet" with exhibitions of contemporary drawings and lithography. 1934 moves to Cologne. Opens a studio in a house, near the cathedral, built by Paul Bonatz. 1943 studio destroyed in bombing raid. Moves to Gaienhofen (Lake Constance). Opens a new studio. His works are in collections in Bonn (Rheinisches Landesmuseum), Essen (Museum Folkwang), Cologne (Museum Ludwig/Sammlung Agfa), and Munich (Fotomuseum), among others. 1989 first international Hugo Erfurth award.

EXHIBITIONS (Selected) — **1893** Hamburg (Kunsthalle) GE // **1909** Dresden (**Internationale Photographie-Ausstellung**) GE // **1925** Berlin (Kipho) GE // **1928** Jena (Germany) (**Neue Wege der Photographie**) GE // **1929** Stuttgart (**Film und Foto**) GE // **1930** Munich (**Das Lichtbild**) GE // **1933** Berlin (**Die Kamera**) GE // **1937** Berlin (**Gebt mir vier Jahre Zeit!**) GE // **1947** Konstanz (Germany) (Wessenberghaus) SE // **1951** Cologne (photokina – 1952, 1958, 1960, 1963, 1976, 1978) GE/SE // **1961** Essen (Germany) (Museum Folkwang) SE // **1976** Munich (Stadtmuseum) SE // **1977** Kassel (Germany) (documenta 6) GE // **1992** Cologne (Museum für Angewandte Kunst) SE // **2000** Dresden (Technische Sammlungen) SE // **2002** Berlin (Kicken Berlin) SE // **2003** London (Tate Modern) SE // **2005** Berlin (Kunstbibliothek) GE // **2007** Leipzig (Kamera- und Fotomuseum) SE // **2009** Essen (Germany) (Villa Hügel) JE (with Heinrich Kühn)

BIBLIOGRAPHY (Selected) — Otto Steinert (ed.): **H.E.: Bildnisse.** Gütersloh 1961 📖 // Bernd Lohse: **H.E.: Der Fotograf der Goldenen 20er Jahre.** Seebruck am Chiemsee 1977 // Bodo von Dewitz (ed.): **H.E.: Menschenbild und Prominentenporträt 1902–1936.** Cologne 1989 // **H.E.: Photograph zwischen Tradition und Moderne.** Cologne 1992 (cat. Agfa Foto-Historama) // Christine Kühn: **Neues Sehen in Berlin. Fotografie der Zwanziger Jahre.** Berlin 2005 (cat. Kunstbibliothek)

"Erfurth cannot be counted among the experimenters and revolutionaries of modern photography. He seems instead to be the epitome of older portrait photography – with sophisticated psychological tact. In a time when the avant-garde preferred to turn away from portraits, Erfurth fulfilled his profession as the creator of many timeless portraits of important, but also unknown contemporaries." — J.A. Schmoll gen. Eisenwerth ✍

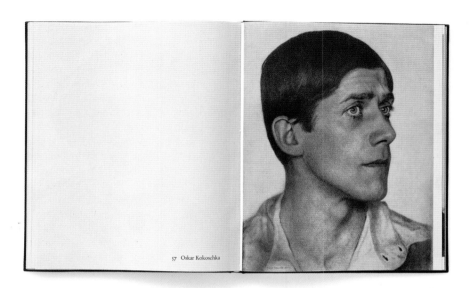

57 Oskar Kokoschka

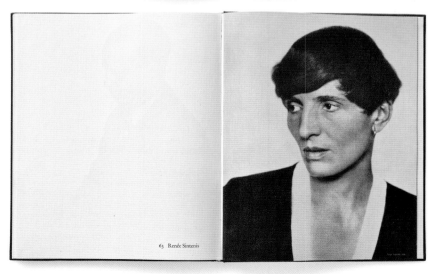

63 Renée Sintenis

Elliott Erwitt *(Elio Romano Erwitz)*

Elliott Erwitt: **Son of Bitch.**
New York (Grossman Publishers)
1974

26.7.1928 Paris (France) — Lives in New York (USA) Photo essays, reportages, documentary films, TV advertising. Magnum photographer. Known especially for his tragi-comic, human and all-too-human photos of dogs. Child of Russian immigrants. Schooling in Milan (1935–1938). 1938–1939 in Paris. 1939 moves to the USA. 1945–1947 studies at Los Angeles City College and (1948–1950) the New School for Social Research (film). 1950 assistant in the New York photographer Valentino Sarra's studio. 1950–1952 works under Roy Stryker for Standard Oil Company, New Jersey. To 1953 serves in the US Army Signal Corps in Germany and France. Since then freelance photographer in New York. Photographs for *Collier's*, *Look*, *Life*, *Holiday*. 1953 associate member of Magnum, full member from 1954. 1966–1969 president of the agency. 1955 participates in *The Family of Man* exhibition. 1959 international attention for his photos of Nixon and Khrushchev debating during a Moscow industrial fair (*The Kitchen Debates*). Also advertising for Air France, KLM, Chase Manhattan Bank. Since the 1970s especially advertising spots as well as features and documentary films, incl. *Beauty Knows no Pain* (1971), *Red, White and Bluegrass* (1973), *Glassmakers of Herat, Afghanistan* (1977).

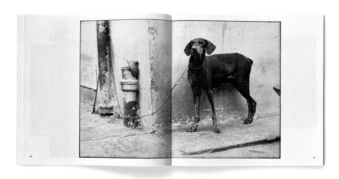

BIBLIOGRAPHY (Selected) — **Son of Bitch**. New York 1974 // **Recent Developments**. New York 1978 // **Personal Exposures**. New York 1988 // **Mois de la Photo**. Paris 1988 (cat. Mois de la Photo) ✍ // **On the Beach**. New York 1991 // **To The Dogs**. New York 1992 // **Between the Sexes**. New York 1994 // **E.E.** Paris 1995 // **Snaps**. London 2001 // **E.E.'s Handbook**. New York 2003 // **Personal Best**. Kempen 2006 // **New York**. Kempen 2008 // **Paris**. Kempen 2010

"Elliott Erwitt is like a storyteller of small, apparently unimportant stories with sudden flashes of spontaneous comedy, to be read like a short and succinct aphorism."
— Robert Delpire

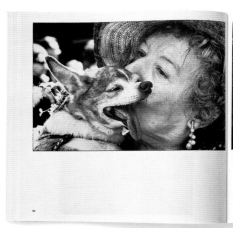

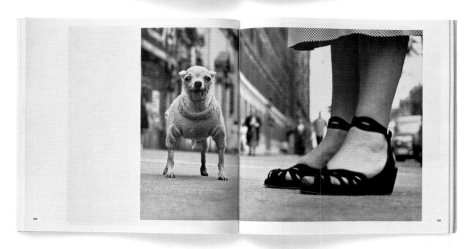

Walker Evans

3.11.1903 St Louis (Missouri, USA) — 10.4.1975 New Haven (Connecticut, USA) Writer, painter, photographer. Photo chronicler of American everyday culture after 1930. Pioneer of a straight documentary style that aestheticized the "banal". According to Susan Sontag, the most important American art photographer after Strand. Youth in Toledo (Ohio), Chicago, and New York. Studies literature at Williams College. Various casual jobs in New York. 1926 moves to Paris with aim to become a writer. Contact with circle around Sylvia Beach (incl. James Joyce). 1927 returns to New York. To 1929 works for a firm of stockbrokers. Friendship with Lincoln Kirstein. First photos with a small roll-film camera. Three photos in a volume of poetry *The Bridge* his first publication. Discovers the oeuvre of > Atget. 1931 series on Victorian villas in the south. 1933 in Havana: photos for the book *The Crime of Cuba*. For the Museum of Modern Art, photo documentation of the exhibition *African Negro Art*. 1935–1937 works as photographer for the Resettlement Administration (RA) and Farm Security Administration (FSA). 1936 reportage on small farmers in Alabama with the writer James Agee for *Fortune* (1941 as book *Let Us Now Praise Famous Men*). 1938: *American Photographs* Museum of Modern Art's first monographed exhibition. First photographs in the subway. 1945–1965 photo editor, photographer for *Fortune*. American industrial landscapes (around 1950). 1965–1974 professor at Yale School of Art and Architecture. Exhibition in the Museum of Modern Art (1971, curated by John Szarkowski) his last big show during his lifetime. 2000 major retrospective in Metropolitan Museum with complementary exhibition project in Museum of Modern Art: *Walker Evans & Company*.

BIBLIOGRAPHY (Selected) — Hart Crane and W.E.: **The Bridge**. Paris/New York 1930 // Carleton Beals and W.E.: **The Crime of Cuba**. Philadelphia 1933 // **African Negro Art**. New York 1935 (Portfolio Museum of Modern Art) // **American Photographs**. New York 1938 (cat. Museum of Modern Art) // James Agee and W.E.: **Let Us Now Praise Famous Men**. Boston 1941 // **Many Are Called**. Boston 1966 // John Szarkowski: **W.E.** New York 1971 (cat. Museum of Modern Art) // Jerald C. Maddox: **W.E.: Photographs from the Farm Security Administration 1935–1938**. New York, 1973 // Lesley K. Baier: **W.E. at Fortune**. Wellesley 1978 (cat. Wellesley College Museum) // Tod Papageorge: **W.E. and Robert Frank: An Essay on Influence**. New Haven 1981 // Jerry Thompson and John T. Hill: **W.E. at Work**. New York 1982 // Michael Brix and Birgit Mayer: **W.E. America. Bilder aus den Jahren der Depression**. Munich 1990 (cat. Städt. Galerie im Lenbachhaus) // Gilles Mora and John T. Hill: **The Hungry Eye**. New York 1993 // Belinda Rathbone: **W.E.: A Biography**. New York 1995 // James R. Mellow: **W.E.** New York 1999 // **W.E.** New York 2000 (cat. Metropolitan Museum) ✍ // **The Lost Work**. Zurich 2000 // **Manuel Alvarez Bravo, Henri Cartier-Bresson, W.E.: Documentary and Anti-Graphic Photographs**. Göttingen 2004 (cat. Fondation Henri Cartier-Bresson) // **W.E.: Lyric Documentary.** Göttingen 2006 (cat. Convento di San Michele, Cagliari) // **American Photographs** (Facsimile Reprint). New York 2012 // David Campany: **W.E. The Magazine Work**. Göttingen 2014

"Walker Evans [...] is among the most influential artists of the twentieth century. His elegant crystal-clear photographs and articulate publications inspired artists of several generations, including Helen Levitt, Robert Frank, Diane Arbus, Lee Friedlander, and Bernd and Hilla Becher. The progenitor of the documentary tradition in American photography, Evans had the extraordinary ability to see the present as if it were already the past and to translate that knowledge and historically inflect vision into enduring art. His principal subject was the vernacular — the ingenious expression of people found in roadside stands, cheap cafés, advertisements, simple bedrooms, and small town streets. For fifty years, from the late 1920s to the early 1970s, Evans recorded the American scene with the nuance of a poet and the precision of a surgeon, creating an encyclopaedic visual catalogue of modern America in the making."

— Philippe De Montebello and Maria Morris Hambourg ✍🏻

Walker Evans: **Chicago,** from:
Fortune, no. 2, February 1947

Louis Faurer *(Louis Fourer)*

28.8.1916 Philadelphia (Pennsylvania, USA) — 2.3.2001 New York (USA) Fashion photography and (independent) street photography. Works in color and b/w, influenced by Brodovitch and Frank. Still today underestimated representative of the so-called "New York School". Child of Polish immigrants. 1934 graduates from South Philadelphia High School. First professional goal: drawing for Disney Studios. 1937–1940 studies at the School of Commercial Art and Lettering in Philadelphia. At the same time first photography. Wins "Photo of the Week" competition in the local *Philadelphia Evening Public Ledger*. Intensifies interest in photography. Influenced by photos of the Farm Security Administration (FSA) and the works of > Evans. During the war serves with the US Signal Corps in Philadelphia. 1947 moves to New York. Meets > Frank and > Evans. Assistant to > Brodovitch and > Bassman at *Junior Bazaar*. There 1948 (January) first fashion photos. After the magazine closes, freelance work for *Harper's Bazaar*, *Life*, and *Vogue*, as well as *Charm*, *Glamour*, *Look*, *Seventeen*, *Mademoiselle*. 1950 contract photography for the short-lived magazine *Flair*. Participates in major group exhibitions such as *In and Out of Focus* (1948), *The Family of Man* (1955), *The New York School* (1985), *On the Art of Fixing a Shadow* (1989), and *Appearances* (1991), perhaps the most important reference to his oeuvre (catalogue title). End of 1968 in London. 1969–1974 in Paris. End of the 1970s, at the urging of > Eggleston and Walter Hopps, rediscovery of his early work. 1978 NEA Award, 1979 and 1980 Guggenheim Fellowship. Also works as teacher, incl. at Yale University (New Haven, 1983 and 1985), the University of Virginia (Charlottesville, 1983–1984) and the School of Visual Arts (1985–1986). Last years of his life in New York. 2002 (posthumous) major retrospective with stops in Houston, Andover, San Diego, Chicago, and Philadelphia.

"**Many people still consider Louis Faurer to be a fashion photographer. He is certainly the author of some of the most tender and most sensitive studies of the genre, made outside traditional styles, at first in New York and later in Paris. But he also had another career. In the last few years a vast public has been able to discover that he was also the author of another quite remarkable oeuvre: photographs of 'the street', mostly unpublished, true urban elegies, their subtle and intuitive character placing him, unfortunately a little late, among the best of post-war photographers.**" — Martin Harrison ✎

EXHIBITIONS (Selected) — **1948** New York (Museum of Modern Art/**In and Out of Focus**) GE // **1955** New York (Museum of Modern Art/**The Family of Man**) GE // **1959** New York (Limelight Gallery) SE // **1977** New York (Marlborough Gallery) SE // **1980** New York (LIGHT Gallery – 1981) SE // **1981** College Park (Maryland) (University of Maryland Art Gallery) SE // **1985** Washington, DC (**The New York School**/Corcoran Gallery of Art) GE // **1990** New York (Howard Greenberg Gallery – 2002) SE // Paris (Bibliothèque nationale) SE // **1991** London (**Appearances**/Victoria and Albert Museum) GE // **1992** Paris (Cnp/Palais de Tokyo) SE // **1995** Berlin (**American Photography** 1890–1965/Kunstbibliothek) GE // **1998** Berlin (Zentrum für Fotografie) SE // **2002** Houston (Texas) (Museum of Fine Arts) SE // Aachen (Suermondt Ludwig Museum) SE // **2005** Paris (Galerie Agathe Gaillard) JE (with Andreas Feininger) // **2009** Hamburg (Flo Peters Gallery) GE

BIBLIOGRAPHY (Selected) — Edith A. Tonelli and John Gossage: **L.F.: Photographs from Philadelphia and New York 1937–1973**. College Park 1981 (cat. University of Maryland Art Gallery) // **L.F.** Paris 1990 (cat. Bibliothèque nationale) // Martin Harrison: **Appearances: Fashion Photography Since 1945**. London 1991 (cat. Victoria and Albert Museum) **L.F.** Paris 1992 (Photo Poche no. 51) ✎ // Jane Livingston: **The New York School**. New York 1992 // Anne Wilkes Tucker: **L.F.** Houston 2002 (cat. Museum of Fine Arts)

Louis Faurer: **The Eight Million,**
from: **Flair,** September 1950

Andreas *(Bernhard Lyonel)* Feininger

Andreas Feininger: **New York.**
Chicago, New York (Ziff Davis
Publishing) 1945

27.12.1906 Paris (France) — 18.2.1999 New York (USA) Bauhaus graduate, photographer, photojournalist, incl. for *Life*. Creator of much admired iconic images. As photo teacher and specialist book author, one of the best-known and most influential proponents of the medium worldwide since the war. Son of the painter Lyonel F., brother of the photographer T. Lux F., all three at the Bauhaus. Childhood and youth in Berlin and Weimar, where his father teaches at the Bauhaus from 1919. There from 1922–1925 attends the carpentry workshop under Walter Gropius. 1925–1928 studies at the Bauhochschule Weimar and the Anhaltischen Bauschule in Zerbst (Germany). First photos. Self-taught. 1929 included in the Stuttgart exhibition *Film und Foto*. Illustrations in *foto-auge* (Franz Roh). Contact with Dephot. First publications in *Vossischen Zeitung* and *Hamburger Illustrierten*. 1932 moves to Paris. 1933 Sweden. Dedicates himself to (architectural) photography. Marries Bauhaus graduate Grete Wysse Hägg. 1939 moves to New York. In the same year publishes his first specialist book in English. 1940 works freelance for the Black Star Agency and *Life*. In addition much read columns in specialist journals. 1962 leaves *Life*. Independent photographer and writer. Over 40 books in the USA. Numerous international editions of his books influential especially on the work of ambitious amateurs. 1972 Robert Leavitt Award from the American Society of Media Photographers. 1987 Lifetime Achievement Award (American Society of Media Photographers). 1998 Kulturpreis from the DGPh (Deutsche Gesellschaft für Photographie: German Photographic Association). *www.andreasfeiningerarchive.com*

"Andreas Feininger united two careers: magazine photographer and teacher. […] This dual activity was reflected not only in the pages of American international illustrated magazines and the teaching columns of *Modern Photography* and *Popular Photography*, but also in numerous books. […] His photographic oeuvre reflects his teaching abilities just as his publications on photo aesthetics and techniques reflect those of an excellent photographer." — L. Fritz Gruber

EXHIBITIONS (Selected) — **1929** Stuttgart (**Film und Foto**) GE // **1955** New York (Museum of Modern Art/**The Family of Man**) GE // **1976** New York (International Center of Photography) SE // **1981** Tucson (Arizona) (Center for Creative Photography) SE // **1990** Berlin (Bauhaus-Archiv) GE // **1997** Bonn (Rheinisches Landesmuseum) GE // **1998** Munich (Die Neue Sammlung) SE // **2000** Essen (Germany) (Museum Folkwang) GE // **2001** Wolfsburg (Germany) (Städtische Galerie) SE // **2002** Bad Arolsen (Germany) (Museum Bad Arolsen) SE // **2004** Stuttgart (Galerie der Stadt Stuttgart) SE // San Diego (California) (Museum of Photographic Arts) SE // **2006** Halle (Germany) (Stiftung Moritzburg) SE // **2008** Bremen (Focke Museum) SE // **2009** Berlin (Bauhaus-Archiv) SE

BIBLIOGRAPHY (Selected) — **New York.** Chicago/New York 1945 // L. Fritz Gruber: **Grosse Photographen unseres Jahrhunderts.** Darmstadt 1964 // **Bauhaus Fotografie.** Düsseldorf 1982 // Jeannine Fiedler (ed.): **Fotografie am Bauhaus.** Berlin 1990 (cat. Bauhaus-Archiv) // **A.F.: Photographer.** New York 1986 (with extensive bibliography of his photobooks and works on photography) // Klaus Honnef and Frank Weyers: **Und sie haben Deutschland verlassen … müssen.** Bonn 1997 (cat. Rheinisches Landesmuseum) // **A.F.: Warum ich fotografiere.** Schaffhausen 1998 (cat. Die Neue Sammlung, Munich) // **Bauhaus: Dessau > Chicago > New York.** Cologne, 2000 (cat. Museum Folkwang, Essen) // **Zwischen Wissenschaft und Kunst. 50 Jahre Deutsche Gesellschaft für Photographie.** Göttingen 2001 // **A.F.** Ostfildern-Ruit 2004 (cat. Galerie der Stadt Stuttgart)

From Chatham Square Elevated Station, the approach to Manhattan Bridge—opened in 1909—swings S-like through the most overcrowded and dilapidated East Side tenements.

38

The misty form of Sixty Wall Tower (Cities Service Building) rises between the Second Avenue El to the left and the fire escapes—typical of a New York street scene—to the right.

39

An excellent spot from which to view New York is the seventieth floor observatory of the RCA Building. From here the city and her boroughs spread their streets and people in panoramic view.

54

City of contrast . . . : tall office buildings with their white-collar workers dominate the foreground, while in the distance East River's bank is lined with dead-end slums and penthouses.

55

Erwin Fieger

Erwin Fieger: **Farbiges London.**
Vienna/Düsseldorf (Econ-Verlag)
1962

10.12.1928 Teplá (Bohemia, today Czech Republic) — 14.4.2013 Stuttgart (Germany) Graphic designer, photographer. As art photographer, a pioneer of color photography in Germany in the 1960s and 70s. Author of a number of international prize-winning books on sport and travel photography. Drafted as air force helper in June 1944. Prisoner of war in Hamburg. After his release, moves to Mittenwald. Active as mountain climber. First attempts at landscape painting, writing, and applied graphics. 1951–1954 studies graphic design at the Staatlichen Akademie der Bildenden Künste (State Academy of Fine Arts) under Professor Eugen Funk in Stuttgart. Takes up photography (exclusively in color) during extensive travels in Europe and the Near East. Five color pages in *Das Deutsche Lichtbild* (1960), his first major photographic publication. In the same year participates as photographer and designer in the *Magie der Farbe* exhibition at photokina. From 1961 publishes numerous much admired photobooks in the context of a new color aesthetic. 1963 guest lecturer for photography at the Hochschule für Gestaltung (University of Art and Design) in Ulm. 1963–1964 photographs for Lufthansa. Curates *Essays in Farbe* exhibition for photokina 1966 (with works by Horst H. Baumann, Peter Cornelius, E.F., Fritz Fenzl, Lajos Keresztes, Horst Munzig, Wim Nordhoek, and Hans W. Sylvester). 1970 as color photographer (with Karlheinz Stockhausen and Heinz Mack) responsible for the design of the cultural section of the German pavilion at the World's Fair in Osaka, Japan. 1972 Olympic photobooks *Sapporo 1972* and *München 1972*. To 1984 photographs all the Winter and Summer Olympics, Ski championships and Football World Cups. A number of conceptually conceived books, which he designed himself, interested in the history and culture of the respective countries as a result of his extensive travels throughout Europe, Asia, Africa, North and South America. 1975–2005 lives in Tuscany. Awards incl. Man Ray Plakette from photokina (1960), gold medal from the photo biennale in Venice (1961), photokina-obelisk (1966), Prix Nadar for his book *13 Photo-Essays* (1969) gold medal from the ADC (Art Directors Club) Germany for *Sapporo 1972* and *München 1972*, Kulturpreis from the DGPh (Deutsche Gesellschaft für Photographie: German Photographic Association) (1974), honorary award from the Deutsche Kulturpreis (1988).

EXHIBITIONS (Selected) — **1960** Cologne (photokina/**Magie der Farbe**) GE // **1961** Stuttgart (Landesgewerbe-Museum/**Essays in Farbe**) SE // **1969** Munich (BMW Galerie Intergraphic) SE // **1981** Cologne Josef-Haubrich-Kunsthalle/**Farbe im Photo**) GE // **1986** Cologne (photokina/**50 Jahre moderne Farbfotografie 1936–1986**) GE // **1988** Cologne (Museum Ludwig/**Zeitprofile**) GE // **1989** Munich (Bayerische Landesbank) SE // Stuttgart (Landesgirokasse) SE // **2004** Berlin (Galerie Fotografie am Schiffbauerdamm) GE

BIBLIOGRAPHY (Selected) — **Magie der Farbenphotographie.** Düsseldorf 1961 // **Farbiges London.** Düsseldorf 1962 (trans. **London: City of Any Dream**. London 1962 // **13 Photo-Essays**. Düsseldorf 1969 // **Japan: Sunrise-Islands**. Düsseldorf 1971 // **Sapporo 1972**. Munich 1972 // **München 1972**. Munich 1972 // **Mexico by E.F.** Düsseldorf 1973 // **Israel by E.F.** Düsseldorf 1975 // **50 Jahre moderne Farbfotografie/50 Years Modern Color Photography 1936–1986.** Cologne 1986 (cat. photokina) // **Zeitprofile. 30 Jahre Kulturpreis Deutsche Gesellschaft für Photographie.** Cologne 1988 (Cat. Museum Ludwig) ✏ // **Ganges by E.F.** Munich 1990 // **Yin and Yang by E.F.** Munich 1994

"In 1973 the photobook entitled *Mexico* by Erwin Fieger appeared. The author's name in the title was also a clear stamp of quality. By this time, Fieger had long since established a reputation among the general public. In the previous Olympic year, he had brought out *Sapporo 1972* and *Munich 1972*. Both books were awarded a gold medal from the Art Directors Club of Germany. In 1971, his most mature work enriched an otherwise rather 'colorful' photobook market: *Japan: Sunrise-Islands*. Its photographic conception was a successful synthesis of content and design, which found its perfect fulfillment in its editorial realization. Fieger always carefully supervised […] the entire course of his projects: from pressing the shutter to the printed book. […] At the end of the 1960s Fieger published a quite remarkable large format photo book *13 Photo-Essays*, the result of various trips to Asia, Africa and America. More impressionistic than figurative, Fieger succeeded in creating a new view of the foreign. The book received the Prix Nadar: the highest international award for this type of book." — Roland Gross ✍

Larry Fink

Larry Fink: **Runway.**
New York (powerHouse Books)
2000

3.11.1941 Brooklyn (New York, USA) — Lives in Martins Creek (Pennsylvania, USA) Prominent exponent of so-called "new social photography". Medium format (6 x 6) and flash as formal aesthetic constants of his beautifully framed research into everyday rites. Stockbridge High School (Massachusetts) 1958–1959 Coe College (Cedar Rapids, Iowa). 1960–1961 New School of Social Research. Private lessons from > Model. Since then he has worked as an independent photographer and influential teacher, incl. at the New School (1968–1972), Yale School of Fine Arts (1977–1978 and 1994), the Cooper Union School of Art (1978–1983), New York University (1987), School of Visual Arts (1995), Bard College (1986 to today). Numerous fellowships and awards, incl. twice the John Simon Guggenheim Fellowship in Photography (1976, 1979). Publications in W, The New Yorker, CQ, The New York Times. Advertising for Adidas and Nike. Major retrospectives in the Museum of Modern Art, Whitney Museum of American Art, San Francisco Museum of Art and at the Rencontres d'Arles.

"**Fink specializes as a photo journalist and photographic author on the behavior of people at different entertainment industry events and spectacles. His photos, generally made indoors with a hand-held flash, bring to light psychologically differentiated details as well as crass caricatures of the situation.**" — Maren Gröning ✎🞄

EXHIBITIONS (Selected) — **1970** New York (Museum of Modern Art – 1978, 1981, 1991, 1992, 1998) GE // **1977** Tucson (Arizona) (Center for Creative Photography) SE // **1979** New York (Museum of Modern Art) SE // **1981** San Francisco (Museum of Art) SE // **1993** Arles (Rencontres internationales de la photographie) SE // **1994** Lausanne (Musée de l'Élysée) SE // **1995** Frankfurt am Main (Fotografie Forum) SE // **1997** Charleroi (Belgium) (Musée de la Photographie) SE // New York (Whitney Museum of American Art) SE // **1998** Los Angeles (Jan Kesner Gallery – 2000) SE // **2001** Paris (VU' La galerie) SE // **2004** New York (Edwynn Houk Gallery) SE // **2005** Berlin (Camera Work) SE // Mannheim (Alte Feuerwache) SE // **2006** Bologna (Galleria d'Arte Moderna) SE // **2007** Florence (Museo Nazionale Alinari della Fotografia) SE // Vienna (Albertina/**Blicke, Passanten – 1930 bis heute**) GE // **2008** Boston (Robert Klein Gallery) SE

BIBLIOGRAPHY (Selected) — **Social Graces**. Millerton/New York 1984 // **Still Working**. University of Washington Press 1994 // **Uma Cidade Assi**. Camara Municipal De Matosinhos 1996 // **Fish and Wine**. Lafayette College 1997 // **Boxing**. powerHouse Books 1997 // **Runway**. powerHouse Books 2000 // **Social Graces**. New York 2001 // Laurie Dahlberg: **L.F.** London 2005 // Janos Frecot and Klaus Albrecht Schröder: **Blicke, Passanten – 1930 bis heute.** Vienna 2007 (cat. Albertina) ✎🞄

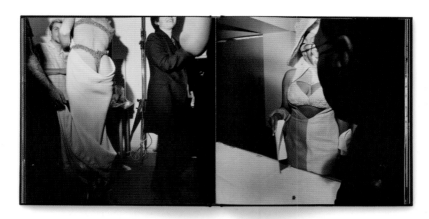

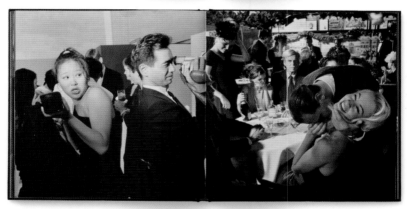

Hans Finsler

Hans Finsler: **So ist Halle – Halle ist schön.** Halle (Verkehrsamt der Stadt Halle) 1930

7.12.1891 Heilbronn (Germany) — 3.4.1972 Zurich (Switzerland) Influential photography teacher. As photographer, prominent exponent of New Objectivity around 1930. Elementary and Latin school in Urach (Württemburg). School-leaving exam in Stuttgart. Studies architecture in Stuttgart and Munich, and art history in Munich, Berlin, and Halle. There Ph.D. under the Heinrich Wölfflin student Paul Frankl. At the same time lectures in art history, advertising, and photography. Conception, organization of programmatic exhibition *Neue Wege der Photographie* in the Roten Turm in Halle. 37 of his works in the important Stuttgart show *Film und Foto* (1929). From April 1930 official head of the photography department of the Kunstgewerbeschule Burg Giebichenstein (Burg Giebichenstein art school) in Halle. 1932 moves to Zurich. There heads a newly created photo class at the Art School. Full professorship from 1938. In the same year elected to the central board of the Swiss Werkbund. Its chairman from 1946 to 1955. 1957 passes his photo class on to his former student Walter Binder. Other students include > Bischof, > Burri, René Groebli, Emil Schulthess. *Mein Weg zur Fotografie* (1971) a printed summary of his creation and teaching interested in truly "direct" photography.

EXHIBITIONS (Selected) — **1928** Halle (Germany)(Museum Moritzburg) SE // **1929** Essen (Germany) (Museum Folkwang) GE // **1933** Basel (Gewerbemuseum) GE // **1951** Saarbrücken (Germany) (Staatliche Schule für Kunst und Handwerk) GE // **1969** Rapperswil (Switzerland) (galerie 58) SE // **1991** Halle (Germany) (Staatliche Galerie Moritzburg) SE // **2004** Rome (Goethe Institut) SE // **2006** Zurich (Museum für Gestaltung) GE // **2008** Halle (Germany) (Stiftung Moritzburg) GE // Bremerhaven (Germany) (Kunsthalle) JE (with Erich Salomon and Richard Fleischhut)

BIBLIOGRAPHY (Selected) — **Mein Weg zur Fotografie.** Zurich 1971 // Karl Steinorth: **Photographen der 20er Jahre.** Munich 1979 // **H.F.: Neue Wege der Photographie.** Leipzig 1991 (cat. Staatliche Galerie Moritzburg, Halle) // **Photographie in der Schweiz von 1840 bis heute.** Wabern-Bern 1992 ✐ // Hugo Loetscher: **Durchs Bild zur Welt gekommen.** Zurich 2001 // **H.F. und die Schweizer Fotokultur. Werk – Fotoklasse – Moderne Gestaltung 1932–1960.** Zurich 2006 (cat. Museum für Gestaltung)

"The dominant theme in Finsler's photographic studies is his use of light to bring out the form and especially the material qualities of his subject, be it a piece of cloth, a light bulb, or a hen's egg. Even if Finsler's own oeuvre is relatively small, his influence as a teacher and the influence of his lectures and texts on Swiss photography of the time is immense. That Finsler's school produced not simply capable photographers but also notable photographic personalities such as Werner Bischof and René Burri bears witness to Finsler's abilities as teacher."
— Willy Rotzler ✍

KIRCHE U. L. FRAUEN AUF DEM MARKTPLATZ

1529 - 1554

erbaut auf Veranlassung des Kardinals Albrecht, indem die Turm-Paare von St. Marien (Hausmannstürme) und St. Gertrauden (blaue Türme) durch ein neues Schiff verbunden wurden.

Meister der Architektur und Skulptur: NICKEL HOFMANN
Meister des Gestühls: ANTON PAUWART VON YPERN
Meister des Taufbeckens: LUDOLF VON BRAUNSCHWEIG

Höhe der Hausmannstürme: 58,70 m
Höhe der blauen Türme: 83,36 m

Arno Fischer

Arno Fischer: **Photographien**.
Leipzig (Connewitzer Verlagsbuch-
handlung) 1997

14.4.1927 Berlin (Germany) — 13.9.2011 Neustrelitz (Germany) Pho-
to essays, reportages, portraits, fashion. Especially street photogra-
phy akin to the work of Robert Frank. Also influential teacher, profes-
sor. Regarded as a leading figure of photography in the German
Democratic Republic. Childhood and youth in Berlin. Woodworking
apprenticeship. In this period also first photos (of wartime destruc-
tion in Berlin). Journeyman's examination. German navy and prisoner
of war. Returns to Berlin. 1947–1953 studies sculpture at the Käthe-
Kollwitz-Kunstschule, the Hochschule für Angewandte Kunst (Col-
lege of Applied Arts) in Berlin-Weissensee as well as the Hochschule
für Bildende Kunst (School of Visual Arts) in Berlin-Charlottenburg.
Beginning of focus on photography with a documentation reflecting
the "Berlin situation". In planning: a book of the same title (no longer
approved after the wall is built). Returns to the college in Weissensee.
There 1956–1971 lectureship in photography. The exhibition *The Family of Man* and Frank's *Les
Américans* influence his style. From 1962 works for the fashion magazine *Sibylle*. With like-minded
photographers founds the group Direkt (from 1965). In this period more journalistic work, incl. for
Magazin, *Freie Welt*, *Wochenpost*, and *Forum*. 1972–1973 guest professor at the Hochschule für
Grafik und Buchkunst (Academy of Visual Arts) in Leipzig. 1983–1985 lectureship. 1985–1993 pro-
fessor. From 1990 also lectureship at the FH (Fachhochschule: University of Applied Sciences and
Arts) Dortmund. 1981 co-initiator of the Arbeitsgruppe Fotografie in the Verband Bildender Künstler in
the German Democratic Republic. A much admired project at the Rencontres d'Arles also reputed in
the west. Major retrospective at the 4th International Fototagen Herten (1997). 2000 receives the Dr
Erich-Salomon Prize from the DGPh (Deutsche Gesellschaft für Photographie: German Photographic
Association).

EXHIBITIONS (Selected) — **1958** Warsaw (Kunstfotografenver-
band) SE // **1985** Berlin (Fotogalerie am Helsingforser Platz)
SE // **1988** Berlin (Akademie der Künste der DDR) SE // **1991**
Douchy-les-Mines (France) (Centre regional de la photogra-
phie) SE // **1995** New York (Laurence Miller Gallery) SE // **1997**
Halle (Staatliche Galerie Moritzburg) SE // **1998** Düsseldorf
(Galerie Zimmer) SE // Berlin (Galerie argus fotokunst – 2005,
2007) SE // **2000** Cologne (photokina) SE // **2004** Nice
(Théâtre de la Photographie et de l'image) SE // **2006** Sonne-
berg (Germany) (Städtische Galerie) // Poznan (Poland)
(Galeria Fotografii PF) SE // Braga (Portugal) (Museu da Ima-
gem) SE // **2007** Manchester (England) (Cornerhouse) GE //
Hatfield (UH Galleries) GE // **2008** Wolverhampton (Wolver-
hampton) GE // Halle (Germany) (Stiftung Moritzburg) SE //
2009 Bonn (Kunst- und Ausstellungshalle der BRD) SE // Er-
furt (Germany) (Kunsthalle/**Die andere Leipziger Schule**) GE

BIBLIOGRAPHY (Selected) — **Polens Hauptstädte. Poznan,
Kraków, Warszawa**. East Berlin 1974 // **Leningrad. Erinnerun-
gen und Entdeckungen**. East Berlin 1981 // **Alt-Delhi – Neu-
Delhi**. East Berlin 1983 // **New York. Ansichten**. East Berlin
1988 // **Berlin 1943–1990**. Douchy-les-Mines 1990 (cat. Cen-
tre Regional de la Photographie) // Ulrich Domröse (ed.):
Nichts ist so einfach wie es scheint. West Berlin 1992 (cat.
Berlinische Galerie) // Ulrich Domröse (ed.): **Positionen kün-
stlerischer Photographie in Deutschland seit 1945**. Cologne,
1997 (cat. Berlinische Galerie) 🖉 // **Photographien**. Leipzig,
1997 (cat. Staatliche Galerie Moritzburg, Halle) // **Situation
Berlin. Fotografien 1953–1960**. Berlin 2001 // **Der Garten/
The Garden**. Ostfildern-Ruit 2007 // Matthew Shaul: **Do Not Re-
freeze: Photography Behind the Berlin Wall**. Manchester
2007 (cat. Cornerhouse) 🖉 // **A.F.: Fotografie**. Ostfildern
2009 (cat. Kunst- und Ausstellungshalle der BRD)

"Fischer's photographic eye intensifies reality through the classical means of photography which gives the subject a graphic corporeality. Coming from sculpture, Fischer soon chose photography because of its rapidity and ability to intensify experience by 'fixing' time. His style is narrative and based not on staged but on 'awaited' reality (the decisive moment). […] Fischer's work relates to society and he never loses sight of the bigger picture. He is not simply interested in misfortune in itself. He also tries to photograph its possible causes. He tries to understand. Thus Fischer displays his political stance in images without being explicitly political." — Inga Knölke ✍

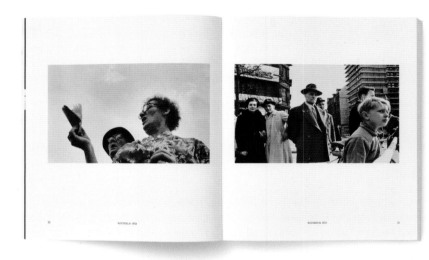

Trude (Gertrude) Fleischmann

Trude Fleischmann,
from: **Das Deutsche Aktwerk.**
Berlin (Bruno Schulz Verlag) 1940

18.12.1895 Vienna (Austria) — 21.1.1990 Brewster (New York, USA)
Nudes, dance photography, and portraits of notable Viennese artists
after 1920. Photography between Pictorialism and modernism. From
about 1980 rediscovery of her early oeuvre. Daughter of a middle-
class Jewish family. School-leaving exam in Vienna. Brief art studies
in Paris. 1913—1916 trains at the Graphischen Lehr- und Versuchs-
anstalt (Graphic Arts Teaching and Research Institute) in Vienna.
Retouch work for Madame d'Ora (Dora Kallmus). From 1919 appren-
tice under Hermann Schieberth. From 1920 her own studio in Vienna.
Meets Adolf Loos and Peter Altenberg. Subsequently especially por-
traits of artists, incl. of Altenberg and Loos, Alban Berg, Karl Kraus,
Grete Wiesenthal, and Stefan Zweig. Also dance studies, and nudes.
Publishes in *Die Bühne*, *Moderne Welt*, *Welt und Mode*, *Uhu*, and *Das
Deutsche Lichtbild*. 1938 flees via Paris to London. 1939 moves to the
USA. 1940—1969 studio in Manhattan. 1942 US citizenship. Fashion
for *Vogue* and portraits of immigrants such as Elisabeth Bergner,
Albert Einstein, Oskar Homolka, and Arturo Toscanini. 1969 moves to Lugano. After a severe accident,
last years with relatives in the USA.

> **"In the 1920s and 30s her studio was a meeting place for artists, musicians and actors […]
> Generally low contrast prints, taken in soft light, her portraits have a melancholy beauty. They
> are unique cultural history documents displaying exceptional craftsmanship."** — Carl Aigner ✏🗓

EXHIBITIONS (Selected) — **1983** Vienna (Museum des 20. Jahr-
hunderts) GE // **1988** Vienna (Galerie Faber) SE // **1997** Bonn
(Rheinisches Landesmuseum) GE // **1998** Vienna (Kunsthalle
im Museumsquartier) GE // **2003** Vienna (Albertina/**Das Auge
und der Apparat**) GE // **2005** New York (Neue Galerie/Portraits
of an Age) GE // Vienna (Albertina/**Portrait im Aufbruch**) GE //
2007 Washington, DC (National Gallery of Art) GE // **2008** New
York (Guggenheim Museum) GE // **2011** Vienna (Wien Muse-
um) SE // **2013** Salzburg (Museum der Moderne) GE

BIBLIOGRAPHY (Selected) — **Geschichte der Fotografie in Ös-
terreich.** Bad Ischl 1983 (cat. Museum des 20. Jahrhunderts,
Vienna) // **T.F.: Fotografien 1918—1938.** Vienna 1988 (cat. Gal-
erie Faber) // Carl Aigner: "Eine fotografische Emigration." In:
Wiener Zeitung, 18.3.1988 ✏🗓 // Hans Schreiber: **T.F.: Foto-
grafien 1918—1938.** Vienna 1992 // Klaus Honnef and Frank
Weyers: **Und sie haben Deutschland verlassen … müssen.**
Bonn 1997 (cat. Rheinisches Landesmuseum) // **Übersee.
Flucht und Emigration österreichischer Fotografen 1920—
1940.** Vienna 1998 (cat. Kunsthalle im Museumsquartier) //
Monika Faber and Klaus Albrecht Schröder (eds): **Das Auge
und der Apparat. Die Fotosammlung der Albertina.** Ostfildern-
Ruit 2003 (cat. Albertina, Vienna) // Monika Faber and Janos
Frecot (eds): **Portrait im Aufbruch. Photographie in Deutsch-
land und Österreich 1900—1938.** Ostfildern-Ruit 2005 (cat.
Albertina, Vienna) // Matthew S. Witkovsky: **Foto: Modernity in
Central Europe, 1918—1945.** Washington, DC, 2007 (cat. Na-
tional Gallery of Art) // **Der selbstbewusste Blick.** Ostfildern
2011 (cat. Wien Museum) // **Focus on Photography.** Munich
2013 (cat. Museum der Moderne, Salzburg)

Franco Fontana

Photoedition 3: Franco Fontana.
Schaffhausen (Verlag Photographie) 1980

9.12.1933 Modena (Italy) — Lives in Cognento (Italy) City and nature as the starting point for geometric/iconic imagery, exclusively in color. Best-known Italian photographer in the 1970s and 80s. Trained interior designer. Takes up photography as true amateur. First photos 1961. Active participation in competitions, and first solo exhibition 1968. Positive response from the public and critics for his color-intensive work, sometimes compared to the paintings of the artists Antoni Tàpies or Mark Rothko. Subsequently dedicates himself fully to art photography. After a period of deliberately grainy (late Pictorialism) photography, growing interest in a strict pictorial language characterized by extreme reduction. Refuses any form of darkroom manipulation. Form only through (tight) framing, perspective, light, and camera settings (aperture, time). In his series *Skyline* (1978) the horizon is vertical and the image divided by homogeneous color-field elements. In *Paesaggio Urbano* (1980) concentration on iconic urban elements. In *Presenzassenza* (1983) for the first time people as part of the found composition. Often seen as restoring (although geometrically interpreted) landscape photography. Breakthrough in the 1970s. Since then one of Italy's best-known photographers and together with > Haas and Pete Turner certainly one of the most recognized color interpreters of his time. More than 40 photobooks. Also campaigns, incl. for Volkswagen, Fiat, Volvo, Audi, Sony, Canon, Kodak, Swissair, and Alitalia. Publishes in *Camera*, *Zoom*, *Art*, *Time*, *Life*, *Epoca*, *Vogue*, *Frankfurter Allgemeine Zeitung.* Numerous workshops and international awards.

"Franco Fontana works with clear compositions, with unambiguous structures and concepts […] As an artist he has developed an instinctive sensibility for forms of expression which can also be analyzed with rules of logic. With his principles he has become a grammarian of an abstract language which, in its simplicity, is also understood by a widespread international public." — David Meili ✍⊐

EXHIBITIONS (Selected) — **1968** Modena (Italy) (Sala di Cultura) SE // **1972** Vienna (Galerie Die Brücke) SE // **1974** Cologne (photokina – 1986) GE // **1975** Berlin (Galerie A. Nagel) SE // **1976** Parma (Italy) (Sala delle Scuderie in Pilotta) SE // **1977** London (The Photographers' Gallery – 1983) SE // **1980** San Francisco (Focus Gallery) SE // **1984** Toulouse (Galerie municipale du Château d'Eau) SE // **1985** Arles (Rencontres internationales de la photographie) SE // **1991** Paris (Espace Photographique) SE // **1992** Bologna (Palazzo di Re Enzo) SE // **1997** Zurich (Galerie Zur Stockeregg) SE // **1999** Linz (Austria) (Museum der Stadt) GE // **2000** Modena (Italy) (Galleria Civica) SE // **2003** Turin (Fondazione Italiana per la Fotografia) SE // **2004** Milan (Palazzo Reale) SE // **2006** Buenos Aires (Museo Nacional de Bellas Artes) SE

BIBLIOGRAPHY (Selected) — **Modena una Città**. Modena 1971 // **Terra da Leggere**. Modena 1975 // **Bologna: Il Volto della Città**. Modena 1975 // F.F. Parma 1976 // **Skyline**. Modena 1978 // **Paesaggio Urbano**. Monza 1980 // **F.F.: Photoedition 3"**. Schaffhausen 1980 ✍⊐ // **Presenzassenza**. Monza 1983 // **Meisterfotos gestalten**. Munich 1983 // **Landscape moments**. Modena 1994 // F.F. Milan 1994 // **Polaroids**. Milan 1997 // **Sorpesi nella luce americana**. Milan 2000 // **The Polaroid Book: Selections from the Polaroid Collections of Photography**. Cologne 2005

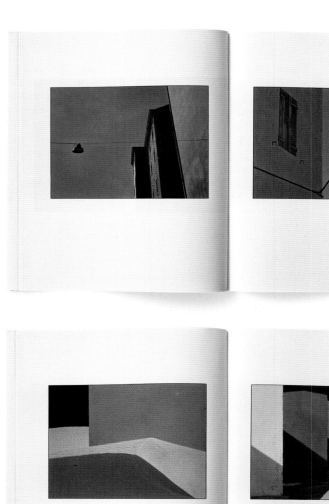

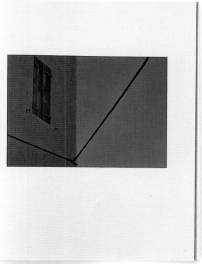

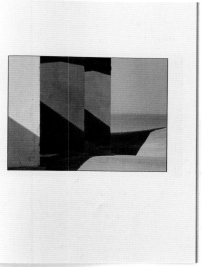

Günther Förg

5.12.1952 Füssen (Germany) — 5.12.2013 Freiburg (Germany) As sculptor, painter, and photographer, the exponent of a multi-media concept of art. Internationally well known since the mid 1980s. 1973–1979 studies at the Akademie der Bildenden Künste (Academy of Fine Arts) in Munich under K.F. Dahmen. 1980 first solo exhibition at Rüdiger Schöttle's gallery (Munich). Subsequently numerous solo and group exhibitions, incl. at documenta 9. 1992–1999 teaches at the Hochschule für Gestaltung (College of Design) in Karlsruhe. Since 1999 professor at the Akademie der Bildenden Künste (Academy of Fine Arts) in Munich. Awards incl. Wolgang Hahn Award (1996), Bundesverdienstkreuz am Bande (2003).

Günther Förg: **Photographs.**
Bauhaus Tel Aviv – Jerusalem.
Ostfildern (Hatje Cantz Verlag)
2002

EXHIBITIONS (Selected) — **1980** Munich (Galerie Schöttle) SE // **1985** Amsterdam (Stedelijk Museum) JE (with Jeff Wall) // **1987** Krefeld (Germany) (Museum Haus Lange) SE // **1993** Stuttgart (Galerie der Stadt Stuttgart) SE // **1995** New York (Luhrig Augustine Gallery) SE // **1997** Zurich (Haus für konstruktive und konkrete Kunst) SE // **1998** Sundern (Germany) (Stadtgalerie) SE // **2002** Weimar (Schillermuseum Weimar) SE // Tel Aviv (Tel Aviv Museum of Art) SE // **2003** Prague (City Gallery Prague/**Von Körpern und anderen Dingen**) GE // (Touring Exhibition visiting Berlin, Moscow, and Bochum) // Hamburg (Deichtorhallen) GE // The Hague (Gemeentemuseum Den Haag – 2006) SE // **2004** Madrid (Fundación Telefónica) GE // Berlin (Galerie Max Hetzler) SE // Santiago de Compostela (Spain) (Centro Galego de Arte Contemporánea) GE // Ulm (Ulmer Museum/**blow up – Zeitgenössische Künstler-Fotografie**) GE // London (The Photographers' Gallery) GE // Rio de Janeiro (Museu de arte moderna) GE // **2005** Basel (Museum für Gegenwartskunst) GE // Vigo (Museo de Arte Contem-poránea) GE // Saint-Étienne (France) (Musée d'Art Moderne de Saint-Étienne) GE // **2006** Bremen (Kunsthalle/**Raum und Fläche**) SE // Delmenhorst (Städtische Galerie Delmenhorst) GE // **2007** Paris (Galerie Lelong Paris) SE // Bietigheim-Bissingen (Städtische Galerie/**Man Ray bis Sigmar Polke**) GE // **2008** Bonn (Bundeskunsthalle) GE // Karlsruhe (Zentrum für Kunst und Medientechnologie) GE // Frankfurt am Main (Städelsches Kunstinstitut/Real) GE // **2009** Los Angeles (Los Angeles County Museum of Art/**Art of Two Germanys/Cold War Cultures**) GE

BIBLIOGRAPHY (Selected) — "Im Grunde ist mir der Betrachter egal". Interview mit G.F. In: **Noëma**, no. 23, April/May 1989 // **Wall Works.** Cologne 1993 // **Das Versprechen der Fotografie. Die Sammlung der DG Bank.** Munich 1998 // **Photographs. Bauhaus Tel Aviv – Jerusalem.** Ostfildern-Ruit 2002 (cat. Schillermuseum Weimar)

"Günther Förg's architectural photography is not spectacular, indeed quite the opposite, but it captures the character of a space, a façade, a perspective. It captures proportions. In doing so it seeks neither the pathetic view, nor the championship of architectural photography. Günther Förg has a regard of everyman, but his regard is the knowing and desolate one of this everyman."
— Jean-Christophe Ammann

Tel Aviv, Zina Dizengoff Square, Genia Averbouch

Tel Aviv, Lavdor House

Martine Franck

Martine Franck: **Tory. Ile aux confins de l'Europe.** Wabern-Bern (Éditions Benteli) 1998

2.4.1938 Antwerpen (Belgium) — 16.8.2012 Paris (France) Magnum member. Portraits, theater photography, and reportages akin to humane photojournalism. Generally large series, mostly b/w. 1952–1954 school in England and the USA. 1956–1957 studies art history in Madrid and then 1958–1962 at the École du Louvre in Paris. Takes up photography. 1963 China, Japan, India. First photos. 1964 assistant to the *Life* photographers Eliot Elisofon and > Mili. Subsequently works as freelance photographer, incl. for *Life*, *Fortune*, *Sports Illustrated*, *Vogue*, *The New York Times*. 1970–1971 member of the VU agency. Founding member of the Paris Viva agency. 1980 associate member of Magnum (full member since 1983). Theater photography for Ariane Mnouchkine, artist portraits. Portraits of old people. Reportage together with the charitable organization Petits Frères des Pauvres. Most recently large essay on the people of the Irish island of Tory. From 1970 married to > Cartier-Bresson.

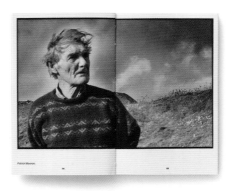

EXHIBITIONS (Selected) — **1971** Paris (Galerie Rencontre) SE // **1981** Chalons-sur-Saône (France) (Musée Nicéphore Niépce) SE // **1982** Toulouse (Galerie municipale du Château d'Eau) SE // **1989** Paris (Centre national de la photographie) SE // **1998** Paris (Maison européenne de la photographie) SE // **1999** Edinburgh (Scottish National Portrait Gallery) GE // **2000** New York (Howard Greenberg Gallery) SE // **2002** Paris (Musée de la Vie romantique) SE // **2004** Arles (Rencontres internationales de la photographie) SE // **2005** Rome (Sala Santa Rita) SE // **2006** Brescia (Italy) (Galleria dell Incisione) SE // **2007** Vienna (WestLicht) SE // **2008** Amsterdam (Stedelijk Museum Post CS/**MAGNUM Photos 60 Years**) GE // Kyoto (Japan) (Kahitsukan Kyoto Museum of Contemporary art) SE

BIBLIOGRAPHY (Selected) — **Le Théâtre du Soleil: 1789.** Paris 1971 // **M.F.** Paris 1976 // **Les temps de vieillir.** Paris 1980 // **De temps en temps.** Paris 1988 // **Le Collège de France.** Paris 1988 // **Von Tag zu Tag.** Munich 1998 // **Tory Island.** Bern 1998 // **Die Magnum-Fotografinnen.** Munich 1999 // **M.F.: Photographe.** Paris 2002 (cat. Musée de la Vie romantique) // **Fables.** Arles 2004 // Chris Boot (ed.): **Magnum Stories.** London 2004 // Brigitte Lardinois: **Magnum Magnum.** Munich 2007

"I don't really like short-term projects. I like to stay with a subject and keep returning to it. That probably relates to the question of how to exist that I needed to work out. Photography for me isn't about jumping in and out of something quickly but, over a period of time, building up a sense of belonging somewhere and being involved with a community. I like to think I am committed to the people I photograph. With the Tory Island community in Ireland, I've been back many times and, although I have already done two books and a film, I'll keep going back. I've built strong friendships. That's what photography is for: connecting with people and communities. This is an approach that runs through my work, which is different to the focus on storytelling required by a magazine feature."

— Martine Franck ✍

Anne Bridget Rodgers, Grainne Doohan.

29

Robert Frank

Robert Frank: **The Americans.**
New York (Grove Press) 1959

9.11.1924 Zurich (Switzerland) — Lives in New York (USA) and Nova Scotia (Canada) Artist with multimedia interests, especially photography, film, and video. Pioneer of a new pictorial language in photography. Without doubt one of the most talked about art photographers of the 20th century. Second son of a Frankfurt businessman who emigrated to Switzerland. 1941 begins photographic apprenticeship under Hermann Segesser (Zurich). 1942–1944 under Michael Wolgensinger. 1946 in Studio Eidenbenz. 1945 Swiss citizenship. Military basic training. 1947 moves to the USA. Contact with > Brodovitch. Fashion for *Harper's Bazaar* and *Junior Bazaar*. Meets > Faurer and somewhat later > Erwitt, > Evans, > Steichen, and Robert Delpire. 1948–1953 commutes between America and Europe. 1953 gives up fashion photography. Photojournalism and portraits, incl. for *Life*, *Look*, *McCall's*, *Vogue*. 1955 Guggenheim Fellowship for his *America* project. 1958 *Les Américains* in Robert Delpire's Parisian publishing house. Takes up film. *Pull My Daisy* (1959) the first of around 20 films, incl. *Me and My Brother* (1965–1968), *Candy Mountain* (1987), *Last Supper* (1992). 1963 US citizenship. 1972 first experiments with Polaroid. Works with the Rolling Stones: cover photo for *Exile on Main Street* and documentary film on their North America tour (*Cocksucker Blues*). 1985 Dr Erich-Salomon Prize from the DGPh (Deutsche Gesellschaft für Photographie: German Photographic Association). 1996 Hasselblad Award. 1990 establishment of a Robert Frank Collection in the National Gallery of Art, Washington, DC. 1994 major retrospective there, with further stops in Yokohama, Zurich, Amsterdam, New York, and Los Angeles.

EXHIBITIONS (Selected) — **1950** New York (Museum of Modern Art – 1953, 1955, 1962, 1964) GE // **1961** Chicago (Art Institute) SE // **1976** Zurich (Kunsthaus – 1996) SE // **1979** Long Beach (California) (Museum of Art) SE // **1985** Stanford (California) (University Museum of Art) SE // **1986** Houston (Texas) (Museum of Fine Arts) SE // **1988** Zurich (Museum für Gestaltung) SE // **1994** Washington, DC (National Gallery of Art) SE // **1996** Paris (Centre Culturel Suisse) SE // **2000** Essen (Germany) (Museum Folkwang – 2008) SE // **2002** Chicago (The Art Institute of Chicago) SE // **2003** Washington, DC (The Corcoran Gallery of Art) SE // **2004** London (Tate Modern) SE // **2005** Winterthur (Switzerland) (Fotomuseum/Fotostiftung Schweiz) SE // **2008** Milan (Museo di Fotografia Contemporanea) SE // **2009** Washington, DC (National Gallery of Art) SE // San Francisco (San Francisco Museum of Modern Art) SE // New York (Metropolitan Museum of Art) SE

BIBLIOGRAPHY (Selected) — **The Americans.** New York 1958 // **Pull My Daisy.** New York 1961 // **The Lines of My Hand.** Tokyo 1972 // **R.F.: Photographer/Filmmaker: Works from 1945– 1979.** Long Beach 1979 (cat. Museum of Art) // Stuart Alexander: **R.F.: A Bibliography, Filmography and Exhibition Chronology 1946–1985.** Tucson 1986 // **New York to Nova Scotia.** Boston 1986 (cat. Museum of Fine Arts, Houston) // **Black White and Things.** Zurich 1994 // **R.F.: Moving Out.** Zurich 1994 (cat. National Gallery of Art, Washington, DC) // **Hold Still – Keep Going.** Zurich 2000 (cat. Museum Folkwang, Essen) // **London – Wales.** Zurich 2003 // **Frank Films.** Zurich 2003 // **Paris.** Göttingen 2008 // Charlie LeDuff: "Robert Frank's Unsentimental Journey." In: **Vanity Fair**, April 2008 ✏⍔ // **Looking in Robert Frank's The Americans.** Washington, DC, 2009 (cat. National Gallery of Art)

"Before Frank, the visual orientation of photographs had been straight, horizontal, vertical. The subject of the picture was always obvious. You knew what the picture was about and what it meant to say. Frank, the shadowy little man, came along and changed the angles, made graininess a virtue, obscure lighting a benefit. His pictures were messy; you weren't sure what to feel, who or what to focus on. Perhaps more importantly, Frank intellectually changed photography — that is, what a photographer was supposed to look at. If Ansel Adams chose to capture the mightiness of nature, how could you argue with that? Where's the fault in stone and sky and snow? There is no fault. And therein lies its fault. Frank snatched photography from the landscapists and the fashion portraitists and concentrated his lens on battered transvestites, women in housedresses, and sunken mouths. Life is difficult and sad and ephemeral. Life is flesh, not stone. Frank, as Janet Malcom wrote, has been overvalued as a social critic and undervalued as a photographic innovator." — Charlie Leduff ✍

U.S. 285, New Mexico

Parade — Hoboken, New Jersey

Leonard Freed

Leonard Freed: **Made in Germany.**
New York (Grossman Publishers)
1970

23.10.1929 Brooklyn (New York, USA) — 30.11.2006 Garrison (New York, USA) Magnum member. Photo essays on Jews in Europe and reportage on the New York police are his best-known series. Child of eastern European Jewish immigrants. Schooling in New York. At first wants to be a painter. After travels in Europe and North Africa returns to New York and in 1954 takes a course at > Brodovitch's Design Laboratory. Meets > Steichen. With his encouragement, takes up photography definitively. 1967 participates in *The Concerned Photographer* exhibition curated by Cornell Capa. 1970 Magnum associate, full member from 1972. Examines racial discrimination and the civil rights movement in the USA. Series on Jews in Germany and Europe. Much admired photos of the world of the New York police. Films for Dutch, Belgian, and Japanese TV. Publishes in *Life*, *Look*, *Paris Match*, *Die Zeit*, *Der Spiegel*, *Stern*, *Sunday Times Magazine*, *New York Times Magazine*, *Geo*, *L'Express*, *Libération*, *Fortune*, among others. Dies of cancer shortly before the opening of his major retrospective in Lausanne.

"**Basically, all the projects I've chosen are to psychoanalyze myself – to find out who I am in relationship to other people. If I photograph black people or Germans or Jews or artists, I'm trying to work out my relationship to them. In a way, all my work is about my identity in relationship to other people. It's a process where at a certain point you have the answer, and you recognize everything from then on is redundant and there is no need to do any more. That's when the work is finished. With the police, I became comfortable with them and I knew how they thought. At that point I thought the work lacked unpoliceman-like photographs, so I made some of police in their homes, away from the job. Then it was done.**" — Leonard Freed ✎◻

EXHIBITIONS (Selected) — **1960** Rotterdam (Rotterdamsche Kunstring) SE // **1967** New York (Riverside Museum/**The Concerned Photographer**) GE // **1973** London (The Photographers' Gallery) SE // **1980** Essen (Germany) (Museum Folkwang) SE // **1984** Paris (Fnac) SE // **1987** Toulouse (Galerie municipale du Château d'Eau) SE // **1992** Berlin (Fnac) SE // **1994** New York (Gallery 292) SE // **2000** Winchester (Massachusetts) (Lee Gallery) SE // **2001** Garrison (New York) (Garrison Art Center) SE // **2003** Paris (Galerie Esther Woewrdehoff) SE // **2004** Berlin (Galerie argus fotokunst – 2008) SE // **2005** Minneapolis (Minneapolis Institute of Arts) SE // **2007** Lausanne (Musée de l'Élysée) SE // The Hague (Fotomuseum) SE // **2008** Berlin (C/O Berlin) SE // **2013** Essen (Museum Folkwang) SE

BIBLIOGRAPHY (Selected) — **Joden van Amsterdam**. Amsterdam 1959 // **Deutsche Juden heute**. Munich 1965 // **Black in White America**. New York 1968 // **Made in Germany**. New York 1970 // **Police Work**. New York 1980 // **La Danse des fidèles**. Paris 1984 // **L.F.** Toulouse 1987 (Galerie municipale du Château d'Eau) // **New York Police**. Paris 1990 // **Photographies 1954–1990**. Paris 1991 // **Amsterdam: The Sixties**. Amsterdam 1997 // **L.F.** Paris 2001 (= Photo Poche no. 90) // **Another Life**. Heerlen 2004 // Chris Boot (ed.): **Magnum Stories**. London 2004 ✎◻ // **Worldview**. Göttingen 2007 (cat. Musée de l'Élysée, Lausanne) // Brigitte Lardinois: **Magnum Magnum**. Munich 2007 // **Made in Germany. Re-Made**. Göttingen 2013 (cat. Museum Folkwang, Essen)

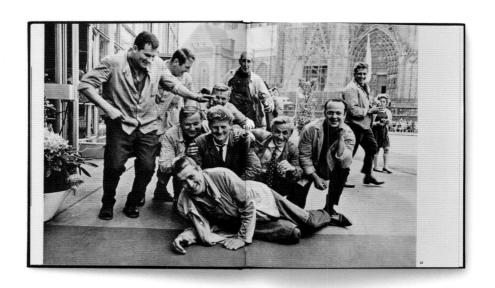

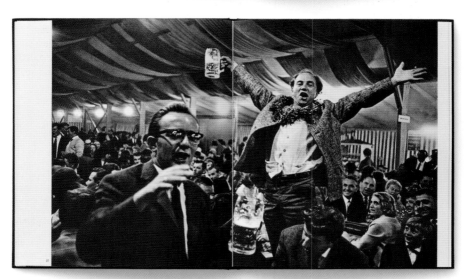

Gisèle Freund

Gisèle Freund: **Untitled (Colette)**, from: **Arts et Métiers Graphiques Photographie,** 1940

19.12.1908 Berlin (Germany) — 31.3.2000 Paris (France) Doctor of sociology. Small-format reportage and portraits, especially of writers and painters (in color and b/w). Collectively, an impressive pantheon of French intellectuals from the 1930s to the 60s. Daughter of a long-established German-Jewish industrial family. Early contact with art: Käthe Kollwitz, Max Slevogt, Max Liebermann are friends of the family. 1923 first camera. Secondary school. 1929 first Leica for her school-leaving exam. 1931–1933 studies in Freiburg and Frankfurt am Main (sociology and art history) under Theodor W. Adorno, Karl Mannheim, and Norbert Elias. Growing interest in journalistic photography. Documents the last "free" May Day demonstration (1932) in Frankfurt. May 1933 flees to Paris. Finishes her studies at the Sorbonne with a dissertation, *La Photographie en France au XIXe siècle.* Photography to earn a living. Meets the bookseller Adrienne Monnier. A portrait of André Malraux the beginning of her exploration of the genre of writers' portraits. 1936 first published reportage (in *Life*). 1937 an essay on the Bibliothèque nationale for the French salon at the World's Fair. From 1938 photos in color (incl. James Joyce for *Time*). In June 1940 flees to the south of France. 1942–1945 Argentina. 1945 returns to France. 1950 reportage on Evita Perón for *Life*. 1950–1952 Mexico. 1953 (again in Paris) works among others for *Paris Match*, *Art et Décoration*, *Point de Vue*. 1954 ends her Magnum membership (since 1947). Independent photographer, reportages and writers' portraits (Jacques Prévert, Jean-Paul Sartre, Simone de Beauvoir). 1957 first trip back to Germany. 1970 autobiography *Le monde et ma caméra*. 1974 *Photographie et société* a much admired social history of photography. Kulturpreis from the DGPh (Deutsche Gesellschaft für Photographie: German Photographic Association) (1978), Grand Prix National des Arts (1980), Légion d'Honneur (1983), Officier du Mérite (1987). 1977 guest of honor at the Rencontres d'Arles.

EXHIBITIONS (Selected) — **1939** Paris (Maison des amis des livres) SE // **1963** Paris (Bibliothèque nationale de France/Site Richelieu-Louvois) SE // **1968** Paris (Musée d'art moderne de la Ville de Paris) SE // **1977** Bonn (Rheinisches Landesmuseum) SE // Kassel (Germany) (documenta 6) GE // **1988** Berlin (Werkbund-Archiv) SE // **1991** Paris (Centre Pompidou) SE // **1995** Frankfurt am Main (Museum für Moderne Kunst) SE // **2004** Valladolid (Spain) (Sala Municipal de San Benito) SE // **2005** New York (Neue Galerie/**Portraits of an Age**) GE // Vienna (Albertina/**Portrait im Aufbruch**) GE // **2007** Luxemburg (Galerie Clairefontaine – 2008) GE // **2008** Milan (Galleria Carla Sozzani) SE // Berlin (Willy-Brandt-Haus) SE // **2014** Berlin (Akademie der Künste) SE

BIBLIOGRAPHY (Selected) — **Photographien**. Munich 1985. ✎ // **G.F.** Berlin 1988 (cat. Werkbund-Archiv) // **G.F.: Gespräche mit Rauda Jamis**. Munich 1993 // "Fotografin G.F.: Der Archipel der Erinnerung." In: **Du**, no. 3, 1993 // **Fotografien zum 1. Mai 1932**. Frankfurt am Main 1995 (cat. Museum für Moderne Kunst) // **G.F.: Berlin – Frankfurt – Paris. Fotografien 1929–1962**. Berlin 1996 (cat. Berliner Festspiele GmbH) // Monika Faber and Janos Frecot (eds): **Portrait im Aufbruch. Photographie in Deutschland und Österreich 1900–1938**. Ostfildern-Ruit 2005 (cat. Albertina, Vienna)

"Gisèle Freund's portraits also interest us today because time distances us ever more from the people she portrayed; we can no longer touch them but they are still present in her photographs. They also interest us as a sociology of the era. An exceptional sociology which concentrates on one object: the world of artists and creativity." — Christian Caujolle ✍

Gisèle Freund: **La Première Usine intellectuelle du Monde,** from: **VU,** no. 463, 1937

Lee *(Norman)* Friedlander

Friedlander. New York (The Museum of Modern Art) 2005

14.7.1934 Aberdeen (Washington, USA) — Lives in New York (USA) Portraits, self-portraits, street photography, nudes, nature, "urban landscapes". Internationally known as a documentary photographer in the tradition of Walker Evans. 1948 develops an interest in photography. 1953–1955 studies at the Los Angeles Art Center School. Course under Edward Kaminski. 1956 moves to New York. Portraits of jazz musicians for record covers. In addition independent work influenced by > Atget, > Evans, and > Frank. 1958 rediscovers and (1970) publishes the work of > Bellocq (1873–1949). 1963 first solo exhibition in George Eastman House. 1966 participates in the important group exhibition *Toward a Social Landscape* (with > Davidson, > Lyon, > Michals, > Winogrand). 1967 (with Winogrand and > Arbus) *New Documents* exhibition in the Museum of Modern Art. 1976 publishes perhaps his most important book, *The American Monument* (for the US Bicentenary). Teaches at the University of California (Los Angeles) and Rice University (Houston). Numerous awards, incl. Guggenheim Fellowships (1960, 1962, 1977), NEA (National Endowment for the Arts) Fellowships (1972, 1977, 1978, 1979, 1980), Edward MacDowell Medal (1986), MacArthur Foundation Fellowship (1990), Hasselblad Award (2005). 2005 major retrospective in New York and Munich.

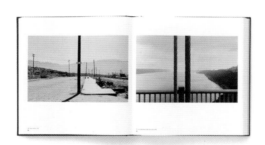

EXHIBITIONS (Selected) — **1963** Rochester (New York) (George Eastman House – 1983) SE // **1966** Rochester (New York) (George Eastman House/**Toward a Social Landscape**) GE // **1967** New York (Museum of Modern Art) JE (with Arbus and Winogrand) // **1974** Cologne (Galerie Wilde) SE // New York (Museum of Modern Art – 1975, 1991, 1994, 2005) SE // **1983** San Francisco (Museum of Modern Art – 1991) SE // **1987** Tokyo (Seibu Museum of Art) SE // **1989** Seattle (Art Museum) SE // **1993** Boston (Institute for Contemporary Art) SE // **1996** Paris (Maison européenne de la photographie) JE (with Jim Dine) // **2001** Cologne (Galerie Thomas Zander – 2003, 2005) SE // **2002** Tucson (Arizona) (Center for Creative Photography – 2008) SE // **2003** Cologne (Die Photographische Sammlung/SK Stiftung Kultur – 2007) SE // **2004** Paris (Jeu de Paume – Site Sully) SE // **2005** Munich (Haus der Kunst) SE // Gothenburg (Hasselblad Center) SE // **2006** Paris (Jeu de Paume – Site Concorde) SE // **2008** New York (Metropolitan Museum of Art) SE // San Francisco (San Francisco Museum of Art) SE

BIBLIOGRAPHY (Selected) — Nathan Lyons (ed.): **Contemporary Photographers: Toward a Social Landscape.** New York 1966 (cat. George Eastman House, Rochester) // Jim Dine and L.F.: **Work from the Same House.** New York 1969 // **Self-Portrait.** New York 1970 // **The American Monument.** New York 1976 // **L.F.: Photographs.** New York 1978 // **Flowers and Trees.** New York 1981 // **Factory Valleys.** New York 1982 // **Nudes.** New York 1991 // **The Jazz People of New Orleans.** London 1992 // **Maria: Photographs by L.F.** Washington, DC, 1992 ✍ // **The Desert Seen.** New York 1996 // **L.F.: Complete Work.** New York 2005 (cat. Museum of Modern Art)

"No photographer has worked so squarely within the tradition of the documentary style or enlarged its dimensions so thoroughly as Lee Friedlander. Using the most basic tools – a 35mm camera loaded with black-and-white film – he has devoted himself to contemporary and canonical subjects, often for decades, and produced distinct bodies of work, all of which are marked by his hungry, democratic eye. His contributions to the art of the portrait and self-portrait, street and travel documentary, the landscape, and the nude have been recognized by museums worldwide." — Richard B. Woodward ✍︎

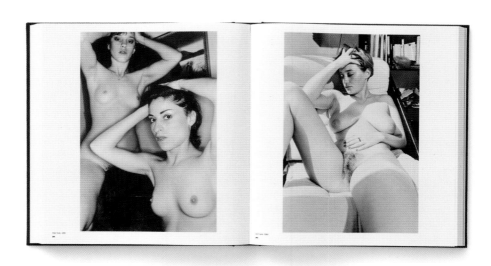

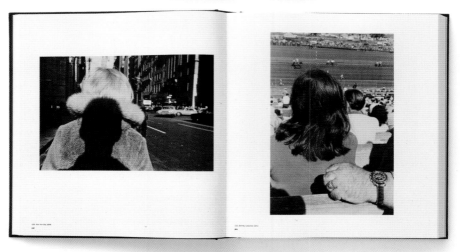

Jaromír Funke

Jaromír Funke/Ladislav Sutnar:
Fotografie vidí povrch.
Prague (École national des métiers graphiques) 1935

1.8.1896 Skutec (Eastern Bohemia, today Czech Republic) — 22.3.1945 Prague (Czechoslovakia) Photograms, abstraction, still lifes, reportages, architectural photography akin to New Vision (Neues Sehen). Pioneer of Czech photo avant-garde around 1930. Child of a Jewish family from Kolín. 1915–1918 studies medicine. 1918 moves to Prague. Studies law at the Karls-Universität there (does not finish). Studies art history, philosophy, and aesthetics theory. Takes up photography. From 1922 works as independent photographer. Member of the progressive Fotoklub Prag, the Ceská fotografická spolecnost, and the photographic section of the Mánes group, an association of artists. From 1931 also works as lecturer, incl. at the Crafts' School in Bratislava and the State Graphics School in Prague. Also active as theater director. Friend of > Sudek. Antipode of > Teige, who put together the Czech contribution to *Film und Foto* (1929). Therefore not shown at Stuttgart. Looking back more influential (because of the realism debate certainly more discredited and persecuted) exponent of Czech avant-garde photography.

"Funke's main aim, one difficult to achieve, was to develop a 'pure' and not illustrative form of photography. He was one of the first photographers who understood that abstraction in photography can be achieved – without suppressing photography's truthfulness of representation – through approaching the subject more closely, by disturbing spatial orientation (diagonal composition, sharp angle) and through rigorous composition of the image with abstract relations replacing illustrative ones." — Antonín Dufek ✎

EXHIBITIONS (Selected) — **1935** Prague (Družstevní Práce) SE // **1943** Kolín (Czech Republic) (Kolín Museum – 1946, 1947, 1953, 1960, 1976) SE // **1976** Aachen (Galerie Lichttropfen) SE // **1977** Bochum (Germany) (Städtisches Museum) SE // **1978** Berlin (Galerie Nagel) SE // **1984** Essen (Museum Folkwang) GE // **1996** Brno (Mährische Galerie) SE // **1999** Munich (Die Neue Sammlung) GE // **2005** Prague (Museum of Decorative Arts/**Czech Photography in the 20th Century**) GE // **2007** Washington, DC (National Gallery of Art) GE // New York (Guggenheim Museum) GE // New York (Howard Greenberg Gallery) GE // Berlin (Kicken Berlin) GE // **2008** Barcelona (Kowasa Gallery) JE (with Jaroslav Rössler and Eugen Wiskovsky) // **2009** Bonn (Kunst- und Ausstellungshalle der BRD) GE

BIBLIOGRAPHY (Selected) — Lubomír Linhart: **J.F**. Prague 1960 // Ludvík Soůcek: **J.F.: Fotografie**. Prague 1970 // **Tschechische Fotografie 1918–1948**. Essen 1984 (cat. Museum Folkwang) // Daniela Mrázková and Vladimír Remeš: **J.F.: Fotograf und Theoretiker**. Leipzig 1986 // Vladimír Birgus: **Tschechische Avantgarde-Fotografie 1918–1948**. Stuttgart/Munich 1999 (cat. Die Neue Sammlung) ✎ // Matthew S. Witkovsky: **Foto: Modernity in Central Europe, 1918–1945**. Washington, DC, 2007 (cat. National Gallery of Art) // **Czech Vision. Avant-Garde Photography in Czechoslovakia**. Ostfildern 2007 (cat. Kicken Berlin/Howard Greenberg Gallery, New York) // Vladimír Birgus and Jan Mlčoch: **Tschechische Fotografie des 20. Jahrhunderts**. Bonn 2009 (cat. Kunst- und Ausstellungshalle der BRD)

Fotografie vidí povrch

Je nabíledni, že nás nikdá nebrzeme pravdivě svět, ale nejmensější vědomosti získáme, když zachrané povrchem věcí. Nikoné povrch často vyhodnné je význačného vlastnosti jejich a jako pomocí předvším rozlišujme předměty, mírníme obrazy, ješ cenkají v oku zpórabouvám nebo odroznéna od zběn a stran kanary. Podobně oku prostša fotografický aparát. Ten zachrané všechny drobné a odretny odrobněho měnů a zprovuje nás o různých a ennohosti povrchů, bo čemu můžeme vzácnost z povrchu i o struktuře. Když zachlyí čočka na spotu stránkě světlo, tedy onu čist paprsků, jak přešli na fotografickou vrstvu získ... drobné, získáváme plevný záznam o plnnění odrošeného světla a tím dovídáme se ... o samé povrce věci. Svou objektivností stává se fotografie pravdomluvným svědkem a dokladem a stává v vztah předmětů.

Nákolik okozek, jak názukájí, nač použítá o spotobách, jeňž fotografie určuje základné a jakou nejcizelejších materiálů, nazváních ve výjahu nohotné dálkové předvádění přírody baravntost do fotomobílé šířky kontrantového obrazu. V něm vytítuna tat dranat, hloobko, tak, ústany říka nebo aveho o všech jejich stoví. O skutečné povrchem normim, gelošrežím a ledklje v ostropvrbosti, tímočtětím jakoň v dle oddránného světla. Alespoň v náspovkě jsou tu předávámy technické pochody, jichž je možno nejvhrobit různorné vlastnosti základ povrchů. Přemá fotografia i fotogram, obnýžení i panchnetičká deska, dlvi i barevný čtat, zvakvní i ametkací, přetváření i provádzění — je-li tělchto technik správně užito a když zábár předváští odpovídá jejich ráza, předvádíua fotografie razumítcho účínkám světla k fotografii provádáté, technicky dokonalé a fotogenicky zacínové.

Structure d'un tissu moderne
Foto Josef Ehm a Eikl
Photographies J. Ehm et ses Eikrys

Nejlepší reprodukce jsou věkátkov, ark lze proučit fotografia linky v její struktury v mědních toustpívých. Plochu je zočitěnáno vłastní bohatství vzásil a vstaly. Na protáší stránk je fotografie pravdivé členok linky, ješ zajímocost byla strohovánu vhodné-opravenje zrkněm. — U fotografii jako negatívnéu materiáls byla pouštá čehéha orthochramatícíkého a nezřmho výrobku vžitval ZP Sch

Povrch kreškrovaná látky - Foto Antonín Dorišk
Surface d'une étoffe à carreaux — A. Dorišk

Lidská kůže

Pavrch kůže nosní se boše v tom smyku jako u geometrických těles. Spíše je to povrchí vzívné tělo, které přípe do styku se vzeškem a se svěklen. Ono dýchá, vyšklaje pet v harku vnitřelá, zo chladu nepozaravné. Kůže ocht vlastní berzsao, má výhy, vyvářemy, kterí jsou v sláděký i ve nákaz vřezom prohovýpkrá ndrói nebo tmých vlastnosti. Na sládění í ruce možno číst minutoer ze stop, kterí z nich zanechá. Zdonří kůže je podobnbkter linky řóší, mává odelyky od nemalého vzestoru gigmateuce, mžít (lvu oná) j) dodšvojí zajímavost. Chorobné zkaz hyoří cené vzežření.

Josef Vnef

Světlo dvou zátronek Nitrophot je dovn sího, oby vědné podošlo boharou kresbu v pretnoch, a zmučené tak přirozel, oby reprodukávola vroby u kozy platí v nešti. K zochrané těchto nuancí zet nejvhodnější číství: luchtní orthochromatícká deska. Obskiztn Radienstoršův Estyner f=30 cm 1: 4,5, zaslonéní no 22, s expozicí 10 vteřin.

Foto Jaroslav Funke a Eikl

Photographies J. Funke et ses Eikrys

Mario _(Caio)_ Garrubba

Caio M. Garrubba: **Fotografie.**
Rom (Cinecittàdue Arte
Contemporanea) 2005

19.12.1923 Naples (Italy) — 2.5.2015 Spoleto (Italy) Leading photo-journalist in Italy in the 1950s and 60s. Schooling in Naples and Rome. Studies medicine, then philosophy. 1947 takes up journalism. Works at first for trade-union newspapers and magazines. 1952 travels to Spain, where he takes his first photographs. First photo publication in the weekly _Il Mondo_. After that worked as independent photojournalist. Still in the 1950s numerous travels incl. to Germany, Switzerland, Holland, Denmark, Sweden, Norway, England, France. Later, especially China and the Soviet Union. As photojournalist exponent of the so-called Scuola Romana (School of Rome: Franco Pinna, Ermanno Rea, Nicola Sansone, Pablo Volta), whose works bear a certain comparison to the "photographie humaniste" of post-war France. Numerous large reportages (also in color) A number of books incl. _China_ (1963), _Laz zaro alla tua porta_ (1967), _I cines_ (1969). Known in Germany through his publications in _twen_. Already appears in its first issue (no. 1, 1959) with photos of a young Christine Kaufmann in a bikini. Later individual photos from his well-known reportages as visual lead for Gerhard Zwerenz's _Politischem ABC_.

"The photos of Caio Mario Garrubba are [...] some of the highest achievements of photographic culture of the last fifty years — to the extent that, to remain in the sphere of reportage, we can place his name next to those of Eugene Smith, Édouard Boubat, Micha Bar-Am, Werner Bischof, Robert Capa, and Henri Cartier-Bresson: figures who to many people are better known but only for reasons of, let's say, publicity. They worked in a very favorable cultural environment. Garrubba, however — and the whole of Italian photography — has suffered from the prejudice of Italian art scholars, who with rare exceptions have considered photography as a marginal creative activity." — Diego Mormorio ✎

EXHIBITIONS (Selected) — **1968** Cologne (photokina) GE // **1995** Munich (Stadtmuseum) GE // **2005** Rome (Cinecittàdue – Arte Contemporanea/**Fotografie** 1953–1990) SE // **2008** Lugano (Switzerland) (Museo d'Arte/**Photo20esimo**) GE

BIBLIOGRAPHY (Selected) — Karl Pawek: **Totale Photographie.** Olten/Freiburg im Breisgau 1960 // **Weltausstellung der Pho-**tographie. Hamburg 1964 // **2. Weltausstellung der Photographie.** Hamburg 1968 // **3. Weltausstellung der Photographie.** Hamburg 1973 // **I Grandi Fotografi: C.G.** Milan 1983 ✎// Hans-Michael Koetzle (ed.): **twen. Revision einer Legende.** Munich 1995 (cat. Stadtmuseum) // **C.M.G.: Photographs.** Rome 2000 // Diego Mormorio: **C.M. Garrubba.** Rome 2005 (cat. Cinecittàdue – Arte Contemporanea) ✎

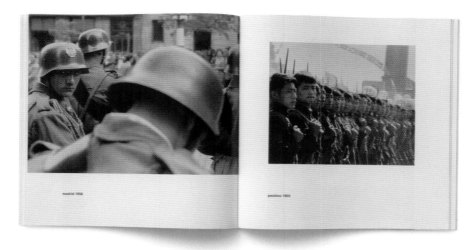

madrid 1956

pechino 1959

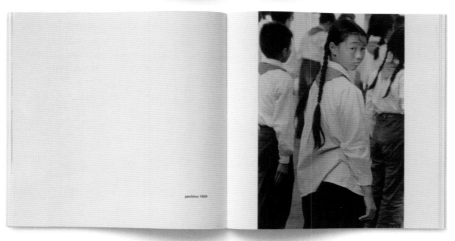

pechino 1959

Mario Giacomelli

1.4.1926 Senigallia (Italy) — 25.11.2000 Senigallia (Italy) People and landscapes of Italy in convincing pictorial forms drawing on the experimental ideas of the 1950s. Internationally one of the best-known post-war Italian art photographers. Grandparents farmers. Grows up in poverty. Loses father in 1934. Mother works in a retirement home laundry. Leaves school at 13. Apprenticeship as printer. 1944 soldier. After the war takes over and expands a destroyed printer's shop. Influenced by Neo-Realist cinema, (1952) buys his first camera (Bernici Comet). *L'approdo* (Washed Ashore, 1952) his first photo with artistic ambitions. Through Giuseppe Cavalli and the photographers' group La Bussola (The Compass) increasingly sensitive to the artistic potential of photography. Through Paolo Monti (head of the group La Gondola) 1955 participates in the *Mostra nazionale di Fotografia* exhibition (Castelfranco, Veneto). At first, the landscape of his region in graphically accented tableaux. Later, especially people in an equally elaborate pictorial language. 1954–1956 series *Vita d'ospizio* (Life in Retirement Home). 1966–1968 series *Verra la morte e avra I tuoi occhi* (after a poem by Cesare Pavese). 1957 photographs in Lourdes. 1962–1963 series *Young Priests* his best-known work today. 1964–1967 photo essay on the life of agricultural workers (*La buona terra*). Numerous publications, incl. in *Camera, Magnum, FotoPrisma, Progresso Fotografico*. 1959 participates in *subjektive fotografie 3*. 1995 Kulturpreis from the DGPh (Deutsche Gesellschaft für Photographie: German Photographic Association).

> **"In Italy, but also in the USA, England and France, Giacomelli's work has been known for decades […]. And everyone agrees that Giacomelli's photographs – mostly of landscapes and people – show a very independent pictorial language. A pictorial language, according to the American photo historian Naomi Rosenblum, whose exceptional quality is that it reconciles the world as it is with the world as it is photographed without unduly accenting the aesthetic and conceptual aspects of the medium."** — Karl Steinorth ✎⌐

EXHIBITIONS (Selected) — **1954** Pescara (Italy) (Palazzo Pomponi) GE // **1964** New York (Museum of Modern Art) SE // **1968** Rochester (New York) (George Eastman House) SE // **1969** Milan (Il Diaframma – 1974, 1975, 1979, 1984) SE // **1972** Paris (Bibliothèque nationale de France) SE // **1975** London (Victoria and Albert Museum) SE // **1977** London (The Photographers' Gallery – 1984, 1986, 1987, 1994) SE // **1984** Arles (Rencontres internationales de la photographie) SE // **1986** Bologna (Galleria d'Arte Moderna – 1994) SE // **1987** Paris (Centre national de la photographie) SE // **1988** Houston (Texas) (Museum of Fine Arts) SE // **1989** New York (International Center of Photography) SE // **1995** Cologne (Museum Ludwig) SE // **2001** New York (Gallery 292) SE // **2002** London (Photofusion) SE // **2005** Paris (Bibliothèque nationale de France – Site Richelieu) SE // Aachen (Suermondt-Ludwig-Museum) SE // Copenhagen (Fotografisk Center) SE // **2008** Tokyo (Metropolitan Museum of Photography) SE // **2009** Milan (Forma) SE // **2013** Salzburg (Museum der Moderne) GE

BIBLIOGRAPHY (Selected) — L. Carluccio and A. Colombo: **M.G.** Milan 1983 // E. Taramelli: **M.G.** Paris 1993 // E. Carli: **G. – la forma dentro.** Milan 1995 // **M.G.: Fotografien 1952–1995.** Ostfildern 1995 (cat. Museum Ludwig) ✎⌐ // Alistair Crawford: **M.G.** London 2001 // **Focus on Photography.** Munich 2013 (cat. Museum der Moderne, Salzburg)

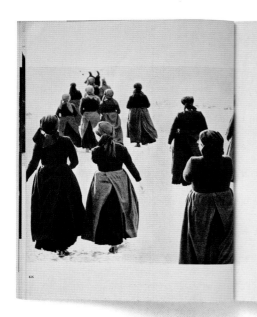

Mario Giacomelli,
from: **Camera,** no. 9, 1958

Ralph (Holmes) Gibson

Ralph Gibson: **Days at Sea**.
New York (Lustrum Press) 1974

16.1.1939 Los Angeles (USA) — Lives in New York (USA) Pioneering art photographer in the 1960s and 70s, also publisher. Exponent of an experimental art photography drawing on Surrealism. When still at school, an extra in films by Alfred Hitchcock and Nicholas Ray. Joins US Marines at 17. There trains in the Naval School of Photography in Pensacola (Florida). 1959 discharge. Studies at the San Francisco Art Institute (1960–1961). At the same time works as assistant to > Lange. First independent work akin to street photography capturing everyday strangeness. 1962 returns to Los Angeles. Independent photographer. 1962 first publication in the magazine *Nexus*. 1966 moves to New York. Meets > Clark, > Frank, > Mark. Collaborates with Frank on his film *Me and My Brother* and works on the book *The Somnambulist*. Founds Lustrum Press. There he publishes his own influential books such as *The Somnambulist* (1970), *Déjà-vu* (1972), and *Days at Sea* (1974), as well as important books by Frank (*Lines of My Hand*, 1971) and Clark (*Tulsa*, 1971). 1979 in Berlin with a DAAD (Deutscher Akademischer Austausch Dienst — German Academic Exchange Service) fellowship. 1985 John Simon Guggenheim fellowship. 1988 Leica Medal of Excellence. Numerous further fellowships and awards for his oeuvre, generally organized in large series (incl. *Quadrants*, 1975–1980; *Chiaroscuro*, 1972–1998; *In Situ*, 1985; *Infanta*, 1971–1998; *L'Histoire de France*, 1971–1998).

EXHIBITIONS (Selected) — **1962** San Francisco (The Photographer's Roundtable) SE // **1970** San Francisco (San Francisco Art Institute) SE // **1973** Cologne (Galerie Wilde) SE // **1979** Berlin (Werkstatt für Photographie) SE // **1982** Paris (Centre Pompidou) SE // **1987** New York (International Center of Photography) SE // **1989** Stockholm (Moderna Museet) SE // **1996** Frankfurt am Main (Kunstverein) SE // **2004** Moscow (Moscow House of Photography – 2008) SE // **2005** Bologna (Galleria d'Arte Moderna) SE // **2007** Tucson (Arizona) (Center for Creative Photography/**Ralph Gibson and Lustrum Press, 1970–1984**) SE // **2008** Moscow (Moscow House of Photogra- phy) SE // **2009** Paris (Photo 4 et Galerie Lucie Weill & Selig- mann) SE // Los Angeles (Fahey/Klein Gallery) SE

BIBLIOGRAPHY (Selected) — **Days at Sea**. New York 1974 // **Syntax**. New York 1983 // **Chiaroscuro**. Paris 1990 // **L'Histoire de France**. Paris 1991 // **Infanta**. New York 1995 // **Lichtjahre**. Kilchberg/Zurich 1996 (cat. Frankfurter Kunstverein) ✍⬚ // **Courant Continu**. Paris 1999 // **Deus ex machina**. Cologne 1999 // **Ex Libris**. New York 2001 // **Refractions**. Göttingen 2006 // **Nude**. Cologne 2009 // **Mono**. New York 2014

"Gibson has assimilated a wide variety of influences from art in his work. Often they are contradictory currents which he has brought together in a timeless personal style blending intellect and emotion, conscious and subconscious, objective form and subjective intuition."
— Peter Weiermair ✍

Bruce Gilden

Bruce Gilden: **Coney Island.**
New York (Westerham Press)
2002

16.10.1946 Brooklyn (New York, USA) — Lives in New York (USA) Small-format camera, daylight and flash as technical/aesthetic constants of his dynamic street photography influenced by William Klein and Diane Arbus. Studies at Pennsylvania State University. Course at the School of Visual Arts in New York City. As photographer mostly self-taught. First solo exhibition 1971. Since then many solo and group exhibitions. Numerous publications, incl. in *Aperture Magazine*, *Creative Camera*, *Camera International*, *Vis-à-Vis*, *Libération*, *Foto Magazin*, *Leica World*. A number of awards and fellowships, incl. National Endowments for the Arts (1980, 1984, 1992), Villa Médicis Hors les Murs (1995), European Publishers Award (1996), Japan Foundation Artists' Fellowship (1999), New York Foundation for the Arts (1979, 1992, 2000). Numerous travels. Tests his method in Haiti, in Ireland, and in Japan, among others. Magnum member since 1998. 2002 publishes book of his early New York photos, entitled *Coney Island*.

EXHIBITIONS (Selected) — **1986** Arles (Rencontres internationales de la photographie) SE // **1989** Paris (Bibliothèque nationale de France) SE // **1990** Paris (Galerie Agathe Gaillard – 1994, 2000) SE // **1993** Lausanne (Switzerland) (Musée de l'Élysée) SE // **1997** New York (Leica Gallery) SE // Bath (Royal Photographic Society) SE // **2000** Dublin (Gallery of Photography) SE // **2002** Copenhagen (Fotografisk Centrum) SE // **2003** Milan (Carla Sozzani Gallery) SE // Frankfurt am Main (Fotografie Forum international) SE // **2006** Valladolid (Spain) (Sala Municipal de Exposiciones) SE // New York (Silverstein Photography) SE

BIBLIOGRAPHY (Selected) — **Facing New York**. Manchester 1992 📖 // **Haiti**. Heidelberg 1996 // **After the Off**. Stockport 1999 // **Go**. London/New York 2000 // **Coney Island**. New York 2002 // **Fashion Magazine**. New York 2006 // **B.G.** Paris 2013 (= Photo Poche 148)

"The cast of characters in Bruce Gilden's theater of the street is outrageous. Sometimes tawdry and out of this world, they are mostly mysterious. To Gilden and his fellow New Yorkers, they're just neighbors. In broad and simple terms, and with great expressive authority, Gilden has captured the uniquely individualistic, self-styled New York personality on the run. In Gilden's world, no one is on the margins of center stage, they are all star players." — Susan Kismaric ✍

Rolf *(Herbert)* Gillhausen

Rolf Gillhausen and Joachim Heldt:
Unheimliches China. Eine Reise durch den roten Kontinent.
Hamburg (Nannen-Verlag) 1959

31.5.1922 Cologne (Germany) — 22.2.2004 Hamburg (Germany) Well-known photojournalist in Germany in the 1950s. Later influential as a "mover" and art director at Stern. 1937–1939 technical apprenticeship in Cologne. Studies engineering but does not finish. Military service and prisoner of war (released 1946). Miner near Cologne. 1947 first Leica and beginning of work as photographer. 1948 moves to Heidelberg. Odd jobs. Meets Fred Ihrt, and works as his assistant to 1951. At same time first publications in *Rhein-Neckar-Zeitung*. 1951 reporter for Associated Press in Bonn. Photo reports from the Rhineland, but also foreign reports. 1955 collaborator for *Stern*. 1956 much admired reportage on the Hungary uprising. Photo report on the Mau Mau movement in Kenya. 1958–1961 together with Joachim Heldt extensive travels through China, India, and Africa. Film and photo re-portage. With the title *Unheimliches China* multi-part photo report in *Stern*. 1960 reportages from Turkey, Cuba, and the USA. 1963 report-age *DDR von innen*. Also travels to USSR, Spain, Sweden, Mexico, and the USA. 1964 replaces Karl Pawek at *Stern* for cover design. 1966 editor-in-chief of *Quick*. Returns to *Stern*. 1976–1978 initiator and (together with Rolf Winter) editor-in-chief of *Geo*. 1981 with Peter Koch and Felix Schmidt editor-in-chief of *Stern*. 1984 leaves *Stern* editorial staff. Numerous publications in *Das Deutsche Lichtbild* (1963, 1964, 1965, 1966, 1967) and in the publications accompanying the three *Weltausstellngen der Photographie* exhibitions (1964, 1973, 1977), curated by Karl Pawek. Member of the DGPh (Deutsche Gesellschaft für Photographie: German Photographic Association) (1971–1984) and ADC (Art Directors Club) (1965–1984). Estate held by the Museum Folkwang/Fotografische Sammlung.

"Gillhausen's reportages were made at a time when photos were increasingly replacing text. His approach to the printed media was pragmatic, without any ambition for recognition as a photographer beyond the press. In his unbroken positive view of the function of the illustrated press, Gillhausen worked as a mover, an ideas man in this branch." — Ute Eskildsen ✐

EXHIBITIONS (Selected) — **1986** Essen (Germany) (Museum Folkwang) SE // **1996** Hamburg (Deichtorhallen) GE // **1997** Bonn (Kunst- und Ausstellungshalle der BRD) GE // **1999** Düsseldorf (Galerie Zimmer) SE // **2001** Berlin (Kunsthaus Lempertz) GE // **2006** Berlin (Willy-Brandt-Haus) JE (with Erich Lessing)

BIBLIOGRAPHY (Selected) — **Film und Fotoreportagen**. Essen 1986 (cat. Museum Folkwang) ✐ // **Deutsche Fotografie. Macht eines Mediums 1870–1970**. Cologne 1997 (cat. Kunst- und Ausstellungshalle der BRD, Bonn) // "Ich war ein guter Macher." In: **Leica World**, no. 2, 1998

Am Schaltpult einer riesigen Maschinenhalle steht eine 22jährige junge Chinesin. Sie bekommt einen Monatslohn von etwa 100 DM – für eine Spezialarbeit, die im Ruhrgebiet mit dem Zehnfachen bezahlt wird. Die Halle gehört zu dem modernsten Walzwerk des Fernen Ostens, das sowjetische Experten in Anshan vor fünf Jahren aufbauten. Dieselben Herren hatten es nach der japanischen Niederlage in der Mandschurei demontiert. Den Wieder-Aufbau ließen sich die roten Brüder teuer bezahlen.

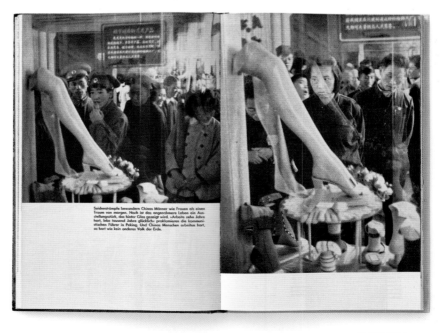

Seidenstrümpfe bewundern Chinas Männer wie Frauen als einen Traum von morgen. Noch ist das angenehmere Leben ein Ausstellungsstück, das hinter Glas gezeigt wird. »Arbeite zehn Jahre hart, lebe tausend Jahre glücklich« proklamieren die kommunistischen Führer in Peking. Und Chinas Menschen arbeiten hart, so hart wie kein anderes Volk der Erde.

Nan Goldin

Nan Goldin: **The Ballad of Sexual Dependency.** New York (Aperture) 1986

12.9.1953 Washington, DC (USA) — Lives in Paris (France) Portraits, self-portraits, the lives of socially marginalized groups. Photography as a visual diary. Also multimedia forms of presentation. Protagonist of an art photography drawing on snapshot aesthetics and interested in the private sphere. Childhood in Washington, DC. After her older sister's suicide, removed from parental care and given to foster parents. Schooling in Lincoln (Massachusetts). First b/w photos and Polaroids of friends (incl. David Armstrong). Evening classes at the New England School of Photography under Henry Horenstein. Through him discovers the work of > Clark. 1974 workshop under > Model. Begins studying at the School of the Museum of Fine Arts, Boston (with > diCorcia and Mark Morrisroe). 1973 takes up color photography (incl. flash and wide-angle aesthetic). 1978 moves to New York. There promoted by Marvin Heiferman (Castelli Graphics). Apart from first group exhibitions especially slide shows (from 1980 with music). 1981: *The Ballad of Sexual Dependency* her most important multimedia presentation to date (1985/86 much admired at the film festivals in Edinburgh and Berlin). Afterwards increasing drug abuse, and 1988 enters rehabilitation center. Subsequently increasing exploration of her own self (slide show: *All By Myself*). In addition series on drag queens (*The Other Side*; *A Double Life*), a project with Nobuyoshi Araki (*Tokyo Love*) and photos of empty rooms (hotel rooms, etc.), entitled *Vakat*, as "places of memory" (Elisabeth Sussman). 1996 major retrospective at the Whitney Museum of American Art. 2001 much admired exhibition in Paris and 2002 in Madrid. 2007 Hasselblad Award.

EXHIBITIONS (Selected) — **1977** Boston (Atlantic Gallery) JE (with David Armstrong) // **1985** Boston (Institute of Contemporary Art) SE // **1987** Arles (Rencontres internationales de la photographie — 1997, 2009) SE // **1988** New York (Pace/MacGill Gallery – 1990, 1993) SE // **1991** Graz (Austria) (Forum Stadtpark) SE // **1992** Berlin (DAAD Galerie) SE // **1993** Stockholm (Fotografiska Museet i Moderna Museet) SE // **1994** Berlin (Neue Nationalgalerie) SE // **1996** New York (Whitney Museum of American Art) SE // **1998** Wolfsburg (Germany) (Kunstmuseum) SE // Hamburg (Kunsthalle) GE // **2001** Paris (Centre Pompidou) SE // **2002** Madrid (Museo Nacional Centro de Arte Reina Sofía/PHotoEspaña) SE // **2003** Avignon (Collection Lambert) SE // **2005** Philadelphia (Pennsylvania Academy of the Fine Arts) SE // **2006** Moscow (Moscow Museum of Modern Art) SE // **2007** Gothenburg (Hasselblad Center) SE // **2008** Stockholm (Kulturhuset) SE // **2009** Arles (Rencontres internationales de la photographie) SE // **2010** Berlin (Berlinische Galerie) SE

BIBLIOGRAPHY (Selected) — **The Ballad of Sexual Dependency.** New York 1986 // **Cookie Mueller.** New York 1991 // **The Other Side.** Zurich/Berlin/New York 1993 // N.G. and Nobuyoshi Araki: **Tokyo Love.** Zurich/Berlin/New York 1995 // N.G. and David Armstrong: **A Double Life.** Zurich/Berlin/New York 1994 // **I'll Be Your Mirror.** New York, 1996 (cat. Whitney Museum of American Art) ✎ // **Emotions & Relations: N.G., David Armstrong, Mark Morrisroe, Jack Pierson, Philip-Lorca diCorcia.** Cologne 1998 (cat. Hamburger Kunsthalle) // **The Devil's Playground.** London 2003 // Guido Costa: **N.G.** London 2006 // **The Beautiful Smile.** Göttingen 2007 (cat. Hasselblad Award)

"Nan Goldin is a passionate chronicler of love in an age of unidentified sexual orientation, glamour, beauty, violence, death, intoxication and masking. [...] Her camera captures the ups and downs of social experiences tied to a desire for the other: Love and hate in intimate relations; moments of loneliness, self-revelation and admiration; a sexuality freed from the constraints of biological definition. But Goldin's story is not abstract. It is told through the lives of people who are part of her own life ..." — Elisabeth Sussman ✍

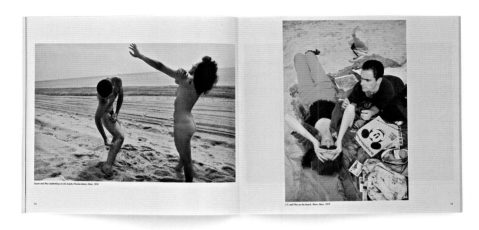

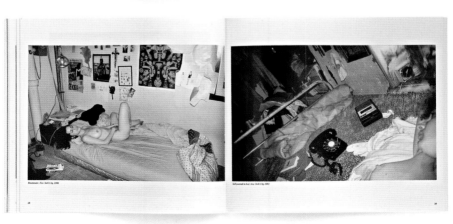

Jean-Paul Goude

1940 Paris (France) — Lives in Paris Dancer, stylist, dramaturge, entertainer, director, photographer. As art director, creator of the Grace Jones "brand" among others. Since the late 1970s one of the most multi-talented figures in France and abroad. Son of an American dancer and a French father. Shortly before the outbreak of WW II, family returns to Europe. Childhood and schooling in Saint Mandé, a petit-bourgeois suburb of Paris. At his father's wish he attends technology-oriented Lycée Volaire. After poor school results changes to Académie de la Grande Chaumière, where he studies painting, drawing, applied arts. At the same time, increasing enthusiasm for film, especially American musicals. Dance lessons with a vague aim of career as musical director. Fashion and design and magazines such as *Esquire* and *Harper's Bazaar* major influences. 1962 travels to New York for the summer. Lessons at the American Ballet Center under Robert Joffrey, who advises against a career in dance. Returns to Paris. There, at the invitation of Kimpy Baumgartner — artistic director for the Printemps department store — designs a wall for Brummel, the store's own brand of men's clothing. Growing success in fashion illustration. After setbacks returns to New York, the beginning of his affinity with Afro-American culture. Returns to Paris and then back to New York. There to 1976 art director for *Esquire*. 1972 first success as stylist for the black model Radiah. Photos for *Esquire* and *Playboy* (incl. the bodybuilder Kellie Everts). Impresario and partner in life of Grace Jones, whose androgynous image due mostly to J.-P.G. Conception of an illustrated supplement for the daily *Le Monde* (*Le Monde illustré*). Advertising spots (incl. Diam's stockings or Egoïste, and Coco by Chanel). Artistic director of the bicentennial of the French Revolution (1989). Advertising for Hermès, Cacharel, Lagerfeld, Gaultier, and Lacroix as well as (since 2001) responsible for the Galeries Lafayette's advertising strategy.

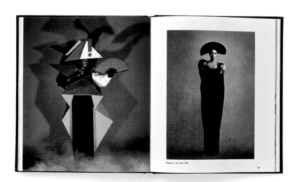

EXHIBITIONS (Selected) — **2006** Paris (Musée de la publicité/ **Und histoire de la photographie publicitaire en France – De Man Ray à Jean Paul Goude**) GE // Paris (Les Arts décoratifs) SE // **2007** New York (Hasted Hunt) SE // Berlin (Galeries Lafayette Berlin) SE

BIBLIOGRAPHY (Selected) — **Jungle Fever.** New York/Paris 1981 // **Splendeurs et Misères du Corps.** Paris 1988 // **The Idealizing Vision: The Art of Fashion Photography.** New York 1991 // David Hillman and Harry Peccinotti: **Nova 1965–1975**. London 1993 // **Azzedine Alaia.** Göttingen 1998 // **So far so Goude.** London 2005 (German edition Munich 2005) ✐ // **J.-P.G.** Paris 2006 (cat. Les Arts décoratifs)

"For more than thirty years Jean Paul Goude has defined our vision and view of the world with his drawings, posters, photographs, films, videos and events. From the *Minets* of the 1960s via the legendary *Esquire* in the 1970s, from Warhol's New York and ethnic culture to Grace Jones, who he reinvented like Pygmalion, from the grandiose parade for the 200th anniversary of the French Revolution, advertising for Kodak and Chanel to Laeitia Casta as theme with variations, every time Jean-Paul Goude caught the spirit of the time and gave it a human form."
— Anonymous/Inside Cover ✑

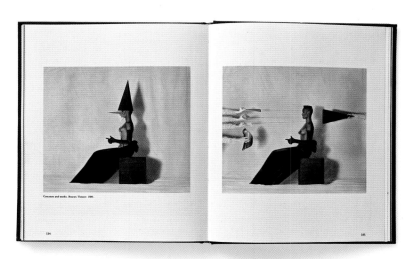

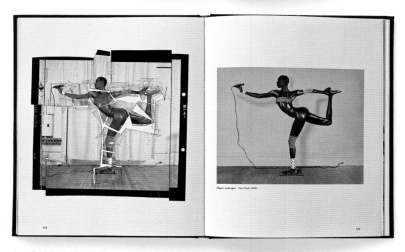

Jean-Paul Goude: **Jungle Fever.**
Paris (Xavier Moreau) 1981

Milton H. *(awthorne)* Greene *(Milton Greengold)*

Milton Greene: **But That's Another Story: A Photographic Retrospective of Milton H. Greene.** Brooklyn (powerHouse Books) 2008

14.3.1922 New York (USA) — 8.8.1985 New York People, fashion, advertising. In America of the 1950s – together with Richard Avedon, Irving Penn, and Bert Stern – one of the best-paid photographers in his field. Still well known, especially for his portraits of Marilyn Monroe. Youngest of five children of a Russian immigrant tailor. Childhood in Sheepshead Bay in New York. Attends Abraham Lincoln High School. At 14 assistant to Eliot Elisofon. His first own work for mail-order catalogues and advertising agencies. Founds a studio with Marty Bauman. Ad campaigns for cars, washing machines, dryers, etc. Separates from Bauman and moves to Macy's as fashion photographer. Resigns. Meets the editor-in-chief of *Look*, Fleur Cowles, who opens the way to editorials. Subsequently rapid rise to "star photographer" (called "Milti"). Prominent especially in the 1950s and 60s with numerous publications in magazines such as *Look*, *Harper's Bazaar*, *Town & Country*, and *Vogue*. Apart from fashion photos above all star portraits: artists, musicians, actors and singers, incl. Sammy Davis, Jr., Marlene Dietrich, Giacometti, Dizzy Gillespie, Cary Grant, Audrey Hepburn, Alfred Hitchcock, Grace Kelly, Norman Mailer, Elizabeth Taylor, Andy Warhol. 1953 photographs Marilyn Monroe for *Look*. Beginning of a four-year intensive friendship with the actress, whom he encourages to get out of her unfavourable contract with 20th Century Fox. They try to set up a company together. In the end (at least) a renegotiation of Marilyn's contract with Fox. Works (incl. lighting and make-up) on the films *Bus Stop* and *The Prince and the Showgirl*. Subsequently the relationship rapidly cools up to the definitive break (1957). Numerous exhibitions particularly of his Marilyn portraits, probably M.G.'s most significant work. A number of awards, e.g. from the American Institute of Graphic Arts and the Art Director's Club.

"Marilyn loved still cameras. And this love was reciprocal. This was never clearer than during the four years she worked together with Milton Greene." — James Kotsilibas-Davis ✍

EXHIBITIONS (Selected) — **2004** Brooklyn (New York) (Brooklyn Museum of Art) GE // **2006** Hamburg (Kunsthaus/**Marilyn**) GE // New York (Staley-Wise Gallery/**Marilyn**) GE // Boca Raton (Florida) (Boca Raton Museum of Art/**Life as a Legend: Marilyn Monroe**) GE // **2008** Lugano (Switzerland) (Museo d'Arte/**Photo2Oesimo**) GE

BIBLIOGRAPHY (Selected) — **Marilyn Monroe und die Kamera. 152 Photographien aus den Jahren 1945–1962.** Munich 1989 // Joshua Greene (ed.): **Milton's Marilyn. Die Photographien von M.H.G.** Munich 1994 ✍ // **The Great LIFE Photographers.** New York 2004 // But That's Another Story: A Photographic Retrospective of M.H.G. Brooklyn 2008

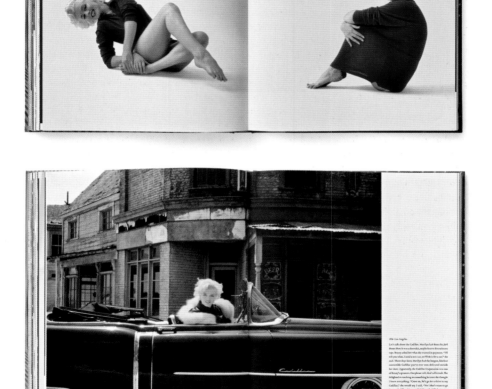

1956, Los Angeles

Let's talk about the Cadillac. Marilyn had done the *Jack Benny Show*. It was a show told, simple host to five minutes tops. Benny asked her what she wanted in payment. "I'll tell you what. I need a new car, so I'll do it for a car," she said. Three days later, Marilyn had the longest, blackest convertible Cadillac you've ever seen delivered outside her door. Apparently, the Cadillac Corporation was one of Benny's sponsors. Our phone call, that's all it took. She delighted in reaching out something because she thought I knew everything. "C'mon on, let's go for a drive in my Cadillac," she would say. I said, "No I don't want to go in your Cadillac. It's too cold." She said, "I'll show you a trick." So off we went in and around. Sit, up, down, side-ways, all she did was turn the heat on. Brilliant!

Philip Jones Griffiths

Philip Jones Griffiths: **Dark Odyssey/Dunkle Odyssee.** New York/Frankfurt am Main (Aperture/Zweitausendeins) 1996

18.2.1936 Rhuddlan (Wales) — 19.3.2008 London (England) Photojournalist. Magnum photographer. Important exponent of the photo essay. Internationally known especially for his graphic Vietnam War reports. Studies in Liverpool (pharmacy). Night manager in a drugstore in London. At the same time photos for the *Manchester Guardian*. From 1961 full-time freelance for the *Observer* (London). 1962 reportages on the war in Algeria. 1966–1968 and 1970 Vietnam. 1971 as a result of his three-year observation of the war, publishes *Vietnam Inc.*, much admired internationally. Considerable influence on opinions concerning US involvement in Vietnam. Also seen as "one of the most detailed studies of war ever". 1966 Magnum candidate. Member since 1970. 1973 Yom Kippur War. 1973–1975 Cambodia. 1977 Thailand. 1980 moves to New York. There Magnum president for five years. More recently reports on modern Vietnam and the Gulf War. From 1974 more documentary films, incl. for the BBC, a feature on the descendants of the ship the *Bounty* on Pitcairn Island. Altogether reportages from 140 countries for all the major international magazines.

"I don't want to diminish the accomplishments of anyone taking a single, beautiful, informative image – that's what I try to do when I look through the viewfinder. If I was a poet I would certainly want each word in the poem to be a beautiful and evocative and meaningful word, but still it's only a word. Stringing words together is what makes a poem. I want to write poetry, not come up with evocative words." — Philip Jones Griffiths ✑

EXHIBITIONS (Selected) — **1967** Ottawa (National Gallery of Canada) GE // **1973** Hamburg (3. Weltausstellung der Fotografie) GE // **1983** London (The Photographers' Gallery) GE // **1998** Bradford (England) (National Museum of Photography, Film and Television) GE // **2000** Paris (Bibliothèque nationale de France/**magnum**) GE (afterwards Rome, Milan, Berlin, New York) // **2004** Newcastle-upon-Tyne (England) (Side Photographic Gallery) SE // **2005** New York (Denise Bibro Fina Art) SE // **2006** Daytona (Southeast Museum of Photography) SE // **2007** London (Trolley Gallery) SE // **2008** Liverpool (National Conservation Centre) SE // Paris (École Nationale supérieure d'architecture) SE // **2009** Newcastle-upon-Tyne (England) (Side Gallery) SE

BIBLIOGRAPHY (Selected) — **Vietnam Inc.** New York 1971 // **Bangkok.** Amsterdam 1979 // **Dark Odyssey.** New York 1996 // **Magnum Photos.** Paris 1997 // Martin Harrison: **Young Meteors: British Photojournalism: 1957–1965.** London 1998 (cat. National Museum of Photography, Film and Television, Bradford) // **magnum.** Paris 2000 (cat. Bibliothèque nationale de France) // **Vietnam Inc** (Revised Edition) London 2001 // **Agent Orange: Collateral Damage in Vietnam.** London 2003 // Chris Boot (ed.): **Magnum Stories.** London 2004 ✑ // **Vietnam at Peace.** London 2006 // Brigitte Lardinois: **Magnum Magnum.** Munich 2007 // **P.J.G.: Recollections.** London 2009

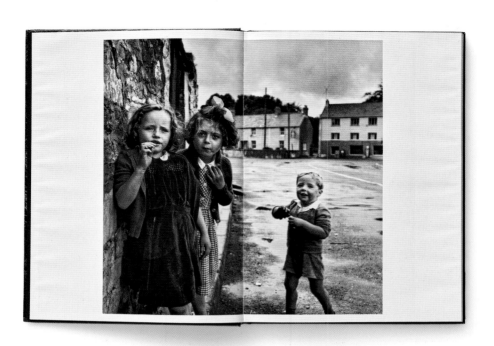

Sid(ney) Grossman

25.6.1914 New York (USA) — 31.12.1955 New York Founding member of the Photo League. As an antipode to Alexey Brodovitch, the exponent of a more socially critical rather than formalistic (independent) art photography. Father dies early. Mother works as cook during the summer months. 1929–1932 high school in the Bronx. Member of his school's photo club. 1934 City College of New York. Subsequently independent photographer. 1936 together with Sol Libsohn and others, founds the New York Photo League. Teacher (1938–1949), secretary (1939–1941, 1946), and (1941–1947) head of this influential school, supported by > Adams, > Smith, Edward Weston, Beaumont Newhall, and Nancy Newhall, among others. A number of large documentary series (some contracted by the WPA, the Work Projects Administration), incl. *The Chelsea Document* (together with Sol Libsohn, 1938–1939), *Negroes in New York* (1939), *Midwest* (1940). 1943–1946 serves in the US Army, stationed in Panama. Photos of the *Black Christ Festival* (1945). 1946–1948 most fruitful period of his work. Series: *Folksingers* (incl. Pete Seeger, Woody Guthrie), *Coney Island*, *New York Recent*, *Mulberry Street*, *American Legion*. 1949 leaves the League (accused of pro-communist activities). 1949–1955 studies art under Hans Hofmann. Opens a photo school in Provincetown. Subjects now include dance (*New York Ballet*, 1951–1955) and nature photography (Cape Cod).

"Whatever the degree of their mutual awareness, Grossman and Brodovitch were significantly unlike their styles and beliefs. Grossman was a politically engaged, ascetic, uncompromising, and sometimes embattled artist whose allegiances were firmly planted in the proletarianism of the political left. Brodovitch, on the other hand, was born and remained an aristocrat, a man of authoritarian taste […]. Even though Grossman soon rejected the ideological simplicity of the idea of photography being instrumental in social change, his original gravitation to this idea continued to reverberate powerfully among a significant number of his peers."

— Jane Livingston ✍

EXHIBITIONS [Selected] — **1939** New York (Photo League) GE // **1940** New York (Museum of Modern Art – 1948) GE // **1961** New York (Image Gallery) SE // **1978** Ottawa (National Gallery of Canada) GE // **1981** Houston (Texas) (Museum of Fine Arts) SE // **1985** Washington, DC (Corcoran Gallery of Art – 1986) GE // **1987** New York (Howard Greenberg Gallery – 1994) SE // **1991** San Francisco (Museum of Modern Art) JE (with Leon Levinstein) // **1999** Madrid (PHotoEspaña) GE // **2006** New York (Howard Greenberg Gallery) GE // **2007** Munich (Galerie Stephen Hoffman) GE // **2009** Vienna (Wien Museum/**Big City**) GE

BIBLIOGRAPHY [Selected] — **Journey to the Cape**. New York 1959 // Anne Tucker: **Photographic Crossroads: The Photo League**. Ottawa 1978 (cat. National Gallery of Canada) // Anne Tucker: **S.G.: Photographs 1936–55**. Houston 1981 (cat. Museum of Fine Arts) // Jane Livingston: **The New York School**. New York, 1992 ✍ // **Photo League**. Madrid 1999 (cat. PHotoEspaña)

Sid Grossman, from: **The New York
School. Photographs 1936–1963.**
New York (Stewart, Tabori &
Chang) 1992

F.C. *(Franz Christian)* Gundlach

F.C. Gundlach: **ModeWelten.
Photographien 1950 bis heute.**
Berlin (Frölich & Kaufmann) 1986

16.7.1926 Heinebach (Germany) — Lives in Hamburg (Germany)
Reportages, portraits, and especially fashion. As a fashion photographer one of the most important exponents of his field in Germany from the 1950s to the 70s. 1936 first camera. 1938 sets up a darkroom. 1936–1943 secondary school. Wartime school-leaving exam and serves as an assistant in the German air force. 1945 wounded and prisoner of war. 1947–1949 photography apprenticeship in Kassel. 1949–1953 assistant to Ingeborg Hoppe in Stuttgart and Ossip Meerson in Paris. From 1949 publishes in magazines such as *Film-Revue*, *Funk-Illustrierte*, *Gong*, *Elegante Welt*, and *Stern*. 1953 begins intensive collaboration with *Film und Frau* (more than 100 covers, over 2,500 editorial pages). 1956 moves to Hamburg. Location trips to Africa and Asia as well as North, Middle and South America. From 1955 works together with Deutsche Lufthansa. 1963 begins intensive collaboration with *Brigitte* (more than 180 covers, over 5,500 editorial pages). Publishes in *Annabelle* and *Revue*. Advertising for Flake, Van Delden, Sinaz, among others. 1967 founds the CC company (Creative Color GmbH). 1971 founds the PPS company (Professional Photo Service) as a service company for photographers with b/w and color labs, rental service and studios. 1975 founds the PPS gallery. There to 1992 presents around 100 exhibitions. First major retrospective 1986 in Bonn with stops in Kassel (Neue Galerie), Berlin (Hochschule der Künste), Hamburg (Museum für Kunst und Gewerbe), Frankfurt am Main (Kunstverein), Bremen (Fotoforum), Erlangen (Kunstverein), as well as Graz, Nancy, Paris, Marseille, and Rotterdam. 1988 named professor at the Hochschule der Künste Berlin. 1999 initiates the Trieenale Hamburg. 2000 founds the F.C. Gundlach Foundation with the aim of caring for and cataloging the *Bild des Menschen in der Fotografie* (Image of People in Photography) collection he had been building up from 1975. 2003 founding director of the Haus der Photographie, Hamburg. Curator for the exhibitions *Berlin en Vogue* (1993), *Das deutsche Auge* (1996), *Martin Munkácsi* (2005), and *The heartbeat of fashion* (2006), among others. 2001 Kulturpreis from the DGPh (Deutsche Gesellschaft für Photographie: German Photographic Association).

EXHIBITIONS (Selected) — **1951** Paris (Librairie Jean Robert) SE // **1986** Bonn (Rheinisches Landesmuseum) SE // **1999** Brunswick (Fotomuseum) SE // **2001** Berlin (Galerie Kicken – 2006) SE // **2004** Graz (Austria) (Landesmuseum Johanneum) SE // **2004** Hamburg (Haus der Photographie/Deichtorhallen) SE // **2009** Berlin (Martin-Gropius-Bau) SE

BIBLIOGRAPHY (Selected) — Klaus Honnef (ed.): **ModeWelten. F.C.G.: Photographien 1950 bis heute.** Berlin 1986 (cat. Rheinisches Landesmuseum, Bonn) // **Fashion Photography 1950–1975.** Cologne 1989 // **Die Pose als Körpersprache.** Cologne 2001 // **Bilder machen Mode.** Graz 2004 (cat. Landesmuseum Johanneum) // **F.C.G.: Das fotografische Werk.** Göttingen 2008 (cat. Haus der Photographie/Deichtorhallen Hamburg)

"F.C. Gundlach's fashion photography, produced over four decades, carries his signature quite clearly. His images in color and black and white are thoughtfully constructed, highly artificial, aesthetically complex structures which, even when removed from their media context — the newspaper or magazine — can effortlessly stand by themselves, be it on a museum wall or in a gallery. Looking back, you could wonder whether F.C. Gundlach, always interested in formal, aesthetic questions, might not have found a career in 'art' as well. But apart from the fact that there was no place for a career as an artist working with photography in the Germany of the 1950s and 60s (even the experiments of 'subjektive photographie' were made as free time activities of applied photographers), F.C. Gundlach had chosen a career in contract photography quite early on and it remained a lifelong creative challenge." — Hans-Michael Koetzle ✎⊐

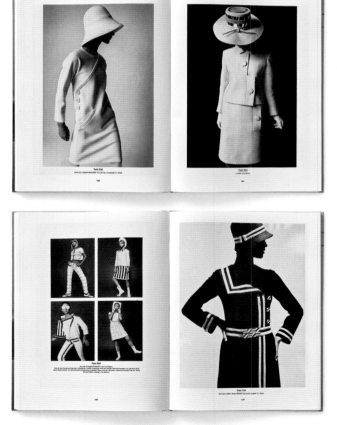

Andreas Gursky

Andreas Gursky: **Fotografien
1994–1998.** Wolfsburg
(Kunstmuseum Wolfsburg) 1998

15.1.1955 Leipzig (Germany) — Lives in Düsseldorf (Germany) Sports grounds, harbor scenes, streets, squares, interiors: the world from a distance, postmodern civilization as slide show. With large-format tableaux in reduced colors, internationally known since the 1980s. 1978–1981 studies at the Folkwangschule (GHS) in Essen, under Michael Schmidt, among others. 1981–1987 Kunstakademie Düsseldorf. 1985 Master's student under > Bernd Becher. First solo exhibition 1987. With Candida Höfer, Axel Hütte, > Ruff, and > Struth currently internationally best-known graduate of the Becker class. 1991–1992 participates in *Siemens Fotoprojekt*. 1993 in the important group exhibition *Die Photographie in der deutschen Gegenwartskunst* (Museum Ludwig), as well as 1997 in the much admired stock-taking *Positionen künstlerischer Photographie in Germany seit 1945* (Berlinische Galerie, Martin-Gropius-Bau). Awards incl. 1st Deutscher Photopreis (1989), RENTA Award (1991), Citibank Photography Prize (1998), Wilhelm Loth Award/Kunstpreis from the city of Darmstadt (2003), Lead Award (2008), Kaiserring Kunstpreis from the city of Goslar (2008). 2008 with the title *Objectivités. La photographie à Düsseldorf*, major review of the Düsseldorf school in the Musée d'art modern de la Ville de Paris.

EXHIBITIONS (Selected) — **1987** Düsseldorf (Flughafen) SE // **1988** Cologne (Galerie Johnen & Schöttle – 1991) SE // **1989** Krefeld (Germany) (Museum Haus Lange) SE // **1991** Nuremberg (Kunsthalle) GE // Munich (Galerie Rüdiger Schöttle – 1997) SE // **1992** Zurich (Kunsthalle) SE // **1993** Cologne (Museum Ludwig) GE // Cologne (Galerie Monika Sprüth – 1996, 2004) SE // **1994** Hamburg (Deichtorhallen) SE // **1995** Frankfurt am Main (Portikus) SE // **1997** Berlin (Berlinische Galerie) GE // **1998** Düsseldorf (Kunsthalle) SE // Wolfsburg (Germany) (Kunstmuseum) SE // **2000** Eindhoven (Netherlands) (Van Abbemuseum) SE // **2001** New York (Museum of Modern Art) SE // **2007** Munich (Haus der Kunst) SE // Basel (Kunstmuseum) SE // **2008** Darmstadt (Mathildenhöhe) SE // Paris (Musée d'art moderne de la Ville de Paris) GE // Krefeld (Germany) (Kunstmuseen) SE // **2009** Stockholm (Moderna Museet) SE // Vancouver (Art Gallery) SE // **2012** Humlebaek (Louisiana Museum of Modern Art) SE // Düsseldorf (Museum Kunstpalast) SE // Düsseldorf (Stiftung Museum Kunstpalast) SE // Humlebaek (Louisiana Museum of Modern Art) SE // **2013** Tokyo (National Art Center) SE // **2014** Osaka (National Museum of Art) SE

BIBLIOGRAPHY (Selected) — **A.G.** Cologne 1988 (cat. Galerie Johnen & Schöttle) // **A.G.** Krefeld 1989 (cat. Museum Haus Lange) // **Renta-Preis, 1991**. Nuremberg 1991 (cat. Kunsthalle) // **A.G.** Zurich 1992 (cat. Kunsthalle) // **Siemens Fotoprojekt 1987–1992**. Berlin 1993 // **A.G.: Fotografien 1984–1993**. Munich 1994 (cat. Deichtorhallen Hamburg) // **Montparnasse**. Cologne 1995 (cat. Portikus, Frankfurt am Main) // **Positionen künstlerischer Photographie in Deutschland seit 1945**. Cologne 1997 (cat. Berlinische Galerie) ✐ // **A.G.: Fotografien 1994–1998**. Wolfsburg 1998 (cat. Kunstmuseum) // **A.G.** New York 2001 (cat. Museum of Modern Art) // Thomas Weski (ed.): **A.G.** Cologne 2007 (cat. Haus der Kunst, Munich) // **A.G.** Ostfildern 2007 (cat. Kunstmuseum Basel) // Ralf Beil and Sonja Fessl (eds): **A.G.: Architektur**. Ostfildern 2008 (cat. Mathildenhöhe Darmstadt) // **Objectivités. La photographie à Düsseldorf**. Paris 2008 (cat. Musée d'art moderne de la Ville de Paris) // **A.G.: Werke/Works 80-08**. Ostfildern 2008 (cat. Kunstmuseen Krefeld) // Stefan Gronert: **Die Düsseldorfer Photoschule. Photographien von 1961–2008**. Munich 2009 // **A.G. Bangkok**, Steidl 2012 (cat.Stiftung Museum Kuntpalast Dusseldorf) // **A.G. at Louisiana**, Ostfildern 2012 (cat. Louisiana Museum of Modern Art) // **A.G.** 2013 (cat. National Art Center Tokyo, National Museum of Art, Osaka)

"Andreas Gursky's photography shows, in broad but at the same time very detailed panoramas, how humans define natural and urban space through their presence. Gursky works exclusively in color. […] The viewpoint is always at a distance and slightly elevated from the front. The viewer's gaze is scattered, not directed, so that individual access from various points is possible […]. The images are based on strict formal structuring and a carefully balanced composition of color, fields, and light. They are thus of explicitly painting-like quality."
— Carolin Förster ✎ꝏ

Ernst Haas

Ernst Haas: **A Colour Retrospective.** London (Thames and Hudson) 1989

2.3.1921 Vienna (Austria) — 15.9.1986 New York (USA) Reports, ads, photo essays in color. Pioneer of color photography with considerable influence on aesthetics, not least the aesthetics of amateur photography. Elementary school, Abitur (school-leaving examination) in Vienna, attends medical school (without finishing), takes drama classes at the Graphische Lehr- und Versuchsanstalt (Graphic Arts Teaching and Research Institute) in Vienna. 1943–1949 works in a photo studio in Vienna. 1947 photo report on the Viennaer Südbahnhof about the first soldiers returning from the war. The works are exhibited at the American Red Cross headquarters in Vienna. Publication of a selection of the photographs in *Heute* magazine ("Und die Frauen warten …", no. 90, 1949), E.H.'s first important publication and the beginning of his international acclaim. Reprint in *Life* ("What's in a picture?") and other national magazines. From 1949 member of Magnum on the initiative of > Capa. Vice-president from 1958. President from 1959. Contributing photographer from 1966. 1951 moves to the USA. Gives up reportage and turns to the photo essay (soon exclusively in color). Extensive essay in color about New York (*Images of a Magic City*) is the first big publication in color in *Life* (nos. 11 and 12, 1953). Also the author of a first portfolio in color in the legendary *twen* magazine (no. 6, 1961). Apart from this, contributions in color to *Look*, *Holiday*, *Vogue*, *Esquire*, and photographs in *Paris Match*, *Queen*, *Stern*, and *Geo*. Also still photography (from 1954), film work (from 1964), and advertising, especially for Philip Morris (Marlboro). 1962 first exhibition of color photography at the Museum of Modern Art (New York). Publishes numerous books, incl. *The Creation*, probably his most important, or at any rate most influential, book (on post-war color aesthetics). Numerous awards and prizes incl. the Kulturpreis of the DGPh (Deutsche Gesellschaft für Photographie: German Photographic Association) (1972), Order of Merit of the *Land* of Vienna (1986) as well as several medals from the ADC (Art Directors Club) New York and Philadelphia. Already in 1958 he is voted one of the "world's ten greatest photographers" by *Popular Photography* magazine.

EXHIBITIONS (Selected) — **1960** Cologne (photokina – 1972, 78) SE // **1962** New York (Museum of Modern Art) SE // **1972** Vienna (Museum des 20. Jahrhunderts – 1986) SE // **1973** Vienna (Österreichisches Museum für Angewandte Kunst) SE // **1976** New York (International Center of Photography) SE // **1986** Rochester (New York) (Rochester Institute of Technology) SE // **1997** Linz (Austria) (Neue Galerie) SE // **2001** Vienna (Johannes Faber Gallery) SE // **2005** Salzburg (Museum der Moderne/Rupertinum) SE // New York (Silverstein Photography) SE // **2008** Vienna (WestLicht) GE

BIBLIOGRAPHY (Selected) — **The Creation**. New York 1971 // **In America**. New York 1975 // **In Germany**. New York 1976 // Samuel S. Walker, Jr (ed.): **Realm of light**. New York 1978 // Bryan Campbell: **Die großen Fotografen. E.H.** Munich 1989 // **A Colour Retrospective**. London 1989 // **Farbfotografien**. Munich 1990 // Freddy Langer: **E.H.** Hamburg 1992 ✍ // **E.H.: Eine Welt in Trümmern. Wien 1945–1948**. Salzburg 2005 (cat. Museum der Moderne) // Peter Coeln, Achim Heine, and Andrea Holzherr (eds): **MAGNUM's first**. Ostfildern 2008 (cat. WestLicht, Vienna) // Pamela Roberts: **A Century of Colour Photography**. London 2007

"Haas's view of the world might well have been in accord with 'Magnum' philosophy. His view through the camera, however, very soon contradicted 'Magnum' photography. His interest in the unstable political world began to wane, and he fell away from psychological and social reportage into the poetic view of the world that had enabled him to ignore the turmoil of postwar Vienna. Instead of prose, he once again concentrated on his 'poésie visuelle'. So rigorously did he dedicate himself to the artistic side of the medium that later he did not even want to be called a 'photojournalist' any more." — Freddy Langer ✎

Heinz Hajek-Halke

Heinz Hajek-Halke, from:
Das Deutsche Aktwerk. Berlin
(Bruno Schulz Verlag) 1940

1.12.1898 Berlin (Germany) — 11.5.1983 Berlin Pioneer of experimental photography, mainly montages, multiple exposures, light graphics. Portraits and self- portraits. Main work between 1930 and 1960. Also worthy of note is his work as a lecturer and important patron (Floris Neusüss, Michael Ruetz). Childhood in Argentina. Returns to Berlin. Trains as a painter and graphic artist. After WW I and the revolution he works as a picture editor, printer, and draughtsman for cinema posters. Self-taught photographer. First photographs in 1925. Joins the Pressephoto company, where, instructed by the more experienced Willi Ruge (1892–1961), he is able to refine his technical knowledge. First photomontages and photograms. Publications in *Das Deutsche Lichtbild*. 1933 escapes to avoid offers by the propaganda ministry. Hide-out on Lake Constance. During the war he works as an aerial photographer for Dornier (Friedrichshafen). After 1945 earns his living as a snake breeder. A new beginning with photomontages and "Lichtgrafiken" (light graphics) in the tradition of > Man Ray, > Moholy-Nagy, > Schad. Recognition of his work by > Steinert. Is admitted to the fotoform group and participates in the "subjektive fotografie" exhibitions. 1955–1967 lecturer in photography at Berlin University of the Arts, finally receiving an honorary professorship. 1965 Kulturpreis of the DGPh (Deutsche Gesellschaft für Photographie: German Photographic Association). In 2002 big retrospective at the Centre Pompidou (Paris). In 2006 Rencontres d'Arles Book Award for the two-volume monograph *Form aus Licht und Schatten* (Form from Light and Shadow).

EXHIBITIONS (Selected) — **1951** Saarbrücken (Germany) (**subjektive fotografie** – 1954) GE // **1957** Cologne (Deutsche Gesellschaft für Photographie – 1965) SE // **1970** Berlin (Landesbildstelle) SE // **1978** Munich (Fotomuseum) SE // **1997** Berlin (Haus am Waldsee) SE // **2002** Paris (Centre Pompidou) SE // Cologne (Priska Pasquer Gallery) SE // **2005** Berlin (Kicken Berlin) SE // **2007** Berlin (Kulturforum am Potsdamer Platz) SE // **2008** Munich (Kunstfoyer der Versicherungskammer Bayern) SE

BIBLIOGRAPHY (Selected) — **H.H.-H.: Experimentelle Fotografie**. Bonn 1955 // **H.H.-H.: Lichtgrafik**. Düsseldorf 1964 // E. Roters: **H.H.-H.** Göttingen 1978 // E. Roters and W. Rhode: **H.H.: Fotografie, Foto-Grafik, Lichtgrafik**. Berlin 1978 (cat. Werner Kunze Gallery) // **Collection de photographies**. Paris 1996 (cat. Centre Pompidou) // **H.H.-H.: Der große Unbekannte. Photographien 1925–1965**. Göttingen 1998 (cat. Haus am Waldsee, Berlin) // **H.H.-H.: Form aus Licht und Schatten.** Göttingen 2005 // **Phantasie und Traum. Das lichtgraphische Spätwerk von H.H.-H.** Munich/Berlin 2008 (cat. Kunstfoyer der Versicherungskammer Bayern)

"Heinz Hajek-Halke, inventor and master of light graphics, is one of those artists only half-famous during their lifetime. In German photography he counts as one of the true greats of the century, on a par with Erich Salomon, August Sander and Albert Renger-Patzsch, with Otto Steinert and Herbert List. His work is gigantic, not only in terms of size. It is unique and unmistakable, wide-ranging and innovative. His career as an artist connects the prewar and the postwar periods. It bridges the abyss of the Third Reich. The separate elements of his work come together in the 1950s, culminating in light graphics, a milestone of Germany photography. Discovering Hajek-Halke in his entirety still lies ahead of us." — Michael Ruetz

Philippe Halsman

Philippe Halsman's Jump Book.
New York (Simon & Schuster) 1959

2.5.1906 Riga (Lettland) — 25.6.1979 New York (USA) Portraits poised between Surrealism and glamour. Magazine photographer greatly in demand in the America of the 1950s and 60s. Childhood and schooling in Riga. 1924–1928 studies electrical engineering at Dresden Technical University. Becomes increasingly interested in art and literature. 1930 moves to Paris, where he starts work as a photographer. First publications in *Vogue*, *VU*, *Voilà*. Portraits include André Malraux, Paul Valéry, Marc Chagall, and Le Corbusier. In 1940 emigrates to the USA, where until his death he works as a freelance photographer for *Look*, *Time*, *Saturday Evening Post*, and most of all *Life* (for which he designs more than 100 covers). Numerous portrait studies, among them Winston Churchill, Ingrid Bergman, Albert Einstein (whose portrait was used as the original for an eight-cent postage stamp), Marilyn Monroe. Numerous awards and prizes, incl. the American Society of Media Photographers Life Achievement in Photography Award (1975). Several books, probably his best-known being *Dalí's Moustache* or *P.H.'s Jump Book*. Voted by *Popular Photography* (1958) as one of the "world's ten best photographers". Several lectureships (among others at the New School for Social Research in 1971). In the year of his death, big retrospective at the International Center of Photography (New York).

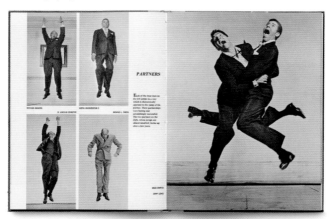

EXHIBITIONS (Selected) — **1963** Washington, DC (Smithsonian Institution – 1998) SE // **1979** New York (International Center of Photography) SE // **1984** Cologne (Museum Ludwig) GE // **1985** Zurich (Galerie Zur Stockeregg) SE // **1998** Washington, DC (Smithsonian Institution) SE // **2004** New York (Howard Greenberg Gallery) SE // **2006** Munich (Stephen Hoffman Gallery) SE // **2014** Lausanne (Musée de l'Elysée) SE

BIBLIOGRAPHY (Selected) — **The Frenchman**. New York 1949 (facsimile reprint: Cologne 2005) // **Dalí's Moustache**. New York 1954 // **P.H.'s Jump Book**. New York 1959 // **P.H. on the Creation of Photographic Ideas**. New York 1961 // **H. at Work**. New York 1989 // **P.H.: A Retrospective**. Boston 1998 (cat. Smithsonian Institution, Washington, DC) 🖉 // **Astonish me!** Munich 2014 (cat. Musée de l'Elysée)

"From the forties to the seventies Philippe Halsman's portraits of beautiful women, powerful men, celebrities, stars, intellectuals and politicians were published on the covers and inside the big American picture magazines *Look*, *Good Housekeeping*, *Ladies' Home Journal*, *Esquire* and most of all *Life*. In Europe, he worked for *Picture Post*, *Paris Match*, the French *Vogue,* and *Stern* magazine. His stunning portraits also appeared in advertisements for 'Old Gold' cigarettes, 'Pond's Cold Cream', cosmetic products by Elizabeth Arden, as well as in campaigns for NBC, Simon & Schuster, Ford and countless other companies. Halsman set the standards as far as VIP portraits were concerned. Amateur and professional photographers were full of praise and the photo magazines devoted one article after another to his work." — Mary Panzer ✍

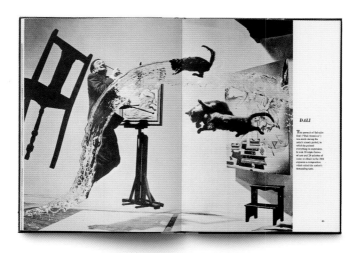

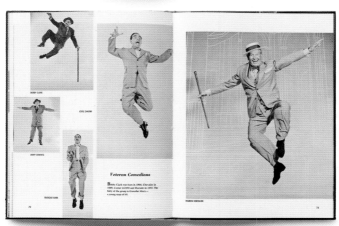

Sam *(uel Joseph)* Haskins

Sam Haskins: **Cowboy Kate & Other Stories.** New York (Crown Publishers) 1965

11.11.1926 Kroonstad (South Africa) — 26.11.2009 Bowral (Australia) 1960s cult photographer. Nude photography in a new, fresh form, often wrapped up in a narrative context. Also photo design and advertising. Childhood and schooling in Johannesburg (Helpmekaar High School). 1948–1950 studies in Johannesburg (Witwatersrand Technical College/Graphic Art) and London (Bolt Court School). 1952–1968 freelance graphic artist and photographer in Johannesburg. In 1968, moves to London and opens a studio. Fashion, nudes, portraits, and advertisements. Achieves his breakthrough with erotic picture stories (in b/w), mainly published in book form. From 1971 experiments increasingly with nudes in color. Numerous exhibitions, incl. *Vier Meister der erotischen Phographie* (Four Masters of Erotic Photography) (photokina 1970 — together with Francis Giacobetti, David Hamilton, and > Shinoyama). Various awards and prizes, among others Prix Nadar (in 1964 for *Cowboy Kate*).

"With Sam Haskins it was the 'narrative moment' that prevailed. He raised nudes to a higher level and published series or small stories in book form. He gave nude models a face again, a name, a personality and only a few props and accessories provided the background to the arranged photos, like a stage setting. With 'Five Girls' or 'Cowboy Kate & Other Stories' he ushered in the break with the traditional-classic nude." — Hans-Eberhard Hess ✎

EXHIBITIONS (Selected) — **1970** Cologne (photokina) GE // **1973** Hamilton (Canada) (McMaster University) GE // Tokyo (Isetan Gallery) SE // **1980** London (National Theatre) SE // **1984** Bologna (Galleria d'Accursio) SE // **1990** Tokyo (Pentax Forum – 1992, 99) SE // **1995** Munich (Stadtmuseum) GE // **2005** Amsterdam (Wouter van Leeuwen Gallery) SE // **2006** London (National Portrait Gallery) SE

BIBLIOGRAPHY (Selected) — **Five Girls.** New York 1962 // **Cowboy Kate & Other Stories.** London 1964 // **November Girl.** London 1966 // **African Image.** London 1967 // **Haskins Posters.** Genoa 1980 // **S.H.A Bologna.** Bologna 1984 // Michael Köhler and Gisela Barche: **Das Aktfoto.** Munich 1985 ✎ // **Grandi Fotografi: S.H.** Locarno 1987 // Hans-Michael Koetzle: **twen. Revision einer Legende.** Munich 1995 (cat. Stadtmuseum)

Raoul Hausmann

12.7.1886 Vienna (Austria) — 1.2.1971 Limoges (France) Key figure of Dadaism. Multimedially interested. Co-inventor of the photomontage. Also photograms, landscapes, experimental nudes, and portraits. Son of history painter Victor Hausmann. The family moves to Berlin in 1900. First artistic attempts at the age of 14. From 1905 friendship with Johannes Baader. 1908–1911 receives his training at the Studien-Ateliers für Malerei und Plastik (Study Workshop for Painting and Sculpture) in Berlin-Charlottenburg. Influenced by Expressionist painters (Erich Heckel, Max Pechstein, Karl Schmidt-Rottluff) he renounces academicism. 1915–1922 lives with > Höch. Meets the anarchists Franz Jung and Otto Gross. First publications in *Die Aktion*. 1918 friendship with Hans Arp, Otto Freundlich, and Kurt Schwitters. Foundation of Club Dada. First photomontages (together with Höch) in August. In 1920 *First International Dada Fair*, organized by Hausmann, George Grosz, and > Heartfield: 1926–1932 spends his summers on Sylt or on the Baltic. Grapples more intensely with the problem of the photographic image. In 1931 applies for a lectureship at the Bauhaus (turned down). Eight works at the *Fotomontage* exhibition organized by César Domela in that same year. Emigrates in March 1933. In Ibiza until 1936: photography, ethnological, and architectural studies. Lives in Zurich, Prague, and Paris after the outbreak of the Spanish Civil War. Finally (until 1944) he lives illegally in Peyrat-le-Château (Haute-Vienne, France). 1944 takes up domicile in Limoges. Renews contacts with Schwitters and > Moholy-Nagy. Until 1959 photograms, photomontages, photo-pictograms. 1958 publication of his book of reminiscences, the autobiographical *Courrier Dada*. 1959 newly awakened interest in painting. 1967 first retrospective (in Stockholm).

EXHIBITIONS (Selected) — **1920** Berlin (**International Dada Fair**) GE // **1931** Berlin (Art Library)/**Fotomontage**) GE // **1936** Zurich (Museum of Design) SE // **1937** New York (Museum of Modern Art/**Fantastic Art, Dada, Surrealism**) GE // **1967** Stockholm (Moderna Museet) SE // **1974** Paris (Musée national d'art moderne) SE // **1980** Malmö (Sweden) (Konsthall) SE // **1981** Hannover (kestnergesellschaft) SE // **1986** Vienna (Museum moderner Kunst) SE // **1994** Berlin (Berlinische Galerie) SE // **1997** Bonn (Rheinisches Landesmuseum) GE // **2001** Saint-Étienne (France) (Musée d'art moderne) SE // **2003** Berlin (Berinson Gallery) SE // **2005** Berlin (Art Library) GE // Paris (Centre Pompidou/**Dada**) GE // **2006** New York (Museum of Modern Art/**Dada**) GE // Washington, DC (National Gallery of Art/**Dada**) GE

BIBLIOGRAPHY (Selected) — Andreas Haus: **R.H.: Kamerafotografien 1927–1957**. Munich 1979 // **Gegen den kalten Blick der Welt. R.H.: Fotografien 1927–1933**. Vienna 1986 (cat. Museum moderner Kunst) // **Der deutsche Spießer ärgert sich. R.H. 1886–1971**. Ostfildern 1994 (cat. Berlinische Galerie) ✑ // Klaus Honnef and Frank Weyers: **Und sie haben Deutschland verlassen … müssen**. Bonn 1997 (cat. Rheinisches Landesmuseum) // Christine Kühn: **Neues Sehen in Berlin. Fotografie der Zwanziger Jahre**. Berlin 2005 (cat. Art Library) // Laurent Le Bon: **Dada**. Paris 2005 (cat. Centre Pompidou)

"Raoul Hausmann was one of the founders of Dada Berlin in 1918 and worked with the Eastern-European constructivists and the Dutch De Stijl group from 1922 onwards. He was one of the most versatile and original artists of his day. His revolutionary ideas and theories had an immediate, sustained impact on the artistic and literary avant-garde in the Berlin of the 1920s. Hausmann, the self-proclaimed 'Dadasoph' and 'director of the Dada Circus', was a painter and typographer, the inventor of the optophonetic poem and the Dada photomontage, a fashion designer and dancer, photographer and writer, anarchist and utopian — the intellectually electrifying source of inspiration of a whole generation." — Jörn Merkert ✍

Raoul Hausmann: **Untitled,** from: **Subjektive Fotografie 2. Ein Bildband moderner Fotografie.** Munich (Brüder Auer Verlag) 1955

Robert Häusser

Robert Häusser: **Ein Fotograf sieht Mannheim.** Mannheim (Verlag Bibliographisches Institut AG) 1957

8.11.1924 Stuttgart (Germany) — 5.8.2013 Mannheim (Germany) Free photographic explorations in b/w close to "Magic Realism in painting". Pioneer of artistic photography in post-war Germany. At the age of 16, first free artistic photographs showing the influence of the photographic avant-garde of the 1920s and 30s (banned in the Germany of that time). 1941 trains as a photojournalist. 1942–1945 military service and captivity. 1946–1952 works on his parents' farm in Mark Brandenburg. Landscape studies, portraits and photographs of rural historical monuments there. 1950 studies photography in Weimar, under Walter Hege among others. First exhibitions and publications. This results in his appointment (1950) to the GDL (Gesellschaft Deutscher Lichtbildner: German Photographic Academy). 1952 moves to Mannheim. This is followed by numerous photobooks and publications in newspapers and magazines. 1960 appointment to the DGPh (Deutsche Gesellschaft für Photographie: German Photographic Association). 1972 closes his studio for applied photography and works exclusively on non-commercial artistic projects. Usually melancholy single shots in b/w, but also sequences, rigorously composed and marked by stark contrasts of light and dark revealing a remarkable "eye for the absurd in the trivial". Several television films about R.H., among others Rudolf Werner's *Das Unsichtbare sichtbar machen* (Making the invisible visible) (1986). Numerous awards, incl. the Schiller Prize of the City of Mannheim (1978), the David Octavius Hill Medal (1984), the Hasselblad Award (1995), and the Kulturpreis of the DGPh (Deutsche Gesellschaft für Photographie: German Photographic Association).

EXHIBITIONS (Selected) — **1959** Mannheim (Probst Gallery) SE // **1972** Munich (Die Neue Sammlung) SE // **1973** Bielefeld (Germany) (Kunsthalle) SE // **1983** Berlin (Nationalgalerie) SE // **1984** Mannheim (Kunsthalle) SE // **1988** Moscow (All-Union Centre for Photojournalism) SE // Stuttgart (Württembergischer Kunstverein) SE // **2000** Speyer (Germany) (Historisches Museum der Pfalz) SE // **2003** Mannheim (Reiss-Engelhorn-Museen/Forum Internationale Fotografie – 2004, 2007, 2009) SE // **2006** Berlin (Deutsches Historisches Museum) SE // **2014** Mannheim (Reiss-Englhorn-Museum) SE

BIBLIOGRAPHY (Selected) — R.H.: **Ein Fotograf sieht Mannheim.** Mannheim 1957 // **Photographische Bilder 1941–1984.** Mannheim 1984 (cat. Städtische Kunsthalle) // **Photographische Bilder. Werkübersicht der Jahre 1941–1987.** Stuttgart, 1988 (cat. Württembergischer Kunstverein) ✐ // **Das fotografische Werk 1940–2000.** Heidelberg 2000 (cat. Historisches Museum der Pfalz, Speyer) // **Aus dem photographischen Werk 1938–2004.** Heidelberg 2004 // **Ins Wort gesetzt. Zeitgenössische Lyrik zu Fotografien von R.H.** Heidelberg 2007 (cat. Reiss-Engelhorn-Museen/Forum Internationale Fotografie) // **Schwarz und Weiß. Geschichten – mit und ohne Fotografie.** Heidelberg 2013. // **R.H. im Auftrag Fotografien aus Handwerk und Industrie.** Heidelberg 2014

"For anyone familiar with Robert Häusser as a person and an artist, his photographic work may appear to assume a wide variety of forms: there is free and applied photography, the fantastic and the matter-of-fact in black and white, there are landscapes and industrial plants, portraits, objects and scenes, harsh reality and a world of dreams. But at its core his photographic work can be condensed to black and white camera pictures of an unmistakable character, rich in contrasts and with a surety of form. And it is this core of the work that makes Robert Häusser so significant as a photographer. Even today he is already part of the history of creative photography — and not only in Germany." — J.A. Schmoll gen. Eisenwerth ✍

John Heartfield (Helmut Herzfeld)

John Heartfield: **Der Sinn des Hitlergrußes,** from: **Arbeiter-Illustrierte-Zeitung,** no. 42, 16.10.1932

19.6.1891 Berlin-Schmargendorf (Germany) — 26.4.1968 East Berlin (Germany) Founding member of the Berlin Dada Group. Pioneer, main exponent of the political photomontage in Germany around 1930. Son of socialist writer Franz Herzfeld (pen name Franz Held). Childhood in Switzerland and Austria. In 1905 moves to Wiesbaden with his brother Wieland Herzfeld(e). Trains to be a bookseller. 1908–1911 studies at the Königlich Bayerische Kunstgewerbeschule (Royal Bavarian School for Arts and Crafts), Munich. Works as a commercial artist. 1913–1914 studies at the Kunst- und Handwerkerschule (School for Arts, Crafts and Trade) in Berlin-Charlottenburg. Gets to know Herwarth Walden (*Der Sturm*), Franz Pfempfert (*Die Aktion*), and George Grosz. 1916 anglicises his name (in protest against the nationalism of the Wilheminian era). 1917 foundation of the publishing house Malik-Verlag and *Neue Jugend*. 1918 co-founds the Berlin Dadaists. Joins the German Communist Party (KPD). Theater work for Erwin Piscator and Max Reinhardt. 1929 publication of the satirical picture book *Germany, Germany über alles* (with Kurt Tucholsky). In 1930 first photomontages for the AIZ (Arbeiter-Illustrierte-Zeitung) (a total of 236 signed montages by 1938). 1931–1932 in the Soviet Union. 1933 in exile in Prague, from 1938 in London. 1950 returns to the German Democratic Republic. Works as designer of book covers and posters and as set designer in Leipzig and Berlin. From 1957 late recognition in East Germany (first retrospective), from 1968 as part of the students' protest in the West (see, for example, works by Klaus Staeck). Estate at the John Heartfield Archive of the Akademie der Künste Berlin (Academy of Fine Arts, Berlin).

"John Heartfield is a classic figure in the sense that his work had an impact, but always more in the arts than in politics." — Heiner Müller ✎⊐

EXHIBITIONS (Selected) — **1929** Berlin (Grosse Berliner Kunstausstellung) GE // Stuttgart (**Film und Foto**) GE // **1957** East Berlin (Akademie der Künste) SE // **1976** West Berlin (Neue Nationalgalerie) SE // **1991** Berlin (Akademie der Künste/Altes Museum) SE // **1997** Bonn (Rheinisches Landesmuseum) GE // **2001** Valencia (Spain) (Institut Valencià d'Art Modern) SE // **2006** Strasbourg (Musée d'Art moderne et contemporaine) SE // **2008** Cologne (Museum Ludwig) JE (with Jacob Kjeldgaard/Marinus) // **2009** Berlin (Berlinische Galerie) SE

BIBLIOGRAPHY (Selected) — Wieland Herzfelde: **J.H.: Leben und Werk.** Dresden 1962 // **J.H.: Krieg im Frieden.** Munich 1972 // Eckhard Siepmann: **Montage: J.H.** Berlin-West 1977 // Roland März: **J.H.: Der Schnitt entlang der Zeit.** Dresden 1981 // Klaus Honnef and Peter Pachnicke: **J.H.** Berlin 1991 (cat. Akademie der Künste/Altes Museum) ✎⊐ // Roland März: **H. montiert. 1930–1938.** Leipzig 1993 // Klaus Honnef and Frank Weyers: **Und sie haben Deutschland verlassen … müssen.** Bonn 1997 (cat. Rheinisches Landesmuseum) // **J.H. en la Colección del IVAM.** Valencia 2001 (cat. Institut Valencià d'Art Modern) // Heinz Willmann: **Geschichte der Arbeiter-Illustrierten-Zeitung 1921–1938.** Berlin 1974 // **J.H.: Photomontages politiques 1930–1938.** Strasbourg 2006 (cat. Musée d'Art moderne et contemporaine) // **Hitler blind – Stalin lahm. Marinus/Heartfield: Politische Fotomontagen der 1930er Jahre.** Göttingen 2008 (cat. Museum Ludwig, Cologne) // Freya Mülhaupt (ed.): **J.H.: Zeitungsausschnitte. Fotomontagen 1918–1938.** Ostfildern 2009 (cat. Berlinische Galerie)

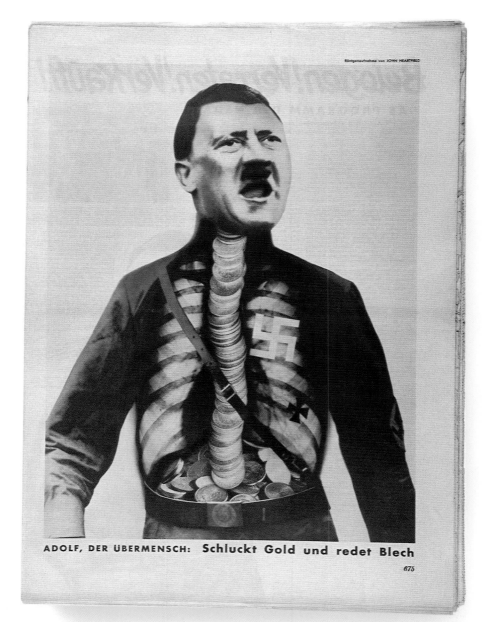

Röntgenaufnahme von JOHN HEARTFIELD

ADOLF, DER ÜBERMENSCH: **Schluckt Gold und redet Blech**

675

John Heartfield: **Adolf, der Übermensch,**
from: **Arbeiter-Illustrierte-Zeitung,**
no. 29, 17.7.1932

Keld Helmer-Petersen

Keld Helmer-Petersen: **122 Colour Photographs.** Copenhagen 1949

23.8.1920 Copenhagen (Denmark) — 6.3.2013 Filmmaker and photographer. Formally rigorous photographic explorations in the spirit of post-war "subjektive fotografie". Pioneer of autonomous camera art in Denmark with a singular oeuvre in color. 1938 first b/w photographs. 1942 first works in color. Encounters the works of > Evans, > Renger-Patzsch, > Wolff. 1948 achieves his breakthrough with *122 Colour Photographs*. 1949 first film experiments, photograms. Extracts from *Colour Photographs* in *Life*. 1950 travels to the USA, where he meets > Avedon, > Faurer, > Feininger, > Jacobi, > Siskind, and Robert Sheehan, as well as filmmakers Lewis Jacobs, Francis Lee, and Hans Richter. 1950–1951 studies at the Institute of Design under > Callahan. 1951 Chicago: architectural studies, film work (16mm). Returns to Denmark. 1956 opening of his own studio. 1957 visits to Ulm (Hochschule für Gestaltung: Ulm School of Design) and Essen (Folkwangschule). Returns to the USA in 1958. Meets Laura Gilpin and Eliot Porter. Back to Denmark via Japan, China, and India. 1964 lectureship at the Royal Academy of Fine Arts (Copenhagen). 1965–1968 lecturer at the School of Graphic Design (Copenhagen). 1978 at the University of Lund, Sweden. 1981 curator of a Siskind exhibition at the Royal Museum of Fine Arts (Copenhagen). Bindesbøll Medal and the Danish Arts and Crafts Council's Award in the same year. 1984 Chairman of the Board, Museum of Photographic Art (Odense). 1986 participates in the review *50 Years Modern Color Photography*. 1990 big retrospective in Odense. 2005 widely acclaimed solo exhibition curated by > Parr at the Rencontres d'Arles.

EXHIBITIONS (Selected) — **1954** Copenhagen (Charlottenborg Exhibition) SE // New York (Museum of Modern Art/**Post-War European Photography**) GE // Saarbrücken (Germany) (**subjektive fotografie 2**) GE // **1962** Viborg (Denmark) (Stiftsmuseum) SE // **1965** Odense (Denmark) (Galleri Exi) SE // **1980** New York (American-Scandinavian Foundation) SE // **1982** Århus (Denmark) (Galleri Image) SE // **1986** Cologne (photokina) GE // **1990** Copenhagen (Museum of Decorative Art) SE // Odense (Denmark) (Museum of Photographic Art) SE // **1994** Copenhagen (Fotografisk Galleri) SE // **1995** Lund (Sweden) (Fotogalleriet) SE // **2005** Copenhagen (Fotografisk Center) SE // Arles (Rencontres internationales de la photographie) SE // London (Rocket Gallery – 2007) SE // **2006** New York (Scandinavia House/Foto: **New Photography from Denmark**) GE // **2007** Houston (Texas) (FotoFest/**Foto: New Photography from Denmark**) GE // New York (Hasted Hunt/**Color before Color**) GE

BIBLIOGRAPHY (Selected) — **122 Colour Photographs**. Copenhagen 1948 // **Fragments of a City: Chicago Photographs**. Copenhagen 1960 // **50 Jahre moderne Farbfotografie/50 Years Modern Color Photography 1936–1986**. Cologne 1986 (cat. photokina) // **Frameworks: Photographs 1950–1990**. Copenhagen 1993 // Martin Parr and Gerry Badger: **The Photobook: A History Volume I**. London 2004 // **K.H.-P.: Photographs 1941–1995**. Copenhagen 2007 ✐

Röntgenaufnahme von JOHN HEARTFIELD

ADOLF, DER ÜBERMENSCH: **Schluckt Gold und redet Blech**

675

John Heartfield: **Adolf, der Übermensch,**
from: **Arbeiter-Illustrierte-Zeitung,**
no. 29, 17.7.1932

Keld Helmer-Petersen

Keld Helmer-Petersen: **122 Colour Photographs.** Copenhagen 1949

23.8.1920 Copenhagen (Denmark) — 6.3.2013 Filmmaker and photographer. Formally rigorous photographic explorations in the spirit of post-war "subjektive fotografie". Pioneer of autonomous camera art in Denmark with a singular oeuvre in color. 1938 first b/w photographs. 1942 first works in color. Encounters the works of > Evans, > Renger-Patzsch, > Wolff. 1948 achieves his breakthrough with *122 Colour Photographs*. 1949 first film experiments, photograms. Extracts from *Colour Photographs* in *Life*. 1950 travels to the USA, where he meets > Avedon, > Faurer, > Feininger, > Jacobi, > Siskind, and Robert Sheehan, as well as filmmakers Lewis Jacobs, Francis Lee, and Hans Richter. 1950–1951 studies at the Institute of Design under > Callahan. 1951 Chicago: architectural studies, film work (16mm). Returns to Denmark. 1956 opening of his own studio. 1957 visits to Ulm (Hochschule für Gestaltung: Ulm School of Design) and Essen (Folkwangschule). Returns to the USA in 1958. Meets Laura Gilpin and Eliot Porter. Back to Denmark via Japan, China, and India. 1964 lectureship at the Royal Academy of Fine Arts (Copenhagen). 1965–1968 lecturer at the School of Graphic Design (Copenhagen). 1978 at the University of Lund, Sweden. 1981 curator of a Siskind exhibition at the Royal Museum of Fine Arts (Copenhagen). Bindesbøll Medal and the Danish Arts and Crafts Council's Award in the same year. 1984 Chairman of the Board, Museum of Photographic Art (Odense). 1986 participates in the review *50 Years Modern Color Photography*. 1990 big retrospective in Odense. 2005 widely acclaimed solo exhibition curated by > Parr at the Rencontres d'Arles.

EXHIBITIONS (Selected) — **1954** Copenhagen (Charlottenborg Exhibition) SE // New York (Museum of Modern Art/**Post-War European Photography**) GE // Saarbrücken (Germany) (**subjektive fotografie 2**) GE // **1962** Viborg (Denmark) (Stiftsmuseum) SE // **1965** Odense (Denmark) (Galleri Exi) SE // **1980** New York (American-Scandinavian Foundation) SE // **1982** Århus (Denmark) (Galleri Image) SE // **1986** Cologne (photokina) GE // **1990** Copenhagen (Museum of Decorative Art) SE // Odense (Denmark) (Museum of Photographic Art) SE // **1994** Copenhagen (Fotografisk Galleri) SE // **1995** Lund (Sweden) (Fotogalleriet) SE // **2005** Copenhagen (Fotografisk Center) SE // Arles (Rencontres internationales de la photographie) SE // London (Rocket Gallery – 2007) SE // **2006** New York (Scandinavia House/Foto: **New Photography from Denmark**) GE // **2007** Houston (Texas) (FotoFest/**Foto: New Photography from Denmark**) GE // New York (Hasted Hunt/**Color before Color**) GE

BIBLIOGRAPHY (Selected) — **122 Colour Photographs**. Copenhagen 1948 // **Fragments of a City: Chicago Photographs**. Copenhagen 1960 // **50 Jahre moderne Farbfotografie/50 Years Modern Color Photography 1936–1986**. Cologne 1986 (cat. photokina) // **Frameworks: Photographs 1950–1990**. Copenhagen 1993 // Martin Parr and Gerry Badger: **The Photobook: A History Volume I**. London 2004 // **K.H.-P.: Photographs 1941–1995**. Copenhagen 2007 ✍

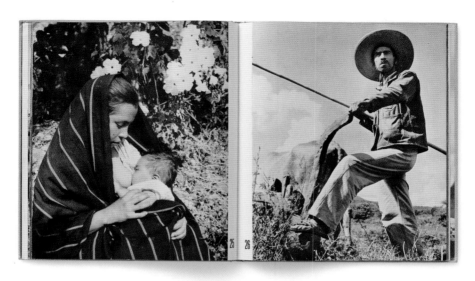

Florence Henri

28.6.1893 New York (USA) — 24.7.1982 Laboissière-en-Thelle (France) Bauhaus pupil. Portraits, self-portraits, object studies, "compositions" in the style of New Vision (Neues Sehen). Childhood in Europe (Paris, Vienna, Munich). From 1906 on the Isle of Wight. 1909 (after her father's death) moves to Rome. There she meets the Futurists around Filippo Tommaso Marinetti. Music lessons in Rome and Berlin. From 1914, attends the art academy in Berlin, a pupil at the studio of Johannes Walter-Kurau. Moves to Paris in 1924. Studies at the Académie Moderne with Fernand Léger and Amédée Ozenfant. In 1927, visiting student at the Bauhaus in Dessau. Courses with > Moholy-Nagy, Wassily Kandinsky, and Paul Klee. In the same year returns to Paris and takes up photography. Advertising and illustration photography as well as her own photographic experiments (often incorporating a mirror or reflecting surfaces). 1929 several of her works exhibited at the *Fotografie der Gegenwart* exhibition in Essen. In the same year member of the Cercle et Carré group (among others César Domela, Le Corbusier, Amédée Ozenfant, Antoine Pevsner, Friedrich Vordemberge-Gildewart). From 1930 portraits of modern women (incl. Erica Brausen, Tulia Kaiser, Margarete Schall). From 1934 artists' portraits (Kandinsky, Léger, Robert and Sonia Delaunay). Numerous publications, among others in *Gebrauchsgraphik*, *AMG Photographie*, *Lilliput*, and (after 1945) in *Du*, *Camera*, and *Creative Camera*. War years in Paris. Less active in the field of photography. In 1974 rediscovered by Ann and Jürgen Wilde. Exhibition in Cologne and edition of a portfolio. In her mid 70s (after a serious accident) she makes collages once again in the spirit of Constructivism.

EXHIBITIONS (Selected) — **1929** Stuttgart (**Film und Foto**) GE // **1930** Munich (**Das Lichtbild**) GE // **1932** New York (Julien Levy Gallery) GE // **1933** Essen (Germany) (Museum Folkwang) SE // **1934** Paris (Galerie de la Pléiade) SE // **1974** Cologne (Wilde Gallery) SE // **1976** Münster (Germany) (Westfälischer Kunstverein) SE // **1978** Paris (Musée d'art moderne de la Ville de Paris) SE // **1980** San Francisco (Museum of Modern Art — 1990) GE/SE // **1994** Hannover (Sprengel Museum — 1999) SE/GE // **1995** Aachen (Suermondt-Ludwig-Museum) SE // **1999** Arles (Rencontres internationales de la photographie) JE (with Denis Roche) // **2004** West Palm Beach (Florida) (Norton Museum of Art) SE // **2005** Berlin (Kunstbibliothek) GE // **2006** Brescia (Italy) (Galleria dell'Incisione) SE // **2007** Nice (Galerie Depardieu) SE // **2008** Munich (Pinakothek der Moderne) GE // **2009** Paris (Jeu de Paume — Site Sully/**Collection Christian Bouqueret**) GE // **2014** Munich (Pinakothek der Moderne) SE

BIBLIOGRAPHY (Selected) — **F.H.: Photographies 1927–1938.** Paris 1978 (cat. Musée d'art moderne de la Ville de Paris) // **Avant-Garde Photography in Germany 1919–1939.** San Francisco 1980 (cat. San Francisco Museum of Modern Art) // Jeannine Fiedler (ed.): **Fotografie am Bauhaus.** Berlin 1990 (cat. Bauhaus-Archiv) // **F.H.: Artist-Photographer of the Avant-Garde.** San Francisco 1990 (cat. San Francisco Museum of Modern Art) // **F.H.: Fotografien aus der Sammlung Ann und Jürgen Wilde.** Aachen 1995 (cat. Suermondt-Ludwig-Museum) // **Mechanismus und Ausdruck. Sammlung. Wilde.** Munich 1999 (cat. Sprengel Museum Hannover) 🗐 // Christine Kühn: **Neues Sehen in Berlin. Fotografie der Zwanziger Jahre.** Berlin 2005 (cat. Kunstbibliothek) // **Female Trouble. Die Kamera als Spiegel und Bühne weiblicher Inszenierungen.** Ostfildern 2008 (cat. Pinakothek der Moderne, Munich) // **Paris. Capitale photographique. 1920/1940. Collection Christian Bouqueret.** Paris 2009 (cat. Jeu de Paume — Site Sully) // Ulrike Müller: **Bauhaus-Frauen. Meisterinnen in Kunst, Handwerk und Design.** Munich 2009

"Like other artists of her generation, for example, Man Ray, Florence Henri uses her photographic skills to earn a living. At her Paris studio she creates portraits by experimenting with innovative and unusual angles and details. She combines objective photography of the German school with the Parisian avant-garde. Her advertising photography is also characterized by extreme perspectives and confusing spatial impressions created by means of mirrors. These still lifes ignore the actual function of the product, which, aesthetically transfigured, becomes the picture content in its own right." — Katharina Menzel ✍

Florence Henri (top, left-hand page):
Porträt eines Künstlers, from: **Europa-Camera,** 1951
Florence Henri (above, right-hand page):
Portrait, from: **Modern Photography,** 1931

Lucien Hervé *(László Elkán)*

Le Corbusier: **Le poème électronique.** Paris (Editions de Minuit) 1958

7.8.1910 Hódmezóvásárhely (Hungary) — 26.6.2007 Paris (France)
Portraits, experimental townscapes, street scenes in the spirit of "Photographie humaniste". Known especially for his sensitive interpretations of Le Corbusier's architecture. 1929 moves to Paris. Various jobs to begin with. Form cutter for haute couture. Photojournalist for *VU* and *Marianne*. 1937 acquires French nationality. During the war, captivity, escape, member of the Resistance. First panel paintings in the Expressionist tradition (exhibited *inter alia* at the Salon d'Automne in Paris). Becomes active as a photographer once more from 1947. Reporter for *France-Illustration* (with a focus on the fine arts). 1949, at the suggestion of Père (Marie-Alain) Couturier, reports on the construction of the Cité radieuse in Marseilles. More than 650 photographs in one day (which are supposed to have prompted the architect, Le Corbusier, to remark: "Vous avez l'âme d'un architecte et savez voir l'architecture" (You have the soul of an architect and an eye for architecture). After that, he accompanies all building projects by Le Corbusier with his camera right round the globe. Also works for architects incl. Alvar Aalto, Marcel Breuer, Walter Gropius, Pier Luigi Nervi, Richard Neutra, Oscar Niemeyer, and Jean Prouvé. Apart from this, photographs of historical buildings, portraits of artists (Jean Cocteau, Fernand Léger, Henri Matisse), and street scenes. Since 1951, numerous exhibitions. 1993 Médaille des Arts plastiques from the Académie d'Architecture, Paris. 2000 Grand Prix de la Ville de Paris.

"There have been occasional attempts to associate Hervé with the New Objectivity, in other words with photographers like Albert Renger-Patzsch or Werner Mantz. The latter, however, approach their edifices front-on, and the resultant photographs show us the buildings in their entirety, without any special lighting effects, although emphasizing their graphical structure as well. […] Anyone wishing to find out where Hervé has his roots, therefore, should rather take a look at the Bauhaus photographers. Or, more precisely, at the representatives of the 'Neues Sehen'." — Olivier Beer ✍

EXHIBITIONS (Selected) — **1951** Milan (Domus) SE // **1963** Paris (Musée des Arts décoratifs — 1966) SE // **1964** Paris (Bibliothèque nationale de France) SE // **1985** Arles (Rencontres internationales de la photographie — 1999) SE // **1988** Paris (Grande Halle de la Villette) SE // **1993** Paris (Galerie Camera Obscura — 1994, 1997, 2007) SE // **1998** New York (Howard Greenberg Gallery) SE // **2002** Paris (Hôtel de Sully) SE // Hamburg (Deichtorhallen) // **2004** Le Havre (Musée Malraux) SE // **2005** Paris (Galerie Baudoin Lebon) SE // **2006** Paris (Musée Carnavalet) JE (with Frédéric Barzilay and Willy Ronis) // **2009** Barcelona (Kowasa Gallery/**The Vision of the Other**) GE

BIBLIOGRAPHY (Selected) — **La plus grande aventure du monde**. Paris 1956 (new edition London 2001) // **Le siège de l'UNESCO à Paris**. Paris 1958 // **L.H.** Budapest 1990 // **Intimité et immensité**. Paris 1994 // Olivier Beer (ed.): **L.H.: L'homme construit**. Paris 2001 // Olivier Beer (ed.): **L.H.** Ostfildern-Ruit 2002 (cat. Deichtorhallen Hamburg) ✍ //**The Eiffel Tower: A Photographic Survey by L.H.** New York 2003 // **Contacts**. Paris 2011

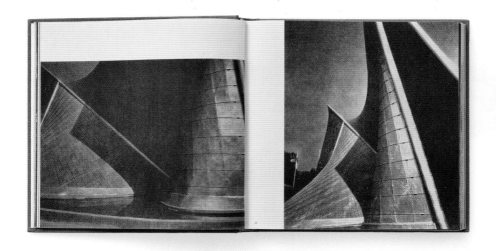

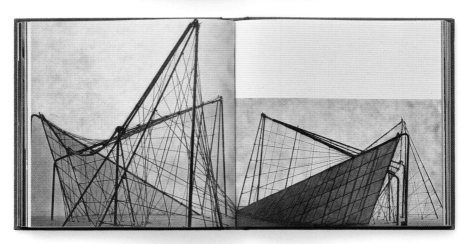

Lewis Wickes Hine

Lewis W. Hine: **Men at Work.
Photographic Studies of Modern
Men and Machines.** New York
(The Macmillan Company) 1932

26.9.1874 Oshkosh (Wisconsin, USA) — 4.11.1940 New York (USA)
Uses the camera in the service of social reform. Main work between
1910 and 1930. His best-known works are cycles on immigrants,
child labor, and the construction of the Empire State Building. High
-school graduate. After his father's early accidental death, from 1892
onwards he has various jobs, working among other things in a factory
for upholstered furniture and as foreman of a team of cleaners. Be-
comes acquainted with Frank A. Manny, Professor of Education and
Psychology at the State Normal School, who urges him to study edu-
cation at the University of Chicago. Moves with Manny to New York.
Supply teacher for natural history at the Ethical Culture School. Takes
up photography in 1903. Immigrants on Ellis Island (1904) is his first
big project with didactic intent. 1906 first essays about the use of
photographs in teaching. Starts working for the National Child Labor
Committee (NCLC) in the same year. Gives up teaching in 1908. Com-
missioned by the NCLC to conduct a large-scale survey into the sub-
ject of child labor (until 1917). Travels, lectures, campaigns. 1918 goes to Europe for the Red Cross.
Documentation of the consequences of war in the Balkans, in Belgium, and France. 1921–1929 again
works for the NCLC, charitable organizations, and business enterprises. 1924 ADC (Art Directors Club)
Medal for his photograph *The Engineer.* 1930 commissioned to produce a report on the construction
of the Empire State Building. 1932 *Men at Work* voted the year's best book for young people. From
1933 only smaller or uncompleted projects. 1939 (with the aid of > Abbott and Elizabeth McCaus-
land) much acclaimed retrospective at the Riverside Museum (New York). Major parts of his estate to
be found today in the George Eastman House (Rochester, New York). Leica Hall of Fame Award (2014).

EXHIBITIONS (Selected) — **1939** New York (Riverside Museum)
SE // **1971** Essen (Germany) (Museum Folkwang) SE // **1977**
Kassel (Germany) (documenta 6) GE // **1978** Bonn (Bahnhof
Rolandseck) SE // **1980** Basel (Kunsthalle) SE // **1990** Paris
(Musée Carnavalet) SE // **1992** Paris (Centre national de la
photographie) SE // **1996** Cologne (photokina) SE // **2000**
Brunswick (Germany) (Museum für Photographie) SE // **2002**
New York (Laurence Miller Gallery) SE // **2004** Boston (Robert
Klein Gallery) SE // **2005** New York (Bonni Benrubi Gallery) SE
// **2006** Milan (Centro Culturale di Milano) SE // **2008** Roches-
ter (New York) (George Eastman House/F**acing the Other
Half**) GE // **2009** Hamburg (Flo Peters Gallery) GE // **2013** Sal-
zburg (Museum der Moderne) GE // **2011** Berlin (Deutsches
Historisches Museum) SE // **2013** New York (Leica Gallery)
SE// **2014** Cologne (photokina) GE

BIBLIOGRAPHY (Selected) — **Men at Work**. New York 1932 // **L.W.
H.: Retrospective Catalogue**. New York 1939 (cat. Riverside
Museum) // **America & L.H.: Photographs 1904–1940**. New
York 1977 // **L.H.** Paris 1990 (cat. Musée Carnavalet) // **L.W.H.**
Paris 1992 // **L.H.: Die Kamera als Zeuge. Fotografien 1905–
1937**. Zurich 1996 // Freddy Langer: **L.H.: The Empire State
Building**. Munich 1998 // Vicki Goldberg: **L.H.: Children at
Work**. Munich, 1999 ✍ // **Focus on Photography**. Munich
2013 (cat. Museum der Moderne, Salzburg) // **DDR Ansichten**.
Ostfildern 2011 (cat. Deutsches Historisches Museum, Berlin)
// **Heartland. An American Road Trip in 1963**. Berlin 2013

"Social documentary photography was still in its infancy early in the twentieth century, yet Hine gave it canonical form. Not that he invented it, but his practice and the tenor of his work would influence American documentary photography for decades to come. He considered himself an artist, knew a good deal about art and photography and occasionally made a bow to artistic traditions, but photography was a relatively new medium with new potentials and new demands, and his task had little precedent in the history of art. He pictured a realm that he hoped his own images might obliterate, and he served a social cause at least as faithfully as aesthetics."

— Vicki Goldberg ✍

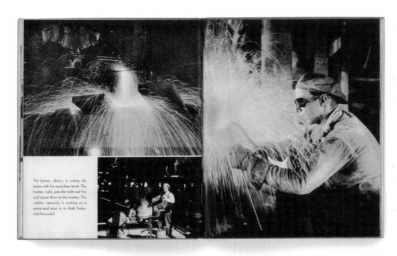

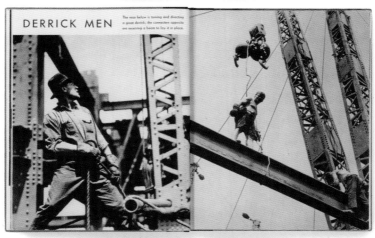

Hiro *(Yasuhiro Wakabayashi)*

Hiro: **Photographs.**
Boston (Bulfinch Press) 1999

3.11.1930 Shanghai (China) — Lives in New York (USA) Student of Avedon and Brodovitch. Internationally known photo designer with a focus on fashion and beauty. Parents Japanese. Childhood in China and Japan. Attends Japan Public School in Tsingtao 1937–1938, Peking High School 1942–1946, and Daiichi High School in Tokyo 1946–1949. 1954 moves to New York. Assistant to Rouben Samberg 1954–1955 and > Avedon 1956–1957. At the same time studies at the New School for Social Research under > Brodovitch (1956–1958). Personal assistant of the Art Director 1958–1960. Partner in Avedon Studio 1958–1971. 1958 opens his own studio in New York. Independent photographer for editorial and advertising with a focus on fashion and cosmetics. First publications in *Harper's Bazaar* and *Opera News*. Staff photographer for *Harper's Bazaar* 1966–1974. From 1981 contract photographer for Condé Nast. Numerous awards and prizes for his work, distinguished by its "elegant simplicity and immediate impact" (Nancy Hall-Duncan), incl. Gold Medal from the ADC (Art Directors Club) New York 1968, Photographer of the Year Award from the American Society of Media Photographers 1969, Society of Publication Designers Award 1979, Photographer Award from the Photographic Society of Japan (1989). 1982 the magazine *American Photographer* dedicates an issue to H. with the question on the cover: "Is This Man America's Greatest Photographer?" Participates in important group exhibitions on the history of fashion (*Shots of Style*, *Appearances*), advertising (*The Art of Persuasion*), and color photography (*Color as Form*, and *50 Years Modern Color Photography*).

EXHIBITIONS (Selected) — **1959** New York (Metropolitan Museum/**Photography in the Fine Arts**) GE // **1968** New York (Hallmark Gallery/**One Hundred Years of Harper's Bazaar**) GE // **1972** Philadelphia (College of Art/**Alexey Brodovitch and His Influence**) GE // **1975** Hempstead (New York) (Emily Lowe Gallery) GE // **1977** Rochester (New York) (George Eastman House/**Fashion Photography**) GE // **1982** Rochester (New York) (George Eastman House/**Color as Form**) GE // **1985** London (Victoria and Albert Museum/**Shots of Style**) GE // **1986** Cologne (photokina/**50 Jahre moderne Farbfotografie**) GE // **1988** New York (International Center of Photography/**The Art of Persuasion**) GE // **1990** New York (FIT/**15th of my 50th With Tiffany**) GE // Paris (Centre Pompidou/**De la réclame à la publicité**) GE // Vienna (Kunstforum/**Modefotografie 1990 bis heute**) GE // **1991** London (Victoria and Albert Museum/**Appearances**) GE // **1992** New York (New York Public Library/**100 Years of Vogue**) GE // **1994** Basel (Art Basel – Galerie zur Stockergg/**Avedon, Hiro, Penn**) GE // **1996** London (Hamiltons Gallery) SE

BIBLIOGRAPHY (Selected) — **H.** New York 1983 // Cecil Beaton and Gail Buckland: **The Magic Image.** London/Boston 1975 // Nancy Hall-Duncan: **The History of Fashion Photography.** New York 1979 // **Color as Form: A History of Color Photography.** Rochester 1982 (cat. George Eastman House) // **Shots of Style: Great Fashion Photographs Chosen by David Bailey.** London 1985 // **50 Jahre moderne Farbfotografie/50 Years Modern Color Photography 1936–1986.** Cologne 1986 (cat. photokina) // **The Art of Persuasion: A History of Advertising Photography.** New York 1988 // **Fighting Fish, Fighting Birds.** New York 1990 // **Appearances: Fashion Photography Since 1945.** London 1991 (cat. Victoria and Albert Museum) // **Sixties, Images, Silver: Twenty-five Photographs from the Sixties by H.** London 1996 (cat. Hamiltons Gallery) // Richard Avedon and Mark Holborn: **H.: Photographs.** Boston 1999 ▱

"Hiro's world encompasses the separate domains of fashion, portraiture, still-life and studies of the human body. His eye scrutinizes men and machines with equal focus. He served an apprenticeship which involved hours of photographing a shoe in Zen-like obedience to his teacher Alexey Brodovitch who had instructed, 'If you look in your camera and you see something you have seen before, don't click the shutter.' In Hiro's world everything is new. The most mundane objects or the most delicate features are transformed. A toenail, the pupil of an eye, a mouth or a light-switch are seen with the same concentration. Concentration is Hiro's most obvious quality. When he takes the whole theater of fashion to the beach, he returns with a metaphysical contemplation." — Mark Holborn ✍

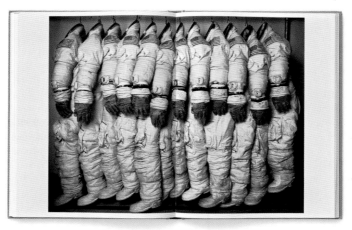

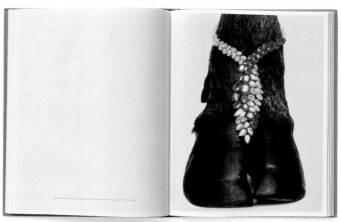

David Hockney

David Hockney: **Cameraworks.**
New York (Alfred A. Knopf) 1984

9.7.1937 Bradford (England) — Lives in Los Angeles (USA) Painter, draughtsman, and stage designer. Polaroid collages are the focal point of his photographic work. Internationally one of the best-known representatives of so-called "Art Photography". 1948–1957 Bradford Grammar School and four-year training at the Bradford School of Art. 1957 national service in Bradford and Hastings. 1959–1962 studies at the Royal College of Art (London). Meets there, among others, Allen Jones and Peter Phillips. Special affinity to the work of Pablo Picasso. 1961 in New York for the first time. Two etchings purchased by the Museum of Modern Art. 1962 diploma and College Life Drawing Prize. Teaching post at Maidstone School in the same year. 1963 first solo exhibition at Kasmin Gallery (London). Finally moves to the USA. Meets > Warhol and Henry Geldzahler. 1964 makes Los Angeles his home. First paintings of swimming pools. 1966 works as a stage designer for the first time (for the Royal Court Theatre London). 1967 greater commitment to photography (a pursuit of his since 1961). To date, more than 30,000 photographs (Polaroids) as well as small "joiners" (montages) in over 150 albums. 1969 visiting professor in Hamburg. 1973 moves to Paris for two years. More oil painting. 1978 final move to Los Angeles. 1982–1984 almost exclusively involved with photography. His Polaroid collages are exhibited for the first time at the Centre Pompidou. In 1985/86 design of the December/January issue for *Vogue* (France). First computer-graphics in color. *Pearblossom Highway* his last large-format photo-collage. From the mid 1990s mainly large-format inkjet prints (from super slides). 1997 longer stay in Great Britain: photographic landscape studies as the starting point for collages (color laser copies). Numerous awards incl. Honorary Doctorate from the University of Oxford and Order of the Companion of Honour (O.C.H.).

EXHIBITIONS (Selected) — **1963** London (Kasmin Gallery – 1968, 1969, 1970, 1972) SE // **1964** New York (Alan Gallery) SE // **1968** New York (Museum of Modern Art – 1979) SE // **1969** New York (Andre Emmerich – 1970, 1972, 1973, 1977, 1980, 1981, 1982, 1983, 1984, 1985, 1986) SE // **1981** London (National Gallery) SE // **1982** Paris (Centre Pompidou) SE // **1983** Basel (Kunsthalle) SE // London (Hayward Gallery) SE // **1988** Los Angeles (County Museum of Art) SE // **1996** Manchester (England) (Manchester City Art Galleries) SE // **1997** Cologne (Museum Ludwig) SE // **1999** Hannover (kestnergesellschaft) GE // **2006** Los Angeles (Louver Gallery) SE // **2008** Vienna (Kunsthalle) SE

BIBLIOGRAPHY (Selected) — **Twenty Photographic Pictures.** New York/Paris 1976 (portfolio, Sonnabend Gallery) // **D.H.: Photographs.** New York/London/Paris 1982 // **D.H.: Fotografien 1962–1982.** Basel/Paris 1983 (cat. Kunsthalle Basel) // **H.'s Photographs.** London 1983 (cat. Hayward Gallery) // **D.H. on Photography.** New York 1983 // **Cameraworks.** New York/London 1984 // **D.H.: A Retrospective.** Los Angeles 1988 (cat. County Museum of Art) // **D.H.: Retrospective Photoworks.** Heidelberg 1997 (cat. Museum Ludwig, Cologne) // **Das Versprechen der Fotografie. Die Sammlung der DG Bank.** Munich 1998 (cat. kestnergesellschaft, Hannover) ✎ // **A Bigger Book.** Cologne 2016

"Instead of using a drawing, what was originally meant to be a quick visual reference of a detail to be transformed into a painting acquired a life of its own as a simultaneous scene created as a photographic montage of a subject taken at one-second intervals ... From hundreds of snapshots, all aimed at a particularized perception of landscapes, interiors and people, and with the bright color spectrum of Matisse and Picasso as his paradigms in mind, the photographer-artist develops a photographically simulated painterly organism: photocollage on the biological principle of photosynthesis." — Günter Engelhard ✎⊐

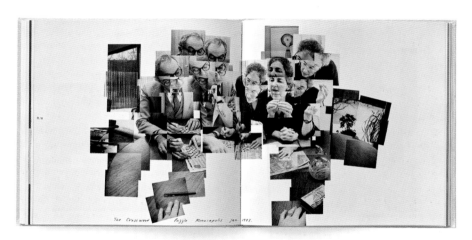

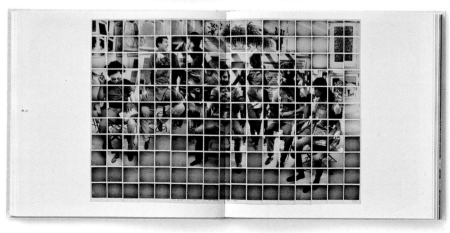

Thomas Höpker

Thomas Höpker: **Yatun Papa.**
Stuttgart (Franckh'sche
Verlagshandlung) 1963

**10.6.1936 Munich (Germany) — Lives in New York (USA) and Berlin
(Germany)** Photo essays, reports, and portraits. Distinguished photo-
journalist in Germany between the 1960s and 90s. Also editor-in-
chief and art director of several magazines. Schooling in Munich,
Stuttgart, Hamburg 1942–1956. During this time, first photographs
using a 9 x 12 plate camera. 1954 and 1956 first photographs for pho-
tokina's camera competition for young people. 1956–1959 studies
art history and archaeology in Göttingen and Munich. Photojournalist
for *Münchner Illustrierte* and *Kristall*. From 1964 press photographer
for S*tern* magazine in Hamburg. Numerous travels reports, incl. India,
South-East Asia, Rhodesia, Spain, and Portugal. Political reports about
Germany. From 1972 also works for television. 1974–1976 GDR cor-
respondent for *Stern*. 1976 *Stern* correspondent in New York. 1978
deputy editor-in-chief (pictures) of the American edition of *Geo*. 1981
gives up his permanent appointment with *Geo*. 1986 art director.
Freelance work for various magazines, incl. *Stern* and *Geo*. Several books. Films: *The Village Arabati*
(1973), *Death in a Cornfield* (1998), *Robinson Crusoe Island* (2000), *Easter Island* (2003), *Ice-cold
Splendor* (2005). Various exhibitions. Kulturpreis of the DGPh (Deutsche Gesellschaft für Photogra-
phie: German Photographic Association) (1968), Order of Merit of the Federal Republic of Germany
(1975). Leica Hall of Fame Award (2014).

EXHIBITIONS (Selected) — **1956** Hamburg (Landesbildstelle)
SE // **1966** Hamburg (**Weltausstellung der Photographie**) GE
// **1975** Lübeck (Germany) (Overbeck Gesellschaft) SE // **1977** Munich (Stadtmuseum) SE // **1979** Kassel (Germany)
(**Deutsche Fotografie nach 1945**) GE // **1986** Frankfurt am
Main (Fotografie Forum) SE // **1988** Cologne (photokina) GE //
1996 Hamburg (Deichtorhallen) GE // **1997** Bonn (Kunst- und
Ausstellungshalle der BRD) GE // **2004** New York (Pace/Mac
Gill) SE // **2005** Munich (Fotomuseum) SE // **2006** Hamburg
(Museum für Kunst und Gewerbe) SE // **2007** Berlin (C/O Ber-
lin) SE // **2008** Erfurt (Germany) (Kunsthalle) SE // **2009**
Vienna (WestLicht) SE

BIBLIOGRAPHY (Selected) — **Lebendiges Kiel**. Kiel 1963 // **Yatun
Papa**. Stuttgart 1963 // T.H. and Eva Windmöller: **Leben in der
DDR**. Hamburg 1976 // T.H. and Günter Kunert: **Berliner Wän-
de**. Munich/Vienna 1976 // T.H. and Heinz Mack: **Expeditionen
in künstliche Gärten**. Hamburg 1977 // **Die großen Foto-
grafen: Th.H**. Munich 1985 // **Ansichten**. Heidelberg 1985 //
T.H. and Eva Windmöller: **New Yorker**. Schaffhausen 1987 //
**Zeitprofile. 30 Jahre Kulturpreis Deutsche Gesellschaft für
Photographie 1959–1988**. Cologne 1988 (cat. photokina) //
Das deutsche Auge. Munich 1996 (cat. Deichtorhallen Ham-
burg) // **Deutsche Fotografie. Macht eines Mediums**. Cologne
1997 (cat. Kunst- und Ausstellungshalle der BRD, Bonn) //
T.H.: New York September 11 by MAGNUM Photographers.
New York 2001 // **T.H.: Photographien 1955–2005**. Munich
2005 (cat. Fotomuseum) ✍

"What characterizes Thomas Höpker's attitude as a photographer and chronicler is his aversion to loud pictures and photos that shock, and his preference for cultivating a cautiously empathetic pictorial language that goes beyond the events of the day. Based on his self-image as a photographer, he defines himself as a documentarist, insisting on the authenticity of the medium, which the practice of digital photography has made so easy to alter and manipulate that the differences between reality and fiction are today scarcely perceived any more. [...] Thomas Höpker's early motifs reflect various influences and sources of inspiration: on the one hand the photographer's search for a succinct style that links up with the achievements of 'subjektive photographie' in terms of form and composition; on the other, his distinct interest in social and societal themes." — Ulrich Pohlmann ✎ɔ

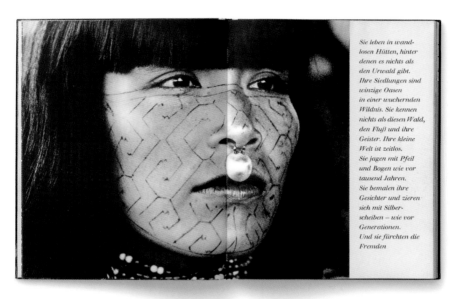

Sie leben in wand-
losen Hütten, hinter
denen es nichts als
den Urwald gibt.
Ihre Siedlungen sind
winzige Oasen
in einer wuchernden
Wildnis. Sie kennen
nichts als diesen Wald,
den Fluß und ihre
Geister. Ihre kleine
Welt ist zeitlos.
Sie jagen mit Pfeil
und Bogen wie vor
tausend Jahren.
Sie bemalen ihre
Gesichter und zieren
sich mit Silber-
scheiben – wie vor
Generationen.
Und sie fürchten die
Fremden

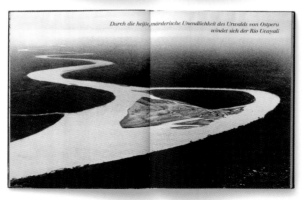

Durch die heiße mörderische Unendlichkeit des Urwalds von Ostperu
windet sich der Rio Ucayali

Horst P. Horst *(Horst Paul Albert Bohrmann)*

Valentine Lawford: **Horst. His Work and his World.** New York (Viking Penguin Inc.) 1984

14.8.1906 Weißenfels, Saale (Germany) — 18.11.1999 Long Island (New York, USA) Leading fashion interpreter of the 1930s and 40s, active into the 1980s. Represents a form of photography schooled in Surrealism and classicist ideals. A master of dramatic lighting. Also still lifes, plant studies, and portraits. Son of a well-to-do merchant. Early contact with the world of art (theater, dance, painting, architecture). Studies at the Kunstgewerbeschule (College for Arts and Crafts) in Hamburg. 1930 moves to Paris. Practical training under Le Corbusier. Meets > Hoyningen-Huene. Through him first contact with *Vogue* in spring 1931. First photographs for the French edition. 1932 goes to the USA, where he works for the first time for American *Vogue* at Condé Nast's invitation. 1935 successor to Hoyningen-Huene in the Paris *Vogue* studios. Fashion and portraits, among others George Cukor, Katharine Hepburn, Cole Porter, Elsa Schiaparelli. In September 1939 final move to the USA. American citizenship in 1943. Serves in the US Army. In 1945 returns to *Vogue* (to work in team with > Penn and > Beaton). 1951 closure of the New York *Vogue* studios. Own studio on the East Side. Intensive work for *House & Garden*. In 1961, at Diana Vreeland's initiative, photo series about the lifestyle of international high society. Commutes regularly between Europe and the USA. In the 1980s works for American *Vogue* and for *Vogue* in France, Great Britain, Italy, and Spain. Works for *Vanity Fair*. 1984 retrospective at the International Center of Photography. 1988 Lifetime Achievement Award of the Council of Fashion Designers of America. 1989 Honorary Doctorate from the University of Bradford.

EXHIBITIONS (Selected) — **1932** Paris (Galerie La Plume d'Or) SE // **1938** New York (Germain Seligman's Art Gallery) SE // **1974** New York (Sonnabend Gallery – 1976, 1977, 1978, 1980) SE // **1984** New York (International Center of Photography) SE // **1985** Venice (Palazzo Fortuny) SE // **1986** London (Hamiltons – 1989, 2006) SE // **1987** Munich (Stadtmuseum) SE // **1989** New York (Holly Solomon Gallery) SE // **1991** Paris (Musée des Arts de la Mode) SE // **1997** Halle (Germany) (Staatliche Galerie Moritzburg, Halle) SE // **2000** Berlin (Camera Work Gallery) JE (with Jacob Hilsdorf and Burghard von Harder) // **2003** Paris (Galerie Odermatt-Vedovi) SE // **2005** Moscow (Moscow House of Photography) SE // **2006** Hamburg (Haus der Photographie/Deichtorhallen) GE // **2007** Atlanta (Georgia) (Jackson Fine Art) SE // **2008** Munich (Bernheimer Fine Old Masters) SE

BIBLIOGRAPHY (Selected) — **H.: Photographs of a Decade.** New York 1944 // **Patterns from Nature.** New York 1946 // **Vogue's Book of Houses, Gardens, People.** New York 1968 // **Salute to the Thirties.** New York 1971 // Valentine Lawford: **H.: His Work and His World.** New York 1984 // **H.** Milan 1987 (cat. Münchner Stadtmuseum) // **H.: Photographien aus sechs Jahrzehnten.** Munich 1991 // **H.: 60 Ans de Photographie.** Paris 1991 (cat. Musée des Arts de la Mode) // **Form.** Altadena 1992 // **H.: Magier des Lichts.** Heidelberg 1997 (cat. Staatliche Galerie Moritzburg, Halle) ✎ // **The heartbeat of fashion. Sammlung F.C. Gundlach.** Bielefeld 2006 (cat. Haus der Photographie/Deichtorhallen Hamburg)

"Horst is an illusionist who uses appropriate props and the right light to create an artificial space, an enchanted atmosphere that transports the model into an artificial world, a world of illusion. […] His style-setting compositions laid the foundations for the oeuvre of younger famous photographers. He might not have revolutionized fashion photography but he perfected it."
— Reinhold Misselbeck ✍

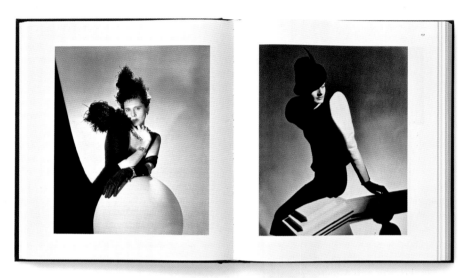

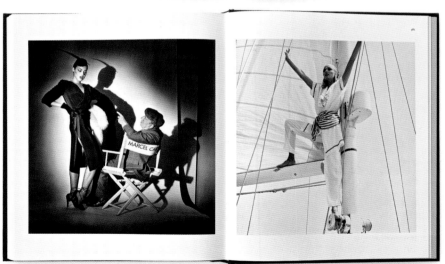

Frank Horvat

Frank Horvat: **Fifty one photographs in black & white.** Stockport (Dewi Lewis) 1998

28.4.1928 Abbazia (Italy) — Lives in Boulogne-sur-Seine (France) Experimental photography, reports, fashion. Especially innovative through his outdoor aesthetic approach schooled in journalism. More recently turned to digital media art. Elementary school in Milan. Gymnasium (grammar school) in Lugano, Switzerland, where his parents had fled after the outbreak of war. 1944 his first camera, a Retina, with which takes his first pictures. 1948 returns to Italy. Studies at the art academy in Brera. 1949–1950 graphic artist with a Milan agency. From 1951 freelance photographer. In the same year first bigger report (about pilgrims in Northern Italy). Also in 1951, meets > Cartier-Bresson and > Capa in Paris. 1952–1954 self-commissioned reports about India. 1954–1955 in London. From 1955 in Paris. Numerous photographs published in *Picture Post*, *Paris Match*, and *Life*. 1955 participates in the *The Family of Man* exhibition. From the end of the 1950s works more in fashion photography. Here he represents an unassuming aesthetic approach inspired by journalism and using a 35mm camera. In 1958 fashion for *Elle* (France) and *Vogue* (Great Britain). 1960–1961 several stays in the USA, fashion for *Harper's Bazaar*, *Glamour*, and *Esquire*. 1959–1961 associate member of Magnum. 1962 photo series about great capitals of the world commissioned by *Revue* magazine. 1962–1977 fashion for *Harper's Bazaar* and *Vogue*. Since the mid 1960s also active as maker of experimental films. The magazine *twen* (no. 8, 1960) presents him as one of the "world's best photographers". More recently, several photo essays for *FAZ-Magazin* (color supplement of the *Frankfurter Allgemeine Zeitung*). Now mainly involved with computer-generated pictures, occasionally reinterpreting older works.

"As an exceptional artist, Frank Horvat constructs his work with discretion and rigor. As a fashion photographer, he escapes into fleeting infatuations; as a photo-reporter, he brings in a harvest of strong and timeless images. In his own way, however, he has accomplished a kind of quiet revolution, introducing the 24 by 36 format from the end of the fifties. […] William Klein owes him something, perhaps, and vice versa. His name will go down amongst the greats in the history of fashion photography." — Jean-Luc Monterosso ✏

EXHIBITIONS (Selected) — **1955** New York (Museum of Modern Art) GE // **1989** Paris (Espace Photographique) SE // **1991** Toulouse (Galerie municipale du Château d'Eau) SE // **1994** Paris (Centre national de la photographie) SE // **1996** Houston (Texas) (FotoFest) SE // Paris (Musée Carnavalet) ES **2000** Cologne (in focus/Galerie am Dom) SE // Paris (Musée Maillol – 2005) SE // **2002** Antwerp (Fifty One Fine Art Photography) SE // **2003** Los Angeles (Fahey/Klein Gallery) SE // **2004** Amsterdam (Wouter van Leeuwen Gallery) SE // **2006** Wadebridge (England) (Tristan's Gallery – 2007) SE // Boulogne-Billancourt (Espace Landowski) SE // **2014** Berlin (Galerie Hiltawski) SE

BIBLIOGRAPHY (Selected) — **F.H.** Paris 1989 (cat. Paris Audiovisuel) ✏ // **Arbres**. Paris 1994 // **Le Bestiaire d'Horvat**. Paris 1994 // **Paris – Londres. London – Paris**. Paris 1996 (cat. Musée Carnavalet) // **Fifty one Photographs in black & white**. Stockport 1998 // **Very Similiar**. Stockport 1999 // **F.H.** Paris 2000 // **Photodiary 1999**. Heidelberg 2000 // **Le Labyrinthe H. 60 ans de Photographie**. Paris 2006 (cat. Espace Landowski, Boulogne-Billancourt) // **House with Fifteen Keys**. Paris 2013

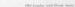

1962 Rome

1961 London (with Hardy Amies)

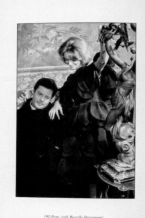

1962 Rome (with Marcello Mastroianni)

1962 Rome (with Federico Fellini)

Eikoh Hosoe

Eikoh Hosoe: **Embrace.**
Tokio (Shashin Hyoronsha
Publishing House) 1974

18.3.1933 Yonezawa (Japan) — Lives in Tokyo (Japan) One of the internationally best-known Japanese camera artists with important book publications in the 1960s, among them "a truly disturbing book" (Gerry Badger) *Killed by Roses* in cooperation with the writer Yukio Mishima. Childhood in Tokyo. During the 1944/45 air raids evacuated to Yonezawa. Wins first prize at the Fuji Photo Contest with *Poddie-Chan*, resulting in a more intensive commitment to photography. Begins to study at the Tokyo College of Photography. Member of the Demokrato artists' group. Graduates from Tokyo College. From now on he works as a freelance photographer. 1956 first solo exhibition (*An American Girl in Tokyo*) at the Konishiroku Gallery, Tokyo. 1957–1959 participates in the annual *Eyes of Ten* photo exhibition at the invitation of Tatsuo Fukushima. In July 1959 founds the Vivo photo agency together with Kikuji Kawada, Akira Satō, Akira Tanno, > Narahara, and > Tōmatsu. In the same year he produces an experimental 16mm film entitled *Navel and Atomic Bomb* together with Tatsumi Hijikata. In 1963, as the result of a most fruitful collaboration with the writer Yukio Mishima, he publishes the book *Barakei* (*Killed by Roses*) which receives several awards incl. a prize from the Photo Critics Society; also his best-known work. 1962 marries Misako Imai, who commits suicide in 1970. 1972 first

EXHIBITIONS (Selected) — **1956** Tokyo (Konishiroku Gallery – 1960) SE // **1968** Tokyo (Nikon Salon – 1977) SE // Osaka (Nikon Salon – 1977) SE // **1969** Washington, DC (Smithsonian Institution) SE // **1970** Phoenix (Arizona) (Phoenix College Library Gallery) SE // **1972** Rochester (New York) (Visual Studies Workshop) SE // **1973** New York (Light Gallery – 1975, 1983) SE // **1974** New York (Museum of Modern Art/**New Japanese Photography**) GE // **1976** Carmel (California) (Friends of Photography) SE // **1982** Rochester (New York) (George Eastman House) SE // **1984** Hamburg (Museum für Kunst und Gewerbe/**Die japanische Photographie**) GE // **1986** Oxford (Museum of Modern Art/**The Eyes of Four**) GE // **1988** Ito (Ikeda Museum of 20th Century) SE // **1990** Osaka (Museum of Modern Art) SE // Houston (Texas) (FotoFest) SE // Tucson (Arizona) (Center for Creative Photography) SE // **1991** New York (International Center of Photography) SE // **1993** Speyer (Germany) (Historisches Museum der Pfalz) GE // **2002** Cologne (Galerie Priska Pasquer/KunstKöln) SE // **2003** Houston (Museum of Fine Arts/**The History of Japanese Photography**) GE // Paris (Hôtel Sully) GE // Kiyosato (Japan) (Kiyosato Museum of Photographic Arts) SE // Barcelona (Kowasa Gallery) SE // **2004** New York (Howard Greenberg Gallery) SE // **2006** Tokyo (Tokyo Metropolitan Museum of Photography) SE // **2008** Los Angeles (Los Angeles County Museum) SE // **2009** San Francisco (San Francisco Museum of Modern Art/**The Provoke Era**) GE

BIBLIOGRAPHY (Selected) — **Otoko to Onna (Man and Woman)**. Tokyo 1961 // E.H. and Yukio Mishima: **Barakei (Killed by Roses)**. Tokyo 1963 // **Kamaitachi**. Tokyo 1969 // **Embrace**. Tokyo 1971 // E.H. and Yukio Mishima: **Barakei Shinshuban (Ordeal by Roses Re-edited)**. Tokyo 1971 // **Embrace**. Tokyo 1974 // **Mark Holborn: Black Sun. The Eyes of Four. Roots and Innovation in Japanese Photography.** New York 1986 // **Photography: The World of E.H.** Ito 1988 (cat. Ikeda Museum of 20th Century) // Thomas Buchsteiner and Meinrad Maria Grewenig (eds): **Japanische Fotografie der 60er Jahre/Japanese Photography in the 1960s.** Heidelberg 1993 (cat. Historisches Museum der Pfalz, Speyer) // **Aperture Masters of Photography: E.H.** New York 1999 // Anne Wilkes Tucker, Dana Friis-Hansen, Ryūichi Kaneko, and Takeba Joe: **The History of Japanese Photography.** New Haven/London 2003 (cat. Museum of Fine Arts, Houston) // **Japon. Un Renouveau Photographique 1945–1975.** Paris 2003 (cat. Hôtel Sully) // **Spherical Dualism of Photography: A World of Eikoh Hosoe.** Tokyo 2006 (Tokyo Metropolitan Museum of Photography) // **Deadly Ashes.** Tokyo 2007 // Ryūichi Kaneko and Ivan Vartanian: **Japanese Photobooks of the 1960s and '70s.** New York 2009

trip to America, where he meets Cole Weston. Workshops at Phoenix College (Arizona), at Columbia College (Chicago), and in Yosemite (California). 1974 establishes the *Photo Workshop School* together with > Araki, Masahisa Fukase, > Moriyama, Tōmatsu, and Noriyaki Yokosuka in Tokyo. 1975 appointed professor at the Tokyo College of Photography. 1987 trip to New York with his son Kenji, where he buys a large-format camera (20 x 24) and experiments with platinotype. 1991 opening of a retrospective (touring exhibition until 2000) at the New York International Center of Photography (Midtown). Has participated in important group exhibitions such as *New Japanese Photography* (New York 1974), *Die japanische Photographie* (Hamburg 1984), and *The History of Japanese Photography* (Houston 2003).

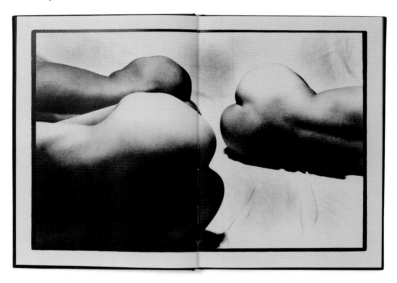

"While Japanese pictorialism had established a long, venerable tradition of the photographic nude, Hosoe's body of work had a strong impact because it infused a sexual charge into the physical connection between the sexes. Hosoe was not alone in addressing such themes at this time: Literature, poetry, film, and other contemporary arts were recognizing sexuality as one of the true and essential human qualities. This is also true of Butoh, a new form of dance pioneered by Tatsumi Hijikata, the 'man' of this series. It is fitting that this, Hosoe's first photobook should also be the fruit of his first collaboration with Hijikata, with whom he would later go on to create the seminal book *Kamaitachi*. […] Hosoe's creative involvement with dance performance and his use of the human form for expression has spanned the breadth of his career."

— Ryūichi Kaneko ✍️

George Hoyningen-Huene

Hoyningen-Huene: **Meisterbild-nisse. Frauen, Mode, Sport, Künstler.** Berlin (Verlag Dietrich Reimer) 1932

4.9.1900 Saint Petersburg (Russia) — 12.9.1968 Los Angeles (USA)
Still lifes, portraits, nudes, travel photography, and fashion photographs, especially for *Vogue* and *Harper's Bazaar*. Innovator of the genre, interpreting fashion in strict observance of form and schooled in classicist ideals (mainly in the studio). Third child of influential Russian Baron Barthold von Hoyningen-Huene and his wife Anne. From 1914 Imperial Lyceum in St Petersburg. 1917–1919 England. 1919–1920 with the British Expeditionary Force in South Russia as an interpreter. 1920 Paris, where in 1923 he studies under André Lhote. 1924 friendship and collaboration with > Man Ray. Takes up fashion illustration inspired by Cubism and Art Deco. 1926 first fashion photos for *Vogue*, stylistically clearly at variance with the Pictorialism of Baron de Meyer. 1930 start of his friendship with > Horst. Trips to Berlin, London, New York, Chicago, Hollywood, and Hammamet in Tunisia. 1935 moves to *Harper's Bazaar* after disagreements with publisher Condé Nast. 1936 Africa. 1938 Greece, South-East Asia, and Australia. After the war, a growing interest in film. By 1950 three documentaries. Takes up residence in Mexico and finally California. Lectureship at the Art Center School of Los Angeles. 1950 works briefly for *Flair*. From 1954 color consultant in Hollywood, among others, for George Cukor. 1967 participation in the Oral History Project of the University of California (Los Angeles). 1980 big retrospective at the International Center of Photography with stopovers in London, Paris, Minneapolis (Minnesota), and Long Beach (California).

EXHIBITIONS (Selected) — **1928** Paris (1er Salon indépendant de la photographie/**Salon de l'Escalier**) GE // **1929** Stuttgart (**Film und Foto**) GE // **1963** Cologne (photokina) GE // **1970** Los Angeles (County Museum) SE // **1974** New York (Sonnabend Gallery – 1977) GE/SE // **1980** New York (International Center of Photography) SE // **1984** New York (Staley-Wise Gallery) SE // Norfolk (Virginia) (Chrysler Museum) SE // **2007** Hamburg (Haus der Photographie/Deichtorhallen) GE // **2009** Paris (Jeu de Paume – Site Sully/**Collection Christian Bouqueret**) GE // Munich (Stadtmuseum) GE

BIBLIOGRAPHY (Selected) — H.K. Frenzel: **H.-H.: Meisterbildnisse.** Berlin 1932 // **African Mirage: The Record of a Journey.** New York/London 1938 // **Egypt.** New York 1943 // **Hellas: A** Tribute to Classical Greece. New York 1943 // **Mexican Heritage.** New York 1946 // Oreste Pucciani: **H.-H.** Los Angeles 1970 (cat. County Museum) // Horst P. Horst: **Salute to the Thirties.** New York 1971 // William A. Ewing: **Eye for Elegance.** New York 1980 (cat. International Center of Photography) // William A. Ewing: **The Photographic Art of H.-H.** London 1986 // **The heartbeat of fashion. Sammlung F.C. Gundlach.** Bielefeld 2007 (cat. Haus der Photographie/Deichtorhallen Hamburg) // **Paris. Capitale photographique. 1920/1940. Collection Christian Bouqueret.** Paris 2009 (cat. Jeu de Paume – Site Sully) // **Nude Visions. 150 Jahre Körperbilder in der Fotografie.** Heidelberg 2009 (cat. Münchner Stadtmuseum)

"From 1926 to 1945 George Hoyningen-Huene photographed extensively, both as a means of livelihood and for his own pleasure. In doing so he earned the profound admiration of his illustrious colleagues, including Edward Steichen, Man Ray, Cecil Beaton, Louise Dahl-Wolfe, and Diana Vreeland; of his successors, among them Horst, Irving Penn, and Richard Avedon; and of a wider public that grew to treasure his cool refined images which appeared bountifully in the pages of the finest fashion and photography magazines."

— William A. Ewing ✎

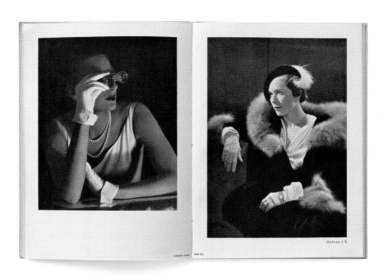

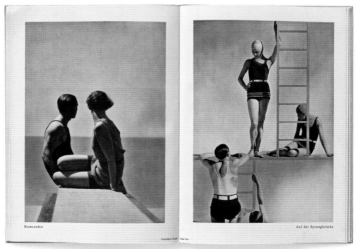

Franz Hubmann

Franz Hubmann: **Wien.
Vorstadt Europas.** Zurich
(Artemis Verlags-AG) 1963

2.10.1914 Ebreichsdorf (Austria) — 9.6.2007 Vienna (Austria) Photojournalist. The doyen of Austrian photography after 1945. Representative of a form of life photography as propagated especially by Karl Pawek. Also topographical photography in color. Trains as a textiles technician. Receives his first camera at the age of 12. 1935–1938 works as a manager of a hat factory. 1938 military service. Until 1945 military service and then prisoner of war. 1946–1949 studies at the Graphische Lehr- und Versuchsanstalt (Graphic Arts Teaching and Research Institute) in Vienna. 1949–1954 in charge of the photo archive of the Austrian National Tourist Office. At the same time works for *Austria International* magazine (edited by Karl Pawek). 1954 founds the cultural magazine *magnum*, together with Pawek, Alfred Schmeller, and Friedrich Hansen-Löve. Portraits of artists (including Hans Arp, Alexander Calder, Marcel Duchamp, Max Ernst, Oskar Kokoschka, Pablo Picasso) and photo essays (among others, *Café Hawelka*) at the center of an oeuvre schooled in a humanist form of photojournalism, until the mid 1960s mainly in b/w. After *magnum* ceases publication (1966), he works freelance. Seventeen television films for the ORF (Austrian Broadcasting Corporation) and around 50 photobooks, especially on contemporary, historical, or folkloristic themes. Sometimes called "Austria's Cartier-Bresson". Numerous exhibitions, among others in Salzburg, Linz, Hamburg, Cologne, Copenhagen, Milan, Rome, Naples, and New York. Numerous distinctions and prizes.

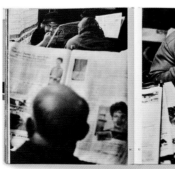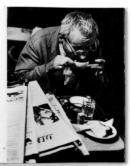

EXHIBITIONS (Selected) — **1959** Vienna (Würthle Gallery) SE // **1999** Munich (Klewan Gallery) SE // Vienna (Palais Harrach) SE // **2000** Salzburg (Austria) (Rupertinum) // **2004** Vienna (WestLicht) SE // **2014** Hamburg (Haus der Photographie/ Deichtorhallen) GE

BIBLIOGRAPHY (Selected) — **Wien. Vorstadt Europas.** Zurich 1963 // **Das Deutsche Familienalbum.** Vienna 1972 // **Café Hawelka**. Vienna 1982 // **Der Wiener Prater**. Vienna 1986 // **Auf den Spuren von Heimito von Doderer**. Vienna 1996 // **Künstlerportraits**. Munich 1999 (cat. Klewan Gallery) // **F.H.: Das photographische Werk**. Vienna 1999 // Margit Zuckriegl and Gerald Piffl (eds): **F.H.: Photograph**. Vienna 2004 // **Waldviertel**. Vienna 2005 // **Augen auf! 100 Jahre Leica**. Heidelberg 2014 (cat. Haus der Photographie/Deichtorhallen Hamburg)

"The ingenuity of Hubmann's work lies in his tracking down of subjects and themes that 'are in the air' […]. He is not only the archivist of memories but the creator of a specific historical awareness recruited from pictures. He created for future generations a concept of culture, picturing the new approach to art and society after the end of the Second World War. He gave the protagonists of a new generation of artists a face, a physiognomy, and an identity. To the pictures of those he portrayed he added the psychological element of pervasive narrative, incorporating them, as part of a whole, into the atmosphere and mood of the times. And for every situation, for every face, for every street corner, he can deliver the authentic story."

— Margit Zuckriegl ✍

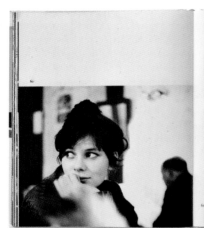
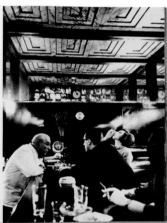

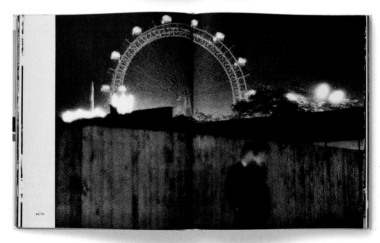

George Hurrell

The Hurrell Style. 50 Years of Photographing Hollywood.
New York (The John Day Company) 1976

1.6.1904 Cincinnati (Ohio, USA) — 17.5.1992 Los Angeles (USA) Sometimes known as the "grand master of Hollywood portraits". Together with Clarence Sinclair and Eugene Robert Richee, in the 1930s and 40s the most important exponent of a glamorous, idealizing style of portraiture. Interested in art early on. 1920 studies at the Art Institute of Chicago and the Academy of Fine Arts. 1925 assistant to the photographer Eugene Hutchinson. 1927 moves to Laguna Beach, California's artist colony. There he does landscape painting and photographic experiments. Art reproductions contracted by artist friends. Meets the wealthy socialite Florence "Poncho" Barnes. In autumn 1927 opens a photo studio in Los Angeles (672 Lafayette Park Place). Meets > Steichen who gives him important advice. 1928 through Barnes, meets the actor Ramon Navarro. Via him makes contact with the MGM advertising department. After convincing portraits of a seductive Norma Shearer (*The Divorce*) contract as head photographer at MGM 1930–1933. Portraits of practically all the stars, incl. Lon Chaney, Joan Crawford, Clark Gable, Greta Garbo, John Gilbert. 1933 opens his own studio on Sunset Boulevard. There portraits of stars from RKO Pictures, Paramount and 20th Century Fox (Marlene

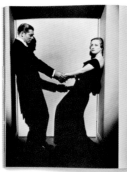
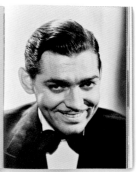

EXHIBITIONS (Selected) — **1965** New York (Museum of Modern Art/**Glamour Poses**) GE // **1976** Los Angeles (Municipal Art Museum/**Dreams for Sale**) GE // **1987** Los Angeles (Los Angeles County Museum of Art) GE // **1992** Zurich (Museum für Gestaltung) GE // **2005** St Louis (Missouri) (Sheldon Art Galleries) SE // **2008** The Hague (Netherlands) (Galerie 't Fotokabinet) GE // Lugano (Switzerland) (Museo d'Arte) GE // London (National Portrait Gallery) GE // **2009** Lausanne (Switzerland) (Musée de l'Élysée) GE // Chalon-sur-Saône (France) (Musée Nicéphore Niépce) GE // Iserlohn (Germany) (Städtische Galerie) GE

BIBLIOGRAPHY (Selected) — **The H. Style: 50 Years of Photographing Hollywood.** New York 1976 // John Kobal: **People Will Talk.** New York 1986 // **Masters of Starlight: Photographers in Hollywood.** New York 1987 (cat. Los Angeles County Museum of Art) // **The Portfolios of G.H.** Santa Monica 1991 // **The Book of Stars by G.H.** Munich 1991 // **G.H.: Hollywood Glamour Portraits.** Munich 1993 // Annemarie Hürlimann and Alois Martin Müller (eds): **Film Stills. Emotions Made in Hollywood.** Zurich 1992 (cat. Museum für Gestaltung) ⌁ // **H.'s Hollywood Portraits: The Chapman Collection.** New York 1997 // Graydon Carter: **Vanity Fair Portraits: A Century of Iconic Images.** London 2008 (cat. National Portrait Gallery)

Dietrich, Gary Cooper, Carole Lombard, Shirley Temple, Mae West, Loretta Young). From 1935 also a studio in New York. 1936 regular contributions in *Esquire*. 1938 contract with Warner Bros (Humphrey Bogart, James Cagney, Bette Davis). 1941 studio in Beverly Hills. 1942 troop photographer with the US Air Force's first film unit. 1945 returns to Hollywood. For Columbia Pictures portraits of Rita Hayworth, Claudette Colbert, and Mae West. 1946–1956 in New York. There above all advertising as his glamorous portrait style is seen as old fashioned. 1956 returns to California. 1960 foundation of Hurrell Productions by Walt Disney. TV commercials for Kelloggs, Sunkist, Johnson & Johnson, among others. Film stills for *M*A*S*H**, *Gunsmoke*, *Star Trek*. Rediscovery of his early work in the exhibition *Glamour Poses* (1965) in the Museum of Modern Art, New York. 1970–1975 still photographer for productions such as *Butch Cassidy and the Sundance Kid*, *The Poseidon Adventure*, *All the President's Men*. 1984 much admired photos of 50-year-old Joan Collins for *Playboy*. Once again portraits of famous actors (Sean Penn, Eric Roberts, Sharon Stone) as part of a documentary (1992) on his professional career.

"Photography, accessible and manipulable, seemingly anchored in reality, always aims to seduce and enchant in the fan magazines. The mandate for the photographer was to transform the stars into creatures of fantasy, both 'real' (through the presence of the image) and heavenly."
— Annemarie Hürlimann

Irina Ionesco

Irina Ionesco: **Nudes.**
Kilchberg/Zurich 1996

3.9.1935 Paris (France) — Lives in Paris Since the 1970s, internationally discussed art photographer with a focus on nudes and erotic photography. Parents Romanian. Elementary and secondary school in Constanta (Romania). 1946 moves to France. There first works as dancer. 1951–1958 appears with various groups. After an illness 1958 gives up dancing and at first takes up painting. A gift of a Nikon the starting point of her self-taught photography from 1964. From 1965 focus of exploration on the female body. Also nude photos of pubescent daughter Eva Ionesco, which leads to considerable debate in the 1970s. 1970 first solo exhibition. 1982 first exhibition of her color photography. 1988 first trip to Egypt. Discovers the Orient. 1989 travels to Mauretania. For UNESCO documents cities sunk in sand and the women living there. 1991 Leonardo da Vinci fellowship; takes photos in Prague for her book *Kafka. Le cercle de Prague*. Since 1995 has commuted between Paris, Cairo, Alexandria, the Mauretanian desert, and the countries of North Africa. Participates in important group exhibitions such as *Das Aktfoto* in Munich (1985) and *Splendeurs et misères du corps* in Fribourg and Paris (1988).

"**Photography is for me essentially a poetic element; I see it as theatrical writing which helps me to hold on to all my fantasies against an endlessly unrolling force. Every sitting, staged like a theater sequence, integrates the woman in a dream world, in which she unveils, mythically, complexly, inventively, step by step, all the facets of the thousand mirrors into which I delve. For me, eroticism can only be experienced through a metaphysical dimension. I love excess, dreams, the unusual. That's why I've taken a sentence from Baudelaire for my own: 'In art, only the bizarre is beautiful'.**" — Irina Ionesco ✐

EXHIBITIONS (Selected) — **1970** Amsterdam (Jalmar Galerie) SE // **1973** London (The Photographers' Gallery) SE // **1974** Paris (Galerie Nikon) SE // Barcelona (Galería Spectrum) SE // **1975** Amsterdam (Canon Photo Gallery) SE // **1976** Rome (Studio d'Arte Contemporanea) SE // **1978** Paris (Fnac Montparnasse) SE // **1979** New York (Hansen Galleries – 1980) SE // **1982** Paris (Galerie Créatis) SE // **1983** Brussels (Galerie Aspects) SE // **1989** Paris (Espace Photographique) SE // **1991** Paris (Galerie Contrejour) SE // **1992** Prague (Institut Français) SE // **1993** Lyon (Galerie Vrais Rêves) SE // **1994** Aarau (Switzerland) (Photogalerie Bild) SE // **2002** Milan (Galleria 70) SE // **2005** Tokyo (Parco Museum of art and beyond) SE // **2006** Brescia (Italy) (Biennale Internazionale di Fotografia) GE // **2007** Paris (Galerie Vivienne) SE // Paris (Galerie Baudoin Lebon – 2009) GE/SE

BIBLIOGRAPHY (Selected) — **Liliacées langoureuses aux parfums d'Arabie.** Paris 1974 // **Femmes sans tain.** Paris 1975 // **Nocturnes.** New York 1976 // **Litanies pour une amante funèbre.** Milan 1976 // **Le temple aux miroirs.** Paris 1977 // I.I. Geneva 1979 // **Cent onze photographies érotiques.** Paris 1980 // **Le divan.** Paris 1981 // **Les Passions.** Paris 1984 // **The Eros of Baroque.** Tokyo 1988 // I.I. Paris 1989 (cat. Espace Photographique) // **Les Immortelles.** Paris 1991 (cat. Galerie Contrejour) // **Méditerranéennes.** Paris 1991 // **Kafka. Le cercle de Prague.** Paris 1992 // **TransEurope.** Paris 1994 (cat. Institut Français, Prague) // **Hiver clinique.** Luxembourg 1996 // **Nudes.** Kilchberg/Zurich 1996 ✐ // **Eva: Eloge de ma fille.** Tokyo 2004 // **L'œil de la poupée.** Paris 2004 // **Le Japon Interdit.** Paris 2004

Yasuhiro Ishimoto

14.6.1921 San Francisco (USA) — 6.2.2012 Tokyo (Japan) After Ken Domon, considered to be the most important Japanese photographer of his generation. Also sets a style in his adaptation of American influences, especially the aesthetic of the Chicago school. Described by Minor White as a "visual bilingual". Son of Japanese immigrants. Spends his first years in the USA. 1924–1939 in Japan. 1939 returns to America. In WW II interned in a camp in Colorado. 1946–1948 studies architecture at the North-Western University of Chicago. 1948–1952 studies photography under > Callahan and > Siskind at the Chicago Institute of Design. Moholy-Nagy Award in 1951 and 1952. 1953 returns to Japan to work on a photo series about the Katsura Palace in Kyoto commissioned by the Museum of Modern Art (New York). In the same year first solo exhibition at the Museum of Modern Art. 1958 first big publication: *Aruhi Arutokoro* (*Someday, Somewhere*) — "a photobook of truly international stature, providing Japanese photographers with a model of expression that transcended both the parochial and the purely documentary tendency dominating Japanese photography of the time" (Parr and Badger). 1969 publishes his second book *Chicago, Chicago*, which confirms his unique position between the photographic cultures of Japan and the USA. Also acquires Japanese nationality in 1969. Numerous solo and group exhibitions, including *New Japanese Photography* at the Museum of Modern Art (New York) in 1974. Numerous awards, among others, Young Photographers' Contest from *Life* magazine (1950), Award of the Japan Photo Critics Association (1957), Mainichi Art Award (1970), and Man of Cultural Distinction (1996), an official Japanese state award.

> **"Ishimoto occupies a unique place in Japanese photography. Founded on an objective detachment, his style stands out against the more emotional attitudes that prevail in Japan. His feeling for the three-dimensional, his subtle technique and the rigorous arrangement of his images have had an influence and left their mark on the work of young Japanese photographers. He is completely immersed in the aesthetics of Japanese culture."**
> — La Recherche Photographique ✍

EXHIBITIONS (Selected) — **1953** New York (Museum of Modern Art – 1961) SE // **1955** New York (Museum of Modern Art/**The Family of Man**) GE // **1954** Tokyo (Takemiya Gallery) SE // **1960** Chicago (Art Institute – 1999) SE // **1962** Tokyo (Shirokiya Department Store) SE // **1974** New York (Museum of Modern Art/**New Japanese Photography**) GE // **1977** Tokyo (Seibu Museum of Art) SE // **1993** Speyer (Germany) (Historisches Museum der Pfalz) GE // **2003** Gap (France) (Théâtre la Passerelle) SE // Houston (Texas) (Museum of Fine Arts/**The History of Japanese Photography**) GE // Paris (Jeu de Paume – Site Sully/Japon 1945–1975: **Un renouveau photographique**) GE // Tokyo (Photo Gallery International – 2005, 2006, 2007) SE // **2006** Paris (Galerie Camera Obscura) SE

BIBLIOGRAPHY (Selected) — **Aruhi Arutokoro (Someday, Somewhere)**. Tokyo 1958 // **Chicago, Chicago.** Tokyo 1969 // **La Recherche Photographique: Japon**. Paris 1990 ✍ // Thomas Buchsteiner and Meinrad Maria Grewenig (eds): **Japanische Fotografie der 60er Jahre/Japanese Photography in the 1960s**. Heidelberg 1993 (cat. Historisches Museum der Pfalz, Speyer) // **Y.I.** Chicago 1999 (cat. Art Institute) // Anne Wilkes Tucker, Dana Friis-Hansen, Ryūichi Kaneko, and Takeba Joe: **The History of Japanese Photography.** New Haven/London 2003 (cat. Museum of Fine Arts, Houston) // Martin Parr and Gerry Badger: **The Photobook: A History Volume I**. London 2004 // Ryūichi Kaneko and Ivan Vartanian: **Japanese Photobooks of the 1960s and '70s.** New York 2009

84

86

90

91

Yasuhiro Ishimoto, from: **Japanese
Photography in the 1960s.**
Heidelberg (Edition Braus) 1993

Graciela Iturbide

Graciela Iturbide: **Images of the Spirit.** New York (Aperture) 1996

16.5.1942 Mexico City (Mexico) — Lives in Mexico City Rituals and festivals, customs and everyday life. B/w pictures examining Latin-American history and culture. Mexico's internationally best-known contemporary female photographer. The first of 13 children. Marries in 1962 and has a daughter and two sons. 1969–1972 studies at the Centro Universitario de Estudios Cinematográficos of the Universidad Nacional Autónoma de México. 1970–1971 works as assistant to > Álvarez Bravo. 1974 trip to Panama, where she works on a photo essay about the country and its people. 1975 exhibition in Mexico City (Galería José Clemente Orozco) entitled *Tres fotógrafas mexicanas* and in the following year in New York City (Midtown Y Gallery). 1980 first solo exhibition. 1982 a presentation of her work at the Centre Pompidou marks the beginning of her international reception. Numerous awards include the > W. Eugene Smith Award (1987), > Hugo Erfurth Award (1989), Rencontres d'Arles Award (1991), and the Hasselblad Award (2008).

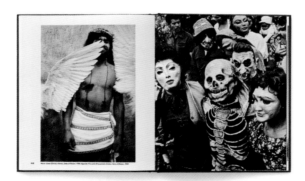

EXHIBITIONS (Selected) — **1975** Mexico City (Galería José Clemente Orozco) GE // **1980** Mexico City (Casa del Lago) SE // **1982** Paris (Centre Pompidou) SE // **1989** Mexico City (Galería Juan Martín – 1993) // **1990** San Francisco (San Francisco Museum of Modern Art) SE // **1991** Arles (Rencontres internationales de la photographie) SE // **1993** Madrid (Sala de Exposición de Telefónica) // Chicago (Chicago Cultural Center) SE // **1994** Salamanca (Spain) (Universidad de Salamanca) SE // **1995** Los Angeles (Gallery of Contemporary Photography) SE // **1996** Monterrey (Mexico) (Museo de Arte Contemporáneo) SE // **2003** Newcastle-upon-Tyne (England) (Side Photographic Gallery) SE // **2004** New York (Robert Miller Gallery) SE // **2005** Santa Monica (California) (Rose Gallery) SE // **2006** New York (Throckmorton Fine Art – 2008) SE // Gentilly (Mai-son Robert Doisneau) SE // **2007** Los Angeles (J. Paul Getty Museum) SE // **2009** Gothenburg (Hasselblad Center) SE // Winterthur (Switzerland) (Fotomueum) SE // **2014** New York (International Center of Photography) Ge

BIBLIOGRAPHY (Selected) — **Avándaro.** Mexico City 1971 // **Los que viven en la arena.** Mexico City 1981 // **Sueños de papel.** Mexico City 1985 // **Juchitán de las mujeres.** Mexico City 1989 // **En el nombre del padre.** Mexico City 1993 // **Fiesta und Ritual.** Bern 1994 // **G.I.: La forma y la memoria.** Monterrey 1996 (cat. Museo de Arte Contemporáneo) // **Images of the Spirit.** New York 1996 ✒ // **G.I. The Hasselblad Award.** Göttingen 2008 // **Asor.** Göttingen 2009

"For the past twenty-five years, Graciela Iturbide has remarkably engaged with the workaday life and seasonal celebrations of various communities throughout Mexico, exploring ways to extend the scope of the 'objective' photograph, with a tale of her own to tell about the immeasurable totality of a country and its innumerable corners of experience; about the ages of life, the decisive role of women, and the passion play of popular Catholicism; about the strange in the familiar and the limits of the knowable when actual phenomena emerge in the generous or unspeakable guises of dream." — Roberto Tejada

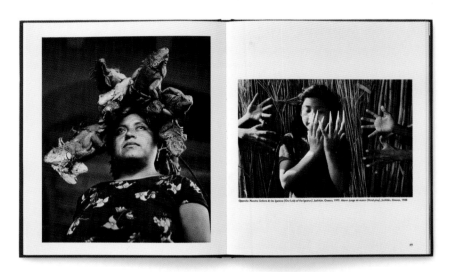

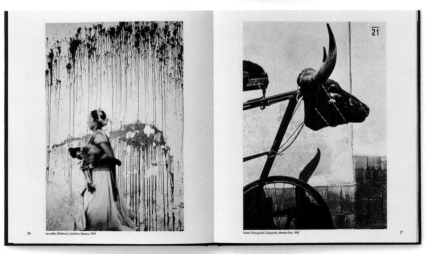

Izis *(Israëlis Bidermanas)*

Izis: **Paris des rêves.** Lausanne (La Guilde du Livre) 1950

17.1.1911 Mariampole (Lithuania) — 16.5.1980 Paris (France) Scenes from everyday life in the spirit of "Photographie humaniste" around 1950. Artists' portraits (Louis Aragon, Marc Chagall, Colette, Jacques Prévert). Funfairs, sideshows, circuses. 1924 trains to be a photographer with the local studio photographer. January 1930 arrives in Paris, where he starts out by working in the Arnal portrait studio. After that he runs a photography business in the 13th *arrondissement*. Specializes in portrait photography in the spirit of the glamour aesthetic of a Studio Harcourt or Studio Arnal. In 1940, at the start of the war, he flees to Ambazac in the Limousin. Retouches work commissioned by the local photographer. A member of the French Resistance under the alias of "Izis". Portraits of his comrades. Active in the liberation of Limoges. Returns to Paris. Becomes acquainted with > Brassaï, Laure Albin Guillot, > Sougez. After that he takes up street photography. 1947– 1954 studio in Paris (66, rue de Vouillé). 1949 becomes acquainted with Marc Chagall, and in 1950 with the poet Jacques Prévert. Together with Prévert (1951) a three-week stay in London for a book he is planning, *Charms de Londres*. 1949–1952 first commissions for *Paris Match*. 1952–1969 staff photographer. 1955 participates in *The Family of Man*. 1978 honorary guest at the Rencontres d'Arles.

EXHIBITIONS (Selected) — **1944** Limoges (France) (Galerie Folklore – 1945) SE // **1946** Paris (Galerie La Béotie) SE // **1949** Paris (Galerie du Siècle) SE // **1951** New York (Museum of Modern Art/**5 French Photographers**) GE // **1952** Chicago (Art Institute – 1955) SE // **1953** London (Foyle's Art Gallery) SE // **1957** New York (Limelight Gallery) SE // **1972** Tel Aviv (Museum of Modern Art/**Retrospective Izis**) SE // **1975** Paris (Galerie Agathe Gaillard) SE // **1977** Berlin (Nagel Gallery) SE // **1978** Toulouse (Galerie municipale du Château d'Eau) SE // Arles (Rencontres internationales de la photographie) SE // **1988** Paris (Mois de la Photo/CNMHS) SE // **1989** Charleroi (Belgium) (Musée de la Photographie – 2007) SE // **1990** Chalon-sur-Saône (France) (Musée Nicéphore Niepce) SE // **1993** Amsterdam (Joos Historisme Museum) SE // **2007** Gentilly (France) (Maison de la photographie Robert Doisneau) SE // **2010** Paris (Hôtel de Ville) SE

BIBLIOGRAPHY (Selected) — **Les yeux de l'âme.** Limoges 1948 // **Paris des rêves.** Lausanne 1950 // **Le Grand Bal du Printemps.** Lausanne 1951 // **Charmes de Londres.** Lausanne 1952 // **Paradisi Terrestre.** Lausanne 1953 // **Israël.** Lausanne 1953 // **Le Cirque d'Izis.** Paris 1965 // **Le Monde de Chagall.** London/Paris 1969 // **Paris des Poètes.** Paris 1978 // **I. de Paris et d'ailleurs.** Paris 1988 (cat. Mois de la Photo) // Marie de Thézy: **I.: Photographies 1944–1980.** Paris 1993 // **I. Photographs Chagall.** Amsterdam 1993 (cat. Joods Historisch Museum) // Annie-Laure Wanaverbecq: **I. à travers les archives photographiques de Paris Match 1949–1969.** Gentilly 2007 (cat. Maison de la photographie Robert Doisneau) ✐ // **I.: Paris des rêves.** Paris 2010 (cat. Hôtel de Ville)

"Curiously enough, it is no doubt this very same manner that made possible both the birth of an original work and its far too reluctant recognition by the public at large. Scarcely celebrated by the world of photography, Izis sought neither distinction nor acknowledgement by forcing open the doors of fame. His modesty and reserve were common to both his photography and the man that he was, a humanist both diffident and discreet." — Annie-Laure Wanaverbecq

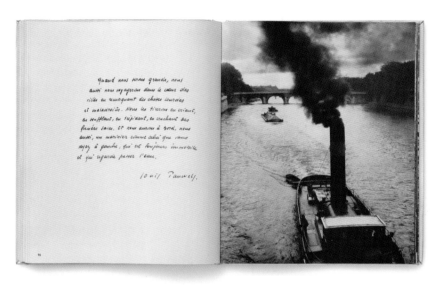

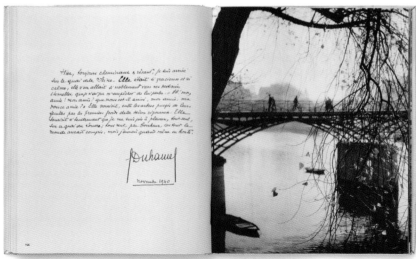

Lotte Jacobi *(Johanna Alexandra Jacobi)*

17.8.1896 Thorn (West Prussia) — 6.5.1990 Concord (New Hampshire, USA) Dance, theater, reports. Especially portraits of distinguished actors, poets, composers. An informal pantheon of artistic Germany before 1933. Her father a photographer (like her grandfather and great-grandfather). Takes her own first photographs at the age of 11. Girls' school in Poznan-Wilda. Private drama lessons. Courses on art history at the academy. Marriage and the birth of a son. 1920 moves to Berlin. Divorce and a move to Munich. 1925–1927 attends the Staatliche Höhere Fachschule für Phototechnik (State Higher College of Photo Technology) in Munich, where one of her teachers is Willy Otto Zielke.

Kelly Wise and James A. Fasanelli:
Lotte Jacobi. Danbury, New Hampshire (Addison House) 1978

1927 returns to Berlin, where, to begin with, she works in her father's studio, which he has meanwhile moved to the capital. Portrait work includes prominent people (Albert Einstein, Lotte Lenya, Peter Lorre, Erich Mendelsohn, > Riefenstahl, and Kurt Weill). Also reports, dance, theater and (at the suggestion of Ernst Fuhrmann) macrophotographic studies. Collaborates with > Heartfield. Friendship with > Modotti, who is in Berlin in 1931. 1928 Ermanox camera. 1929 first Leica. Numerous publications in *BIZ* (Berliner Illustrirte Zeitung), *Die Dame*, *Uhu*, *Der Querschnitt*, *MIP* (Munchner Illustrierte Presse), *AIZ* (Arbeiter-Illustrierte-Zeitung: Workers' Pictorial Newspaper), *Leipziger Illustrierte*. 1932–1933 Moscow, Tajikistan, Uzbekistan. Around 6,000 photographs. 1935 banned from professional work. In September via London to New York. At the end of 1936 opens a studio near Central Park. Portraits and photojournalism under difficult conditions. Meets > Abbott. Marries Erich Reiss in 1940. Gives up studio in 1955. Moves to Deering, New Hampshire. Exhibition in Essen 1973 the start of her international reception. 1983 (together with Tim N. Gidal) Dr Erich-Salomon Prize of the DGPh (Deutsche Gesellschaft für Photographie: German Photographic Association).

"Lotte Jacobi did not develop a distinct style in formal terms. The way she approaches her subjects varies a great deal; pictures worked out to the last detail are rare. Her portraits point rather to the type of encounter, its intensity, and the means by which it is communicated, they also point to the workings of chance, to impatience and a photographic practice poised between tradition and modernity." — Ute Eskildsen ✍

EXHIBITIONS (Selected) — **1930** Munich (**Das Lichtbild**) GE // **1942** New York (Museum of Modern Art – 1948, 1951, 1960) GE // **1959** Manchester (New Hampshire) (Currier Gallery) SE // **1964** New York (303 Gallery) SE // **1972** Hamburg (Landesbildstelle) SE // **1973** Essen (Germany) (Museum Folkwang – 1990, 1994) SE/GE // **1981** Munich (Stadtmuseum) SE // **1993** Berlin (Bodo Niemann Gallery) SE // **1994** New York (International Center of Photography) SE // **1997** Berlin (Das Verborgene Museum) SE // Bonn (Rheinisches Landesmuseum) GE // **2004** New York (Jewish Museum) SE // New York (National Museum of Women in the Arts) SE // **2007** Washington, DC (National Gallery of Art) GE // New York (Guggenheim Museum) GE

BIBLIOGRAPHY (Selected) — **Menschen von Gestern und Heute.** Essen 1973 (cat. Museum Folkwang) // Kelly Wise and James A. Fasanelli: **L.J.** Danbury 1978 // **L.J.: Russland 1932/33.** Berlin 1988 // **L.J. 1896–1990: Berlin – New York – Deering.** Essen 1991 (cat. Museum Folkwang) ✍ // **Fotografieren hieß teilnehmen. Fotografinnen der Weimarer Republik.** Düsseldorf 1994 (cat. Museum Folkwang) // **Atelier L.J.: Berlin – New York.** Berlin 1997 (cat. Das Verborgene Museum) // Klaus Honnef and Frank Weyers: **Und sie haben Deutschland verlassen … müssen.** Bonn 1997 (cat. Rheinisches Landesmuseum) // Matthew S. Witkovsky: **Foto: Modernity in Central Europe, 1918–1945.** Washington, DC, 2007 (cat. National Gallery of Art)

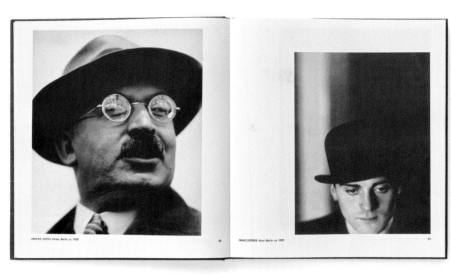

ARNOLD ZWEIG, Writer, Berlin, ca. 1930 38

FRANZ LEDERER, Actor, Berlin, ca. 1929 39

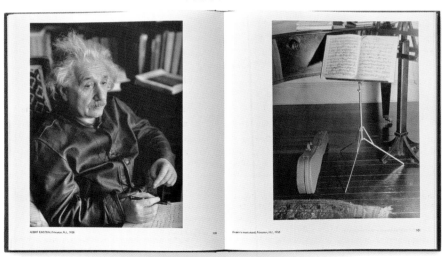

ALBERT EINSTEIN, Princeton, N.J., 1938 100

Einstein's music stand, Princeton, N.J., 1938 101

Yousuf Karsh *(Howsep Karshian)*

Yousuf Karsh: **Karsh Portraits.**
New York (Little, Brown &
Company) 1976

23.12.1908 Mardin (Turkey) — 13.6.2002 Boston (Massachusetts, USA) A portraitist of celebrities from the world of politics, art, and entertainment, he was himself a celebrity of his time. Internationally the best-known portrait photographer of the second half of the 20th century. Known for his lighting effects schooled in the Hollywood glamour tradition. Childhood in the south-east of Turkey. 1924 emigration to Canada. Attends school in Sherbrooke (Province of Quebec). First forays into photography in the photo studio of his uncle, George Nakash. Trained as a photographer by John H. Garo in Boston. 1932 opens a portrait studio in Ottawa, where he quickly becomes a much sought-after portrait photographer. This is followed by numerous portraits of international celebrities from politics, show business and art. Photographs include Humphrey Bogart, Fidel Castro, Albert Einstein, Clark Gable, Ernest Hemingway, John F. Kennedy, Pablo Picasso, and George Bernard Shaw. Probably his best-known work is a portrait of Winston Churchill taken in 1941 (and published as a cover for *Life* magazine in the same year). Canadian citizenship in 1946. First solo exhibition in 1959. 1967–1969 professor at Ohio University. 1972–1974 professor at Emerson College in Boston. Numerous honors and awards, among others, the Canada Council Medal (1965), Officer of the Order of Canada (1967), Medal of Service of the Order of Canada (1968), Honorary Fellow of the Royal Photographic Society (1970), Gold Medal of the National Association of Photographic Art (1974), Companion of the Order of Canada (1990).

EXHIBITIONS (Selected) — **1959** Ottawa (National Gallery of Canada – 1989) SE // **1967** Montreal (Expo '67) SE // **1968** Montreal (Museum of Fine Arts) SE // Boston (Museum of Fine Arts) SE // **1973** Santa Barbara (California) (Museum of Art) SE // **1981** Bonn (Rheinisches Landesmuseum/**Lichtbildnisse**) GE // **2000** Berlin (Kronprinzenpalais) SE // **2003** Canberra (Australia) (National Gallery of Australia) JE (with Athol Smith) // **2004** Berlin (Camera Work) GE // New York (Queens Museum of Art) GE // London (Tom Blau Gallery) SE // **2005** Helsinki (Finnish Museum of Photography) GE // Santiago de Compostela (Spain) (Fundación Pedro Barrié de la Maza) GE // **2006** Carmel (California) (Weston Gallery) SE // Nice (Théâtre de la Photographie et de l'Image) SE // Paris (Centre culturel canadien) SE // **2008** Boston (Museum of Fine Arts) SE // **2009** Chicago (Art Institute of Chicago) SE // Barcelona (Kowasa Gallery/**The Vision of the Other**) GE // **2011** Cologne (Museum Ludwig) GE

BIBLIOGRAPHY (Selected) — **Faces of Destiny: Portraits by K.** Chicago 1946. // **In Search of Greatness: Reflections of Y.K.** New York 1962. // **Faces of our Time.** Toronto 1971. // **K. Portraits.** Toronto/New York 1976 // Klaus Honnef (ed.): **Lichtbildnisse. Das Porträt in der Fotografie.** Cologne 1982 (cat. Rheinisches Landesmuseum Bonn) // **K.: A Fifty-Year Retrospective.** Boston 1983. // James Borcoman (ed.): **K.: The Art of the Portrait.** Ottawa 1989 (cat. National Gallery) // **American Legends: Y.K.** Boston 1992. // Gottfried Knapp: "Ins Charakteristische verklärt." In: **Süddeutsche Zeitung**, 15.7.2002 ✍ // Maria Tippett: **Portrait in Light and Shadow: The Life of Y.K.** New Haven/London 2007 // **Ichundichundich. Picasso im Fotoporträt.** Cologne 2011 (cat. Museum Ludwig).

As a private citizen I approached Winston Churchill in 1941 with awe. He was more than the Great Man of the twentieth century; he was even more than an institution. He had become, and will always remain, a gigantic presence in human history. But as a photographer I had a job to be done and it had to be done fast. — Mr. Churchill, to be was then, had been addressing the Canadian Parliament in Ottawa on December 30; he was in no mood for portraiture and two minutes were all he would allow me as he passed from the House of Commons Chamber to an anteroom — two supposedly minutes in which I must try to put on film a man who had already written or inspired a library of books, baffled all his biographers, filled the world with his fame, and was, on this occasion, with dread. — He marched in scowling, and regarded my camera as he might regard the German enemy. His expression suited me perfectly, if I could capture it, but the cigar thrust between his teeth seemed somehow incompatible with such a solemn and formal occasion. Instinctively I removed the cigar. At this the Churchillian scowl deepened, the head was thrust forward belligerently, and the hand placed on the hip in an attitude of anger. So he stands in my portrait in what has always seemed to me the image of England in those years, defiant and unconquerable. — With a swift change of mood, because towards me when I was finished, extending his hand and saying, "Well, you can certainly make a roaring lion stand still to be photographed."

SIR WINSTON CHURCHILL

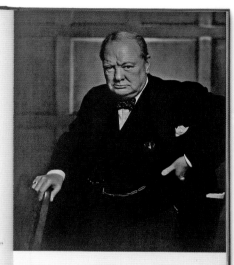

I arrived in Havana on that most important of its modern national holidays, the 26th of July – the anniversary of Fidel Castro's first onslaught against the dictator Batista. I had come, at his ambassador's invitation and with the friendly encouragement of the Canadian government, to photograph the man who had first caught the world's imagination as a fugitive in the Sierra Maestra mountains, and who had since transformed the Cuban scenery. But first I was to hear him speak. — Our plane from Mexico City touched down only a few hours before Fidel was to make a major address in the capital's main square. I was greeted at the airport by two officials of the Protocol Office who first took me to a hotel to rest briefly, and then to the plaza. Our automobile, an Alfa Romeo, had security clearance that carried us past guards and through the tens of thousands waiting for the speech. The crowd had come from all over Cuba; the people were young and enthusiastic, and there was an air of carnival, heightened by bands selling the delicious Cuban ice cream. — Without ceremony, abruptly, Castro appeared on the podium. He was dressed in army fatigues, as usual, with the ever-present cap on his thick black hair. — Fidel proved a magnetic speaker, dedicated to the point of fanaticism, punctuating every new thought with his finger, building to crescendos as he loaded Cuban solidarity and attacked imperialism, until the crowd yelled and screamed in support. On this day, he spoke for only two-and-a-half hours instead of the customary six – rather short speech for him. There were many foreigners present who, like me, were free to wander at will in an open space at the foot of the podium, not more than fifteen feet from the speaker. — The next day I was invited to tour Havana and its surroundings. My companion was none other than Señora Celia Sánchez, the wise, energetic Secretary of State and one of the most powerful people in Cuba. At the end of our tour, we inspected two or three possible places for photography. I chose a simple ceremonial room, with a few bookshelves, and walls to mark as to suggest a barracks. It turned out to be Castro's own office. — I set up my equipment and went home to the Canadian Embassy where I was staying as a guest of the Ambassador, Kenneth Brown. And then I waited to learn when Castro would see me. Days passed. They were pleasant enough; the weather was wonderful, and I was free to explore where I wished. Nowhere did I see people with sad faces, or with unhealthy, ill-fed bodies. But places there left Cuba only once a week, and my time for departure was fast approaching. — On the last day, I phoned the Protocol Office every hour: when would the Prime Minister be free? My frustration was not eased by the ill-mannered habits of the embassy phone, which periodically went out of order. Nor word after my o'clock that last evening did word come that two cars were on their way to fetch me. — Castro arrived in the room we had chosen, quietly, graciously, but looking grave and tired. He is taller than appears from photographs. He shook my hand and immediately re-assumed the belt and pistol which is part of his uniform. Then he apologized for keeping me waiting so long; he had had many guests and duties during the previous days of the anniversary celebration. – As I studied the camera, I suggested that to start he might try to recapture the mood of our first moments together. "I'm sorry, I cannot," he replied charmingly. "I am not a good enough actor. I cannot play myself." – Our session lasted three-and-a-half hours. From time to time we would stop to refresh ourselves with Cuban rum and cake. – "Tell me," he said, "about photographing Helen Keller." Then he asked about Shaw, Churchill, Camus, Cocteau, and mostly about Hemingway, whose house near Havana is a shrine. I was impressed that Castro – a revolutionary – should have room in his life for these creative humanitarians.

FIDEL CASTRO

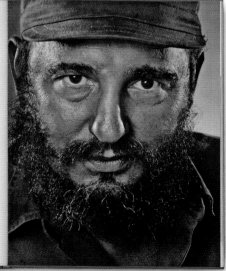

Yousuf Karsh: **A Fifty-Year Retrospective.** Toronto (University of Toronto Press) 1983

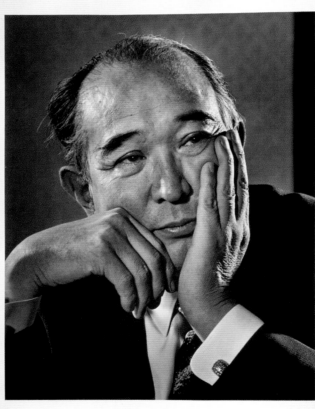

Akira Kurosawa
1969

One of Japan's "Living Human Treasures" and a master of the cinema. A time of this portrait, he h just emerged from a pe of intense self-doubt to produce yet another cla film destined to be stud by students of cinemat phy the world over.

"There is probably no other photographer in the world who has created so many portraits embedded in mankind's collective memory as Yousuf Karsh. Born in 1908 in the Armenian part of Turkey, Yousuf Karsh came to Canada via Syria. Still a young man, he soon found his profession and his calling. Everyone who stepped in front of Karsh's enormous plate camera became a legend even while still in the darkroom: not only the great names in politics, science, the arts and glamour, who in countless numbers granted him admission, but also the nameless workers and farmers whom he heroised in his striking photo-series, transforming them into human monuments." — Gottfried Knapp ✍

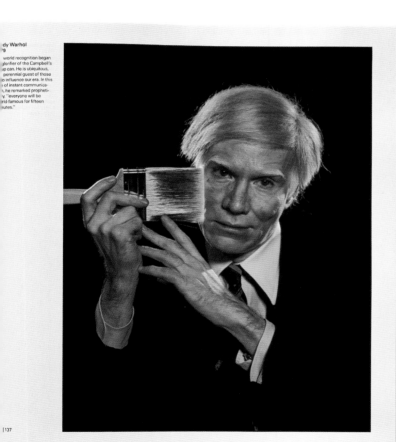

dy Warhol
'9

world recognition began
glorifier of the Campbell's
up can. He is ubiquitous,
perennial guest of those
o influence our era. In this
e of instant communica-
, he remarked propheti-
y, "everyone will be
rld-famous for fifteen
utes."

|137

Peter Keetman

Cover of **Subjektive Fotografie.
Ein Bildband moderner
europäischer Fotografie**. Bonn
(Brüder Auer Verlag) 1952

**27.4.1916 Wuppertal-Elberfeld (Germany) — 8.3.2005 Marquartstein
(Germany)** Architectural studies, object photography, pictures of
people, experiments with light. Important representative of "subjek-
tive fotografie" after the war. Schooling, Gymnasium (grammar
school) in Wuppertal-Elberfeld, Schondorf am Ammersee, and Bad
Godesberg. 1935–1937 Bayerische Staatslehranstalt für Lichtbildwe-
sen (Bavarian State School for Photography) in Munich. Apprentice's
examination. Works for Gertrud Hesse (Duisburg) and C.H. Schmeck
(Aachen). 1940–1947 military service, wounded, convalescence.
1947–1948 resumes his photographic training in Munich and Stutt-
gart (Meisterschule Adolf Lazi). Master craftsman's examination in
1948. Freelance since 1952. From 1949 member of the fotoform
group (Siegfried Lauterwasser, Wolfgang Reisewitz, Toni Schneiders,
> Steinert, Ludwig Windstosser). Participates in the first self-presen-
tation of the group, which causes a sensation at the Cologne photoki-
na (1950). Also participates in the programmatic *subjektive foto-
grafie* exhibitions (1951, 1954, 1958), conceived by Steinert. Along with portraits or object
photography in the spirit of the New Objectivity, mainly experiments with light (oscillating figures)
that have a considerable influence on the vocabulary of form of the post-war period, and in particular
on the creative amateur photography. Presentation of his works at practically all important photo
exhibitions of the 1950s and 60s. Also commissions from industry (Volkswagen) and advertising
(Bahlsen, Gervais, Hipp) as well as illustration photography for a number of topography photobooks
(Munich, Bavaria, Salzburg) published by Thorbecke Verlag. Member of the DGPh (from 1951), the
GDL (1957), and the Bund Freischaffender Foto-Designer (Association of Freelance Photo-designers)
(1969). 1991 Cultural Award of the DGPh. 1993 transfer of his archive to the Museum Folkwang, Es-
sen. Since 2001 the Peter Keetman Award of the Volkswagen art foundation for contemporary young
artists.

EXHIBITIONS (Selected) — **1950** Cologne (photokina – 1951,
1952, 1958, 1980) GE // **1951** Saarbrücken (Germany) (Sta-
atliche Schule für Kunst und Handwerk – 1954) GE // **1981**
Munich (Fotomuseum) SE // **1995** New York (Howard Green-
berg Gallery) SE // **1996** Essen (Germany) (Museum Folk-
wang) SE // **1997** Berlin (Berlinische Galerie) GE // **1998** Lud-
wigshafen (Germany) (Kunstverein) GE // **2003** Wolfsburg
(Germany) (Kunstmuseum) SE // **2006** Berlin (Kicken Berlin)
SE

BIBLIOGRAPHY (Selected) — **subjektive fotografie**. Bonn 1952
// **subjektive fotografie 2**. Munich 1955 // **Eine Woche im**
Volkswagenwerk. Berlin 1985 (**A Week at the Volkswagen fac-
tory. Photographs from April 1953**. London 1987. // **Volkswa-
gen. A Week at the Factory**. San Francisco 1992) // **fotoform**.
Berlin 1988 // **subjektive fotografie**. Stuttgart 1989 (cat. Insti-
tut für Auslandsbeziehungen) // Rolf Sachsse: **P.K.: Bewegung
und Struktur**. Amsterdam, 1996 // **Positionen künstlerischer
Photographie in Deutschland seit 1945**. Cologne 1997 (cat.
Berlinische Galerie) ⌁ // **Zwischen Abstraktion und Wirklich-
keit. Fotografie der 50er Jahre**. Ludwigshafen 1998 (cat. Kun-
stverein) // Gijs van Tuyl and Holger Broeker (eds): **Volks-
wagenwerk 1953**. Wolfsburg 2003 (cat. Kunstmuseum)

"By interpreting formative energies Keetman's aim is to bring out the intrinsic form of objects, themes, and subjects. To achieve this, he uses all the artistic possibilities that photographic technique can offer him." – Ulrich Domröse 🖊

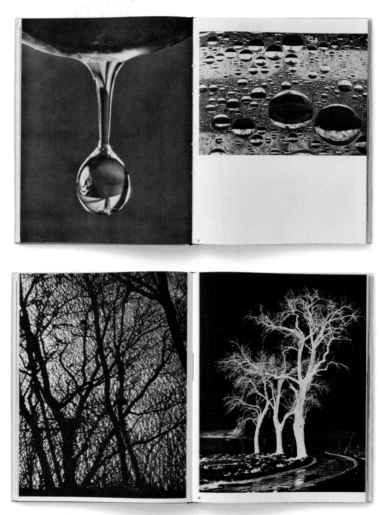

Peter Keetman (right-hand pages): **Reflective drops, Trees in negative, Plastic vibrations,** from: **subjektive fotografie. Ein Bildband moderner europäischer Fotografie.** Bonn (Brüder Auer Verlag) 1952

Seydou Keïta

André Magnin (ed.): **Seydou Keïta**. Zurich (Scalo Verlag) 1997

1921 Bamako (Mali) — 21.11.2001 Paris (France) Along with Malick Sidibé, the best-known photographer of sub-Saharan Africa, with an emphasis on studio portraits. After well-received exhibitions in Europe and the USA, achieves international acclaim as an artist from the beginning of the 1990s. The first of five children. Son of a cabinet-maker. Day and month of his birth unknown. Apprenticed to his father and uncle. The latter makes him a present of a Kodak Brownie Flash camera for eight snapshots. This marks the beginning of his interest in photography. He starts out by working as both cabinet-maker and photographer. Mainly self-taught as a photographer. Mountaga Trahoré and Pierre Garnier, a local photo dealer, helps him to acquire his technical knowledge. 1948 opens a professional studio in Bamako-Coura, New Bamako, "en face prison civile" (opposite the prison). He specializes in portrait commissions, mostly in the 13 x 18 cm photo format. Individual and group portraits preferably in natural lighting conditions and against changing, usually patterned backgrounds. Altogether approximately 30,000 negatives. Works freelance until 1962. After Mali becomes independent, he enters the civil service as an official photographer on the orders of the new socialist government. In New York in 1991, first exhibition of his photographs, to begin with still classified as "Unknown". Thanks to André Magnin's researches, the author is identified. This leads to the international reception of his work through festivals (Rouen), exhibitions (New York, Paris, Berlin), and numerous publications in newspapers, magazines, and books.

"The thousands upon thousands of portraits taken by Keïta are an extraordinary document of Malian society between the end of the forties and the beginning of the sixties. Seydou Keïta's photographs are — beyond their sociological interest — indisputable works of art that are devoid of all trickery, eccentricity or delusion of the senses. This lends them an objective character and a dimension of timelessness. Seydou Keïta seems intuitively to have invented or reinvented the art of the portrait through his search for the utmost precision. In the age of multiculturalism this work of rare beauty quite naturally takes its place in the history of photography."

— André Magnin ✍

EXHIBITIONS (Selected) — **1993** Rouen (Rencontres Photographiques de Normandie) SE // **1994** Paris (Fondation Cartier pour l'Art Contemporain) // **1997** New York (Gagosian Art Gallery) SE // **2000** Berlin (Haus der Kulturen der Welt) GE // **2003** London (National Portrait Gallery) SE // **2004** Tokyo (Hara Museum of Contemporary Art) SE // **2005** Toronto (Alliance Française) SE // **2006** Dublin (Douglas Hyde Gallery) SE // **2007** Cleveland (Museum of Contemporary Art) SE // **2008** Barcelona (Kowasa Gallery/**La Fotografia en Mali**) GE

BIBLIOGRAPHY (Selected) — André Magnin, Issa Baba Traoré, and Hervé Chandès: **S.K.** Paris 1994 (cat. Fondation Cartier pour l'Art Contemporain) // Youssouf Tata Cissé: **S.K.** Paris 1995 // André Magnin (ed.): **S.K.** Zurich 1997 ✍ // **Anthologie de la Photographie africaine et de l'Océan Indien**. Paris 1998 // **Porträt Afrika. Fotografische Positionen eines Jahrhunderts**. Berlin 2000 (cat. Haus der Kulturen der Welt) // **S.K.** Arles 2002 (= Photo Poche no. 63) // Okwui Envezor (ed.): **Events of the Self**. Göttingen 2010

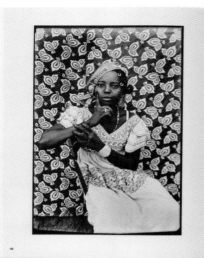

André Kertész (Kertész Andor)

André Kertész: **Day of Paris.**
New York (J.J. Augustin Publisher)
1945

2.7.1894 Budapest (Hungary) — 28.9.1985 New York (USA) Portraits of artists, Parisian interiors, still lifes, street scenes, nudes (*Distortions*). Commissioned work for fashion, advertising, reports. Independent spirit somewhere between Surrealism and New Objectivity. As such, one of the most prominent representatives of classic modernism. His family is part of the assimilated Jewish middle-class. The second of three sons. Early interest in things visual. First camera in 1912. Works to begin with as an accountant on the Budapest stock exchange. 1914 military service. First published photograph is in the *Erdekes Ujság* magazine in 1917. Returns to the stock exchange, taking photographs after work. In September 1925 moves to Paris, where he soon becomes part of the "Hungarian colony" in Montparnasse. Gets to know, among others, Piet Mondrian, and takes photographs in his atelier. 1927 first exhibition at the Galerie Au Sacre du Printemps. 1928 participates in the *Salon Indépendent de la Photographie* (with > Abbott, > Krull, > Man Ray, > Outerbridge) and in 1929 in the legendary *Film und Foto* exhibition. First publications in *L'Art Vivant*, *Die Dame*, *Uhu*, *Variétés*, later photo essays, reports especially for *Art et Médecine* and *VU*. 1929 sees his first studies of nudes reflected in distorting mirrors (*Distortions*). 1933 first book: *Enfants*. Moves to New York in 1936 with his wife Elisabeth. Contract with the Keystone Agency (1936–1937). Contact with > Brodovitch and (in April 1937), first publication in *Harper's Bazaar*. Assignments from *Vogue*, *Town & Country*, *Coronet*. 1944 American citizenship. Starts to work for *Fortune*. 1945 publishes the book *Day of Paris* (designed by Brodovitch). 1946 exclusive contract with *House & Garden*. First solo exhibition in Chicago in the same year. By 1962 more than 3,000 photographs published. From 1963 onwards, is only working freelance. 1975 honorary guest at the Rencontres d'Arles. In 1984 he bequeaths his estate (100,000 negatives) to the French state.

EXHIBITIONS (Selected) — **1927** Paris (Au Sacre du Printemps) SE // **1928** Essen (Germany) (**Das Lichtbild**) GE // **1929** Stuttgart (**Film und Foto**) GE // **1932** New York (Julien Levy Gallery – 1937) GE // **1934** Paris (Galerie de la Pléiade – 1935, 1936) GE // **1936** Paris (**Exposition internationale de la photographie contemporaine**) GE // **1937** New York (Museum of Modern Art/**Photography 1839–1937**) GE // **1946** Chicago (Art Institute – 1985) SE // **1963** Paris (Bibliothèque nationale de France) SE // Venice (Biennale) SE // **1964** New York (Museum of Modern Art) SE // **1967** New York (Riverside Museum/**The Concerned Photographer**) GE // **1971** Stockholm (Moderna Museet) SE // **1972** London (The Photographers' Gallery) SE // **1977** Paris (Centre Pompidou) SE // **1986** Paris (Palais de Tokyo – 1990) SE // **1992** Bonn (Kunst- und Ausstellungshalle der BRD) SE // **2005** New York (Bruce Silverstein Photography) SE // **2006** Paris (Maison européenne de la photographie) SE // **2007** Daytona Beach (Florida) (Southeast Museum of Photography) SE // **2008** Berlin (Berinson Gallery) SE

BIBLIOGRAPHY (Selected) — **Day of Paris**. New York 1945 // **A.K.: Photographer**. New York 1964 (cat. Museum of Modern Art) // **A.K.: Sixty Years of Photography, 1912–1972**. New York 1972 // **Distortions**. New York 1976 // **A.K.: Of New York**. New York 1976 // **A.K.: A Lifetime of Perception**. New York 1982 // **A.K. Of Paris and New York**. New York 1985 (cat. Art Institute of Chicago) // **A.K.: Ma France**. Paris 1990 (cat. Palais de Tokyo) // **Pantheon der Photographie im XX. Jahrhundert**. Bonn 1992 (cat. Kunst- und Ausstellungshalle der BRD) ✎ // Alain D'Hooge: **K., Made in USA**. Paris 2003 // Anne de Mondenard: **L'odyssée d'une icône**. Arles 2006 (cat. Maison européenne de la photographie) // **A.K. – The Polaroids**. New York 2007 (cat. Southeast Museum of Photography, Daytona Beach) // **A.K.: The Early Years**. New York 2008 (cat. Bruce Silverstein Photography)

"Even though André Kertész employed modern photographic methods, using surprising perspectives and bold details, his work still gives the impression of being unpretentious. In the trivia and trivialities, the marginal occurrences on the edges of our awareness, Kertész discovered the typical. Out of these incidentals he distilled his subjective view of the world."

— Klaus Honnef

André Kertész:
L'élégance du métier, from: **VU,** no. 264, 1933

Ihei *(Ihee)* Kimura

Ihei Kimura: **Pari (Paris)**.
Tokio (Nora-sha) 1974

12.12.1901 Tokyo (Japan) — 31.5.1974 Tokyo Important representative of a realistic, documentary camera art in the Japan of the 1950s and 60s. Often quoted in the same breath as Ken Domon. Shows an early interest in photography and is self-taught. He becomes even more interested in the medium at the beginning of the 1920s, while working for a sugar wholesaler in Tainan (Taiwan). 1922 returns to Japan. 1924 opens a photo studio in Nippori (Tokyo). Becoming familiar with 35mm photography (Leica) he turns to reportage and street photography. He is thus one of Japan's first photojournalists and regarded as a pioneer of a discreet exploration of everyday life (in contrast to the pictorialism predominant in Japan until that time). 1932 establishes the short-lived *Kōga* (*Photograph*) avant-garde magazine (18 issues) together with Yasuzō Nojima and Iwata Nakayama. 1933 founds the Japan Workshop (Nipponō) group together with Yōnosuke Natori and other photographers in the spirit of photographic realism. After disagreements within the group and its ultimate break-up, he founds the Central Workshop group (Chūō Kōbō) together with Nobo Ina and others. During WW II he works in Manchuria for the Tōhō-sha publishing company. Publications in *Front* and the *Berliner Illustrirte Zeitung*. From 1950 president of the then recently established Japan Professional Photographers Society. With > Domon, an apologist for a documentary approach, especially in the field of amateur photography. 1951 assistant in Japan to > Bischof, who invites him to Europe. September to December 1954 travels extensively through Europe with stays in France (especially Paris), Italy, West and East Germany, and Scandinavia. Makes contact with Magnum. Meets > Cartier-Bresson, who introduces him to > Doisneau, the beginning of a friendship that lasts for two decades. Second stay in Paris in July 1955. Continues a series about Paris (in color) that he had already begun in 1954 in which, with his working-class background, he shows more interest in the working-class districts (e.g. Ménilmontant) than in the grander aspects of the metropolis. 1960 third and final trip to Paris. During the 1970s he works on a book that is published posthumously under the title *Pari* and becomes the much discussed object of an exhibition at the Rencontres d'Arles in 2004.

EXHIBITIONS (Selected) — **1933** Tokyo (Kinokuniya Gallery) SE // **1939** Tokyo (Mitsukoshi Gallery) SE // **1956** Tokyo (Takahimaya Gallery) SE // **1963** Cologne (photokina) GE // **1966** Tokyo (Fuji Photo Salon) SE // **1968** Tokyo (Nikon Salon — 1969, 1970, 1972) SE // **1992** Tokyo (Metropolitan Museum of Photography) SE // **2003** Houston (Texas) (Museum of Fine Arts/**The History of Japanese Photography**) GE // **2004** Arles (Rencontres internationales de la photographie) SE // Paris (Maison européenne de la photographie) SE

BIBLIOGRAPHY (Selected) — **Japan Through a Leica**. Tokyo 1938 (facsimile reprint: Tokyo 2006) // **Select Pictures by Ihei Kimura.** Tokyo 1954 // **Photography of the World '60**. Tokyo/ New York 1960 // **Pari**. Tokyo 1974 // **A Collection of I.K.'s Best Photographs** (3 vols.) Tokyo 1980 // **La Recherche Photographique: Japon**. Paris 1990 // **I.K.: Photographs**. Tokyo 1992 (cat. Metropolitan Museum of Photography) // **Teihon**: I.K. Tokyo 2002 // Anne Wilkes Tucker, Dana Friis-Hansen, R. Kaneko, and Takeba Joe: **The History of Japanese Photography**. New Haven/London 2003 (cat. Museum of Fine Arts, Houston) // **Rencontres de la Photographie 2004**. Arles 2004 (cat. Rencontres internationales de la photographie) ✍ // **Kimura Ihei in Paris: Photographs, 1954–1955**. Tokyo 2006

"Ihei Kimura has left his mark on contemporary Japanese photography. In the first half of the 1930s he began to specialize in portraits of the literati, and in snapshots from the working-class areas of the national capital. Up to and after the Second World War he worked tirelessly at his photography, continuing until his death in 1974. In all his chosen fields – photojournalism, the portrait and the snapshot – he was considered the greatest living Japanese photographer."
— Yukio Yamazaki ✍

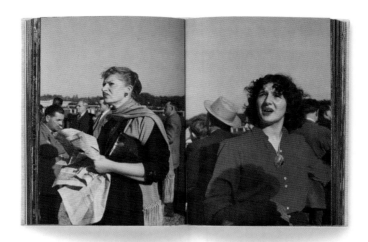

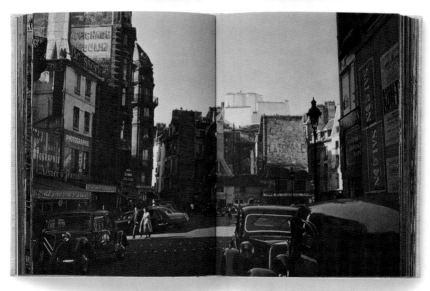

William Klein

William Klein: **Rome. The City and its People.** New York (The Viking Press) 1959

19.4.1928 New York (USA) — Lives in Paris (France) Painter, graphic artist, filmmaker, photographer. As a camera artist, one of the most influential personalities in the Europe of the early 1950s and 60s. Childhood and youth in New York. Studies sociology. Military service in Germany. In Paris from 1947. Studies briefly under André Lhote and Fernand Léger. First exhibitions of own paintings in Brussels and Paris from the beginning of the 1950s. 1954 returns to New York. Photos for a "New York diary", which is published in France in 1956 under the title *New York* and which — rather like > Frank's *Les Américains* — can hardly be overestimated as regards its influence on the generation of younger photographers. A photobook "frenzied and wild, but revealing" (L. Fritz Gruber). More city portraits of Rome, Moscow, and Tokyo. 1955 contract with *Vogue* magazine. Until 1965 — under the aegis of > Liberman — numerous fashion-photo series for Condé Nast. Representative of a modern (outdoor) fashion photography inspired by journalism. Also intensely involved with film. *Broadway by Light* (1958) is the first of more than 20 (shorter and feature) films, among them *Cassius le Grand* (1964/65), *Loin du Vietnam* (1967, together with Jean-Luc Godard, Joris Ivens, Claude Lelouch, Chris Marker, and Alain Resnais), and *Mr. Freedom* (1967/68). 1965–66 *Qui êtes-vous, Polly Maggoo?*, a bitterly ironic reckoning with the world of haute couture and probably his best-known film work. At the end of the 1970s mainly does commercial spots. Altogether around 100 TV commercials. Returns to photography (now also in color) at the beginning of the 1980s. Numerous exhibitions, including photokina in 1963 as part of the *Grosse Photographen unseres Jahrhunderts* (Great Photographers of Our Century) exhibition (the youngest of a total of 30 camera artists). Numerous other exhibitions and awards, among them the Cultural Award of the DGPh (1988), and the Hugo Erfurt Award of the City of Leverkusen/Agfa (1993).

EXHIBITIONS (Selected) — **1956** Paris (Librairie La Hune) SE // **1963** Cologne (photokina) SE // **1967** Amsterdam (Stedelijk Museum) SE // **1978** London (The Photographers' Gallery) SE // **1980** New York (Museum of Modern Art) SE // **1986** Paris (Centre national de la photographie) SE // **1993** Cahors (France) (Le Printemps de la Photo) SE // **2001** New York (Howard Greenberg Gallery) SE // **2002** Paris (Maison européenne de la photographie – 2008) SE // **2003** Luxembourg (Galerie d'art contemporain Am Tunnel & Espace Edward Steichen) SE // **2004** Moscow (Moscow House of Photography) SE // Antwerp (Museum voor Fotografie) SE // Tokyo (Tokyo Metropolitan Museum of Photography) SE // Berlin (Martin-Gropius-Bau) SE // **2005** Madrid (PHotoEspaña) SE // Paris (Centre Pompidou) SE // **2014** Hamburg (Haus der Photographie/Deichtorhallen) GE

BIBLIOGRAPHY (Selected) — **New York**. Paris/Milan/London 1956 // **Rome**. Paris/Milan/New York 1958 // **Rome: The City and its People**. New York 1959 // L. Fritz Gruber (ed.): **Grosse Photographen unseres Jahrhunderts**. Berlin/Darmstadt/Vienna 1964 📖 // **Moscou**. Tokyo/Milan/Hamburg/New York 1964 // **Tokyo**. Tokyo/Milan/Hamburg/Paris/New York 1964 // **W.K.: Photographs**. New York 1981 // **Close up**. Heidelberg 1989 // **In and Out of Fashion**. Heidelberg 1993 // **New York 1954.55**. Heidelberg 1996 // **Paris + Klein**. Paris 2002 (cat. Maison européenne de la photographie) // Martin Parr and Gerry Badger: **The Photobook: A History Volume I**. London 2004 // **Augen auf! 100 Jahre Leica**. Heidelberg 2014 (cat. Haus der Photographie/Deichtorhallen Hamburg)

"Of course, the sky-riding photographer William Klein also created a stir with the fashion-photo series he did for *Vogue*, all of them equally audacious whether in black or white, or color. Here photography seems to have been driven to excess, both dynamically and statically. But these pictures are simply the daring eye-exercises of an artist who rides roughshod over the traditional customs of photography. The vibrantly impatient way William Klein uses the camera makes it look as if there is a photographic form of Tachisme opening up. To anyone taking a closer look it becomes clear that what seems to be dissolution, is in fact a more intensive form of seeing and taking pictures that is now more in keeping with the times." — L. Fritz Gruber ✍

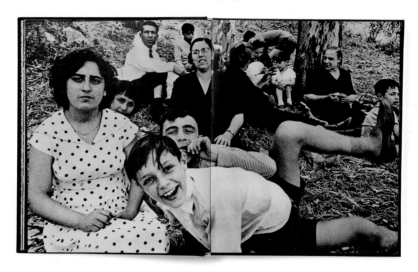

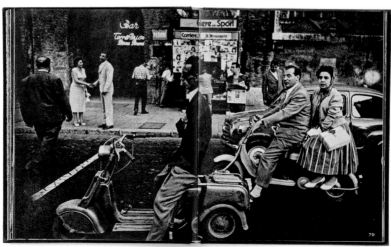

Nick Knight

Nick Knight. New York (Harper-Collins, Collins Design) 2009

24.11.1958 London (England) — Lives in Petersham (England) and London Fashion photography and portraits. After his much-acclaimed publications in *i-D* and *The Face*, one of the most influential young photographers of the 1990s. 1979–1982 studies at Bournemouth and Poole College of Art and Design, graduating with distinction. Publishes his first book when still a student (*Skinheads*). 1990 chief picture editor for *i-D*. 1992–1993 conceives the *Plant Power* exhibition commissioned by the Natural History Museum. A commission to shoot a catalogue of Japanese designer Yohji Yamamoto is the starting point of his international career as a fashion and advertising photographer. Names he has worked for include Dior, Yves Saint Laurent, Jil Sander, Shiseido, Louis Vuitton, Calvin Klein, Lancôme, Vivienne Westwood. Apart from that, he has also worked for *The Sunday Times*, *Vogue*, *Visionaire*, *Dazed & Confused*, *The Face*, *George*, and *i-D*. Since 1993 has been exploring the potential offered by digital technology (see his *Plant Power* project). Numerous awards, incl. the Halina Award for Best Young British Fashion Photographer (1989); voted "the world's most influential fashion photographer" by *The Face* magazine (1995), Terence Donovan Award of the Royal Photographic Society (2001), and Moët Chandon Fashion Tribute (2006). Also lectures and seminars. Honorary Fellowship from Bournemouth College since 1998. November 2000 foundation of an online platform for fashion, as well as experimental and interactive projects (SHOWstudio.com).

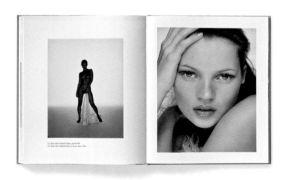

EXHIBITIONS (Selected) — **2000** Dresden (Deutsches Hygiene-Museum) GE // **2002** Paris (Maison européenne de la photographie/**Yohji Yamamoto/'May I help you?'**) GE // Tokyo (Hara Museum of Contemporary Art/**Yohji Yamamoto/'May I help you?'**) GE // Hamburg (Haus der Photographie/Deichtorhallen – 2006) GE

BIBLIOGRAPHY (Selected) — **Skinhead**. London 1982 // **N.K..** Munich 1994 ✍ // **Flora**. Munich 1997 // **Look at Me – Fash-**ion Photography. **1965 to Present**. London 1998 (cat. British Council) // **Bilder, die noch fehlten**. Ostfildern-Ruit 2000 (cat. Deutsches Hygiene-Museum, Dresden) // Marion de Beaupré (ed.): **Archeology of Elegance. 20 Jahre Modephotographie**. Munich 2002 (cat. Deichtorhallen Hamburg) // **The heartbeat of fashion. Sammlung F.C. Gundlach**. Bielefeld 2006 (cat. Haus der Photographie/Deichtorhallen Hamburg) // **N.K. Photographien 1994–2009**. New York 2009

"Nick Knight's photographs cannot be explained by preconceived notions. His fashion photographs are not about fashion in its elitist context. His images of men and women do not serve to reinforce the values of masculinity and femininity. They go beyond sexuality. His photographs are related to his personal, sometimes romantic, vision of the world."

— Satoko Nakahara ✍

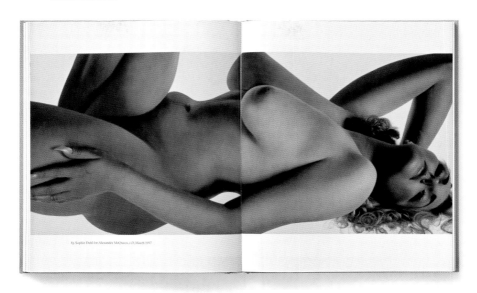

65, Sophie Dahl for Alexander McQueen, *i-D*, March 1997

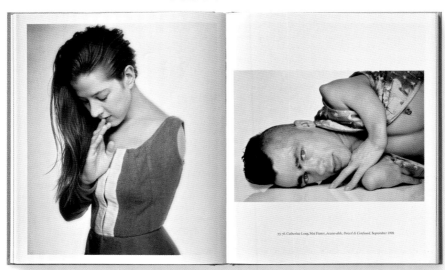

75, 76, Catherine Long, Mui Fraser, *Access-able*, *Dazed & Confused*, September 1998

Herlinde Koelbl

Herlinde Koelbl: **Feine Leute.**
111 Photographien der Jahre
1979 bis 1985. Nördlingen
(Franz Greno) 1986

31.10.1939 Lindau (Germany) — Lives in Neuried (Germany) Usually large-scale cycles, often dealing with themes that are socially taboo. Since the end of the 1980s, one of Germany's most widely discussed photographers. Original aim is to work in fashion design, but takes up photography in the 1970s. Self-taught. Apart from commissioned work for international newspapers and magazines (*Zeit*, *Stern*, *New York Times*) conceptual free cycles (b/w and color). *Das deutsche Wohnzimmer* (The German Living Room) her first work to attract attention nationally. Achieves her breakthrough with male nudes (1984) and an essay on "high society" (1986). Increasingly interested in concomitant interview and text work. In-depth research for her long-term project *Jüdische Portraits* (Jewish Portraits), portraits of German writers in *Im Schreiben zu Haus* (At Home with Writing), and her comparative portraits of politicians in *Spuren der Macht* (Traces of Power). Also films, television productions. Numerous awards. Several prizes, including the Leica Medal of Excellence (1987), Dr Erich-Salomon Prize (2001), Günter-Fruhtrunk Prize (2006). Member of the DGPh and Bund Freischaffender Fotodesigner.

EXHIBITIONS (Selected) — **1980** Munich (Kunstverein) SE // **1983** Sidney (Australian Centre for Photography) SE // **1984** Bonn (Rheinisches Landesmuseum – 1986) SE // **1985** Ingolstadt (Germany) (Kunstverein – 1991, 1994, 1996) SE // **1986** Munich (Stadtmuseum – 1990) SE // **1987** New York (Marjorie Neikrug Gallery) SE // **1990** Hamburg (Museum für Kunst und Gewerbe – 2002, 2007) SE // **1992** Halle (Germany) (Staatliche Galerie Moritzburg) SE // **1993** Cincinnati (Ohio) (Art Academy) SE // **1994** Houston, Texas (Center for Photography (**Women in Photography**) SE // **1996** Munich (Städtische Galerie im Lenbachhaus) SE // **1998** Frankfurt am Main (Kunsthalle Schirn) SE // **1999** Berlin (Deutsches Historisches Museum) SE // **2000** Munich (Haus der Kunst) SE // **2001** Sydney (Jewish Museum) SE // Melbourne (Jewish Museum) SE // **2002** Bonn (Haus der Geschichte) SE // **2004** Berlin (Filmmuseum) SE // **2005** Berlin (C/O Berlin) SE // **2008** Munich (Villa Stuck) SE // **2009** Berlin (Martin-Gropius-Bau) SE // **2014** Berlin (Deutsches Historisches Museum) SE

BIBLIOGRAPHY (Selected) — **Das deutsche Wohnzimmer.** Munich 1980 // **Dienst am Volk.** Munich 1982 // **Män**ner. Munich 1984 // **Feine Leute.** Nördlingen 1986 // **Jüdische Portraits.** Frankfurt am Main 1989 // **Kinder.** Frankfurt am Main 1994 // **Opfer.** Heidelberg 1996 // **Starke Frauen.** Munich 1996 // **Im Schreiben zu Haus.** Munich 1998 // **Spuren der Macht.** Munich 1999 // **Die Meute. Macht und Ohnmacht der Medien.** Munich 2001 // **Schlafzimmer: London, Berlin, Moscow, Rome, New York, Paris.** Munich 2002 // **Die Kommissarinnen.** Berlin 2004 (cat. Filmmuseum) // **Haare.** Ostfildern 2007 // **H.K.: Mein Blick.** Göttingen 2009 (cat. Martin-Gropius-Bau, Berlin) ✍ // **Targets.** Munich 2014 (cat. Deutsches Historisches Museum, Berlin)

"Herlinde Koelbl is a phenomenon. Since the mid 1970s, the photographer, who lives near Munich, has been working on long-term visual projects intellectually close to sociology and every-day and cultural history. She has a lot of staying power. The subjects she chooses never cease to surprise. She regularly asks astonishing questions. That they were ultimately the right ones is shown by the success of her exhibitions, films and meanwhile around two dozen books […] Koelbl tells of German living-rooms and Jewish intellectuals, of writers and polite society, the world's bedchambers, children, male nudes, strong women. At first sight, this strikes us as erratic, volatile, irresolute. None of that. Koelbl's – definitely cross-medial – interest is in people. The at first glance seemingly disparate pieces of her oeuvre come together in the end, almost logically, to form an astounding encyclopedia of human drives and vices, hopes and fears, the depths of despair and the pinnacles of pleasure. What Herlinde Koelbl offers is a guided look at what it can – also – mean to be human." — Hans-Michael Koetzle ✍

84

85

44

45

Rudolf Koppitz

Rudolf Koppitz.
Wien (Gottschamel) 1937

3.1.1884 Schreiberseifen (Austria, today Czech Republic) — **8.5.1936** Vienna (Austria) Dance studies, nudes, landscapes, portraits influenced by Symbolism and Art Nouveau. Late Pictorialist on the threshhold to the New Objectivity. The most important of the forgotten Austrian camera artists before 1930. His parents weavers, he grows up in poverty. Volksschule (lower secondary school). From 1897 learnt weaving. At the same time apprenticed as photographer to Robert Rotter in Freudenthal. 1901 apprentice examination. Moves to Troppau and then Brünn (today Brno). There does retouching work in the Atelier Carl Pietzner. 1903–1907 military service in Vienna. During this time he probably becomes acquainted with the works of Heinrich Kühn, Hugo Henneberg, > Stieglitz, and > Steichen. After military service he continues to travel around: Northern Bohemia, Meran, Troppau, Dresden. 1912 works for four months for Dora Kallmus in his studio in Vienna. There he studies at the "Graphische" (Höhere Graphische Bundes-Lehr- und Versuchsanstalt: Higher Graphic Arts Teaching and Research Institute), where from 1913 he is assistant to Heinrich Kessler. 1914–1918 military service as a reconnaissance pilot. 1918 returns to the "Graphische" in Vienna. Assistant teacher for retouching work, later professor. Also private teaching. 1924 much acclaimed exhibition on the premises of the Chamber of Trade, Industry and Commerce. After that he takes part in almost 60 exhibitions in Europe, Canada, Japan, and the USA; at least 16 in Great Britain alone. 1930 appointed head of the photography department. Gold Medal of the Vienna Photographischen Gesellschaft (Photographic Society). Around this time, he moves away from art-photography printing techniques and soft-focus effects. In his final years he turns to "home-county photography" that is indisputably in the spirit of the times.

"Symbolism and documentarist approaches, 'blurred' bromoil and crisp bromide prints, family idylls and the trenches, nude female dancers and the furrowed faces of farmers stand in seemingly diametrical opposition to one another. [...] In none of his creative phases did Rudolf Koppitz belong to an 'avant-garde' – and until recently this was one of the preconditions to be met if any art-historical material of this kind was not to be ignored [...]." — Monika Faber ✍

EXHIBITIONS (Selected) — **1924** Vienna (Kammer für Handel, Gewerbe und Industrie) SE // **1930** Boston (Camera Club) SE // (Touring exhibition: Rochester [New York], Washington [DC], San Francisco, Fort Dearborn [Illinois], Philadelpia) // **1936** Vienna (Museum für Kunst und Industrie) SE // **1983** Vienna (Museum des 20. Jahrhunderts) GE // **1995** Vienna (Historisches Museum der Stadt Wien) SE // **1996** Iowa City (Iowa) (The University of Iowa Museum of Art) SE // **1997** Providence (Rhode Island) (David Winton Ball Gallery) SE // **1999** Cologne (Rudolf Kicken Gallery) SE // **2002** Berlin (Kicken Berlin) JE (with Heinrich Kühn) // **2003** Vienna (Albertina/**Das Auge und der Apparat**) GE // **2007** Washington, DC (National Gallery of Art) GE // **2008** New York (Guggenheim Museum) GE // **2009** Berlin (Kicken Berlin/**Hidden Modernism**) GE

BIBLIOGRAPHY (Selected) — Josef Gottschamel and Rudolf Hans Hammer (eds): **R.K.** Vienna 1937 (= Meisterbücher der Photographie 3) // **Geschichte der Fotografie in Österreich.** Bad Ischl 1983 (cat. Museum des 20. Jahrhunderts, Vienna) // Monika Faber (ed.): **R.K.** Vienna 1995 (cat. Historisches Museum der Stadt Wien) ✍ // Monika Faber and Klaus Albrecht Schröder (eds): **Das Auge und der Apparat. Die Fotosammlung der Albertina.** Ostfildern-Ruit 2003 (cat. Albertina, Vienna) // Matthew S. Witkovsky: **Foto: Modernity in Central Europe, 1918–1945.** Washington, DC 2007 (cat. National Gallery of Art) // Annette and Rudolf Kicken, and Simone Förster (eds): **Points of View: Masterpieces of Photography and Their Stories.** Göttingen 2007 // **R.K. – Photogenie 1884–1936.** Vienna 2013

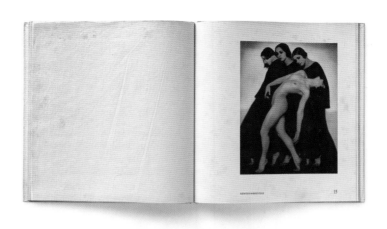

NUR MENSCH 16

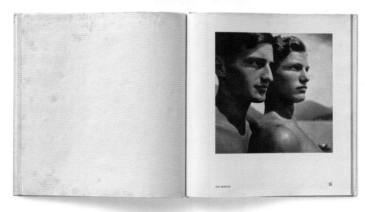

NEWCOMPOSITION 15

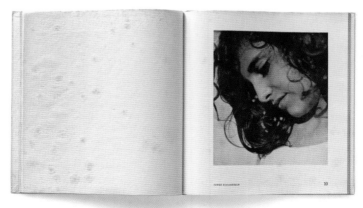

JUNGE MÄDCHEN 10

Alberto Korda *(Alberto Fernando Díaz Gutiérrez)*

Korda: A Revolutionary Lens.
Göttingen (Steidl) 2008

14.9.1928 Havanna (Cuba) — 25.5.2001 Paris (France) Photojournalism, advertising, fashion. Chronicler of the Cuban revolution and author of the "Che" portrait, which — apart from the Mona Lisa — is thought to be the most reproduced picture in art history. School in Havana. 1944–1947 studies business management at the Havana Business Academy. From 1950 works as a sales representative for pharmaceutical products of the Instituto Biológico Cubano (IBC). Marries Julia López Cruz in 1951 (divorced in 1958). 1952–1953 sales representative for soaps, typewriters, and office furniture. In 1954 first advertising photos for an insurance company (Godoy y Sayán). In the same year (together with Luis Peirce Beyrs) opens the Korda Studios (from 1956 Studios Korda). 1956 meets and marries Norka, real name Natalia Magali Méndez Ramírez (divorced in 1963). In January 1959 victory of Fidel Castro's revolution. In the same month (with Raúl Corrales, Osvaldo Salas, and Roberto Salas) report on Castro's first official journey abroad to Venezuela. In April 1959 accompanies Castro to the USA. 5 March 1960, portrait of "Che" Guevara — photographed at a funeral ceremony for the victims of an act of sabotage — his most famous picture. 1962 reports *With Fidel to Santiago* and *Fidel in the Sierra Maestra* in *Revolución* and *Cuba* magazine. In the same year he meets his third wife, Marta Teresa Guffanti Pérez (Mónica). In 1963 with Fidel in the USSR. Further trips to the USSR (1964), France, Poland, the GDR (1965), and Canada (1967). 1968 expropriation. Switches to underwater photography. Longer stays in Spain, France, and Italy. In 1978 group exhibition in Mexico City is the starting point of his international reception. Gives up underwater photography in 1979. Appointment as chief photographer for the new *Opina* magazine. Separates from Mónica and lives with Almi Alonso. In 1987 works as fashion photographer for CONTEX. 1997 solo exhibition in Los Angeles, his first trip to the USA as an artist. Several awards incl. *Réplica del Machete de Máximo Gómez* and *First Degree Order of Felix Varela*. In May 2001 invitation to the film festival in Cannes. He dies shortly afterwards in Paris.

EXHIBITIONS (Selected) — **1978** Mexico City (Museum of Modern Art/**Hecho en Latinoamérica**) GE // **1979** Mexico City (Museo de Arte Carrillo/**Historia de la Fotografía Cubana**) GE // Arles (Rencontres internationales de la photographie/**Soirée Latinoamericaine**) Projection // **1980** Mexico City (Mexican Council of Photography) JE (with Agustin Victor Casasola) // **1982** Paris (Centre Pompidou/**La Photographie Contemporaine en Amérique Latine**) GE // **1983** New York (Westbeth Gallery/**Cuban Photography 1959–1982**) GE // **1985** Milan (Il Diaframma) SE // **1988** Agrigento (Sicily) (Centro Culturale Editoriale Pier Paolo Pasolini) SE // **1989** Perpignan (France) (Visa Pour l'Image) SE // **1990** Paris (Galerie du Jour Agnès B.) SE // **1997** Buenos Aires (Recoleta Cultural Centre/**Fotos del Che**) SE // **1998** Havana (Fototeca of Cuba/**Retrospective**) SE // Los Angeles (Couturier Gallery) SE // Seattle (Washington) (Photographic Center Gallery) SE // **1999** Oslo (Henie Onstad Kunstsenter) SE // **2000** London (Royal National Theatre/**Cuba, sí! 50 Years of Cuban Photography**) GE // **2001** Los Angeles (Los Angeles County Museum of Art/**Shifting Tides. Cuban Photography after the Revolution**) GE

BIBLIOGRAPHY (Selected) — **Cuba par Korda.** Paris 2002 // Cristina Vives and Mark Sanders (eds): **K.: A Revolutionary Lens.** Göttingen 2008 ✎⊐

"Korda was not aware that his best photographs – including his portrait of Che, which he later called *Heroic Guerrilla* – were the result of an artistic 'construction' that was only possible because of the degree of independence that exists between reality and its representation; and moreover, because of the possibility that this representation 'constructed' by him was capable of becoming 'another' reality. Neither was he aware that he was shaping the Revolution's iconography through the iconography of its leaders. This process took him years, and he did it, basically, using Fidel's figure as a model. Che was never the most privileged 'subject' of this photographic endeavor, as Korda was not as close to him as he was to Fidel. In fact Che appears in only a very few rolls of film. This is perhaps why, in so many interviews, Korda referred to *Heroic Guerrilla* as only a 'lucky break'." — Cristina Vives ✐

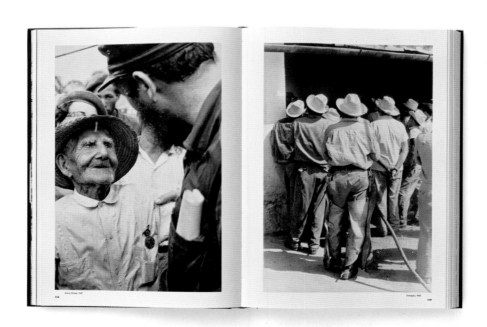

Josef Koudelka

Josef Koudelka: **Gypsies.**
New York (Aperture) 1975

10.1.1938 Moravia (Czechoslovakia) — Lives in Paris (France) Member of the Magnum Group. Known for his cycle on the gypsies of Eastern Europe and his pictures of the brutal ending of the Prague Spring in 1968. First photographs around 1952. 1956–1961 engineering studies at Prague Technical University. Gets to know the photographer and critic Jiri Jenícek. At his suggestion, first exhibition in Prague (Divadlo Semafor, 1961), where he meets Anna Fárová. Begins his work on gypsies in Czechoslovakia. 1961–1967 works as a full-time aeronautical engineer in Prague and Bratislava. 1967 first exhibitions of his gypsy photographs. Takes photographs of the invasion of Prague by Warsaw Pact troops in 1968. International reception of his (anonymously) printed and distributed photos. Emigration in 1970. Lives in England until 1979 and from 1980 in France. In 1971 associate member and from 1974 full member of Magnum. 1978 Prix Nadar for his book *Gitans*. In 1984 his most important solo exhibition to date at the London Hayward Gallery, curated by Robert Delpire. First publication of the Prague photos under his name. 1986 first panoramic photographs as part of his work for the DATAR project (a scheme to photograph France's natural and built environments). 1987 acquires French nationality. In 1990 returns to Czechoslovakia for the first time. Photographic work on Eastern Europe. Numerous awards, including the Grand Prix national de la photographie (1987), Hugo Erfurth Award (1989), Hasselblad Award (1992), Centenary Medal of the Royal Photographic Society (1998).

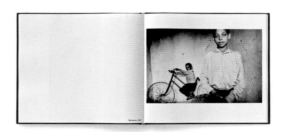

EXHIBITIONS (Selected) — **1975** New York (Museum of Modern Art) SE // **1976** Chicago (Art Institute) SE // **1978** Amsterdam (Stedelijk Museum) SE // **1984** London (Hayward Gallery) SE // **1988** Paris (Centre national de la photographie) SE // **1989** Calais (France) (Galerie de l'ancienne Poste) SE // **1990** Prague (Kunstgewerbemuseum) SE // **1991** San Francisco (Museum of Modern Art) SE // **1992** Gothenburg (Sweden) (Hasselblad Center) SE // **1997** Tokyo (Metropolitan Museum of Photography) SE // **1998** Cardiff (National Museums and Galleries of Wales) SE // **2002** Arles (Rencontres internationales de la photographie) SE // **2003** Rome (Mercati di Traiano) SE // **2005** Budapest (Hungarian House of Photography) SE // **2011** Arles (Les Rencontres d'Arles) SE

BIBLIOGRAPHY (Selected) — **Diskutujeme o morálce dneška.** Prague 1965 // Alfred Jarry and J.K.: **Kral Ubu**. Prague 1966 // **Gipsies**. New York 1975 (cat. Museum of Modern Art) // **I Grandi Fotografi: J.K.** Milan 1982 // J.K. Paris 1984 // **Exils.** Paris 1988 // **J.K.: Mission Photographique Transmanche.** Douchy-les-Mines 1989 (cat. Centre régional de la Photographie Nord-Pas-de-Calais) // **Prague, 1968**. Paris 1990 // **J.K.: Fotografie Divadlo za Branou 1965–1970.** Prague 1993 // **The Hasselblad Awards 1980–1995**. Gothenburg 1996 ⌲ // **Reconnaissance: Wales**. Wales 1998 (cat. The National Museums and Galleries of Wales) // **Chaos**. Paris 2000 // Chris Boot (ed.): **Magnum Stories**. London 2004 // J.K. Paris 2006 // **Invaze 68**. Prague 2008 (in German: **Invasion Prag 68**. Munich 2008)

"Koudelka is one of the great photographers of our time. During his years of travel in various countries, he has been concerned with human conditions, expressed especially in images of the everyday life of gypsies, their poverty and independence, their festivities and cultural heritage. Strict form is merged with poetic vision in his photographs and there is also a tension between sensuality and a harsh, grainy socio-documentary realism in his portraits of people at the margins of society." — Rune Hassner

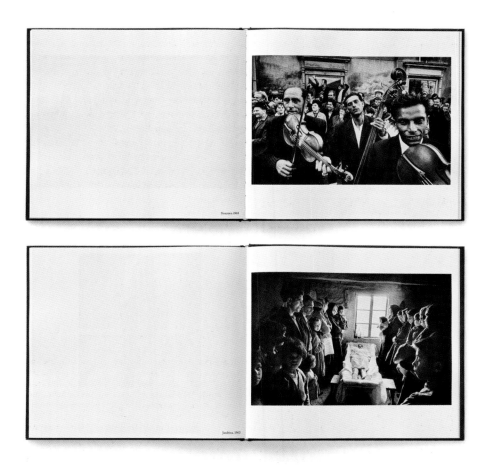

Germaine Krull

Germaine Krull: **100 x Paris.**
Berlin (Verlag der Reihe) 1929

29.11.1897 Wilda (today Poland) — 31.7.1985 Wetzlar (Germany)
Object photography, nudes, portraits, material studies and reports.
Late rediscovery of a pioneer of modern photography. Her father an
engineer who changes jobs frequently, the family spending the years
between 1897 and 1912 in Italy, France, Switzerland, and Austria.
From 1912 in Munich. Between 1915 and 1918 studies photography
at the Lehr- und Versuchsanstalt für Lichtbildwesen (Photography
Teaching and Research Institute). Opens a photo studio in Munich
(Schwabing). Makes contact with socialist groups around Kurt Eis-
ner. 1920 put on trial for high treason and expelled from Bavaria. 1921
USSR. 1923 in Berlin. Sets up a studio with Kurt Hübschmann. 1925–
1926 in Amsterdam. 1926 moves to Paris. Close friendship with Eli
Lotar. 1928 participates in the *Salon de l'Escalier*, the first exhibition
of modern camera art in France. Starts to work as a press photogra-
pher for *VU*, *Variétés*, *Die Dame*, also publications in *AMG Photogra-
phie*. 1928 publication of the groundbreaking book *Métal*, which pays
homage to the steel creations of the machine age. 1929 presentation of her works at major exhibi-
tions in Essen and Stuttgart. 1935 Monte Carlo. 1941 emigrates to Brazil, 1942 to Africa. There she
joins the Free French Expeditionary Corps. 1944 takes part in the invasion in the south: Naples, Italy,
Saint-Tropez, France, finally Paris. 1946 moves to Bangkok, where she is the co-proprietor of the Hotel
Oriental. Documentation of Thailand's religious places. 1966–1967 in Paris. Returns to India. Becomes
a Buddhist. Records her memoirs (*Click entre deux guerres*, and *La vie mène la danse*). 1982 after a
stroke, she spends her last years in Europe.

EXHIBITIONS (Selected) — **1928** Paris (1er Salon indépendant
de la photographie/**Salon de l'Escalier**) GE // **1929** Essen
(Germany) (**Fotografie der Gegenwart**) GE // Stuttgart (**Film
und Foto**) GE // **1967** Paris (Musée du Cinéma/Palais de Chail-
lot) SE // **1977** Bonn (Rheinisches Landesmuseum) SE //
1988 Arles (Rencontres internationales de la photographie)
SE // **1999** Essen (Germany) (Museum Folkwang) SE // **2003**
San Francisco (Robert Koch Gallery/**Concealed Identity**) GE //
2006 Hannover (Sprengel Museum) JE (with Heidi Specker) //
2008 Cologne (Stiftung Fotografie und Kunstwissenschaft)
SE // **2009** Paris (Jeu de Paume – Site Sully/**Collection Chris-
tian Bouqueret**) GE // Munich (Stadtmuseum) GE

BIBLIOGRAPHY (Selected) — **Der Akt**. Dachau, 1918 // **Kara-
Mappe**. Leipzig, 1923 // **Métal**. Paris 1928 (facsimile reprint:
Cologne 2003) // **100 x Paris**. Berlin 1929 // **Marseille**. Paris
1935 // **G.K.: Fotografien 1922–1966**. Cologne 1977 (cat.
Rheinisches Landesmuseum, Bonn) // Kim Sichel: **G.K. Avant-
garde als Abenteuer**. Munich 1999 (cat. Museum Folkwang,
Essen) / ✍ // Martin Parr and Gerry Badger: **The Photobook: A
History Volume I**. London 2004 // Herbert Molderings: **Die
Moderne der Fotografie**. Hamburg 2008 // **Paris. Capitale
photographique. 1920/1940. Collection Christian Bou-
queret.** Paris 2009 (cat. Jeu de Paume – Site Sully) // **Nude
Visions. 150 Jahre Körperbilder in der Fotografie**. Heidelberg
2009 (cat. Münchner Stadtmuseum)

"To understand Germaine Krull's photographic work, one must take account of her political and professional convictions, which were obsessively individualistic. Her work and her life were indissolubly bound up with one another. Photography proved to be a pragmatic instrument that allowed her to survive in a large number of different places and to respond to the cultures she witnessed. Germaine Krull was one of the most influential photographers in the period between the two wars, and yet she was strikingly unaware of the effect her work had on others."
— Kim Sichel ✍o

Rue Mallet-Stevens, Auteuil, Dächer Rue Mallet-Stevens, Auteuil, roofs
Toits de la Rue Mallet-Stevens, Auteuil

Rue Royale, im Hinter- Rue Royale, Madeleine Church
grund die Madeleine-Kirche in the background
Rue Royale, au fond l'Eglise de la Madeleine

66 67

Fritz Kühn

Fritz Kühn: **Kompositionen in Schwarz und Weiß**. Munich (Verlag F. Bruckmann) 1959

29.4.1910 Mariendorf (Germany) — 31.7.1967 East-Berlin (Germany) Trains as artistic locksmith, draughtsman, type designer, photographer. Especially landscapes, nature and plant studies in a pictorial language schooled in the New Objectivity. 1916–1924 attends school in Berlin. Apprenticeship as a tool-maker. During this time he takes his first photographs. Apprenticeship examination. Works as locksmith. In his father's company from 1931. 1937 acquires the certificate of master craftsman and establishes his own company. 1938 *Geschmiedetes Eisen* (Wrought Iron) (Wasmuth Verlag) his first, much acclaimed specialist and text book. In 1943 his workshop is destroyed in an air raid and relocated to Wriezen (east of Berlin). After the war, he does a great deal of building work in the Federal Republic of Germany and the German Democratic Republic. Also restoration and reconstruction of wrought-iron work that has been damaged.

At the same time he is extremely active as a photographer and publicist. *Sehen und Gestalten* (Seeing and Designing) in 1951 the most popular, and *Kompositionen in Schwarz und Weiss* (Compositions in Black and White) in 1959, the most important of a total of six photobooks. 1952 participates in the *Eisen und Stahl* (Iron and Steel) exhibition in Düsseldorf. Impressed by what he sees, he turns to more modern forms of expression in his metal design and photography (the keyword is "subjektive fotografie"). 1954 National Prize of the GDR. 1960 participates in the important exhibition *Ungegenständliche Photographie* (Abstract Photography) at the Neue Sammlung München (with, among others, Kilian Breier, > Keetman, > Steinert). As a "formalist" he is a lone wolf among photographers in the GDR, and soon forgotten after his death. His estate is on permanent loan to the Berlinische Galerie. Since 2004 the F.K. Gesellschaft (F.K. Society) has been active in the cultivation and artistic reappraisal of his works. *www.fritz-kuehn-stiftung.de*

 "Right from the start, Kühn revealed himself to be a photographer of objects in a broad sense, devoting himself to the photographic interpretation of forms, both natural and man-made […] His work as a photographer moved parallel to his practical work as an artistic locksmith, but also independently of it, as the realization of a specific way of seeing."
— Andreas Krase

EXHIBITIONS (Selected) — **1941** Berlin (Kunstdienst) SE // **1955** Freiberg (Germany) (Bergbaumuseum) SE // **1956** Potsdam (Heimatmuseum) SE // **1987** Berlin (Passage Gallery) GE // **1997** Berlin (Martin-Gropius-Bau) GE // **1998** Berlin (Lapidarium) SE // **2001** Halle (Germany) (Staatliche Galerie Moritzburg) SE // Kiel (Kunsthalle) SE

BIBLIOGRAPHY (Selected) — **Sehen und Gestalten**. Leipzig 1951 // **Aus meiner Gräsermappe**. Leipzig 1953 // **Licht – Land – Wasser**. Berlin 1958 // **Kompositionen in Schwarz und Weiss**. Munich 1959 // **Stufen**. Berlin 1964 // **Gottes harte Herrlichkeit**. Berlin 1964 // Andreas Krase: **F.K.: Das photographische Werk 1931–1967**. Berlin 1998 (cat. Berlinische Galerie)

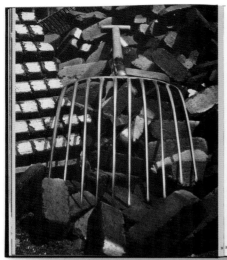
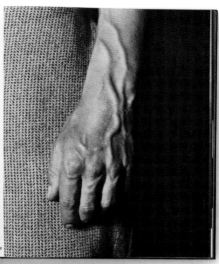
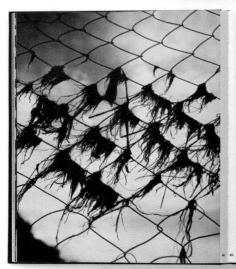

David LaChapelle

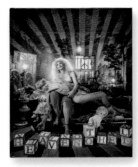

David LaChapelle: **Heaven To Hell**.
Cologne (TASCHEN) 2006

1963 Hartford (Connecticut, USA) — Lives in New York (USA) and Los Angeles (USA) Iconoclast of the 1990s, shooting star of fashion photography. The author of extremely imaginative, garishly colored scenarios schooled in Dadaism, Pop Art, kitsch, and the everyday myths of the 20th century. Childhood in North Carolina, where, encouraged by his mother, he takes his first cheerfully playful photographs. Moves to New York at age 15. First job with Studio 54, at the time the "temple of pop culture and its stars" (Jochen Siemens). Returns to North Carolina to finish high school. At the beginning of the 1980s he is back in New York, where — influenced by the cinematic art of Federico Fellini, for example — he studies art at the Art Students League and the School of Visual Arts. First professional photography job for *Interview* magazine. Specializes in fashion photography, where he creates bizarre "compositions of baroque and ironical voluptuousness" (Siemens). No doubt one of the most innovative designers of the 1990s. Numerous publications, among others in *Rolling Stone*, *Interview*, *Vanity Fair*, *Vogue* (France), *The Face*, *The New York Times Magazine*, *i-D*, *Spin*, *Flaunt*, *Esquire*. 1997 *LaChapelle Land* his first much acclaimed photobook (receiving the Art Directors Award for the best book design). Numerous other awards, incl. Best New Photographer of the Year (from Photo France and American Photo), and the ICP's Applied Photography of the Year Award (1996). Also advertising, for instance for Camel, Pepsi, Levi's, Diesel Jeans, Parfums Gaultier, and MAC Cosmetics. Currently working on his first independent feature film *Goodbye, Ruby Tuesday*. 1998 important solo exhibition at the Rencontres d'Arles.

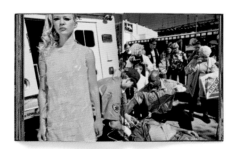

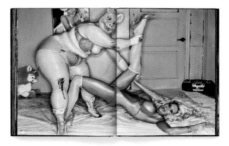

EXHIBITIONS (Selected) **1998** Arles (Rencontres internationales de la photographie) SE // **1999** New York (Tony Shafrazi Gallery — 2002, 2007, 2008) SE // **2001** Berlin (Galerie Camera Work) SE // **2002** Hamburg (Triennale der Photographie) GE // Vienna (KunstHaus) SE // **2003** Moscow (Moscow House of Photography) SE // **2005** New York (Staley-Wise Gallery) SE // **2007** Buenos Aires (Malba Museum) SE // Milan (Palazzo Reale) SE // **2008** Florence (Forte Belvedere) SE // **2009** Paris (La Monnaie de Paris) SE

BIBLIOGRAPHY (Selected) — **LaChapelle Land**. New York 1996 // **Un Nouveau Paysage humain**. Arles 1998 (cat. Rencontres internationales de la photographie) 🖾 // **Hotel LaChapelle**. New York 1999 // **D.L.** Hamburg 2000 (= **Stern** Portfolio no. 16) // **Heaven to Hell**. Cologne 2006 // **Image Makers: Image Takers**. London 2007 // Gianni Mercurio and Fred Torres (eds.) **D.L.** Florence 2009 (cat. La Monnaie de Paris) // **Lost + Found. Part I**. Cologne 2017 // **Good News. Part II**. Cologne 2017

"LaChapelle is an interpreter of his time, traversing with iconoclastic force the worlds of photography, music, cinema, fashion, pop culture and the video clip, and appropriating all the possible meanings of the nouns that define the refusal to accept things as they are: irony, sarcasm, derision, transgression, reinterpretation […] He has little in common with the tradition of visionary photography, preferring to dream in a multiple register and, when it suits him, using Dadaism, Surrealism, kitsch, cyber culture and, especially, politically incorrect bad taste."
— Giovanna Calvenzi ✍

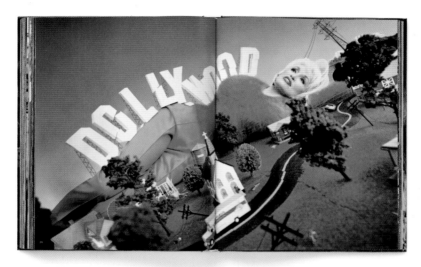

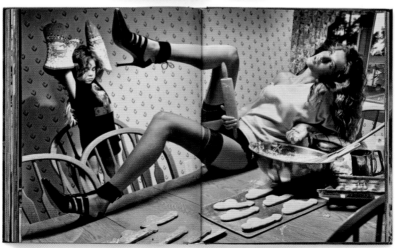

Inez van Lamsweerde & Vinoodh Matadin

Inez van Lamsweerde and Vinoodh Matadin: **Photographs**. Florence (Pitti Immagine) 2001

25.9.1963 Amsterdam (Netherlands) — Lives in Amsterdam and New York (USA) — 29.9.1961 Amsterdam — Lives in Amsterdam and New York In collaboration with fashion designer Vinoodh Matadin, pioneer of a computer-based digitally generated world of images. Her fashion photography and portraits may also be interpreted as a visual reaction to mankind in the era of genetic engineering. Studies at the Gerrit Rietveld Academie 1985–1990. Since 1986 has lived and worked together with fashion designer Vinoodh Matadin. 1992–1993 on a one-year scholarship to New York, where she worksd at the PS1 Contemporary Art Center. International breakthrough with the two series *Final Fantasy* and *Thank You Thighmaster*. 1996 takes part in the important group exhibition, *Fotografie nach der Fotografie* (Photography after Photography) with stopovers in Munich (Aktionsforum Praterinsel), Krems, Erlangen, Cottbus, Odense, and Winterthur. 1997 begins her cooperation with French designer duo M/M Paris. A much acclaimed campaign for Yohji Yamamoto marks the beginning of meanwhile regular forays into the world of advertising. Ads for Yves Saint Laurent, Balenciaga, Chloé, Valentino, Gucci, Givenchy, Roberto Cavalli, Gaultier, Gap, Pucci, Ungaro, Balmain, Joop Jeans, and H&M. Also editorials for *Vogue*, *V Magazine*, *W Magazine*, *Harper's Bazaar*, *GQ*, *Self Service*, *Purple Fashion*, *Visionaire*, *Butt*, *Arena Homme Plus*, and *032c*.

EXHIBITIONS (Selected) — **1996** Zurich (Kunsthaus) SE // Munich (Aktionsforum Praterinsel/Fotografie nach der Fotografie) GE // **2000** Groningen (Netherlands) (Groninger Museum) SE // **2001** Florence (Stazione Leopolda) SE // **2002** Brussels (AEROPLASTICS contemporary – 2004, 2007) GE // **2003** The Hague (Fotomuseum/**Fotografen in Nederland 1852–2002**) GE // Helmond (Netherlands) (Gemeentemuseum Helmond – 2004, 2007) GE // **2004** New York (Fisher Landau Center For Art) GE // Antwerp (Museum voor Fotografie) GE // Graz (Austria) (Neue Galerie Graz am Landesmuseum Joanneum) GE // **2005** The Hague (Gemeentemuseum Den Haag) GE // Moscow (Moscow House of Photography) GE // Vienna (Kunsthalle Wien) GE // **2006** Amsterdam (Melkweg Gallery) GE // Cologne (Museum Ludwig) GE // **2007** Rotterdam (Nederlands Fotomuseum/**Dutch Eyes**) GE // **2010** Amsterdam (Fotografiemuseum Amsterdam) SE

BIBLIOGRAPHY (Selected) — I.v.L. Zurich 1996 (cat. Kunsthaus) // **Fotografie nach der Fotografie**. Dresden 1996 (cat. Aktionsforum Praterinsel) // Camilla Nickerson and Neville Wakefield (eds): **Fashion. Photography of the Nineties.** Zurich 1996 // Photographs. Hamburg 1999 (cat. Deichtorhallen) // **Photographs**. Munich/Florence 2001 (cat. Stazione Leopolda, Florence) ✍ // **Frauen sehen Frauen.** Munich 2001 // Wim van Sinderen: **Fotografen in Nederland. Een Anthologie 1852–2002.** The Hague 2002 (cat. Fotomuseum Den Haag) // **Dutch Eyes: A Critical History of Photography in the Netherlands.** Zwolle 2007 (cat. Nederlands Fotomuseum, Rotterdam) // Susan Bright: **Art Photography Now.** Heidelberg 2008 // **I.v.L. & V. M.** Hamburg 2009 (= **Stern** Portfolio no. 55) // **I. v. L./V. M. Pretty Much Everything.** Cologne 2011

"The photographic research of Inez van Lamsweerde and Vinoodh Matadin is a journey through the realms of beauty, desire and transformation. Quite wrongly, people have associated van Lamsweerde and Matadin's work singularly with the new hybrid of digital technology and art, believing that their use of digital manipulation is the only instructive label for their content. In fact, according to these two artists, technology is only a tool — useful only if it changes our relationship with the world, only if it allows issues of the present to become more relevant."

— Francesco Bonami ✍

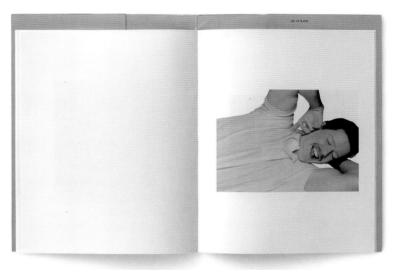

Dorothea Lange

Dorothea Lange: **Farming is a Way of Death**, from: **Ken**, vol. 1, no. 1, 7.4.1938

25.5.1895 Hoboken (New Jersey, USA) — 11.10.1965 San Francisco (USA) Reports on social issues against the background of the Depression of the 1930s. FSA photographer. Creator of singularly evocative pictures with "iconic status". 1913 leaves high school to become a photographer. Jobs at various photo studios, including that of Arnold Genthe. From 1917 attends courses held by Clarence H. White at Columbia University, New York. 1918 darkroom work in the photographic department of a drugstore in San Francisco. 1919 opens her own portrait studio. Friendship with Roy Partridge and his wife > Cunningham. 1920 marries the painter Maynard Dixon. After 1930 devotes herself to social issues. After divorcing Dixon (1935) she marries social scientist Paul Schuster Taylor, who puts her in touch with the Resettlement Administration (from 1937 the FSA: Farm Securitry Administration). Works for this organization until 1939. With Taylor (1939) publication of the important book *An American Ex-odus*. 1942 takes photographs in internment camps for Americans of Japanese extraction. 1943–1945 works for the Office of War Information. 1945–1953 interrupts her work for health reasons. 1954–1955 two larger photo essays in *Life*. 1955–1957 photographic study of the Californian judicial system (turned down by *Life*). 1958–1963 travels extensively through Asia, Europe, the Middle East, and Latin America. During her lifetime, programmatic group exhibitions: *The Family of Man* (MoMA, 1955), *The Bitter Years* (MoMA, 1962). Dies of cancer shortly before the opening of her big retrospective at MoMA, New York, curated by John Szarkowski.

EXHIBITIONS (Selected) — **1934** Oakland (California) (Willard Van Dyke Gallery) SE // **1966** New York (Museum of Modern Art) SE // **1973** London (Victoria and Albert Museum) SE // **1994** San Francisco (Museum of Modern Art) SE // **1998** Paris (Hôtel de Sully) SE // **2000** Charleroi (Belgium) (Musée de la Photographie) GE // **2002** New York (Edwynn Houk Gallery) SE // Los Angeles (J. Paul Getty Museum) SE // **2004** Munich (Amerika Haus) SE // **2005** San Francisco (Gendell Gallery – 2006) SE // **2006** Tel-Hai (Israel) (Open Museum of Photography at Tel-Hai) SE // **2009** Madrid (PHotoEspaña) SE

BIBLIOGRAPHY (Selected) — D.L. and Paul Schuster Taylor: **An American Exodus: A Record of Human Erosion.** New York 1939 // George P. Elliott: **D.L.** New York 1966 (cat. Museum of Modern Art) // Milton Meltzer: **D.L.: A Photographer's Life.** New York 1978 // **D.L.: Photographs of a Lifetime.** New York 1982 // **D.L.: American Photographs.** San Francisco 1994 (cat. Museum of Modern Art) // Elizabeth Partridge: **D.L.: A Visual Life.** Washington, DC 1994 // **D.L.** Paris 1998 (cat. Hôtel de Sully) // **Des images pour convaincre.** Charleroi 2000 (cat. Musée de la Photographie) // Naomi Rosenblum: **A History of Women Photographers.** New York 2000 // Mark Durden: **D.L.** London 2001 (new edition: London 2006) // Sam Sturdzé, A.D. Coleman, Ralph Gibson, and Pierre Borhan: **D.L.: The Heart and Mind of a Photographer.** Boston 2002 // Judith Keller: **D.L. Photographs from the J. Paul Getty Museum.** Los Angeles 2002 // Linda Gordon and Gary Y. Okihiro (eds): **D.L. and the Censored Images of Japanese American Internment.** New York/London 2006 // Gilles Mora and Beverly W. Brannan: **FSA. The American Vision.** New York 2006 // Anne Whiston Spirn: **Daring to Look. D.L.'s Photographs and Reports from the Field.** Chicago/London 2008 // **D.L.: Los Años Decisivos 1930–1946.** Madrid 2009 (cat. PHotoEspaña) // Linda Gordon: **D.L.: A Life Beyond Limits.** New York/London 2009

"Part of what makes Dorothea Lange's work so compelling, and therefore so appropriate to reconsider, is its vital and imaginative personal vision. Her pictures of people invoke real, physical, even sensual presences. They are the ordinary man and woman seen seriously and heroicized through eloquent gesture. These people embody their history; they personify character, tenacity, and courage against terrific misfortune. The pictures are saved from sentimentality by Lange's intelligence and by her realization of the complexity of events, circumstances, and character." — Sandra S. Phillips ✍

Frans Lanting

Frans Lanting: **Eye to Eye: Intimate Encounters with the Animal World**.
Cologne (TASCHEN) 1997

13.7.1951 Rotterdam (Netherlands) — Lives in Santa Cruz (California, USA) Internationally well-known animal and landscape photographer with many admired publications. Prominent representative of a wild-life photography interested in environmental conservation. Studies at Erasmus University in Rotterdam. 1977 graduates with Masters in Environmental Economics. Directly thereafter moves to the USA. Takes up photography. Subsequently becomes one of the leading animal and wildlife photographers internationally. Extensive reportage travels through the Amazon basin, Africa, and Antarctica. Marries the author, editor and producer Christine Eckstrom. Regular book projects together. Numerous publications and articles in magazines such as *Natural History*, *Stern*, *Outdoor Photographer*, *Audubon*, *Life*. Since 1987 more than 30 large photo series in *National Geographic Magazine*. Studio with affiliated gallery and photo agency in Santa Cruz (California). Numerous Awards, including World Press Photo (1988, 1989), Wildlife Photographer of the Year (1991), the Ansel Adams Prize from the Sierra Club (1997), Second prize in the category Nature and Environmental Studies at World Press Photo (1997), Lennart Nilsson Award (2005). Co-founder of the North American Nature Photographers Association (NANPA) as well as member of the International League of Conservation Photographers (ILCP). *www.franslanting.com*

> **"He celebrates the land and its wildlife with spare, evocative prose and with photographs that are extraordinary in capturing motion, form and color. […] Mr. Lanting's photographs take creatures that have become ordinary and familiar and transform them into haunting new visions."**
> — George Schaller ✍

EXHIBITIONS (Selected) — **1983** Santa Cruz (California) (Museum of Natural History) SE // **1994** Perpignan (France) (Visa pour l'Image) GE // **1995** Bath (Royal Photographic Society) SE // **1996** Houston (Texas) (Museum of Natural Science) SE // **1997** New York (American Museum of Natural History) SE // Pittsburgh (Pennsylvania) (Carnegie Museum of Natural History – 2003, 2010) SE // **1998** Vienna (Naturhistorisches Museum – 2003, 2007) SE // **1999** Verona (Centro Internazionale di Fotografia Scavi Scalgeri – 2006) SE // **2000** Leiden (Netherlands) (National Museum for Natural History) SE // **2001** Glasgow (Scotland) (Glasgow Art Gallery) SE // **2003** Moscow (Pushkin Museum) SE // **2005** Daytona Beach (Florida) (Southeast Museum of Photography) SE // Chicago (Field Museum) SE // **2006** Hamburg (Museum für Kunst und Gewerbe) SE // **2007** Washington, D.C. (National Geographic Museum) SE // **2009** Minneapolis (Minnesota) (Bell Museum of Natural History) SE // **2010** Bolzano (Italy) (Museo della Natura) SE

BIBLIOGRAPHY (Selected) — **Holland. Magie van de Werkelijkheid**. Utrecht 1980 // **Feathers**. Portland (Oregon) 1982 // **Islands of the West**. San Francisco 1986 // **Elephant Seals**. Minneapolis 1989 // **Albatrosses of Midway Island**. Minneapolis 1990 // **The Total Penguin**. New York 1990 // **Madagascar: A World Out of Time**. New York 1990 // **Forgotten Edens**. New York 1993 // **Peace on Earth**. Tokyo 1993 // **Okavango: Africa's Last Eden**. San Francisco 1993 // **Animal Athletes**. Riverside 1996 // **Bonobo, The Forgotten Ape**. Berkeley 1997 // **Eye to Eye: Intimate Encounters with the Animal World**. Cologne 1997 // **Living Planet**. New York 1999 // **Penguin**. Cologne 1999 // **Jungles**. Cologne 2000 // **Life: A Journey through Time**. Cologne 2006 // **National Geographic. Around the World in 125 Years**. Cologne 2014

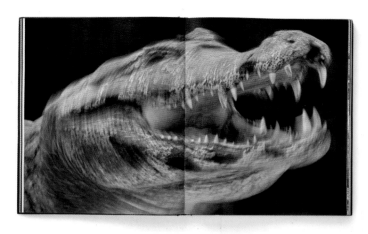

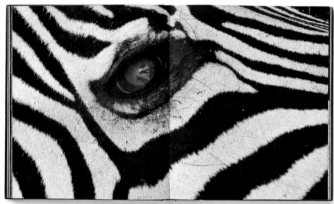

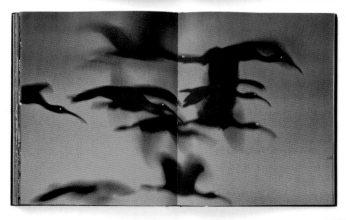

Sergio Larraín

Sergio Larraín: **Valparaiso.**
Paris (Éditions Hazan) 1991

1931 Santiago de Chile (Chile) — 7.2.2012 Ovalle (Chile) Author of an oeuvre that is as small as it is mature in terms of its formal aesthetics, close in spirit to Robert Frank and Henri Cartier-Bresson. His few books, the expression of a radically uncompromising authorial photography, are now much sought after. First, music lessons, taking up photography in 1949. In the same year he begins to study forestry at the University of California, Berkeley (until 1953). 1954 studies at the University of Michigan, Ann Arbor, before traveling extensively throughout Europe and the Middle East. First works freelance. Later staff photographer for the Brazilian *O Cruzeiro* magazine. 1956 two of his works purchased by the MoMA (New York). 1958 scholarship from the British Council. Works on a photo cycle on London. In the same year meets Cartier-Bresson, who opens the door to Magnum for him. Associate from 1959, full member from 1961. 1959—1961 works from Paris for international magazines. 1961 returns to Chile. There, at Pablo Neruda's invitation, report on his house. 1968 becomes acquainted with the Bolivian guru Óscar Ichazo, under whose influence he gives up photography and devotes himself to mysticism, esotericism, yoga, painting, and writing.

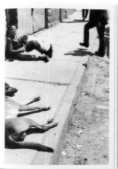

EXHIBITIONS (Selected) — **1965** Chicago (Art Institute) SE // **1991** Arles (Rencontres internationales de la photographie) SE // **1998** Paris (Fnac Montparnasse) SE // **1999** London (The Photographers' Gallery) SE // Valencia (Spain) (Institut Valencià d'Art Modern) SE // **2000** Berlin (Imago Fotokunst) SE // **2002** Gentilly (France) (Maison Robert Doisneau) SE // **2003** Paris (Fondation Henri Cartier-Bresson) GE // **2013** Arles (Les Rencontres d'Arles) SE

BIBLIOGRAPHY (Selected) — **El Rectangulo en la Mano.** Santiago 1963 // **Una Casa en la Arena.** Barcelona 1984 // **Valparaiso.** Paris 1991 (cat. Rencontres internationales de la photographie, Arles) // **Londres 1958—1959.** Paris 1998 // **S.L.** Valencia 1999 (cat. Institut Valencià d'Art Modern) // Robert Delpire and Henri Cartier-Bresson (eds): **Les choix d' Henri Cartier-Bresson.** Paris 2003 (cat. Fondation Henri Cartier-Bresson) // Martin Parr and Gerry Badger: **The Photobook: A History Volume II.** London 2006 // Brigitte Lardinois: **Magnum Magnum.** London 2007 ✎ // **S.L.** Paris 2013 (cat. Les Rencontres d'Arles)

"Standing well back from the evidence before him, Larraín looks with a clandestine, fleeting eye that shows reality via unusual, hidden doorways. He celebrates the uncertain, reveals secrets and rhythms that are often syncopated. He observes no formal rules, obeys no preconceived ideas. Liberated from convention, without looking for a particular performance, his eye, always alert, is free to wander, to improvise according to what attracts it."

— Guy Le Querrec ✍

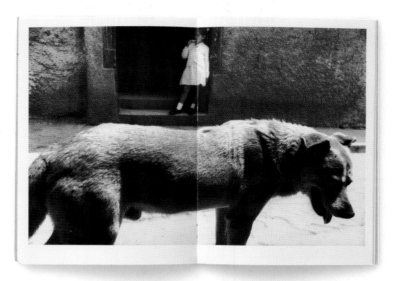

Jacques-Henri Lartigue

(Jacques Haguet Henri Lartigue)

Richard Avedon (ed.): **Jacques Henri Lartigue. Diary of a Century.** New York (The Viking Press) 1970

13.6.1894 Courbevoie (France) — 12.9.1986 Nizza (France) An amateur photographer, he creates an oeuvre that feeds on personal experience and is today considered as early example of the playful use of the medium. Born into a well-to-do Parisian family. His father, a successful businessman, introduces him to the techniques of photography. His first camera at the age of eight, and his first own photographs at the age of ten. All his life an amateur in the true sense of the word, an aficionado, who uses the medium of pictures to explore the immediate horizon of his experience. To start with, mainly incidents from the family's daily life. Photographic documents of a carefree, upper-middle-class childhood at the time of the Belle Epoque. Later, photos of automobile races or of the early flights of aviation pioneers and sporting events in which motion blur becomes an important stylistic device. This makes him, according to Jörg Krichbaum, "the photographic artist who discovered how to bring the 'cinematic element' into photography". His pictures at any rate show a remarkable stylistic confidence, full of wit and a love of experimentation. 1915 attends the Paris Académie Julian under Jean-Paul Laurens. After that he makes a name for himself mainly as a painter. Numerous exhibitions in the Paris salons of the 1930s. Friendship with painters such as Pablo Picasso and Kees van Dongen, writers such as Colette

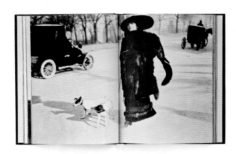

EXHIBITIONS (Selected) — **1963** New York (Museum of Modern Art) SE // **1966** Cologne (photokina) SE // **1971** London (The Photographers' Gallery) SE // **1975** Paris (Musée des arts décoratifs) SE // **1980** Paris (Grand Palais) SE // **1982** New York (International Center of Photography) SE // **1994** Arles (Rencontres internationales de la photographie) SE // **1998** Frankfurt am Main (Fotografie Forum International) SE // **2002** Biarritz (France) (Terre d'images) SE // **2003** Paris (Centre Pompidou) SE // **2008** Guangzhou (China) (Guangdong Museum of Art) SE

BIBLIOGRAPHY (Selected) — **The Photographs of J.-H.L.** New York 1963 (cat. Museum of Modern Art) ✍ // Richard Avedon (ed.): **J.-H.L.: Diary of a Century.** New York 1970 // **Les Autochromes de J.-H.L. 1912–1927.** Paris 1980 // Henri Chapier: **J.-H.L.** Paris 1981 // **J.-H.L.** Paris 1983 // **J.-H.L. Album.** Bern 1986 (cat. Stiftung für die Photographie) // Florette Lartigue: **J.-H.L. La Traversée du siècle.** Paris 1990 // **J.-H.L. Photograph.** Vienna 1998 // **L.'s Riviera.** Paris/New York 1998 // **L. – L'Album d'une vie.** Paris 2003 (cat. Centre Pompidou)

and Jean Cocteau, film directors such as Federico Fellini and François Truffaut. 1963 sees the begin-ning of the international reception of his photographic oeuvre (to that date meant only for private consumption) after a first big comprehensive retrospective at MoMA, New York, and a photo report in *Life* magazine (29 November 1963). First exhibition in Germany at photokina 1966. In France, first solo exhibition in 1975 (at the Musée des arts décoratifs). Altogether around 100,000 photographs (b/w, from 1912 also in color), which he donates to the French State in 1979. Since the remarkable monograph *Diary of a Century* (1970), conceived by > Avedon, more than two dozen published books. Numerous international exhibitions. Numerous awards, incl. Cultural Award of the DGPh, Officer of the Légion d'honneur (1986). In the year of what would have been his 100th birthday (1994), big retro-spectives held posthumously in Arles and Paris. *www.lartigue.org*

"**Lartigue saw, as though for the first time, the transient relationships of life in flux. Earlier photography had seen one thing at a time; the individual facts preceded the relationship. But what Lartigue sought was the ephemeral image itself. He saw the momentary, never-to-be-repeated images created by the accidents of overlapping shapes, and by shapes interrupted by the picture edge. This is the essence of modern seeing: to see not objects but their projected images.**" — John Szarkowski ✍🗋

Robert Lebeck

Robert Lebeck:**Romy Schneider.**
Letzte Bilder eines Mythos.
Schaffhausen (Edition Stemmle)
1986

21.3.1929 Berlin (Germany) — 14.6.2014 Berlin Portraits, photo essays, reports. Important representative of a photojournalism schooled in classical paradigms. Staff photographer for *Stern* magazine. Childhood and youth in Berlin. 1944–1945 military service on the Eastern Front. Until summer 1945 an American prisoner of war. After that, he continues his school education. 1948 Abitur (school-leaving exam) in Donaueschingen (Baden-Württemberg). Begins to study ethnology in Zurich the same year. 1949 an uncle arranges for him to change to Columbia University in New York. In North America he takes a close look at the illustrated press there (especially *Life* and *Look*), whose photography and layout have a lasting effect on him. 1951 (because of the USA's involvement in Korea) he returns to Germany. Studies geology in Freiburg. From 1952 (with a Retina IA, which he has been given as a present) first attempts at photography. Gets to know the photographer Herbert Tobias, who gives R.L. practical experience in using the darkroom. Publishes his first photograph in a newspaper on 15 July 1952, the *Rhein-Neckar-Zeitung*. Until 1955 freelance photojournalist for various Heidelberg newspapers. First big photo report in issue no. 4/1955 of the illustrated magazine *Revue*. From 1955 head of the Frankfurt *Revue* office. 1960 moves to *Kristall*, for which he successfully writes his first large, internationally well-received report from abroad in the same year ("Des Königs Schwert in schwarzer Hand" (The King's Sword in a Black Hand), *Kristall* 16/1960). 1966–1977 photojournalist for *Stern*. 1977–1978 editor-in-chief of *Geo* (together with Klaus Harpprecht). From 1979, back with *Stern*. Several exhibitions of his work as photojournalist (in b/w and color) schooled in > Smith and > Eisenstaedt. 1991 Dr Erich-Salomon Prize of the DGPh, 2007 Henri Nannen Award. Also makes a name for himself as a collector of historical photographs and illustrated magazines. In 2001, exhibition of his collection about the history of photojournalism at the Museum Ludwig, Cologne (*Kiosk*).

EXHIBITIONS (Selected) — **1962** Hamburg (Museum für Kunst und Gewerbe) SE // **1991** Perpignan (France) (Convent de Minimes) SE // Cologne (Museum Ludwig – 2001) SE // **1993** Speyer (Germany) (Historisches Museum der Pfalz) SE // **1999** Hamburg (Gruner + Jahr) SE // **2004** Berlin (Camera Work) SE // Berlin (Willy-Brandt-Haus) SE // Mannheim (Reiss-Engelhorn-Museen) SE // **2007** Hamburg (Flo Peters Gallery) SE // **2008** Berlin (Martin-Gropius-Bau) SE // **2014** Berlin (Johanna Breede Photokunst) SE

BIBLIOGRAPHY (Selected) — **Tokio, Moskau, Leopoldville**. Hamburg, 1962 (cat. Museum für Kunst und Gewerbe) // **Augen-** zeuge R.L. 30 Jahre Zeitgeschichte. Munich/Lucerne 1984 ✎ // **Romy Schneider**. Schaffhausen 1986 // **Begegnungen mit Großen der Zeit**. Schaffhausen 1987 // **Fotoreportagen**. Stuttgart 1993 // **Vis-à-vis**. Göttingen 1999 // **Rückblenden**. Düsseldorf 1999 // **R.L.: The Mystery of Life**. Hamburg 1999 (= **Stern** Portfolio no. 14) // Bodo von Dewitz and R.L.: **Kiosk. Eine Geschichte der Fotoreportage/A History of Photojournalism**. Göttingen 2001 (cat. Museum Ludwig/Agfa Foto-Historama) // **Unverschämtes Glück**. Göttingen 2004 // **Neugierig auf Welt. Erinnerungen eines Fotoreporters**. Göttingen 2004

"Photography, particularly journalistic photography, can be emotional, brutal, obscene, sentimental. Lebeck's photography is none of that. It always remains irritatingly sober. His pictures always have something of the dissecting eye of a surgeon about them. Some people might take this for coldness, and indeed his unemotional way of seeing things and people can sometimes be provocative. But precisely this coolness, this lack of involvement, this inner distance from the object and event (which should not be mistaken for indifference) are what make Lebeck's works so forceful." — Heinrich Jaenecke ✍

Annie Leibovitz

Annie Leibovitz: **Photographs.**
New York (Pantheon Books/Rolling
Stone Press) 1983

2.10.1949 Waterbury (Connecticut, USA) — Lives in New York (USA)
Staged portraits of American celebrities from the worlds of (pop) culture, politics, and high society. Star photographer of the 1980s and 90s. Studies painting and photography at San Francisco Art Institute. 1970 takes first photographs for *Rolling Stone* magazine. 1971 Bachelor of Fine Arts. 1973–1981 chief photographer with *Rolling Stone*. 1975 photographic documentation of The Rolling Stones' concert tour. 1981 collaborates on the pilot issue of *Vanity Fair*. Its chief photographer since 1983. Along with staged portraits (including Whoopi Goldberg, Lauren Hutton, John Lennon and Yoko Ono, Bette Midler, Tom Wolfe) her work also includes reports and advertising. Her campaigns for American Express (1987) and the Gap fashion company (1988) are much acclaimed. Numerous awards and prizes, including Photographer of the Year of the American Society of Magazine Photographers (1984), and the Applied Photography Annual Infinity Award of the ICP. Designs the Pirelli Calendar 2000. Friend of Susan Sontag until her death in 2004.

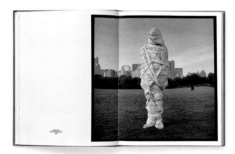

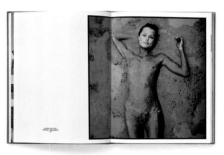

EXHIBITIONS (Selected) — **1983** New York (Sidney Janis Gallery – 1986) SE // **1986** Arles (Rencontres internationales de la photographie) SE // **1991** New York (International Center of Photography) SE // **1992** Paris (Palais de Tokyo) SE // **1994** Rochester (New York) (George Eastman House) SE // **1999** Washington, DC (National Portrait Gallery) SE // **2001** Paris (Galerie Kamel Mennour) SE // **2005** Amsterdam (Fotografiemuseum Amsterdam) SE // **2006** Berlin (C/O Berlin – 2009) SE // Detroit (Michigan) (Detroit Institute of Arts) SE // Brooklyn (New York) (Brooklyn Museum of Art) SE // **2007** San Diego (San Diego Museum of Art) SE // Washington, DC (Corcoran Gallery of Art) SE // **2008** Paris (Maison européenne de la photographie) SE // London (National Portrait Gallery) // **2009** Berlin (C/O Berlin) SE

BIBLIOGRAPHY (Selected) — **A.L.: Photographs.** New York 1983 // **Rolling Stone. Die Photographien aus dem legendären Magazin.** Munich 1989 // **Photographs 1970–1990.** New York 1991 ✏ // **Our Mothers.** New York 1996 // **Olympic Portraits.** Boston 1996 // **Women.** New York 1999 // **Nudes.** Paris 2001 (cat. Galerie Kamel Mennour) // **American Music.** New York 2003 // **A Photographer's Life 1990–2005.** New York 2006 // **At Work.** New York 2008 // **A.L.** Cologne 2014

"Leibovitz has been pursuing her vocation as a photographer for more than twenty years now, and her works have been published for just as long. Her career is not that of someone who has had to fight for recognition of her work, and does not exactly reflect a lack of familiarity with the realm of business. Her aim has always been to create expressive, honest photos to specifications for assignments that needed to be completed by 'the day before yesterday'. Editors, art directors and the public got to see the results, still damp as it were, practically without delay. This is typically American, as typically American as she is. Her pictures are somehow in harmony with the people who look at them, as well as the people pictured in them. Her closeness to popular American culture, which distinguishes so many of her works, arises quite naturally from Annie Leibovitz's personality. She is the right medium for her medium." — Ingrid Sischi ✍

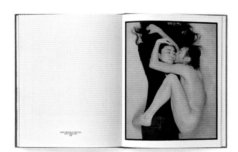

Neil Leifer

Neil Leifer: **Muhammad Ali —
Memories.** New York (Rizzoli)
1992

28.12.1942 New York (USA) — Lives in New York Photographer and filmmaker. As a sports photographer, one of the best known in his field. Worked mainly for *Sports Illustrated*, but also shot for *Life*, *Time*, *Look*, *The Saturday Evening Post* and *Newsweek*. Grew up in New York City on the Lower East Side. First became interested in photography as a teenager. Started taking pictures in 1955 and shot first sports photos as staff photographer for his high school newspaper. On his sixteenth birthday (December 28, 1958), photographs the Championship Game between the Giants and the Baltimore Colts. By 1960, is already contributing his pictures to *Sports Illustrated*. There, as a "boy wonder", his first cover photo appears in 1961. Still a teenager, he had quickly become an established professional sports photographer. After years of freelance assignments, becomes a staff photographer at *Sports Illustrated* in 1972, at *Time* in 1978, and at *Life* in 1988. By 1990, when he leaves Time Inc., 170 of his photos have been published on the cover of *Sports Illustrated* and 40 more have graced the cover of *Time*. Among his covers for *Time* were pictures of Presidents Ronald Reagan, George H. W. Bush, and Jimmy Carter; actors Clint Eastwood, Paul Newman, and Burt Reynolds; and many athletes including Mike Tyson, Carl Lewis, and Eric Heiden, among others. He has had 16 books published to date, including *Sports* (1979), seen by some as perhaps "the best of its kind ever". He has covered 15 Olympic Games (eight summer and seven winter games), four football/soccer World Cups, 15 Kentucky Derbies, 10 Superbowls, as well as almost every heavyweight title fight since the 1960 bout between Floyd Patterson and Ingemar Johansson. He has covered his favorite subject, Muhammad Ali, over 70 times, in thirty-five of Ali's fights and another thirty-five photo sessions away from the ring. He now devotes his time to filmmaking, mainly documentaries. His two most recent efforts were two short documentaries. *Portraits of a Lady* (2007) and *Dark Light* (2009) were both made for HBO. In 2006, he is honoured with the prestigious Lucie Award for achievement in sports photography and opens the Neil Leifer Gallery at Caesars Palace in Las Vegas.

EXHIBITIONS (Selected) — **1978** New York (Nikon House Gallery — 1984) SE // **1996** New York (LIFE Gallery) SE // Washington, DC (Govinda Gallery – 2001, 2004) SE // **1997** Perpignan (Visa Pour l'Image) SE // **1999** New York (Pop Int'l Gallery – 2000, 2001, 2002, 2003, 2004) SE // **2001** New York (International Center of Photography) SE // Los Angeles (Peter Fetterman Photographic Works) SE // **2003** Dallas (Photographs Do Not Bend Gallery) SE // **2003** Santa Fe (Monroe Gallery of Photography – 2006) SE // **2004** Los Angeles (Apex Fine Art) SE // **2005** Louisville (Paul Paletti Gallery) SE // **2006** Austin (University of Texas) SE // **2007** Auckland (Sky Tower) SE // **2009** Century City (Annenberg Space for Photography) SE

BIBLIOGRAPHY (Selected) — **Sports.** New York 1978 // **N.L.'s Sports Stars.** New York 1985 // **Muhammad Ali: Memories. Photographs by N.L.** New York 1992 // **Safari.** New York 1992 // **Sports.** New York 1992 // **The Best of L.** New York 2001 // **Portraits.** Los Angeles 2003 // **G.O.A.T.** Cologne 2004 // **A Year in Sports.** New York 2006 // **Ballet in the Dirt: The Golden Age of Baseball.** Cologne 2007 // **Guts and Glory: The Golden Age of American Football, 1958–1979.** Cologne 2008

> "If you are a sports fan, you have to be a Neil Leifer admirer, for you have been seeing his pictures and they have been shaping your impressions and memories for five decades."
> — Bob Costas

Norton Triumphs;
Breaks Ali's Jaw

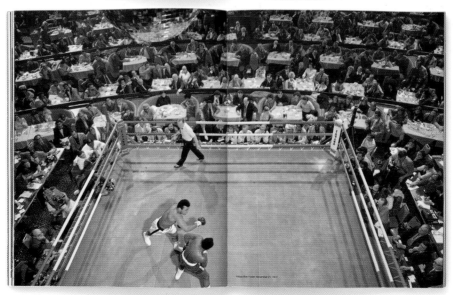

Saul Leiter

3.12.1923 Pittsburgh (Pennsylvania, USA) — 26.11.2013 New York (USA) Pioneer of a new fashion photography, sometimes described as "lyrical", that makes use of the Leica and color. Also (free) street photography. In formally aesthetic terms, one of the most innovative camera artists, who achieved acclaim only late in life. Grows up in Pittsburgh and Cleveland (Ohio), son of an Orthodox Talmud scholar. In keeping with his parents' wishes, he starts to study theology in Cleveland. Leaves theology school in 1946 and moves to New York to become a painter. Becomes acquainted with Richard Pousette-Dart, who awakens his interest in photography. At the end of the 1940s frequent visits to photo exhibitions, especially the big > Cartier-Bresson retrospective at MoMA in New York (1946). Association with > Smith. From Smith he receives several photographs from the *Spanish Village* cycle (which he sells to purchase his first professional camera, a Leica I(C)) and a copy of > Brodovitch's *Ballet* photobook, which probably has a lasting influence on him. Street photography (in New York) and portraits (both in b/w) at the beginning of his career as a photographer. First presented to a larger public as part of the exhibition *Always the Young Stranger* (1953), conceived for MoMA by > Steichen. Opens a studio for portrait, fashion, and advertising in Bleecker Street (from 1963 on Lower Fifth Avenue, which he gives up in 1981). Contact with Henry Wolf, who first publishes S.L. in *Esquire*; and from 1958 in *Harper's Bazaar*. Until well into the 1970s, he works mainly as a fashion photographer, but, in contrast to the clear pictorial language of > Avedon, S.L. pursues a rather more painterly style (supported by soft-focus effects, reflections, etc.). Also portraits and street scenes (Venice, Rome, Paris), reminiscent of > Klein. Also photo essays for *Elle* and *Show*, fashion for British *Vogue*, for *Queen*, and *Nova*. Also makes a name for himself as a painter and graphic artist. Along with > Levitt he counts among those few photographers whose work in color is on a par with his b/w work. Since the retrospective at the Fondation Henri Cartier-Bresson (2008), he has been the subject of international discussion.

> **"Saul Leiter's vision is founded on a rapid eye for absorbing spontaneous events. Confronted by a dense web of data, fleeting moments in space and time, he employs an array of strategies — oblique framings, complex intersecting planes and ambiguous reflections — to distil an urban visual poetry that is by turns deeply affectionate, edgy and breathtakingly poignant. He takes risks — flouting conventions of camera technique and apparently indifferent to the limits of the light-gathering capacity of emulsions."** — Martin Harrison ✎

EXHIBITIONS (Selected) — **1953** New York (Museum of Modern Art) GE // **1991** London (Victoria and Albert Museum) GE // **1993** New York (Howard Greenberg Gallery – 1997, 2002, 2005, 2008, 2009) SE // **2002** New York (Howard Greenberg Gallery) GE // **2008** Paris (Fondation Henri Cartier-Bresson) SE // Paris (Galerie Camera Obscura) SE // **2009** Munich (f5,6 Gallery) SE // Atlanta (Georgia) (Jackson Fine Art) GE // **2012** Hamburg (Haus der Photographie/Deichtorhallen) SE

BIBLIOGRAPHY (Selected) — Martin Harrison: **Appearances: Fashion Photography Since 1945**. London, 1991 // Jane Livingston: **The New York School.** New York, 1992 // **S.L.: Early Color.** Göttingen 2006 ✎ // **S.L.** Arles 2007 (= Photo Poche no. 113) // **S.L.** Göttingen 2008 (cat. Fondation Henri Cartier-Bresson) // **S.L.** Heidelberg 2012 (cat. Haus der Photographie/Deichtorhallen, Hamburg)

Saul Leiter: **Saul Leiter's Dream World,**
from: **Color Photography Annual.** New York
(Ziff-Davis Publishing Company) 1960

Helmar Lerski *(Israel Schmuklerski)*

Helmar Lerski: **Der Mensch mein Bruder**. Dresden (Verlag der Kunst) 1958

18.2.1871 Straßburg (France) — 29.11.1956 Zurich (Switzerland) A lone wolf among the avant-garde around 1930. His experimental portraits are central to a comparatively small oeuvre schooled in Expressionist cinema. Son of Polish immigrants. The family move to Switzerland in 1876. Traineeship at a private banking house in Zurich. 1893 he moves to the USA. Casual jobs, drama classes. Works for the German theater in Chicago. 1896 changes his name to Helmar Lerski. Develops an interest in photography. 1911 first documented publication of a picture; first exhibitions from 1912. 1915 returns to Europe. Takes up residence in Berlin. 1916–1927 lighting specialist and cameraman for the film business. From 1928 mainly portrait photography. 1931 *Köpfe des Alltags* (Everyday Faces), his most important publication. 1931 travels for the first time to Palestine for a book he is planning entitled *Jüdische Köpfe* (Jewish Faces). 1932–1948 second stay in Palestine (interrupted 1937–1939). 1936 photo project *Verwandlungen durch Licht* (Metamorphosis through Light) (137 documented photographs of a person's face with light projected onto it from different angles). 1945–1947 film and photo work with puppeteer Paul Löwy. 1948 returns to Switzerland (Zurich).

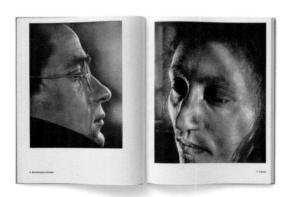

EXHIBITIONS (Selected) — **1930** Berlin (Staatliche Kunstbibliothek) SE // **1936** Jerusalem (Divan Art Gallery) SE // **1949** Jerusalem (Bezalel-Museum) SE // Zurich (Kunstgewerbemuseum) SE // **1955** Luxembourg (Musée de l'État) SE // **1958** Hamburg (Staatliche Landesbildstelle) SE // **1982** Essen (Germany) (Museum Folkwang – 2002) SE // **1995** Paris (Hôtel de Sully) SE // **1996** New York (Howard Greenberg Gallery – 2004) SE // **2000** Ontario (Art Gallery of Ontario) SE // **2005** Berlin (Kunstbibliothek) GE // **2006** Dresden (Kupferstich-Kabinett/**Mensch!**) GE // **2009** Berlin (Berinson Gallery) SE

BIBLIOGRAPHY (Selected) — **Köpfe des Alltags.** Berlin 1931 // Anneliese Lerski (ed.): **Der Mensch – mein Bruder.** Dresden 1958 // **H.L.: Verwandlungen durch Licht.** Freren 1982 (cat. Museum Folkwang) ⌁ // **H.L.: Metamorphosen des Gesichts.** Göttingen 2002 (cat. Museum Folkwang, Essen) // Christine Kühn: **Neues Sehen in Berlin. Fotografie der Zwanziger Jahre.** Berlin 2005 (cat. Kunstbibliothek) // Wolfgang Hesse and Katja Schumann (eds): **Mensch! Photographien aus Dresdner Sammlungen.** Marburg 2006 (cat. Kupferstich-Kabinett, Dresden)

"The aim of his pictures was not to illustrate the way someone looks, or is, but how Helmar Lerski wanted to show him, how he was able to use his working materials – light, shooting angle, and perspective – to shape his subject and thus achieve a result that was quite different from reality. Superficially speaking, one might call Lerski an Expressionist, whose pictures reveal and conjure up emotions that exist only on the focusing screen of the camera and in the imagination of the man behind it." — Andor Kraszna-Krausz ✎

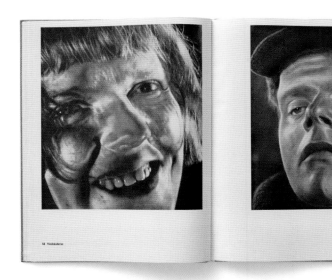

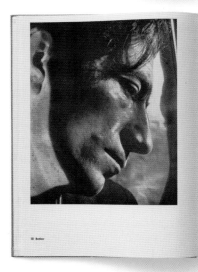

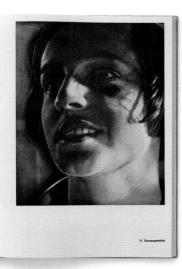

Helen Levitt

Helen Levitt: **A Way of Seeing**. New York (Horizon Press) 1981

31.8.1913 Brooklyn (New York, USA) — 29.3.2009 New York (USA)
Street photography in b/w and color. Children playing, everyday people. Influence of Henri Cartier-Bresson is clear. Also extensive documentation of naive (children's) street painting. Main work around 1940. Leaves high school 1930. Works for a portrait photographer in the Bronx. Attends the Photo League. Makes contact with Ben Maddow, Willard van Dyke, and (in 1935) > Cartier-Bresson. 1936 first Leica. Street photography for a start. 1938 assists > Evans in the preparation of *American Photographs* (MoMA, New York). 1941 assistant editor for Luis Buñuel. 1944–1945 assistant editor in the film department of the Office of War Information. 1946–1947 film documentary *The Quiet One* (about the problems of a black child) with James Agee and Janice Loeb. 1959 takes up photography again, firstly in color, and since 1980 mainly in b/w again. Guggenheim grant in 1959 and 1960. 1991–1992 big retrospective in San Francisco (Museum of Modern Art), with further stopovers in New York (Metropolitan Museum) and Washington, DC (National Museum of American Art). 2008 International Prize for Photography from the Foundation of Lower Saxony.

"It was neither the sensational nor the stereotype that aroused Levitt's interest; what she was aiming at was the fortuitous and the idiosyncratic, all those interactions to which nobody pays much attention, apart from those directly involved, a neighborly chat, for example, or children playing. [...] Over several decades she repeatedly renewed her way of seeing things through her work with color photographs long before this became common among street photographers, whereas more recently she has used both varieties — continuing her quest for the transcendental in everyday life." — A.D. Coleman ✍

EXHIBITIONS (Selected) — **1943** New York (Museum of Modern Art – 1949, 1955, 1963, 1974, 1978) SE/GE // **1952** Chicago (Institute of Design) SE // **1975** New York (Pratt Institute) SE // **1982** San Francisco (Fraenkel Gallery – 1986, 1994, 1996) SE // **1985** Stockholm (Fotografiska Museet – 1989) SE/GE // **1987** New York (Laurence Miller Gallery – 1989, 1990, 1991, 1992, 1996, 1997, 2000, 2004, 2005) SE // **1988** London (The Photographers' Gallery) SE // **1991** San Francisco (Museum of Modern Art) SE // **1997** Kassel (Germany) (documenta 10) GE // **1998** Frankfurt am Main (Kunstverein) SE // **2001** Paris (Centre national de la photographie) SE // **2006** Munich (f5,6 Gallery) SE // **2007** Paris (Fondation Henri Cartier-Bresson) SE // **2008** Hannover (Sprengel Museum) SE // Amsterdam (Fotografiemuseum Amsterdam) SE // **2010** Cincinnati (Ohio) (Cincinnati Art Museum) GE // **2010** Madrid (Museo Colecciones ICO) SE

BIBLIOGRAPHY (Selected) — **A Way of Seeing**. New York 1965 // Jane Livingston: **H.L.** Washington, DC, 1980 // **In the Street: Chalk Drawings and Messages 1938–1948**. Durham 1987 // Jane Livingston: **The New York School: Photographs 1936–1963**. New York 1992 // Sandra Philips and Maria Morris Hambourg: **H.L.** San Francisco 1992 // Colin Westerbeck and Joel Meyerowitz: **Bystander**. Boston 1994 // **Das Versprechen der Fotografie. Die Sammlung der DG Bank**. Munich 1998 ✍ // Peter Weiermair (ed.): **H.L.** Munich 1998 (cat. Frankfurter Kunstverein) // **Here and There**. New York 2003 // **Slide Show**. New York 2008 // **H.L.: Fotografien 1937–1991**. Ostfildern 2008 (cat. Sprengel Museum Hannover) // Kevin Moore: **Starbust. Color Photography in America 1970–1980**. Ostfildern 2010 (cat. Cincinnati Art Museum)

Alexander Liberman

(Alexander Simeonovitch Liberman)

Alexander Liberman: **The Artist In His Studio**. New York (The Viking Press) 1960

4.9.1912 Kiev (Ukraine) — 19.11.1999 Warren (Connecticut, USA) As art director of American *Vogue* he was the great antipode to Brodovitch. Also abstract painting, sculpting, and portrait photography throughout his lifetime. Childhood in St Petersburg and Moscow. 1921 escapes from Russia via Berlin to London. Moves to Paris in 1925, where he attends school and takes the baccalaureate. 1929 trains briefly in André Lhote's atelier. Changes to architect Auguste Perret. Along with that, works in the studio of poster designer Cassandre. 1932 assistant art director of the illustrated magazine *VU* published by > Vogel. In 1936 the magazine is sold to the conservative publisher Piere Laval and he stops working for *VU*. 1941 arrives in New York where he starts out as a freelance artist. From spring onwards he works in *Vogue*'s art department. Succeeds Mehemed Fehmy Agha as art director of the American *Vogue* from March 1943. 1951 edition of the much acclaimed anthology *The Art and Technique of Color Photography*. 1959 exhibition of his photo cycle *The Artist in His Studio* at the MoMA, New York. 1960 first exhibition of his sculptures and panel paintings at the Betty Parsons Gallery, New York. 1962 appointed editorial director of all Condé Nast publications (until 1995). His own artists' portraits also appear regularly in *Vogue*. He also discovers and encourages > Penn.

EXHIBITIONS (Selected) — **1959** New York (Museum of Modern Art) SE // **1977** Mountainville (New York) (Storm King Art Center) SE // **1985** Fort Worth (Texas) (Fort Worth Art Museum) SE // **1986** Cologne (photokina/**50 Years Modern Color Photography**) GE // **2006** Paris (Maison européenne de la photographie/**Regarder** VU) GE // **2007** Chalon-sur-Saône (France) (Musée Nicéphore Niépce/**Regarder** VU) GE

BIBLIOGRAPHY (Selected) — **The Art and Technique of Color Photography**. New York 1951 // **The Artist in His Studio**. New York 1960 // **50 Jahre moderne Farbfotografie/50 Years Modern Color Photography 1936–1986**. Cologne 1986 (cat. photokina) // Dodie Kazanjian and Calvin Tomkins: **Alex. The Life of A.L.** New York 1993 // **Then: Photographs 1925–1995.** New York, 1995 📖 // Hans-Michael Koetzle: "A.L." In: **Leica World**, no. 1, 1996 // Hans-Michael Koetzle: "A Magazine Like a Film." In: **Leica World**, no. 1. 2007 // Michel Frizot and Cédric de Veigy: **VU. Le magazine photographique 1928–1940**. Paris 2009

"Photographs are not art, as Alex has insisted for several decades, to the annoyance of several eminent photographers. […] Whether or not he is right about this, it is an assumption he has acted on in his own extensive use of the camera. Alex takes pictures without pretensions. He is not looking for decisive moments, or abstract patterns, or the powerful juxtaposition of forms under light; he records parties, vacations, friends, people he admires, things that interest him."
— Calvin Tomkins ✍

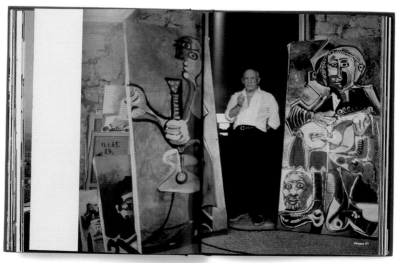

Peter Lindbergh

Peter Lindbergh: **Images of Women.** Köln (Snoeck) 2008

23.11.1944 Lissa (Poland) — Lives in Paris, Arles (France) and New York (USA) Since the 1980s one of the internationally most discussed interpreters of fashion. Prefers to take photographs in b/w, in a pictorial language schooled in early German cinema. Childhood in Duisburg (Germany). Works as a window dresser for Karstadt and Horten in Duisburg. At the age of 18 goes to Switzerland and eight months later from Lucerne to Berlin. Evening classes at the Academy of Fine Arts. Hitchhikes to Arles in search of his idol Vincent van Gogh. Some months later he moves on, spending two years in Spain and Morocco. Returns to Germany. Studies (free painting) at Krefeld Art School (Germany). While still studying, has his first exhibition at the renowned Galerie Denise René Hans Mayer in 1969. Conceptual Art his last foray into the realm of art. 1971 takes up photography. Works for two years as assistant to photographer Hans Lux in Düsseldorf. From 1973 freelance photographer in Düsseldorf. 1978 his much acclaimed fashion photographs in *Stern* magazine mark the starting point of his international career as a fashion photographer. Moves to Paris in the same year. Works first for the Italian, then for the English, French, German, and American editions of *Vogue*, later for *Marie Claire*, *The New Yorker*, *Vanity Fair*, *Allure*, and *Rolling Stone*. 1992 works for four years under contract with the American *Harper's Bazaar* in New York. At the same time campaigns for Giorgio Armani, Jil Sander, Prada, Donna Karan, Calvin Klein. Portraits of Catherine Deneuve, Mick Jagger, Nastassja Kinski, Madonna, John Malkovich, Charlotte Rampling, Sharon Stone, John Travolta, Tina Turner, and many more. 1992 first documentary film (60 min): *Models — the Film*, with Naomi Campbell, Cindy Crawford, Linda Evangelista, Tatjana Patitz, and Stephanie Seymour. His second documentary film (*Inner Voices*, 1999) was about Lee Strasberg and his Actors' Studio. 1996 *Missing You* music video for Tina Turner in Los Angeles. 1988 Highest Achievement Award for Fashion

EXHIBITIONS (Selected) — **1985** London (Victoria and Albert Museum — 1991) GE // **1986** Paris (Centre Pompidou) SE // **1987** London (National Centre of Photography) GE // **1989** New York (Holly Solomon Gallery) GE // London (National Museum of Photography) GE // **1991** Barcelona (Mercat del Born) SE // London (Royal College of Art) GE // Düsseldorf (Hans Mayer Gallery) SE // **1992** Marseilles (Musée de la vieille Charité) SE // **1993** Paris (Centre national de la photographie) GE // **1994** London (Saatchi Gallery) GE // **1995** Berlin (Kunstbibliothek) GE // Nagoya (Japan) (Nagoya Art Museum) GE // **1996** Frankfurt am Main (Kunsthalle Schirn) SE // Los Angeles (Fahey Klein Gallery) SE // Tokyo (Bunkamura Museum of Art) SE // **1997** Osaka, Japan (Daimura Museum) SE // New York (James Danziger Gallery — 1993) SE/GE // London (Hamiltons Gallery) SE // Berlin (Camera Work Gallery) SE // Berlin (Museum Hamburger Bahnhof) SE // **1998** Hamburg (Museum für Kunst und Gewerbe) SE // Milan (Palazzo del Arte) SE // Rome (Palazzo delle Esposizioni) SE // Vienna (KunstHaus) SE // **2002** Düsseldorf (Hans Mayer Gallery) SE // **2003** Oberhausen (Germany) (Ludwig Gallery Schloss Oberhausen) SE // **2006** Milan (FORMA) SE // **2007** Berlin (Camera Work) SE // **2010** Berlin (C/O Berlin) SE

BIBLIOGRAPHY (Selected) — Ingried Brugger: **Modefotografie von 1900 bis heute.** Vienna 1990 (cat. Kunstforum Länderbank) // Martin Harrison: **Appearances: Fashion Photography Since 1945.** London 1991 (cat. Victoria and Albert Museum) ✐ // **Bildermode — Modebilder. Deutsche Modephotographien 1945–1995.** Stuttgart 1995 (cat. Institut für Auslandsbeziehungen) // **Ten Women.** Munich 1996 // **Images of Women.** Munich 1997 // **P.L.: Portfolio.** Paris 1998 // **P.L.: Invasion.** Hamburg 2002 (= **Stern** Portfolio no. 29) // **P.L.: Untitled 116.** Munich 2006 // **Images of Women.** Cologne 2008 // **On Street.** Munich 2010 (cat. C/O Berlin) // **P.L.: A Different Vision on Fashion Photography.** Cologne 2016 // **P.L.: Shadows on the Wall.** Cologne 2017

Photography in New York. 1990 and 1991 Grand Prix and Gold Medal at the international Festival for Fashion Photography in Budapest and Barcelona. 1995 and 1997 received accolade of Best International Fashion Photographer/The Fashion Awards, Paris (selected by a jury of 400 from the international world of fashion photography). 1996 honorary member of the ADC Germany. Also in 1996 the Raymond Loewy Design Award (Europe's best endowed prize for design). 1996 design of the highly acclaimed Pirelli Calendar. Numerous television portraits of Lindbergh, including *Poet des Glamours* (Poet of Glamour) (60 min, ZDF television); *P.L. Profile* (45 min, V.H.–1); *P.L. A Portrait* (60 min, Paris Première and Centre National de la Cinématographie).

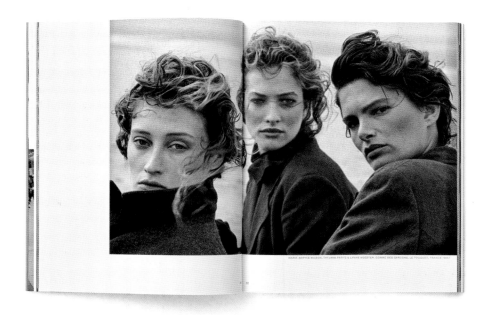

MARIE-SOPHIE WILSON, TATJANA PATITZ & LYNNE KOESTER, COMME DES GARÇONS, LE TOUQUET, FRANCE 1987

"Peter Lindbergh started in Paris around the same time as Paolo Roversi, and worked for many of the same magazines. But his approach developed along very different lines, his strong, high-contrast black and white photography reflecting what he calls 'my heavy German expressionist side'. His dramatic serial style results from his interest in the cinema: his work has integrated references from directors ranging from Fritz Lang to Jim Jarmusch, as it has similarly paid homage to photographers as far apart as Lartigue and Blumenfeld." — Martin Harrison

O. (Ogle) Winston Link

O. Winston Link: **Steam, Steel & Stars**. New York (Abrams) 1987

16.12.1914 Brooklyn (New York, USA) — 30.1.2001 South Salem (New York, USA) Successful as industry and advertising photographer. At the end of the 1950s takes up the world of trains. The last steam locomotives impressively staged as dinosaurs of the end of an industrial age. Second of three children. Father a teacher, who introduces him to photography. After graduating from the Manual Arts High School in Brooklyn, studies at the local Polytechnic Institute. There 1937 B.A. in civil engineering. 1937–1942 photographer for the PR firm Carl Byoir Associates. 1942 moves to the Columbia Institute Laboratory in Mineola, Long Island. There secret reconnaissance work for the US government. At this time first photos of the nearby Long Island Railroad.
After the war works as independent advertising and industry photography. 1955 in West Virginia for a contract, discovers the world of the Norfolk & Western Railroad, the last railway company to use only steam engines: "The finest steam engines ever built." Subsequently takes up a theme that would become central to his independent work. Generally night shots with a sophisticated lighting presenting the trains majestically. Between commercial contracts regular trips to Virginia, West Virginia, Maryland, and North Carolina (the region covered by the Norfolk & Western Railroad). Also photos of train stations and technical personnel, cleaners, guards, station masters, and those areas marked by the railway. To 1960 altogether 20 photo shoots along the Norfolk & Western lines, producing around 2,400 photos (most made with sophisticated flash) extensively documenting the waning of the age of steam in the USA and of a culture which marked rural America. After being ignored for decades, from 1983 growing interest in his work. In the same year he closes his New York studio and moves to South Salem (New York). *Steam, Steel & Stars* his first independent book establishing his reputation as railway photographer, followed by *The Last Steam Railroad in America* (1995), confirming his status as chronicler of a technology. 2000 first plans for his own museum in the historic Norfolk & Western Passenger Station in Roanoke (Virginia). The museum, designed by Raymond Loewy, opens in 2004. *www.linkmuseum.org*

EXHIBITIONS (Selected) — **1983** London (National Railway Museum) SE // Norfolk (Virginia) (Chrysler Museum – 2005) SE // **2003** Katonah (New York) (Candace Perich Gallery – 2005) SE/GE // **2004** New York (Robert Burge 20th Century Photographs, Ltd) SE // Sydney (Australian Centre for Photography/ **Night Vision**) GE // **2005** Amsterdam (Foam/Fotografiemuseum Amsterdam) SE // **2006** Tokyo (Photo Gallery International) GE // **2007** New York (Danziger Projects) SE // **2008** Hamburg (Museum der Arbeit) SE //Rochester (New York) (George Eastman House) // **2010** Fürth (Germany) (Kunst Galerie Fürth) SE

BIBLIOGRAPHY (Selected) — **Night Trick on the Norfolk and Western Railway, 1955–60**. London 1983 (cat. National Railway Museum) // **Ghost Trains: Railroad Photographs of the 1950s**. Norfolk (Virginia) 1983 (cat. Chrysler Museum) // **Steam, Steel & Stars**. New York 1987 // **Steam, Steel and Stars. Amerikas letzte Dampfzüge**. Nuremberg 1989 ✍ // **The Last Steam Railroad in America**. New York 1995 // **The Last Steam Railroad in America**. New York 2000 // Thomas H. Garver: **The Last Steam Railroad in America**. New York 2003 // Thomas H. Garver: **O.W.L. – The Man and the Museum**. Roanoke (Virginia) 2004

"It took thirty years for the full significance of Winston Link's work to be recognized. The only aim of the project, or so I thought, was a romantic documentation of fading age of steam engines. In the meantime we can see that his work has a much greater significance. What Winston preserved for us today appears as a wonderful and multifaceted character sketch of individual life in small town America — a life that has almost disappeared today." — Thomas H. Garver ✍🏼

El Lissitzky (Lasar [Jelieser] Markovich Lissitzki)

23.11.1890 Potshinok (Russia) — 30.12.1941 Moscow (Soviet Union) Painting, architecture, typography, photography in the service of advertising and political propaganda. Central personality in Constructivist Art around 1930. Childhood in Vitebsk, White Russia, and Smolensk. 1909 Turned down by St Petersburg Art Academy. Moves to Germany. Studies architecture at Darmstadt Polytechnic. Graduates in 1914 and returns to Russia. 1914 head of the graphics workshop at the Artistic Technical Institute in Vitebsk founded by Marc Chagall. First "Suprematist" works under the term "Proun" [acronym of Pro + Unovis = Project for the Affirmation of the New]. 1921 moves to Moscow, where he teaches at Vkhutemas [state art and technical school]. 1922 in Berlin, preparation of the First Exhibition of Russian Art at the Berlin Van Diemen gallery. Gets to know > Höch, > Hausmann, > Moholy-Nagy, and Kurt Schwitters. 1923 first solo exhibition at the Kestnergesellschaft, Hannover. 1924–1925 stays at a health resort in Switzerland. Advertisements for Pelikan using the latest artistic techniques [photomontage, photogram, multiple exposure]. 1925 returns to Moscow. 1927 marries Sophie Küppers. 1928 design of the much acclaimed Soviet Pavilion at the Cologne Pressa. 1929 *Film und Foto* exhibition, design of the Soviet Section. Designs exhibitions in Dresden and Leipzig (1930), Paris (1934, 1936), and New York (1939). From 1932 responsible for the design of the propaganda magazine *USSR in Construction*. His design for the Soviet Pavilion at the International Exhibition in Belgrade not realized.

"The variety of Proun art was the order of the day. Lissitzky proclaimed the so-called 'Proun designer', who was supposed to concentrate all elements of modern knowledge and all systems and methods in his work and, with their help, to form plastic elements that 'corrode everything they touch'. He was probably a prime example of this type of artist. Not only his works from all walks of artistic creativity underscore this view, but also the transformations his art has undergone." — Kai-Uwe Hemken ✍

EXHIBITIONS [Selected] — **1923** Hannover [Kestnergesellschaft] SE // **1925** Dresden [Kühl und Kühn Gallery] SE // **1929** Stuttgart [Film und Foto] GE // **1976** Cologne [Gmurzynska Gallery] SE // **1977** Oxford [Museum of Modern Art] SE // **1982** Halle [Germany] [Staatliche Galerie Moritzburg] SE // **1988** Hannover [Sprengel Museum – 1999] SE // **1990** New York [Houk Friedman Gallery] SE // Eindhoven [Netherlands] [Municipal Van Abbemuseum] SE // **2005** Berlin [Kunstbibliothek] GE

BIBLIOGRAPHY [Selected] — Sophie Lissitzky-Küppers [ed.]: **E.L.: Erinnerungen, Briefe, Schriften.** Dresden 1967 // **E.L.** Cologne 1976 [cat. Gmurzynska Gallery] // **E.L. 1890–1941.** Oxford 1977 [cat. Museum of Modern Art] // **E.L.: Maler, Archi-** tekt, Typograf, Fotograf. Halle 1982 [cat. Staatliche Galerie Moritzburg] // **E.L. 1890–1941.** Hannover 1988 [cat. Sprengel Museum] // **E.L.: Experiments in Photography.** New York 1990 [cat. Houk Friedman Gallery] // **E.L. 1890–1941: Architect, Painter, Photographer, Typographer.** Eindhoven 1990 [cat. Municipal Van Abbemuseum] // **Kai-Uwe Hemken: E.L.: Revolution und Avantgarde.** Cologne 1990 ✍ // **E.L.: Jenseits der Abstraktion.** Munich 1999 [cat. Sprengel Museum Hannover] // Martin Parr and Gerry Badger: **The Photobook: A History Volume I.** London 2004 // Christine Kühn: **Neues Sehen in Berlin. Fotografie der Zwanziger Jahre.** Berlin 2005 [cat. Kunstbibliothek] // Steven Heller: **Iron Fists: Branding the 20th-Century Totalitarian State.** London 2008

El Lissitzky (photography and layout): **Den vier Siegen gewidmet,** from: **USSR in Construction**, no. 2, February 1934

Herbert List

Herbert List: **Licht über Hellas.**
Munich (Callwey Verlag) 1953

7.10.1903 Hamburg (Germany) — 4.4.1975 Munich (Germany) As a camera artist, the representative of a "fotografia metafisica" schooled in Surrealism. Son of a coffee importer. Attends grammar school (Gymnasium) in Hamburg. 1921–1923 practical experience at the Landfried coffee company in Heidelberg. At the same time he studies literature and art history. 1924 enters his father's company. From 1926 travels extensively through the coffee-growing countries of Latin America (Brazil, Guatemala, El Salvador, Costa Rica). Spends some time in San Francisco. 1929 returns to Hamburg. Takes over the List & Heineken company. Becomes involved with photography under the guidance of > Feininger. First camera pictures around 1930, in particular still-life pictures influenced by > Man Ray and Giorgio De Chirico. 1935 emigrates first to Paris, and then to London. Works as freelance photographer. First publications in *Vogue*, *Life*, *Harper's Bazaar*, as well in the photo yearbooks put out by *Arts et Métiers Graphiques* magazine. 1937 (under the pseudonym "Gil") first solo exhibition at the Galerie Chasseur d'images in Paris. Travels to Italy and Greece. 1941 (after the invasion by German troops) returns to Germany. Works as photographer, for example for *die neue linie* and *Die Dame*. In the last year of the war he serves in the Wehrmacht (Norway). From 1945 he is back in Munich. Along with free cycles (*Memento 1945* – Munich war ruins) photo essays for *Look*, *Epoca*, *Picture Post*, and *Du*. Art editor for *Heute* magazine. Trips to Greece, Italy, Spain, and France. From the early 1960s his interest in photography wanes. Builds up a collection of freehand drawings by Old Masters. Günter Metken considers him to be "the most prominent German photographer in the first 15 years after the War". Since 1975 his estate has been looked after by Max Scheler and his heirs.

EXHIBITIONS (Selected) — **1937** Paris (Galerie Chasseur d'images) SE // **1951** Saarbrücken (Germany) (Staatliche Schule für Kunst und Handwerk – 1954) GE // **1976** Munich (Die Neue Sammlung) SE // **1981** New York (International Center of Photography) SE // **1988** Frankfurt am Main (Fotografie Forum) SE // **1993** Munich (Glyptothek) SE // **1995** Munich (Stadtmuseum – 2000) SE // **2003** Würzburg (Museum im Kulturspeicher) SE // Sankt Ingbert (Museum Sankt Ingbert) SE // **2004** Chicago (Stephen Daiter Gallery) SE // **2008** Milan (Metropol Dolce & Gabbana) SE // **2010** Vienna (WestLicht) SE

BIBLIOGRAPHY (Selected) — **Licht über Hellas.** Munich 1953 // **Caribia.** Hamburg 1958 // "Der Photograph H.L." **Du**, no. 382, July 1973 // **Photographien 1930–1970.** Munich 1976 // **Fotografia Metafisica.** Munich 1980 ✎ // **Hellas.** Munich 1993 // **Italy.** Munich 1995 // **H.L.: Memento 1945. Münchner Ruinen.** Munich 1995 (cat. Stadtmuseum) // **H.L.: Die Monographie.** Munich 1999 (cat. Stadtmuseum) // Matthias Harder: **Walter Hege und H.L. Griechische Tempelarchitektur in photographischer Inszenierung.** Berlin 2003

"Delayed by the War and the Third Reich, List's photos caught the eye of the German public fifteen years too late. It was a delay not only in terms of time, but also in terms of the spirit. […] Even before he left Germany, List had planned the publication of 'Zeitlupe Null', which was meant to contain his early 'metaphysical' still lifes; the book never materialized. And when the photobook *Licht über Hellas* […] was finally published by Callwey in 1953, the photos, taken in 1937/38, were felt to be a re-birth of the Western tradition, a return to the healing springs. This misinterpretation turned List into something like the documentarist of a false cultural renaissance and weakened his appeal when the restoration was laid bare by critical theory." — Günter Metken ✎

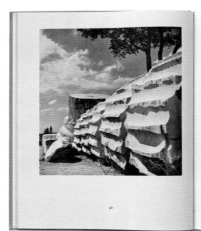

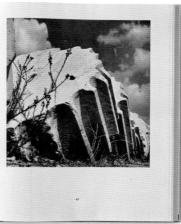

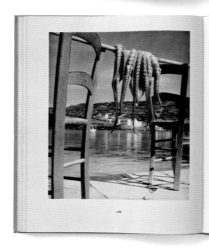

George Platt Lynes

George Platt Lynes: **Photographs
1931–1955**. Los Angeles
(Twelvetrees Press) 1981

15.4.1907 East Orange (New Jersey, USA) — 6.12.1955 New York (USA)
Ballet, fashion, and portrait photography using a pictorial language
that adheres strictly to form, very much in vogue around 1940. Espe-
cially well known today for his male-nude studies that sprang from
his homoerotic interests. Has serious plans for a literary career from
the start. Spends one semester at Yale University. Afterwards,
courses in book-dealing at Columbia University. From 1924, corre-
sponds intensively with Gertrude Stein. 1925 first trip to France. 1927
acquaintance and then close friendship with art-book publisher Monroe
Wheeler and his friend Glenway Wescott. Bookshop in New Jersey.
First photos at the end of the 1920s, especially portraits (Jean Coc-
teau, René Crevel, Gertrude Stein). Becomes acquainted with the gal-
lerist Julien Levy. First exhibition at his legendary gallery. Death of
father. Turns to fashion and advertising. In 1933 opens a studio in
New York. *Ménage à trois* with Wescott and Wheeler. 1935 photo-
graphs of the American Ballet founded by George Balanchine. 1936 present at the Museum of Modern
Art exhibition *Fantastic Art, Dada and Surrealism* with *The Sleepwalker*. Successful in advertising and
fashion photography. Numerous publications in *Vogue*, *Town & Country*, *Harper's Bazaar*. From 1939
increasingly occupied with the male nude. 1947–1948 chief photographer for the Los Angeles *Vogue*
studios. Numerous portraits of celebrities. 1948 returns to New York. Gradually loses interest in com-
mercial work. At the beginning of the 1950s publication (under a pseudonym) of his nudes in the
Swiss homoerotic magazine *Der Kreis*. Increasing debts, studio bankruptcy, failing health. After he
dies (of lung cancer) he is soon forgotten. Jack Woody's monograph (Twelvetrees Press, 1981)
marks the beginning of a new reception of his work that is sometimes classified with Surrealism.

EXHIBITIONS (Selected) — **1932** New York (Julien Levy Gallery –
1934, 1937) SE/GE // New York (Museum of Modern Art – 1936)
GE // **1941** New York (Pierre Matisse Gallery) SE // **1960** Chicago
(Art Institute) SE // **1977** Kassel (documenta 6) GE // **1980** Bos-
ton (Institute of Contemporary Art) SE // **1981** New York (Robert
Miller Gallery) SE // **2004** New York (John Stevenson Gallery) SE
// **2005** Brooklyn (New York) (Wessel + O'Connor Fine Art) SE //
New York (Howard Greenberg Gallery) SE // **2007** Hamburg
(Haus der Photographie/Deichtorhallen) GE

BIBLIOGRAPHY (Selected) — Lincoln Kirstein: **G.P.L.: Portraits
1931–1952**. Chicago 1960 (cat. Art Institute) // Stephen P.
Prokopoff: **G.P.L.: Photographic Vision**. Boston 1980 (Institute
of Contemporary Art) // Jack Woody: **G.P.L.: Photographs
1931–1955**. Pasadena 1981 // Peter Weiermair: **G.P.L.** Inns-
bruck 1982 (enlarged new edition: Berlin 1989) 🔊 // **G.P.L.:
Photographien aus der Sammlung des Kinsey Institute**.
Munich 1993 // Jack Woody: **G.P.L.: Portraits 1927–1955**.
Santa Fe 1994 // David Leddick: **G.P.L.** Cologne 2000 // **The
heartbeat of fashion. Sammlung F.C. Gundlach**. Bielefeld
2006 (cat. Haus der Photographie/Deichtorhallen Hamburg)

"Lynes is a master of studio photography and the careful use of lighting. There are no quick or spontaneous pictures. Each photograph leaves nothing to chance, following a structure whose syntax is subject to architectural rules. The gestures and poses are carefully chosen, reflecting a cleverly worked out stage plan. There is an almost dialectal relationship between the erotic, private themes and the icy, formalist manner in which they are treated. The figures are isolated in the spaces they occupy; their sophisticated twists and turns are reminiscent of pictures of the early Renaissance, of the nudes of a Luca Signorelli or Paolo Uccello. They remain, motionless, in these spaces created by light. Isolated as they are — not in an existentialist but rather a narcissistic sense — they are the object of desire." — Peter Weiermair ✍

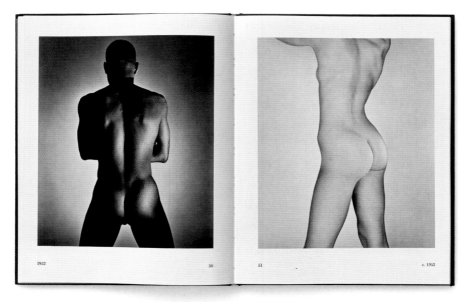

(Daniel Joseph) Danny Lyon

Danny Lyon: **Memories of Myself.**
London (Phaidon Press) 2009

16.3.1942 Brooklyn (New York, USA) — Lives in Ulster County (New York, USA) Photographer, filmmaker. Photo cycles of biker gangs, the civil rights movement in the Southern States, and the demolition of Lower Manhattan are the best-known works by this committed, self-taught photographer with an interest in social issues and an educational mission. His father, a doctor (and amateur photographer) from Sankt Ingbert (Saar), emigrated to the USA in 1935. His mother had emigrated there from Gomel (White Russia) in 1923. Together with his brother he spends the summer of 1959 in Europe: Italy, France, the Federal Republic of Germany. There he purchases his first camera (Exa). 1959–1963 studies early and medieval history (B.A.). Works for the *Phoenix* university paper. In 1961 discovers the work of > Frank. This is followed by an increased involvement with photography. 1962 first contacts with the civil rights movement (SNCC: Student Nonviolent Coordinating Committee), on whose behalf he travels across the Southern States. Photographs published *inter alia* in the book *The Movement* (New York, 1964). Makes contact with Hugh Edwards (curator at the Art Institute of Chicago), who encourages him to continue his work on the essay (and later book) *The Bikeriders*. 1965 portfolio in *Du*. 1967–1973 Magnum associate. From November 1966 back in New York. There he does a photo series about demolition work in Lower Manhattan. In 1969 completes his much acclaimed prison project (*Conversations with the Dead*) with a first publication in *Esquire*. In the same year *Soc. Sciences 127*, the first of ten semi-documentary films. Afterwards he works as a writer and director of films. In 1991 big retrospective with stopovers in Tucson, Essen (Germany), Odense (Denmark), Stockholm, London, Washington, DC, San Francisco, Chicago, Rochester (New York), and Brooklyn (New York).

EXHIBITIONS (Selected) — **1966** Chicago (Art Institute – 1969) SE // Rochester (New York) (George Eastman House/**Toward a Social Landscape**) GE // **1970** San Francisco (Art Institute) SE // **1982** Philadelphia (Pennsylvania) (Museum of Art) SE // **1992** Essen (Germany) (Museum Folkwang) SE // **2003** Paris (Galerie Kamel Mennour) SE // **2004** Los Angeles (Fahey/Klein Gallery) SE // **2005** New York (Museum of the City of New York) SE // **2006** New York (Edwynn Houk Gallery) SE // **2007** New York (Whitney Museum of American Art) SE // **2010** Daytona Beach (Florida) (Southeast Museum of Photography) SE

BIBLIOGRAPHY (Selected) — Nathan Lyons (ed.): **Contemporary Photographers: Toward a Social Landscape.** New York 1966 (cat. George Eastman House, Rochester) // **The Bikeriders.** New York 1968 // **The Destruction of Lower Manhattan.** New York 1969 // **Conversations with the Dead.** New York 1971 // **The Paper Negative.** Bernalillo 1980 // **Pictures from the New World.** Millerton (New York) 1981 // Jonathan Green: **American Photography: A Critical History 1945 to the Present.** New York 1984 ✍ // **Merci Gonaïves.** Clintondale (New York) 1988 // **I Like to Eat Right in the Dirt.** Clintondale (New York) 1989 // **D.L.: Photo, Film.** Heidelberg 1992 (cat. Museum Folkwang, Essen) // **Memories from the Southern Civil Rights Movement.** Chapel Hill 1992 // **Knave of Hearts.** Santa Fe 1999 // **D.L.: Forty Years.** Paris 2003 (cat. Galerie Kamel Mennour) // **The Destruction of Lower Manhattan.** New York 2005 // **Like a thief's dream.** New York 2007 // **Memories of Myself.** London 2009

"The overt militancy of the themes, the support of liberal causes, and Lyon's early association with Robert Frank — the two formed their own film company, Sweeney Films, in 1969 — made Lyon the most extravagantly praised young photographer of the decade. His social commentary mirrored the New Left's fantasies of adventurous egalitarianism, cross-cultural community, and revolutionary machismo. His work followed the long-honored American tradition of making the cultural outcast the cultural hero. His personal journalism made him appear as the sixties answer to Robert Frank." — Jonathan Green ✍

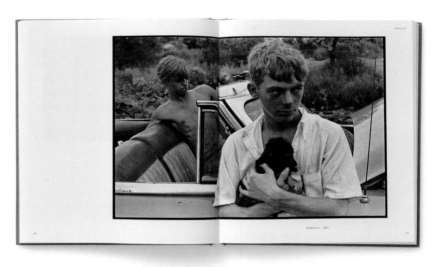

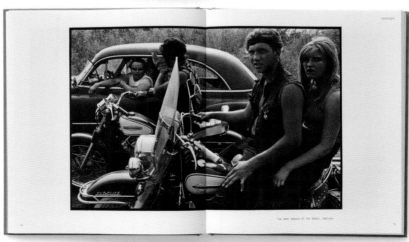

Dora Maar *(Henriette Theodora Markovitch)*

Cover of **Arts et Métiers Graphiques Photographie**, 1932

22.11.1907 Paris (France) — 16.7.1997 Paris Though famous mainly as Pablo Picasso's lover, muse, and aide, she herself is active as a painter and photographer. Key photos of Surrealism around 1935. Daughter of Croatian architect Joseph Markovitch, who lives in Paris. When she is three her parents move with her to Buenos Aires. School in Argentina. 1926 returns to Paris. Studies at the Union Centrale des Arts Décoratifs, the École de Photographie, and the Académie Julian. Painting lessons with André Lhote. There she meets > Cartier-Bresson. Takes up photography. Rolleiflex photographs in the spirit of Surrealism and New Vision (Neues Sehen). At the beginning of the 1930s (meanwhile as D.M.) opens a studio with Pierre Kéfer in Neuilly (later moves to Rue Campagne-Première 9). During this time, she is friends with > Brassaï, gets to know > Sougez, and makes contact with > Man Ray (who makes several portraits of her). Montages, photograms, fashion photography, and advertising as well as socially interested street photography (in Barcelona, London, and Paris). In close contact with the Surrealists around André Breton. Her montage *Rue d'Astorg 29* and her photograph *Portrait of UBU* become the movement's "icons". Also portraits, among others, of René Crevel, Georges Hugnet, Yves Tanguy. 1934 closure of the Kéfer-Dora Maar studio and the opening of her own studio. In 1935 stills photography for the film director Jean Renoir (*Le Crime de Monsieur Lange*). 1936 (second) momentous meeting with Picasso (in Paris) leading to a close relationship with the painter. Photographic documentation of the creation of *Guernica* (1937). Returns to painting. 1946 separation from Picasso. Nervous breakdown. Withdraws into herself. End of 1998, auction of her estate (paintings, drawings, photographs) in Paris.

EXHIBITIONS (Selected) — **1932** Brussels (**Internationale de la photographie**) GE // **1935** Paris (Galerie Billiet-Vorms) GE // **1936** London (New Burlington Galleries) GE // New York (Museum of Modern Art/**Fantastic Art, Dada and Surrealism**) GE // **1938** Amsterdam (Robert Gallery) GE // **1939** Copenhagen (**École française de photographie**) GE // **1985** Paris (Centre Pompidou — 1996, 2009) GE // **1990** Paris (Galerie 1900–2000) SE // **1995** Valencia (Spain) (Centre Cultural Bancaixa) SE // **1998** Paris (Hôtel de Sully) GE // **2001** Munich (Haus der Kunst) SE // **2009** Paris (Jeu de Paume – Site Sully/**Collection Christian Bouqueret**) GE // Manchester (Manchester Art Gallery/**Woman Artists and Surrealism**) GE // **2011** Cologne (Museum Ludwig) GE

BIBLIOGRAPHY (Selected) — Edouard Jaguer: **Surrealistische Photographie**. Cologne 1984 // **Explosante-fixe**. Paris 1985 (cat. Centre Pompidou) // Edouard Jaguer: **D.M.: Œuvres anciennes**. Paris 1990 (cat. Galerie 1900–2000) // **D.M.: Fotografía**. Barcelona 1995 (cat. Centre Cultural Bancaixa, Valencia) // **Collection de photographies**. Paris 1996 (cat. Centre Pompidou) // **Pablo Picasso et Dora Maar**. Paris 1998 (cat. Maison de la Chimie) // Christian Bouqueret: **Les Femmes Photographes de la Nouvelle Vision en France 1920–1940**. Paris, 1998 (cat. Hôtel de Sully) // **D.M.** Munich 2001 (cat. Haus der Kunst) // **Paris. Capitale photographique. 1920/1940. Collection Christian Bouqueret**. Paris 2009 (cat. Jeu de Paume – Site Sully) // **La subversion des images**. Paris 2009 (cat. Centre Pompidou) // **Ichundichundich. Picasso im Fotoporträt**. Cologne 2011 (cat. Museum Ludwig)

"It was Paul Eluard who introduced her to Picasso at the premiere of Jean Renoir's film *Le Crime de Monsieur Lange* (1936), on which she collaborated as a photographer. They met again; Picasso agreed to be photographed [...] She was very beautiful, just as the portraits of Man Ray or Rogi André testify, brilliant and already well known in artistic circles. Picasso was smitten in an instant, especially as her perfect Spanish created an extra bond of complicity between them. So she supplanted Brassaï as the photographer of his painted work and, during 1937, captured with her camera all the stages of *Guernica*, while posing for *La Femme qui pleure*."
— Annick Lionel-Marie ✐

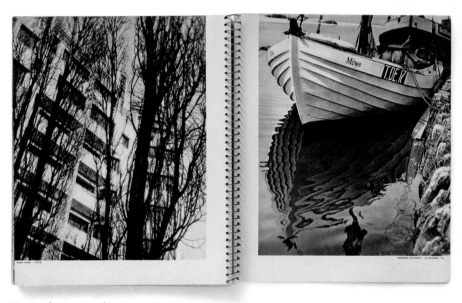

Dora Maar (left-hand page):
Untitled, from: **Arts et Métiers Graphiques Photographie**, 1932

Felix H. Man *(Hans Felix Sigismund Baumann)*

Felix H. Man: **Foreign Minister Stresemann with Count Zech**, from: **Berliner Illustrirte Zeitung**, no. 34, 25.8.1929

30.11.1893 Freiburg im Breisgau (Germany) — 30.1.1985 London (England) Significant representative (even if by no means the "inventor") of modern reportage. Active from 1929. Interrupts his art studies in Munich after being called up for military service (1915). While serving at the Front he takes his first photographs using a Vest Pocket Kodak (*Ruhe an der Westfront* [Quiet on the Western Front]). After 1918, various jobs. Finally completes his studies (painting and art history) in Berlin. In 1927 illustrator for *BZ* [*Berliner Zeitung*] *am Mittag*. First photographs for the Ullstein publishing company's *Tempo* magazine. From 1929, under the name of Felix H. Man, photo-reportage for *Münchner Illustrierte Presse* (under Stefan Lorant) and *Berliner Illustrirte Zeitung*. From June 1929 works for *Dephot*. 1931: *Day in the Life of Mussolini* (which he himself sees as a "milestone in the development of photojournalism"). 1932–1933 reports from abroad for Ullstein (Libya, Tunisia, USA). 1934 emigrates to London. 1935–1936 works for the *Weekly Illustrated*, *Daily Mirror*, *Lilliput*. From 1938 chief photographer for *Picture Post* magazine (founded by Stefan Lorant) (until 1953 around 300 photo reports). 1948 acquires British nationality. From 1953 is occupied with the history of artists' lithography (among others *150 Years of Artists' Lithography*). Moves to Switzerland, and from 1971 is in Rome. Collaboration on *Handelsblatt*. Correspondent for *Die Welt*. Awards include the Cultural Award of the DGPh (1965), and the Grosses Bundesverdienstkreuz (Grand Cross of the Order of Merit of the Federal Republic of Germany) (1980).

"**Together with Stefan Lorant, at the time picture editor of *Münchner Zeitung* [sic], Man shaped a new style of reportage with photo series that moved away from the individual picture, to become one of the trailblazers of photojournalism in Germany and in Europe.**"
— Frank Weyers ✍

EXHIBITIONS (Selected) — **1967** Hamburg (Landesbildstelle) SE // **1971** Munich (Stadtmuseum) SE // **1975** Stockholm (Moderna Museet) SE // **1977** Kassel (Germany) (documenta 6) GE // **1978** Bielefeld (Germany) (Kunsthalle) SE // **1983** London (Victoria and Albert Museum) SE // **1988** Cologne (photokina) GE // **1997** Bonn (Rheinisches Landesmuseum) GE // **2001** Cologne (Museum Ludwig/Agfa Foto-Historama) GE // **2005** Berlin (C/O Berlin) GE

Lucerne/Frankfurt am Main 1972 // **F.H.M.: 60 Jahre Fotografie**. Bielefeld 1978 (cat. Kunsthalle) // **F.H.M.: Sixty Years of Photography**. London, 1983 (cat. Victoria and Albert Museum) // **Photographien aus 70 Jahren**. Munich 1983 // **Zeitprofile. 30 Jahre Kulturpreis Deutsche Gesellschaft für Photographie**. Cologne 1988 (cat. photokina) // Klaus Honnef and Frank Weyers: **Und sie haben Deutschland verlassen ... müssen**. Bonn 1997 (cat. Rheinisches Landesmuseum) ✍ // **50 Jahre Deutsche Gesellschaft für Photographie**. Göttingen 2001 // Bodo von Dewitz and Robert Lebeck: **Kiosk. Eine Geschichte der Fotoreportage/ A History of Photojournalism**. Göttingen 2001 (cat. Museum Ludwig/Agfa Foto-Historama, Cologne)

BIBLIOGRAPHY (Selected) — **F.H.M.: Pionier des Bildjournalismus**. Munich 1971 (cat. Stadtmuseum) // Tim N. Gidal: **Deutschland – Beginn des Modernen Photojournalismus**.

Felix H. Man: **Mussolini receiving a visitor in his study in the Chigi Palace in Rome**, from: **Berliner Illustrirte Zeitung**, no. 11, 15.3.1931

Man Ray *(Emmanuel Radnitzky)*

Man Ray: **Photographies
1920–1934 Paris**. Paris
(Cahiers d'Art) 1934

**27.8.1890 Philadelphia (Pennsylvania, USA) — 18.11.1976 Paris
(France)** Painting, object art, photography, film. Artist with a multime-
dia interest arising from the spirit of Dadaism. Central to his oeuvre
are portraits, photograms, solarizations. Undoubtedly the best-
known international representative of the photographic avant-garde
around 1930. 1911 moves to New York. Meets > Stieglitz and Marcel
Duchamp (1913). First photographic reproductions of his works of
art. 1916 first portraits. 1917 first *cliché verre*. 1921 first photo in an
exhibition. Publishes the *New York Dada* magazine together with
Duchamp. In June 1921 moves to Paris. Portraits of writers commis-
sioned by Adrienne Monnier. 1922 opens a studio in Montparnasse.
1923–1926 with > Abbott as his assistant. 1922 first rayographs: a
selection in the portfolio *Champs délicieux* (text by Tristan Tzara).
1922 publishes in *Vanity Fair*, from 1924 quite frequently in *Vogue*.
1929 meets > Lee Miller. First solarizations. 1931 *Électricité* advertis-
ing brochure. Contributions to *VU*, *Art et Médecine*, *Minotaure*. 1935 first fashion photos for *Harper's
Bazaar*. 1934 *Man Ray: Photographies*, his most important monograph during his lifetime. 1940
returned to the USA (New York, Hollywood) via Lisbon. In 1944, last photographs for *Harper's Bazaar*.
After that, his interest in photography subsides. Marries Juliet Browner in 1946. Back in Paris from
1951. 1961 Gold Medal at the Venice Biennale. 1966 Cultural Award of the DGPh. 1998 big retrospec-
tive at the Grand Palais (Paris). Buried in Montparnasse cemetery (Paris).

EXHIBITIONS (Selected) — **1921** Paris (Librairie Six) SE // **1928**
Paris (1er Salon indépendant de la photographie/**Salon de
l'Escalier**) GE // **1929** Stuttgart (**Film und Foto**) GE // **1932**
New York (Julien Levy Gallery) SE // **1944** Pasadena (Califor-
nia) (Art Institute) SE // **1962** Paris (Bibliothèque nationale)
SE // **1966** Los Angeles (County Museum) SE // **1981** Paris
(Centre Pompidou) SE // **1988** Washington, DC (Smithsonian
Institution) SE // **1990** New York (International Center of Pho-
tography) SE // **1998** Paris (Grand Palais) SE // 2007 Madrid
(PHotoEspaña) SE // **2008** Berlin (Martin-Gropius-Bau) SE //
2008 Paris (Pinacothèque de Paris) SE // **2013** Brühl (Max
Ernst Museum) SE

BIBLIOGRAPHY (Selected) — M.R.: **Photographies 1920–1934,
Paris**. Paris, 1934 // **Self-portrait**. Boston, 1963 // **M.R. Photog-
raphe**. Paris, 1981 (cat. Centre Pompidou) // **Perpetual Motif:
The Art of Man Ray**. Washington, DC, 1988 (cat. Smithsonian
Institution) // **M.R.: Bazaar Years**. New York 1990 (cat. Interna-
tional Center of Photography) // Emmanuelle de l'Écotais and
Alain Sayag (eds): **M.R.: La photographie à l'envers**. Paris
1998 (cat. Grand Palais) // Manfred Heiting (ed.): **M.R. 1890–
1976**. Cologne 2000 ✐ // John P. Jacob and Noriko Fuku
(eds): **Despreocupado pero no indiferente**. Madrid 2007 (cat.
PHotoEspaña) // **Atelier M.R. Unconcerned but not indifferent**.
Paris 2008 (cat. Pinacothèque de Paris)

"Man Ray was an artist who refused to submit to any rules, for whom the medium in which he was working was only a vehicle for his ideas. He succeeded in extending the frontiers of our ideas of photography and profoundly and emphatically called into question the traditional notion of beauty. He who, to begin with, only intended to use his camera to document his paintings, with the aid of rarely used darkroom techniques, freed photography from its image as a tool for documenting reality. Man Ray used his camera to create pictures that were the result of his imagination and brought him the reputation of being the most creative photographer of our century." — Katherine Ware ✍🏻

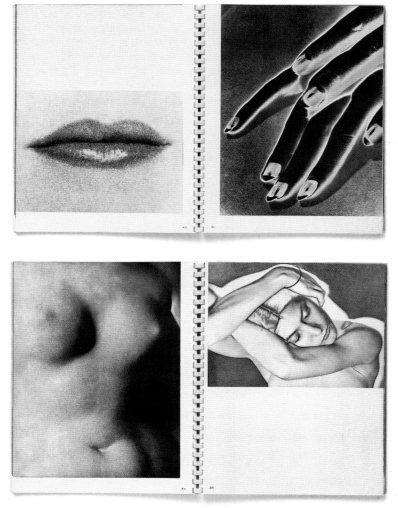

Manassé (Olga Spolarics/ Adorján von Wlassics)

Adorján and Olga von Wlassics
(Wog): **Der Akt. Eine Sinfonie in Licht und Schatten.** Berlin
(Oswald Arnold Verlag) 1941

6.5.1895 Budapest (Hungary) — 2.9.1969 Vienna (Austria) — 27.4.1893 Vesprém (Hungary) — Beginning of 1947 Vienna Glamour and eroticism clearly verging on kitsch. Around 1930 achieve international recognition for their montages and their ironical treatment of the traditional roles of the sexes. Adorján Franz Marie Vlassics (*sic*) is the son of an officer in the imperial and royal army. During WW I in the First Infantry Regiment. Decorated several times. From 1918 active as a photographer in Budapest. 1920 marries Olga Spolarics and opens a photo studio (Wlasics [*sic*]), address Opernring 19. By 1925 they rename it Manassé. The company moves several times, finally to Vienna, Kärntner Ring 15. 1924 first press publication of a work. This is followed by numerous publications, particularly in the *Wiener Magazin*. 1935 open a branch in Bucharest. 1936 they sell the Manassé company name and move to Berlin. There, they form the company WOG (Wlassics/Olga/Geschke) company. Shortly before the end of the war they return to Vienna. After W.'s death in 1948, Olga opens another studio (Foto Wlassics). Marries Hans Rothen. Takes up painting and becomes a member of the Künstlerbund. Takes part in several exhibitions in the 1950s. Rediscovery of the photographic oeuvre on the occasion of the exhibition *Geschichte der Fotografie in Österreich* (History of Photography in Austria).

"The nude montages of the Atelier Manassé take today's observer at least to the limits of grotesqueness and clowning, of criticism and affirmation. The irony with which a traditional image of the role of the woman in the photo was drawn and overdrawn never turned into cynicism or social criticism, opened no new perspectives or unexpected connections. This alone distinguishes the montages essentially from those of the Dadaists and Surrealists — whose ideas for pictures and technical tricks, incidentally, the Wlassics copied." — Monika Faber ✍

EXHIBITIONS (Selected) — **1983** Vienna (Museum des 20. Jahrhunderts) GE // **1985** Munich (Stadtmuseum) GE // **1998** Vienna (Kunsthalle) SE // **2007** Washington, DC (National Gallery of Art) SE // Paris (Maison européenne de la photographie) GE

BIBLIOGRAPHY (Selected) — **Geschichte der Fotografie in Österreich.** Bad Ischl 1983 (cat. Museum des 20. Jahrhunderts, Vienna) // Michael Köhler and Gisela Barche (eds): **Das Aktfoto.** Munich 1985 (cat. Stadtmuseum) // Monika Faber: **Die Montierte Frau.** Vienna 1988 ✍ // Monika Faber: **Die Frau, wie Du sie willst.** Vienna/Munich, 1998 // Matthew S. Witkovsky: **Foto: Modernity in Central Europe, 1918–1945.** Washington, DC, 2007 (cat. National Gallery of Art) // Alessandro Bertolotti: **Livres de Nus.** Paris 2007 (cat. Maison européenne de la photographie)

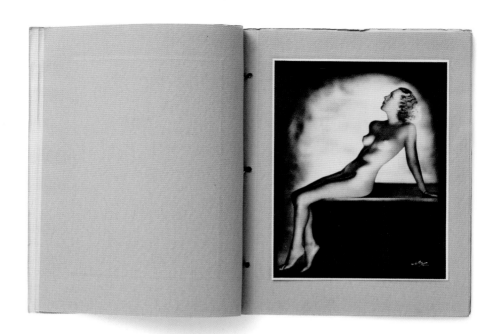

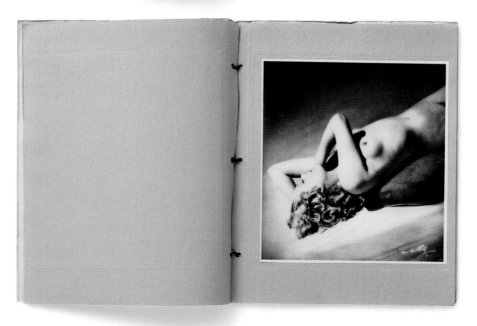

Sally Mann

Sally Mann: **Unmittelbare Familie**.
Munich (Knesebeck Verlag) 1997

1.5.1951 Lexington (Virginia, USA) — Lives in Lexington Childhood and adolescence: her own family, in particular her three daughters, are at the center of portrait work, much acclaimed since the end of the 1980s and also the subject of controversy. More recently, landscape and nature studies. Daughter of a country doctor in Lexington. Putney School, Bennington College (Vermont) and Friends World College, Long Island (New York) (1966–1972). 1974 B.A. from Hollins College in Roanoke (Virginia). 1975 receives her M.A. (Verbal Communication) from the same college. Receives her training in photography from Praestegaard Film School (1971), Aegean School of Fine Arts (1972), Apeiron (1973), and > Ansel Adams's Yosemite Workshop (1973). Holds numerous solo exhibitions and participates in exhibitions from the end of the 1970s. In 1985 first photographs of her daughters Emmett, Jessie, and Virginia growing up in a natural, unaffected atmosphere: "often naked or half-naked, sometimes dirty, their skin marked by bee-stings or scratches, sometimes lost in the sensuous daydreams of puberty" (Dodie Kazanjian). Relaxed, self-assured poses arising from a dialogue as psychological studies, large-format camera and (comparatively) slow b/w films, the technical standards for pictures that were soon being discussed internationally. Even before her exhibitions *Immediate Family* (Houk Friedman, 1992) and *At Twelve* (Edwynn Houk, 1992) she was the subject of heated debate as "one of the most admired and reviled photographers of the early 1990s" (Dodie Kazanjian). In the mid-1990s came a radical break and a turning towards a form of landscape photography that only at first sight is schooled in romantic ideas. First presented to a larger public as part of the *Mother Land* exhibition (Edwynn Houk). Numerous publications, among others in *American Photo*, *New York Times Magazine*, *Photographies* magazine, *Zoom*. NEA Fellowships (1982, 1988, 1992), and Photographer of the Year Award 1995 by the Friends of Photography.

EXHIBITIONS (Selected) — **1988** New York (Marcuse Pfeiffer Gallery) SE // **1990** Chicago (Edwynn Houk Gallery – 1992) SE // Paris (Mois de la Photo) GE // **1992** New York (Houk Friedman Gallery – 1995) SE // **1993** Tokyo (Photo Gallery International) SE // Carmel (California) (Center for Creative Photography) SE // **1994** Tampa (Florida) (Museum of Art) SE // Frankfurt am Main (**Prospect 93**) GE // **1997** New York (Edwynn Houk Gallery – 1999, 2003) SE // Berlin (Bodo Niemann Gallery) SE // **1998** Austin (University of Texas) SE // Madrid (PHotoEspaña) SE // **2004** Rome (Istituto Nazionale per la Grafica) SE // Washington, DC (Corcoran Gallery of Art) SE // Paris (Galerie Karsten Greve – 2005, 2007) SE // **2007** Stockholm (Kulturhuset) SE // Jena (Germany) (Galerie im Stadtmuseum) SE // **2008** Cologne (Karsten Greve Gallery) SE // **2009** New York (Gagosian Gallery) SE

BIBLIOGRAPHY (Selected) — **Second Sight: The Photographs of S.M.** Boston 1982 // **Sweet Silent Thought**. Durham 1987 (cat. North Carolina Center for Creative Photography) // **At Twelve: Portraits of Young Women**. New York 1988 // **Still Time**. Clifton Forge 1988 (cat. Allegheny Highlands Arts and Crafts Center) // **Immediate Family**. New York 1992 (**Unmittelbare Familie**. Munich 1997) // **Still Time**. New York 1994 // A.D. Coleman: **Critical Focus: Photography in the International Image Community**. Tucson 1995 📖 // **Mother Land**. New York 1997 (cat. Edwynn Houk Gallery) // **What Remains**. New York 2003 // **Deep South**. New York 2005 // **Proud Flesh**. New York 2009 (cat. Gagosian Gallery)

"What makes Mann's pictures notable is that she places her considerable skills as a picture-maker — including patience, deliberation, a classical sense of form, a musician's ear for the tonalities of silver, and absolute mastery of her tools and materials — at the service of her commitment to looking as clear-sightedly as possible at the young." — A.D. Coleman ✍

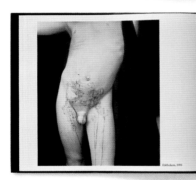

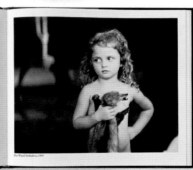

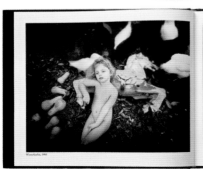

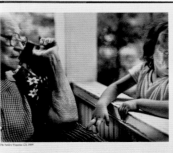

Robert Mapplethorpe

Robert Mapplethorpe: **Lady Lisa Lyon**. New York (The Viking Press) 1983

4.11.1946 New York (USA) — 9.3.1989 Boston (Massachusetts, USA) Cult photographer of the 1980s. Portraits, male nudes inspired by classicism. Also controversial photos from the New York "leather scene" and much acclaimed still-life images of flowers, some of them in color. Studies art at the Pratt Institute in Brooklyn 1963–1969. Initially, free collages, costume jewelry, installations. From 1970, becomes involved in photography. Self-taught. First photographs using a Polaroid camera (portraits and self-portraits). 1976 moves to the 2.25 in. square format. Portraits of renowned New York artists and intellectuals. Studies of plants in the style of New Objectivity (New Objectivity) of the 1920s. Devotes himself to the nude, incl. male models. Rigorously composed studies of the body in the tradition of > Hoyningen-Huene and > Horst. 1977 participation in the documenta 6 in Kassel. 1979 first solo exhibition in Europe (Jurka Gallery, Amsterdam). 1980–1983 *Lisa Lyon* cycle. Films, book projects, exhibitions. At the instigation of his patron and friend, Sam Wagstaff, he builds up his own photo collection. 1988 establishes the R.M. Foundation to support AIDS research and photo-art projects. His photographic estate is also with the foundation (www.mapplethorpe.org). 1988 big retrospective at the Whitney Museum of American Art in New York. He dies soon afterwards — at the peak of his international acclaim — of AIDS. Censorship of his (posthumous) *The Perfect Moment* exhibition at the Corcoran Gallery of Art in Washington, DC, marks the beginning of a more restrictive cultural policy in the United States.

"Mapplethorpe's immaculate black and white images of men bursting with strength and vitality have long dominated advertising (and brought hosts of gay models into the mainstream). Now that color and trash are the order of the day, his impact seems to be weakening, but impressions are deceptive. In reality, the image of men and women is steeped in the gay image of the body, which this photographer, as no other, has enshrined in high and mass culture."
— Ulf Erdmann Ziegler ✍

EXHIBITIONS (Selected) — **1973** New York (Light Gallery) SE // **1977** New York (Holly Solomon Gallery) SE // **1978** New York (Robert Miller Gallery – 1979, 1981, 1983, 1985, 1987, 1991) SE // **1979** Amsterdam (Jurka Gallery – 1980, 1982, 1988) SE // **1981** Frankfurt am Main (Frankfurter Kunstverein) SE // **1983** Paris (Centre Pompidou) SE // **1988** Amsterdam (Stedelijk Museum) SE // **1989** Paris (Galerie Baudoin Lebon – 1998) SE // **1993** Stockholm (Moderna Museet) SE // **2002** Berlin (Thomas Schulte Gallery – 2004) SE // Salzburg (Austria) (Thaddaeus Ropac Gallery – 2004, 2005, 2006, 2008) SE // **2004** Berlin (Deutsche Guggenheim) SE // St. Petersburg (State Hermitage Museum) SE // **2005** Moscow (Moscow House of Photography) SE // New York (Guggenheim Museum)

SE // **2006** Edinburgh (Scottish National Gallery of Modern Art) SE // **2008** New York (Whitney Museum of American Art) SE

BIBLIOGRAPHY (Selected) — **Lady Lisa Lyon**. New York 1983 // **Black Book**. New York 1986 // **Some Women**. Boston 1989 // **Flowers**. Boston 1990 // **Mapplethorpe**. New York 1992 // Patricia Morrisroe: **R.M**. New York 1995 // Ulf Erdmann Ziegler: "Das Bild des Mannes". In: **Kunstzeitung**, no. 31, 1999 ✍ // **Autoportrait**. Santa Fe 2001 // **R.M.: Polaroids**. Munich 2008 (cat. Whitney Museum of American Art) // Daniel Girardin and Christian Pirker: **Controverses. Une histoire juridique et éthique de la photographie**. Arles 2008

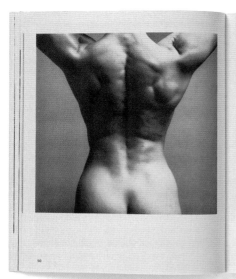

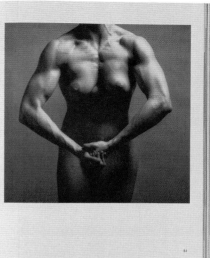

50

51

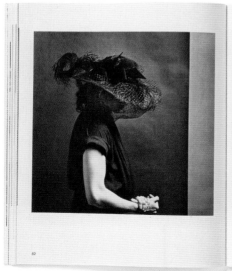

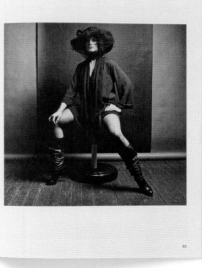

62

63

Robert Mapplethorpe 1970–1983.
London (Institute of Contemporary
Arts) 1983

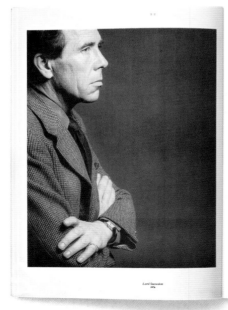

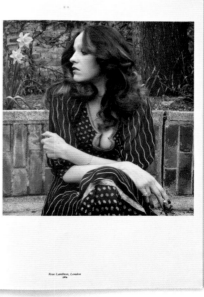

Lord Snowdon
1976

Rose Lambton, London
1976

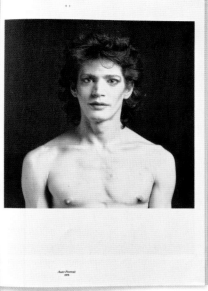

Easter Lilies
1979

Auto Portrait
1979

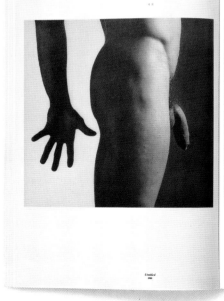

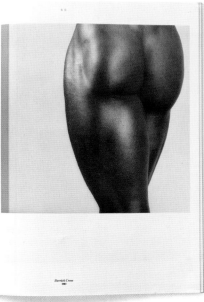

Untitled
1981

Derrick Cross
1983

Charlotte March

8.10.1929 Essen (Germany) — 29.5.2005 Hamburg (Germany) Fashion and portraits. In the 1960s and 70s one of the most distinguished German fashion photographers. Daughter of Werner March, one of the architects in charge of the construction of the Berlin Olympic Stadium, her mother Russian. The parents return from China to Germany immediately before their daughter is born. 1950–1954 attends the Alsterdamm art school in Hamburg. After that works as a freelance designer. 1955 turns to photography. Self-taught. From 1956 freelance photography (editorial and advertising). Between 1960 and 1969 numerous publications in *twen* magazine (people, mainly fashion in b/w and color). Also publications in *Vogue* (Italy), *Harper's Bazaar* (London), *Elle* (Paris), *Marie Claire* (Paris) and, for many years, *Brigitte*, where, along with > Gundlach, she was one of the most important contributors. Own studio from 1961. 1968 Cultural Award of the DGPh: "in recognition of her artistic work, which [...] enriched fashion and advertising photography in Germany through creative impulses with a clear style of their own and found recognition worldwide." In 1977 publication of the photobook *Mann, oh Mann* (which causes a sensation) as a tribute to the "unusual, tender, vulnerable, beautiful male". Numerous awards from the ADC New York (in particular for her photo series in *twen*). Numerous exhibitions, among others participation in the first and second World Exhibition of Photography (1964 and 1968). Estate is part of the Falckenberg Collection (Hamburg).

twen cover, no. 1,
January 1967.
Photo: Charlotte March
twen cover, no. 6,
June 1966.
Photo: Charlotte March

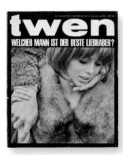 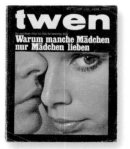

EXHIBITIONS (Selected) — **1973** Hannover (Spectrum-Photogalerie) SE // **1986** Cologne (photokina/**50 Jahre moderne Farbfotografie 1936–1986**) GE // **1988** Cologne (photokina) GE // **1995** Munich (Stadtmuseum/**Die Zeitschrift twen**) GE (touring exhibition with stopovers in Hamburg, Velbert and Frankfurt am Main) // **2002** Madrid (Biblioteca Nacional/**twen**) GE // **2003** Ulm (Germany) (Kunstverein/**Mythos twen**) GE // **2004** Hamburg (Photography Monika Mohr Gallery) GE // Brussels (Young Gallery) SE // **2005** Berlin (C/O Berlin/**Einblicke in die Sammlung der Deutsche Gesellschaft für Photographie**) GE // **2007** Schleswig (Germany) (Stadtmuseum Schleswig/**Einblicke in die Sammlung der Deutsche Gesellschaft für Photographie**) GE // **2008** Berlin (Camera Work/**Fashion – 9 decades of fashion photography**) GE

BIBLIOGRAPHY (Selected) — **C.M.: Modelle und Menschen**. Hannover 1973 (cat. Spectrum-Photogalerie) // **50 Jahre moderne Farbfotografie/50 Years Modern Color Photography 1936–1986**. Cologne 1986 (cat. photokina) // **Zeitprofile. 30 Jahre Kulturpreis Deutsche Gesellschaft für Photographie**. Cologne 1988 (cat. photokina) // Hans-Michael Koetzle (ed.): **Die Zeitschrift twen**. Munich 1995 (cat. Stadtmuseum) // F.C.Gundlach: **Bildermode Modebilder. Deutsche Modephotographien 1945–1995**. Stuttgart 1995 (cat. Institut für Auslandsbeziehungen) // **Photographie des 20. Jahrhunderts. Museum Ludwig Köln**. Cologne 1996 // Hans-Michael Koetzle and Carsten M. Wolff: **Fleckhaus. Deutschlands erster Art Director**. Munich 1997 // Hans-Michael Koetzle: "C. M." In: **Foto-magazin**, no. 12, 2004 ✍

"Fashion photography is information and suggestion, message and temptation. As if by intuition Charlotte March has understood how to merge these two aspects. Her work is a balancing act between emotion and objectivity. Clearly they are images of their time. And yet they seem fresh, modern — even four decades later. Charlotte March first appeared in *twen* in July 1960. There she soon became the fashion photographer most in demand. In retrospect, she sometimes regrets being perpetually reduced to *twen*. And yet: it was a brilliant start to her career. And there is rarely a magazine that has presented her pictures in a bigger, better and more ideally matched way." — Hans-Michael Koetzle ✍

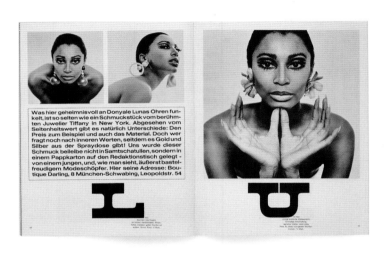

Was hier geheimnisvoll an Donyale Lunas Ohren funkelt, ist so selten wie ein Schmuckstück vom berühmten Juwelier Tiffany in New York. Abgesehen vom Seltenheitswert gibt es natürlich Unterschiede: Den Preis zum Beispiel und auch das Material. Doch wer fragt noch nach inneren Werten, seitdem es Gold und Silber aus der Spraydose gibt! Uns wurde dieser Schmuck beileibe nicht in Samtschatullen, sondern in einem Pappkarton auf den Redaktionstisch gelegt - von einem jungen, und, wie man sieht, äußerst bastelfreudigem Modeschöpfer. Hier seine Adresse: Boutique Darling, 8 München-Schwabing, Leopoldstr. 54

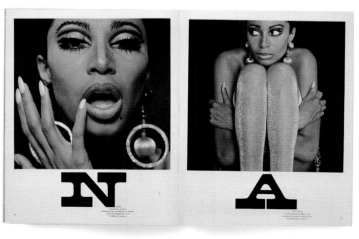

Charlotte March: **Luna,**
from: **twen,** no. 1, 1967

Mary Ellen Mark

Mary Ellen Mark: **Twins**.
Göttingen (Steidl Verlag) 2003

20.3.1940 Philadelphia (Pennsylvania, USA) — 25.5.2015 New York (USA) Drug addicts, the mentally ill, prostitutes, street kids: people in need or on the fringes of society are the subject of a documentarist clearly influenced by Smith. 1958–1962 studies art at the University of Pennsylvania (B.A.). After that works briefly in a city planning department. 1963–1964 returns to university. Studies photography at the Annenberg School of Communications (M.A.). 1965–1966 on a Fulbright Scholarship to Europe: photographic exploration in particular of Turkey. 1966 returns to New York. First publications in local magazines (*New York, Evergreen, Jubilee*). From 1967 still photography for films such as *Alice's Restaurant, Apocalypse Now, Ragtime, Fellini-Satyricon, Catch–22*, which catch the attention of the national press. 1970 a report in *Look* is her first big publication (*What the English Are Doing About Heroin*). 1971 stills photography for the film *One Flew Over the Cuckoo's Nest*. This gives her access to the world of psychiatric hospitals. *Ward 81* is the much acclaimed result of her photographic research into the hospital system. International breakthrough with *Falkland Road* (prostitution in Bombay). Also essays about Mother Teresa, street kids (*Streetwise*), and travelling circuses in India. Publications in practically all the big international magazines (*Life, Look, Stern, Paris Match, Geo*, etc.). 1977–1981 Magnum member. 1981–1988 Archive Pictures. Own agency since 1988. Awards include the Leica Medal of Excellence (1982), Dr Erich-Salomon Prize of the DGPh (1994), Infinity Award of the ICP (1997), and the Cornell Capa Award (2001).

EXHIBITIONS (Selected) — **1976** Graz (Austria) (Forum Stadtpark) SE // **1979** Berlin (A. Nagel Gallery) SE // **1982** Riverside (California) (California Museum of Photography) SE // **1983** Carmel (California) (Friends of Photography) SE // **1992** New York (International Center of Photography – 2001) SE // **1993** Bath, England (Royal Photographic Society) SE // **1994** Bradford (England) (National Museum of Photography) SE // **1996** Cleveland (Ohio) (Cleveland Museum of Art) SE // **1998** Mexico City (El Centro de la Imagen) SE // **2000** Philadelphia (Pennsylvania) (Museum of Art) SE // **2002** Vienna (WestLicht) SE // **2003** Gothenburg (Sweden) (Hasselblad Center) SE // **2004** Moscow (Moscow House of Photography) SE // Chicago (Museum of Contemporary Photography) SE // The Hague (Fotomuseum) SE // **2006** Salo (Finland) (Salo Art Museum) SE // **2007** Reykjavik (Iceland) (National Museum of Iceland) SE

BIBLIOGRAPHY (Selected) — **Passport**. New York 1974 // **Ward 81**. New York 1979 // **Falkland Road**. New York 1981 // **Mother Teresa's Missions of Charity in Calcutta**. Carmel 1985 // **Streetwise**. Philadelphia 1988 // **M.E.M.: 25 Years**. Boston 1991 // **Indian Circus**. San Francisco 1993 // **A Cry for Help**. New York 1996 // **M.E.M.: Portraits**. Washington, DC 1997 // **American Odyssey 1963–1999**. New York 1999 (cat. Philadelphia Museum of Art) // **M.E.M. 55**. London 2001 // **M.E.M.** Paris 2002 (= Photo Poche no. 96) // **Twins**. Göttingen 2003 // **Seen Behind the Scene: Forty Years of Photographing on Set**. London 2008

"It is difficult to qualify her work, to put a label on it. Mary Ellen Mark is always to be found at the frontiers of reportage, of documentary photography, of the portrait. One might venture to say that, all things considered, she is a 'social portraitist'. And it is in this singular way of seizing reality, in this intersection of different photographic genres that the entire appeal of her images resides." — Caroline Bénichou ✐

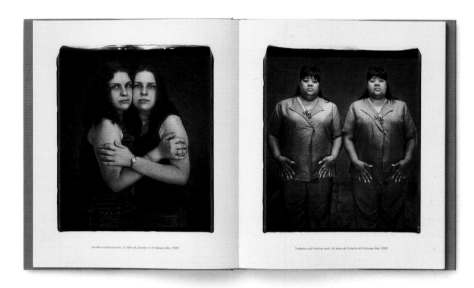

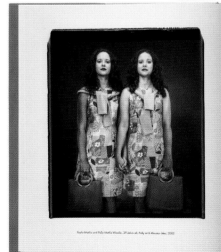

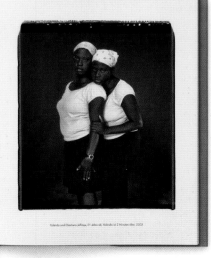

Jim Marshall

Trust. Photographs of Jim Marshall.
London (Omnibus Press) 2009

3.2.1936 Chicago (USA) — 24.3.2010 New York (USA) Seen by many as the ultimate Rock 'n' Roll photographer. Intimate connoisseur of the scene and its protagonists. Star photos more in the spirit of reportage than glamour or people photography. 1938 moves to San Francisco. Grows up with mother after father, a house painter, leaves them. Various jobs while at high school. Serves in the Air Force. With savings buys a Leica M2 as first professional camera. A lucky snapshot, a happy chance, of the jazz saxophonist John Coltrane in 1959 in the streets of San Francisco the starting point of his career as chronicler of the rock and pop scene in the 1960s. 1966 only photographer backstage at the last Beatles' live concert in Candlestick Park in San Francisco. 1967 at the Monterey Pop Festival, 1969 at Woodstock and Altamont. Also in 1969 documentation of Johnny Cash's legendary show at San Quentin State Prison. Portraits of Chubby Checker, Joan Baez, Bob Dylan, and (perhaps the best known) Janis Joplin backstage on a couch with a bottle of Southern Comfort in her hand. Unvarnished and authentic photos using available light and without elaborate staging. After drug problems, in the 1970s withdraws from the business for a time. In the 1980s returns with photos of a new generation of musicians incl. photos of the Red Hot Chili Peppers, Ben Harper, and The Cult. A number of books, incl. *Not Fade Away: The Rock & Roll Photography of Jim Marshall*. Sudden death in a New York Hotel. *www.marshallphoto.com*

"**Marshall's most famous images, which wound up on more than 500 album and CD covers, in magazines, newspapers and on posters, include his shot of Hendrix setting fire to his electric guitar at the Monterey Pop Festival, Dylan rolling a tree down the littered streets of Greenwich Village on an early morning walk and Cash flipping his middle finger directly into the camera lens at San Quentin State Prison. […] He considered himself a photojournalist, not a celebrity photographer, and also spent time in the '60s documenting poverty in Appalachia and the civil rights movement.**" — Randy Lewis

EXHIBITIONS (Selected) — **2002** Los Angeles (Fahey/Klein Gallery/**Faces in Music 1952–2002**) GE // **2004** Salina (Kansas) (Salina Art Center) GE // **2005** Los Angeles (Fahey/Klein Gallery – 2010) SE // London (Blink) SE // San Francisco (Robert Koch Gallery) GE // **2009** Portland (Maine) (Portland Museum of Art/**Backstage Pass: Rock & Roll Photography**) GE // **2010** New York (Staley-Wise Gallery) SE

BIBLIOGRAPHY (Selected) — **Not Fade Away: The Rock & Roll Photography of J.M.** New York 1997 // **Not Fade Away: Die Rock 'n' Roll-Fotografien von J.M.** Zurich 1997 // **Proof.** San Francisco 2004 // **Jazz.** San Francisco 2006 // **Trust.** London 2009 // **Match Prints.** New York 2010

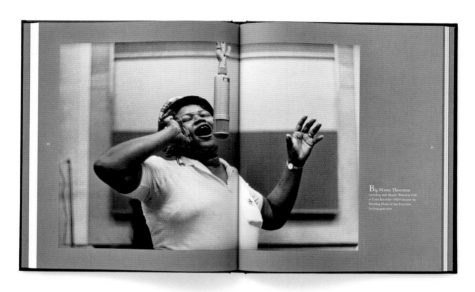

Big Mama Thornton recording with Muddy Waters in 1965 at Coast Recorders, which became the Wheeling House in San Francisco. It's long gone now.

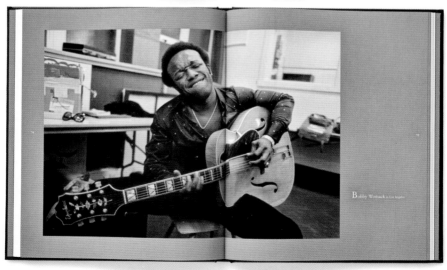

Bobby Womack in Los Angeles

Herbert Matter

Herbert Matter: **Calder,**
from: **Portfolio,** no. 3, 1951

25.4.1907 Engelberg (Switzerland) — 8.5.1984 Southampton (New York, USA) Advertising artist and photographer. Fashion and artists' portraits (notably Alberto Giacometti). Together with Ernst A. Heiniger and Hermann Eidenbenz, a pioneer of a new style in poster art and advertising. 1925–1927 studies painting at the École des Beaux-Arts in Geneva and 1928–1929 at the Académie Moderne in Paris (with Fernand Léger and Amédée Ozenfant). Self-taught as photographer. 1929–1932 working for Cassandre, Le Corbusier, and mainly Deberny & Peignot in Paris. Works for *Arts et Métiers Graphiques* 1930–1936. In 1932 Returns to Zurich. Groundbreaking posters for the Swiss National Tourist Office. 1936 moves to New York. Photography for *Harper's Bazaar*, *Vogue*, *Town & Country*. Design of the Swiss Pavilion for the New York 1939 World Exhibition. 1946–1957 staff photographer for Condé Nast. After that he works freelance. 1946–1966 consultant for Knoll International and 1958–1968 the Guggenheim Museum, and the Museum of Fine Arts in Houston (Texas). 1952–1976 Professor of Photography at Yale University. In 1951 cover for *Portfolio* no. 3 (edited by > Brodovitch). Graphics syllabus for the New York Studio School. Among other things, he participates in the important group exhibitions *neue fotografie in der schweiz* (New Photography in Switzerland) (Basel, 1933), *Weltausstellung der Photographie* (World Exhibition of Photography) (Lucerne, 1952), and *Photographie in der Schweiz von 1840 bis heute* (Photography in Switzerland from 1840 to the present) (Zurich, 1974). His estate is with the Schweizerische Stiftung für die Photographie (Swiss Foundation of Photography) in Winterthur, Switzerland.

> **"Herbert Matter went his own way; a graphic artist, he was a self-taught photographer, able, for example in portraits from the end of the 1920s, to live out his penchant for the moving, indeed pulsating, form of the material world. Matter achieved renown mainly for his travel posters which were the first to use photography and photomontage in an unusual way."** — Willy Rotzler ✍

EXHIBITIONS (Selected) — **1943** New York (Pierre Matisse Gallery) SE // **1962** New York (American Institute of Graphic Arts) SE // **1978** New Haven (Connecticut) (Yale University) SE // Zurich (Kunsthaus) SE // **1979** New York (Marlborough Gallery) SE // **1986** Chur, (Switzerland) (Bündner Kunstmuseum) GE // **2000** Arles (Rencontres internationales de la photographie) SE

BIBLIOGRAPHY (Selected) — **Poet's Camera.** New York 1949 // **Photographie in der Schweiz von 1840 bis heute.** Teufen 1974 (cat. Kunsthaus Zürich) // **13 Photographs: Alberto Giacometti and Sculptures.** Hamden 1978 (Portfolio Ives-Sillman) // **Alberto Giacometti.** Bern 1987 // **Photographie in der Schweiz von 1840 bis heute.** Wabern-Bern 1992 ✍ // Steven Heller: **Merz to Émigré and Beyond: Avant-Garde Magazine Design of the Twentieth Century.** London 2003 // **Calder by M.** Paris 2013

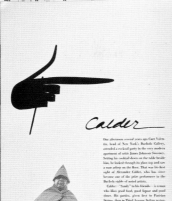

Calder

One afternoon several years ago Curt Valentin, head of New York's Buchholz Gallery, attended a cocktail party in the very modern apartment of critic James Johnson Sweeney. Setting his cocktail down on the table beside him, he looked through its glass top and saw a man asleep on the floor. That was his first sight of Alexander Calder, who has since become one of the prize performers in the Buchholz stable of noted artists.

Calder—"Sandy" to his friends—is a man who likes good food, good liquor and good times. His parties, given first in Parisian bistros, then in Third Avenue Italian restaurants in Manhattan, and more recently in his Roxbury, Conn. home, have been famous for two decades. Unfortunately, alcohol, even in mild doses, makes him sleepy. To counteract its effect at parties, he dances,

Top: Sheet-metal stagie poster to Calder exhibition. Left: Sandy Calder.

piggled cheerfully, to be greeted after a puzzled pause by perfunctory applause."

This portrait is as unfair as it is vicious. Wolfe, an immensely serious man himself, could not understand people who were not afflicted by the same grave emotions that wracked him. In none of his writings did he ever display any affection for modern artists, lighthearted people or children, so he could not have understood Calder who is all of these.

Calder is the third generation of a family of sculptors. His grandfather, Alexander Milne Calder, created the giant statue of William Penn that stands on top of the Philadelphia city hall. His father, A. Stirling Calder, designed the arch which stands in New York's Washington Square. He was responsible for getting Sandy into the Metropolitan Museum of Art when he used his four year old son, clad in leotards, as the model of the statue, "Man Cub," which the museum bought.

Sandy resisted the family tradition as long as he could. He took an engineering degree from Stevens Institute in Hoboken, then worked for an electric utility, a department store, a window sash company and a lumber trade journal. He even disguised himself as a hamberjack and fled to the forests of Washington state. Inevitably, however, he returned to the Art Students League where he studied under John Sloan and drew illustrations for the *Police Gazette*. In 1926 he surrendered completely and went to live on the Left Bank, from which, according to Elizabeth Hawes who knew him then, "he boasted over Paris in a lovely orange suit" for the next few years.

Calder's first big break, after the success of his toy circus and his wire sculpture, came when architect José Luis Sert invited him to design a mercury fountain for the

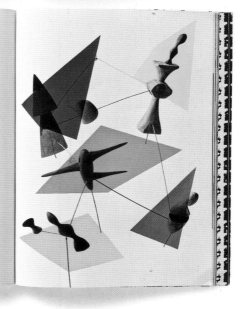

Mr. Logan was not able to make it work . . . Again and again the little wire figure soared through the air, caught at the outstretched hands of the other doll—and missed inglgloriously. It became painful. People craned their necks and looked embarrassed. But Mr. Logan was not embarrassed. He giggled happily with each new failure and tried again. It went on and on . . . At length Mr. Logan settled the whole matter by taking one little figure firmly between two fat fingers . . . and carefully hooking it onto the other's arms. Then he looked up at his audience and

Hanging groups of brightly colored wooden shapes, below and opposite page, called "Constellations," absorbed Calder's attention in the late 1940s. They look like three-dimensional representations of the abstract shapes favored by Miro, Arp and other modern painters.

Roger Mayne

Roger Mayne: **The street photographs of Roger Mayne.** London (Zelda Cheatle Press) 1986

5.5.1929 Cambridge (England) — 7.6.2014 Street photography influenced by Strand, Cartier-Bresson, and Smith. Outstanding photojournalist and documentarist of the England of the 1950s. 1942–1947 public school. 1947–1951 reads chemistry at Balliol College, Oxford. 1950 turns to photography. Self-taught. December 1951, first publication in *Picture Post*. 1952–1953 military service. 1954 moves to London. Freelance photographer. Photographic exploration of the area around Southam Street (his probably most important cycle to this day). 1956 first solo exhibition (which receives accolades from *The Times*). At the same time the starting point of his rapid rise to acclaim as a socially committed documentary photographer. Chronicler of "Teenage London" (Teddy Boys). Marries Ann Jellicoe in 1962. 1962–1963 photo essay in color on "The British at Leisure", commissioned by the Milan Triennale. After that, more street photography in color. 1962 and 1965 in Spain and Greece. 1966–1969 lectureship at Bath Academy of Art, Corsham. Since 1971 exclusively free topics. 1975 moves to Lyme Regis, Dorset. 1976–1979 natural landscape photography (in color). 1978–1984 trips to Dubrovnik, Rhodes, and Corfu. From 1980, also painting and drawing. 1986–1992 visits to Kyoto, Tokyo, Hong Kong, Macao, Goa. From 1991 (birth of his granddaughter Zoe) family photographs once again. Important group exhibitions since the beginning of the 1980s: *British Photography 1955–65* (1983), *Subjective Photography* (1984), *Through the Looking Glass – British Photography 1945–89* (1989), *The Sixties* (1993) and (together with Ian Berry, > Bulmer, > Donovan, Robert Freeman, David Hurn, > Bailey, > Jones Griffiths, > McCullin, Ken Russell and > Lord Snowdon) part of the exhibition *Young Meteors* (1998) curated by Martin Harrison. Numerous publications in the *Observer, Queen, Vogue, Time & Tide, New Left Review, Peace News*, and *The Sunday Times*.

EXHIBITIONS (Selected) — **1954** Saarbrücken (Germany) (**subjektive fotografie 2**) GE // **1956** London (Institute of Contemporary Arts – 1978) SE // **1959** London (A.I.A. Gallery) SE // **1965** Bristol (England) (Arnolfini Gallery) SE // **1983** London (The Photographers' Gallery) GE // **1984** Essen (Germany) (Museum Folkwang) GE // **1986** London (Victoria and Albert Museum) SE // **1989** London (Barbican Arts Centre – 1993) GE // New York (Prakapas Gallery) SE // **1992** London (Zelda Cheatle Gallery – 1999) SE // **1993** New York (Laurence Miller Gallery) JE (together with Henri Cartier-Bresson and Helen Levitt) // **1998** Bradford (England) (National Museum of Photography, Film and Television) GE // **2001** St Ives (England) (Tate Museum) SE // **2004** New York (Gitterman Gallery – 2007) SE // London (National Portrait Gallery) SE // **2006** Melbourne (Australia) (NGV National Gallery of Victoria International/**After Image: Social Documentary Photography in the 20th century**) GE // **2009** London (Bernard Quaritch) SE

BIBLIOGRAPHY (Selected) — **Shell Guide to Devon.** London, 1975 // **The Street Photographs of R.M.** London 1986 (cat. Victoria and Albert Museum) ✍ // Martin Harrison: **Young Meteors: British Photojournalism: 1957–1965.** London 1998 (cat. National Museum of Photography, Film and Television, Bradford) // **R.M.: Photographs.** London 2001

"The phenomenon of Roger Mayne crosses the firmament of the medium from the beginning of the 1950s to the middle of the 1960. He photographs after that too, of course, but more privately, and in recent years he has turned to drawing and etching. In his most productive years he was not only deeply engaged in projecting the art of photography through exhibitions, writing and his own work, but was a forceful presence in mass circulation journalism — with which ambitious photography in Britain has been intimately bound up in the modern period (but, arguably, less so in the 1980s)." — Mark Haworth-Booth ✍

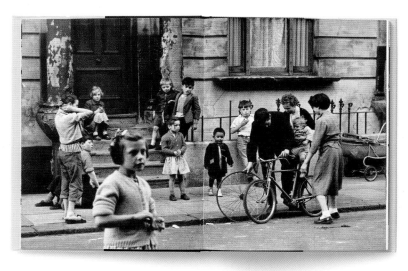

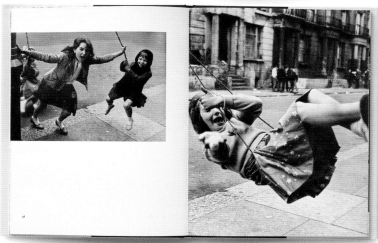

Willy *(Wilhelm)* Maywald

Wilhelm Maywald: **Portrait + Atelier.** Zurich (Arche) 1958

15.8.1907 Kleve (Germany) — 21.5.1985 Paris (France) Important, much published fashion photographer in the Paris of the 1940s to the early 70s. Sometimes called the "master of pose". Also artists' portraits, and reports. Second child of a hotel owner. Childhood in Kleve (Lower Rhine). Starts to show an interest in the cinema, cinema posters, and the art of the Expressionists. Leaves grammar school (Gymnasium) in 1925 and attends the Cologne School of Arts and Crafts. 1926 changes to the Handwerker- und Kunstgewerbeschule Krefeld (Krefeld Trade, Arts and Crafts School). 1928 first photographs taken on holiday in Garmisch. In the fall, he continues his studies at the private art school Kunstschule des Westens in Berlin. Contacts with the Binder photo studio and the world of film. In 1931 *Der Blick aus meinem Fenster* (The view from my window) his first published photograph. Moves to Paris in October. Assistant to Harry Ossip Meerson and his own studio in Rue de Vanves, and from 1933 larger studio near Denfert-Rochereau. 1935 first photo exhibition at a Paris gallery. 1938 publication of his photo essay on Renoir's garden (Cagnes-sur-Mer) in *Verve*. Further publications in *Femina* and *Vogue*. After outbreak of WW II, internment in various camps in the South of France. In 1941 escape via Marseilles to Cagnes, from there to Switzerland in 1942. From 1943 works as a photographer in Ascona and Zurich. 1946 returns to Paris, where he meets Christian Dior. 1947 photographs of Dior's first collection (which is celebrated as the "New Look"). Also fashion photography for Fath, Heim, Griffe and, increasingly, portraits of artists (Chagall, Cocteau, Léger, Picasso, Soulages, Utrillo, Zadkine). 1949 new studio at the Rue de la Grande Chaumière. Publications in *Film und Frau*, *Harper's Bazaar* and other international magazines. 1959 photokina award as well as the Prize for Best Fashion Photograph at the 7th Congress of the International Silk Association (Munich). 1961 opens his own gallery in Paris. From the mid-1970s more exhibitions of his photographic work. An autobiography entitled *Die Splitter des Spiegels* (Shards of a Mirror) published one month after his death.

EXHIBITIONS (Selected) — **1935** Paris (Galerie in der Rue de la Boétie) JE (with Dora Maar and Pierre Boucher) // **1939** Paris (Galerie Berton) SE // **1945** Zurich (Irma Hönigsberg Gallery) JE (with Hans Staub) // **1949** Paris (Galerie Maeght) SE // **1963** Kleve (Städtisches Museum Haus Koekkoek — 1978, 1992, 1995) SE // **1977** Cagnes-sur-Mer (France) (Château-Musée) SE // **1982** New York (Fashion Institute of Technology) SE // **1984** Paris (Goethe-Institut) SE (afterwards in Bordeaux, Nancy, Angoulême, Montpellier and Heidelberg) // **1986** Paris (Musée de la Mode et du Costume) SE // **1990** Vienna (Kunstforum Länderbank) GE // **1993** Paris (Fnac — forum des Halles) SE // **2005** Lisbon (Fundação Arpad Szenes-Vieira da Silva) SE // **2006** Paris (Galerie Sylvain di Maria) SE // **2007** Kleve (Germany) (Stiftung B.C. Koekkoek-Haus) SE // Paris (Musée Carnavalet) SE // **2011** Cologne (Museum Ludwig) GE

BIBLIOGRAPHY (Selected) — **Portrait + Atelier.** Zurich 1958 // **Kleve, Burg und Stadt unter dem Schwan.** Kleve 1959 // **Helene und W.M. Kleve.** 1963 (cat. Städtisches Museum Haus Koekkoek) // **Die Splitter des Spiegels. Eine illustrierte Autobiographie.** Munich 1985 // **W.M. et la Mode.** Paris 1986 (cat. Musée de la Mode et du Costume) // **Modefotografie von 1900 bis heute.** Vienna 1990 (cat. Kunstforum Länderbank) // **Fotos vom Niederrhein.** Kleve 1992 (cat. Städtisches Museum Haus Koekkoek) // Elizabeth Pineau: **W.M.: L'Élégance du regard.** Paris 2002 // **Ateliers de artistas.** Lisbon 2005 (cat. Fundação Arpad Szenes-Vieira da Silva) // **W.M. – Glanz und Eleganz.** Kleve 2007 ✍ // **Ichundichundich. Picasso im Fotoporträt.** Cologne 2011 (cat. Museum Ludwig)

"Maywald was one of the first photographers to discover the theme of the artist in his studio. Between the two World Wars, Montparnasse, where he lived, was the center of the Bohemian world. Here he got to know numerous artists, whom he called on and photographed in their own surroundings. The artists usually posed as gentlemen, not while they were at work. With Maywald, the studio functioned as an attribute. What distinguishes the pictures is their composure and a careful chiaroscuro *mise-en-scène*. Maywald's other fields of activity were dance and film. Before the War, Robert Piguet was the first to allow Maywald to photograph his fashion collection." — Guido de Werd ✍

Fernand Léger
1881–1955

«Große Volumen von Farben auf einer großen Fläche...
Wir bewegen uns der Zukunft entgegen,
und die Zukunft ist das Kollektive.
Jawohl, gewisse soziale und künstlerische Zeichen deuten an,
daß eine Renaissance der Wandmalerei
im Entstehen begriffen ist. Die Kunst der Monumente
kann und muß diese neue Einsicht verwenden,
indem sie sie erweitert...
Diese Kunst ist in ihrem Ausdruck statisch,
sie läßt die Wand bestehen,
neben einer dynamischen Auffassung, welche die Wand zerstört.»

«Les grands volumes de couleurs sur une grande surface...
On se dirige vers l'avenir,
et l'avenir c'est le collectif. Oui, il apparaît
à certains indices sociaux et artistiques
qu'une renaissance de l'art mural est à l'horizon.
L'art monumental
peut et doit utiliser, en l'amplifiant, cette conception nouvelle...
Cet art est statique
par son expression même, il respecte le mur à côté
d'une conception dynamique qui,
elle, détruit le mur.»

Le Corbusier
*1887

«Immer der Mangel an Zeit.
Die Ideen, die Farben, die Pinsel, die Zeichenstifte sind im
Reisegepäck. In der Hast der Reisen,
in Versammlungen, in Komiteesitzungen, in dem Babel der
verschiedensten Sprachen, die man vernimmt,
gibt es kein einziges Mittel, das einfacher, schneller und
wirksamer wäre, als das Zeichnen;
es wird zur Stenografie des Wanderers wider Willen.
Malen bedeutet weiter nichts
als die notwendige Zeit, um eine reichliche Schicht
Farbe aufzutragen...»

«Le temps toujours refusé.
L'idée, les thèmes, les couleurs, les pinceaux, les crayons,
les feuilles de papier à lettre sont dans
le bagage du voyageur. Jamais,
dans le tumulte du voyage et des assemblées, des
comités, dans le Babel des langues affrontées,
jamais le moyen n'est si simple,
rapide et efficace que le dessin qui devient la sténographie
d'un homme ambulant malgré lui.
Peindre n'est rien matériellement que le temps nécessaire pour
étendre à bonne épaisseur une couleur...»

Will McBride

Will McBride: **Knips. Berliner Bilder aus den 50er Jahren.** Berlin (Rembrandt Verlag) 1979

10.1.1931 St. Louis (Missouri, USA) — 29.1.2015 Berlin (Germany) Along with painting and sculpting, photography in the sense of a visual diary. Photo chronicler of 1960s youth culture, especially for the magazine *twen*, which captures the spirit of the times. Childhood and youth in Chicago and environs. Attends Grosse Pointe High School and studies at the University of Vermont. Also takes courses in drawing at the Art Institute of Chicago and the Detroit Society of Arts and Crafts. From 1948 to 1950 studies English Literature at the University of Vermont. Parallel to this, private lessons with the artist Norman Rockwell. 1950–1951 studies painting at the National Academy of Design, New York. 1951–1953 takes Art History, Painting, and Illustration at Syracuse University (New York): B.F.A. 1953–1955 military service with the US Army in Würzburg. First photographic works. 1955–1958 trips to Italy, France, and Switzerland. Takes up residence in Munich. Moves to Berlin. There he studies philology at the Free University, as well as painting and photography. From 1961 back in Munich as a freelance photographer. Photo essays and reports, especially for *Quick*, *twen*, *Eltern*, and *Jasmin* magazines. Contributes to *Geo*, *Stern*, *Life*, *Look*, and *Paris Match*. Advertising and object photography, e.g. for Lufthansa, Pan Am, Audi, Levi's. From 1965 his own photo studio in Munich. 1972 first solo exhibition at the Christoph Dürr Gallery, Munich. In the same year moves to Casoli di Camaiore (Tuscany). There he concentrates on sculpting and painting. 1983 returns to Germany. Studio for photography, painting, and sculpting, first in Frankfurt, then Berlin. In 1995 major contribution to the big retrospective *twen. Revision einer Legende* (*twen*. Review of a legend) at Münchner Stadtmuseum. 2004 Dr Erich-Salomon Prize of the DGPh (Deutsche Gesellschaft für Photographie: German Photographic Association). *www.will-mcbride-art.com*

"McBride's pictures speak of events lived out at first-hand, of longings and anxiety, of subjective responses and personal experiences. It was precisely by restricting himself to a German reality viewed from the inside that he succeeded in capturing a compelling portrait of an entire generation, its ideas and ideals, its hidden fears, in images that are as persuasive as they are forceful." — Klaus Honnef ✍

EXHIBITIONS (Selected) — **1981** Hamburg (PPS. Galery) SE // **1983** Hamburg (Art + Book) SE // **1992** Frankfurt am Main (Kunstverein) SE // **1995** Munich (Stadtmuseum) GE // **2000** Berlin (Camera Work Gallery- 2007) SE // **2005** Leipzig (Kamera- und Fotomuseum) SE // Bologna (Italy) (Galleria d'Arte Moderna / CAM) SE // **2006** Berlin (argus fotokunst gallery) SE // **2007** Kaufbeuren (Germany) (Kunsthaus) SE

BIBLIOGRAPHY (Selected) — **Zeig mal!** Wuppertal 1974 // **Knips. Berliner Bilder aus den 50er Jahren.** Berlin 1979 // **Foto- Tagebuch 1953–1961.** Berlin 1982 // **Siddharta.** Kehl am Rhein 1982 // **Boys.** Munich 1986 // **40 Jahre Fotografie.** Schaffhausen 1992 // **My Sixties.** Cologne 1994 ✍ // Hans-Michael Koetzle (ed.): **twen. Revision einer Legende.** Munich 1995 (cat. Stadtmuseum) // Hans-Michael Koetzle and Carsten M. Wolff: **Fleckhaus. Deutschlands erster Art Director.** Munich 1997 // **I, W. McB.** Cologne 1998 // **Coming of Age.** New York 1999 // **Romy. Fotografische Erinnerungen Paris 1964.** Munich 2002 // **Mein Italy.** Munich 2003 // **Berlin im Aufbruch. Fotografien 1956–1963.** Leipzig 2013

Don*(ald)* McCullin

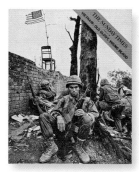

Don McCullin: **Vietnam: Old Glory, Young Blood,** from: **The Sunday Times Magazine,** 24.3.1968

9.10.1935 London (England) — Lives in Braughing (England) Since the 1960s known primarily as a war chronicler. Moved more recently to nature: landscapes and still-life photography. Art scholarship for the Hammersmith School of Arts and Crafts. Leaves after the death of his father (1949). Various jobs. 1953–1955 served in the Royal Air Force, where he works in aerial reconnaissance. Turns to photography on leaving the Air Force, showing a distinct interest in people living on the fringes of society (the handicapped, the homeless). 1958 first published photograph, *The Guv'nors of Seven Sisters Road.* 1961 pictures of the building of the Berlin Wall, resulting in the British Press Award. Works for the *Observer.* From 1964 staff photographer on *The Sunday Times Magazine.* In this capacity he witnesses all the great conflicts of the time after 1945: Cyprus, Vietnam, Cambodia, Middle East, India, Pakistan, Biafra, El Salvador, Northern Ireland. 1984 leaves *The Sunday Times* (after it is taken over by publisher Rupert Murdoch). Since then working freelance. Mainly still lifes and landscapes. Awards include the Grand Prix of the American Society of Media Photographers for his complete works (1978), Dr Erich-Salomon Prize of the DGPh (Deutsche Gesellschaft für Photographie: German Photographic Association) (1992), CBE (Commander of the British Empire) (1993). 1995 marries photographer Marilyn Bridges (divorced). Portfolios in *Camera, Creative Camera, Photo* (Paris), *Zoom, Photographies Magazine.*

"In the life of great photographers there is often a certain meeting, a friendship that triggers their career and defines its course. None of this is true for Don McCullin. He discovered photography on his own, almost as a surprise, while struggling with all his strength against the straitjacket of post-war English society – a society where he did not feel at home. Equally it was he who decided that misery, pain, fear and death were the only challenges he wanted to confront with his photography. Equally, too, he felt on his own on the dangerous killing fields around the world when confronted with the suffering of victims, even when surrounded by his colleagues."

— Robert Pledge ✎

EXHIBITIONS (Selected) — **1971** London (Kodak Gallery) SE // **1980** London (Victoria and Albert Museum) SE // **1988** London (Hamiltons – 1994, 2000) SE // **1991** Bath (Royal Photographic Society) SE // **1992** Arles (Rencontres internationales de la photographie) SE // **1993** Paris (Centre national de la photographie) SE // **1994** Chambéry (France) (Maison de la Culture) SE // Paris (Galerie Agathe Gaillard) SE // **1998** Bradford (England) (National Museum of Photography, Film and Television) GE // **2001** Paris (Maison européenne de la photographie) SE // **2002** Amsterdam (Fotografiemuseum Amsterdam) SE // **2005** Charleroi (Belgium) (Musée de la Photographie) SE // **2006** Arles (Rencontres internationales de la photographie) GE // **2007** London (National Portrait Gallery) SE // **2009** Berlin (C/O Berlin) SE

BIBLIOGRAPHY (Selected) — **The Destruction Business.** London 1971 // **Homecoming.** London 1979 // **The Palestinians.** London 1980 // **Hearts of Darkness.** London 1980 // **I Grandi Fotografi: D.McC.** Milan 1987 // **Skulduggery.** London 1987 // **Open Skies.** London 1989 // **Unreasonable Behaviour: An Autobiography.** New York 1992 // **D.McC.** Paris 1992 ✎ // **Sleeping with Ghosts: A Life's Work in Photography.** London, 1994 // Martin Harrison: **Young Meteors: British Photojournalism: 1957–1965.** London 1998 (cat. National Museum of Photography, Film and Television, Bradford) // **India.** London 1999 // **D.McC.: Photographies 1961–2001.** Paris 2001 (cat. Maison européenne de la photographie) // **In England.** London 2007

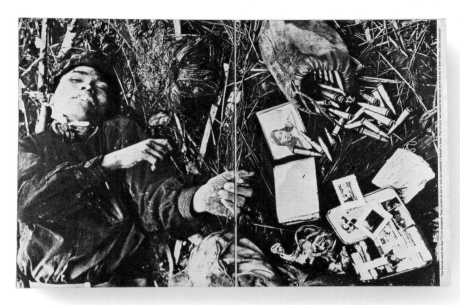

"The Marines search the dead VCs for documents. Then you find out that they're dead [the members] a familiar exercise. They all carry nice snapshots and all carry these nice little pictures of their dead relatives." South Vietnam, 1968.

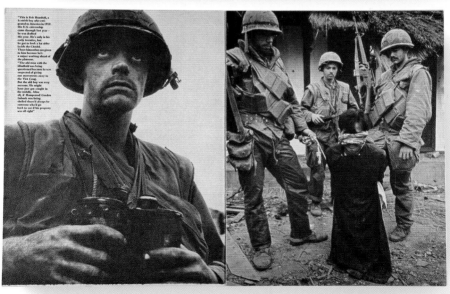

"This is Bob Hunskell, a Scottish boy who emigrated to America in 1959. His U.S. citizenship came through last year—he was drafted this year. He's only in his early twenties, but he got to look a bit older beside the Citadel. Those binoculars are given to him because he's a sniper working ahead of the platoons.

"The old man with the blindfold was being questioned because he was suspected of giving our movements away to the Viet Cong. But the old boy was very nervous. He might have just got caught in the middle. After all, if Hampstead Garden Suburb was being shelled they'd always be someone who'd go back to see if his property was all right."

Steve McCurry

Steve McCurry: **Portraits.**
London (Phaidon Press) 1999

24.2.1950 Philadelphia (Pennsylvania, USA) — Lives in New York (USA)
Magnum member. Especially known for his reports on Afghanistan. Numerous publications in *National Geographic*. Photojournalism at the intersection of reportage, landscape, and travel photography. Studies at Pennsylvania State University (cinematography and history), where he receives his B.A. Afterwards spends two years working for local newspapers. Later moves to India as a freelance photographer. 1979 eye witness of the Soviet invasion of Afghanistan, the starting point for his photographic work as well as of his affinity for the country and its culture. 1980 Robert Capa Gold Medal for his coverage of Afghanistan (published in *Time*). Afterwards regular photo reports from combat areas and areas of international conflict in Europe (former Yugoslavia), the Near East (Iran, Iraq, Lebanon, Yemen), the Far East (Cambodia, Philippines), returning again and again to Afghanistan, where he takes his probably best-known photograph in 1984: the portrait of a young girl with haunting green eyes (identified as Sharbat Gula years later). Printed in June 1985 as the cover image of *National Geographic*, the picture becomes the icon of the decade and something like the photographer's trademark. Magnum member since 1986. Numerous awards, incl. World Press Photo (1985, 1992), Picture of the Year Competition (1992, 1996, 1997, 1998, 2000), Book of the Year (2000), Photographer of the Year (2002), Lucie Award for Photojournalism (2003). Since 2005 Honorary Fellow of the Royal Photographic Society of Great Britain. *www.stevemccurry.com*

EXHIBITIONS (Selected) — **2001** Portland. (Oregon) (Radiant Light Gallery) SE // Annapolis (Maryland) (Vision Workshops) 2001 // **2002** Daytona Beach (Florida) (Southeast Museum of Photography – 2007) SE // Oslo (Stenerson Museum) SE // Lisbon (Palacio dos Aciprestes) SE // Madrid (School of Photography) SE // **2003** Baltimore (Maryland) (Levering Hall/Johns Hopkins University) SE // Philadelphia (Arthur Ross Gallery/University of Pennsylvania) SE // Rochester (New York) (George Eastman House) SE // Santa Monica (California) (Peter Fetterman Gallery – 2004) SE // **2004** Ottawa (Canada) (Phil Woods Gallery) SE // Boca Raton (Florida) (USA) (Boca Museum of Art) SE // **2005** San Diego (California) (Museum of Photographic Arts) SE // London (Asia House) SE // Amsterdam (Fotografiemuseum Amsterdam/**Things as they are**) GE // **2006** New York (United Nations Headquarter) SE // Modena (Italy) (Galleria ModernArte) SE // **2007** Los Angeles (Fahey/Klein Gallery) SE Denver (Colorado) (Camera Work) SE // **2008** Iserlohn (Germany) (Städtische Galerie) SE // **2009** Schleswig (Germany) (Stadtmuseum/**Retrospektive**) SE

BIBLIOGRAPHY (Selected) — **The Imperial Way.** Boston 1985 // **Monsoon.** London 1988 // **Portraits.** London 2000 // **South Southeast.** London 2000 // **Sanctuary.** London 2002 // **The Path to Buddha.** London 2003 // Chris Boot (ed.): **Magnum Stories.** London 2004 // Mary Panzer: **Things as they are.** London 2005 (cat. Fotografiemuseum Amsterdam) ✐ // Anthony Bannon (ed.): **S.M.** London 2005 // **Looking East.** London 2006 // Brigitte Lardinois: **Magnum Magnum.** Munich 2007 // **The Iconic Photographs.** London 2012 // **National Geographic. Around the World in 125 Years.** Cologne 2014 // **Afghanistan.** Cologne 2017

"While his earlier photographs are raw by comparison, by the time McCurry revisited he had perfected a craft that was old-fashioned, in the traditions of humanist reportage, while employing a heightened awareness of light and color within a seductive, contemporary Pictorialism. Always informative and relentlessly optimistic, his pictures have become a central ingredient of *National Geographic* from the early 1980s to the present — in forty major stories and some of its most memorable covers — as the magazine sought to outshine its rivals with the brilliance of its pictures." — Bruno Ceschel ✍

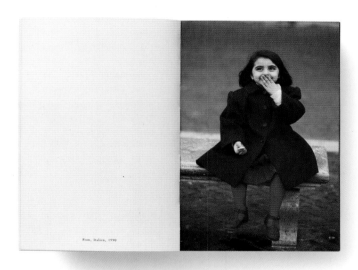

Rom, Italien, 1990

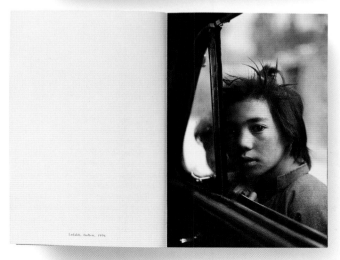

Ladakh, Indien, 1976

Frances McLaughlin *(Frances McLaughlin-Gill)*

22.11.1919 New York (USA) — 23.10.2014 Notable fashion photographs from the 1940s and 50s. Has worked especially for *Vogue*. Childhood in Connecticut. Returns to New York. There (until 1941) she takes studies in art at the Pratt Institute. At the same time courses in photography with Walter Civardi. Among the finalists in the Prix de Paris competition organized by *Vogue*, resulting in a job as "fashion coordinator". Soon changes to photography, to begin with as assistant. From 1943 (promoted by > Liberman) photographer for Condé Nast (*Vogue, Glamour, House & Garden*). Freelance work from 1955. Between 1964 and 1973 also television commercials. Author of several books, among them *A Classical Approach to Photography* (about her husband, the photographer Leslie Gill).

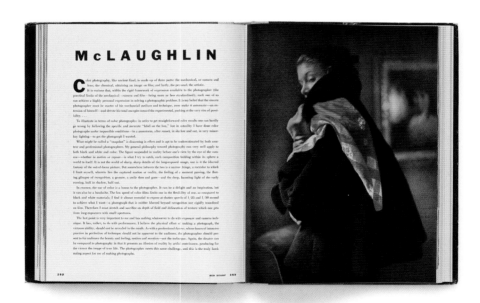

EXHIBITIONS (Selected) — **1986** Cologne (photokina) GE // **1991** London (Victoria and Albert Museum) GE // **2004** New York (Staley-Wise Gallery/**Suzy to Twiggy: The Fashion Revolution 1950–1970**) GE

BIBLIOGRAPHY (Selected) — Alexander Liberman: **The Art and Technique of Color Photography.** New York 1951 // Polly Devlin: **Vogue Book of Fashion Photography.** New York 1979 // **50 Jahre Moderne Farbfotografie 1936–1986.** Cologne 1986 (cat. photokina) // Martin Harrison: **Appearances: Fashion Photography Since 1945**. London 1991 (cat. Victoria and Albert Museum) ✍

"Liberman saw in Frances McLaughlin, then only twenty-four years old, the ideal interpreter of junior fashions. He noted later that her work was 'pure, the kind of photographic vision which bordered on improvisational theater, catching the model's face at a sensitive moment rather than following an artificial grammar inherited from the European photographers who were the stars of the moment'." — Martin Harrison ✍

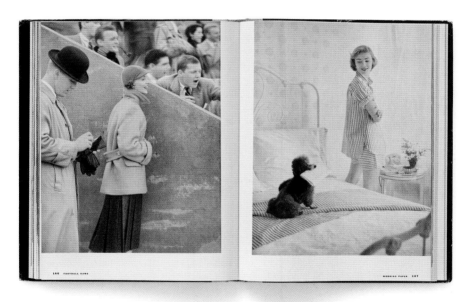

Frances McLaughlin: **Red Scarf, Football Game, Morning Paper,** from: **The Art and Technique of Color Photography.**
New York (Simon & Schuster) 1951

Ralph Eugene Meatyard

Ralph Eugene Meatyard.
New York (Aperture) 1974

15.5.1925 Normal (Illinois, USA) — 7.5.1972 Lexington (Kentucky, USA)
Lone wolf in American photography from the 1950s to the 60s. Influences of Zen and modern literature. Known for his symbolic photographic explorations in b/w, heightened by the use of props (masks) or a deliberate lack of definition. High school in Normal. 1944 serves with the Navy. 1946—1949 trains to be an optician in Chicago. Works briefly as an optician. 1950 takes courses at Illinois Wesleyan University (history, philosophy, economics). From 1950 works as an optician for Tinder-Krauss-Tinder. First camera in the same year. 1954 joins the Lexington Camera Club, where he receives instruction from Frank Van Deren Coke. Member of the Photographic Society of America (PSA). In 1956, together with > Ansel Adams, Ruth Bernhard, > Callahan, > Siskind, Edward Weston, and > White, participates in the *Creative Photography* exhibition curated by Coke. Takes part in courses run by Henry Holmes Smith at Indiana University, Bloomington. Participates in the *Sense of Abstraction* exhibition organized by Nathan Lyons at MoMA, New York. 1967 opened his own optician's business. In 1968 curator of the *Photography 1968* exhibition, the first of three exhibitions (presenting important "schools" in American photography). In 1970, the year he is diagnosed as having cancer, he begins his last cycle: *The Family Album of Lucybelle Crater.*

"Comic and tragic, grotesque and beautiful at the same time, Meatyard's pictures ask the persistent, insoluble questions that animate our existence. […] There was probably no other American photographer of his day who combined so steadfastly and energetically the intellectual force of an allusive, metaphorical content and the formal power of a sophisticated aesthetic."
— James Rhem ✎

EXHIBITIONS (Selected) — **1956** New York (Photographer's Gallery) JE (with Van Deren Coke) // **1957** New Orleans (Louisiana) (Tulane University) SE // **1961** Albuquerque (New Mexico) (University of New Mexico) SE // **1962** Louisville (Kentucky) (J.B. Speed Museum) JE (with Walt Lowe) // **1970** Chicago (Institute of Design) SE // **1973** New York (Witkin Gallery) SE // **1974** Louisville (Kentucky) (J.B. Speed Museum) JE (with Henry Holmes Smith) // **1977** New York (Pace/MacGill Gallery) JE (with William Wegman) // **1978** San Francisco (Museum of Modern Art) JE (with Clarence John Laughlin) // **1979** Akron (Ohio) (Akron Art Museum) SE // **1994** Durham (North Carolina) (Duke University) SE // **1996** Arles (France) (Rencontres internationales de la photographie) SE // **1998** New York (Howard Greenberg Gallery – 2007) SE/GE // **2002** San Francisco (Fraenkel Gallery – 2005, 2007) SE // **2004** New York (International Center of Photography) SE // **2005** Tucson (Arizona) (Center for Creative Photography) SE

BIBLIOGRAPHY (Selected) — **R.E.M.** Lexington 1970 // **The Family Album of Lucibelle Crater.** New York 1974 // **R.E.M.: A Retrospective.** Normal 1976 (cat. Illinois State University) // **The Photographs of R.E.M.** Williamstown 1977 (cat. Williams College Museum of Art) // **R.E.M.: Caught Moments – New Viewpoints.** London 1983 (cat. Olympus Gallery) // **R.E.M.: American Visionary.** New York 1991 // **R.E.M.: In Perspective.** Udine 1996 // **R.E.M.** Paris 2000 (= Photo Poche no. 87) ✎ // **A Fourfold Vision.** San Francisco 2005 (cat. Fraenkel Gallery) // Guy Davenport: **R.E.M.** Göttingen 2005

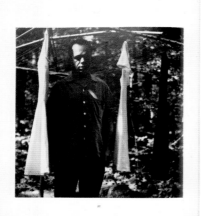

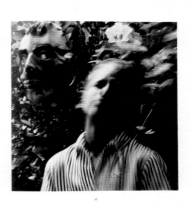

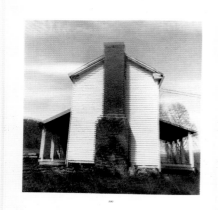

Joel Meyerowitz

3.6.1938 New York (USA) — Lives in New York Leading exponent of New Color Photography in the USA since the 1960s. Street photography and, increasingly, landscapes and portraits 1956–1959 Ohio State University, Columbus. Studies painting and medical illustration (B.A.). 1959 returns to New York and works there till 1962 as a designer and art director. Takes up (35mm) street photography under the influence of work by > Frank. Self-taught. Photographs in b/w and from the outset on transparency material, whose expensive conversion into dye transfer prints initially discouraged a wide uptake. Examples in Sally Eauclaire: *American Independents* (1987), *Aperture* (no. 78), and his own book *Wild Flowers* (1983). 1973 opens his own color laboratory. Subsequently mainly works in and known for color photography. From 1976 also and primarily in large format (8 x 10 in.). Mainly landscapes and portraits. 1978 publishes his first, much-praised book, *Cape Light*, which has long since enjoyed the status of a photography classic. Lectureship at the Cooper Union and from 1977 associate professorship of photography at Princeton University (New Jersey). Also publicity for various clients. Numerous grants and awards, among them Guggenheim fellowships (1971, 1979), Photographer of the Year (Friends of Photography, 1981), and a National Endowment for the Humanities grant (for a planned book on the history of street photography). 1998 *POP* ("a feature-length documentary about a road trip with his father").

"**A close friend of Garry Winogrand, Joel Meyerowitz began his career in the 1960s as a street photographer who recognized his debt to the Cartier-Bresson aesthetic. Like Helen Levitt and Winogrand, Meyerowitz started off by alternating between black-and-white and color photographs. In 1972 he permanently adopted color, simultaneously switching to large format in order to enjoy its greater descriptive value. Nonetheless, many of his images, such as a beautiful 1978 series on Saint Louis and the Gateway Arch, continued to bear the dynamic characteristics of 35mm street photography.**" — Gilles Mora ✍

EXHIBITIONS (Selected) — **1966** Rochester (New York) (George Eastman House) SE // **1968** New York (Museum of Modern Art) SE // **1978** Boston (Massachusetts) (Museum of Fine Arts) SE // **1980** Amsterdam (Stedelijk Museum) SE // **1981** San Francisco (Museum of Modern Art) SE // **1986** New York (Brooklyn Museum) SE // **1990** New York (James Danziger Gallery — 1992, 1996) SE // **1994** Chicago (Art Institute) SE // **1997** Santa Monica (California) (Peter Fetterman Gallery) SE // **2002** New York (Museum of the City of New York) SE // **2004** Cologne (Galerie Thomas Zander — 2007) SE // **2006** New York (Edwynn Houk Gallery — 2008) SE // Paris (Jeu de Paume) SE // **2007** Rotterdam (Nederlands Fotomuseum) SE // **2008** Thessalonica (Greece) (Contemporary Art Centre) SE // Hamburg (Haus der Photographie/**New Color Photography**) GE // **2013** Paris (Maison européenne de la photographie) SE

BIBLIOGRAPHY (Selected) — **Cape Light.** Boston 1978 // **St. Louis and the Arch.** Boston 1981 // **Wild Flowers.** Boston 1983 // **A Summer's Day.** New York 1986 // **The Arch.** Boston 1988 // **Redheads.** New York 1990 // **A Sense of Place.** Washington, DC, 1990 // **Bay/Sky.** Boston 1993 // **The Nutcracker.** New York 1993 // **The Nature of Cities.** Milan 1994 // J.M. and Colin Westerbeck: **Bystander: A History of Street Photography.** Boston 1994 // **At the Water's Edge.** Boston 1997 // Colin Westerbeck: **J.M.** London 2005 // **J.M.: Out of the Ordinary.** Rotterdam 2007 (cat. Nederlands Fotomuseum) // Gilles Mora: **The Last Photographic Heroes: American Photographers of the Sixties and Seventies.** New York 2007 ✍

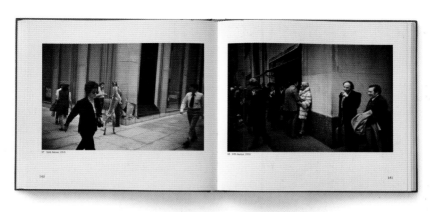

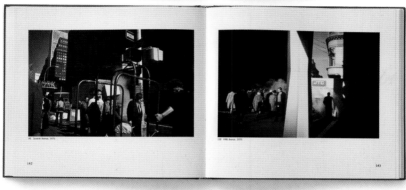

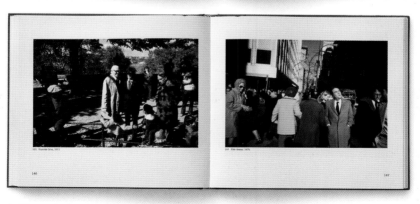

Joel Meyerowitz: **Out to Lunch,** from:
Sally Eauclaire: **American Independents:**
Eighteen Color Photographers.
New York (Abbeville Press) 1987

Duane (Stephen) Michals

Duane Michals: **Real Dreams.
Photo Stories by Duane Michals.**
Rochester (Light Impressions)
1976

18.2.1932 McKeesport (Pennsylvania, USA) — Lives in New York (USA)
Narrative sequences from the 1960s. Staged photo stories in b/w, inspired by psychoanalysis or Surrealism, to make manifest inner dreams, anxieties, obsessions. Son of Czech immigrants, father steelworker, mother housekeeper. Shows a keen interest in art early on at high school. Attends a watercolor course at the Carnegie Institute in Pittsburgh (Pennsylvania). Thanks to good school results, awarded a scholarship to the University of Denver (B.A. 1953). Goes straight from college into military service. Tank corps lieutenant in Germany. After discharge (1956) continues his studies at the Parsons School of Design in New York. Training in graphic design. Breaks off his studies after one year to take a post as assistant art director with the magazine *Dance*. 1958 responsible for layout in the PR department of Time, Inc. 1958 goes on a three-week visit to the Soviet Union, which is beginning to open up. First pictures taken with a borrowed Argus C3. Mainly portraits, deliberately without any claim to professionalism but still of great simplicity and immediacy. Participation as early as 1959 in a group exhibition in the Image Gallery in New York (with > Winogrand). Subsequently concentrates on photography as a vehicle of expression. Technical instruction from his friend, the photographer Daniel Eutin. 1966 first so-called "photo stories": shot on location using only available light and deliberately minimal technology. Parallel with his artistic work, internationally known since the 1970s, commercial pho-

EXHIBITIONS (Selected) — **1963** New York (Underground Gallery — 1965, 1968) SE // **1966** Rochester (New York) (George Eastman House/**Toward a Social Landscape**) GE // **1968** Chicago (Art Institute — 1988) SE // **1970** New York (Museum of Modern Art) SE // **1971** Rochester (New York) (George Eastman House — 1990) SE // **1973** Cologne (Kölnischer Kunstverein) SE // **1976** New York (Sidney Janis Gallery — 1978, 1980, 1983, 1985, 1987, 1989, 1991, 1992, 1994, 1997) SE // **1978** Cologne (Galerie Wilde — 1979, 1984) SE // **1982** Paris (Musée d'art moderne de la Ville de Paris) SE // **1984** Oxford, (Museum of Modern Art) SE // **1989** Hamburg (Museum für Kunst und Gewerbe) SE // **1990** San Diego (Museum of Photographic Arts) SE // **1992** Paris (Espace Photographique) SE // **1995** Brunswick (Germany) (Photomuseum) SE // **2000** Frankfurt am Main (Fotografie Forum International) SE // **2001** Madrid (PHotoEspaña/Galería Max Estrella) SE // **2003** New York (Pace/MacGill Gallery — 2005, 2008) SE // **2004** Duisburg (Germany) (Landschaftspark Duisburg/Pumpenhalle) SE // Düsseldorf (Galerie Clara Maria Sels) SE // **2006** Amherst (Massachusetts) (Mead Art Museum) SE // Los Angeles (Fahey/Klein Gallery) SE // **2008** Verona (Italy) (Scavi Scaligeri/Centro Internazionale de Fotografia) SE // **2009** Charleroi (Belgium) (Musée de la Photographie) SE // Arles (Rencontres internationales de la photographie) SE // **2013** Salzburg (Museum der Moderne) GE

BIBLIOGRAPHY (Selected) — Nathan Lyons (ed.): **Contemporary Photographers: Toward a Social Landscape.** New York 1966 (cat. George Eastman House, Rochester) // **Sequences.** New York 1970 // **Real Dreams: Photo Stories by D.M.** Rochester 1976 // **D.M.: Photographies de 1958 à 1982.** Paris 1982 (cat. Musée d'art moderne de la Ville de Paris) // **D.M.: Photographs/Sequences/Texts 1958–1984.** Oxford 1984 (cat. Museum of Modern Art) // **Album: The Portraits of D.M. 1958–1988.** Pasadena 1988 // **D.M.: Photographien 1958–1988.** Hamburg 1989 (cat. Museum für Kunst und Gewerbe) // **The Essential D.M.** London 1997 // **Quantum & Metafisica.** Düsseldorf 2004 (cat. Galerie Clara Maria Sels) // **Foto Follies.** London 2007 // **Focus on Photography.** Munich 2013 (cat. Museum der Moderne, Salzburg)

tography for *Esquire*, *Mademoiselle*, *Show*, later also for *Vogue*, *The New York Times*, *Horizon*, and *Scientific American*. Numerous accolades and awards, incl. a CAPS grant (1975), an NEA grant (1976), an ICP Infinity Award for Art (1981), and a Gold Medal for Photography from the National Arts Club, New York (1994).

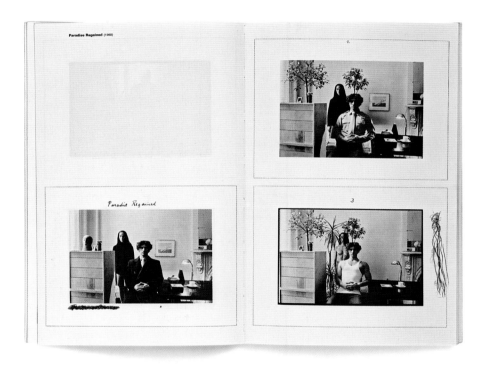

Paradise Regained (1968)

Paradise Regained

"However unconventional his solutions, Michals neither leads the charge against photographic traditions, nor does he indulge in experiments with form merely for the sake of innovation. His drive to extend the potential of his medium is always grounded in the need to find the liveliest possible form of expression for the matter in hand and a variety of moods, from the serious to the sensual and even the comic. One of the many themes – which address the essence of such abstract concepts as time, fantasy and soul, but also deal with sexual desire, human dependency and the acceptance of death – always acts as a catalyst for the creation of a work."
— Marco Livingstone ✍

Boris Mikhailov

Boris Mikhailov: **Case History.**
Zurich (Scalo Verlag) 1999

25.8.1938 Charkov (Ukraine) — Lives in Charkov (Ukraine) and Berlin (Germany) Internationally most highly respected Ukrainian photo artist of the present day. Freelance series as critical-ironical commentaries on the culture of everyday life in his country. Trains as an engineer, and works for years in engineering, all the while pursuing a keen interest in photography. First pictures at the age of 28. Forced in the late 1960s to abandon his profession after nude studies of his wife are discovered by the KGB and condemned as "pornography". Subsequently devotes himself completely to photography. As well as small commissions, works freelance on series and sequences in the manner of a conceptual photo art, which is a clear departure from the doctrine of Socialist Realism: staged scenes, self-dramatizations, over-paintings, and cycles with found material at the center of his quasi-subversive art, which has been much discussed in the West since the mid-1990s. Examples: *Red Series* (1968–1975), *Private Series* (late 1960s), *Calendar Series* (late 1960s), *Luriki* (1971–1985), *Sots Art* (1975–1986), *Viscidity* (1982), *Series of Four* (1982–1983), *Salt Lake* (1980), *By the Ground* (1991), *At Dusk* (1993), *I am not I* (1993). A number of major prizes, incl. the Hasselblad Award in 2000, Citibank Photography Prize (2001), Kraszna-Krausz Book Award (2001).

EXHIBITIONS (Selected) — **1990** Tel Aviv (Museum of Contemporary Art) SE // **1992** Graz (Forum Stadtpark) SE // **1995** Frankfurt am Main (Portikus) SE // **1996** Kiev (Soros Center of Contemporary Art) SE // **1997** Berlin (Galerie in der Brotfabrik) SE // **1998** Hannover (Sprengel Museum) SE // **1999** Paris (Centre national de la photographie) SE // **2000** Gothenburg (Sweden) (Hasselblad Center SE // **2003** Winterthur (Fotomuseum/**Eine Retrospektive**) SE // Berlin (Galerie Barbara Weiss – 2004, 2007) SE // Munich (Barbara Gross Galerie – 2007) SE // Leipzig (Hochschule für Grafik und Buchkunst) SE // **2004** Barcelona (Palau de La Virreina) SE // Moscow (Moscow House of Photography) SE // Porto (Museu de Arte Contemporânea de Serralves) SE // Boston (Institute of Contemporary Art) SE // **2005** Geneva (Centre de la Photographie) SE // Amsterdam (Fotografiemuseum Amsterdam) SE // **2007** Hannover (Sprengel Museum) SE // Arles (Rencontres internationales de la photographie) SE

BIBLIOGRAPHY (Selected) — **If I Were a German.** Dresden 1995 // Brigitte Kölle (ed.): **B.M.** Cologne 1995 (cat. Portikus, Frankfurt am Main) // Brigitte Kölle (ed.): **At Dusk**. Cologne 1996 // Brigitte Kölle (ed.): **By the Ground**. Cologne 1996 // **9 x Fotografie**. Berlin 1997 (cat. Galerie in der Brotfabrik) // **Unfinished Dissertation**. Zurich 1998 // **Les Misérables.** Hannover 1998 (cat. Sprengel Museum) // **Case History.** Zurich 1999 // **Äußere Ruhe.** Düsseldorf 2000 // **B.M.: The Hasselblad Award 2000.** Gothenburg 2000 (cat. Hasselblad Center) // **B.M.: Eine Retrospektive.** Zurich 2003 (cat. Fotomuseum Winterthur) // **Look at me I look at water.** Göttingen 2004 // **B.M., Ilya Kabakov. Verbal Photography.** Porto 2004 (cat. Museu de Arte Contemporânea de Serralves) // **Suzi et cetera.** Cologne 2006 // **Yesterday's Sandwich.** London 2007 // **Maquette Braunschweig.** Göttingen 2010

"Boris Mikhailov is unquestionably the leading photographer with a 'Soviet background' today. In recent years his exhibitions and books have attracted enormous international attention. At this point in his over thirty year long career, Boris Mikhailov continues to develop his great theme — his narrative of the wreck of the Soviet utopia. Boris Mikhailov's stance is critical; his work is consistently humanist in approach, with strong emotional elements and a sense of humor that audiences in both East and West have found moving. Despite working under extremely difficult circumstances, he has always succeeded in creating deeply engaging and exciting photographic art." — Gunilla Knape ✎◻

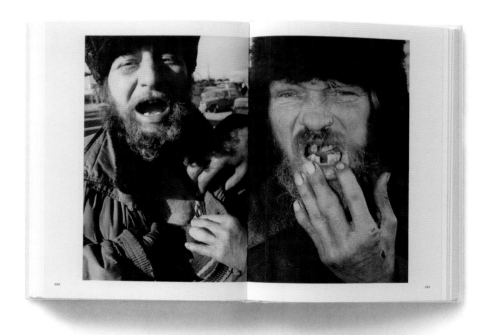

Gjon Mili

Gjon Mili: **Photographs & Recollections.** Boston (New York Graphic Society) 1980

28.11.1904 Korça (Albania) — 14.2.1984 Stamford (Connecticut, USA)
Photojournalist, *Life* photographer. Known in particular for his studies of movement inspired by > Edgerton and his stroboscope technology. Childhood in Romania. 1923 moves to the USA. 1923–1927 studies electrical engineering at Massachusetts Institute of Technology, graduating in 1927. In 1928–1938 works as an engineer and lighting technician at Westinghouse Electric in Cambridge (Massachusetts). Self-taught as a photographer. 1937 gets to know > Edgerton, the inventor of the stroboscope. First experiments with this process. Photographs tennis star Bobby Riggs for *Life*. Subsequently associated with the magazine for many years. 1939 moves to New York and works exclusively as a photographer. Photo reports and portraits (incl. Pablo Casals, Édith Piaf, Jean-Paul Sartre), mainly for *Life*. Also sport, music, dance, and theater photography. His best-known photograph is a portrait of Pablo Picasso drawing with light. Works periodically as assistant to Edward Weston. A pioneer of photoflash or high-speed photography. 1963 prize of the American Society of Magazine Photographers. Several books. Numerous exhibitions particularly in connection with the magazine *Life*. Also short films, e.g. about Dave Brubeck, Lester Young, Pablo Casals, and Pablo Picasso. 1980 major retrospective at the International Center of Photography in New York.

"**Photographs taken with the stroboscope flash capture forms that the naked eye could never see. In this way Edgerton took highly imaginative staccato pictures of sequences of movement and pathways of objects moving almost with the speed of light. Gjon Mili used this multiple-exposure technique to capture on film the whirling of drumsticks, or a dance-step in ballet. The camera here goes beyond the realm of the visible into a world of forms to which the eye normally has no access.**" — Beaumont Newhall ✎

EXHIBITIONS (Selected) — **1942** New York (Museum of Modern Art – 1952) SE // **1964** New York (Time-Life Building) SE // **1970** New York (Lincoln Center for the Performing Arts) SE // Arles (Musée Réattu) SE // **1971** Paris (Musée des Arts décoratifs) SE // **1979** Cambridge (Massachusetts) (Massachusetts Institute of Technology) SE // **1980** New York (International Center of Photography/Retrospektive) SE // **1981** Arles (Rencontres internationales de la photographie/Retrospektive) SE // **2003** Canberra (Australia) (National Gallery of Australia) GE // **2005** Munich (Galerie Stephen Hoffman) GE // **2006** New York (Staley-Wise Gallery) GE // Hamburg (Haus der Photographie/Deichtorhallen) GE // **2007** Hamburg (Flo Peters Gallery) GE // **2011** Cologne (Museum Ludwig) GE

BIBLIOGRAPHY (Selected) — **The Magic of the Opera.** New York 1960 // **Picasso's Third Dimension.** New York 1970 // **G.M.: Photographies.** Paris 1971 (cat. Musée des Arts décoratifs) // **Photographs & Recollections.** Boston 1980 // Beaumont Newhall: **Geschichte der Photographie.** Munich 1984 ✎ // **The Great LIFE Photographers.** New York 2004 // **Ichundich- undich. Picasso im Fotoporträt.** Cologne 2011 (cat. Museum Ludwig)

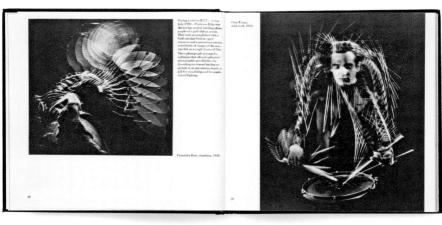

During a visit to M.I.T.—it was July 1939—Professor Edgerton showed me several startling photographs of a golf club in action. They were accomplished with a flash unit that fired at rapid sequence and captured on one has a multitude of images of the moving club on a single frame of film.

These photographs presaged a technique that offered unlimited photographic possibilities for detecting movement but that required, to an uncommon degree, a gift for visualizing and for sophisticated lighting.

Franziska Boas, drumbeat, 1939.

Gene Krupa, stick work, 1941.

28 29

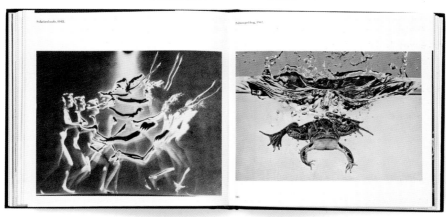

Solarized nude, 1942.

Submerged frog, 1941.

(Elizabeth) Lee Miller

Jane Livingston: **Lee Miller Photographer.** London
(Thames and Hudson) 1989

23.4.1907 Poughkeepsie (New York, USA) — 27.7.1977 Sussex (England)
Model, photographer, journalist. Portraits, self-portraits, fashion, nude studies, the free development of image concepts in the spirit of Surrealism. War correspondent during WW II. Unquestionably one of the most scintillating talents in 20th-century photography. Second of three children. 1925 first visit to Paris. Studies at the École Medgyes (stage design). 1926 returns to New York, where she is a student at the Art Students League. 1927 meets Condé Nast, who discover her for *Vogue*. March 1927 her face appears on the cover of *Vogue* (drawing by George Lepape). Subsequently much sought-after as a model for famous fashion photographers (Arnold Genthe, > Horst, > Hoyningen-Huene, Arthur Muray, > Steichen). 1929 returns to Paris. Student, model, and lover of > Man Ray. Together they discovered solarization. From 1930 has her own studio in Paris. Commissions include sports fashions for *Vogue*. 1932 closes the studio and returns to New York. 1932 at Julien Levy: her only solo exhibition during her lifetime (30 December 1932 to 25 January 1933 – see *Julien Levy: Portrait of an Art Gallery*. Cambridge, Mass., 1998). 1934 marries Aziz Eloui Bey, an Egyptian. Lives in Egypt. Travels in France, holidays with Man Ray, Pablo Picasso, Paul Éluard. Meets the painter and art lover Roland Penrose. 1939 leaves Bey and joins Penrose in England. From 1940 photographer under contract to *Vogue*. 1942 war correspondent, with work incl. photographs of the liberation of Dachau concentration camp. 1945 Vienna. 1946 Budapest, Bucharest. 1947 marries Penrose. Articles for *Vogue* on the Biennale in Venice (1948), Picasso (1951), and (from 1966) on cookery. 1976 guest of honor at the Rencontres d'Arles. 1989 major retrospective visiting Washington, DC, New York (International Center of Photography), New Orleans (Louisiana), Minneapolis (Minnesota), San Francisco, Chicago, and Santa Monica (California). Estate (40,000 negatives) held by the L.M. Archive in Sussex.

EXHIBITIONS (Selected) — **1931** Paris (Galerie de la Pléiade) GE // **1932** New York (Julien Levy Gallery – 1933) GE/SE // **1955** New York (Museum of Modern Art/**The Family of Man**) GE // **1978** London (Mayor Gallery) SE // **1986** London (The Photographers' Gallery) SE // New York (Staley-Wise Gallery) SE // **1989** Washington, DC (Corcoran Gallery of Art) SE // **1992** Cologne (Museum Ludwig) SE // **1995** Berlin (Deutsches Historisches Museum) GE // **2001** Edinburgh (Scottish National Gallery of Modern Art) SE // **2002** Berlin (ART + INTERIOR) SE // **2008** Paris (Jeu de Paume) SE

BIBLIOGRAPHY (Selected) — **Grim Glory: Pictures of Britain under Fire**. London 1940 // **Wrens in Camera**. London 1945 // Antony Penrose: **The Lives of Lee Miller**. London 1985 // Jane Livingston: **L.M.: Photographer**. London 1989 (cat. Corcoran Gallery of Art, Washington, DC) // **L.M.: An Exhibition of Photographs 1929–1964**. Los Angeles 1991 (cat. California/International Arts Foundation) // **L.M.'s War: Photographer and Correspondent with the Allies in Europe 1944–45**. London 1992 // **Ende und Anfang**. Berlin 1995 (cat. Deutsches Historisches Museum) // Richard Calvocoressi: **L.M.: Portraits from a Life**. London 2002 // Mark Haworth-Booth: **L.M.** Paris 2008 (cat. Jeu de Paume) // **Fotografin – Muse – Model**. Zurich 2013

"Lee Miller's name, when it is known to the contemporary audience, is associated primarily with her status in any of three roles. She may be remembered as one of the great beauties of the European-American social and artistic scene of the 1920s and 30s; as Man Ray's model, lover and photographic collaborator in Surrealist Paris; or, finally, as Lady Penrose, the illustrious wife of Sir Roland. She was all of these things. But perhaps more important for her, and for us, she was herself an artist. Indeed, it is not too much to say that Lee Miller was one of the most distinctive and accomplished photographers of her generation." — Jane Livingston ✍

Lisette Model *(Élise Amélie Félice Stern / Seybert)*

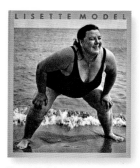

Lisette Model.
New York (Aperture) 1979

10.11.1901 Vienna (Austria) — 30.3.1983 New York (USA) Street photography in accordance with a radical new way of looking at things. Also fashion and portraits. Influential, not least as a teacher (Arbus). Daughter of an upper-middle-class Jewish family, with the name of Stern. Family name changed to Seybert on the initiative of her father (because of growing anti-Semitism in Vienna after 1900). Second of three children. Very talented musically, one of her teachers being Arnold Schönberg. 1926 moves to Paris. 1933 (for reasons still unknown) suddenly abandons music and takes up photography. Technical instruction from her sister Olga and her girlfriend, the photographer Rogie André. 1934 *Nice*: series about the Promenade des Anglais her first major work, published in the magazine *Regards* (no. 59, 1935). Meets Evsa Model, her future husband. 1935–1938 travels in the South of France and Italy. 1938 emigrates to the USA with Evsa.

In New York gets to know Beaumont Newhall, > Ansel Adams, and > Brodovitch, who soon becomes her chief mentor. 1941–1955 numerous pieces in *Harper's Bazaar* (incl. her Coney Island photo report). 1940 first acquisitions of selected works by MoMA, New York. Up to 1947 her most productive period, with several major work groups incl. *Lower East Side*, the series *Passers-by* and *Reflections*, and series featuring the New York night life (*Nick's, Gallagher's*). 1944 becomes an American citizen. 1946 spends time in San Francisco. Portraits there of famous artists (incl. > Lange, > Cunningham, and Edward Weston) and circus photographs. 1951 takes up teaching post at the New School for Social Research. One of her students is > Arbus. 1953 first trip to Europe since the war (incl. Paris and Rome). 1978 guest of honor at the Rencontres d'Arles. 1981 honorary doctorate from the New School. 1982 medal of the city of Paris. On 4 March 1983 a lecture at Haverford College is her last public appearance. Estate held by the Musée des beaux-arts du Canada.

EXHIBITIONS (Selected) — **1940** New York (Museum of Modern Art) GE // **1941** New York (Photo League) SE // **1943** Chicago (Art Institute) SE // **1955** New York (**The Family of Man**) GE // **1976** Washington, DC (Sander Gallery) SE // **1981** New Orleans (New Orleans Museum) SE // **1990** Ottawa (Musée des beaux-arts du Canada) SE // **1992** Cologne (Museum Ludwig) SE // **1996** New York (PaceWildensteinMacGill) JE (with Diane Arbus) // **2000** Vienna (Kunsthalle) SE // **2002** New York (Gallery 292) SE // **2003** Paris (Galerie Baudoin Lebon – 2007) SE // **2004** Los Angeles (Fahey/Klein Gallery) // **2005** Guangzhou (China) (Guangdong Museum of Art) SE // **2007** New York (Hasted Hunt) SE // **2009** Madrid (Fundación Mapfre) SE // **2010** Paris (Jeu de Paume) SE

BIBLIOGRAPHY (Selected) — **L.M.** New York 1979 (facsimile reprint: New York 2007) // **L.M.** Ottawa 1991 (cat. Musée des beaux-arts du Canada) // Jane Livingston: **The New School**. New York 1993 // **L.M.: Photographien 1933–1983.** Heidelberg 1992 (cat. Museum Ludwig Cologne) ✍ // **L.M.: Fotografien 1934–1960.** Vienna 2000 (cat. Kunsthalle) // **L.M.** Paris 2002 // Eugenia Parry: **L.M.** Santa Fe 2006 // Eugenia Parry: **Shooting Off My Mouth: Spitting Into the Mirror. Lisette Model – A Narrative Autobiography.** Göttingen 2009 // **L.M.** Paris 2010 (cat. Jeu de Paume)

"With her photographs Model touched almost every fleeting element that makes up the nebulous, regulative force we call 'the norm': patriotism, sexual identity, the genetic code. Her pictures of a man at a war demonstration in 1942 in New York, of the transvestite Albert-Alberta in Hubert's Flea Circus, of a midget, and of Percy Pape, who appeared in the circus as a 'human skeleton', show her interest in people who were either imprisoned in particular social orders or, in complete contrast, relegated to the margins of society." — Ann Thomas ✍

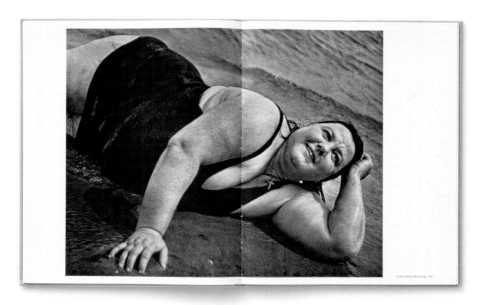

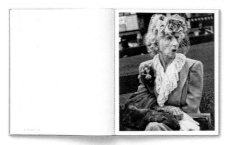

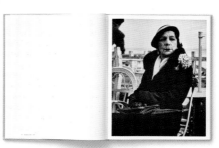

Tina Modotti *(Assunta Adelaide Luigia Modotti)*

17.8.1896 Udine (Italy) — 5.1.1942 Mexico City (Mexico) Strictly formal still lifes, plant studies, portraits, socially concerned photo reports. A small but multi-faceted oeuvre as the expression of a life lived intensely without regard for bourgeois conventions. Father a carpenter, mother a dressmaker. Elementary school, then factory work. Introduced to photography by her uncle. 1913 emigrates to the USA. Marries the writer and painter Roubaix de l'Abrie Richey. From 1917 lives in Los Angeles. 1920 moves to Hollywood. Film roles. Models for photographers such as Jane Reece, Johan Hagemayer, and (in particular) Edward Weston. 1922 death of her husband. 1923 moves with Weston to Tacubaja, shortly after to Mexico City. Gets to know José Clemente Orozco, Diego Rivera, Alfaro Siqueiros. At Weston's side she increasingly becomes interested in photography, discovers her own themes and an individual pictorial style. 1925–1926 San Francisco. Meets > Lange. Leaves Weston. Earns her living with photography. Numerous portraits. Lives with the painter and convinced Communist Xavier Guerrero, her photographs increasingly informed by a sharpened socio-political awareness. 1930 deported from Mexico. Via Rotterdam to Berlin with her friend and final life partner Vittorio Vidali. Gets to know Egon Erwin Kisch and Lotte Jacobi. October 1930 moves to Moscow. Gives up photography in favor of left-wing political activity. 1936 Spain, active in the civil war, partly with the medical corps. Gets to know > Capa and Gerda Taro. Paris. 1939 returns to Mexico. Dies of heart failure after an evening at the home of architect and former Bauhaus mandarin Hannes Meyer.

EXHIBITIONS (Selected) — **1924** Mexico (Aztec Land Shop) JE (with Edward Weston) // **1975** San Francisco (Museum of Modern Art) GE // **1977** New York (Museum of Modern Art) SE // **1991** Arles (Rencontres internationales de la photographie) JE (with Edward Weston) // **1995** Philadelphia (Pennsylvania) (Museum of Art) SE // New York (Throckmorton Fine Art) SE // **2000** Stockholm (Moderna Museet) SE // **2004** Brunswick (Germany) (Museum für Photographie) SE // **2010** Vienna (Kunst Haus) SE

BIBLIOGRAPHY (Selected) — Christiane Barckhausen: **T.M.: Wahrheit und Legende einer umstrittenen Frau**. Berlin 1989 // Constance Sullivan: **Women Photographers**. New York 1990 // Riccardo Toffoletti: **T.M.: Perché non muore il fuoco**. Udine 1992 // Naomi Rosenblum: **A History of Women Photographers**. New York 1994 // Sarah M. Lowe: **T.M.: Photographs 1923–1929**. New York 1995 (cat. Throckmorton Fine Art) // Margaret Hooks: **T.M.: Eine Biographie**. Munich 1997 // Patricia Albers: **Shadows, Fire, Snow: The Life of T.M.** New York 1999 // Letizia Argenteri: **T.M.: Between Art and Revolution**. London/New Haven 2003

"Tina Modotti, photographer and revolutionary, Weston's lover, friend of Frida Kahlo and Manuel Álvarez Bravo, transformed her life into a work of art in a Mexico in upheaval. She photographed folk art, social inequalities, portrayed famous people as well as farmers and workers, worked for *El Machete* and *Mexican Folkways*. Her most effective photographs are those she made just for the pleasure – sensual, willowy, abstract or real forms taking up those symbols of progress which greatly influenced the photography of her time." — Riccardo Toffoletti ✍

Tina Modotti (right-hand page):
Untitled, from: **Modern Photography,**
1931

László Moholy-Nagy

László Moholy-Nagy: 60 Fotos.
Berlin (Klinkhardt & Biermann)
1930

20.7.1895 Bácsborsód (Hungary) — 24.11.1946 Chicago (USA) Painting, kinetic art, photography, film, industrial design, architecture. Multi-media trailblazer of modernism. Constructivist and leading exponent of New Vision (Neues Sehen). Senior figure at the Bauhaus who came to the fore in particular with his "photograms". 1915–1917 war service. Wounded. Starts drawing in the military hospital. 1918 breaks off his law studies. Contact with the revolutionary artists' circle around the journal *Ma*. 1919 Vienna. 1920 moves to Berlin. 1922 first photograms. In the same year participates in the *Dada and Constructivist Congress*. 1923–1928 at the Bauhaus he takes over the foundation design course and the position of form master in the metal workshop (as successor to Johannes Itten). Edits the series known as the *Bauhaus Books* (with Walter Gropius). 1925 publishes his groundbreaking *Painting, Photography, Film*. Involves himself in typography, photography, painting. From 1925 bold bird's-eye and worm's-eye views shot with a Leica. 1928 moves from Dessau to Berlin. Founds a studio for graphic design there. Stage designs, exhibition design, film work. 1929 *Film und Foto*: designs the opening exhibition and shows 97 of his own works. 1934 Amsterdam. 1935 emigrates to England. Designs posters and shop-window displays. Film commissions, three documentary photobooks. 1937 moves to the USA. Appointed director of the newly founded New Bauhaus, on the recommendation of Gropius, though it closes for financial reasons. Opens his own School of Design (from 1944 called Institute of Design). Alongside this, private commissions from the business world. *Vision in Motion* appears posthumously as a résumé of his pedagogical ideas.

EXHIBITIONS (Selected) — **1922** Berlin (Galerie Der Sturm — 1923, 1924, 1925) SE // **1929** Stuttgart (**Film and Foto**) GE // **1946** Chicago (Institute of Design) SE // **1947** Chicago (Art Institute – 1976) SE/GE // **1961** Düsseldorf (Kunstmuseum) GE // **1968** Stuttgart (Württembergischer Kunstverein) GE // **1972** Berlin (Bauhaus-Archiv – 1987, 1990) SE/GE // **1976** Paris (Centre Pompidou – 1978, 1995) SE/GE // **1991** Kassel (Germany) (Museum Fridericianum) SE // **1996** Essen (Germany) (Museum Folkwang – 2000) SE/GE // **2009** Madrid (PHotoEspaña) SE // Frankfurt am Main (Schirn Kunsthalle) SE // **2010** Madrid (Círculo de Bellas Artes) SE

BIBLIOGRAPHY (Selected) — **Malerei Photographie Film.** Munich 1925 (facsimile reprint: Tübingen 1974) // **Von Material zu Architektur.** Munich 1929 // **László Moholy-Nagy: 60 Fotos.** Berlin 1930. // **Vision in Motion.** Chicago 1947 // Andreas Haus: **L.M.-N.: Fotos und Fotogramme.** Munich 1978 // Krisztina Passuth: **L.M.-N.** Weingarten 1986 // **50 Jahre New Bauhaus.** Berlin 1987 (cat. Bauhaus-Archiv) // Jeannine Fiedler: **Fotografie am Bauhaus.** Berlin 1990 (cat. Bauhaus-Archiv) // **L.M.-N.** Stuttgart 1991 (cat. Museum Fridericianum, Kassel) // **L.M.-N.: Fotogramme 1922–1943.** Munich 1996 (cat. Museum Folkwang, Essen) // **Bauhaus: Dessau > Chicago > New York.** Cologne 2000 (cat. Museum Folkwang, Essen) // Herbert Molderings: **Die Moderne der Fotografie.** Hamburg 2008 // **M.-N. The Photograms. Catalogue Raisonné.** Ostfildern 2009 // **L.M.-N.** Munich 2009 (cat. Schirn Kunsthalle) // **L.M.-N.: El arte de la luz.** Madrid 2010 (cat. Círculo de Bellas Artes)

"Moholy's photography was […] no 'expert' medium, it was a general vehicle for the reformed artistic expression. He himself had little knowledge of photo technology and never spoke of himself as a photographer, only as a painter. So it is quite understandable that it never occurred to him to set up a photography class at the Bauhaus. Moholy's artistic credo placed photography, too, absolutely within the context of his pedagogical agenda of a 'New Vision'."
— Andreas Haus ✍

39 *Entkörpertes Haus.*
Dematerialized house.
La maison perd sa forme matérielle.

40 *Großform gegen das Licht.*
Giant form against the light.
Grande forme à contre-jour.

Moï Ver/Moshé Raviv-Vorobeichic (Moses Vorobeichic-Raviv/Moï Ver)

Moshé Raviv-Vorobeichic:
Ein Ghetto im Osten. Wilna.
Zurich (Orell Füssli Verlag) 1931

5.12.1904 Lebedevo (near Vilnius, Lithuania) — 18.1.1995 Safed (Israel) Painter, photographer. Known as a Bauhaus student. Experimental photo essays, reportages or abstract painting, especially exploration of Jewish culture, tradition, and realities of life. 1924 studies painting at the Stefan Batory University (Vilnius). 1927 transfers to Bauhaus (to 1928). Foundation course under Josef Albers, and courses with Wassily Kandinsky, Paul Klee, Hinnerk Scheper. Takes up photography. 1928 in Paris: photo course at the École Technique de Photographie et Cinématographie. 1928 returns to Vilnius, with Leica reportages on Jewish life. 1931 photobook *Paris* under the pseudonym Moï Ver ("the first modern photo portrait of Paris" – Herbert Molderings). Conception of a photobook entitled *Ci-Contre* for the series *Fototek* (edited by Franz Roh) (2004 appears as facsimile of the book dummy). Apart from that, especially reportages for *VU* and *Paris-Soir*. 1932 in Tel Aviv for the Globe-Photo agency. Photo report on the Jewish Olympics, the Maccabiah. 1934 definitive move to Palestine. Works as freelance advertising graphic artist and photographer. From 1948 photography, applied graphics for the state of Israel. Takes the Hebraic name Moshé Raviv. Gives up photography and concentrates on painting. The facsimile reprint (2004) and > Parr and Badger's reference to M.R.'s Paris book (see *The Photobook: A History Volume I*) also known to the public at large.

EXHIBITIONS (Selected) — **1929** Zurich (Zionistischer Kongress) SE // **1932** Paris (**Palästina, gestern und heute**) SE // **1969** Jerusalem (Israel Museum) SE // **1970** Ein Harod (Israel) (Museum of Art) SE // **1995** Berlin (Bauhaus-Archiv) GE // **1997** Bonn (Rheinisches Landesmuseum) GE // **2004** Munich (Pinakothek der Moderne) SE // **2005** Cologne (Stiftung Photographie und Kunstwissenschaft) SE // **2008** Paris (Jeu de Paume – Site Sully/**Collection Christian Bouqueret**) GE

BIBLIOGRAPHY (Selected) — **Ein Ghetto im Osten.** Wilna. Zurich 1931 // **Paris. 80 Photographies de M.V.** Paris 1931 (facsimile reprint: Göttingen 2004) // Herbert Molderings: "Wer ist Vorobeichic?" In: **Fotogeschichte**, no. 26, 1987 // Jeannine Fiedler (ed.): **Fotografie am Bauhaus**. Berlin 1995 (cat. Bauhaus-Archiv) // Klaus Honnef and Frank Weyers: **Und sie haben Deutschland verlassen ... müssen.** Bonn 1997 (cat. Rheinisches Landesmuseum) // Martin Parr and Gerry Badger: **The Photobook: A History Volume I**. London 2004 // **Ci-contre. 110 Photos de Moï Ver**. Cologne 2004 // Herbert Molderings: **Die Moderne der Fotografie**. Cologne 2008 ✍🏻

"After he had finished the design of his Vilnius book, he immediately dedicated himself to a new book project. The topic changed, but his photographic eye remained the same. Instead of a Vilnius still stuck in a medieval way of life, it was the modern metropolis of Paris, the city where Vorobeichic had lived for nearly ten years […] With eighty photos he created a portrait of the city, based on his virtuoso use of a single photographic process: the sandwich montage. In some cases he placed up to five negatives on top of one another, creating a whirlpool of perspectives and photographic axis. […] Before the eyes of the viewer, a tangled dance of diagonals, grid structures, white and black spots. Everything spins, tilts, swirls around; movement, velocity, tempo are trumps." — Herbert Molderings ✍

Jean-Baptiste Mondino

1949 Aubervilliers (France) — Lives in Paris (France) Fashion, beauty, advertising. Cult photographer of the 1990s. Described as a "diviner of the spirit of the age", an "inventor of suggestive images", and a "visual magician of epoch-making calibre". French of Italian origin. Starts out as a disc jockey and composer. Makes the leap into the world of advertising as art director of a record label. Takes up photography, video, and computer art. Self-taught as a photographer. Becomes one of the most sought-after advertising and fashion photographers. Has worked with innumerable international rock stars, incl. Björk, Bryan Ferry, Sting, David Bowie, Boy George, Madonna, Prince, Neneh Cherry, and Tom Waits, but also politicians like Nelson Mandela and designers like Starck.

"'Beauty, fashion, sex' are the essential sources of inspiration for Mondino's pictures, also contemporary rock and pop music, cinema, the disco scene and international youth and everyday culture with its wealth of clichés form the flotsam of the poetry of the trivial and the mundane. An endless stream of ideas, an incredibly fertile imagination, coruscating black humor, bizarre erotic visions, and the breathtaking speed at which Mondino succeeds in fusing all influences and ideas into popular images of the highest aesthetic and technical quality have led to him becoming the 'image guru' of many of the greatest international pop stars." — Déjà vu ✎

EXHIBITIONS (Selected) — **2002** Hamburg (Deichtorhallen) GE // Paris (Maison européenne de la photographie) GE // **2004** Beijing (798 Photo Gallery) GE // **2006** Los Angeles (M + B) SE

BIBLIOGRAPHY (Selected) — **Azzedine Alaia.** Göttingen 1998 // Lisa Lovatt-Smith (ed.): **Fashion images/Images de mode 3.** Göttingen 1998 // **Déjà vu.** Munich 1999 ✎ // Marion de Beaupré, Stéphane Baumet, and Ulf Poschardt (eds): **Archeology of Elegance 1980–2000.** Paris 2002 // **Two much.** Munich 2003 // **Guitar Eros.** Munich 2006

58 · jean-baptiste mondino · madonna · jean paul gaultier bustier · 1987

59 · jean-baptiste mondino · staring at the origin of the world of gustave courbet · vogue france · 2000

Jean-Baptiste Mondino:
**Archeology of Elegance
1980–2000**. Paris
(Flammarion) 2002

Sarah Moon

Sarah Moon: **Vrais semblants.**
Paris (Delpire) 1993

17.11.1941 Vichy (France) — Lives in Paris (France) Fashion and portrait photography. Major interpreter of a new romantic femininity. One of the best-known exponents of her specialty since the 1980s. After completing her studies in art, works as a sought-after haute-couture fashion model. Takes up photography. 1967 first highly regarded campaign for Cacharel. Since 1968 freelance photographer for editorial and advertising. Numerous publications in *Marie Claire*, *Harper's Bazaar*, *Nova*, *Vogue*, *Elle*, *Frankfurter Allgemeine Magazin*, and *Stern*, among others. Exponent of what is sometimes described as "impressionist" fashion photography, clearly schooled in Pictorialism. Also film work. A total of over 150 publicity films (incl. for L'Oréal, Cacharel, TWA, Dupont, Revlon) and a series of full-length films (*Mississippi One*, 1990, *Contacts*, 1994, *Henri Cartier-Bresson. Point d'interrogation*, 1995). Has shown her work at almost all the major fashion photography exhibitions (*Fashion Photography*, Amsterdam 1980, *Shots of Style*, London 1985, *Appearances: Fashion Photography Since 1945*, London 1991). Numerous awards, incl. the Grand Prix National de la Photographie (1995), and the 2007 Kulturpreis of the DGPh (Deutsche Gesellschaft für Photographie: German Photographic Association), with her husband Robert Delpire.

"As a photographer, Sarah Moon rejects any categorization today. Her fashion profession co-exists with her interior landscapes, portraits, flower still lifes, views of the city and country-side. And it would seem these images all belong to the same family, the same vision, the same unique point of view, which cannot simply be reduced to professional competence."

— Christian Caujolle ✍

EXHIBITIONS (Selected) — **1975** Paris (Galerie Delpire – 1982) SE // **1983** New York (International Center of Photography) SE // **1994** Arles (Rencontres internationales de la photographie) SE // **1995** Paris (Centre national de la photographie) SE // **1996** Frankfurt (Fotografie Forum) SE // **1998** Berlin (Galerie Camera Work) SE // **2001** London (Michael Hoppen Photography – 2005) SE // **2003** Paris (Maison européenne de la photographie) SE // Paris (Galerie Camera Obscura – 2005) SE // **2004** New York (Howard Greenberg Gallery) SE // **2005** Tokyo (Art Museum of Nihon University) SE // **2006** Milan (Galleria Carla Sozzani) SE // **2007** Brussels (Box Galerie) SE // **2009** Zurich (Galerie Zur Stockeregg) SE

BIBLIOGRAPHY (Selected) — **Modinsolite**. Paris 1975 // **Souvenirs improbables**. Paris 1980 // **Pacific Press Service**. Tokyo 1984 // **Vrais semblants**. Paris 1991 // Christian Caujolle: "Le regard tendre de S.M." In: **Dépêche mode**, 1995 ✍ // **S.M.** Paris, 1998 (= Photo Poche no. 78) // **S.M.: Zufällige Begegnungen. Photographien**. Munich 2001 // **S.M. 1 2 3 4 5**. Paris 2008

2
Triantos Palace

3
Shoy Me Fashion

27
Animos

28
Masudes

Inge Morath *(Inge Mörath)*

Dominique Aubier: **Fiesta in Pamplona. Photographien von Galle, Chapestro, Nisberg und Inge Morath.** Zurich (Manesse Verlag) 1955

27.5.1923 Graz (Austria) — 30.1.2002 New York (USA) Magnum photographer. Travel pictures, photo reports, and portraits informed by a desire to create valid pictorial images, mostly in b/w. Childhood in Breisgau, Munich, Eberswalde near Berlin, Schirmeck near Strasbourg, Viches and Darmstadt. 1938 the family returns to Berlin. Secondary school-leaving certificate and a year of voluntary service, then studies Romance languages in Berlin, with a stay of several months in Bucharest. Takes finals towards the end of the war, then forced labor in a factory. Escapes during an air raid and flees to Salzburg with a refugee column. From August 1945 translator for the United States Information Services in Salzburg. 1946 moves to Vienna and steps up her journalistic and literary activities, writing among other things a radio play for the newly founded radio station Rot-Weiss-Rot (Red-White-Red). Early 1948 editor with the short-lived cultural magazine *Der Optimist*. Gets to know the writers Ingeborg Bachmann and Ilse Aichinger among others at this time. From March 1948 picture editor for the magazine *Heute*, published by the American military government. Moves to Paris at the invitation of > Capa and works for the Magnum agency (organizing and secretarial work). 1951, during a stay in Venice, first photographs of her own. Trains in photography with Simon Guttmann in London. 1953 returns to Paris. In the same year accepted by Magnum (initially as associate, from 1956 as a full member). Subsequently numerous b/w photo reports from Ireland, France, Italy, and particularly Spain. First major publications in *Life*, *Holiday* magazine, and *L'Œil*. Further travels to the USA, Iran, Mexico, Russia, and China. From the late 1950s several portrait sittings with Saul Steinberg (*Le Masque*). Married to playwright Arthur Miller. 1991 Austrian National Prize for Photography (awarded for the first time).

EXHIBITIONS (Selected) — **1956** Vienna (Galerie Würthle) SE // **1980** Zurich (Kunsthaus) SE // Vienna (Museum Moderner Kunst) SE // **1982** Salzburg (Austria) (Galerie Fotohof) SE // **1992** Salzburg (Fotogalerie im Rupertinum) SE // Linz (Austria) (Neue Galerie) SE // **1999** Vienna (Kunsthalle) SA // **2000** Paris (Galerie Esther Woerdehoff – 2002) SE // New York (Leica Gallery – 2003) SE // **2003** Graz (Austria) (Künstlerhaus Graz am Landesmuseum Joanneum) SE // Bologna (Galleria d'Arte Moderna) SE // Paris (Fondation Henri Cartier-Bresson) SE // Vienna (WestLicht – 2008) SE/GE // **2005** Salzburg (Galerie Fotohof) SE // Chicago (Chicago Cultural Center) SE // **2008** Amsterdam (Stedelijk Museum Post CS/**MAGNUM Photos 60 years**) GE // Berlin (Instituto Cervantes/**Das Spanienbild im Fotobuch**) GE // **2014** Hamburg (Haus der Photographie/Deichtorhallen) GE

BIBLIOGRAPHY (Selected) — **Guerre à la tristesse.** Paris 1955 // **Steinberg. Le Masque.** Paris 1966 // **Große Photographen unserer Zeit: I.M.** Lucerne 1975 // **Russian Journal 1965–1990.** New York 1991 // **Fotografien 1952–1992.** Salzburg 1992 // **Die Donau.** Salzburg 1995 // **Photographien.** Munich 1999 // **Portraits.** Salzburg 1999 // Chris Boot (ed.): **Magnum Stories.** London 2004 ✍ // Brigitte Lardinois: **Magnum Magnum.** Munich 2007 // Peter Coeln, Achim Heine, and Andrea Holzherr (eds): **MAGNUM's first.** Ostfildern 2008 (cat. WestLicht, Vienna) // Inge Morath: **First Color.** Göttingen 2009 // **Iran.** Göttingen 2009 // **Augen auf! 100 Jahre Leica.** Heidelberg 2014 (cat. Haus der Photographie/Deichtorhallen Hamburg)

"The tools of her photographic trade hail from the 'school' of Henri Cartier-Bresson and Magnum photography of the 1950s. […] In this sense Inge Morath was and still is a travel and photo report photographer whose pictorial material is destined for the print media. But alongside, as a direct response to the 'commissioned' picture, a whole stream of 'free' images comes into being, a reservoir of intimate and personal photos, whose innocence of any intended purpose allows them a quasi novelistic level of narrative." — Margit Zuckriegl ✍

Yasumasa Morimura

Filippo Maggia and Marinella Venanzi (eds): **Yasumasa Morimura: Requiem for the XX Century. Twilight of the Turbulent Gods.** Milan (Skira) 2008

11.6.1951 Osaka (Japan) — Lives in Osaka Important representative of staged photography, familiar to an international public since the 1990s. His roles are mostly inspired by personalities from art history and contemporary popular culture, with an approach reminiscent of Cindy Sherman. Studies at the Kyoto City University of Art, graduating in 1978. Since the mid-1980s well known as an important representative of "staged photography", in which he (very much in the tradition of the Japanese Kabuki theater) always stages himself (as a woman) in carefully arranged, lavishly embellished roles, relating himself to works of Western art (*Mona Lisa*), stars of the cinema (Vivien Leigh), and other icons of (popular) culture. First solo exhibition in 1983. International breakthrough with touring exhibitions such as *Zones of Love: Contemporary Art from Post-Modern Japan* (Tate Gallery Liverpool, 1991), and *Japanese Art after 1945: Scream Against the Sky* (Guggenheim Museum SoHo, 1994).

EXHIBITIONS (Selected) — **1983** Kyoto (Galerie Marronnier) SE // **1988** Tokyo (Gallery NW House) SE // **1990** Frankfurt am Main (Kunstverein/**Japanische Kunst der 80er Jahre**) GE // Paris (Pavillon des Arts) GE // **1991** New York (Luhring Augustine — 1996, 1999, 2005, 2007) SE // **1993** Jouy-en-Josas (France) (Fondation Cartier pour l'art contemporain) SE // **1994** Tokyo (Museum of Contemporary Art — 1998) SE // **1997** Houston (Texas) (Contemporary Arts Museum) SE // Cahors (France) (Printemps de Cahors) SE // **1999** London (White Cube) SE // Paris (Galerie Thaddaeus Ropac — 2005, 2008) SE // **2000** Madrid (Fundación Telefónica) SE // **2002** Madrid (Galerie Juana de Aizpuru — 2005, 2008) SE // Santa Fe (New Mexico) (SITE Santa Fe) SE // Kawasaki (Japan) (Kawasaki City Museum) SE // **2003** Tokyo (Shugoarts — 2005, 2006, 2007) SE // Houston (Texas) (Museum of Fine Arts/**The History of Japanese Photography**) GE // **2004** Osaka (MEM INC — 2005) SE // **2006** Milan (Galleria Ca' di Fra') SE // **2007** Moscow (Gary Tatintsin Gallery) SE // Yokohama (Japan) (Yokohama Museum of Art) SE // Venice (Galleria di Piazza San Marco) SE // **2008** Verona (Italy) (Byblos Art Gallery) SE

BIBLIOGRAPHY (Selected) — **La photographie contemporaine japonaise. Douze points de vue.** Paris 1990 (cat. Pavillon des Arts) // **Kisekae Ningen No. 1.** Tokyo 1994 // **Rembrandt's Room.** Tokyo 1994 // **A Story of M'sself — Portraits.** Tokyo 1998 // **Daughter of Art History.** New York 2003 // Anne Wilkes Tucker, Dana Friis-Hansen, Ryūichi Kaneko and Takeba Joe: **The History of Japanese Photography.** New Haven/London 2003 (cat. Museum of Fine Arts, Houston) // Filippo Maggia and Marinella Venanzi (eds): **Y.M.: Requiem for the XX Century. Twilight of the Turbulent Gods.** Milan 2008 (Milan) SE ✍

"Morimura presents a political discourse, about both the power in the world and the power of the media. He plays literally with his own skin, putting the very sense of the absurd at stake and trying to see at which point an attempt at maniacal imitation becomes grotesque or neurotic, sick or unresolved. His own vision — not only of customs and history, but also of art history, cannot but originate from the West, to be transported to the East, notwithstanding such bizarre paradoxes as the fact that Van Gogh learnt to paint from Japanese prints and the Japanese then made great strides to collect his paintings. The tradition that defeats and colonizes minds, for the moment, is just one: that which was born out of the American victories in the two World Wars of the twentieth century." — Angela Vettese ✍

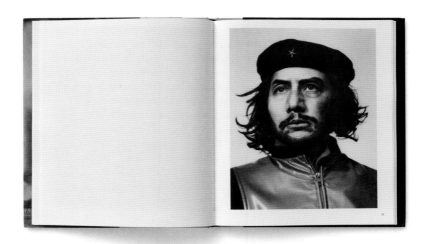

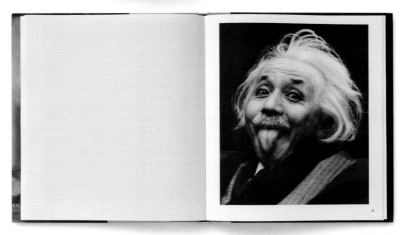

Daido Moriyama

Daido Moriyama: **Shinjuku**.
Tucson (Nazraeli Press) 2002

10.10.1938 Ikeda (Japan) — Lives in Tokyo (Japan) Ranks among Japan's internationally best-known photo artists. Portrayer of social change in a radical pictorial language learned from photographers such as Frank or Klein. Father insurance agent with Sumimoto Life Insurance Company. Childhood in Hiroshima, Tokyo, and Kyoto. Becomes interested in graphic design at age 17. Leaves high school in Kyoto early and attends evening classes at the School of Industrial Art in Osaka. Day job designing gift paper in a graphic art studio. 1958 father killed in a train crash. From now on works as a freelancer, with frequent visits to the photographic studio of Takeji Iwamina, one of Japan's best-known photographers at the time. Gives up his design work and takes up photography instead, with Iwamina as his teacher. 1961 moves to Tokyo with the aim of joining the photographers' group Vivo (> Hosoe, Kikuji Kawada, > Narahara, Akira Satō, Akira Tanno, > Tōmatsu) — a plan which fails because the group has recently broken up. Becomes (till 1963) Hosoe's personal assistant. 1963 marries Michiko Sugiwara and gives up the job of personal assistant. Takes up freelance street photography, developing — under the influence in particular of the work of > Klein (*New York*) and > Tōmatsu (*Occupation*) — the raw, hard, high-contrast snapshot aesthetics that would be typical of his work from now on. First major publication in *Camera Mainichi*. 1967 prize for young talent awarded by the Japanese Photo Critics Association. 1968 *Japan: A Photo Theater* as his first wholly independent book publication. 1969 works on *Provoke* nos. 2 and 3. Further radicalization of his picture style, also under the influence of the prose of Jack Kerouac (*On the Road*). 1970 first solo exhibition under the title *Scandalous*. In the 1970s does some teaching and runs a gallery (CAMP). 1974 shows 26 works in a group exhibition of Japanese photographers in MoMA (New York). Creative crisis after the death of his friend Takuma Nakahira (1977). Comeback as an artist only in the early 1980s with *Light and Shadow*. Prizes include Photographer of the Year (1983), Mainichi Art Award for *Shinjuku* (2002). 1999 major retrospective in the San Francisco Museum of Modern Art.

EXHIBITIONS (Selected) — **1970** Tokyo (Plaza Dick) SE // **1974** Tokyo (Ginza Nikon Salon — 1976, 1977) SE // **1974** New York (Museum of Modern Art) GE // **1976** Tokyo (CAMP — 1978) SE // **1982** Tokyo (Konishiroku Photo Gallery) SE // **1990** Tokyo (Zeit-Foto Salon) SE // **1992** Tokyo (Il Tempo) SE // **1993** New York (Laurence Miller Gallery) SE // **1995** Tokyo (Taka Ishii Gallery — 1996, 1997, 2000, 2002) SE // **1998** Los Angeles (Taka Ishii Gallery — 1999) SE // **1999** New York (Metropolitan Museum) SE // San Francisco (San Francisco Museum of Modern Art) SE // **2000** Essen (Essen) (Museum Folkwang) SE // Winterthur (Fotomuseum) SE // **2001** San Diego (Museum of Photographic Arts) SE // Cambridge (Massachusetts) (Harvard University Art Museums) SE // **2002** London (White Cube) SE // **2003** Paris (Fondation Cartier) SE // **2013** Kassel (Fotobook Festival) SE

BIBLIOGRAPHY (Selected) — **Japan: A Photo Theater.** Tokyo 1968 // **Farewell Photography.** Tokyo 1972 // **Hunter.** Tokyo 1972 // **Mayfly.** Tokyo 1972 // **Tales of Tono.** Tokyo 1976 // **Japan: A Photo Theater II.** Tokyo 1978 // **Light and Shadow.** Tokyo 1982 // **A Journey to Nakaji.** Tokyo 1987 // **M.D. 1970–1979.** Tokyo 1989 // **Lettre à Saint-Lou.** Tokyo 1990 // **Daido Hysteric no. 4.** Tokyo 1993 // **Daido Hysteric no. 6.** Tokyo 1994 // **Imitation.** Tokyo 1995 // **A Dog's Time.** Tokyo 1995 // **Japanese Photographers Vol. 37: D.M.** Tokyo 1997 // **Osaka Daido Hysteric no. 8.** Tokyo 1997 // **Shinjuku.** Tucson 2002 // **D.M.** Arles 2003 (cat. Fondation Cartier, Paris) // Vicki Goldberg: **Light Matters: Writings on Photography.** New York 2005 // **Hawaii.** USA 2007

"Daido Moriyama's vision resides in the heart of darkness, literally and figuratively. The world he records is black, stunned rather than illuminated by light, threatening, chaotic, incomprehensible, compulsively erotic, obsessed, eccentric, fixated on consumption, devastated by accidents, always off-kilter, sometimes ruined, sometimes empty — a world unaware of its own instability, a world in need of Prozac. His photographic technique, all blur and scratches, bleach and dust, joins with his subject matter to conjure documents on the verge of disintegration. At times Moriyama tinkers with the limits of perception, which he makes look hopelessly narrow, and with the limits of photography, which he makes seem very limited indeed. This is a tough vision, even a fierce one, individual, authentic, and pursued to the far reaches of its own premises."
— Vicki Goldberg ✍

Ugo Mulas

Germano Celant: **Ugo Mulas.**
New York (Rizzoli) 1990

28.8.1928 Pozzolengo (Italy) — 2.3.1973 Milano (Italy) Freelance works between Neo-Realism and conceptual photo art. Internationally known for his b/w portraits of artists from 1960s New York. Schooling in Desenzano on Lake Garda. 1945–1948 military service. 1948–1952 studies law in Milan. Shortly before taking finals, moves to the Brera Academy of Fine Arts. 1952–1953 copywriter for a Milan photographic agency. First works of his own from 1954. Fashion and advertising, and also photo reports for various newspapers and magazines. With the start of the 1960s, mainly portraits of artists (among them Dino Buzzati, Alberto Giacometti, Eugenio Montale, Salvatore Quasimodo). Up to 1972 numerous photos and series of photos of the Biennale. From 1960 picture contributions to *Illustrazione Italiana*, *Settimo Giorno*, *Novità*, *Domus*, and *Du*, among others. Advertising for Pirelli and Olivetti. Collaborates with Giorgio Strehler, for whom he works as a stage photographer until the mid-1960s. Several trips to New York (1964, 1965, and 1967). Documents the flourishing New York art scene. His portraits incl. Christo, Jim Dine, Roy Lichtenstein, Kenneth Noland, Claes Oldenburg, Robert Rauschenberg, James Rosenquist, George Segal, Frank Stella, > Warhol, Tom Wesselmann — b/w photographs which still rank among U.M.'s best works and are reminiscent in their journalistic approach of > Namuth. 1970 start of the series *Le Verifiche*, in which U.M. grapples conceptually with the medium of photography.

"**To Mulas, photography was two things, because it not only reproduces the real, but because it also interprets it by drawing it toward itself. He saw it as a field of personal, emotional and sensitive forces through which he could tell or write fairy tales, poems or visual music. The images or the fragments of the world he was able to fix in a frame, or in thirty-six frames, were words or sentences that enabled him to express an inner experience. By means of photography, he questioned his existence, his emotions, his cultural context, the photographic language itself.**" — Germano Celant ✍

EXHIBITIONS (Selected) — **1967** Milan (Il Diaframma) SE // **1973** Parma (Italy) (Palazzo della Pilotta) SE // **1977** Kassel (Germany) (documenta 6) GE // **1982** Rimini (Italy) (Palazzo Gambalunga) SE // **1984** Geneva (Musée Rath) SE // **1989** Frankfurt am Main (Kunstverein) GE // **1992** Paris (Fnac-Montparnasse) SE // **1998** Munich (Vereinte Versicherungen) GE // **2007** Rome (Museo Nazionale delle Arti del XXI Secolo) SE // **2007** Milan (Padiglione d'Arte Contemporanea) SE // **2008** Turin (Galleria d'Arte Moderna) SE // **2009** Madrid (PHotoEspaña) SE

BIBLIOGRAPHY (Selected) — **U.M.: Immagini e Testi.** Parma 1973 (cat. Università di Parma) // **U.M.: A. Calder a Sachè et a Roxbury 1961–1965.** Rimini 1982 (cat. Palazzo Gambalunga) // **U.M.: Fotografo 1928–1973.** Zurich 1984 (cat. Musée Rath) // **Kunst und Photographie 1960–1980.** Frankfurt am Main 1989 (cat. Kunstverein) // Germano Celant: **U.M.** New York 1990 ✍ // **Künstlerportraits.** Munich 1998 (cat. Vereinte Versicherungen) // Pier Giovanni Castagnoli: **U.M.: La Scena dell'arte.** Milan 2007 // Pier Giovanni Castagnoli: **U.M.: La Scena dell'arte. Photocolors.** Milan 2008

1961

29. *Kunze Biasm, 1961*

29. *Tancredi, 1961*

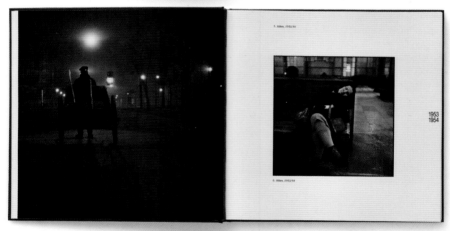

5. *Milan, 1953/54*

1953
1954

6. *Milan, 1953/54*

Martin Munkácsi *(Márton Munkácsi/Memelstein)*

Martin Munkácsi: **Nudes.**
New York (Greenberg Publisher)
1951

18.5.1896 Kolozsvár/Klausenburg (Hungary, today Cluj-Napoca, Romania) — 14.7.1963 New York (USA) Pioneer of modern photojournalism. Known as the trailblazer of a new form of fashion interpretation indebted to sports and snapshot photography. Fourth of ten children. 1912 to Budapest. 1914 publishes his first poems in newspapers and magazines. 1921–1922 first sports photos for *Az Est*. 1927 moves to Berlin. Three-year contract with Ullstein. First publication in the *Berliner Illustrirte Zeitung* on 14 October 1928. Further publications in *Die Dame*, *Koralle*, *Uhu*, and internationally in *VU*, *AMG Photographie*, and *Modern Photography*. Working trips to Sicily, Turkey, Palestine, Egypt, Algeria, and Hungary. 1932 first visit to the USA. 1933 takes up fashion photography at the suggestion of > Brodovitch. Creator of a new picture style outside the studio with the models out of doors and quite often in motion. First examples in *Harper's Bazaar* in December 1933. 1934 emigrates to the USA. Subsequently rises to become one of the leading fashion photographers of his time. Contracted as photographer to *Harper's Bazaar*. Works for *Life* and *Ladies' Home Journal*. 1945 autobiographical novel *Fool's Apprentice*. 1951 coffee-table book *Nudes*, with layout design by Brodovitch. Publicity for R.J. Reynolds and Ford, and film cameraman (*Hansel and Gretel*, *Bob's Declaration of Independence*). 1963 last assignment for *Harper's Bazaar*. Dies of a heart attack.

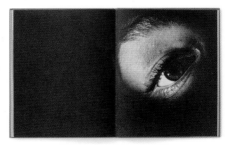

EXHIBITIONS (Selected) — **1978** New York (International Center of Photography — 2006) SE // **1980** San Francisco (Museum of Modern Art) GE // **1985** New York (Howard Greenberg Gallery — 1992, 2009) SE // **1996** Hamburg (Deichtorhallen) GE // **1997** Bonn (Kunst- und Ausstellungshalle der BRD) GE // **2004** Madrid (PHotoEspaña) GE // **2005** Hamburg (Haus der Photographie/Deichtorhallen) SE // **2007** San Francisco (San Francisco Museum of Modern Art) SE // **2008** Moscow (Moscow House of Photography) SE

BIBLIOGRAPHY (Selected) — **Nudes.** New York 1951 // Tim N. Gidal: **Deutschland – Beginn des modernen Photojournalismus.** Lucerne 1972 // Nancy White and John Esten: **Style in Motion.** New York 1979 // **M.M.** Düsseldorf 1980 // **M.M.: Retrospective.** New York 1994 // **Das deutsche Auge.** Munich 1996 (cat. Deichtorhallen Hamburg) // **Deutsche Fotografie. Macht eines Mediums 1870–1970.** Cologne, 1997 (cat. Kunst- und Ausstellungshalle der Bundesrepublik Deutschland, Bonn) // Horacio Fernández: **Variaciones en España. Fotografía y arte 1900–1980.** Madrid 2004 (cat. PHotoEspaña) // F.C. Gundlach (ed.): **M.M.** Göttingen 2005 (cat. Haus der Photographie/Deichtorhallen Hamburg) ✎

"'Think while you shoot!' – This was how he formulated his artistic credo for the fashion magazine *Harper's Bazaar* in 1935. These four words perfectly epitomize his way of working: his photographs appear spontaneous, natural, dynamic and full of a zest for life. They bear witness to a gift that few other photographers possess, namely an intuitive grasp of the moment. He could gauge movements in a flash, sense momentary dispositions so that he could be in the right place at the right time to press the shutter release. His way of working was highly efficient. Unlike many of his photographer colleagues, he does not have countless variants of one and the same motif; a hugely powerful concentration of attention allowed him almost always to achieve publishable results with just a few exposures." — F.C.Gundlach ✍

Martin Munkácsi: **Aufmarsch der Reichswehr,** from: **Berliner Illustrirte Zeitung,** special issue 21.3.1933

James (Allen) Nachtwey

James Nachtwey: **L'Enfer.**
Paris (Phaidon) 1999

14.3.1948 Syracuse (New York, USA) — Lives in New York (USA) Long-standing member of Magnum. Known particularly as an unsparing portrayer of international wars and conflicts. Childhood in Massachusetts. 1966–1970 studies history and political science at Dartmouth College, New Hampshire. Serves for a time in the Merchant Marine. From 1972 works as a news editor with NBC. First photographs, in his free time, of subjects of his own choice. Self-taught. 1976–1980 newspaper reporter in New Mexico. 1980 moves to New York. There — with the support of Howard Chapnick (Black Star) — sets out on his career as a freelance photojournalist. Contract photographer with *Time* from 1984. Magnum member 1986–2001. 1981 first overseas assignment on civil strife (in Northern Ireland). Since then numerous photo reports from hot spots all over the world, incl. El Salvador, Nicaragua, Guatemala, Lebanon, the West Bank and Gaza, Israel, India, Sri Lanka, Afghanistan, the Philippines, South Korea, Somalia, the Sudan, Rwanda, South Africa, Russia, Bosnia, Chechnya, Romania, Brazil, USA. Publications in *Time*, *Life*, *National Geographic*, *Geo*, *Stern*. Numerous awards, incl. the Robert Capa Gold Medal, World Press Photo Award, ICP Infinity Award (three times), Magazine Photographer of the Year and a Eugene Smith Memorial Grant. 2001 (with Antonin Kratochvil and others) founds the VII Internet agency. Subject in the same year of an award-winning and much-discussed documentary by Christian Frei entitled *War Photographer* and portraying J.N. as the most talked-about war photographer of the 20th century.

EXHIBITIONS (Selected) — **1989** New York (International Center of Photography – 2000) SE // **1992** Gothenburg (Sweden) (Hasselblad Center) SE // **1994** Prague (Carolinum) SE // **1997** Boston (Massachusetts College of Art) SE // **2000** Madrid (PHotoEspaña) SE // **2001** Rome (Palazzo Esposizione) SE // **2002** San Diego (Museum of Photographic Arts) SE // Paris (Bibliothèque nationale de France – Site Richelieu) SE // **2003** Tokyo (Tokyo Metropolitan Museum of Photography) SE // Berlin (C/O Berlin) SE // **2007** Amsterdam (Fotografiemuseum Amsterdam) SE

BIBLIOGRAPHY (Selected) — **Deeds of War.** London 1989 // **J.N.: Photojournalist.** Gothenburg 1992 (cat. Hasselblad Center) ☐ // **Guerras fratricidas.** Barcelona 1996 // **Inferno.** London 1999 (**L'Enfer.** Paris 1999) // Mary Panzer and Christian Caujolle: **Things as they are. Photojournalism in Context since 1955.** London 2005 // **National Geographic. Around the World in 125 Years.** Cologne 2014

"Nachtwey describes a dark side in [his] photographs. They can be viewed individually — in an exhibition, as timeless symbolic images — or in sequences, in a journalistic context, with written reports, on the printed page. As a photojournalist, Nachtwey shares the compassion and humanistic approach of the legendary 'crusader' and *Life* photographer W. Eugene Smith, who once pointed out in a discussion about his story on Japanese fishermen crippled by mercury pollution: 'There is, of course, no objective truth in a photograph, but you can be subjective *and honest.*' In the same vein, Nachtwey comments on his photojournalistic work that there exists no real impartiality, you have some sense of justice and injustice — who the oppressor is and who the oppressed are." — Rune Hassner ✎

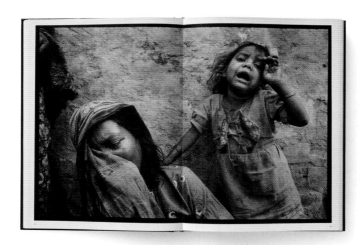

Takuma Nakahira

中平卓馬

原点復帰—横浜

NAKAHIRA TAKUMA

DEGREE ZERO — YOKOHAMA

Takuma Nakahira: **Degree Zero – Yokohama.** Tokyo (Osiris Co.) 2003

6.7.1938 Tokyo (Japan) — 3.9.2015 Yokohama (Japan) Important representative of Japanese photography in the 1970s. Co-editor of *Provoke* magazine. Makes a name for himself mainly with landscapes and urban landscapes using a particularly radical pictorial language. Studies languages (specializing in Spanish) at the Tokyo University of Foreign Languages. After that works for a publishing company. Finally turns to photography. 1968, together with Takahiko Okada, Kōji Taki, Yutaka Takanashi and > Moriyama (who joins them slightly later) he publishes the short-lived (only three published issues) but influential art magazine *Provoke*. There he is something like the spokesman for the movement whose aesthetic impetus can scarcely be overestimated. All in all, one of the central personalities of the photo avant-garde of the 1960s and 70s. The group breaks up in 1970 after the publication of a photobook (*Mazu tashikarashisa no sekai o sutero*), which recapitulates the history of *Provoke*. In the same year he publishes *For a Language to Come*, probably his most important book, sometimes referred to as the "apogee of the Provoke period" (Parr and Badger).

"For a Language to Come immediately follows Takuma Nakahira's work on *Provoke*, continuing to challenge the essential ideas of photography. The majority of his work in this period focused on the 'landscape', which he deals with in a complicated manner." — Ryūichi Kaneko ✎

EXHIBITIONS (Selected) — **1989** Yamaguchi (Japan) (Yamaguchi Prefectural Museum of Art) GE // **2003** Yokohama (Japan) (Yokohama Museum of Art) SE // Houston (Texas) (Museum of Fine Arts/**The History of Japanese Photography**) GE // **2004** Tokyo (Nadiff) SE // Cologne (Galerie Claudia Delank/**Zeitgenössische Fotografie aus Japan und Korea**) GE // Tokyo (Shugoarts – 2007) SE // **2005** Graz (Austria) (Kunsthaus Graz im Landesmuseum Johanneum) GE // Graz (Camera Austria/Kunsthaus Graz – Eisernes Haus) GE // Vigo (Spain) (Museo de Arte Contemporánea de Vigo) GE

BIBLIOGRAPHY (Selected) — **For a Language to Come.** Tokyo 1970 (facsimile reprint: Göttingen 2001) // **Mazu tashikarashisa no sekai o sutero (First Discard the World of Pseudo-Certainty).** Tokyo 1970 // **Naze shokubutsu zukan ka (Why an Illustrated Book of Flora).** Tokyo 1973 // Kishin Shinoyama and T.N.: **Kettōshahin ron (Dueling Theories of Photography).** Tokyo 1977 // **Aratanaru gyōshi (Fresh Gaze).** Tokyo 1983 // **Adieu à X.** Tokyo 1989 // **Eleven Photographers in Japan, 1965–75.** Yamaguchi 1989 (cat. Yamaguchi Prefectural Museum of Art) // Shigeichi Nagano, Kōtarō Iizawa, and Naoyuki Kinoshita (eds): **T.N.** Tokyo 1999 (= Japanese Photographers no. 36) // **Degree Zero – Yokohama.** Tokyo 2003 (cat. Yokohama Museum of Art) // Anne Wilkes Tucker, Dana Friis-Hansen, Ryūichi Kaneko, and Takeba Joe: **The History of Japanese Photography.** New Haven/London 2003 (cat. Museum of Fine Arts, Houston) // Martin Parr and Gerry Badger: **The Photobook: A History Volume I.** London 2004 // Ryūichi Kaneko and Ivan Vartanian: **Japanese Photobooks of the 1960s and '70s.** New York 2009 ✎

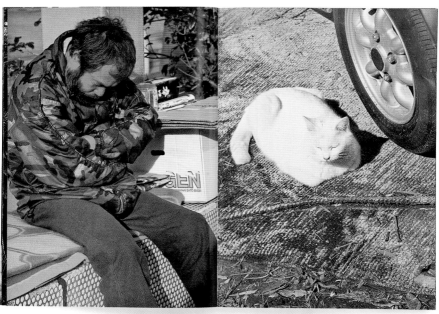

Hans Namuth

17.3.1915 Essen (Germany) — 13.10.1990 East Hampton (New York, USA) Photographer of the Spanish Civil War. From the 1950s mainly portraits of American artists. The major photo chronicler of the New York School. Senior secondary school in Essen. Apprenticeship as a bookseller. Active in the youth movement. 1933: after a brief period of detention, emigrates to Paris. Friendship with > Capa and Georg Reisner (1911–1940). With the latter, from 1935 commercial portrait photography on Majorca. 1936–1937 photo reports from the Spanish Civil War, mainly for the magazine *VU*. The two of them run a photographic studio together in Paris. Publications in *AMG Photographie*, *Regards*, *Life*. Interned in 1939. Following Reisner's suicide, joins the Foreign Legion. April 1941 via Oran (Algeria), Casablanca, Martinique, and Puerto Rico to the USA. 1946–1947 takes courses with > Brodovitch and Josef Breitenbach at the New School for Social Research. 1950 opens a studio in New York. Portraits of artists as the main focus of his work. Photo chronicler of the New York School. Up to the late 1980s photographs over 300 painters, sculptors, and conceptual artists, usually in their studios, often as they work (incl. Stuart Davis, Roy Lichtenstein, Robert Rauschenberg, James Rosenquist, George Segal, Richard Serra, > Warhol). Also films about artists (Josef Albers, Alexander Calder, Jackson Pollock, > Stieglitz), which have long since been regarded as classics of the genre.

"For his first photo report documenting the work process itself, Namuth was fortunate enough to get the most suitable artist imaginable, namely Jackson Pollock. Pollock's 'drip paintings' […], produced in a single operation, were ideal for recording in a sequence of photographs. Moreover, for the action painter à la Pollock, it is the act of painting that is truly creative; the picture is merely the residue of this, the means of preserving the evidence. Namuth's Pollock sequence has thus gone down as a milestone in the history both of photography and of art. Action sequences have had their undisputed place in the repertoire of the artist portrait ever since." — Michael Köhler ✍

EXHIBITIONS (Selected) — **1967** New York (Museum of Modern Art) SE // **1979** Paris (Musée d'art moderne) SE // **1980** Amsterdam (Galerie Fiolet) SE // **1982** Woodstock (New York) (Catskill Center for Photography) SE // **1986** Munich (Städtische Galerie im Lenbachhaus) SE // **1988** Arles (Rencontres internationales de la photographie) SE // **1998** Munich (Vereinte Versicherungen) GE // **1999** Washington, DC (Smithsonian Institution) SE // **2003** Barcelona (Palau de La Virreina) GE // **2005** New York (Neuberger Museum of Art) GE // **2008** Tucson (Arizona) (Center for Creative Photography) GE

BIBLIOGRAPHY (Selected) — **Artists 1950–1981**. New York 1981 // H.N. and Georg Reisner: **Spanisches Tagebuch 1936.** Berlin 1986 (cat. Städtische Galerie im Lenbachhaus, Munich) // **Kunst in Amerika.** Stuttgart 1988 // **Los Todos Santeros.** Berlin 1989 // **Künstlerportraits**. Munich 1998 (cat. Vereinte Versicherungen) ✍ // Carolyn Kinder-Garr: **H.N.: Portraits.** Washington, DC, 1999 (cat. Smithsonian Institution)

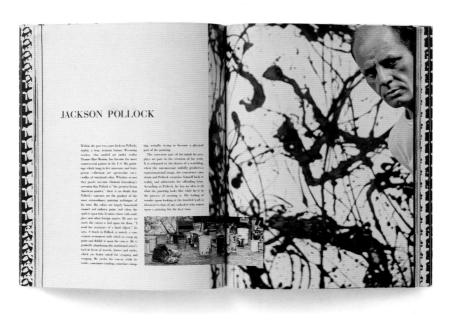

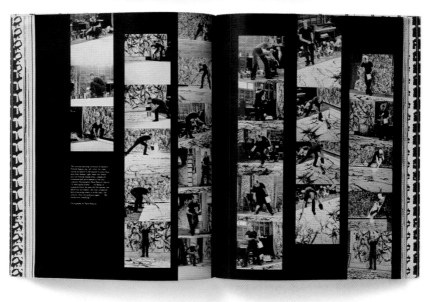

Hans Namuth: **Jackson Pollock,**
from: **Portfolio,** no. 3, 1951

Ikkō Narahara

3.11.1931 Omuta (Japan) — Lives in Tokyo (Japan) Important photographer of the pre-*Provoke* era. Member of the Vivo group and, in his early work, a representative of a documentary approach. Takes up a more subjective approach during the 1960s. 1950 begins to study law at Chūo University in Tokyo. Graduates in 1954. Buys his first camera in the same year. 1956 first solo exhibition – *Human Land* – at the Matsushima Gallery in Tokyo. After positive reactions to the exhibition, he finally decides to take up photography. At the same time he writes his doctorate in history at Waseda University, which he completes in 1959. 1957 participates in the epoch-making *Eyes of Ten* group exhibition in Tokyo. 1959 founder member of the Vivo photographers' co-operative, "which was going to release the new wave of Japanese photography" (*La Recherche Photographique*). 1961 the Vivo group breaks up. 1962–1965 lives in Paris and travels extensively throughout Europe. 1970–1974 takes up residence in New York, and travels through the USA. Numerous exhibitions and publications. 1974 participates in the important New York exhibition *New Japanese Photography*. 1976 represented at the *Neue Fotografie aus Japan* (New Photography from Japan) exhibition in Graz, Austria. Ever since his book *Shōmetsu shita jikan* (*Where Time Has Vanished*), internationally acknowledged as one of the most important Japanese photographers of the second half of the 20th century. Numerous awards, incl. the Ministry of Education Art Prize (1968), Annual Award of the Photographic Society of Japan (1986), National Photography Award at the Higashikawac International Photography Festival (1987). and the 1996 Medal of Honor of the Japanese Government.

EXHIBITIONS (Selected) — **1956** Tokyo (Matsushima Gallery) SE // **1958** Tokyo (Fuji Photo Salon – 1960, 1965) SE // Osaka (Fuji Photo Salon) SE // **1972** Tokyo (Seibu Gallery – 1983) SE // **1973** Rochester (New York) (George Eastman House) SE // **1974** New York (Museum of Modern Art/**New Japanese Photography**) GE // **1975** New York (Light Gallery) SE // **1976** Graz (Austria) (Stadtmuseum/**Neue Fotografie aus Japan**) GE // **1981** London (The Photographers' Gallery) SE // **1985** Seoul (South Korea) (Walker Hill Center) SE // **1987** Tokyo (P.G.I. Gallery) SE // **1993** Speyer (Germany) (Historisches Museum der Pfalz) GE // **2002** Paris (Maison européenne de la photographie) SE // **2003** Houston (Texas) (Museum of Fine Arts/**The History of Japanese Photography**) GE // **2009** Cologne (Galerie Priska Pasquer) SE

BIBLIOGRAPHY (Selected) — **Yōropa: Seishi shita jikan (Europe: Where Time Has Stopped)**. Tokyo 1967 // **Supein: Ida naru gogo (España Gran Tarde)**. Tokyo 1969 // **Japanesku (Japanesque)**. Tokyo 1970 // **Ōkoku (Man and His Land)**. Tokyo 1971 // **Ikiru yorokobi (Celebration of Life)**. Tokyo 1972 // **Shōmetsu shita jikan (Where Time Has Vanished)**. Tokyo 1975 // **Ōkoku (Domains)**.Tokyo 1978 // **Anthology of the Photography of the Shōwa Period, Vol. 9: I.N.** Tokyo 1983 // **Venetsia no yoru (Venice – Nightscapes)**. Tokyo 1985 // Ningen no tochi (Human Land). Tokyo 1987 // **Venetsia no hikari (Venetian Light)**. Tokyo 1987 // **Kū (Emptiness)**. Tokyo 1994 // Shigeichi Nagano, Kōtarō Iizawa, and Naoyuki Kinoshita (eds): **I.N.** Tokyo 1997 (= Japanese Photographers no. 31) // Thomas Buchsteiner and Meinrad Maria Grewenig (eds): **Japanische Fotografie der 60er Jahre/Japanese Photography in the 1960s.** Heidelberg 1993 (cat. Historisches Museum der Pfalz, Speyer) // Gabriel Bauret and I.N.: **I.N.: Photographies 1954–2000.** Paris 2002 (cat. Maison européenne de la photographie) ✎ // Anne Wilkes Tucker, Dana Friis-Hansen, Ryūichi Kaneko, and Takeba Joe: **The History of Japanese Photography.** New Haven/London 2003 (cat. Museum of Fine Arts, Houston)

"He is a travel photographer … and goes to a place that is a seeming hell and wants to show that calm is possible there too. 'More than once' he writes, 'I had the impression that the spirit of my photographs had reached that level of detachment and achieved that liberty of the soul which attains nothingness: Zen.' But soon the photographer departs, taking other journeys and regarding the world with an almost mocking, light eye. He lives in Tokyo, Paris, New York, and visits Barcelona, Pompeii or Venice. He stages and arranges models into humorous compositions, captures the traces of lightning, catches a fleeting light in a Venetian street. Ikkō Narahara tries to take 'the heavens in his hands'." — Jean-Luc Monterosso ✍

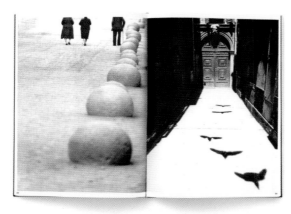

Ikkō Narahara: **Europe: Where Time Has Stopped.** Tokyo (Kajima Inst. Shuppankai) 1967

Floris M._(ichael) Neusüss

Floris Neusüss: **Nachtstücke.
Fotogramme 1957 bis 1997.**
Köln (Rheinland-Verlag GmbH)
1997

3.3.1937 Remscheid-Lennep (Germany) — Lives in Kassel (Germany)
Professor, teacher, curator, author, photographer. His focus in the theory and practice of photography is on the exploration of the photogram. 1955–1963 studies at the School of Art and Design in Wuppertal (with Ernst Oberhoff), at the Bayerischen Staatslehranstalt für Photographie (Bavarian National Institute of Photography) in Munich (with Hanna Seewald), and at the College of Fine Arts in Berlin (with > Hajek-Halke). 1954 first photograms. 1963 first body photogram. 1966 begins teaching at the Staatlichen Werkkunstschule (State School of Art and Design) in Kassel. From 1971 teaches the experimental photography class at the Kunstakademie Kassel (Academy of Arts, now university). 1972 starts a college gallery (Fotoforum Kassel). Mounts numerous exhibitions there on the theme of Art and Photography. Comes to the fore himself with photography without a camera. 1971–1975 pieces on photographic syntax. 1976 "body dissolutions" and photogram performances. From 1982 photogram portraits. From 1984 large-format photogram pieces and "night pictures" (photograms out of doors and at night). 1990 exhibition *Presence with Absence* in the Zurich Art Museum as the end result of his years of research into the history of the photogram. Hermann Claasen Prize in 1995.

"Unlike conventional photographers, Neusüss does not seek his images in the world of the visible, but in realms which are not accessible to that most extrinsic of all eyes, the eye of the camera. Since his artistic beginnings around 1960, he has used photography in an unphotographic way: not to capture images seen in the real world and optical impressions as likenesses, but to invent pictures that make visible something of what is going on before his inner eye. Neusüss belongs to the anti-positivist and anti-rationalist movement in art, in other words to the tendency that – since the great modernist schism around 1850 – has given precedence to the representation of the invisible over the reproduction of the image on the retina." — Herbert Molderings ✍

EXHIBITIONS (Selected) — **1963** Cologne (photokina) SE // **1976** London (The Photographers' Gallery) SE // **1977** Kassel (Germany) (Kasseler Kunstverein) SE // **1983** Munich (Fotomuseum) SE // **1992** Heidelberg (Heidelberger Kunstverein) SE // **1995** New York (Sander Gallery) SE // **1997** Bonn (Rheinisches Landesmuseum) SE // **1999** Berlin (Galerie Camera Work) SE // **2001** Halle (Germany) (Staatliche Galerie Moritzburg) SE // **2004** Berlin (Georg-Kolbe-Museum) SE // **2006** Fribourg (Switzerland) (Naturhistorisches Museum) SE // **2007** Berlin (Villa Grisebach Gallery) SE // London (Atlas Gallery/**Retrospective**) SE // **2012** Munich (Münchner Stadtmuseum, Sammlung Fotografie) SE

BIBLIOGRAPHY (Selected) — **Fotografie 1957–1977.** Kassel 1977 (cat. Kasseler Kunstverein) // **Fotogramme – die lichtreichen Schatten.** Kassel 1983 // **Das Fotogramm in der Kunst des 20. Jahrhunderts.** Cologne 1990 // **Nachtstücke. Fotogramme 1957 bis 1997.** Cologne 1997 (cat. Rheinisches Landesmuseum, Bonn) ✍ // F.M.N. and Peter Cardorff: **ULOs Wunderbar.** Düsseldorf 2000 // **Körperbilder.** Halle 2001 (cat. Staatliche Galerie Moritzburg) // Renate Heyne (ed.): **Kunst und Fotografie. F.N. und die Kasseler Schule für Experimentelle Fotografie 1972–2002.** Marburg 2003 // F.M.N. and T.O. Immisch (eds): **Die zweite Avantgarde. Das Fotoforum Kassel 1972–1982.** Halle 2008 // **Traumbilder. Fotografien 1958 bis 1983.** Ostfildern 2012 (cat. Münchner Stadtmuseum)

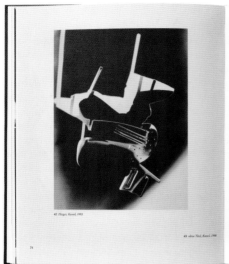

42 *Flieger, Kassel, 1993*

43 *ohne Titel, Kassel, 1988*

74

41 *Zum Unbekannten verkommene einer Gleichlung, Kassel, 1988*

72

Arnold Newman

3.3.1918 New York (USA) — 9.6.2006 New York Portraits of artists are at the center of his freelance and commissioned photographic work (editorial and advertising). Sometimes described as the father of the "environmental portrait". Second of three sons. Elementary school in Atlantic City (New Jersey). Graduates from high school in Miami Beach (Florida). Studies art briefly in Coral Gables (Florida), breaks off in 1938 for financial reasons. Takes a job in a portrait studio in Philadelphia (Pennsylvania). Gets to know Ben Rose, a pupil of > Brodovitch. First freelance work under the influence of the photography of the Farm Security Administration (FSA) (Jack Delano, > Evans, > Lange, Arthur Rothstein). 1939 works in photo studios in Philadelphia, Baltimore (Maryland), and Allentown (Pennsylvania). June 1941 New York. Encouraging meeting with Beaumont Newhall and > Stieglitz. First exhibition in the A.D. Gallery (with Rose). 1942–1945 had his own studio in Miami Beach. 1946 moves to New York. Works for *Fortune* and *Harper's Bazaar*. August 1947 first of 24 cover photos for *Life*. From 1948 advertising. 1949 portrait commission for *Portfolio* marks the start of his collaboration with Fred Zachary (*Holiday*, *Travel & Leisure*, *Town & Country*). 1954 first visit to Europe. Subsequently countless trips to Europe, Africa, Japan, Latin America, Australia, and repeatedly Israel. Travel essays and above all portraits. Artists: Georges Braque, Pablo Picasso, Frank Stella, > Warhol; politicians: Konrad Adenauer, John F. Kennedy, Richard Nixon, Itzhak Rabin; writers: Truman Capote, Jean Cocteau, Vladimir Nabokov; entrepreneurs: Friedrich Krupp, Rupert K. Murdoch; photographers: > Abbott, > Brassaï, > Cartier-Bresson, > Kertész, > Stieglitz, > Strand. 1959 start of his collaboration with *Look*. *Bravo Stravinsky* (1967) is probably his best-known book. Numerous exhibitions. Many awards, incl. several honorary doctorates. Substantial parts of his estate (negatives, contact sheets, transparencies and over 2,000 original prints) deposited in 2006 with the Harry Ransom Humanities Research Center at the University of Texas at Austin.

EXHIBITIONS (Selected) — **1941** New York (A.D. Gallery) JE (with Ben Rose) // **1945** Philadelphia (Pennsylvania) (Museum of Art – 2007) SE // **1951** New York (Camera Club) SE // **1956** Santa Barbara (California) (Museum of Art) SE // **1963** Venice (Biennale) SE // **1972** Rochester (New York) (George Eastman House – 1994) SE // **1979** London (National Portrait Gallery) SE // **1980** Arles (Rencontres internationales de la photographie) SE // **1986** San Diego (California) (Museum of Photographic Arts) SE // **1992** Washington, DC (National Portrait Gallery) SE // New York (Howard Greenberg Gallery – 1999, 2003, 2007) SE // **1999** New York (International Center of Photography) SE // **2000** Washington, DC (Corcoran Gallery of Art) SE // **2003** Toulouse (Musée municipal du Château d'Eau) SE // **2008** Berlin (Kicken Berlin) SE

BIBLIOGRAPHY (Selected) — **Bravo Stravinsky.** Cleveland 1967 // **One Mind's Eye: The Portraits and Other Photographs of A.N.** Boston 1974 // **Faces USA.** New York 1978 // **The Great British.** Boston 1979 (cat. National Portrait Gallery, London) // **Artists: Portraits from Four Decades by A.N.** Boston 1980 // A.N. and Robert Sobieszek: **A.N.** Englewood Cliffs 1983 // **Five Decades.** San Diego 1986 (cat. Museum of Photographic Arts, San Diego) // A.N. and Bruce Weber: **A.N. in Florida.** West Palm Beach 1987 (cat. Norton Gallery) // **A.N.'s Americans.** Boston 1992 (cat. National Portrait Gallery, Washington, DC) // **El Regalo de Newman: 50 años de fotografía.** La Coruña 1997 // **A.N.: Selected Photographs.** New York 1999 // Philip Brookman: **A.N.** Cologne 2000 ✐ // **A.N. – The Early Work.** Göttingen 2008 (cat. Howard Greenberg Gallery, New York)

"Crafted with a deep understanding of the creative process, Newman's art is widely seen and reproduced in print media. He has, over time, influenced our vision of the world by projecting on a global screen the defining images of political leaders, cultural icons, and everyday people. Often, when we think of Pablo Picasso, Igor Stravinsky, Jackson Pollock, or Lyndon B. Johnson, to name but a few, we conjure up one of his images." — Philip Brookman ✍

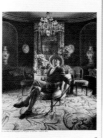
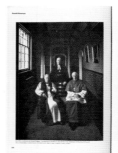

Arnold Newman: **The Great British,**
from: **Creative Camera,** November 1979

Helmut Newton *(Helmut Neustädter)*

Helmut Newton: **Archives de Nuit.** Paris (Crédit Foncier de France) 1992

31.10.1920 Berlin (Germany) — 23.1.2004 Los Angeles (USA) Fashion, beauty and portraits, nude photography. As an interpreter of erotic fantasies, one of the most talked-about photo artists of the 1980s and 90s. Son of a Berlin button manufacturer. Primary school, secondary school, American School in Berlin. 1936–1938 apprenticeship in the studio of Berlin photographer Else Simon (> Yva). 1938 flees from Germany. For a brief period press photographer with the Singapore *Straits Times*. From 1940 in Australia. Serves in the Australian army for four years. Australian citizenship from 1944. In the same year opens a photo studio in Melbourne. 1948 marries actress June Browne (stage name Alice Springs). Returns to Europe in 1956. Works for a year in London for English *Vogue*. 1957 moves to Paris. Until the early 1970s contributes fashion photographs on a regular basis to *Vogue* (France, USA, Britain, and Italy), *Elle*, *Marie Claire*, *Jardin des Modes*, *Playboy*, *Nova*, and *Queen*. After a heart attack (1971) gives up regular magazine work and turns to freelance projects: portraits and in particular erotic scenes in b/w and color. First solo exhibitions in 1975. Publishes his first book – *White Women* – in 1976. His reception worldwide reaches a high point in the 1980s with retrospective exhibitions in Groningen, Vienna, London, Paris, Tokyo, Fukuoka, Madrid, Moscow, Bologna, Copenhagen. Numerous accolades and awards, incl. (1992) the Großes Bundesverdienstkreuz der Bundesrepublik Deutschland (Grand Order of Merit of the Federal Republic of Germany). Creates the basis for a foundation with headquarters in his native Berlin (opened posthumously). Provides a forum, with changing exhibitions, for the continued presentation and discussion of his oeuvre, also in dialogue with works by other artists (such as > Clark, > Gibson, > LaChapelle, > Nachtwey, > Secchiaroli, > Weegee). *www.helmutnewton.com*

EXHIBITIONS (Selected) — **1975** Amsterdam (Canon Gallery) SE // Paris (Galerie Nikon) SE // **1976** London (The Photographers' Gallery) SE // **1984** Paris (Musée d'art moderne) SE // **1987** Bonn (Rheinisches Landesmuseum) SE // **1988** Berlin (Berlinische Galerie) SE // **1989** Madrid (Fundacion Caja de Pensiones) SE // **1992** Paris (Crédit Foncier) SE // **1993** Hamburg (Deichtorhallen) SE // **1997** Berlin (Camera Work) SE // **2000** Berlin (Neue Nationalgalerie) SE // **2003** Moscow (Moscow House of Photography) SE // **2004** Berlin (Helmut Newton Stiftung – 2005, 2006, 2007, 2008) SE // **2005** Munich (Hypo Kunsthalle) SE // **2006** Milan (Palazzo Reale) SE

BIBLIOGRAPHY (Selected) — **White Women**. New York 1976 // **Sleepless Nights**. New York 1978 // **Big Nudes**. Paris 1981 // **World Without Men**. New York 1984 // **Portraits**. New York 1986 // **H.N.'s Illustrated No. 1**. New York 1987 (No. 2, 1987; No. 3, 1991; No. 4, 1995) // **Archives de Nuit**. Paris 1992 // **Pola Women**. Munich 1992 // **Aus dem photographischen Werk**. Munich 1993 // **Pages from the Glossies**. Zurich 1998 // H.N. and Alice Springs: **Us and Them**. Zurich 1998 // **SUMO**. Cologne 1999 // **Work**. Cologne 2000 // **Sex and Landscapes**. Zurich 2001 // **Autobiographie**. Munich 2002 // **A Gun for Hire**. Cologne 2005 // **Polaroids**. Cologne 2011

Helmut Newton: **SUMO.**
Cologne (TASCHEN) 1999

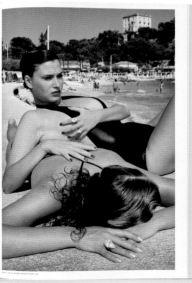

"From fashion photography to portraits, from nude studies to pictures from the world of ballet, from the erotic to the subject of death — Newton's work seems to encompass an almost baroque abundance of themes, embodying also facets of the world of glamour, dissemblance and dramatization as shaped by the mass media. Newton's art rests on his not being dazzled by this world; he not only shines a light on it but also strips it of its mask." — Zdenek Felix

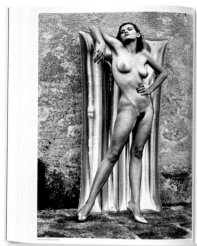

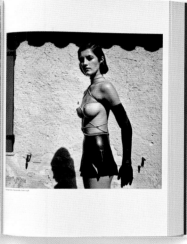

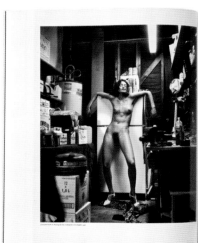

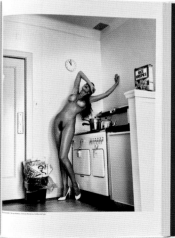

Lennart Nilsson

Lennart Nilsson: Ett barn blir till (A Child is Born). En bildskildring av de nio manaderna före födelsen – en praktisk radgivare för den blivande mamman. Stockholm 1965

22.8.1922 Strängnäs (Sweden) — 28.1.2017 Photojournalist, scientific photographer. Known internationally for his color photos (and films) about the progress of human life as it grows in the womb. Starts working as a freelance photojournalist in the mid-1940s. Contract photographer with the Stockholm publishers Åhlén and Åkerlund. One of his first commissions is a photo report on the liberation of Oslo. Publishes major photo essays (*A Midwife in Lapland*, 1945; *Polar Bear Hunting in Spitzbergen*, 1947), also in international magazines such as *Life*, *Picture Post*, *Illustrated*. In the mid-1950s turns to nature photography. Investigation of the world of ants or life under water. From the 1960s, with the help of special endoscopes, the photographic exploration of the human body. At the center of his interest: new life in the making. *A Child is Born* remains his best-known book to date. Publishes his science photography in *Time*, *Life*, *Paris Match*, *Geo*, *Stern*. From the 1960s also film and television productions: *The First Days*, 1966; *Killer and Cancer Cells*, 1967/68; *The Saga of Life*, 1982; *The Miracle of Life*, 1983; *The Miracle of Love*, 2000. Accolades include the Hasselblad Award (1980), Emmy Award (1982, 1983, 1996), ICP Infinity Award (1992), Kulturpreis of the DGPh (Deutsche Gesellschaft für Photographie: German Photographic Association) (1993), an honorary doctorate from the Technical University of Brunswick (2002). The Lennart Nilsson Award for science photography, worth 100,000 Swedish kronor (about 11,000 Euros, or 15,000 US dollars) has been in existence since 1998. He has been a member of the Swedish Society of Medicine since 1969. *www.lennartnilsson.com*

EXHIBITIONS (Selected) — **1955** New York (Museum of Modern Art/**The Family of Man**) GE // **1962** Stockholm (Fotografiska Museet – 1963) GE/SE // **1977–79** USA/Europe (touring exhibition of the Swedish Cultural Institute) SE // **1990** Gothenburg (Sweden) (Hasselblad Center) SE // **1991** New York (International Center of Photography – 1992) GE/SE // **1992** Houston (Texas) (FotoFest) SE // **1993** Toulouse (Galerie municipale du Château d'Eau) SE // **1995** Madrid (Museo Nacional de Ciencias Naturales) SE // **2000** Prague (Town Hall) SE // **2002** Stockholm (Kulturhuset/**Photographs 1942–2002** – 2008) SE // **2003** Odense (Denmark) (Brandts Museet for Fotokunst) SE // **2004** Helsingborg (Sweden) (Dunkers Kulturhus/**Photographs 1942–2002**) SE // Horten (Germany) (Preus fotomuseum/**Photographs 1942–2002**) SE // **2005** Luleå (Sweden) (Norrbottens museum/**Photographs 1942–2002**) SE // Uppsala (Sweden) (Galleri London) SE // **2006** Gothenburg (Sweden) (Hasselblad Center) SE // **2008** Mannheim (Reiss-Engelhorn-Museen/**Preisträger der Hasselblad Foundation**) GE

BIBLIOGRAPHY (Selected) — **Sweden in Profiles**. Stockholm 1954 // **Liv i hav/Life in the Sea**. Stockholm 1959 // **Myror/Ants**. Stockholm 1959 // **Halleluja**. Stockholm 1963 // **Ett barn blir till/A Child is Born**. Stockholm, 1965 // **Se manniskan/Behold Man**. Stockholm 1973 // **Så blev du till. En fotoberättelse**. Stockholm 1975 // **Vårt inre i närbild**. Stockholm 1982 // **Nära naturen/Close to Nature**. Stockholm 1984 // **Kroppens försvar/The Body Victorious**. Stockholm 1985 // **Eine Reise in das Innere unseres Körpers**. Hamburg 1987 // **Ein Kind entsteht. Bilddokumentation über die Entwicklung des Lebens im Mutterleib**. Munich 1990 // **Images of Life**. Gothenburg, 1998 // **Hans livs bilder**. Stockholm 2002 // L.N. and Hans Wigzell: **Livet**. Stockholm 2006 // **Weltstars der Fotografie – Preisträger der Hasselblad Foundation**. Mannheim 2008 (cat. Reiss-Engelhorn-Museen) ✍

"Lennart Nilsson's iron will and a tendency towards the obsessive evidently enable him to overcome every obstacle in order to achieve the picture he wants. He has infinite patience, the eye of a journalist, an artist's feeling for color and form and unique technical skill and ingenuity."
— Rune Hassner

Nästan sex veckor har gått sedan befruktningen och det är snart fyra veckor sedan menstruationen hoppade över. Om några dagar får man veta om nästa menstruation kommer, eller om den skall hoppa över den här gången också....

Barnet, en liten knubbig varelse på drygt 1½ centimeter med små korta armar och ben, växer i sin amnionhåla, väl försågd vid navelsträngen. Den stora mörka skuggan på magen är allt blod som strömmar genom hjärtat och levern. Snart en glad hallmig växer gränskten i sin smala mjälk, från den krummer färska blodkroppar in till barnets blodomlopp. Största delen av blodkropparna ligger nu inne i barnet utan i den stora moderkakan, där blodet blir syresatt och får ny näring och där kolsyra och slaggprodukter lämnas.

Ansiktet

4 veckor, 4 millimeter. Ansiktet är bara en punna, som hänger ut över den primitiva munöppningen. Tre hjärtbågor är man bakom det stora hjärtat. På den stora bilden av samma embryo (sid. 52) ser man också var ögat håller på att bildas.

5½ veckor, 15 millimeter. Näshinnan är meckförgad av pigment, den har bildats en list och franslde den en breddlinea. Ovanför ögat ser man den lilla breda nätylan till en ögonlockskant. Örat växter långt ned på huben.

8 veckor, 3 centimeter. Det är mera ansiktet nedandele ägonenrna, men underöklen är försträngte inte ordunrligt utveunou än innan ser ut att sitta lägre än de då. Nu växer moderdelen av ansiktet snabbt, barnet växer mer och mer på näcken och proportionerna blir mera svensmo.

4 månader, 16 centimeter. Hakan är fortfarande spöd och ansiktet verkar för smalt i förhållande till breddern mellan ögonen, men också är för näsa, ögonlocken lockar ut ändre ögonfrynen. Det henar på att ögonen göra stora redan förn börjat. Sedan växer ansiktet i kapp.

Porträtt av samma barn som i den tredje lilla bilden. Ögonlocken är halvslutna, om några dagar skall de slutas helt och inte öppnas igen förrän i den sjunde manaden. Under den tunna huden syns skimrar ignetom. Det finns inget riktigt skinn i kroppen än.

Ken *(Takeshi)* Ohara

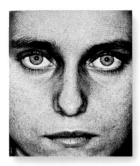

Ken Ohara: **One.**
Tokio (Tsukiji Shokan
Publishing Co.) 1970

13.8.1942 Tokyo (Japan) — Lives in Glendale (California, USA) Serial portraits contributing to a broadening of the idea of the portrait. Photo art according to a clear concept, whether with regard to the pictorial language, the rhythm of the shots, or the interaction with the subject. Seven internationally highly regarded projects between 1970 and 2003. As the son of an executive with Fuji Film (Japan), early familiarity with the medium. Has access as a young boy to various photographic publications that his father brings home. 1956 they see the exhibition *The Family of Man*, mounted in a touring version in a Tokyo department store. August 1961 accompanies his father on a business trip to the USA. Decides spontaneously to remain in the USA. Takes a temporary job (partly to improve his English) in a Japanese restaurant in downtown Manhattan. At the same time (until 1966) studies part-time at the Art Students League. Looking for an assistantship, he is recommended by Art Kane to try > Hiro. 1966–1970 assistant in the studios of Hiro and > Avedon, respectively. 1970 publishes his first and still most important book, *One,* the reading of which was described by John Szarkowski (in the year it came out) as "a really very strange experience". 1970–1971 works as a freelance photographer for *Harper's Bazaar.* 1972 photographic trip (ultimately without result) to Africa, India, and Japan. 1974 shows work at the major MoMA exhibition *New Japanese Photography.* The same year a Guggenheim grant for his project *Contacts.* At the end of the 1970s (partly as a reaction to the lukewarm response to his artistic work) abandons freelance projects and takes up fashion and advertising photography. 1988 moves to Glendale (California). In the early 1990s resumes his artistic activity.

EXHIBITIONS (Selected) — **1970** Tokyo (Sony Building Gallery) SE // **1971** Tokyo (Asahi Pentax Gallery) SE // **1974** New York (Museum of Modern Art – 1993) GE (touring exhibition visiting Seattle, San Francisco, Portland, Minneapolis, Denver, St Louis, and Champaign, Illinois) // **1979** Tokyo (Nikon Salon Ginza) SE // **1986** Tokyo (Shadai Gallery/Tokyo Institute of Polytechnics) SE // **1996** Tokyo (Artgraph Gallery Ginza) SE // **1997** Zurich (Museum für Gestaltung) GE // **1999** Los Angeles (Los Angeles County Museum) GE // **2000** Los Angeles (Stephen Cohen Gallery) SE // **2001** Hamburg (Hamburger Kunsthalle) SE // **2002** San Francisco (San Francisco Museum of Modern Art) GE // **2004** New York (Metropolitan Museum of Art) GE // **2006** Essen (Germany) (Museum Folkwang) SE // Wolfsburg (Germany) (Städtische Galerie Wolfsburg) SE // Munich (Fotomuseum) SE

BIBLIOGRAPHY (Selected) — **One.** Tokyo 1970 (facsimile reprint: Cologne 1997) // John Szarkowski and Shoji Yamagishi (eds): **New Japanese Photography.** New York 1974 (cat. Museum of Modern Art) // **The History of Modern Japanese Photography.** Tokyo 1977 // **The Complete History of Japanese Photography.** Tokyo 1986 // Robert A. Sobieszek: **Ghost in the Shell: Photography and the Human Soul, 1850–2000.** Cambridge, MA, 1999 (cat. Los Angeles County Museum) // Martin Parr and Gerry Badger: **The Photobook: A History Volume I.** London 2004 // Andrew Roth (ed.): **The Open Book.** Gothenburg 2004 // **One.** Tucson 2005 (= One Picture Book no. 31) // **With.** Santa Fe 2006 // **K.O.: Erweiterte Portraitstudien.** Göttingen 2006 (cat. Museum Folkwang, Essen)

"Apart from his loyalty to the traditional (and increasingly unconventional) black-and-white medium, a further unifying feature of his work is the continual attempt to broaden the genre of the portrait. Precisely because the portrait has been from the start the most prevalent of photographic motifs, Ohara wanted to show that the familiar norms operating in the reproduction of the human image can be appreciably changed in order to broaden our perception of other people and of ourselves. His work is 'formalistic' to the extent that it displays a very careful handling – aimed at claiming our attention – of the intrinsically photographic compositional devices of choice of picture detail, range of tonal values and sizing; the same is true of length of interval, duration, repetition and variation. Nonetheless many of the project titles – *One* (1970), *Contacts* (1974–1976), *With* (1994–1998) – play down Ohara's unique presence and influencing control and betray a deeper need to divide the work (and the authorial recognition) between photographer, camera and human subject." — Sally Stein ✍

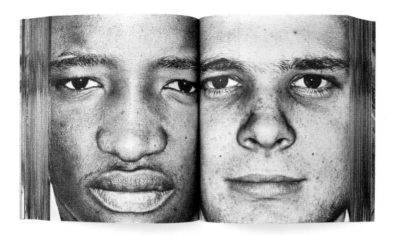

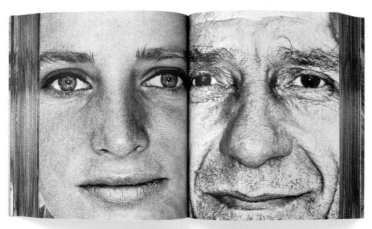

Ruth Orkin

3.9.1921 Boston (Massachusetts, USA) — 16.1.1985 New York (USA) Filmmaker, photographer. Portraits of musicians, photo reports, essays (e.g. on Jewish immigrants in the USA), and freelance long-term projects on the subject of "The view from my window". Her mother – Mary Ruby – is a celebrated star of silent films. Childhood in Hollywood. 1931 her first camera. 1935–1939 Beverly Hills and Eagle Rock High School. 1940 Los Angeles City College. 1941 office girl at Metro Goldwyn Mayer, then in the Women's Army Auxiliary Corps. Self-taught. 1943 moves to New York. First jobs for *Theatre Week* and *Chess Review*. 1945 first publications in the *New York Times*. Courses at the Photo League. Meets her future husband, the photographer Morris Engel. 1945–1952 freelance work for *Life*, *Look*, *Ladies' Home Journal*, *Cosmopolitan*, *Coronet*. 1946–1950 portraits of well-known musicians and conductors (Leonard Bernstein, Isaac Stern, et al.). 1951 third prize in the first *Life* competition for young photographers. In the same year in Israel photographing the story of the Israel Philharmonic. 1953 *Little Fugitive*, a film she makes with Engel, wins an Oscar nomination and a Silver Lion in Venice. From the 1950s repeatedly returns to photographing the view from the window of her apartment overlooking Central Park. A collection of these photographs appears in her first (and most important) book: *A World Through My Window*. 1959 voted one of the ten major American women photographers.

BIBLIOGRAPHY (Selected) — **A World Through My Window.** New York 1978 // Lee D. Witkin and Barbara London: **The Photograph Collector's Guide.** London 1979 ✎ // **A Photo Journal.** New York 1981 // **More Pictures from My Window.** New York 1983 // **50 Jahre moderne Farbfotografie/50 Years Modern Color Photography 1936–1986.** Cologne 1986 (cat. photokina) // **Musicians.** New York 1987 // **R.O.: A Retrospective.** New York 1995 // **Above and Beyond.** New York 1999 (cat. Howard Greenberg Gallery) // **Howard Greenberg: An American Gallery.** New York 2007 (cat. Howard Greenberg Gallery)

"Orkin has a special talent for photographing people, and she is comfortable working up close – a danger zone for many photographers, who prefer the safety of distance and non-involvement. […] As a result, many of her photographs of celebrities capture intimate and revealing moments that seem to go beyond a public image." — Lee D. Witkin ✍

Ruth Orkin: **A World Through My Window.** New York (Harper and Row) 1978

José Ortiz Echagüe

21.8.1886 Guadalajara (Spain) — 7.9.1980 Madrid (Spain) Engineer and entrepreneur. Exponent, as an amateur photographer, of a late Pictorialism. Regarded as Spain's major photo artist. His first camera, at 12, is a Kodak box 8 x 8. Subsequently an intense involvement with the medium. 1903 trains as an engineer at the Military Academy in Guadalajara. 1909–1912 military service in Spain and North Africa. 1911 pilot's license. 1923 founds the Sociedad de Construcciones Aeronauticas (CASA). 1950 general manager of the SEAT car company. Freelance photographic projects from 1903. Inventory of Spanish landscapes, people and buildings (palaces and castles) in a Pictorialist style (mostly carbon pigment prints) which rejects all New Objectivity or experimental developments. International uptake from 1928. Numerous (mostly self-published) books. *España, Tipos y Trajes* (12 editions, 70,000 copies) his best known. Many accolades, incl. honorary membership of the Real Sociedad Fotográfica (Madrid). Estate (30,000 negatives, 1,500 vintage prints) held by the University of Navarra.

"For seventy years, this engineer, officer, pilot and entrepreneur photographed his country in the same style, with the same subject matter. The act of taking pictures has the effect of making time stand still. Some of Ortiz Echagüe's photographs convey the impression that they are perhaps not photographs at all: the grainy, impressionistic, extremely finely shaded Fresson prints look as if they have been painted. Neither wrist watches or telegraph poles, airplanes or cars disfigure the ideal world of Ortiz Echagüe. This archaic portrait of Spain made Ortiz Echagüe famous. The series of his international exhibitions culminated in 1960 in the show *Spectacular Spain* in the Metropolitan Museum of Art in New York. They still shape the image we have of Spain today." — Jörg Bader ✎

EXHIBITIONS (Selected) — **1928** Turin (Gruppo Piemonteste) SE // **1935** London (Royal Photographic Society – 1958) // **1952** Washington, DC (Smithsonian Institution) // **1960** New York (Metropolitan Museum) SE // **1962** Madrid (Biblioteca Nacional – 1980) // **1992** Arles (Rencontres internationales de la photographie) SE // **1999** Paris (Hôtel de Sully) SE // **2004** Madrid (PHotoEspaña) GE // **2009** Montpellier (France) (Pavillon Populaire) SE // **2014** Madrid (Real Academia de Bellas Artes) SE

BIBLIOGRAPHY (Selected) — **Spanische Köpfe.** Berlin 1929 // **España. Tipos y trajes.** Madrid 1933 // **España. Pueblos y paisajes.** Madrid 1938 // **España mística.** Madrid 1943 // **España. Castillos y alcázares.** Madrid 1956 // **Spanien. Landschaften und Portraits 1903–1964.** Munich 1979 // **Fotografías 1903–1964.** Madrid 1998 // Jörg Bader: "Schwarz ist die Macht." In: **Süddeutsche Zeitung**, 22.1.1999 ✎ // **La fotografía de J.O.-E.: técnica, estética y temática.** Pamplona 2000 // Horacio Fernández: **Variaciones en España. Fotografía y arte 1900–1980.** Madrid 2004 (cat. PHotoEspaña) // Margit Kern (ed.): **Das Spanienbild im Fotobuch/España a través de la cámara.** Leipzig 2008 (cat. Instituto Cervantes Berlin) // **Norte de África.** Madrid (cat. Real Academia de Bellas Artes)

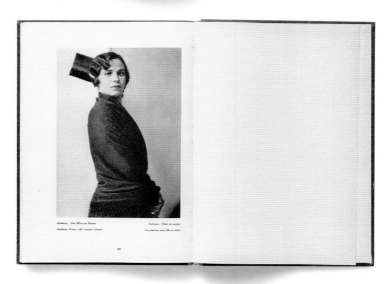

José Ortiz Echagüe: **Spanische Köpfe.** Berlin (Wasmuth Verlag) 1929

Paul *(Everard)* Outerbridge, Jr

Paul Outerbridge: **Photographing in Color.** New York (Random House) 1940

15.8.1896 New York (USA) — 17.10.1958 Laguna Beach (California, USA) Advertising, object photography under the influence of both Surrealism and New Objectivity. Daring nude studies processed with complicated three-color carbro technology. One of the most innovative photographers between the wars, and a creative mediator between art and commerce. Elementary school in New York. Hill School in Pottstown (Pennsylvania). Cutler School, New York. From 1915 studies anatomy and aesthetics at the Art Students League, New York. 1916 works as a stage designer. 1917 joins the British Royal Flying Corps, later the US army. 1918–1919 California. 1921 marries Paula Smith. Studies at the Clarence H. White School of Photography, at the same time decides definitively to take up photography. From 1921 first publications in *Vanity Fair*, among them his famous *Ide Collar* (November 1922). Subsequently rises to become one of the leading object and advertising photographers with numerous publications in *Vogue*, *Vanity Fair*, and *Harper's Bazaar*, among others. Contact with > Stieglitz and the sculptor Alexander Archipenko. 1925 moves to Paris. Becomes acquainted there with Constantin Brancusi, Georges Braque, Salvador Dalí, Marcel Duchamp, Pablo Picasso, Igor Stravinsky, and the photographers > Abbott and > Hoyningen-Huene. Sets up a large but short-lived studio. Leaves his wife Paula and (1928) moves to Berlin. 1929 shows work in the groundbreaking exhibition *Film und Foto* in Stuttgart. In the same year returns to New York. 1930 starts experimenting with carbro color printing. Successful advertising photography using the carbro process. 1943 moves to Hollywood, shortly after to Laguna Beach. Sets up a modest portrait studio. Travels through the USA, Mexico, and South America on behalf of various magazines. All in all around 600 works of high quality. 1958 dies of lung cancer.

EXHIBITIONS (Selected) — **1923** New York (Art Center) SE // **1928** Paris (1er Salon indépendant de la photographie/**Salon de l'Escalier**) GE // **1929** Stuttgart (**Film und Foto**) GE // **1937** New York (Museum of Modern Art) GE // **1959** Washington, DC (Smithsonian Institution) SE // **1981** Laguna Beach (California) (Laguna Art Museum) SE // **1987** Paris (Musée national d'art moderne) SE // **2005** Berlin (Kunstbibliothek) GE // **2007** New York (Peter Hay Halpert Fine Art) SE // **2009** Los Angeles (J. Paul Getty Museum) SE // **2009** Stuttgart (Staatsgalerie/ **Film und Foto: Eine Hommage**) GE // **2013** Salzburg (Museum der Moderne) GE

BIBLIOGRAPHY (Selected) — **Photographing in Color.** New York 1940 // **P.O. Jr.: Photographien.** Munich 1993 // Graham Howe and others: **P.O.: Photographs.** New York 1980 // Elaine Dines: **P.O.: A Singular Aesthetic. Photographs and Drawings 1921– 1941.** Laguna Beach 1981 (cat. Laguna Art Museum) // Manfred Heiting (ed.): **P.O. 1896–1958.** Cologne, 1999 // Christine Kühn: **Neues Sehen in Berlin. Fotografie der Zwanziger Jahre.** Berlin 2005 (cat. Kunstbibliothek) // Pamela Roberts: **A Century of Colour Photography.** London 2007 // Paul Martineau: **P.O. Command Performance.** Los Angeles 2009 (cat. J. Paul Getty Museum) // Phillip Prodger, Graham Howe, and William A. Ewing (eds): **P.O. New Color Photographs from Mexico and California, 1948–1955.** Portland, Oregon 2009 // **Focus on Photography.** Munich 2013 (cat. Museum der Moderne, Salzburg)

"Paul Outerbridge's contribution to the history of photography lies in his incomparable technical virtuosity, which he combined with a creative flair for abstract and geometric design. With his experiences in color printing, which he shared with the public in several essays and in his book *Photographing in Color* (1940), he showed how photography can best give expression to commercial interests and personal passions. He was able to transform everyday objects as it were into abstractions, in which the harmonious alternation of mass and line, light and shade calls into question our traditional perception of them. But his interest lay not only in commercially marketable pictures but also in an exploration of the female body [...] By transferring these impulses onto light-sensitive photo paper he took photography a little further into the realm of the aesthetic and the deeply personal. For this reason his work was unique in his own time and still remains so today." — Elaine Dines-Cox and Carol McCusker ✎⃝

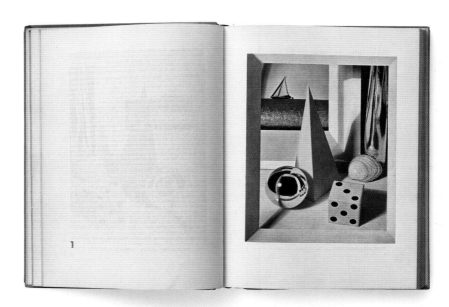

1

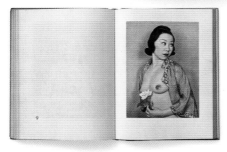

9

2

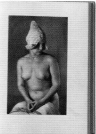

Norman Parkinson

(Ronald William Parkinson Smith)

Norman Parkinson: **50 Years of Portraits and Fashion.** London (National Portrait Gallery) 1981

21.4.1913 London (England) — 15.2.1990 Singapore Photojournalism. Pioneer in the 1940s of a "New Naturalism" in fashion and portrait photography. 1927–1931 educated at Westminster School in London. 1931–1933 trains in the studio of Speaight and Sons Ltd, London. 1934 opens his own studio with Norman Kibblewhite. 1935–1940 photo reports for *Bystander* and British *Vogue*. Fashion according to aesthetic principles clearly learned from > Munkácsi. Simultaneously (1937–1960) a farmer. 1945–1960 fashion photography and portraits for *Vogue* (international). 1952 first advertising photography. 1960–1964 co-editor and innovative photographer with *Queen*. 1963 moves to the island of Tobago. Once more a farmer. 1981 official photographer to the royal family. In the same year major retrospective at the National Portrait Gallery. Designs the Pirelli Calendar in 1985. Freelances for *Vogue*, *Elle*, *Life*, *Town & Country*. Numerous awards. 1968 Honorary Fellowship of the Royal Photographic Society.

"Parkinson traced the variety displayed in his work to an inherent 'mixture of rustic and urbane genes'. […] After 1949, when Parkinson began annual visits to New York to work for American *Vogue*, the urbanity is increasingly in evidence. The American experience was undoubtedly beneficial in expanding Parkinson's range and professionalism, but entailed the sacrifice of specifically English qualities which had informed his most individual work."

— Martin Harrison ✍

EXHIBITIONS (Selected) — **1935** London (Parkinson Studio) SE // **1978** London (The Photographers' Gallery) SE // **1980** Oxford (Museum of Modern Art) GE // **1981** London (National Portrait Gallery) SE // **1985** London (Victoria and Albert Museum) GE // **2004** London (National Portrait Gallery) SE // London (Hamiltons) SE // New York (Staley-Wise Gallery/**Retrospective 1935–1990**) SE // **2006** Hamburg (Haus der Photographie/Deichtorhallen) GE // **2008** London (The Parking Lot) SE

BIBLIOGRAPHY (Selected) — Alexander Liberman: **The Art and Technique of Color Photography.** New York 1951 // Nancy Hall-Duncan: **The History of Fashion Photography.** New York 1979 // **50 Years of Portraits and Fashion: Photographs by N.P.** London 1981 (cat. National Portrait Gallery) // **Lifework.** London 1984 // **N.P.: Photographs 1935–1990.** London 1994 // Martin Harrison: **Appearances: Fashion Photography Since 1945.** London 1991 ✍ // **Alle Pirelli-Kalender.** Munich 2001 // **The heartbeat of fashion. Sammlung F.C. Gundlach.** Bielefeld 2006 (cat. Haus der Photographie/Deichtorhallen Hamburg)

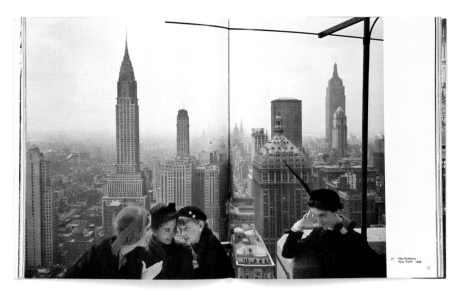

56 Hat fashions
New York 1949

57

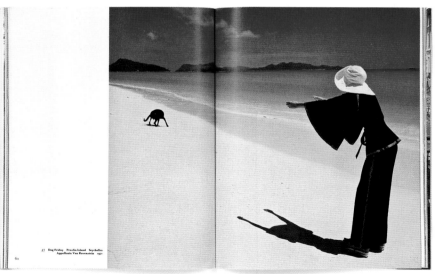

55 Dog Friday Praslin Island Seychelles
Apollonia Van Ravenstein 1971

60

Gordon *(Roger Alexander Buchanan)* Parks

30.11.1912 Fort Scott (Kansas, USA) — 7.3.2006 New York (USA) Fashion, portraits, and – for *Life* – numerous photo reports on the everyday life of black people in the USA. Writer, filmmaker, musician, but made his mark above all as a photojournalist. According to > Beaton "the first internationally famous black photographer". Apart from portraits and fashion (mainly for *Vogue*), also numerous photo reports essentially on "black" themes (racism, the civil rights movement). Elementary school in Saint Paul (Minnesota). Then various jobs as a bus driver, piano player, and (from 1935) a waiter with Northern Pacific. Takes up photography under the influence of *Life* and cinema newsreels. 1942–1943 works for the Farm Security Administration (FSA) (under Roy Stryker). 1943–1945 at the US Office of War Information. Then works again for Stryker at the Standard Oil Company. 1948–1961 contract photographer for *Life*. Till the 1970s numerous photo essays and reports on the emancipation of the blacks in North America (e.g. *The Black Muslims*, 1963; *The Death of Malcolm X*, 1965; *On the Death of Martin Luther King, Jr.*, 1970). Also films (including *The Learning Tree*, 1969), piano and orchestral compositions and several autobiographically inspired books. Numerous accolades and awards. Works are in MoMA (New York), International Center of Photography (New York), and the Library of Congress (Washington, DC).

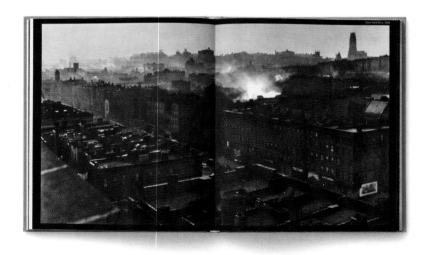

EXHIBITIONS (Selected) — **1953** Chicago (Illinois) (Art Institute) SE // **1966** Cologne (photokina) SE // **1977** Kassel (documenta 6) GE // **1989** Cologne (Museum Ludwig) SE // **1994** New York (Howard Greenberg Gallery – 2006) SE

BIBLIOGRAPHY (Selected) — **Flash Photography.** New York 1947 // **A Poet and his Camera.** New York 1969 // **Born Black.** New York 1971 // **Moments Without Proper Names.** London 1975 // **The Concerned Photographer 2.** New York 1972 // **40 Jahre Fotografie.** Schaffhausen 1989 // **Voices in the Mirror.** New York 1990 // Klaus Honnef: "Ikone der Schwarzen." In: **Die Welt**, 9.3.2006 ✍ // **Collected Works**. Göttingen 2012

"The camera for Parks was 'a weapon against adversity', and his color comprised all the nuances between white and black. His repudiation of social injustice determined his view of things. With powerfully expressive and stirring pictures for the legendary magazine *Life* showing how tough life was for Afro-Americans in the sixties, he changed the thinking of white America."
— Klaus Honnef ✍

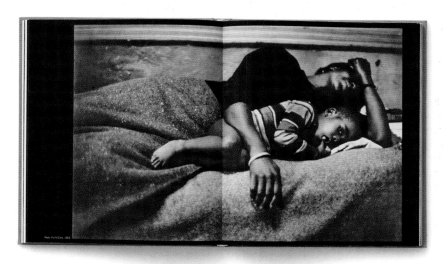

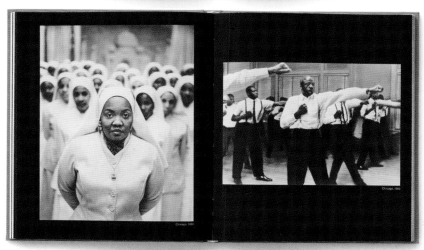

Gordon Parks from: **The Concerned Photographer 2.** New York (Grossman Publishers) 1972

Martin Parr

Martin Parr: **Common Sense.**
Stockport (Dewi Lewis Publishing)
1999

23.5.1952 Epsom (England) — Lives in Bristol (England) Member of Magnum. Trailblazer of a new European color photography. Currently one of the most talked-about photo artists. Also active as a collector, curator, and editor. Studies at Manchester Polytechnic, Faculty of Art and Design, 1970–1973. Under the influence of the oeuvre of > Ray-Jones and the color photography of > Eggleston in conjunction with the world of "vernacular photography", for which he has a particularly high regard, develops an idiosyncratic, critically ironic pictorial style. Uses a combination of daylight and flash, which sometimes lends surreal qualities to his color photography of the everyday and the trivial. Increasingly also advertising and editorial photography, including fashion for the Italian magazine *Amica*. From the 1970s recurrent periods as a lecturer, at the National College of Art and Design (Dublin), the Chelsea School of Art (London), and the University of Industrial Arts (Helsinki), among others. Numerous solo and group exhibitions. Participates in the major show *British Photography from the Thatcher Years* in 1991 at MoMA, New York. Edits, with Gerry Badger, *The Photobook: A History* (2 vols, London 2004/2006). 2004 artistic director of the Rencontres d'Arles. Many awards incl. the Dr Erich-Salomon Prize of the DGPh (Deutsche Gesellschaft für Photographie: German Photographic Association) (2006), and the Baume et Mercier Award at the PHotoEspagna Festival (2008).

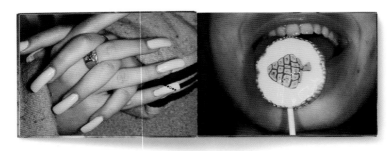

EXHIBITIONS (Selected) — **1974** York (England) (Impressions Gallery) SE // **1987** Paris (Centre national de la photographie – 1995) SE // **1991** New York (Museum of Modern Art) GE // **1995** London (The Photographers' Gallery) SE // **1998** Bradford (England) (National Museum of Photography, Film and Television) SE // **1999** Hannover (Sprengel Museum) SE // **2000** Berlin (Altes Postfuhramt) SE // **2002** London (Barbican Art Gallery) SE // **2003** Copenhagen (National Museum of Photography) SE // Madrid (Museo Nacional Centro de Arte Reina Sofía) SE // **2004** Hamburg (Deichtorhallen) SE // **2008** Munich (Haus der Kunst) SE // **2009** Paris (Jeu de Paume) SE // **2012** Fremantle (Western Australian Maritime Museum) SE // **2014** Paris (Maison européenne de la photographie) SE

BIBLIOGRAPHY (Selected) — **Bad Weather**. London 1982 // **The Last Resort**. Stockport 1986 // **The Cost of Living**. Manchester 1989 // **Home and Abroad**. London 1995 // **Small World**. Stockport 1995 // **Common Sense**. Stockport 1999 // **Benidorm**. Hannover 1999 (cat. Sprengel Museum) // **La Tendre Albion**. Paris 2000 // **M.P.: Photographic Works 1971–2000**. London 2002 (cat. Barbican Art Gallery) // Vicki Goldberg: **Light Matters: Writings on Photography**. New York 2005 ✍ // Sandra Phillips: **M.P**. London 2007 // **Luxury**. London 2009 // **No Worries**. Fremantle 2012 (cat. Western Australian Maritime Museum) // **Grand Paris**. Paris 2014. (cat. Maison européenne de la photographie)

"Martin Parr is the emperor of bad taste. He explored the territory in the 1970s and planted his flag on it in the early 1980s, before most British photographers understood what a rich resource vulgarity was. […] Parr is at once the most successful and most controversial photographer in Britain. Some of his pictures have been shown in the London Underground system and at bus stops throughout the country. He has been a member of Magnum since 1994, although he doesn't fit the usual humanitarian-documentarian Magnum profile, but practices an amusing, over-the-top, occasionally gross social critique or makes deadpan records of such mundane contemporary acts as cell phone use and falling asleep on subways. Henri Cartier-Bresson reportedly said, when Magnum was considering him, that Parr was from 'a different solar system'."
— Vicki Goldberg ✍

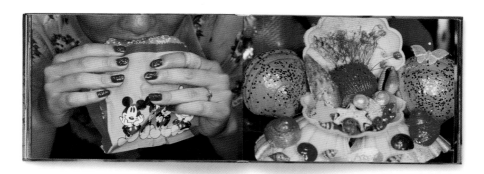

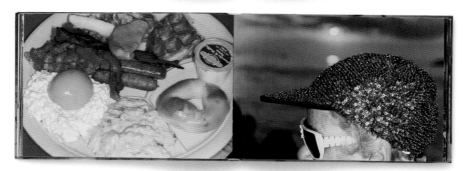

Irving Penn

Irving Penn: **Moments Preserved.**
New York (Simon & Schuster)
1960

16.6.1917 Plainfield (New Jersey, USA) — 7.10.2009 New York (USA)
Fashion and portrait photographer, author of remarkable plant studies and a series of extraordinary ethnographical essays. Unquestionably one of the major photo artists of the 20th century. 1934–1938 studies at the Philadelphia Museum School of Industrial Art. Takes course in design given by > Brodovitch. 1938–1940 freelance designer in New York. At the same time preliminary sketches for paintings and first photographs (house façades, shop signs, etc.), suggesting possible influence by > Atget. 1940–1941 with Saks Fifth Avenue, initially as assistant to Brodovitch, then as his successor. Gives up this job. Longish stay in Mexico. Devotes himself intensively there to painting and photography. Returns and (from 1943) works as an assistant to *Vogue* art director > Liberman. At first just design schemes for covers. In the same year produces his own first cover page (October issue 1943). Subsequently around 160 covers for the magazine. 1944–1945 serves as a medic and photographer with the American Field Service in Italy and India. After the war works again as a photographer for Condé Nast. Fashion photos and portraits, dance photos (from 1946), editorial still lifes (from 1947). 1951 photographs in France, Spain, and Morocco. In the following year first publicity photos for American and international clients. Hundredth *Vogue* cover in January 1965. 1967 constructs a traveling studio. Subsequently numerous ethnographical essays for *Vogue*. Also in 1967 first photo essay on flowers. 1972 still life with cigarette ends (as an exhibition in 1975 in MoMA, New York). 1982 first portraits for the re-launched *Vanity Fair*. Kulturpreis of the DGPh (Deutsche Gesellschaft für Photographie: German Photographic Association) (1987). Ranks with > Avedon as an innovator in the field of fashion and portrait photography. A purist, he formulates his pictorial ideas "without flourishes and irritating backgrounds" (Wilfried Wiegand). Photographs of "Spartan economy" and "compelling serenity" (Klaus Honnef). Looked upon in his lifetime as a "classic of photography". "Possibly the major living photographer" (Wilfried Wiegand). Coffee-table book *Passage* (1991) the highly regarded summing-up of his working life.

EXHIBITIONS (Selected) — **1954** Cologne (photokina – 1963) SE/GE // **1961** New York (Museum of Modern Art – 1975, 84) SE // **1963** Washington, DC (Smithsonian Institution) SE // **1977** New York (Metropolitan Museum of Art) SE // **1986** Paris (Centre national de la photographie) SE // **1988** New York (PaceMacGill – 1990, 1991, 1994, 1999, 2004, 2005, 2007, 2008) SE // **1998** Hamburg (Deichtorhallen – 2006) SE/GE // **2000** Paris (Maison européenne de la photographie) SE // **2001** Essen (Germany) (Museum Folkwang) SE // **2003** San Francisco (Museum of Modern Art) SE // **2004** Paris (Maison européenne de la photographie) SE // Houston (Museum of Fine Arts) SE // **2005** Washington, DC (National Gallery of Art) SE // **2007** Berlin (Camera Work) SE // **2009** Los Angeles (J. Paul Getty Museum) SE

BIBLIOGRAPHY (Selected) — **Moments Preserved**. New York 1960 // **Worlds in a Small Room**. New York 1974 // **Flowers**. New York 1980 // **I.P.** New York 1984 (cat. Museum of Modern Art) // **Issey Miyake**. Schaffhausen 1988 // **Passage: A Work Record**. New York 1991 // Klaus Honnef (ed.): **Pantheon der Photographie im XX. Jahrhundert**. Bonn 1992 (cat. Kunst- und Ausstellungshalle der BRD) // **I.P. Eine Retrospektive**. Munich 1997 // **I.P.: Objects for the Printed Page**. Essen, 2001 (cat. Museum Folkwang) // **Earthly Bodies. I.P.'s Nudes, 1949–50**. New York 2002 // **Photographs of Dahomey**. Ostfildern 2004 // **The heartbeat of fashion. Sammlung F.C. Gundlach**. Bielefeld 2006 (cat. Haus der Photographie/Deichtorhallen Hamburg) // **Small Trades**. Los Angeles 2009 (cat. J. Paul Getty Museum)

"Technically his art is perfection: the way he manages light is perfect, only occasionally intensifying into sharp contrast; there is an admirable delicacy in the flow of lines in his pictures, often ending in triangular forms; he treats his subjects with meticulous care, staging them mostly with almost Spartan economy. At a first fleeting glance, one could take Irving Penn for a classic of photography." — Klaus Honnef ✍

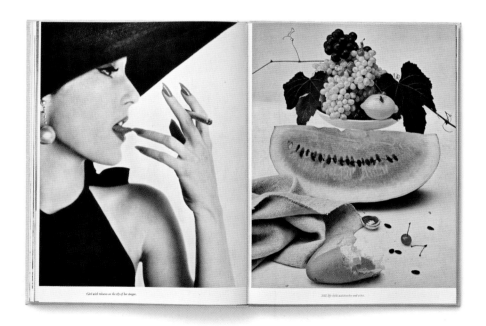

Girl with tobacco on the tip of her tongue.

Still life with watermelon and a bee.

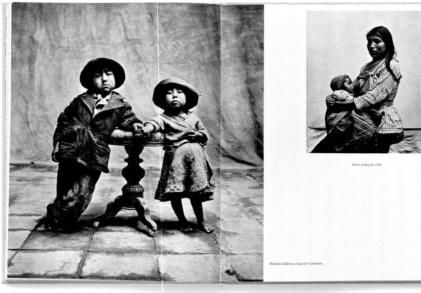

Mother feeding her child.

Mountain children in Cuzco for Christmas.

99

Funnymen

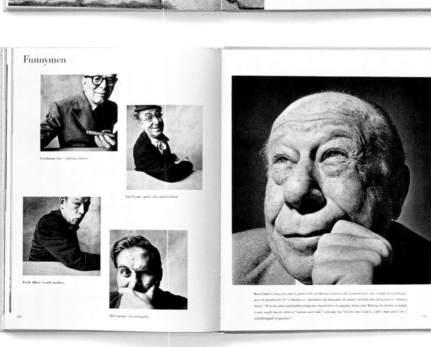

Goodman Ace—*infinitely tendrous.*

Ed Wynn—*gentle, silly, and is widowed.*

Fred Allen—*mostly melodious.*

Sid Caesar—*shy and juggling.*

Bert Lahr's *jowny face and his panlor tricks of elaborate composure and scrambled words came straight out of burlesque, an art he described for TV's Omnibus as "machine and slam-pants, the greatest vaulifying and refining force in American history." When his talents and fumbline timing were transformed to the puzzling Beckett play* Waiting for Godot, *he defined it some simplify than the critics as "abstract music hall," confessing that "the first time I read it, I didn't understand it, but I could distinguish its greatness."

454

455

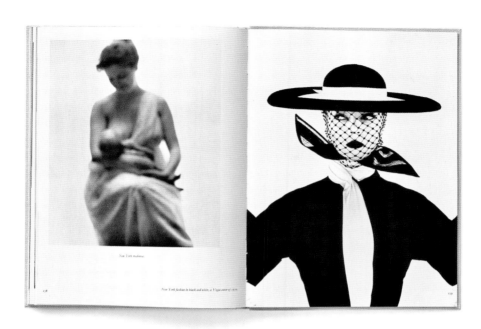

New York madame.

New York fashion in black and white, a Vogue cover of 1950.

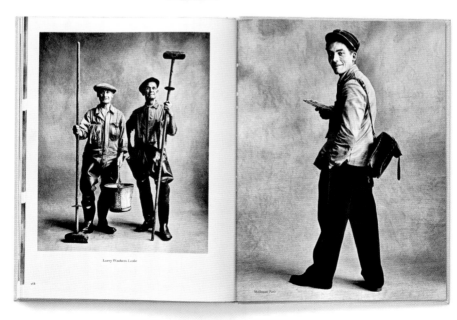

Lorry Washers, London

Milkman, Paris

Gilles Peress

Gilles Peress: **Farewell to Bosnia.**
Zurich (Scalo Verlag) 1994

29.12.1946 Neuilly-sur-Seine (France) — Lives in Brooklyn (New York, USA) Photojournalist, Magnum photographer. Known for his freelance documentary long-term projects in the spirit of "concerned photography". 1966–1968 studies at the Institut d'Études Politiques, 1968–1971 at the Université de Vincennes. Self-taught as a photographer. First photo report (1970) about the coal-mining district around Decazeville (France). In the same year first of many stays in Northern Ireland. Starts his long-term project *Hate thy Brother* (revolving around the themes of intolerance and nationalism), with pivotal chapters on Bosnia and Rwanda. 1975 moves to New York. 1979 photo report on Iran. 1981 Prix du premier livre photo for the draft of his book *Télex Persan*. Further subjects: Turkish migrant workers in Germany, Algerian immigrants in France, the legend of Simón Bolívar, the memorial ceremonies for Charles de Gaulle, General Franco, Coco Chanel. Numerous publications in *The New York Times Magazine*, *The Sunday Times Magazine*, *Du*, *Life*, *Stern*, *Geo*, *Paris-Match*, *Parkett*, *Aperture*, *Doubletake*, *The New Yorker*, *The Paris Review*. Numerous accolades including the W. Eugene Smith Award (1984), Ernst Haas Award (1989), Dr Erich-Salomon Prize of the DGPh (Deutsche Gesellschaft für Photographie: German Photographic Association) (1995), ICP Infinity Award (1994, 1996). A member of Magnum since 1971, twice president, three times vice-president of the agency.

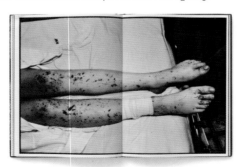

EXHIBITIONS (Selected) — **1977** Cambridge (Massachusetts) (Massachusetts Institute of Technology) SE // **1980** Tokyo (Adaku Grand Gallery) SE // **1981** Paris (Palais du Luxembourg) SE // **1984** Paris (Musée d'art moderne) SE // **1987** Chicago (Museum of Contemporary Photography) SE // **1989** Rochester (New York) (International Museum of Photography) SE // **1990** Chicago (Art Institute) SE // **1993** Winterthur (Switzerland) (Fotomuseum) SE // **1995** Essen (Germany) (Museum Folkwang) SE // **1996** New York (Howard Greenberg Gallery) SE // **2004** Berlin (C/O Berlin) SE // Paris (Galerie Fait et Cause) SE // **2006** New York (Howard Greenberg Gallery/**Photo Libris**) GE //

2008 Barcelona (**CCCB/Magnum. 10 Sequences. The role of cinema in the photographic imaginary**) GE

BIBLIOGRAPHY (Selected) — **Télex Persan.** Paris 1984 (facsimile reprint: Zurich 2000) // **Power in the Blood: Photographs of Northern Ireland.** New York 1993 // **Farewell to Bosnia.** Zurich 1994 // **Le Silence.** Zurich 1995 // **Les Tombes.** Zurich 1998 // **A Village Destroyed. May 14, 1999.** Berkeley 2002 // **Haines.** Arles 2004 (= Photo Poche Histoire no. 7) // Chris Boot (ed.): **Magnum Stories.** London 2004 📖 // Brigitte Lardinois: **Magnum Magnum.** Munich 2007

"The starting point for me was about running away from propaganda. Because I was raised in the 1960s, because I studied political science and philosophy, I saw the world around me as defined by propaganda and rhetoric. Even before I started photography, I began to see that there was a disjunction between available languages and reality. I had no trust in the media or any other representations of society for that matter, and I was looking for a process that would allow me to formalize my relationship to reality beyond words." — Gilles Peress ✍

Pierre et Gilles *Pierre Commoy / Gilles Blanchard*

Dan Cameron and Bernard Marcadé: **Pierre et Gilles. L'Œuvre complet 1976–1996.** Cologne (TASCHEN)1996

1950 La Roche-sur-Yon (France) — Lives in Paris (France) — 1953 Le Havre (France) — Lives in Paris Extravagantly staged, hand-colored portraits influenced by popular culture and everyday kitsch, baroque pomp, and Christian iconography. Groundbreaking also as catalysts of a camp aesthetic. Childhood and adolescence in a Catholic environment, which explains the affinity both have with Christian symbols and iconography. P.: studies photography in Geneva. G.: attends and obtains a diploma from the Art College in Le Havre; 1974 works for several months with Annette Messager, painting, collages, advertising, and illustrations for various magazines. P.: after military service, in 1973 works in Paris as a photographer for magazines such as *Rock & Folk*, *Dépêche Mode,* and *Interview.* Start of their joint art production (and long-term relationship) in 1976, after meeting at a party celebrating the opening of a Kenzo boutique. Apartment and studio in the Rue des Blancs-Manteaux in Paris, where from 1977 they produce their first works — inspired, for example, by the garish coloring of pictures from photo booths. Clear division of labor, with P. taking over the photo-technical part, and G. over-working the prints by hand. Placards, postcards, record sleeves. Work with Thierry Mugler. Colored portrait photos with friends as models (*Grimaces* series). Further work groups (selection): *Palace* (1978), *Adam et Ève* (1982), *Les Enfants des voyages* (1982), *Garçons de Paris* (1983), *Paradis* (1983), *Naufragés* (1986), *Pleureuses* (1986), *Au bord du Mékong* (1994), *Boxeurs thaï* (1994), *Plaisirs de la forêt* (1995). 1979 move to the Bastille district. First visit to India. 1983 first "solo" exhibition in the Galerie Texbraun in

EXHIBITIONS (Selected) — **1983** Paris (Galerie Texbraun) SE // **1985** Tokyo (Ginza Art Space) SE // **1986** Paris (Galerie Samia Saouma – 1988, 1993) SE // **1990** New York (Hirschl & Adler Modern) SE // **1992** Berlin (Raab Galerie) SE // London (Raab Gallery – 1993) SE // **1994** Arles (Rencontres internationales de la photographie) SE // **1996** Paris (Maison européenne de la photographie) SE // **1997** Munich (Fotomuseum) SE // Glasgow (Gallery of Modern Art) SE // **1998** Valencia (Spain) (Museo de Bellas Artes) SE // Paris (Galerie Jérôme de Noirmont – 2000, 2004, 2006, 2009) SE // **2000** New York (New Museum of Contemporary Art) SE // **2003** New York (Robert Miller Gallery) SE // **2004** Seoul (South Korea) (Museum of Arts) SE // Singapore Art Museum) SE // **2005** Shanghai (Museum of Contemporary Art) SE // Moscow (Moscow House of Photography) SE // **2007** Paris (Jeu de Paume) SE // **2009** Berlin (C/O Berlin) SE

BIBLIOGRAPHY (Selected) — **P. et G.** Tokyo 1985 (cat. The Ginza Art Space) // Michel Beltrami: **P. et G. L'Odyssée imaginaire.** Paris 1988 // Simon Watney: **P. et G.** New York 1991 (cat. Galerie Hirschl & Adler Modern) // Nicholas and Momus Currie: **P. et G.** Cologne 1993 // Michel Nuridsany: **P. et G., un naturel con-** fondant. Arles 1994 (cat. Rencontres internationales de la photographie) // Dan Cameron and Bernard Marcadé: **P. et G. L'Œuvre complet 1976–1996.** Cologne 1996 // **P. et G.: Grit and Glitter.** Glasgow 1997 (cat. Gallery of Modern Art) // José Miguel Cortes, Eduardo Mendicutti, and Sarah Leturcq: **P. et G.** Valencia 1998 (cat. Museo de Bellas Artes) // Catherine Francblin: **P. et G. – Douce violence.** Paris 1998 (cat. Galerie Jérôme de Noirmont) // Jérôme Sans: **P. et G. – Arrache mon cœur.** Paris 2001 (cat. Galerie Jérôme de Noirmont) // **Album P. et G.** Paris 2002 (cat. Galerie Jérôme de Noirmont) // Bernard Marcadé, Parang Park, and Jérôme Sans: **P. et G. – Beautiful Dragon.** Seoul 2004 (cat. Seoul Museum of Art) // Bernard Marcadé, Venka Purushothaman, and Kwok Kian Chow: **P. et G. – Beautiful Dragon.** Singapore 2004 (Singapore Art Museum) // Jean- Jacques Aillagon, Frédéric Blanc, and Éric Troncy: **P. et G. – Le grand amour.** Paris 2004 (cat. Galerie Jérôme de Noirmont) // Éric Troncy: **P. et G. – Sailors and Sea.** Cologne 2005 // **P. et G. – Retrospective.** Shanghai 2005 (cat. Museum of Contemporary Art) // Paul Ardenne: **P. et G. – Un monde parfait.** Paris 2006 (cat. Galerie Jérôme de Noirmont) // Paul Ardenne and Jeff Koons: **P. et G.: double je, 1976–2007.** Cologne 2007 (cat. Jeu de Paume) ✍

Paris. Work with musicians like Etienne Daho and Amanda Lear. 1985 first music video for the group Mikado. 1996 first retrospective in the young Maison européenne de la photographie of their basically overloaded oeuvre, with its inspiration in pop and kitsch, and its overtones of Christian and Far Eastern culture. By now the internationally best-known ambassadors for a good-humored, self-confident camp aesthetic. Also numerous portraits, of Catherine Deneuve, Serge Gainsbourg, Nina Hagen, Madonna, Paloma Picasso, and others. 2007 major retrospective in the Jeu de Paume (Paris). 2008 awarded the prize CULTURESFRANCE / Créateurs sans frontières for a life's work with a wide international appeal.

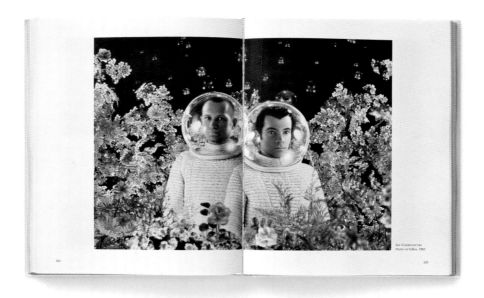

Les Cosmonautes
Pierre et Gilles, 1991

"Dan Cameron on Pierre et Gilles: 'Pierre et Gilles are true reformers; the prospect of leaving the world in the same dreary, unembellished state in which they found it is an intolerable one for them.' So it's about embellishment, and embellishment, of course, in the broader sense of *embellishment for all*, in democratic fashion, under the absolutely estimable aspect of reconciliation." — Paul Ardenne

Robert Polidori

Robert Polidori: **Parcours Muséologique Revisité.** Göttingen (Steidl) 2009

10.2.1951 Montreal (Canada) — Lives in New York (USA) and Paris (France) Travel and architectural photography. Mainly substantial series, usually compiled over several years. Major exponent of a conceptual documentarism (exclusively in color). Son of Corsican parents. Father a rocket designer. The family move to Canada, and then to the USA. Childhood in Seattle and New Orleans. Studies art in Yellow Springs (Ohio). 1969 moves to New York. Starts out as a filmmaker, with four experimental films being shown at festivals and workshops in New York. Takes up photography. Self-taught. Initially mainly travel and architectural photography for international magazines. Publications in *The New Yorker*, *Vanity Fair*, *Geo*, among others. At the same time, long-term projects on subjects of his own choice. Cycles in the spirit of a conceptual documentarism. Mostly using available light and a medium- or large-format camera (5 x 7 in.). The best-known of his picture cycles (shot under extremely difficult circumstances) are those about the radiation-contaminated cities Chernobyl and Pripyat — described by the *Frankfurter Allgemeine Zeitung* (23 October 2004) as "Still lifes of horror" — and his photographic investigation of the consequences of the hurricane Katrina flood disaster. 2009 book publication (3 vols) of his analysis of the restoration work in Versailles, started in the 1980s. Accolades include the World Press Photo (1998), Alfred Eisenstaedt Award (1999), Alfred Eisenstaedt Award for Magazine Photography (2002), the Liliane Bettencourt Prix de la Photographie (2008).

"The list of words used by Polidori himself and by the art critics to describe him is a long one: photojournalist, artist, photographing sociologist, anthropologist; the 'muse of memory', he says, and astrology too can be found in his pictures. And if you listen to him long enough, and if you can follow the thoughts that direct his eye, you learn to see Polidori's pictures differently. The unpeopled, brightly colored house façades in Havana, for example. For Polidori these are not 'simply house façades', but a visual narrative about a country at a standstill, or, in his words, in a state of 'arrested development'. You can search for ever in these pictures, nothing, absolutely nothing moves, nothing tells of becoming, everything only of dying." — Jochen Siemens ✐

EXHIBITIONS (Selected) — **1998** Paris (Institut du monde arabe) SE // **2003** New York (Pace/McGill Gallery) SE // Berlin (Camera Work – 2008) GE // **2005** Salem (Massachusetts) (Peabody Essex Museum) SE // London (Flowers Central) SE // **2006** Berlin (Martin-Gropius-Bau) SE // New York (Metropolitan Museum of Art) SE // New York (Edwynn Houk Galley – 2008) SE // **2007** New York (Cook Fine Art) GE // **2009** Montreal (Musée d'art contemporain) SE

BIBLIOGRAPHY (Selected) — **Versailles.** Cologne 1996 // **Schlösser im Loiretal.** Cologne 1997 // **Das antike Libyen.** Cologne 1999 // **Havana.** Frankfurt am Main/Zurich/Vienna 2002 // **Moods of La Habana.** Hamburg 2003 // **Sperrzonen – Pripjat und Tschernobyl.** Göttingen 2004 // **Heroes of the revolution.** Hamburg 2004 // **R.P.'s Metropolis.** Göttingen 2005 // **R.P.** Hamburg 2005 (= **Stern** Portfolio no. 41) ✐ // **After the flood.** Göttingen 2006 // **Transitional States/Parcours Muséologique Revisité.** Göttingen 2009 // **Parcours Muséologique Revisité.** Göttingen 2009 // **Some Points in Between … Up Till Now.** Göttingen 2010

Salle à manger (et chambre du Roi à appartement de Madame du Barry (1743-1793) Louis XVI bis · Louis XV, 2008

Lit et chambre du Barry

Bras sud salon, antenne reine, Escalier Louis-Philippe (1773-1850) Louis-Louis I · Le Hoqa, 1977

Fragments d'architecture Louis (1743-1793) Antichambre et salle Louis-Philippe (1773-1850) · Le Hoqa, 2001

John Rawlings

1912 Ohio (USA) — 1970 New York (USA) Fashion photography, advertising, and color portraits. Prevails over a fashion interpretation schooled in classical ideals. Master of daylight photography. Studies at Wesleyan University (Delaware, Ohio). In the early 1930s moves to New York. Works as freelance window decorator for department stores and private businesses. Creates his most effective designs with 35mm camera documentations and also society portraits. Latter work attracts the attention of Condé Nast. Results in his (1963) internship at *Vogue* studios. Publishes first work in the magazine the same year. 1937 moves to London and is commissioned by Nast and Edna Woolman Chase sets up a functional studio. Takes original fashion photography initially influenced by > Beaton, > Horst, and > Hoyningen-Huene. Alongside fashion editorials, increasingly undertakes (fashion-) portraits, including those of Lauren Bacall, Joan Crawford, and Marlene Dietrich. 1940 returns to USA. Exempt from military service. Gradually turns away from the classicism of his role models and towards natural poses in everyday ambience. Especially for his daylight-studio (East Fifty-Fourth Street) photographic style considered distinctly American. 1942 marries fashion editor Babs Willaumez. Also undertakes advertising photography and television ads. His daily rate of $10,000 makes him one of the best-paid photographers of his day. Estate administered by the Fashion Institute of Technology in New York.

"**John Rawlings was one of the most prolific commercial photographers of the twentieth century. During his three-decade affiliation with Condé Nast Publications, from 1936 to 1966, Rawlings produced over 200 *Vogue* and *Glamour* covers, a staggering 11,000 pages of editorials, fashion features and ad campaigns, and an impressive roster of television commercials. Rawlings's work, perhaps more than that of any other mid-century American fashion photographer, distinguishes itself as a veritable time capsule from the era in which American fashion and American Style truly came into their own.**" — Kohle Yohannan ✎

EXHIBITIONS (Selected) — **1986** Cologne (photokina) GE // **1990** Vienna (Kunstforum Länderbank) GE // **1991** London (Victoria and Albert Museum) GE // **2006** Hamburg (Haus der Photographie/Deichtorhallen) GE // **2008** London (The Photographers' Gallery/**Fashion in the Mirror**) GE

BIBLIOGRAPHY (Selected) — Alexander Liberman: **The Art and Technique of Color Photography.** New York 1951 // **100 Studies of the Figure.** New York 1951 // **The Photographer and His Model.** New York 1966 // Polly Devlin: **Vogue Book of Fashion Photography.** New York 1979 // **50 Jahre Moderne Farbfotografie 1936– 1986.** Cologne 1986 (cat. photokina) // **Modefotografie von 1900 bis heute.** Vienna 1990 (cat. Kunstforum Länderbank) // Martin Harrison: **Appearances: Fashion Photography Since 1945.** London 1991 (cat. Victoria and Albert Museum) // Kohle Yohannan: **J.R.: 30 Years in Vogue.** Santa Fe 2000 ✎ // **The heartbeat of fashion. F.C. Gundlach Collection.** Bielefeld 2006 (cat. Haus der Photographie/ Deichtorhallen Hamburg)

RAWLINGS

The advantage of color in photography is often said to be that it makes a picture more "realistic," but surely this notion, if we actually take, misses the important point completely. In a painting it tells any more "realistic" than a line drawing? Could color add any greater measure of realism to a magnificent action photograph from Korea? The real advantage of color, it seems to me, is that it adds a new eloquence to a picture and is a way of getting at the emotions of people more effectively than black and white can ever do. This faculty resides in color itself. This is no mere esthetic opinion; it is a matter of psychological fact. It is well known that red—any blob of red—has the power to stir our emotions with greater violence than the more "soothing" colors such as blue and green. (That is why red is a favorite color for flags, and why we speak of "seeing red" when we are angry.) Of course, the artist, whether photographer or painter, chooses colors whose emotional impact is related to his subject matter. It is difficult to think of a Rembrandt done in the frivolous blues and pinks of a Boucher. But, again, the artist's aim is not to reproduce colors literally, but to choose those colors which have the emotional effect he wants.

If a good picture is not bound to a slavish literalness in the use of color, the good photographer should feel equally free. Today the technical equipment of the color photographer can translate many notes of the phenomena of light with the camera than the painter can with pigments. The technique is there; we must simply discover how to use it. Photographers must learn to see and feel in terms of color. We must catch up with the potentialities of our new equipment.

To find out just what our equipment can do, experimentation is of the first importance. We must not be too timid in holding to a set of "rules." We must remember that the camera eye can catch effects which are too subtle or fleeting for the human eye. This is recognized as a commonplace in action shots. All of us are familiar with one or another of those great news photographs which have caught the emotional reactions of a crowd, or of a single individual, with a degree of insight which is almost embarrassing. But the camera lens is able to do the same thing with color. Some of my color photographs were obtained by using lenses with a high aberration point which upset the normal color balance of the apertures. In the end, of course, the way a photographer makes use of such experiment adds up to a kind of personal signature. Over a period of time any photographer, just as any painter, will be found to favor certain moods—certain values in terms of color—which are closest to him. But only by the freest experimentation can he "find" himself in his medium and bring the finished picture near to his imaginative conception of it.

Too often we photographers carefully try to achieve a "red" or "blue" which is the "real" red or blue. In this we act as though there were a whole set of proper colors, put away in some official boxes of standards, which have to be followed as rigidly as the butcher's scale follows the official definition of the pound. But, fortunately, photographers don't have to be such literal tradesmen. We are free to use hundreds of different reds and blues—and the easiest thing is waiting to discover them for us. It is only up to us to make the most, as artists, of this miraculous third eye which science has given us.

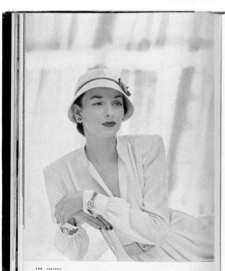

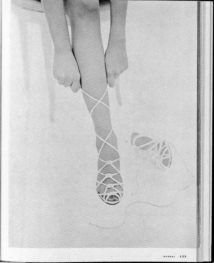

John Rawlings, from: **The Art and Technique of Color Photography.** New York (Simon & Schuster) 1951

Tony Ray-Jones *(Holroyd Anthony Ray-Jones)*

Tony Ray-Jones,
from: **Album,** April 1970

7.6.1941 Wells (England) — 13.3.1972 London (England) The most important British social-documentary photographer of the generation after Bill Brandt. Significantly influenced "independent photography" from the 1960s to 90s. Attends primary school in Hampstead, England. 1951–1957 Christ's Hospital boarding school near Horsham. 1957 to 1961 studies graphic design and photography at the London School of Printing and becomes acquainted with the oeuvre of > Brandt. 1961 to 1964 study grant for USA. Studies at Yale University in New Haven (M.F.A.). Simultaneously (1963) studies under >Brodovitch at his Design Laboratory (in the studio of > Avedon) in New York. 1964 develops *Sky Magazine* with Brodovitch (not published). Diverse freelance work cycles include photography on African Americans in New Haven. End of 1965 returns to London. Commissioned work for *Harper's Bazaar, Observer* and *Sunday Times* includes portraits of Rock Hudson, Richard Chamberlain, and Margaret Rutherford. Also works on a book about social rites, festivals, sports events and more in Britain (influenced by > Frank's *The Americans*). *A Day Off: An English Journal*, his most important work. Failed attempts to gain Magnum membership. October 1968 publishes first work in *Creative Camera*. April 1970 portfolio appears in the impressive photography magazine *Album* (editor/director: Bill Jay). 1971–1972 professorship at the San Francisco Art Institute. Returns to London. Dies of leukemia at age 30.

EXHIBITIONS (Selected) — **1969** London (Institute of Contemporary Arts) SE // **1972** San Francisco (Museum of Art) SE // Cologne (photokina) SE // **1973** Cologne (Galerie Wilde) SE // **1977** Kassel (documenta 6) GE // **1978** Berlin (Galerie Breiting) JE (with Weegee) // **1979** Amsterdam (Galerie Fiolet) SE // **1992** Paris (Fnac Étoile) SE // **1999** Hannover (Sprengel Museum) GE // **2008** Aberystwyth (Wales) (Arts Centre) GE // **2013** London (Science Museum) JE (with Martin Parr)

BIBLIOGRAPHY (Selected) — **A Day Off: An English Journal.** London 1974 // **Loisirs anglais.** Paris 1978 // **T.R.-J.** Manchester 1990 // **Mechanismus und Ausdruck. Die Sammlung Ann und Jürgen Wilde.** Munich 1999 (cat. Sprengel Museum Hannover) // Martin Parr and Gerry Badger: **The Photobook: A History Volume I.** London 2004 // Russell Roberts: **T.R.-J.** London 2005 ✍ // David Alan Mellor: **No Such Thing As Society. Photography in Britain 1967–87. From the British Council and the Arts Council Collection.** London 2008 (cat. Aberystwyth Arts Centre)

"Tony Ray-Jones is primarily known for his wry portrayal of English social life. Born in England, in 1941, he studied and lived in America before embarking on a series of journeys throughout England's seaside resorts, cities, towns, and villages to explore both the significance and idiosyncrasies of ancient customs and modern leisure. His story culminates in a period of focused and coherent photographic activity (between 1966 and 1969) when he worked with a sense of purpose derived from the belief in photography as art, as encountered in America, and galvanized by the cultural ambivalence towards the medium that he found when he returned to England. Although he died when he was only thirty years old, he formulated a visual style and aesthetic framework both intelligent and mature, and his influence was immediate and enduring. In Britain, Ray-Jones was a vital element in the postwar, transatlantic dialogue concerning the art and appreciation of photography." — Russell Roberts ✍ᴅ

Albert Renger-Patzsch

Albert Renger-Patzsch: **Die Welt ist schön. Einhundert photographische Aufnahmen von Albert Renger-Patzsch.** Munich (Kurt Wolff Verlag) 1928

22.6.1897 Würzburg (Germany) — 27.9.1966 Wamel (Germany) Landscapes, cityscapes, industrial photography, object photography, and plant studies. Pioneer of the New Objectivity in Germany. 1903–1905 attends elementary school in Dresden. 1907–1910 high school and vocational training in Sondershausen (Germany) and 1910 to 1916 in Dresden. 1919 after the war (both brothers die) begins studying chemistry at the TH Dresden (University of Technology). 1920 meets Karl Ernst Osthaus, director of the Folkwang photography archive in Hagen (Germany). Discontinues chemistry studies. Produces first photographs for Ernst Fuhrmann's planned book series *Die Welt der Pflanze* (The World of Plants). 1923 in Berlin; pharmacist in Romania. 1924 returns to Museum Folkwang and Auriga Publishers. 1926 acquires business registration as freelance photographer. 1927 meets Carl Georg Heise, director of the Lübeck Museum of Art and Art History. First large-scale museum exhibition (Behnhaus in Lübeck). 1928 publishes groundbreaking book promoting the reception of the New Objectivity, *Die Welt ist schön* (The World is Beautiful), published by Kurt Wolff Verlag with a dust jacket by Friedrich Vordemberge-Gildewart. At the end of 1929 moves to Essen. Studio spaces in Museum Folkwang. Begins collaborating with architects Fritz Schupp and Rudolf Schwarz. 1930 photographs for the Zündapp Plant (Nuremberg). 1933 succeeds Max Burchartz and holds a short-term chair for "Bildmässige Photographie" (pictorialism) at the Folkwang School in Essen. Industrial contracts include those from Boehringer, Pelikan Plants, Schubert & Salzer, and Kaffee Hag. Other large-format illustrated volumes produced after the war include *Bäume/Trees* and *Gestein/Rocks*, financed by industrialist Ernst Boehringer. Kulturpreis of the DGPh (Deutsche Gesellschaft für Photographie: German Photographic Association). 1963 television portrait of the WDR network in Cologne. 1975 Ann and Jürgen Wilde oversee establishing and initiating the Albert-Renger-Patzsch Archive in Zülpich-Mülheim near Cologne.

EXHIBITIONS (Selected) — **1928** Berlin (Staatliche Kunstbibliothek – 1932) SE // Zurich (Kunstgewerbemuseum) SE // **1931** Essen (Germany) (Museum Folkwang) SE // **1966** Essen (Ruhrlandmuseum) SE // **1996** Bonn (Kunstmuseum) SE // **2005** Berlin (Kunstbibliothek) GE // **2008** Paderborn (Germany) (Städtische Galerie Am Abdinghof) SE

BIBLIOGRAPHY (Selected) — **Die Welt ist schön.** Munich 1928 // **Eisen und Stahl.** Berlin 1930 // **A.R.-P. der Photograph.** Berlin 1942 // **Bäume.** Ingelheim am Rhein 1962 // **Gestein.** Ingelheim am Rhein 1966 // **Fotografien 1925–1960.** Bonn 1977

(cat. Rheinisches Landesmuseum) // **Ruhrgebiet-Landschaften 1927–1935.** Cologne 1982 // **Späte Industriephotographie.** Frankfurt am Main 1993 (cat. Fototage) // **Das Spätwerk.** Ostfildern 1997 (cat. Kunstmuseum Bonn) // **Meisterwerke.** Munich 1997 (cat. Sprengel Museum Hannover) ✍ // **Die Welt der Pflanze.** Ostfildern 1998 (cat. SK Stiftung Kultur, Cologne) // Christine Kühn: **Neues Sehen in Berlin. Fotografie der Zwanziger Jahre.** Berlin 2005 (cat. Kunstbibliothek) // **Pflanzen Dinge Ruhrgebiet. A.R.-P. zum 111. Geburtstag.** Paderborn 2008 (cat. Städtische Galerie am Abdinghof)

"Albert Renger-Patzsch's contribution to avant-garde photography of the 1920s and early 1930s now has a secure place in the history of the medium. What August Sander achieved for the portrait and Karl Blossfeldt for plant photography, Renger-Patzsch achieved for documentary and object photography. His most important publication, which first appeared in 1928, provocatively entitled *Die Welt ist schön* (The World is Beautiful), became one of the most influential photography books of the period. On the basis of their almost clinical purity, deliberate coolness, and utter lack of passion, his detailed views of technical devices, industrial products, and natural organisms serve as masterly examples of a new way of seeing, equating objectivity and order with beauty as well as technology with art." — Ann and Jürgen Wilde ✍

93

Bettina Rheims

Bettina Rheims/Serge Bramly:
Chambre Close. Eine Fiktion.
Munich (Gina Kehayoff) 1992

18.12.1952 Paris (France) — Lives in Paris Editorial and advertising photographer. Also completes expressive cycles, especially nude studies. Images of strippers, transsexuals, and young (androgynous) beauties. Her new view of female eroticism a subject of debate since the early 1980s. Daughter of auctioneer and art expert Maurice Rheims (1910–2003). Takes first photographs during schooldays. In the early 1970s works briefly as a model in New York. 1975 returns to Paris. From 1978 produces professional photography. 1980 widely acclaimed exhibition at the Jean-Marc Bustamante Gallery. The same year publishes her photographic series about acrobats and strippers in *Egoïste* and *Photo*. 1981 first solo exhibition at the Centre Pompidou (*Portraits*) and in Galerie Texbraun (*Nus*). 1982 portrait series of stuffed animals. First advertising photo (for Coriandre perfume). First fashion photos for Jean-Charles de Castelbajac. In addition album covers, film posters (including François Truffaut's *Vivement dimanche*), and celebrity portraits for French and European newspapers. Regularly works for *Elle* and *Paris Match*. 1987 first comprehensive catalogue in conjunction with her exhibition in the Espace Photographique (Paris). 1990 *Modern Lovers* cycle. 1991–1992 *Chambre Close* and *Les Espionnes* cycles. Beginning 1992 produces spots for Chanel and other clients. Campaign for Ferré. 1994 Grand Prix de la photographie de la Ville de Paris. 1995 official portrait of French President Jacques Chirac. 1996 the exhibition *Pourquoi m'as-tu abandonnée* as part of the opening event for the Maison européenne de la photographie. 1997–1998 *I.N.R.I.* cycle (modern, controversial photographic interpretation of the life of Jesus Christ). In the middle of 2000 *A Room in the Museum of Art in Frankfurt am Main* in the framework of the series *Szenenwechsel*.

EXHIBITIONS (Selected) — **1980** Paris (Jean-Marie Bustamante) GE // **1981** Paris (Centre Pompidou – 1983, 1985) SE/GE // Paris (Galerie Texbraun – 1982, 1983, 1984) SE/GE // **1984** New York (Galerie Daniel Wolf) SE // **1987** Paris (Espace photographique de la ville) SE // **1989** Munich (Stadtmuseum) SE // **1990** Paris (Maison européenne de la photographie – 1996, 2000) SE // **1993** Cologne (Galerie Apicella) SE // **1997** Tokyo (Odakyu) SE // **1999** Berlin (Deutsches Historisches Museum/Kronprinzenpalais) SE // **2000** Frankfurt am Main (Museum für Moderne Kunst) SE // **2005** Vienna (KunstHaus) SE // Düsseldorf (NRW-Forum Kultur und Wirtschaft) SE // **2006** Rotterdam (Kunsthal) SE // Moscow (Moscow House of Photography) SE // **2007** Hannover (kestnergesellschaft) SE // **2008** Berlin (C/O Berlin) SE // Milan (FORMA) SE

BIBLIOGRAPHY (Selected) — **B.R.** Paris 1987 (cat. Paris Audiovisuel) // **Female Trouble.** Munich 1989 (cat. Stadtmuseum) // **Chambre Close. Eine Fiktion.** Munich 1992 // **Les Espionnes.** Cologne 1992 (cat. Galerie Apicella) // **Animal.** Munich 1994 // **Photographie des 20. Jahrhunderts, Museum Ludwig Köln.** Cologne 1996 // **B.R.: Exhibition.** Munich 1997 (cat. Odakyu, Tokyo) // *I.N.R.I.* Munich 1998 // **Das Versprechen der Fotografie. Die Sammlung der DG Bank.** Munich 1998 ✐ // **More Trouble.** Munich 2004 // **Retrospective.** Munich 2004 // **Can You Find Happiness.** Munich 2004 // **Rose, c'est Paris.** Cologne 2011

"Regardless from which vantage point her images are observed, Bettina Rheim's work shows no consideration for the taboos that our Western societies seem to increasingly construct: androgyny, sexual identity, and exhibitionism, for example [...] She has an excellent technique at her disposal and, in many respects, recalls the photographs of Mapplethorpe and Newton, whose deeper sense she has obviously grasped. She makes no concessions in her works. [...] In addition, she explores the boundaries of clichés and questions our understanding of the vulgar. This passionate and polemic body of work by a woman possesses a beneficial portion of cheerful provocation. [...] The works by Bettina Rheims are and remain disturbing, and that's not the least of their merits." — Christian Caujolle ✍

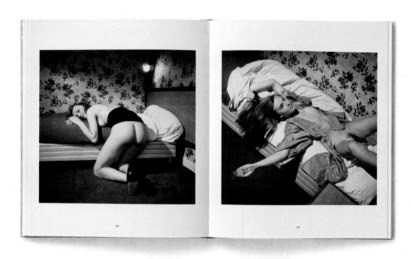

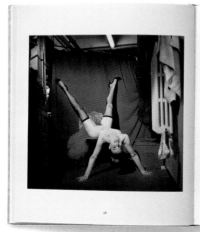

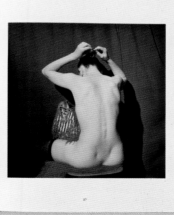

Marc Riboud

24.6.1923 Lyon (France) — 30.8.2016 Paris (France) Photojournalist and documentarist. Long-time Magnum member. Internationally known for his reports from the Far East (China, Vietnam, and Cambodia). 1937 takes first photographs. 1943–1944 active in the French Resistance. Following the war (1945–1948) studies engineering at the École Centrale de Lyon. 1948–1951 works in the engineering office of a metalworking factory in Villeurbanne (Lyon). Turns his attention towards professional photography. 1952 moves to Paris. At the invitation of > Capa and > Cartier-Bresson joins Magnum (October 1952). 1954 longer stay in London. 1955 travels by land to India and remains a year. Afterwards spends five months in China. Fascinated by the Orient he embarks on several journeys to the Far East, in particular Japan, Indonesia, North and South Vietnam, Cambodia, and regularly returns to China. In the 1960s witnesses the liberation movements in Africa. 1962 extensive reportage on the Algerian War. 1959–1973 (not including 1965) Vice-president of Magnum (Europe). 1975–1976 President. Since 1980 contributes largely b/w photo essays on self-chosen topics. *Flower Against the Bayonets*, *Painter of the Eiffel Tower*, and *Return of Khomeini* included among the photographs hailed as his best-known pictorial creations. Commissioned by Renzo Piano to document construction work on the New York Times building. Numerous prizes include the 2001 Lifetime Achievement Award of Leica Camera AG (Solms).

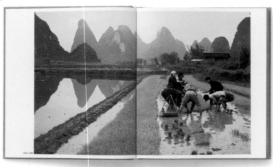

EXHIBITIONS (Selected) — **1963** Chicago (Art Institute) SE // **1975** New York (International Center of Photography – 1988, 1997) SE // **1976** Arles (Rencontres internationales de la photographie) SE // **1985** Paris (Musée d'art moderne de la Ville de Paris) SE // **1996** Paris (Centre national de la photographie) SE // **1997** London (Barbican Centre) SE // New York (Howard Greenberg Gallery – 2008) SE // **2000** London (Hackel Bury Gallery) SE // **2001** New York (Leica Gallery) SE // **2002** Paris (Galerie Agathe Gaillard) SE // **2004** Paris (Maison européenne de la photographie) SE // **2005** Guangzhou (China) (Guangdong Museum of Art) SE // **2006** Minneapolis (Minneapolis Institute of Arts) SE // Milan (Palazzo Reale) SE // **2008** Beijing (Paris-Beijing Photo Gallery) SE // Paris (La Chambre claire) SE // **2009** Leeds (Leeds City Art Gallery) SE // Paris (Espace Polka) SE

BIBLIOGRAPHY (Selected) — **Femmes Japonnaises.** Paris 1959 // **Ghana.** Lausanne 1964 // **Le bon usage du monde.** Lausanne 1964 // **Les trois bannières de la Chine.** Paris 1966 // **Face of North Vietnam.** New York 1970 // **Bangkok.** New York 1972 // **Chine: Instantanés de voyage.** Paris 1980 // **Gares.** Paris 1983 // **I Grandi Fotografi: M.R.** Milan 1983 // **M.R.: photos choisies, 1953–1985.** Paris 1985 // **L'embarras du choix.** Paris 1988 // **Le Grand Louvre.** Paris 1989 // **Angkor. Sérénité bouddhique.** Paris 1992 // **Daya Bay.** Paris 1994 // **Quarante ans de photographie en Chine.** Paris 1996 // **M.R.: 50 ans de photographie.** Paris 2004 (cat. Maison européenne de la photographie) ✍ // **M.R.: Sous les pavés.** Paris 2008 (cat. La Chambre claire)

"Marc Riboud is a humanist who loves life. Obviously. This is what shines through with his first photographs: the descending peacock, the visit to Jaipur, the pensioner from Villeurbaine slumped in his armchair, the fog of Huang Shan, and his daughter's laughter while playing with her full-grown rabbit. Marc calls these images moments of happiness for the eyes. But Marc is also someone who commits himself, who addresses the difficulty of being Arab or Congolese, who speaks about the atrocities of war, and in doing so never develops his film in blood."
— Robert Delpire ✍

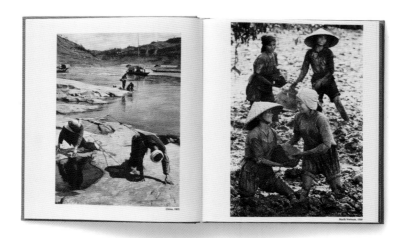

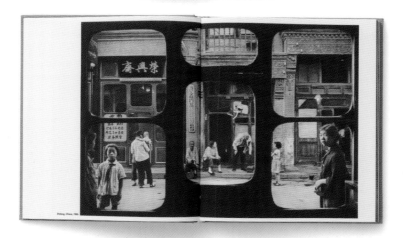

Marc Riboud, from: The Concerned
Photographer 2. New York
(Grossman Publishers) 1972

Eugene Richards

Eugene Richards: **Cocaine True, Cocaine Blue.** New York (Aperture) 1994

25.4.1944 Dorchester (Massachusetts, USA) — Lives in New York (USA) Important photojournalist of the middle generation. Chronicler of suffering (also outside North America): AIDS, drugs, crime, poverty, illness, and aging. 1962–1968 studies English at Northeastern University in Boston (Massachusetts) and attends photography courses conducted by Minor White at MIT (Massachusetts Institute of Technology). 1968–1970 social work in the Mississippi Delta. Founds the private initiative RESPECT in support of African-Americans in Memphis (Tennessee). 1973 returns to Dorchester and publication of his first book. 1978 nominated for Magnum membership (full membership from 1981 to 1995). His wife Dorothea diagnosed with cancer. Photo diary of her suffering (*Exploding Into Life*). 1988–1993 completes essays on a hospital's emergency ward (*The Knife and Gun Club*), drug addiction (*Cocaine True, Cocaine Blue*), as well as on aging, crime, and a Kansas City street gang. Likewise reportages from Europe, Black Africa, and Central America. Several publications, especially in *Life*. Numerous prizes for his committed reportages in the tradition of > Smith include the Guggenheim Fellowship Award (1980), W. Eugene Smith Memorial Award (1981), Leica Oskar Barnack Prize (1993/94), and Robert F. Kennedy Lifetime Achievement Journalism Award (1998). The film work includes *Aruyo Mi Niño: I Hug My Child* (1999), *but, the day came* (2000). Since 2006 member of the photography group VII.

"What it is exactly I do is a question I roll around in my head all the time. Now I'm at a point where I think of myself less as a photographer because I write, dabble in films – and feel in a kind of netherland. In the past, it would have been easy to say that 'I'm a photojournalist,' and I'd very much like to be a photojournalist too, but I seldom work as one now. Definitions are shifting, the world is changing, and there are fewer and fewer opportunities to do the kind of social photography I want to do, whether it's looking at health conditions in an African village or commenting on the nature of war, violence, and the drug world. So I often do other things."

— Eugene Richards ✍🏻

EXHIBITIONS (Selected) — **1997** Arles (Rencontres internationales de la photographie – 2009) SE // **1998** Paris (Centre national de la photographie) SE // **2002** Tucson (Arizona) (Center for Creative Photography) JE (with Jose Galvez, Alexis Rodríguez-Duarte) // **2004** New York (Leica Gallery) SE // **2005** Boston (Art Institute of Boston) SE // **2006** New York (Hasted Hunt) SE

BIBLIOGRAPHY (Selected) — **Few Comforts or Surprises: The Arkansas Delta.** Cambridge 1973 // **Dorchester Days.** Massachusetts 1978 // **Exploding Into Life.** New York 1986 // **Below The Line: Living Poor in America.** New York 1987 // **The Knife and Gun Club: Scenes from an Emergency Room.** New York 1989 // **Cocaine True, Cocaine Blue.** New York 1994 // **Americans We.** New York 1994 // **E.R.** Paris 1997 (= Photo Poche no. 68) // Janine Altongy and E.R.: **Stepping through the Ashes.** New York 2002 // Chris Boot (ed.) **Magnum Stories.** London 2004 ✍🏻 // **The Fat Baby.** London 2004 // **The Blue Room.** London 2008

(Robert George) Bob Richardson

Terry Richardson (ed.):
Bob Richardson. Bologna
(Damiani editore) 2007

3.1.1928 Brooklyn (New York, USA) — 5.12.2005 New York (New York, USA) Fashion photographer. Among the most radical interpreters of the spiritual climate of the 1960s and 70s. Child of Irish immigrants. One of six children. Grows up in Rockville Centre, New York. Studies art at the Parsons School of Design and the Pratt Institute (without obtaining degree). 1963 first large photo spreads in *Harper's Bazaar*, under Ruth Ansel and Bea Feitler, initiate a career with highs and lows. First marriage to Barbara Mead (a daughter is born). Beginning 1965 marries the actress Norma Kessler. 1965 birth of only son, later fashion photographer > Terry Richardson. Numerous publications in the fashion press of the 1960s. Undertakes campaigns for the fashion and cosmetics industry. His often drastically aggressive gaze (wide-angle, hard contrast b/w exposures, grainy texture) merges with provoking zeitgeist-embracing poses which significantly influence fashion photography of the 1970s and 1980s (> Lindbergh, Steven Meisel, and > Weber). Social breakdown the result of health problems (evidence of schizophrenia from the 1960s) as well as his alarming drug abuse and alcoholism. Periods of homelessness. Becomes largely forgotten. Rediscovery through fashion historian Martin Harrison. In the 1990s works as fashion photographer again. Assignments for *L'Uomo Vogue*. 1997 widely acclaimed solo exhibition at the Staley Wise Gallery (New York) as the comeback of "a 'groundbreaker of photography' who transmitted the excitement and regrets of a generation of free spirits before disappearing into a shadow-land of mental illness and homelessness." (Cathy Horyn).

"I wanted to put reality in my photographs. Sex, drugs, and rock 'n' roll — that's what was happening. And I was going to make it happen." — Bob Richardson ✎

EXHIBITIONS (Selected) — **1982** Paris (Grand Palais) GE // **1997** New York (Staley Wise Gallery) SE // **2007** Paris (Hôtel de ville) GE

BIBLIOGRAPHY (Selected) — Polly Devlin: **Vogue Book of Fashion Photography. The First Sixty Years.** New York 1979 // Diana Vreeland: **Allure.** New York 1980 // **Alexey Brodovitch.** Paris 1982 (cat. Grand Palais) // Martin Harrison: **Appearances: Fashion Photography Since 1945.** London 1991 // Virginie Chardin: **Paris en couleurs. De 1907 à nos jours.** Paris 2007 (cat. Hôtel de ville) // Terry Richardson (ed.): **B.R.** Bologna 2007 ✎

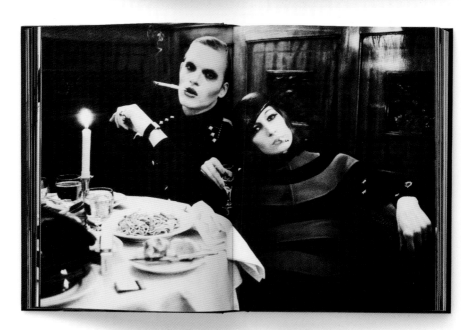

Terry Richardson

Terry Richardson: **Terryworld.**
Cologne (TASCHEN) 2004

1965 New York (USA) — Lives in New York Fashion photography (editorial and advertising) evoking a trendy snapshot and anything-goes aesthetic. His images willingly provoke against the backdrop of a new globalized youth culture. Controversial since the late 1990s. Son of fashion photographer > Bob Richardson. Spends childhood in Hollywood and Ojai (California). 1970 parents separate. Raised by mother, a dancer and stylist well connected with the international fashion scene. Moves to Woodstock. Mother suffers serious head injury from a car accident. Unable to work, she lives on welfare. At an early age T.R. shows a strong interest in music. Performs in punk bands such as *Doggy Style*, *Signal Street Alcoholics*, and *The Invisible Government*. After the groups disband he turns his attention towards photography. With his mother's help becomes an assistant for Tony Kent. Takes first photographs in the spirit of a rather intimate snapshot aesthetic. As radically uninterested in technical and formal-aesthetic brilliance as provoking when depicting physicality and sex. In effect creates a decidedly raw and direct visual language occasionally compared to that of > Goldin and > Tillmans. In the late 1990s discovered by the fashion industry as the ambassador of a youthful life-affirming esprit. Collaborates on a variety of ads for prominent labels. Works for Hugo Boss, Eres, Gucci, Levi's, Matsuda, Miu Miu, Stussy, and Sisley among other labels. Also undertakes editorials for *Harper's Bazaar*, *Vogue*, *Penthouse*, *The Face*, *GQ*, and *Sports Illustrated*. Numerous book publications and most recently music videos. 2002 participates in the highly acclaimed touring exhibition *Archeology of Elegance*, shown in Hamburg, New York, Los Angeles, Tokyo, and London. 2010 Pirelli Calendar. *www.terryrichardson.com*

EXHIBITIONS (Selected) — **2001** New York (Guggenheim Museum) GE // **2002** Hamburg (Haus der Photographie/**Archeology of Elegance**) GE // Winterthur (Fotomuseum/**Chick Clicks**) GE // **2003** Berlin (Kunst-Werke Berlin e.V.) SE // **2004** New York (Deitch Projects) SE // Bologna (L'Inde Le Palais) SE // **2005** Naples (Rosario Farina Haute Couture) SE // Catania (Italy) (Galleria Arte Contemporanea) SE // Palermo (Francesco Pantaleone Arte Contemporanea) SE // **2006** Rome (Mondo Bizzarro Gallery) SE // Brescia (Galleria Marchina Arte Contemporanea) SE // Milan (Stragapede & Perini Art Gallery) SE // **2007** London (Michael Hoppen Gallery/**Fashion**) GE // Berlin (C/O Berlin/**Stripped Bare. Der entblößte Körper**) SE // **2008** The Hague (Galerie 't Fotokabinet) GE

BIBLIOGRAPHY (Selected) — **Hysteric Glamour**. Tokyo 1998 // **Son of Bob**. Tokyo 1999 // **Feared by Men, Men Desired by Women**. London 2000 // **Giorgio Armani: Twenty-Five Photographers**. New York 2001 (cat. Guggenheim Museum) // Marion de Beaupré, Ulf Poschardt, and Stéphane Baumet (eds): **Archeology of Elegance, 1980–2000. 20 Jahre Modephotographie**. New York 2002 (cat. Deichtorhallen Hamburg) // **Too much**. Berlin 2003 (cat. Kunst-Werke) // Hans-Michael Koetzle: "T. R.: Mobilmachung der Emotionen." In: **Photo Technik International**, no.5, 2003 ✍ // **T.R.** Hamburg 2003 (= **Stern Portfolio** no.34) // **Kibosh**. Bologna 2004 // **Terryworld**. Cologne 2004 // **Wives, Wheels, Weapons**. New York 2008

"Supposedly, Terry got his first camera as a child and the first thing he did was to explore his immediate surroundings; later came making portraits of his rocker friends. In other words, Richardson's art evolved from the spirit of the private, the everyday, the permanent joy of living. 'Feel good.' 'Have fun.' 'Have sex.' These could have been a few of the maxims for his life, and, in the Postmodern Age, they would prove to be highly compatible with the interests of the fashion and leisure industry. In the 1990s, Richardson's first published work appeared in *W magazine*, *Harper's Bazaar*, *Vogue*, *i-D* and *The Face*. He created at the same time his frequently controversial campaigns for Costume National, Levi's and, most of all, Sisley, the label Richardson has collaborated with since 1998. His 'Sisley Diaries' have a cult status among a certain younger clientele here, and they best sum up Richardson's aesthetics: 'A good photograph should be a call to arms. It should say: Fucking now. The time is ripe. Come on.'" — Hans-Michael Koetzle ✍

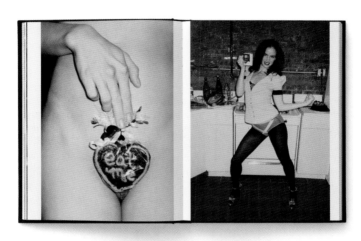

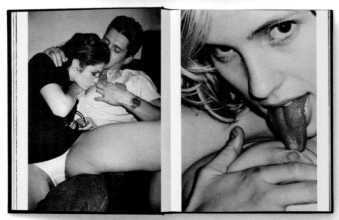

Leni Riefenstahl *(Helene Amalia Bertha Riefenstahl)*

Leni Riefenstahl: **Schönheit im Olympischen Kampf.** Berlin (Deutscher Verlag) 1937

22.8.1902 Berlin (Germany) — 8.9.2003 Pöcking (Germany) Brilliant career in four media – dance, acting, film, and photography – and over the course of three political systems (Weimar Republic, Nazi Germany, and the Federal Republic). As an artist, as ingenious as she is controversial. Beginning 1918 studies modern dance and ballet under Helene Grimm-Reiter, Jutta Klamt, Eugenie Eduardowa, and Mary Wigman. 1923 first solo dance performance in Munich, later in Berlin. Tour follows. 1926 stage appearance for the premiere of *Der heilige Berg* (The Holy Mountain) by Arnold Fanck, where she plays the leading role beside Luis Trenker. Additional leading roles include those in *Der grosse Sprung* (1927), *Die weiße Hölle vom Piz Palü* (The White Hell of Pitz Palu) (1929), and *Stürme über dem Montblanc* (Storm over Montblanc) (1930). 1931 founds her own film production company (L. R.-Film GmbH). 1931–1932 *Das blaue Licht* (The Blue Light). 1933 performs in *SOS Eisberg* (SOS Iceberg) and directs *Sieg des Glaubens* (Victory of the Faith: the Nuremberg rally of the Nazi Party). 1934 *Tiefland* (Lowlands) (project start). *Triumph des Willens* (Triumph of the Will) (1934 Nuremberg rally of the Nazi Party). 1935 founds the production company Olympia Film GmbH. 1936–1938 production work on *Olympia – Fest der Völker* and *Olympia – Fest der Schönheit*. Grand Prix at the 1937 World's Fair for *Triumph of the Will*. 1938 Gold medal for the film *Olympia* shown at the Venice Biennale. 1940–1945 stills photography for *Lowlands*. 1945 arrested by American soldiers. Court trial in Dachau. June: acquitted and released. 1947 committed to a private institution (three months). 1948 Olympic Gold Medal for the *Olympia* film. Rehabilitation through the German and allied forces denazification board. 1956 first trips to Africa. 1959 film retrospective at the Venice Biennale. 1962–1977 trips to Sudan. Photographic and film projects with the Nuba. 1972 Olympic Games photographer for *The Sunday Times* in Munich. 1974 first Indian Ocean deep-sea diving expedition. 1980 first exhibition of her photographic works in the Sheibu Museum, Tokyo. 1993 *The Power of the Image*: documentary film on L.R. by Ray Müller. 1995 film retrospective in Leipzig. *www.leni-riefenstahl.de*

EXHIBITIONS (Selected) — **1980** Tokyo (Sheibu-Museum) SE // **1991** Tokyo (Bunkamura-Kulturzentrum) SE // **1996** Milan (Palazzo della Ragione) SE // **1997** Rome (Palazzo delle Esposizione) SE // **1998–1999** Potsdam (Germany) (Filmmuseum) SE // **2000** Berlin (Galerie Camera Work – 2006) SE // **2001** Los Angeles (Fahey/Klein Gallery) SE // **2002** London (Atlas Gallery – 2004) SE // **2004** Prague (Galerie Louvre) SE // **2005** Bielefeld (Germany) (Samuelis Baumgarte Galerie) SE

BIBLIOGRAPHY (Selected) — **Schönheit im Olympischen Kampf.** Berlin 1937 (facsimile reprint: Munich 1988) // **Die**

Nuba – Menschen wie von einem anderen Stern. New York/Munich 1973 // **Die Nuba von Kau.** New York/Munich 1976 // **Korallengärten.** Munich 1978 // **Mein Afrika.** Munich 1992 // **Memoiren.** Munich 1987 // **L.R.** Berlin 2000 (cat. Galerie Camera Work) // Angelika Taschen (ed.): **L.R.: Fünf Leben.** Cologne 2000 // Elisabeth Bronfen: "Triumph der Verführung." In: **Die Zeit**, no. 43, 19.10.2000 ✍ // **Olympia.** Cologne 2002 // **Africa.** Cologne 2002 // Martin Parr and Gerry Badger: **The Photobook: A History Volume I.** London 2004 // **Africa: L.R.** Cologne 2005

"Leni Riefenstahl poses a problem insofar as, despite the fact that her film aesthetic can be morally and aesthetically rejected, there can be no denying that her visual thinking has consistently influenced our zeitgeist. Her impact alone clearly makes her one of the most important artists of the twentieth century, and her visual language is both quoted and further developed in the most diverse media: from Johann Kresnik's contemporary dance theater to the Pop Art of Andy Warhol, and from George Lucas's *Star Wars* to sports films and advertising aesthetics." — Elisabeth Bronfen ✍

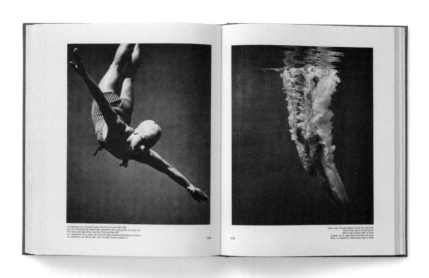

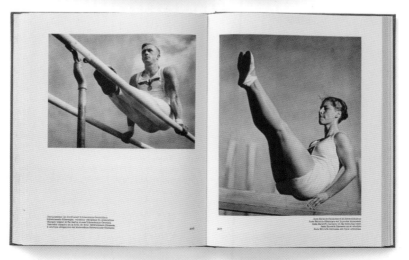

Herb Ritts

HERB RITTS PICTURES

Herb Ritts: **Pictures.**
Santa Fe (Twin Palms Publishers)
1988

13.8.1952 Los Angeles (USA) — 26.12.2002 Los Angeles Fashion, beauty, and glamour — masterfully staged and consistently abreast of the zeitgeist. As a chronicler of postmodern desires, among the most prominent commissioned photographers of the 1980s and 90s. Studies at Bard College (Annandale-on-Hudson, New York). Self-taught photographer. Friend of the actor Richard Gere. 1978 photographic portraits of the actor help launch the unprecedented career of R., working as a furniture salesman at that time. Publishes the Gere portraits in *Vogue* and *Esquire*. Results in portrait assignments from *Mademoiselle*: photographs of Brooke Shields and Liz Taylor. Befriends > Weber, periodically his student. For a longer period one of the most sought after and highest-paid portrait and fashion photographers. Works appear in *Newsweek*, *Vanity Fair*, *Rolling Stone*, *Interview*, *Tatler*, *Vogue* (France), *Vogue Hommes*, *L'Uomo Vogue*, *Per Lui*, *Harper's Bazaar*, *GQ*, and *Playboy*, among other magazines. Campaigns for Donna Karan, Armani, Versace, Calvin Klein, Valentino, Gap, Chanel, Cartier, and Guy Laroche, among other labels. Numerous b/w portraits include those of Boris Becker, Charles Bukowski, Tom Cruise, Dizzy Gillespie, Elton John, Jack Nicholson, Madonna, Julia Roberts, Meryl Streep, and John Travolta. Music videos for Michael Jackson, Janet Jackson, and Madonna. 1989 named fashion photographer of the year by the California Fashion Institute. 1991 Infinity Award for Applied Photography of the ICP, New York. 1996 retrospective in the Boston Museum of Fine Arts attracts over 250,000 visitors. Also in Boston the 2010 opening of the H.R. Gallery for Photography made possible through a donation of the H.R. Foundation. Portraits of Ben Affleck for *Vanity Fair* are among the last works of the artist who dies of AIDS. *www.herbritts.com*

EXHIBITIONS (Selected) — **1988** Los Angeles (Fahey/Klein Gallery – 1989, 1992, 1994, 1996, 1997, 2003) SE // New York (Staley-Wise Gallery – 1990, 1992, 1994, 1997, 1999, 2000, 2005) SE // **1990** Hamburg (PPS. Galerie – 1991) SE // **1991** Cahors (France) (Le Printemps de la Photo) SE // **1992** Tokyo (Parco Gallery – 1995) SE // **1996** Boston (Massachusetts) (Museum of Fine Arts) SE // **1997** Vienna (Kunsthaus) SE // **1999** Paris (Fondation Cartier) SE // **2000** Hamburg (Museum für Kunst und Gewerbe) SE // **2002** Hamburg (Deichtorhallen) GE // **2003** Los Angeles (Fahey/Klein Gallery) SE // **2004** Tokyo (Daimaru Museum) SE // **2006** Brooklyn, NY (Wessel + O'Connor Fine Art) SE

BIBLIOGRAPHY (Selected) — **Pictures.** Santa Fe 1988 // **Man/Woman.** Santa Fe 1989 // **Duo.** Santa Fe 1991 // **Notorious.** New York 1992 // **Photographs.** Milan 1993 // **Africa.** Boston 1994 // **Modern Souls.** New York 1995 // **Work.** Boston 1996 (cat. Museum of Fine Arts) // David Leddick: **The Male Nude.** Cologne 1998 // **H.R.** Paris, 1999 (cat. Fondation Cartier) ✐ // **Archeology of Elegance.** Munich 2002 (cat. Deichtorhallen, Hamburg)

"For being so erroneously artificial, Ritts's photographs possess a hard to grasp but calculated sensuality. They work with charm, finesse, irony, intelligence, and elegance. His impressive oeuvre has to be read like an heroic epic whose characters are the stars, the standardized micro society of a globalized monoculture, which create an alarmingly unflattering portrait of today's world as our epoch ends." — Patrick Roegiers ✍

Alexander *(Mijailovich)* Rodchenko

Alexander Rodchenko,
from: **Trizad Dniji (30 Days),**
Year 4, no. 12, December 1928

5.12.1891 Saint Petersburg (Russia) — 3.12.1956 Moscow (Soviet Union) Painter, sculptor, set designer, architect, typographer, and photographer. One of the main figures of Russian Constructivism. Artistically outstanding photomontages, reportages, and portraits. 1910–1914 studies at the Kazan School of Art and meets future wife Varvara Fyodorovna Stepanova (1894–1958) here. 1914 moves to Moscow. Studies graphic design at the Stroganov Institute for the Decorative and Applied Arts. 1918 changes focus from abstract painting to building three-dimensional constructions. 1918–1921 collaborates in the Visual Arts department of the People's Commission for Education (IZO). 1920 founding member of the Moscow Inchuk (Institute for Artistic Culture). 1920–1930 teaches metalworking class at the art and technical school Vkhutemas/Vkutein. Turns his attention towards photo-collages and graphic design. Designs for magazines such as *Kino-fot* and *LEF*. 1924 creates first camera-generated images and portraits, including those of Nikolai Asseyev, Vladimir Mayakovsky, and Sergei Tretyakov. Beginning 1925 contributes photography to *30 Dnei*, *Dajosch*, *Ekran*, *Sovetskoe foto*. 1927–1928 regularly collaborates on *Novyi LEF* (photographs, cover design, and texts). 1928–1932 member of the October Group. 1933 sent on assignment to Karelia. Reportage on the White Sea channel construction for the magazine *SSSR na strojke* (*USSR in Construction*). Designs several magazine issues with Stepanova. Book designs/concepts include those for the publisher Izogiz. 1935–1941 reportage on the sports parade held on the Red Square and the photo series *Moscow* and *Circus*. 1943–1944 artistic director of the art institute House of Technology. 1951 committee of the Moscow Artists' Union (Mossk). 1954 rehabilitated. 1957 first Moscow exhibition (House of Journalists). 1964 first monograph appears in the series *Photography as Art*.

EXHIBITIONS (Selected) — **1928** Moscow (**Ten Years of Soviet Photography**) GE // **1929** Stuttgart (**Film und Foto**) GE // **1935** Moscow (**Master of Soviet Art Photography**) GE // **1937** Moscow (**First All-Union Exhibition of Soviet Art Photography**) GE // **1957** Moscow (House of Journalists – 1968) SE // **1971** New York (Museum of Modern Art – 1998) SE // **1977** Paris (Musée d'art moderne de la Ville de Paris – 2007) SE // **1978** Cologne (Museum Ludwig) SE // **1981** Paris (Centre Pompidou) SE // **1986** Paris (Centre national de la photographie) SE // **1991** Vienna (Museum für angewandte Kunst) JE (with Varvara Stepanova) // **1999** Hannover (Sprengel Museum) SE // **2002** New York (Museum of Modern Art/**The Russian Avant-garde Book 1910–1934**) GE // **2008** Berlin (Martin Gropius Bau) SE // **2009** Amsterdam (Fotografiemuseum Amsterdam) SE // **2009** Cologne (Museum Ludwig) GE // **2013** Vienna (WestLicht) SE

BIBLIOGRAPHY (Selected) — Lubomir Linhart: **A.R.** Prague 1964 ✍ // Leonid F. Volkov-Lannit: **A.R.** Moscow 1968 // Hubertus Gassner: **R. Fotografien.** Munich 1982 // **A.R.** Paris 1986 (cat. Centre national de la photographie) // **A.M.R.: Aufsätze, Autobiographische Notizen, Briefe, Erinnerungen.** Dresden 1993 // Alexander Lavrentiev: **A.R.: Photography 1924–1954.** Cologne 1995 // **A.R.: Painting, Drawing, Collage, Design, Photography.** New York 1998 (cat. Museum of Modern Art) // **A.R.: Das Neue Moskau.** Munich 1998 (cat. Sprengel Museum Hannover) // **The Russian Avant-garde Book 1910–1934.** New York 2002 (cat. Museum of Modern Art) // **Rodtschenko photographe, la révolution dans l'œil.** Paris 2007 (cat. Musée d'art moderne de la Ville de Paris) // **Politische Bilder. Sowjetische Fotografien 1918–1941. Die Sammlung Daniela Mrázkowá.** Göttingen 2009 (cat. Museum Ludwig, Cologne)

"The contemporary situation of photography and particularly reportage, as well as its emancipation from the topical and visual pre-inventory of painting, would be unthinkable without the tremendous influence of Soviet photography of the 1920s, and by the work of Rodchenko in particular. With his original, audacious, and innovative approach, he burned and left behind all the bridges to earlier photographic processes." — Lubomir Linhart ✐

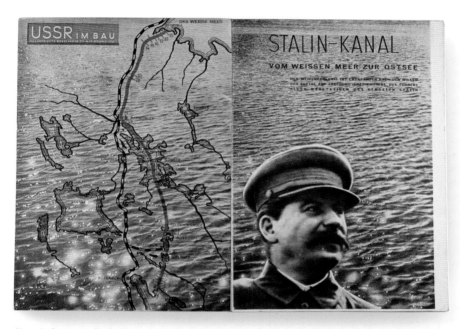

Alexander Rodchenko: **The Stalin Canal from the White Sea to the Baltic,** from: **USSR in Construction,** no. 12, December 1933

George Rodger

Inge Bondi: **George Rodger.**
London (Gordon Frazer) 1975

19.3.1908 Hale (England) — 24.7.1995 Smarden (England) WW II reportage and photographs of the Nuba people are the best-known work of this prominent Magnum photographer. His father works in the shipbuilding and cotton trades. Attends school in St Bees College, Cumbria. Later lives in Yorkshire due to economic difficulties with father's farming work. 1926 takes post as "apprentice deck officer" with the Merchant Navy. In addition writes travelogues. First publication in the *Baltimore Sun* (accompanied by his enlightening illustrations in the margins). As a result turns his attention towards photography. 1929–1936 various jobs in USA. 1936 returns to England. Works as a portrait photographer for the BBC's own magazine *The Listener*. 1939 freelances for the Black Star photo agency. At the outbreak of the war, serves as rear gunner in the Royal Air Force. European war correspondent for *Life* magazine. The only British photographer delivering reportages from nearly every WW II theater of operations (Africa, Europe, Middle and Far East). Publishes in *Picture Post* and *Illustrated*. Photographs the liberation of Bergen-Belsen concentration camp. Afterwards turns away from war reportage. 1947 founding member of Magnum. From the 1950s to 80s produces travelogues (primarily in Africa) followed by numerous publications in *Life*, *Holiday*, *National Geographic*, and *Paris Match*. 1976 soirée at Rencontres d'Arles (*British Photographers*). 2008 *MAGNUM'S first*: the rediscovered first group show from 1955/1956 (> Bischof, > Cartier-Bresson, > Capa, > Haas, Erich Lessing, Jean Marquis, > Morath, and G.R.) as widely acclaimed touring exhibition shown in Vienna, Hamburg (Flo Peters Gallery) and Munich (Versicherungskammer Bayern).

"His people are indeed people of flesh and blood, whose emotions are not only mirrored in their faces, but in their whole being. For him, man belongs in the context of his environment: whether the flower seller in Trafalgar Square or the rainmaker of the Latuka, Roger sees the *condition humaine* **as the outcome of its environment. Looking at his pictures, we feel part of the scene. His extraordinary gift to accept the diversity of the human and the animal condition rubs off on those who look at his work."** — Inge Bondi ✍

EXHIBITIONS (Selected) — **1955** New York (Museum of Modern Art/**The Family of Man**) GE // **1974** London (The Photographers' Gallery – 1979, 1984, 1987, 2005) SE // **1990** Lausanne (Switzerland) (Musée de l'Élysée) SE // **1994** Bath (Royal Photographic Society) SE // **1995** London (Barbican Art Gallery) SE // Berlin (Deutsches Historisches Museum) GE // **2001** New York (Leica Gallery) SE // Madrid (PHotoEspaña) SE // **2004** Tokyo (Photo Gallery International) SE // **2005** Paris (Fnac Ternes) SE // **2008** Amsterdam (Stedelijk Museum Post CS/**MAGNUM Photos 60 years**) GE // London (Atlas Gallery) SE // Vienna (WestLicht) GE // **2009** Munich (Art foyer of the Versicherungskammer Bayern building) SE

BIBLIOGRAPHY (Selected) — **Le village des Noubas.** Paris 1955 // Inge Bondi: **G.R.** London 1975 ✍ // **G.R. en Afrique.** Paris 1984 // **G.R.: Magnum Opus. Fifty Years in Photojournalism.** Berlin 1987 // **The Blitz: Photographs of G.R.** London 1990 // **Humanity and Inhumanity: The Photographic Journey of G.R.** London 1994 // **Ende und Anfang. Photographen in Deutschland um 1945.** Berlin 1995 (cat. Deutsches Historisches Museum) // Chris Boot (ed.): **Magnum Stories.** London 2004 // Brigitte Lardinois: **Magnum Magnum.** Munich 2007 // Peter Coeln, Achim Heine, and Andrea Holzherr (eds): **MAGNUM's first.** Ostfildern 2008 (cat. WestLicht, Vienna) // **National Geographic. Around the World in 125 Years.** Cologne 2014

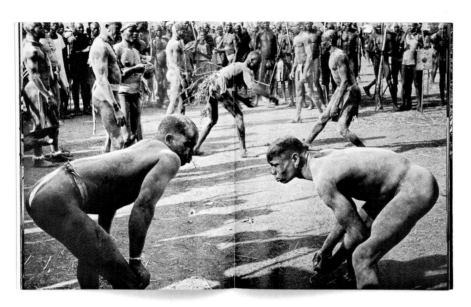

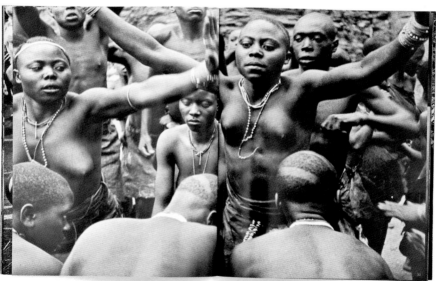

Willy Ronis

Willy Ronis: **Belleville – Ménilmontant.** Paris (B. Arthaud) 1954

14.8.1910 Paris (France) — 12.9.2009 Paris Nude studies, reportages, street photography. Expressive work evoking "Photographie humaniste". With Doisneau, Boubat, and Izis, the best-known exponent of this style. Quits law studies and turns his attention towards art and music. 1926 receives first camera. 1932 enters family business. 1936 father's death. Beginning of his journalistic activities. Befriends > Seymour and > Capa. 1938–1939 extensive reportages include the strikes at the Citroën manufacturing plant. Trips to Greece, Yugoslavia, and Albania. 1941–1944 various temporary jobs in Southern France. 1944 returns to Paris. 1945–1950 resumes work as photojournalist. Member of the Group of XV and photography agency Rapho. Fashion, advertising, industrial photography, illustration (for Musée Vasarely, among other clients), and reportages in Algeria and Eastern Europe. 1972 settles in Southern France. Teaches in Avignon, Aix-en-Provence, and Marseille. 1981 studio in Venice. 1983 returns to Paris. Numerous publications include those in *Regards*, *L'Illustration*, and *Life*. Awards and prizes include the Gold Medal at the Venice Biennale (1957), Grand Prix National des Arts et Lettres (1979), Prix Nadar (1981) for his book *Sur le fil du hasard*, and the Commandeur de l'Ordre National du Mérite (2001). 1983 bequeaths his archive (95,000 negatives) to the French state as the "donation of Willy Ronis".

"'With our eyes, we see only what we are': this thought borrowed from the Talmud could also qualify as Willy Ronis's artistic credo. With his eyes, the depicted world is never recognized in exaggerated gestures and sensational moments. According to Ronis, adventure and deep emotions are never measured against great distances, the aura of historically rich architecture, or geographic superlatives. Instead, truly extraordinary things happen just around the corner in the small neighborhood café, on the streets and squares of his city, in Paris." — Sylvia Böhmer ✐

EXHIBITIONS (Selected) — **1951** New York (Museum of Modern Art) GE // **1955** New York (Museum of Modern Art/**The Family of Man**) GE // **1980** Arles (Rencontres internationales de la photographie) SE // **1985** Paris (Palais de Tokyo) SE // **1994** Paris (Hôtel de Sully) SE // **1995** Oxford (Museum of Modern Art) SE // **1996** Paris (Pavillon des Arts) SE // **1999** Montpellier (France) (Galerie Photo) GE // **2000** Charleroi (Belgium) (Musée de la Photographie) SE // **2004** Aachen (Suermondt-Ludwig-Museum) SE // **2006** Paris (Hôtel de Ville) SE // **2008** Toulouse (Château d'Eau) SE // **2009** Arles (Rencontres internationales de la photographie) SE // **2011** Hamburg (Haus der Photographie/Deichtorhallen) GE // **2013** Münster (Picasso-Museum) EA

BIBLIOGRAPHY (Selected) — **Belleville – Ménilmontant.** Paris 1954 // **Sur le fil du hasard.** Paris 1980 // **Mon Paris.** Paris 1985 // **W.R.** Paris 1991 (= Photo Poche no. 46) // **Toutes belles.** Paris 1992 // **Quand je serai grand.** Paris 1993 // Paul Ryan: **W.R.** London 2002 // Sylvia Böhmer, Matthias Harder, and Nathalie Neumann: **W.R.: La vie en passant.** Munich 2004 ✐ // Jean-Claude Gautrand: **W.R.: Stolen Moments/Gestohlene Augenblicke/Instants dérobés.** Cologne 2005 // **W.R.: Paris-couleurs.** Paris 2006 // **Ce jour-là.** Paris 2008

50

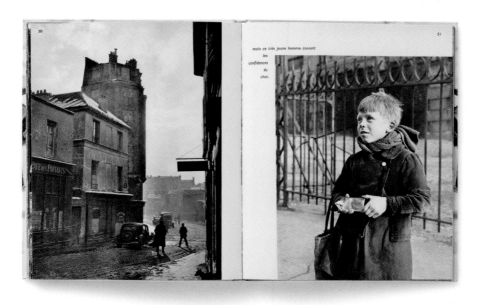

51

mais ce très jeune homme connaît
les
confidences
du
chat.

60
Tout au contraire, cette foule attentive apporte comme une offrande
ses espoirs qui refleurissent au mois de Mai.

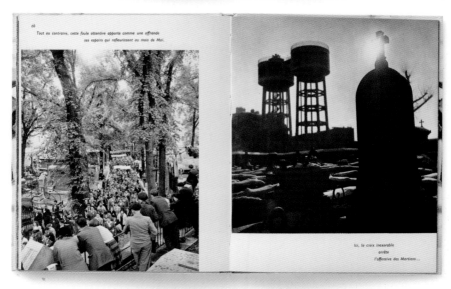

Ici, la croix inexorable
arrête
l'offensive des Martiens...

Sanford H. Roth

Sanford H. Roth: **The French of Paris.** New York (Harper & Brothers Publishers) 1953

1906 New York (USA) — 1962 Rome (Italy) Photojournalist based in Paris. Pronounced interest in the world of art, literature, and movies. Work published in practically every major magazine of the 1950s and 60s. Turns his attention to photography immediately after studying. Meets > Stieglitz in New York and through him becomes acquainted with art world masters such as Matisse, Picasso, Rodin, and Cézanne. Regularly visits Stieglitz's 5th Avenue galleries (291 Gallery and Intimate Gallery) without as yet feeling drawn to the idea of photographic art. Continues working as businessman for a while. Makes final decision to devote himself to photography and (1947) moves to Paris. Completes intensive photographic study of the city's more peaceful corners. Parallel to this an intensive exploration of the genre of the artist portrait. Photographs Braque, > Brassaï, Chagall, Colette, > Man Ray, Matisse, Renoir, Utrillo, and Vlaminck, as well as Picasso, with whom he shares a lifelong friendship. Numerous publications in *Time*, *Life*, *Look*, *Harper's Bazaar*, *Vogue*, *Paris-Match*, *Nouveau Fémina*, and the German zeitgeist magazine *twen*. 1951 large touring exhibition throughout the American West initiated by the Western Association of the Art Museum Directors and the Art Institute of Chicago. 1953 publishes controversial illustrated volume on Paris with a prologue by Aldous Huxley. Participates in Steichen's legendary *The Family of Man* exhibition. 1983 posthumous retrospective at the Château d'Eau in Toulouse.

EXHIBITIONS (Selected) — **1952** Los Angeles (Los Angeles County Museum) SE // **1953** Goldendale (Washington) (Maryhill Museum of Fine Arts) SE // Pasadena (California) (Pasadena Art Institute) SE // San Francisco (M.H. de Young Memorial Museum) SE // **1954** Chicago (Art Institute) SE // Los Angeles (Dalzell Hatfield Gallery) SE // **1955** New York (Museum of Modern Art/**The Family of Men**) GE // **1956** Rome (Al Ferro Cavallos Gallery) SE // **1957** Montclair (New Jersey) (Montclair Art Museum/**Creative Photography**) GE // **1980** Los Angeles (Los Angeles Art Association) SE // **1983** Toulouse (Galerie municipale du Château d'Eau) SE // **1987** New York (Chartwell Gallery) SE // **1988** Los Angeles (Los Angeles County Museum of Art/**Masters of Starlight**) GE

BIBLIOGRAPHY (Selected) — **Mon Paris.** Paris 1953 // **The French of Paris.** New York 1953 // **S.H.R.** Toulouse 1983 (cat. Galerie municipale du Château d'Eau) ✍ // Beulah Roth: **Paris in the Fifties: Photographs by S.R.** San Francisco 1988 // **Portraits Années 50: Photographies de S.R.** Paris 1989

"Sanford H. Roth's work is known only to a few insiders – this being what happens in the case of discreet people who, instead of identifying with photography, wish only to amuse themselves making it. He preferred being a good friend of Maurice de Vlaminck, Picasso, and all the other famous artists far better at venerating our country's reputation than our ambassadors, and who have carried it forth into the distance. Infatuated with Paris, in the 1950s Sanford associated himself with the entire mythical world of art and movies. Luckily, during these years, in no time at all photography would distance itself from its chemistry and its 'mechanics' and become aware of its true task: to bear witness through information and chronicles in pictures."

— Jean Dieuzade ✍

Arthur Rothstein

Cover **US Camera**, 1936.
Design: Alexey Brodovitch

17.7.1915 New York (USA) — 1985 New Rochelle (New York, USA) Photojournalist and editor in America from the 1930s to 70s. Significant in the history of photography as an early member of the legendary Farm Security Administration (FSA). 1929–1932 Stuyvesant High School, New York. 1932–1935 studies at Columbia College, New York, under Roy Stryker, and during studies establishes a photo club. Abandons original plan to study medicine and chemistry. Beginning 1935 (with photographers like Charlotte Brooks, Esther Bubley, Marjory Collins, Jack Delano, > Evans, > Lange, Russell Lee, Carly Mydans, > Parks, > Shahn, John Vachon, and Mary Post Wolcott) works for the Farm Security Administration (FSA) headed by Stryker. Begins organizing a photo lab and developing an archive system. Close contact with Evans and Shahn, who influence his visual language while Lee aids the advancement of his photographic technique. 1935 first photo assignment. 1936 travels to Oklahoma, where arid terrains, dust storms, and soil erosion uniquely further his photography. Creates his best-known image (a farmer and his sons in a dust storm), "one of the most celebrated photographs of the FSA" (Marc Vosort). 1940 leaves the FSA to work at *Look* magazine. 1941 founds the ASMP (American Society of Magazine Photographers). 1941–1943 works for the Office of War Information. 1943–1946 photographer for the US Army Signal Corps. Serves in India, Burma, and China. 1946–1971 photo editor at *Look* in New York. 1971–1972 editor of the magazine *Infinity*. 1972–1976 associate editor of *Parade* magazine. 1976 photo editor at *Parade*. Numerous prizes include the First Color Photography Prize (1955), Prize of the ADC (Art Directors Club) New York (1963), Sprague Prize (1967), and the Prize of the Photographic Society of America (1968). Member of the Royal Photographic Society (beginning 1968). Member of the Photographic Historical Society (beginning 1969).

EXHIBITIONS (Selected) — **1956** Rochester (New York) (George Eastman House – 1976) SE // **1960** Milan (Biblioteca Communale) SE // **1963** Washington, DC (Smithsonian Institution) SE // **1966** Cologne (photokina) SE // **1967** New York (Kodak Exhibition Center) SE // **1973** Boston (University of Massachusetts) SE // **1978** New York (Prakapas Gallery) SE // **1980** New York (Rizzoli Gallery) SE // Fort Lauderdale (Florida) (Art Institute) SE // Paris (Centre Pompidou) SE // **1981** Woodstock (Catskill Center for Photography) SE // Denver (Colorado) (Art Institute) SE // **1983** Sarasota (Art Center) SE // **2000** Charleroi (Belgium) (Belgium) (Musée de la Photographie) GE // **2004** Erlangen (Germany) (Städtische Galerie/**Amerika 1935–1943**) GE // Santiago de Compostela (Spain) (Fundación Pedro Barrié de la Maza/**Iconos**) GE // Washington, DC (The Corcoran Gallery of Art/**Common Ground**) GE // **2005** San Francisco (Scott Nichols Gallery) GE // **2006** Vancouver (Monte Clark Gallery) GE // **2008** Lugano (Museo d'Arte/**Photo20esimo**) GE

BIBLIOGRAPHY (Selected) — **The Depression Years as Photographed by A.R.** New York 1978 // **Words and Pictures**. New York 1979 // Donald Worster: **Dust Bowl: The Southern Plains in the 1930s**. New York 1979 // **Photography from 1839 to Today. George Eastman House, Rochester, NY.** Cologne 1999 ✍ // **Des images pour convaincre**. Charleroi 2000 (cat. Musée de la Photographie) // Gilles Mora and Beverly W. Brannan: **FSA: The American Vision**. New York 2006

"Arthur Rothstein, a former Roy Stryker student, was the first photographer hired by Stryker to work for the FSA. Rothstein's initial tasks were to copy documents and photograph agency events while Stryker puzzled over the development of the agency's photographic project. Rothstein became a valuable member of the FSA and quickly learned to make the kind of photographs that Stryker wanted: images both informative and symbolic of the general conditions throughout the devastated country." — George Eastman House ✍️

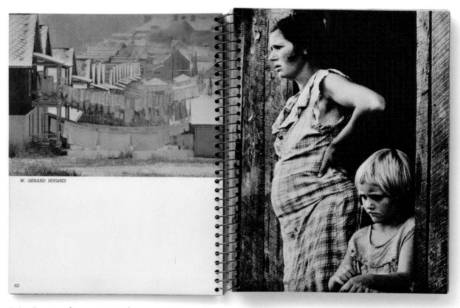

Arthur Rothstein (right-hand page):
Untitled, from: **US Camera,** 1936

Paolo Roversi

Paolo Roversi: **Libretto.**
Paris (Editions Stromboli) 2000

25.9.1947 Ravenna (Italy) — Lives in Paris (France) Fashion and portraiture, editorial, and advertising photography. Internationally celebrated as the exponent of a deeply emotional and atmospheric interpretation of fashion. 1964 first contact with photography during a trip to Spain with his parents. Takes first amateur photographs. Acquires professional experience in the field through the local photographer Nevio Natali. 1970 begins collaborating with the Associated Press (AP). Initially works on portraits and reportage, including an AP commissioned photo report on Ezra Pound's funeral in Venice. In the same year (1970) opens a portrait studio with Giancarlo Gramantieri in Ravenna. 1971 meets Peter Knapp, on whose invitation (November 1973) he travels and moves to Paris to complete photographic reports for the Huppert agency. 1974 assists Lawrence Sackmann (nine months). Definitively focuses on producing professional photography. Increasingly more fashion, initially for *Elle* and *Dépêche Mode*. First important publication in *Marie Claire*. 1980 breakthrough with a campaign for Christian Dior. The same year takes his first 8 x 10 works with Polaroid camera, resulting in his signature style. 1981 opens a Paris studio (9 rue Paul Fort). Editorial work for *Harper's Bazaar*, *Vogue* (Italy and Great Britain), *Uomo Vogue*, *Interview*, *Arena*, *i-D*, *W*, and *Marie Claire*. Campaigns include those for Giorgio Armani, Cerruti 1881, Comme des Garçons, Christian Dior, Alberta Ferretti, Romeo Gigli, Givenchy, Krizia, Valentino, Yves Saint Laurent, and Yohji Yamamoto. In addition works on ads for Dim, Evian, Gervais, Kenzo, and Woolmark. Numerous solo and group exhibitions include *Shots of Style* (1985), *Comme des Garçons* (1986), *Appearances* (1991), *Vanités* (1993). Prizes include the Prix Jasmin (1991), Prix Quatrième Festival International de la Photo de Mode (1993), Trophée de la Mode (1996), and China Fashion Awards (2001). Retrospective and projection (Théâtre antique) at the Rencontres d'Arles 2008. *www.paoloroversi.com*

EXHIBITIONS (Selected) — **1985** London (Victoria and Albert Museum — 1991) GE // **1989** New York (Solomon Gallery) SE // **1993** Paris (Galerie Camera Obscura — 2002) SE // **1994** Tokyo (Photo Gallery International) SE // London (Hamilton Gallery) SE // Toulouse (Galerie municipale du Château d'Eau) SE // **1997** Zurich (Scalo Books & Looks) JE (with Robert Frank) // **2000** Milan (Galleria Carla Sozzani) SE // **2002** New York (PaceMacGill) SE // **2005** Lille (France) (Transphotographique) SE // **2006** Yokohama (Japan) (Yokohama Red Brick Warehouse Number 1) SE // **2008** Arles (Rencontres internationales de la photographie) SE // **2009** Berlin (Camera Work) SE

BIBLIOGRAPHY (Selected) — **Shots of Style.** London 1985 (cat. Victoria and Albert Museum) // **Una Donna.** Milan 1989 // Martin Harrison: **Appearances: Fashion Photography Since 1945.** London 1991 (cat. Victoria and Albert Museum) *⚠* // **Angeli.** Paris 1993 (cat. Galerie Camera Obscura) // **P.R.** Toulouse, 1994 (cat. Galerie municipale du Château d'Eau) // **Al-Mukalla.** Paris 1995 (cat. Galerie Camera Obscura) // **Images Cerruti.** Paris 1999 // **Nudi.** Paris 1999 // **Libretto.** Paris 2000 // **Studio.** Göttingen 2006

"Although Roversi has regularly worked for *Marie Claire*, as well as a few years for British and Italian *Vogue*, his most sympathetic clients have been individual designers. His catalogs for the Milanese designer Romeo Gigli are the most perfect expression of a graceful and filigree beauty in today's fashion photography." — Martin Harrison ✍

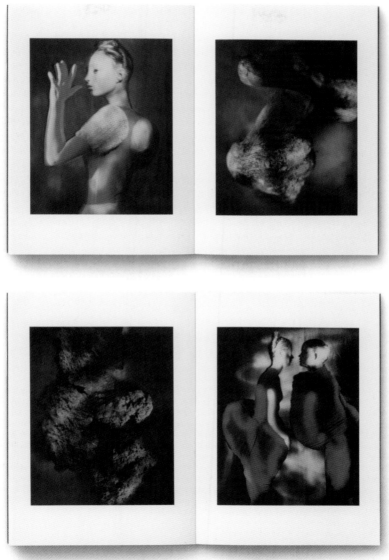

Thomas Ruff

Thomas Ruff: **Fotografien 1979 – heute.** Cologne (Verlag der Buchhandlung Walther König) 2001

10.2.1958 Zell am Harmersbach (Germany) — Lives in Düsseldorf (Germany) Student of Bernd Becher. Artistic breakthrough with large-format portraits. Art photography in the sense of the medium's interest in critical reflection. Increasing use of digital imaging. 1977–1985 studies at the Kunstakademie (Art Academy) in Düsseldorf (from the beginning of October 1978 in the class of > Becher). Small-format color *Interieurs* (beginning 1979) at the start of his artistic exploration with the medium. 1981 begins his series of (ambitiously planned 100) photographic busts of friends created with a process whose precision derives from engaging a highly effective photographic technique for documenting details (always frontal and against a neutral backdrop) in wall-size formats and in color. 1987 begins photographing building complexes and industrial compounds in monochromatic colors and diffused light. Appropriates existing visual material (of scientific origin and press) in the cycles *Sterne* (Stars) and *Zeitungsfotos* (News Photos). 1992 begins the series *Nachtbilder* (Night Pictures). Infra-red photography capturing nocturnal scenery: factory facilities harboring menacing atmospheric qualities and also conveying the iconography of movies. Pioneer in the field of digital image processing and large-format image presentation with the Diasec process. 1992 represented at documenta 9. 1995 exhibition in the German pavilion at the Venice Biennale. 1990 receives Dorothea von Stetten Art Prize, Bonn. 2003 Hans Thoma Prize in Bernau.

EXHIBITIONS (Selected) — **1981** Munich (Galerie Rüdiger Schöttle – 1984, 1987, 1989, 1991, 1995, 1998, 2000, 2001, 2003, 2007) SE // **1987** Cologne (Galerie Johnen & Schöttle – 1989, 1991, 1992, 1994, 1997, 1999, 2004) SE // **1988** Velbert (Germany) (Museum Schloss Hardenberg) SE // **1989** Amsterdam (Stedelijk Museum) SE // **1992** Lucerne/Zurich (Mai 36 Galerie – 1993, 1995, 1997, 1999, 2001, 2003, 2005) SE // **1996** Malmö (Sweden) (Rooseum) SE // **1997** Paris (Centre national de la photographie) SE // **2000** New York (Zwirner & Wirth – 2001) SE // **2001** Baden-Baden (Staatliche Kunsthalle) SE // **2002** Essen (Germany) (Museum Folkwang) SE // Munich (Lenbachhaus) SE // **2003** Liverpool (Tate Liverpool) SE // Hannover (kestnergesellschaft) SE // **2007** Hannover (Sprengel Museum) SE // Stockholm (Moderna Museet) SE // **2008** Paris (Musée d'art moderne de la Ville de Paris) GE // **2009** Rivoli-Turin (Italy) (Castello di Rivoli Museo d'Arte Contemporanea) SE

BIBLIOGRAPHY (Selected) — **Porträts Häuser Sterne.** Amsterdam 1989 (cat. Stedelijk Museum) // **T.R.** Frankfurt am Main 1992 // **Andere Porträts + 3D.** Venice 1995 (cat. Biennale) // **T.R.** Malmö 1996 (cat. Rooseum) // **T.R.** Paris/Arles/France 1997 (cat. Centre national de la photographie) // **Das Versprechen der Fotografie. Die Sammlung der DG Bank.** Munich 1998 // **T.R.: Fotografien 1979 – heute.** Cologne 2001 (cat. Staatliche Kunsthalle Baden-Baden) // **Nudes.** Munich 2003 // **Machines/Maschinen.** Ostfildern-Ruit 2003 // Patricia Drück: **Das Bild des Menschen in der Photographie. Die Porträts von T.R.** Berlin 2004 // **T.R.** Milan 2009 (cat. Castello di Rivoli Museo d'Arte Contemporanea) // Stefan Gronert: **Die Düsseldorfer Photoschule. Photographien von 1961–2008.** Munich 2009

"Thomas Ruff astounds with his ever newer images, respectively created in larger groupings. But the context of what at first appears to be such a diverse series of images evolves to the overview of a complete body of work investigating photography as an image medium, and comparable to the seemingly contradictory groups of images by the painter Gerhard Richter."
— Wulf Herzogenrath

Porträt 1990

Porträt 1999

Sebastião *(Ribeiro)* Salgado

Sebastião Salgado: **Workers.**
New York (Aperture) 1993

8.2.1944 Aimorés (Brasil) — Lives in Paris (France) Internationally one of the most controversial contemporary photojournalists. Largely b/w reportages from the "Third World". The sixth of eight children. 1964–1967 studies economics in Vitoria, Brazil. 1968 obtains Masters degree from the University of São Paulo and the Vanderbilt (Nashville, USA). 1968 works in the Ministry of Finance (Brazil). Opposes the military regime. As a result (1969) moves to Europe. Initially post-graduate courses in Paris. Later works for the International Coffee Organization (1971–1973) from London. During this period decides to focus on professional photography. Self-taught and influenced by the work of > Cartier-Bresson, > Evans, > Lange, and > Smith. 1973 reportage on the drought-plagued Sahel region of Africa launches his international reception. 1974 member of the newly founded Sygma agency. 1975 changes to Gamma. 1979–1994 member of Magnum. Later founds his own agency (Amazonas Images based in Paris) with his wife Lélia Wanick Salgado. From the middle of the 1980s develops comprehensive cycles on manual labor in the era of automation (*Workers*) and waves of migration throughout the world. Travels to over 60 countries, especially Latin America and Africa. Frequently collaborates with charity organizations such as Médecins sans frontières, the Red Cross, and the Children's Fund. Publications in practically every major illustrated magazine. Numerous prizes include the Oskar Barnack Prize (1985, 1992), Dr Erich-Salomon Prize (1988), Hasselblad Prize (1989), Alfred Eisenstaedt Award (1999), as well as several World Press Photo prizes and honors as "photographer of the year".

EXHIBITIONS (Selected) — **1986** Paris (Centre national de la photographie – 1993) SE // **1987** Lausanne (Switzerland) (Musée de l'Élysée – 1987, 1994, 2013) // **1989** Gothenburg (Sweden) (Hasselblad Center) SE // **1990** San Francisco (Museum of Modern Art) SE // **1995** Rochester (New York) (George Eastman House) SE // **1996** Hamburg (Deichtorhallen) SE // **1998** Mexico City (Museo de Arte Moderno) SE // **2000** Paris (Maison européenne de la photographie) SE // **2003** London (Barbican Art Gallery) SE // Tokyo (Tokyo Metropolitan Museum of Photography) SE // **2004** São Paulo (Museu de Arte Contemporânea da USP) SE // **2005** Paris (Bibliothèque nationale de France – Site Richelieu/Site François Mitterrand) SE // **2007** Milan (FORMA) SE // **2008** Berlin (C/O Berlin) SE // **2013** London (Natural History Museum) SE // Toronto (The Royal Ontario Museum) SE // Paris (Maison Européenne de la Photographie) SE // **2014** Stockholm (Fotografiska) EA // New York (International Center of Photography) SE

BIBLIOGRAPHY (Selected) — **Sahel. L'Homme en détresse.** Paris 1986 // **Autres Amériques.** Paris 1986 // **Les Cheminots.** Paris 1989 // **An Uncertain Grace.** New York 1990 // **S.S.** Paris 1993 // **Workers: An Archaeology of the Industrial Age.** New York 1993 // **Terra.** Paris 1997 // **Serra pelada.** Paris 1999 // Peter Sager: **Augen des Jahrhunderts.** Regensburg 1998 🖉 // Mary Panzer and Christian Caujolle: **Things as they are. Photojournalism in Context since 1955.** London 2005 // **Africa.** Cologne 2007 // **Genesis.** Cologne 2013 // **Children.** Cologne 2015 // **Kuwait: A Desert on Fire.** Cologne 2016 // **Exodus.** Cologne 2016

"Even without their sensational aspects, Salgado's images are spectacular enough. Whether fire fighters or steelworkers, he presents heroes of the working world, sometimes bordering on socio-romantic transfiguration. Workers in Cuban sugar cane plantations swing their machetes like archaic warriors. Ethiopian refugees, draped in cloths, stand at the edge of the desert as though inhabiting an ancient tragedy. Extreme situations, extreme images. Their pathos and their elegiac gesturing stem as much from the subject matter as from the manner of their depiction. Mother and child groups, scenes of the Passion, and masses of people in motion; images such as these relate biblical stories, and Salgado quotes them with the fervor of a Marxist liberation theologist." — Peter Sager ✍

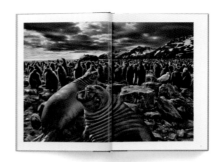

Sebastião Salgado: **Genesis.**
Cologne (TASCHEN) 2013

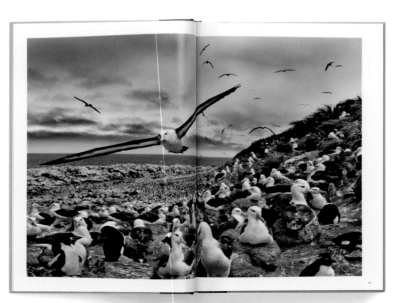

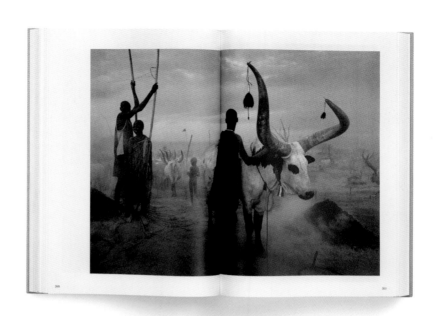

Erich Salomon

28.4.1886 Berlin (Germany) — 7.7.1944 Auschwitz (Poland) Pioneer of modern photojournalism responsible for numerous trendsetting publications in Germany's developing illustrated press between the wars. Child of an upper-class Jewish family. 1906–1909 studies zoology and engineering. 1909–1914 studies law (obtains law degree). 1914 military service, imprisonment. After the war and prison camp internment (1919) his various jobs include working for a car and motorcycle rental company. From 1925 works in the advertising department of the publishing empire Ullstein Verlag. Turns his attention to photography. From 1927 takes his own photographs, initially with a Contessa Nettel (13 x 18). Later uses a handheld Ermanox with an extremely fast lens (Ernostar f2) allowing him to take interior photographs virtually unnoticed. 1928 breakthrough as photo reporter with images of the Hein murder trial. Results in the famed photo reportage work in which he restrains himself in order to better develop his "highly expressive, realistic style" (Peter Hunter). As a photographer, one of the most published photojournalists of his day. Occasionally referred to as the "court photographer of the Weimar Republic". Numerous national (largely *Berliner Illustrirte*) and international (*Fortune* etc.) publications. 1933 flees Germany. Lives in The Hague. Works for the international press under complicated conditions. (Leica) reportages from England, France, and Switzerland. 1940 lives in hiding after German forces invade the Netherlands. 1943 arrested in Scheveningen, in the Netherlands. Deported to Theresienstadt in what is now the Czech Republic. Dies with wife and son Dick in the gas chamber in Auschwitz. Dr Erich-Salomon Prize of the DGPh (Deutsche Gesellschaft für Photographie: German Photographic Association), for exceptional achievement in the field of press photography, established in 1971. Estate administered by the museum Berlinische Galerie.

EXHIBITIONS (Selected) — **1935** London (Royal Photographic Society) SE // **1937** London (Ilford Gallery) SE // **1956** Cologne (photokina) SE // **1957** Hamburg (Museum für Kunst und Gewerbe) SE // **1974** Stockholm (Fotografiska Museet) SE // **1977** Zurich (Kunsthaus) SE // **1981** Amsterdam (Stedelijk Museum) SE // **1997** Bonn (Rheinisches Landesmuseum) GE // **2000** New York (Gallery 292) SE // **2001** Amsterdam (Huis Marseille) SE // Cologne (Museum Ludwig/Agfa Foto-Historama) GE // **2004** Strasbourg (Musée d'Art moderne et contemporain) SE // **2005** Berlin (Berlinische Galerie) SE // **2006** Winterthur (Germany) (Fotomuseum) SE // **2008** Berlin (Helmut Newton Foundation) GE

BIBLIOGRAPHY (Selected) — **Berühmte Zeitgenossen in unbewachten Augenblicken.** Stuttgart 1931 // **Porträt einer Epoche.** Frankfurt am Main 1963 // **Aus dem Leben eines Fotografen.** Munich 1981 // **Fotografien 1928–1938.** Berlin 1986 (cat. Berlinische Galerie) // **Leica Fotografie 1930– 1939.** Berlin 1986 (cat. Berlinische Galerie) // **Der unsichtbare Photograph.** Nördlingen 1988 ⚹ // Bodo von Dewitz and Robert Lebeck: **Kiosk. Eine Geschichte der Fotoreportage/A History of Photojournalism.** Göttingen 2001 (cat. Museum Ludwig/Agfa Foto-Historama) // **E.S. 1886–1944.** Strasbourg 2004 (cat. Musée d'art moderne et contemporaine) // Janos Frecot (ed.): **E.S.: "Mit Frack und Linse durch Politik und Gesellschaft". Photographien 1928–1938.** Munich 2004 (cat. Berlinische Galerie, Berlin) // **Pigozzi and the Paparazzi.** Berlin 2008 (cat. Helmut Newton Foundation)

"The importance of the individuals and situations he photographed is not what imbues Salomon's images with their historical status, but rather their visually-rich worldliness compressed to a human language. His gaze captures the most complex of discursive situations at that moment when the threads of communication connect in a unique and unrepeatable fashion. He shows the unbridgeable contrasts and differences of opinion which his contemporaries, the lack of prospects, and the course of politics itself hope to symbolize – and which continue to haunt us as the images of a permanent failure." — Janos Frecot ✍

Britische Politiker beim Besuch in Berlin im August 1931 auf einem Empfang. Von links nach rechts : Max Planck; der englische Premierminister Ramsay Macdonald; Albert Einstein ; Reichsaußenminister Dr. Dietrich ; Geheimrat Schmitz von der I. G.-Parbengesellschaft und Reichsaußenminister Dr. Curtius.

Strasemann mit Journalisten in einem Gartke-Café.

August Sander

August Sander: **Antlitz der Zeit.**
Munich (Transmare/Kurt Wolff
Verlag) 1929

17.11.1876 Herdorf (Germany) — 20.4.1964 Cologne (Germany) A taxonomy of the German people in accord with a vaguely sociological model is the most famous work of this internationally known exponent of New Objectivity art photography around 1930. Also architectural and landscape photography. 1890–1896 works as child laborer in an iron ore mine in Herdorf, in the German region of Siegerland. During this period gains knowledge of the medium through a local photographer. Purchases his own camera. 1897–1901 military service. Assists in the Trier studio of the photographer Georg Jung. Years of travel, with stays in Berlin, Magdeburg, Halle, Dresden, and Leipzig. Manages the Photographischen Kunstanstalt Greif photography studio in Linz (Austria). Marries Anna Seitenmacher. Three children. First exhibitions and prizes. 1910 settles in Cologne. Studio in Lindenthal-Cologne. 1914–1918 war service. Establishes contact with the Rhineland's Group of Progressive Artists (Heinrich Hoerle, Anton Räderscheidt, and Franz Wilhelm Seiwert). Conceives his (contrary to Erna Lendvai-Dircksen and Erich Retzlaff) long-term study of people without basing it on race but rather on sociological categories "Menschen des 20. Jahrhunderts" (People of the 20th Century) (intended as 45 portfolios with 12 plates each). 1929 *Antlitz der Zeit* appears as publication in progress (prologue by the writer Alfred Döblin). Takes landscape and architectural photographs, and plant studies. 1944 oldest son dies in Gestapo incarceration. Moves important parts of his archive to Kuchhausen (Germany). Destruction of Cologne studio during the war. 1951 solo exhibition at photokina outwardly signals the recognition he has attained. 1955 participates in critically acclaimed MoMA (New York) exhibition *The Family of Man*. 1960/1961 Federal Cross of Merit, and the Kulturpreis Prize of the DGPh (Deutsche Gesellschaft für Photographie: German Photographic Association). Estate administered by Photography Collection/SK Stiftung Kultur, Cologne.

EXHIBITIONS (Selected) — **1927** Cologne (Kölnischer Kunstverein – 1976) SE // **1951** Cologne (photokina) SE // **1959** Cologne (Deutsche Gesellschaft für Photographie) SE // New York (Museum of Modern Art) SE // **1978** Linz (Austria) (Stadtmuseum) SE // **1980** Philadelphia (Pennsylvania) (Museum of Art) SE // **1986** Paris (Pavillon des Arts) SE // **1995** Bonn (Kunstmuseum) SE // **1999** Cologne (SK Stiftung Kultur – 2001, 2006, 2007, 2008, 2011) SE // **2002** Winterthur (Fotomuseum) SE // San Francisco (San Francisco Museum of Modern Art) SE // **2003** Berlin (Martin-Gropius-Bau) SE // **2004** New York (Metropolitan Museum of Art) SE // **2005** Linz (Austria) (Landesgalerie) SE // **2006** Amsterdam (Fotografiemuseum Amsterdam) SE // **2008** Los Angeles (J. Paul Getty Museum) SE // **2009** Paris (Fondation Henri Cartier-Bresson) // Cagliari (Galleria Comunale d'Arte) SE // **2014** Munich (Pinakothek der Moderne) SE

BIBLIOGRAPHY (Selected) — **Antlitz der Zeit.** Munich 1929 // **Deutschenspiegel.** Gütersloh 1962 // **Menschen ohne Maske.** Lucerne/Frankfurt am Main 1971 // **Rheinlandschaften.** Munich 1975 // **Menschen des 20. Jahrhunderts.** Munich 1980 // **Köln-Porträt.** Cologne 1984 // **Die Zerstörung Kölns.** Munich 1985 // **Köln wie es war.** Cologne 1988 // **A.S.: "In der Photographie gibt es keine ungeklärten Schatten."** Berlin 1994 (cat. Kunstmuseum Bonn) // **A.S.: Landschaften.** Munich 1999 (cat. SK Stiftung Kultur, Cologne) // **Fotografie! Das 20. Jahrhundert.** Munich 1999 ⌨ // **Menschen des 20. Jahrhunderts. 7 Bde. und Studienband.** Cologne, 2001 (cat. SK Stiftung Kultur) // **A.S.: Linzer Jahre 1901–1909.** Munich 2005 (cat. Landesgalerie Linz/Die Photographische Sammlung/SK Stiftung Kultur, Cologne) // **Sardinien. Photographien einer Italyreise 1927.** Munich 2009 (cat. Galleria Comunale d'Arte di Cagliari)

"Sander's accomplishment was to make the traditional working methods used to produce carefully arrange portraits viable for the new tasks of documentary photography. He reconciled studio work with documentary photography, an act which took on special significance through the systematic approach that was central to his life achievement. Today this work is widely regarded as an early example of conceptual art, and influencing developments in the visual arts. Through his portrait work, Sander greatly contributed to photography's recognition as art. Therefore, alongside Albert Renger-Patzsch, he is considered to be one of our century's most internationally renowned German photographers." — Reinhold Misselbeck ✍

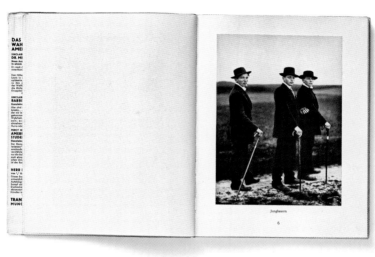

Jungbauern

6

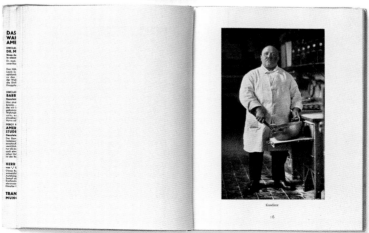

Konditor

16

Jan Saudek

Jan Saudek. Fotograf ceský.
Prague (Nakladeteství Slovart)
2005

13.5.1935 Prague (Czechoslovakia) — Lives in Prague In the 1980s the Czech Republic's most successful international art photographer. Focuses on nudes and eroticism: hand-colored figure studies set against morbid backdrops, viewed with skepticism by art critics. After 1939 his father (bank clerk), persecuted for being Jewish, is the only one of seven brothers to survive the holocaust. 1950–1983 J.S. works for a printer. Explores painting, drawing, and photography in his free time. 1953 (according to his own account) takes his first artistically significant photograph. 1954–1956 military service. 1958 first marriage, with Marie S. (two children). 1959 purchases first professional camera: Flexaret 6 x 6. 1963 first exhibition in Prague. Makes final decision to devote his life to photography. In the same year becomes acquainted with The *Family of Man* exhibition catalogue and decides to concentrate on depicting "the life of man from birth to death" (Christiane Fricke). 1966 produces his until now best-known photograph *Life*. 1969 travels throughout USA. Solo exhibitions at the University of Indiana in Bloomington. 1970 separates from Marie and moves into a basement apartment: the damp walls inspire his signature visual staging of (from 1977) recurring hand-colored pictorial inventions (as female nude studies). From the middle of the 1970s his international recognition increases. Collaborates with Paula Pia (Antwerp and Brussels), Karsten Fricke (Bonn), Marlène and Jean-Pierre Vorlet (Lausanne), and Anita Neugebauer (Basel). 1977 significant appearance at the Rencontres d'Arles. 1983 publishes first monograph, *The World of Jan Saudek*. 1984 after two decades of jobs taken to survive in the industry receives his first official work permit as photographer. Membership in the Union of Artists of the Czech Republic. 1988–1995 collaborates with the Amsterdam-based Torch Gallery. Since 1990 under contract with Art Unlimited publishers. 1989–1991 photographs for the Japanese fashion label Matsuda. 1990 awarded Chevalier des Arts et Lettres. Short film entitled *J.S. – Photographe tchèque*. From middle of the 1990s focuses increasingly on painting. 1998 comprehensive retrospective in Los Angeles.

EXHIBITIONS (Selected) — **1963** Prague (Theater am Gleaner) SE // **1969** Bloomington (Indiana) (University of Indiana) SE // **1976** Chicago (Art Institute) SE // **1977** Arles (Rencontres internationales de la photographie – 1990) SE // **1978** Rochester (New York) (George Eastman House) SE // **1979** Antwerp (Galleries Paula Pea) SE // **1980** Cologne (photokina) SE // **1984** Paris (Centre Pompidou – 1991) SE // **1985** Munich (Stadtmuseum) SE // **1986** Paris (Centre national de la photographie) SE // Frankfurt am Main (Fotografie Forum – 1987, 1989) SE // **1987** Paris (Musée d'art moderne de la Ville de Paris) SE // **1992** Toulouse (Galerie municipale du Château d'Eau) SE // **1998** Los Angeles (Bergamot Station Arts Center) SE // **2004** Brescia (Italy) (Museo Ken Damy – 2007) SE // **2006** Moscow (Moscow House of Photography) SE // **2008** Milan (Padiglione d'Arte Contemporanea) SE // **2009** Bonn (Kunst- und Ausstellungshalle der BRD/**Tschechische Fotografie des 20. Jahrhunderts**) GE

BIBLIOGRAPHY (Selected) — **The World of J.S.** Geneva 1983 // **35 Jahre Fotografie** – J.S. Frankfurt am Main 1986 (cat. Fotografie Forum Frankfurt) // **J.S.: 200 Photographs 1983–1986.** Paris 1987 (cat. Musée d'art moderne de la Ville de Paris) // **J.S.: Life, Love, Death and Other Such Trifles.** Amsterdam 1991 // **J.S.: Photographs 1987–1997.** Cologne 1997 // J.S. Cologne 1998 ✍ // **J.S. Fotograf ceský.** Prague 2005 // Daniela Mrázková: **Saudek.** Cologne 2006

"No other photographer has focused quite like Jan Saudek with such thoroughness and for so long on women as his subject. The photographer investigates every conceivable aspect of this miracle – not merely as an observer, but rather as someone inextricably bound to this process. He makes unmistakably clear what this means: 'I lack the option to make portraits of the lives of others. So I make portraits of my own life.'" — Christiane Fricke ✍

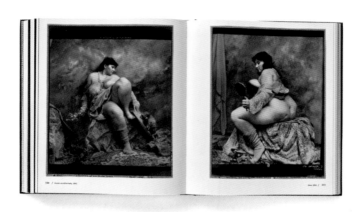

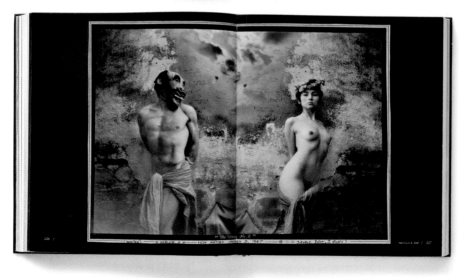

Roger Schall

Roger Schall: **Paris de jour.**
Paris (Éditions Arts et Métiers
Graphiques) 1937

25.7.1904 Nancy (France) — 1995 Paris (France) Portraits and reportages that present a new way of seeing. Also illustrations, nude studies, and fashion photography. Son of a photographer. 1911 moves to Paris, where he studies art under Germain Pilon. Beginning 1918 retoucher in his father's business. Military service. 1929 purchases first Leica. 1931 opens studio in Montmartre with brother Raymond. Periodically employs as many as 14 co-workers. Numerous publications in *VU*, *Art et Médecine*, and *L'Art vivant*. Photographs in *Die Dame* and *Berliner Illustrirte*. Beginning 1934 takes fashion photography for *Vogue*. 1944 publishes well-received book on Paris during the Occupation: *À Paris sous la botte des nazis*. Following the war works for *Paris Match*, *Life*, *Plaisir de France*, and *Marie Claire*. Creates ads and portraits of Coco Chanel. At the end of the 1960s abandons photographic activities.

"Photographers such as Ergy Landau, André Steiner, Nora Dumas, François Kollar, Eli Lotar, Émeric Feher, Ylla and many younger photographers, increasingly able to make a living from photo assignments for the press and advertising, very willingly made use of 'New Photography.' Among them, too, were Rémy Duval, Jean Moral, Pierre Boucher, René Zuber, Roger Parry, and Roger Schall." — Andreas Haus and Michel Frizot ✍

EXHIBITIONS (Selected) — **1939** Paris (Galerie Leleu) GE // **1982** Paris (Salon d'Automne) SE // **2003** New York (Patricia Laligant Photographs/**Paris under the Heel of the Nazis**) SE // **2004** New York (Zabriskie Gallery/**French Photography from the 1930's and 1940's**) GE // **2009** Paris (Jeu de Paume – Site Sully/**Collection Christian Bouqueret**) GE

BIBLIOGRAPHY (Selected) — **Formes nues.** Paris 1935 // **Paris de jour. 62 photographies de S.** Paris 1937 // **À Paris sous la botte des nazis.** Paris 1944 // Pierre d'Espezel and R.S.: **Paris relief.** Paris 1945 // Marie de Thézy and Claude Nori: **La Photographie humaniste 1930–1960. Histoire d'un mouvement** en France. Paris 1992 (cat. Bibliothèque historique de la Ville de Paris) // **Paris: The City and its Photographers.** Boston 1992 // **Christian Bouqueret: Des années folles aux années noires.** Paris 1997 // Michel Frizot: **Neue Geschichte der Fotografie.** Cologne 1998 ✍ // **Paris au quotidien 1939– 1945: Vu par R.S.** Paris 2005 // Anne de Mondenard and Michel Guerrin: **Réalités. Un mensuel français illustré (1946–1978).** Arles 2008 (cat. Maison européenne de la photographie) // **Paris. Capitale photographique. 1920/1940. Collection Christian Bouqueret.** Paris 2009 (cat. Jeu de Paume – Site Sully) // Michel Frizot and Cédric de Veigy: **VU. Le magazine photographique 1928–1940.** Paris 2009

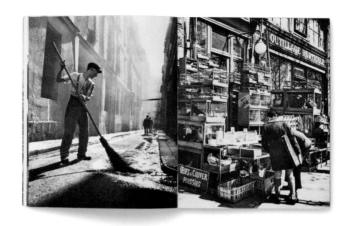

Steve Schapiro

Steve Schapiro: **American Edge.**
Santa Fe (Arena Editions) 2000

1934 Brooklyn (New York, USA) — Lives in Chicago (USA) Initially photojournalist in the spirit of classical reportage. Chronicles the civil rights movement in the USA with numerous publications in *Life*. Later takes up film stills, set photography, and cinema advertising. Grows up in New York. Graduates from Bard College. First photos at nine years old, at summer camp. Influenced especially by the work of > Cartier-Bresson takes up street photography. As such explores his hometown of New York. Student of > Smith, who teaches him not only technical fundamentals but also a specific view of the world and the ideal of "concerned photography". Since 1961 has worked as freelance photojournalist. Publishes in *Life*, *Look*, *Time*, *Newsweek*, *Rolling Stone*, *Vanity Fair*, *Sports Illustrated*, *People*, *Paris Match*. Chronicles the civil rights movement in America in the 1960s. Follows Bobby Kennedy's presidential campaign. Essays on Haight Ashbury and the Pine Ridge Sioux Indian Reservation. Present as photographer at the March on Washington for Jobs and Freedom (1963), and at the Selma to Montgomery March (1965). After Martin Luther King's murder in Memphis for *Life*, where in the aftershock of the events he takes some of his most important photos. Also reportages on > Warhol and the New York art scene. 1970 — with the closure of *Life* — switches to film. Set photography, advertising, posters for the major Hollywood production companies. Photos for *The Godfather*, *The Way We Were*, *Taxi Driver*, *Midnight Cowboy*, *Rambo*, *Risky Business*, *Billy Madison*, among others. Also record covers for David Bowie and Barbra Streisand. 1969 participates in the important group exhibition *Harlem On My Mind* in the Metropolitan Museum, New York. Art Directors Club Cube Award for his book *Schapiro's Heroes* (with photos of Muhammad Ali, James Baldwin, Samuel Beckett, Ray Charles, Truman Capote, Robert Kennedy, Martin Luther King, Jr, Jacqueline Kennedy Onassis, Barbra Streisand, and > Warhol). More recently documentary photography on India, on the Newport Jazz Festival, and on immigration reform. *www.steveschapiro.com*

EXHIBITIONS (Selected) — **1969** New York (Metropolitan Museum/**Harlem On My Mind**) GE // **1996** New York (Weill Art Gallery/**America and the Civil Rights Movement, 1954– 1968**) GE // **2000** New York (Bonnie Benrubi Gallery) SE // Perpignan (France) (Visa pour l'Image) GE // Los Angeles (Fahey/Klein Gallery – 2001, 2002, 2008) SE/GE //**2003** Chicago (Stepen Daiter Gallery) SE // **2007** Washington, DC (Smithsonian) GE // Santa Fe (New Mexico) (Monroe Gallery of Photography) SE // **2008** London (Hamiltons Gallery – 2009) GE/SE // Paris (Galerie Thierry Marlat) SE // Montreal (Musée des Beaux Arts) GE // **2009** Atlanta (Georgia) (Jackson Fine Arts) JE (with Helen Levitt)

BIBLIOGRAPHY (Selected) — **American Edge.** Santa Fe 2000 // **Schapiro's Heroes.** New York 2007 // **The Godfather Family Album.** Cologne 2008 // **Taxi Driver.** Cologne 2010 // **Then and Now.** Ostfildern 2012 // **Barbra Streisand by S. S. and Lawrence Schiller.** Cologne 2014 // **James Baldwin: The Fire Next Time. Photographs by S.S.** Cologne 2017

"We could no longer imagine the situation of Walker Evans or Robert Frank, adrift in the heartland, surprising America in its naked, interior innocence and being surprised by it — because nothing surprised us. In Schapiro's moment, every picture contained pictures and every person was a picture too, pre-costumed, posed and they're to be taken. Look at his celebrity portraits of Jack and Jackie Kennedy, of Chuck Berry and Ray Charles, of Magritte doubling his own image, and Warhol mimicking the pose of his own self-portraits. Schapiro takes their pictures, but he also captures the cool opacity of creatures who understood that history had become pictures and that pictures became history." — Dean Hickey

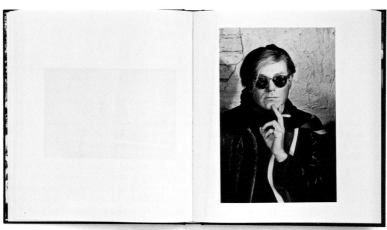

Xanti Schawinsky *(Alexander Schawinsky)*

Xanti Schawinsky Foto

Xanti Schawinsky. Foto.
Bern (Benteli Verlag) 1989

26.3.1904 Basel (Switzerland) — 11.9.1979 Locarno (Switzerland)
Bauhaus student. Interested in photography, typography, and advertising. Active as stage designer, exhibition designer, and painter. Photography used for advertisements. Also independent experiments: collages, multiple exposures, color photographs, halftone images. Attends school in Basel and Zurich. 1921–1923 training in Theodora Merrill's architect office (Cologne). 1923–1924 School of Applied Arts in Berlin (under Bruno Paul). 1924–1929 Bauhaus: foundation course conducted by > Moholy-Nagy. Studies under Oskar Schlemmer, Paul Klee, Wassily Kandinsky, Adolf Meyer, and attends lectures conducted by Walter Gropius. Free Expression painting, advertising art, experimental photography (beginning around 1925). 1929–1931 director of the Graphic Design Department at the Building Authority in Magdeburg (Sachsen). 1932–1933 works freelance in Berlin. 1933 moves to Milan and works in the Boggeri Studio. Ads for Motta, Cinzano, and Olivetti. 1936 moves to USA. Until 1938 professor at Black Mountain College (North Carolina). 1938–1961 works in New York as exhibition designer, advertising graphic designer, painter, and photographer. Teaching posts at New York City College and New York University. In the 1960s abandons art photography to a large extent in favor of painting.

EXHIBITIONS (Selected) — **1937** Black Mountain (North Carolina) (Black Mountain College) SE // **1961** Darmstadt (Germany) (Bauhaus archive) SE // **1975** Bologna (Galleria d'Arte Moderna) SE // **1978** Munich (Galleria del Levante) GE // **1986** Berlin (Bauhaus archive) SE // **1989** Munich (Städtische Galerie im Lenbachhaus) SE // **1990** Berlin (Bauhaus-Archiv) GE // **1997** Bonn (Rheinisches Landesmuseum) GE // **2000** Essen (Germany) (Museum Folkwang) GE // **2002** Munich (Deutsches Museum/**Das zweite Gesicht**) GE // **2005** Zurich (Artef Fine Art Photography Gallery – 2007) GE/SE // **2008** Lugano (Switzerland) (Museo d'Arte) GE

BIBLIOGRAPHY (Selected) — **X.S.** Bologna 1975 (cat. Galleria d'Arte Moderna) // Emilio Bertonati: **Das experimentelle Photo in Deutschland 1918–1940.** Munich 1978 (cat. Galleria del Levante) // Vittorio Fagone: **X.S.: La Fotografia. Dal Bauhaus a Black Mountain.** Locarno 1981 // Hans Heinz Holz: **X.S.: Bewegung im Raum – Bewegung des Raumes.** Zurich 1981 // **X.S.: Malerei, Bühne, Grafikdesign, Fotografie.** Berlin 1986 (cat. deckung." In: **Süddeutsche Zeitung,** 25/26.11.1989 ✐ // **X.S. Foto.** Bern 1989 // Jeannine Fiedler (ed.): **Fotografie am Bauhaus.** Berlin 1990 (cat. Bauhaus Archive) // **X.S.: Magdeburg 1929–31. Fotografien.** Dessau 1993 // Klaus Honnef and Frank Weyers: **Und sie haben Deutschland verlassen ... müssen.** Bonn 1997 (cat. Rheinisches Landesmuseum) // **Bauhaus: Dessau > Chicago > New York.** Cologne 2000 (cat. Museum Folkwang, Essen)

"Xanti Schawinsky had the newest photographic techniques at his disposal. He knew the photocollages of the Dadaists, solarized images, as well as the photograms of Man Ray and Christian Schad. Though stylistically linked with his friend Herbert Bayer, he developed his own original and experimental treatment of the medium. Xanti Schawinsky proved himself a master of optical transformations, and equally a master at combining photography and painting."
— Dorothea Baumer ✎

Hugo Schmölz

Hugo Schmölz: **Fotografierte Architektur 1924–1937.** Munich (Mahnert-Lueg Verlag) 1982

21.1.1879 Sonthofen (Germany) — 27.4.1938 Cologne (Germany) Photography in the spirit of the New Objectivity. Important interpreter of architecture in Germany between the wars. His father owns a wholesale business for butter and cheese. 1885–1893 H.S. attends the secondary school Grund- und Königliche Realschule in Kempten. 1893–1896 studies photography under Richard Eder in Kempten. Until 1895 attends vocational school in Kempten. 1896–1901 years of traveling and apprenticeships as photographer, with stays in Zurich, Oberstdorf (Allgäu), Munich (Atelier Elvira), Leutkirch (Allgäu), Wiesbaden, and Frankfurt am Main. 1901–1910 retoucher and photographer under Hubert Lill in Mannheim. 1910–1911 photographer for Winkler & Leitner in Berlin. 1911 at the State Art Institute Photographischen Kunstanstalt Urania in Berlin. November 1911 starts his own business in Cologne (with the portraitist Eugen Bayer). 1914–1918 military service. November 1924 separates from Bayer and opens his own business in Cologne. Work as architectural photographer for Adolf Abel, Otto Bartning, Dominikus Böhm, Paul Bonatz, and others. 1928 participates in the *Pressa* exhibition. 1930 founding member of Cologne-based photographers' association Vereinigung Kölner Fachphotographen (VKF). 1934 appointed to the GDL (Gesellschaft Deutscher Lichtbildner: German Photographic Academy). Befriends > Erfurth. 1938 memorial exhibition in Cologne. His studio is taken over by son Karl Hugo S. (1917–1986). Estate of around 10,000 negatives.

EXHIBITIONS (Selected) — **1932** Cologne (Kunstgewerbemuseum – 1938) GE/SE // **1951** Cologne (photokina) JE (with Hugo Erfurth and August Kreyenkamp) // **1996** Leverkusen (Germany) (Erholungshaus der Bayer AG) GE // **2001** Brühl (Germany) (Rathausgalerie) GE // **2002** Cologne (KunstKöln) JE (with Karl Hugo Schmölz) // **2007** Cologne (Die Photographische Sammlung/SK Stiftung Kultur) GE

BIBLIOGRAPHY (Selected) — **H.S.: Fotografierte Architektur 1924–1937.** Munich 1982 ⧉ // **Photographie des 20. Jahrhunderts. Museum Ludwig Köln.** Cologne 1996 // Klaus Honnef (ed.): **Der fixierte Blick. Deutschland und das Rheinland im Fokus der Fotografie.** Cologne 1996 (cat. Erholungshaus der Bayer AG, Leverkusen) // Wolfgang Vollmer (ed.): **Stadt|Bild|Köln. Photographien von 1880 bis heute.** Göttingen 2007 (cat. Die Photographische Sammlung/SK Stiftung Kultur, Cologne)

"As a photographer, Hugo Schmölz always thought of himself as serving architecture, as its interpreter and mediator. He had little influence on the selection of architects and contractors [...]; yet the number and the variety of the buildings and models he photographed were so great that Schmölz can be considered one of the most important and most consistent chroniclers of German architecture in the 1920s and 1930s." — Rolf Sachsse ✑

Gotthard Schuh

Gotthard Schuh: **Inseln der Götter.** Zurich (Buchclub Ex Libris) 1941

22.12.1897 Berlin (Germany) — **29.12.1969** Küsnacht (Switzerland) Important Swiss photojournalist of the period between the wars with an accordingly modern visual language. Spends childhood and youth in Switzerland. Attends canton school in Aarau, vocational school in Basel. 1917–1918 border control service, military academy. 1919–1920 lives as painter in Basel and Geneva. 1920 travels extensively through Italy. Afterwards lives and works as a painter in Krailling near Munich. First art exhibition of his own. 1922 exhibits in Tannhauser Gallery in Munich. 1926 suffers crisis as artist and returns to Switzerland. 1927 takes his first photographs. 1929 first professional (and later repeatedly reproduced) photographs in connection with an Italian journey. 1931 first publication in the *Zürcher Illustrierten* (Arnold Kübler, director). Results in reportages for *Zürcher Illustrierte, Berliner Illustrirte, Föhn, VU, Paris Match,* and *Life.* 1935 Zürich is the first of altogether 15 books published during his lifetime. 1938 travels to Indonesia on work assignment. 1941 publishes *Inseln der Götter,* undeniably his most important book. In the same year termination of *Zürcher Illustrierten.* Temporarily works for *Du* magazine. Afterwards (until 1960) as picture editor for the *Neuen Zürcher Zeitung.* Further original reportages include those from Germany and Italy. 1955 participates in *The Family of Man* exhibition. 1958 his *Java Boy* is Zurich station poster motif. Along with Paul Senn, Hans Staub, and Jakob Tuggener, one of the most distinguished Swiss reportage photographers of the 1930s and 40s. 1961 returns to painting. Estate administered by the Swiss Foundation for Photography.

"Even though at first glance Schuh's early photographs are not 'typically 1930s', he clearly qualifies as a champion of the 'New Photography'. Schuh never paid homage to 'artistic photography' (as advocated by *Camera* up until 1947). Like his colleagues at the *Zürcher Illustrierten,* he was a picture-reporter and, from the start, without the technical and aesthetic constraints of 'art photography', he hunted down pictures with his eyes wide open." — David Streiff ✍

EXHIBITIONS (Selected) — **1955** New York (Museum of Modern Art) GE // **1967** Zurich (Helmhaus) SE // **1982** Zurich (Kunsthaus) SE // **1999** Arles (France) (Rencontres internationales de la photographie) SE // **2000** Paris (VU' La galerie) SE // **2004** Gentilly (France) (Maison Robert Doisneau) SE // **2005** Prague (Langhans Galerie/**Galerie VU', Paris**) GE // **2007** Winterthur (Switzerland) (Fotostiftung Schweiz) GE // **2009** Winterthur (Fotostiftung Schweiz) SE // **2010** Chalon-sur-Saône (France) (Musée Nicéphore Niépce) SE // **2012** Winterthur (Fotostiftung Schweiz) GE

BIBLIOGRAPHY (Selected) — **Inseln der Götter.** Zurich 1941 // **50 Photographien.** Basel 1942 // **Frühe Photographien 1929–1939.** Zurich 1967 // **Photographien aus den Jahren 1929–1963.** Bern 1982 (cat. Kunsthaus Zürich) ✍ // **Photographie in der Schweiz von 1840 bis heute.** Wabern-Bern 1992 // **Bilderstreit. Durchbruch der Moderne um 1930.** Zurich 2007 (cat. Fotostiftung Schweiz, Winterthur) // **G.S.: Eine Art Verliebtheit.** Göttingen 2009 (cat. Fotostiftung Schweiz) // Peter Pfrunder (ed.): **Schweizer Fotobücher 1927 bis heute.** Baden 2012 (Katalog Fotostiftung Schweiz)

143

Im Halbschatten der Hüttenverschläge
immer wieder dasselbe Bild: Mutter und
Kind

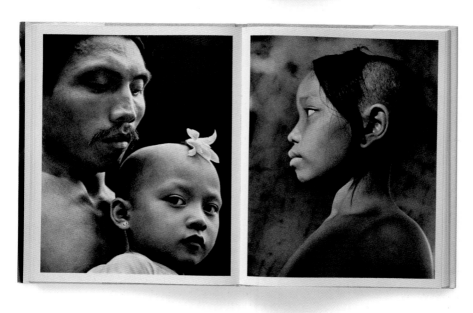

Tazio Secchiaroli

I Grandi Fotografi: Tazio Secchiaroli. Milan (Fabbri) 1983

26.11.1925 Rome (Italy) — 24.7.1998 Rome Frequently referred to as "the originator of the Paparazzi". From the 1960s produces, in particular, stills photography and portraits of actors. 1941 leaves school after his father's death. Boilerman on the railroad, 1943 errand boy at Cinecittà. 1944 works as street photographer in Rome. 1951 works for the American news agency International News Service. "Apprentice years" at the VEDO (Visioni Editoriali Diffuse Ovunque) agency founded by Adolfo Porry-Pastorell. First sensational publications in the newspaper *Momento Sera*. 1956 founds the agency ROMA'S PRESS PHOTO. In the 1950s numerous publications include those in *L'Europeo*, *L'Espresso*, *Epoca*, *Paris Match*, *Time*, and *Life*. Meets Federico Fellini, whose film *La Dolce Vita* is significantly inspired by S.'s character and work as a *paparazzo*. Abandons journalistic photography. Works as set photographer for Fellini (*8½*, *Satyricon*, *La città delle donne*, and other films). Also shoots portraits of international screen stars such as Marlon Brando, Marcello Mastroianni, Gregory Peck, and especially Sophia Loren. 1980 first solo exhibition (in Milan). 1983 abandons photographic work.

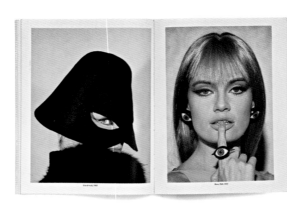

EXHIBITIONS (Selected) — **1968** Hamburg (2nd International Photography Fair) GE // **1980** Milan (Palazzo delle Stelline) SE // **1982** Paris (Musée d'art moderne de la Ville de Paris) GE // **1990** Milan (Cartiere Milani di Fabriano) SE // **1996** Milan (Galleria Photology – 1999) SE // **1999** Madrid (PHotoEspaña) SE // **2002** Montpellier (France) (Le Pavillon Populaire) SE // **2003** Chalon-sur-Saône (France) (Musée Nicéphore Niépce) SE // **2004** Milan (Spazio Oberdam) SE // **2006** Florence (Libreria d'arte Assolbri) SE // **2007** Madrid (PHotoEspaña) GE // **2008** Berlin (Helmut Newton Foundation) GE

BIBLIOGRAPHY (Selected) — **I Grandi Fotografi: T.S.** Milan 1983 // **T.S.: Dalla Dolce Vita ai Miti del Set.** Milan 1998 // **Fellini 8½.** Milan 1998 // Enrica Viganò: **NeoRealismo. La nueva imagen en Italia. 1932–1960.** Madrid 2007 (cat. PHotoEspaña) // **Pigozzi and the Paparazzi.** Berlin 2008 (cat. Helmut Newton Foundation)

"Following the call of his talent, Secchiaroli soon gave up working as a street photographer [...] He gathered his first experiences as a set photographer and finally became one of those photographers who, between clapboards, elicited [...] the gazes and gestures of movie stars."
— Diego Mormorio

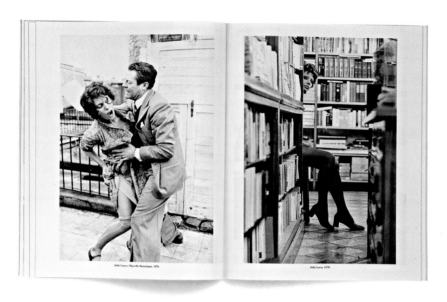

Friedrich Seidenstücker

26.9.1882 Unna (Germany) — 26.12.1966 Berlin (Germany) Pioneer of an unpretentious style of street photography. Chronicler of everyday life in major cities around 1930. Also sports photography, photographs of animals, and nude studies. 1901–1903 studies engineering in Hagen. Postgraduate courses at the Technische Universität Berlin. At the same time enrolls in a sculpture class. During WW I works as Zeppelin designer for Zeppelin Bau AG in Berlin. Afterwards (until 1921) studies animal sculpture under August Gaul. Works freelance for a period. 1930 (Great Depression) abandons animal sculpture and works exclusively as photographer for magazines of the Ullstein publishing empire (*Berliner Illustrirte Zeitung*, *Die Dame*, *Scherl's Magazin*, and *Die Woche*) producing mostly animal photographs and street scenes: small everyday occurrences like his popular image of women hopping puddles in the rain (*Pfützenspringerinnen*), editorially well conceived, formally well visualized, and not lacking humor. Occasionally referred to as the "flâneur with a camera". In addition, photographs nude studies, sports events, and an impressive cycle on people at their place of work. After the war produces an extensive photo series on the war-damaged capital. From the middle of the 1950s no further photographs appear. Is posthumously accepted and accordingly appreciated as a major exponent of the 1930s avant-garde. Among other exhibitions, represented at the San Francisco Museum of Modern Art's 1980 exhibition *Avant-Garde Photography in Germany 1918–1939* curated by Frank Van Deren Coke. Estate administered by the Bildarchiv Preussischer Kulturbesitz in Berlin.

> **"Friedrich Seidenstücker was an observer who seemed to capture the fleeting moment with an astounding lightness. He put candid reality before everything else."**
> — Gabriele and Helmut Nothhelfer ✍

EXHIBITIONS (Selected) — **1962** Berlin (Rathaus Wilmersdorf) SE // **1974** Kassel (Germany) (Fotoforum) SE // **1977** Kassel (documenta 6) GE // **1979** Cologne (Galerie Wilde) SE // **1982** Cologne (Kölner Kunstverein/photokina) SE // **1987** Berlin (Nationalbibliothek) SE // **1996** Cologne (SK Stiftung Kultur) SE // Hannover (Sprengel Museum) SE // **2005** Essen (Germany)(Museum Folkwang) GE // **2013** Salzburg (Museum der Moderne) GE

BIBLIOGRAPHY (Selected) — Gabriele and Helmut Nothhelfer (eds): **F.S. 1882–1966.** Berlin 1980 ✍ // **Von Weimar bis zum Ende.** Dortmund 1980 // **Das Berliner Zoo-Album.** Berlin 1984 // **Der faszinierende Augenblick.** Berlin 1987 // **Von Tieren und von Menschen.** Berlin 1986 // **Der humorvolle Blick.** Hannover 1997 (cat. Sprengel Museum) // **Nützlich, süß und museal: Das fotografierte Tier/The Photographed Animal: Useful, Cute, and Collected.** Göttingen 2005 (cat. Museum Folkwang, Essen) // **Focus on Photography.** Munich 2013 (cat. Museum der Moderne, Salzburg)

Friedrich Seidenstücker (top):
Jaguars/Emerging Walruses,
from: **Das Deutsche Lichtbild,** 1933

Friedrich Seidenstücker (above,
right-hand page): **Untitled,** from:
Das Deutsche Lichtbild, 1937

David Seidner

David Seidner: **The Face of Contemporary Art.** Munich (Gina Kehayoff Verlag) 1996

1957 Los Angeles (USA) — 6.6.1999 Miami Beach (Florida, USA) Shooting star of 1980s, fashion, beauty, and portrait photography. Frequently compared to masters of the genre (> Avedon, > Beaton, > Horst, > Hoyningen-Huene, and > Penn). Takes first photographs at age 14. First cover at 19, and first exhibition at 21. Early success results in numerous publications, especially in *Vogue* (France and Italy), *Vanity Fair*, and *The New York Times Magazine*. Co-editor of the New York art magazine *Bomb*. Two-year exclusive contract with Yves Saint Laurent. Later fragmentary pictorial inventions influenced by the music of John Cage. Broken imagery created with the use of mirrors (also in color) possibly inspired by the fashion photography of > Blumenfeld. 1986 commissioned by newly founded Musée des Arts de la Mode in the Louvre to photograph historic costumes for the exhibition opening's catalog. Ads for Bill Blass, Bergdorf Goodman, Revlon, and L'Oreal. Also (possibly influenced by > Liberman) artists' portraits, which include those of Louise Bourgeois, Eric Fischl, Jenny Holzer, Richard Serra, > Sherman, Cy Twombly, as well as studio visits (in color). Compilation of photo essays on artists' studios as the final self-produced book project of the photographer who (1999) dies of AIDS. Prizes include the Eisenstaedt Award for Portrait Photography conferred by the magazine *Life* and Columbia University.

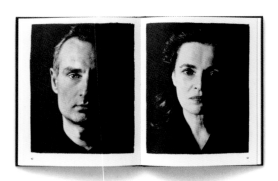

EXHIBITIONS (Selected) — **1978** Paris (La Remise du Parc — 1980, 1983) SE // **1979** Los Angeles (Institute of Contemporary Art) SE // **1981** New York (Clock Tower) SE // **1982** Rome (Galerie Ugo Ferranti) SE // Nuremberg (Galerie Ursula Erhardt) SE // Utrecht (Netherlands) (Galerie Ton Peek) SE // **1985** Paris (Galerie Samia Saouma — 1989) SE // **1986** Paris (Musée des Arts de la Mode) SE // **1993** New York (Robert Miller Gallery — 1995) SE // **1996** Paris (Maison européenne de la photographie) SE // **1999** New York (Staley-Wise Gallery) SE // **2004** New York (Yancey Richardson Gallery) GE // Paris (Maison européenne de la photographie) GE // **2007** New York (Cook Fine Art) SE // **2008** Paris (Fondation Pierre Bergé — Yves Saint Laurent) SE

BIBLIOGRAPHY (Selected) — **Moments de Mode.** Paris 1986 (cat. Musée des Arts de la Mode) // **D.S.** Munich 1989 ⬚ // **Nudes.** Munich 1995 // **The Face of Contemporary Art.** Munich/Paris 1996 (cat. Maison européenne de la photographie) // **Artists' Studios.** Paris 1999 // Patrick Mauriès: **D.S.** Paris 2008 (cat. Fondation Pierre Bergé-Yves Saint Laurent)

"What could be considered Seidner's formalism – the extreme refinement of his compositions, his affinity for a linear and calligraphic defining of the body – is actually woven from the stuff of rapture and instability. Nothing demonstrates this better than the way that he works: a love for long pauses, which give the body the chance to expose itself, develop, and display its own measure of time, rhythm, and elegance." — Patrick Mauriès ✍

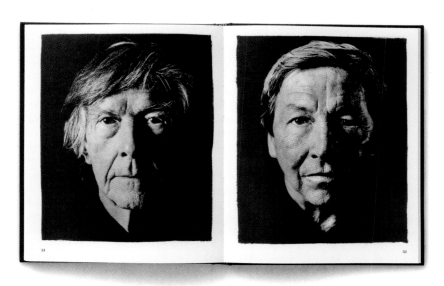

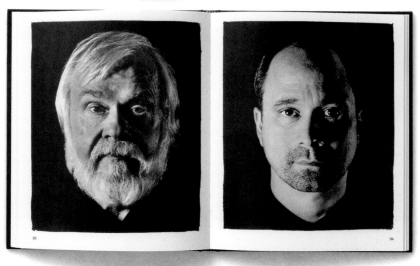

Andres Serrano

Andres Serrano: **The Morgue.**
Reims (Palais du Tau) 1993

15.8.1950 New York (USA) — Lives in Brooklyn (New York, USA) Sexuality and death lie at the center of his artistic work, which confronts religious taboos. Controversial figure since the end of the 1980s. 1967–1969 courses at the Brooklyn Museum Art School. Largely self-taught as a photographer. 1985 National Studio Program grant (P.S.1 Contemporary Art Center). 1986 NEA (National Endowment for the Arts) grant. 1987 Advancement Award of the New York Foundation of the Arts. The same year creates his (152 x 102 cm) color piece (Ciba-chrome) entitled *Piss Christ.* Two years later the piece is a subject of debate in right-wing circles regarding the limits of (government-funded) art. Along with > Mann, > Mapplethorpe, Jock Sturges, and filmmaker Martin Scorsese (*The Last Temptation of Christ*), A.S. is target of unprovoked conservative attacks. Meanwhile internationally known as artist. Death, sexuality, poverty, and violence form the center of his interests undeniably inspired by Christian norms and taboos. As a rule, large cycles produced in color. *Body Fluids* (confrontation with blood, milk, sperm, and urine), *Morgue* (images from the study of pathology), *Nomads* (the homeless), and *The History of Sex,* among his best-known works to date. 1994 participates in important group exhibitions such as *Art in the Age of AIDS* (Canberra) and *The Portrait in Recent Art* at the University of Pennsylvania.

EXHIBITIONS (Selected) — **1985** New York (Museum of Contemporary Hispanic Art) SE // **1988** New York (Stud Gallery – 1989, 1990) SE // **1991** Paris (Galerie Yvon Lambert – 1992, 1994, 1997, 1998, 2005) SE // **1992** Amsterdam (Institute of Contemporary Art) SE // **1994** Cahors (France) (Le Printemps de Cahors) SE // **1995** Chicago (Illinois) (Museum of Contemporary Art) SE // **1996** Malmö (Sweden) (Konsthal) SE // **1997** Groningen (Netherlands) (Groninger Museum) SE // **1998** Seattle (Washington) (Greg Kucera Gallery) SE // **2000** Bergen (Norway)(Art Society) SE (touring exhibition: Stavanger, Tromso, Oslo, Helsinki, Kaunas, Aachen, London) // **2005** Berlin (C/O Berlin) SE // Moscow (Moscow House of Photography) SE // **2007** Madrid (Círculo de Bellas Artes) SE // **2008** Lausanne (Musée de l'Élysée) GE // New York (Yvon Lambert Gallery) SE

BIBLIOGRAPHY (Selected) — **The Morgue.** Reims 1993 (cat. Galerie Yvon Lambert) // **Le Sommeil de la Surface.** Arles 1994 // **Le Printemps de Cahors.** Cahors 1994 (cat. Le Printemps de Cahors) // **A.S.** Malmö 1996 (cat. Malmö Konsthall) // **A History of A.S.** Groningen 1997 (cat. Groninger Museum) // **Art at the Turn of the Millennium.** Cologne 1999 // **Big Women.** Turin 2000 // **America and Other Work.** Cologne 2004 // **Diccionario de Fotógrafos/A Dictionary of Photographers 1998–2007.** Madrid 2007 (cat. PHotoEspaña) ✍ // Daniel Girardin and Christian Pirker (eds): **Controverses. Une histoire juridique et éthique de la photographie.** Arles 2008 (cat. Musée de l'Élysée, Lausanne)

"Since their first appearance at the beginning of the 1980s, Andres Serrano's images have addressed the contemporary world's most controversial topics. Bodily fluids, exclusion, fanaticism, religion, disease, and death appear in each of his series. This might explain why his work has often been the subject of fierce debate, as when, in 1989, he achieved international fame soon after two senators denounced his work, *Piss Christ* (1987), on the floor of the United States Senate. Both Serrano's choice of subject matter and the manner in which he treats it have consistently positioned his work within the parameters of great controversy. The forcefulness of his images evolves from advertising devices, citing, for example, his use of lighting and especially how he engages language: the precision of his titles and the choice of words are always presented in a manner as brief as they are eloquent." — Diccionario de Fotógrafos ✍

David Seymour (David Szymin/"Chim")

20.11.1911 Warsaw (Poland) — 10.10.1956 Suez (Egypt) Founding member and president of Magnum. Reportage reflecting a (progressive) humane photojournalism. Son of a well-known publisher. 1914 moves with family to Russia. 1919 returns to Warsaw. 1931 obtains degree at the Academy for Graphic Arts in Leipzig. 1931–1933 studies printing techniques at the Sorbonne. Meets > Capa and > Cartier-Bresson. Creates expressive photography under the pseudonym "Chim". From 1934 completes photo reports for *Regards*, *VU*, *Ce soir*, and *Vie ouvrière*. Reportages from the Spanish Civil War. 1939 Mexico and New York. 1942–1945 works under the name Seymour as a photographer and interpreter for the US army. Photo reports for UNICEF (postwar children in Europe). 1947 founding member of Magnum. After Capa's death (1954) agency president. 1956 is killed during the Suez Crisis. 1967 participates posthumously in the programmatic exhibition *The Concerned Photographer* in the Riverside Museum (New York).

"One of Magnum's strengths was the complementary personalities of its founders. David 'Chim' Seymour was the more reserved, fastidious partner, and, in Henri Cartier-Bresson's description of him, 'delicate'. He was more thoughtful than colorful. Quiet and cultured, he had no appetite for dramatic gestures; he did not cultivate the reputation of the dashing war photographer, nor of 'the artist'. Unlike André Friedmann, who changed his name to Robert Capa as a way of developing his romantic appeal, David Szymin changed his to Seymour for wholly practical reasons: traveling to Europe with the US Army during World War II, he sought to protect his parents from German reprisals in the event of his capture. Yet Chim (as he was known to everyone) was Magnum's link with the beginnings of photojournalism. While Capa drove the ideas and fronted the show, Chim was possibly his most important partner in the enterprise – the quiet thinker behind the scenes. He anchored early Magnum with his intellectual reasoning, pragmatism and talent for strategic planning, and he co-authored with Capa its organizational vision."
— Chris Boot ✍

EXHIBITIONS (Selected) — **1955** New York (Museum of Modern Art/**The Family of Man**) GE // **1956** Cologne (photokina – 1958, 1963) GE/SE // **1966** Jerusalem (Israël Museum) SE // **1967** New York (School of Visual Arts) SE // **1995** Milan (Fondazione Antonio Mazzotta) GE // **1996** Paris (Hôtel de Sully) GE // **1996** New York (International Center of Photography) SE // **2008** Amsterdam (Stedelijk Museum Post CS/**MAGNUM Photos 60 Years**) GE // **2010** New York (International Center of Photography – 2013) SE

New York 1974 // **Front populaire**. Paris 1976 // **Les grandes photos de la guerre d'Espagne**. Paris 1980 // **Zeitblende. Fünf Jahrzehnte Magnum-Photographie**. Munich 1989 // Giuliana Scimé: **Fotografia della libertà e delle dittature da Sander a Antonio Mazzotta** // **Chim: The Photographs of D.S.** New York 1996 (cat. International Center of Photography) // Tom Beck: **D.S. (Chim)**. London 2006 // Chris Boot (ed.): **Magnum Stories**. London 2004 ✍ // Brigitte Lardinois: **Magnum Magnum**. Munich 2007 // Cynthia Young (ed.): **The Mexican Suitcase**. New York 2010 (cat. ICP) // Cynthia Young (ed.): **We Went Back. Photographs from Europe 1933–1956 by Chim**. New York 2013. (cat. International Center of Photography)

BIBLIOGRAPHY (Selected) — **Children of Europe**. Paris 1949 // **The Vatican**. New York 1950 // **Cornell Capa: The Concerned Photographer**. New York 1968 // **D.S. – Chim: 1911–1956.**

David Seymour: **Chim – un homme de paix,** from: **Camera,** no. 12, December 1958

Charles *(Rettew)* Sheeler

Charles Sheeler: The Photographs.
Boston (Museum of Fine Arts)
1987

16.7.1883 Philadelphia (Pennsylvania, USA) — 7.5.1965 Dobbs Ferry (New York, USA) Painter, filmmaker, and photographer. Pioneer of New Objectivity art photography in USA. 1903–1906 studies under William Merritt Chase at the Pennsylvania Academy of Fine Arts in Philadelphia. Befriends Morton Schamberg. Encouraged by Schamberg (1910), develops strong interest in photography. 1908 first solo exhibition (paintings). 1913 shows six paintings at the Armory Show. 1917 first exhibition of photographs. 1919 moves to New York. Befriends > Stieglitz. 1920 film production work with > Strand (*Manhatta*). 1922 meets Edward Weston. 1926–1929 editorial photography (portraits) for Condé Nast (*Vogue, Vanity Fair*). Also advertising photography, including for Firestone and Kodak. 1927 photographs of the new Ford factory (*The Plant*) in Detroit (Michigan). 1929 travels throughout Europe with stays in Paris, Chartres, and Stuttgart (*Film und Foto*). 1933 death of his wife Katherine. Followed by extensive travels while producing few important pictures. Hardly mentioned as artist in his later years. 1968 retrospective in Washington, DC, launches his new reception.

"**The fact remains that, as an artist, Sheeler painted, drew, and photographed his entire life. Establishing himself first as a painter, and then as a rebellious Chase student who exhibited at the Armory Show in 1913, between 1916 and 1930 he went on to become a leading exponent of modern American photography. Over the next twenty-five years, he explored with equal perspicuity the role that photography could have in the making of paintings. His work as a straight photographer won for him the admiration of Stieglitz, Steichen, and Strand; and his later pioneering work, regarding the use of photographic imagery, made him a forerunner of many divergent artists of the 1960s and 1970s […].**"— Theodore E. Stebbins, Jr, and Norman Keyes, Jr ✍

EXHIBITIONS (Selected) — **1917** New York (Modern Gallery) JE (with Morton Schamberg and Paul Strand) // **1929** Stuttgart (**Film und Foto**) GE // **1931** New York (Julien Levy Gallery) GE // **1939** New York (Museum of Modern Art) SE // **1954** Los Angeles (UCLA) SE // **1968** Washington, DC (Smithsonian Institution) SE // **1987** Boston (Museum of Fine Arts) SE // **2003** New York (Metropolitan Museum of Art) SE // Winterthur (Switzerland) (Fotomuseum) SE // **2004** Frankfurt am Main (Städelsches Kunstinstitut) SE // **2006** Washington, DC (National Gallery of Art/**Across Media**) SE // Chicago (Art Institute/**Across Media**) SE // **2009** Stuttgart (Staatsgalerie/**Film und Foto: Eine Hommage**) GE

BIBLIOGRAPHY (Selected) — **Contemporary Photographer**: C.S. Culpeper 1967 // **C.S.** Washington, DC 1968 (cat. Smithsonian Institution) // **C.S.: Paintings, Drawings, Photographs.** Boston 1987 (cat. Museum of Fine Arts) ✍ // **C.S.: Across Media.** Washington, DC, 2006 (cat. National Gallery of Art)

New York, Park Avenue, 1920

New York, Broadway at Seventh Avenue, c. 1920

Delmonico Building, New York, 1926

View, World City, New York, 1932

Cindy Sherman

Cindy Sherman.
Paris (Flammarion/Jeu de Paume)
2006

19.1.1954 Glen Ridge (New Jersey, USA) — Lives in New York (USA)
Narrative (self-)stagings serving as a criticism of media and culture from a feminist perspective. Internationally one of the best-known exponents of postmodern art photography. Studies at State University in Buffalo (New York). 1976 obtains B.A. 1977 moves to New York City. Creates first narrative self-stagings while studying. Breakthrough at the end of the 1970s with *Untitled Film Stills*, a b/w photo series in which she photographs herself in roles reflecting movies of the 1950s. Female stereotypes and the male gaze directed at women (as sex symbol, victim, etc.) also the topic of the following ten (color) works arranged largely in cycles. 1980 *Real Screen Projections* series; 1981 *Centerfolds* (ironic paraphrasing of *Playboy* magazine centerfolds "established" since 1953); 1982 *Pink Robes* and *Color Tests*; 1983 *Fashion* (for *Interview* magazine); 1985–1989 *Disasters* and *Fairy Tales*; 1988–1990 *History Portraits* series; 1991 *Civil War*; 1992 *Sex Pictures*. Further use of (medical) puppets here (> Bellmer), indicating a return to the self from within a pictorial realm in favor of various (not always by chance revulsion-inspiring) objects or materials (as the pictorial antithesis of photo design glamour). 1982 participates in documenta 7. Since then (at auctions) among the most expensive exponents of postmodern art photography. 2000 receives the Hasselblad Award for her complete works.

"Cindy Sherman's images lie. Yet what they show us makes recognizable, at a focused, caricaturized, and even perverted pitch, what exists and what makes a claim to control us: conventionalized projections of sexuality, beauty, power, and violence, which serve both as media strategies for suppressing the real and as 'fakes' to help them establish their claim to reality." — Barbara M. Henke ✍

EXHIBITIONS (Selected) — **1980** New York (Metro Pictures – 1981, 1982, 1983, 1985, 1987, 1989, 1990, 1992) SE // **1982** Amsterdam (Stedelijk Museum) SE // **1984** Tokyo (Seibu Gallery of Contemporary Art) SE // **1987** New York (Whitney Museum of American Art) SE // **1991** Basel (Kunsthalle) SE // **1993** Paris (Centre Pompidou) SE // **1995** Hamburg (Deichtorhallen) SE // **1996** Rotterdam (Museum Boymans-Van Beuningen) SE // **1998** Cologne (Museum Ludwig) SE // **1999** Hannover (kestnergesellschaft) GE // **2001** New York (Museum of Modern Art) GE // **2003** London (Serpentine Gallery) SE // Edinburgh (Scottish National Gallery of Modern Art) SE // **2004** Hannover (kestnergesellschaft) SE // **2005** St. Louis (Contemporary Art Museum) SE // **2006** Paris (Jeu de Paume/Site Concorde) SE (Kunsthaus Bregenz, Louisiana Museum of Modern Art/Humblebæk, Martin-Gropius-Bau, Berlin) // **2014** Zurich (Kunsthaus) SE

BIBLIOGRAPHY (Selected) — C.S. Saint-Étienne 1983 // C.S. New York 1984 // **C.S.** New York 1987 (cat. Whitney Museum of American Art) // **Untitled Film Stills.** London 1990 // **History Portraits.** New York 1991 // C.S. Stuttgart/Basel 1991 (cat. Kunsthalle Basel) // **Fitcher's Bird: Photographs by C.S.** New York 1992 // **C.S.: 1975–1993.** New York 1993 // **C.S. im Gespräch mit Wilfried Dickhoff.** Cologne 1995 // **C.S.** Rotterdam 1996 (cat. Museum Boymans-Van Beuningen) // **Das Versprechen der Fotografie – Die Sammlung der DG Bank.** Munich 1998 (cat. kestnergesellschaft, Hannover) ✍ // **C.S.** London 2003 (cat. Serpentine Gallery) // **Clowns.** Munich 2004 // **Working Girl.** St. Louis 2005 (cat. Contemporary Art Museum) // **C.S.** Paris 2006 (cat. Jeu de paume) // **A Play of Selves.** Ostfildern 2007

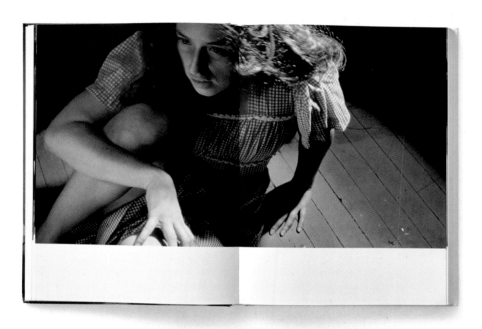

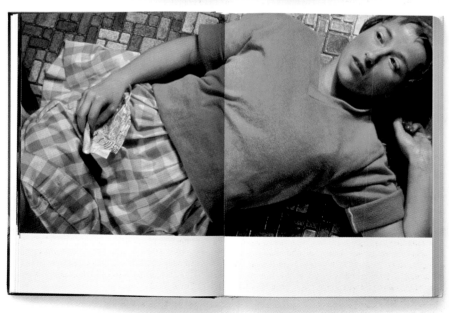

Kishin Shinoyama

Kishin Shinoyama: **Water Fruit.**
Tokyo (Asahi Press) 1991

3.12.1940 Tokyo (Japan) — Lives in Tokyo One of the internationally best-known Japanese photographers. Since the 1970s especially known as the author of nude photography schooled in the aesthetic of the pin-up. Studies at Nihon University, from which he graduates 1958. Joins the Light Publicity agency. From 1968 works as a free-lance photographer. Numerous awards since the mid 1960s. Travels extensively. 1970 (with Francis Giacobetti, David Hamilton, and > Haskins) part of the much discussed photokina exhibition *Girls – 4 masters of erotic photography*: "The exhibition, which was arranged by Christian Diener, created something of a scandal, because the Cologne Fair organizers had seven nudes by Haskins and Shinoyama, together with the titles, either removed or pasted over because the organizers thought what they represented to be of an 'extremely lesbian content' and their statements 'utterly repulsive'." (Pohlmann) 1975 he publishes probably his most important book *Hareta Hi* (*A Fine Day*): "It is not only an early conceptual exercise by a Japanese photographer, but also one executed completely in colour" (Parr and Badger). In the following year present at the Rencontres d'Arles. Awards include Japan Advertising Photographers' Association Award (1961), Most Promising Young Photographer Prize of the Japan Photo Critics Association (1966), Minister of Education's Prize for Promising Young Artist (1973), Mainichi Art Prize (1979), Golden Eye Award for Photography at the Three Continents Festival, Nantes (1997).

EXHIBITIONS (Selected) — **1968** Tokyo (Ginza Salon) SE // **1970** Tokyo (Ginza Matsuzakaya Department Store) SE // Cologne (photokina) GE // **1972** Tokyo (Daimaru Department Store) SE // **1974** Tokyo (National Museum of Modern Art/15 Photographers) GE // **1975** Arles (Rencontres internationales de la photographie) GE // **1976** Toulouse (Château d'Eau) SE // Venice (Biennale/Japanese Pavilion) SE // **1978** Paris (Musée des Arts décoratifs) GE // **1985** Tsukuba (International Exposition) SE // **1987** Paris (Centre Pompidou) SE // **1992** Tokyo (Shinjuku Mitsukoshi Museum) SE // **1993** Speyer (Historisches Museum der Pfalz) GE // **2002** Tokyo (Shibuya Parco Museum) SE // **2007** Paris (Jousse Entreprise) SE // **2008** Tokyo (T&G ARTS – 2009) SE // Paris (Paris Photo) SE // **2010** London (Michael Hoppen Contemporary) SE

BIBLIOGRAPHY (Selected) — **Nude.** Tokyo 1970 // **Olele Olala.** Tokyo 1971 // **Hareta Hi.** Tokyo 1975 // **Gekisha: 135-nin O Onna Tomodachi.** Tokyo 1979 // **Momoe Yamaguchi.** Tokyo 1980 // **Shinorama Nippon.** Tokyo 1989 // **Tokyo Nude.** Tokyo 1990 // **Ulrich Pohlmann: Die photokina Bilderschauen. Kultur, Technik und Kommerz.** Cologne 1990 (cat. Historisches Archiv der Stadt Köln) // **Water Fruit.** Tokyo 1991 // Thomas Buchsteiner and Meinrad Maria Grewenig (eds): **Japanische Fotografie der 60er Jahre/Japanese Photography in the 1960s.** Heidelberg 1993 (cat. Historisches Museum der Pfalz, Speyer) ⌁ // **Okinawa for Young Girls.** Tokyo 1997 // **Tokyo Addict.** Tokyo 2002 // **Auf den Traumpfaden de Königs.** Munich 2003 // **Nude by Kishin.** Tokyo 2009

"Kishin Shinoyama is tremendously popular in Japan. His success as a commercial photographic designer and his extraordinarily broad range of photographic work have contributed to his fame. One of his early works is a series on tattoos and tattooing. Although tattooing has periodically been a taboo subject, it was again of public interest after the Second World War. Valued as a collectors' item, tattooed skin on the one hand is vested with a macabre aura, and, on the other hand, because of its association with the Yakuza circles (an organization similar to the Mafia), it has fallen somewhat into disrepute. With this particularly Japanese version of presenting nude photography, Shinoyama presents an intimate and genuine impression of the subculture of the underworld of Tokyo at night."
— Thomas Buchsteiner and Meinrad Maria Grewenig ✍ﾛ

Stephen *(Eric)* Shore

Stephen Shore: **Uncommon Places.**
New York (Aperture) 1982

8.10.1947 New York (USA) — Lives in Tivoli (New York, USA) Principal exponent of New Color Photography. Trivial, uneventful urban situations form the center of his oeuvre; internationally well received since the 1970s. Shows interest in photography at an early stage. Largely self-taught. 1970 attends workshop conducted by Minor White. At the age of 15 works in > Warhol's "Factory". Initially shoots b/w photography. Turns his attention towards color photography and plate cameras. 1971 first important solo exhibition in the Metropolitan Museum of Art. Commissioned work includes photo assignments for the Metropolitan Museum (*The Gardens at Giverny*) and magazines such as *Fortune* and *Architectural Digest*. Grants and prizes include the NEA (National Endowment for the Arts) grant (1974, 1979), Guggenheim fellowship (1975), American Academy in Rome (1980), and a MacDowell Colony fellowship (1993), and the Kulturpreis of the DGPh (Deutsche Gesellschaft für Photographie: German Photographic Association) (2010). Participation in important group exhibitions includes *New Topographics* (George Eastman House, 1975), *American Images* (Corcoran Gallery, 1979), *Capturing Time* (J. Paul Getty Museum, 1997), and *The American Century* (Whitney Museum, 1999). 1978 attends *Jeunes photographes américains* at the Rencontres internationales de la photographie in Southern France (Arles).

EXHIBITIONS (Selected) — **1971** New York (Metropolitan Museum of Art) SE // **1976** New York (Museum of Modern Art) SE // **1977** Düsseldorf (Kunsthalle) SE // **1983** New York (Pace/MacGill Gallery – 1989) SE // **1984** Chicago (Illinois) (Art Institute) SE // **1985** Tucson (Arizona) (Center for Creative Photography) SE // **1990** Jouy-en-Josas (France) (Fondation Cartier) SE // **1995** New York (PaceWildensteinMacGill) SE // **1996** Rochester (New York) (George Eastman House) SE // **1999** Cologne (SK Stiftung Kultur) SE // **2001** Düsseldorf (Galerie Conrads – 2002) SE // **2004** Munich (Pinakothek der Moderne) JE (with Thomas Struth) // Vienna (Akademie der Bildenden Künste) // **2005** Paris (Jeu de Paume/Site Sully) SE // **2007** New York (International Center of Photography) SE // **2008** Kansas City (Kemper Museum of Contemporary Art) SE // Hamburg (Haus der Photographie/**New Color Photography**) GE //**2010** Düsseldorf (NRW Forum Kultur und Wirtschaft/

Stephen Shore und die Neue Düsseldorfer Fotografie) GE // **2009** Rochester, New York (George Eastman House) GE

BIBLIOGRAPHY (Selected) — **Andy Warhol.** Boston/Stockholm 1968 // **The City.** New York 1971 // Sally Eauclaire: **The New Color Photography.** New York 1981 ⌐ // **Uncommon Places.** New York 1982 // **The Gardens at Giverny: A View of Monet's World.** New York 1983 // **Photographs 1973–1993.** Munich 1995 // **The Velvet Years.** London 1995 // **American Surfaces.** Munich 1999 // **Uncommon Places. 50 unpublished photographs 1973–1978.** Düsseldorf 2002 (cat. Galerie Conrads) // **Uncommon Places – America.** New York 2004 // **The Nature of Photography.** London 2007 // **A Road Trip Journal.** London 2008 // **S.S.** London 2008 // **New Topographics.** Arizona 2009 // Britt Salvesen [ed.]: **New Topographics.** Göttingen 2009. (cat. George Eastman House)

"Of the principal color photography formalists, Stephen Shore has most successfully adapted Evans' objectivity and aesthetic autonomy. Yet unlike Evans, who so ably absorbed the significance and sensuousness of his subjects, recognizing the potent ambiguities in the real, Shore avoids mythic possibilities for purely pictorial meaning. Whether photographing deserted intersections, dirt roads, parking lots, esplanades, or Monet's gardens, Shore's paradigms are order, balance, and serenity. [...] By adjusting and readjusting his framing, Shore strives to eliminate every visual loophole and inconsistency. Nonetheless, he avoids obvious solutions. Inexplicable and instinctive adjustments guide Shore's work." — Sally Eauclaire ✍

Julius Shulman

Julius Shulman: **Architecture and its Photography.** Cologne (TASCHEN) 1998

10.10.1910 Brooklyn (New York, USA) — 15.7.2009 Los Angeles (USA)
America's most important interpreter of architecture of the 1940s to 1960s – in particular Californian modernism. Works with leading architects such as Neutra, Soriano, and Frey. Rediscovered in the 1990s. Son of Russian-Jewish immigrants. Third of four children born of Yetta and Max Shulman. Spends childhood on a farm in Connecticut. 1920 family moves to Los Angeles. With father's support he opens a store for mass-produced clothing in Boyle Heights. At an early age shows interest in photography and radio technology. Also possesses a deep love of nature. After finishing at Roosevelt High School (1928) studies at the University of California in Los Angeles and the University of California in Berkeley. 1936 interrupts studies and returns to Los Angeles. The same year photographs an apartment house by Richard Neutra (The John and Pauline Kuhn House), marking the beginning of an intensive collaboration that continues up to Neutra's death (1970). In retrospect "one of the founders of architectural photography" (Philip J. Ethington), he soon has an expanding circle of prominent clients incl. Oscar Niemeyer, Mies van der Rohe, Albert Frey, Raphael Soriano, and Frank Lloyd Wright. Today his photographs, especially those of the Case Study House (considered an economic housing development program in the spirit of modernism), qualify as icons of architectural photography and the epitome of the "Southern California lifestyle". Numerous publications in leading magazines include those in *Arts & Architecture*, *House & Garden*, *Good Housekeeping*, *Better Homes and Gardens*, *Life*, *Look*, and *Time*. Alongside well-known editorial staff members also obtains prestigious clients from the business world. At the zenith of his career (1962) publishes book with didactic intentions entitled *Photographing Architecture and Interiors*. 1986 abandons architectural photography. At the age of 90 (collaborating with Juergen Nogai) resumes his work. 2004 bequeaths his archive of more than 250,000 negatives and photographs to the Getty Research Institute (GRI). Numerous honors and prizes include the Gold Medal for Architec-

EXHIBITIONS (Selected) — **2003** San Francisco (Stephen Wirtz Gallery) SE // **2004** New York (Yancey Richardson Gallery) SE // Santa Monica (Craig Krull Gallery – 2005, 2007) SE // **2005** Frankfurt am Main (Deutsches Architektur Museum/**A Lifetime for Architecture**) SE // Los Angeles (J. Paul Getty Museum/**Modernity and the Metropolis**) SE // **2006** Alicante (Spain) (Museo de la Universidad de Alicante) SE // Chicago (Art Institute of Chicago/**Modernity and the Metropolis**) SE // Washington, DC (National Building Museum) SE // **2008** Los Angeles (Fahey/Klein Gallery) SE // **2009** Lausanne (Switzerland) (Musée de l'Élysée/**This Side of Paradise**) GE // Hamburg (Galerie Renate Kammer/**Architecture and the Abstract Image**) GE // **2010** Mannheim (ZEPHYR) SE

BIBLIOGRAPHY (Selected) — Peter Gössel (ed.): **J.S.: Architektur und Fotografie/Architecture and its Photography.** Cologne 1998 // **Richard Neutra: Complete Works.** Cologne 2000 // **Modernism Rediscovered.** Cologne 2000 // **Case Study Houses: The Complete CSH Program.** Cologne 2002 // **Vest Pocket Pictures.** Tucson 2007 // **J.S.: Modernism Rediscovered.** Cologne 2007 // Niklas Maak: "Ansichtskarten aus der Zukunft." In: **Frankfurter Allgemeine Zeitung**, 18.7.2009 ✍️

tural Photography from the American Institute of Architects (1969), the Austrian Decoration for Science and Art (2002), and doctoral degree of the California Institute of the Arts (2005). 2005 founds the Julius Shulman Institute through Woodbury University.

"Julius Shulman's photographs never show houses: they show what these houses promise. In some of his most beautiful photographs, one sees a house in Palm Springs, and Shulman manages to reveal in a single image the entire mythology which made so-called Martini modernism, the bungalow architecture of the late 1940s to the 1960s, so effective. This house has glass walls, an open garage, a fireplace, and a pool in front. Many viewers saw in this a homage to the realms of outer space during an age fascinated by the moon. On the other hand, this architecture was created during the great trek west, a movement fueled by 19th-century America, and which gave the *pursuit of happiness* a specific geographic direction, before coming to a total standstill with the completed urbanization of Los Angeles. This came about at the same time as the cowboy movies which mythicized going West, and, as much as the movies did, it conjured up an adventurous and more open past." — Niklas Maak ✍

Malick Sidibé

Malick Sidibé: **Chemises.**
Göttingen (Steidl) 2007

Around 1935 Soloba (Mali) — 14.4.2016 Bamako (Mali) Together with Seydou Keïta, he is internationally best-known photographer from sub-Saharan Africa. Known especially as chronicler of the youth and music culture in Mali in the 1950s and 60s. Attends school in Bougoumi, 165 kilometers from Bamako. Shows an early talent in drawing. Through the new governor of French Sudan, Emilie Louveau, attends the École des Artisans Soudanais (Sudanese Crafts School) from 1952. 1955 diploma as jeweler. Thereafter photo apprentice under Gérard (Gégé la pellicule). 1956 a Brownie Flash is his first camera for reportages and portraits. The year after, opens his own studio (Studio Malick) in Bamako (Rue 30, Angle 19). Apart from baptisms, weddings, and parties, especially photos during the surprise parties (*surpat*) of the young Malian fans of Rock 'n' Roll. 1976 following a democratization of photography ("small cameras for everyman") and the foreseeable end of the music clubs, he gives up his reportage work. Thereafter specializes in passport photos and camera repair. From the mid 1990s – through exhibitions, e.g. in the Fondation Cartier, Paris – becomes well-known internationally. 2003 Hasselblad Award for his life's work. 2009 PHotoEspaña Baume et Mercier Award.

EXHIBITIONS (Selected) — **1995** Paris (Fondation Cartier) SE // **1999** Chicago (Museum of Contemporary Art) SE // **2000** Geneva (Contemporary Art Center) SE // Berlin (Haus der Kulturen der Welt) GE // **2001** Amsterdam (Stedelijk Museum) SE // **2002** London (Hackelbury Fine Art) SE // **2003** Gothenburg (Sweden) (Hasselblad Center) SE // **2004** Antwerp (Fifty One Fine Art Photography) SE // **2005** New York (Jack Shainman Gallery) SE // **2006** Maputo (Mozambique) (Centre Culturel Français) SE // **2007** Johannesburg (Afronovo Gallery) SE // **2008** Amsterdam (Foam) SE // Bénin (Fondation Zinsou) SE // **2009** Madrid (PHotoEspaña) GE

BIBLIOGRAPHY (Selected) — André Magnin (ed.): **M.S.** Zurich 1998 ✍ // **Porträt Afrika. Fotografische Positionen eines Jahrhunderts.** Berlin 2000 (cat. Haus der Kulturen der Welt) // **Photographs.** Göttingen 2003 (cat. Hasselblad Award) // **Bagadaji.** Plouha 2008 // **Chemises.** Göttingen 2007 (cat. Foam) // **M.S.** Bénin 2008 (cat. Fondation Zinsou) // **Años 70. Fotografía y vida cotidiana.** Madrid 2009 (cat. PHotoEspaña) // Okwui Envezor (ed.): **Events of the Self.** Göttingen 2010

"Malick Sidibé's photo studio, in the Bagadaji quarter in the heart of Bamako, became the 'in' meeting place for young people. Malick Sidibé never missed a single party, which took place every Sunday on the banks of the Niger. The youths, organized in clubs, competed against each other, and Malick captured every carefree moment, the spontaneity, liberty and happiness, until the crack of dawn. His thousands of well-preserved photos provide a unique memory and testimony of the 1950s and 60s. From his close-up expeditions he brought back photos distinguished by their simplicity and great beauty, full of veracity and neither spectacular nor decorative. These snapshots of everyday life, parties and leisure unveil for us his love of people, his passion for photography. The poses are rarely rehearsed; instead his so penetrating and generous spirit offers us unbelievable moments of truth and complicity." — André Magnin ✍

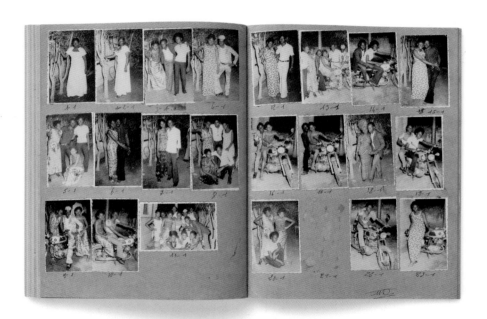

Jeanloup Sieff

30.11.1933 Paris (France) — 20.9.2000 Paris Reportages and portraits. Especially fashion and erotic photography. Stylistically influential during the 1960s for art photography founded on the aesthetics of Surrealism and New Objectivity. Primary school in Paris. Takes first photographs at age 15. Following secondary school studies philosophy (discontinues). Later spends several weeks at the École Vaugirard (studies photography) and the Vevey School of Photography (Switzerland). Returns to Paris. First (unsuccessful) attempts to establish himself as photographer. Photo assignment from *Elle* (1955) begins his professional career. Successor to retired *Elle* photographer Lionel Kazan. The same year his first exhibition. Works on fashion photography, portraits, and reportages. Abandons permanent position at age 25. 1958–1961 Magnum member. Reportage on the death of Pope Pius XXII. Creates photo reports from China, Poland, and Turkey. Freelance work includes assignments for *Jardin des Modes* and *Réalités*. 1961 travels to New York. First assignment: essay on the Newport Jazz Festival for the magazine *Show*. Meets the artist and fashion editor Marvin Israel. Works for *Harper's Bazaar* as well as for *Esquire*, *Look*, and *Life*. In Europe works for *Nova*, and British *Vogue*. 1965 returns to Paris. Publishes primarily in *Queen*. Beginning 1971 no further editorial obligations. Book projects as well as work for radio and television. Prizes include the Prix Niépce (1959), Silver Medal of the ADC (Art Directors Club) London (1967), and the Silver Medal of the Cannes Advertising Film Festival (1975).

"**For over thirty years, Jeanloup Sieff has enjoyed the rare pleasure of practicing his photographic craft with a visible nonchalance, and by doing so placed himself outside of fashions and overzealous categorizations … Whether in his fashion photographs, portraits, reportages, nude studies, or in his books and marvelous texts, which give expression to the invisible, memories, and emotions, Jeanloup Sieff wages a perpetual battle of the senses with a technique that never ceases to fascinate him.**" — Claude Nori ✎◻

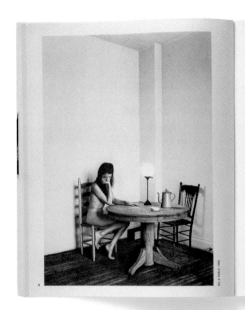

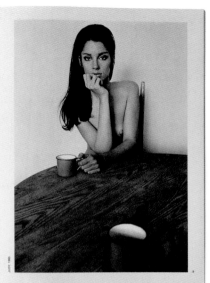

Jeanloup Sieff, from: **Camera,**
no. 4, 1969

Aaron Siskind

Aaron Siskind: **Places.
Photographs.** New York (Farrar,
Strauss and Giroux) 1976

4.12.1903 New York (USA) — 8.2.1991 Providence (Rhode Island, USA)
Member of the Photo League. Later the exponent of art photography characterized by strict formal qualities and inclined toward abstraction. Also important as an educationalist. Attends DeWitt Clinton High School. Receives teacher training at the City College of New York (Bachelor of Social Sciences in Literature). 1926–1949 works as English teacher at various New York schools. Beginning 1929 intensively explores photography at the same time. 1932–1941 member of the Photo League. 1936 works (collaboratively) on critically acclaimed *Harlem Document* cycle. Around 1945 turns his attention away from social-minded documentary photography and toward abstract expressionism. Develops strong interest in (subjective) semi-abstract art photography. 1950–1951 accepts teaching post in photography at Trenton College (New Jersey) and (with > Callahan) at Black Mountain College (North Carolina). 1951 with Callahan's help receives appointment at the Institute of Design in Chicago's Photography Department and (until 1959) serves as professor of photography. 1961–1971 directs the Photography Department at above. 1971–1976 accepts teaching post at the Rhode Island School of Design in Providence. 1966 Guggenheim Fellowship. 1976 NEA Grant. 1979 Guest of Honor at the Rencontres d'Arles. *www.aaronsiskind.org*

"Aaron Siskind began taking pictures in the early 1930s. As a member of the Photo League, he produced what are now classic documentary studies, among them the 'Most Crowded Block' and 'The Harlem Document'. While these early works portray the pressing social conditions of the time, many of the compositions foreshadowed Siskind's eventual development toward abstraction. Later, during the 1940s, Siskind would committedly lead his imagery away from literal subject matter and more towards the formal relationship between light, structure, and texture." — Bruce Silverstein ✍

EXHIBITIONS (Selected) — **1941** New York (Photo League) SE // **1947** New York (Egan Gallery – 1949, 1950, 1954) SE // Rochester (New York) (George Eastman House – 1963, 1965) SE // **1955** Chicago (Illinois) (Art Institute – 1964, 1975) SE // **1965** New York (Museum of Modern Art) SE // **1972** Providence (Rhode Island) (Art Museum of the Rhode Island School of Design) SE // New York (Light Gallery – 1974, 1976, 1978, 1981, 1983) SE // **1973** San Francisco (Art Institute) SE // **1979** Oxford (Museum of Modern Art) SE // **1982** Tucson (Arizona) (Center for Creative Photography) SE // **1984** Washington, DC (National Museum of American Art) SE // **2001** New York (Bruce Silverstein Gallery) SE // **2003** Tucson (Arizona) (Center for Creative Photography) SE // New York (Whitney Museum of American Art) SE // New York (Robert Mann Gallery – 2008) SE // Paris (Galerie Françoise Paviot) SE // **2004** Houston (Texas) (The Museum of Fine Arts) SE // **2005** Lisbon (Portugal) (Museu Nacional de Arte Antiga) SE // **2006** Berlin (Galerie Berinson) SE // **2007** New York (Hasted Hunt) SE // **2009** Milan (Museo di Fotografia Contemporanea) GE

BIBLIOGRAPHY (Selected) — **A.S.: Photographs.** New York 1959 // **Places: Photographs.** New York 1976 // **Harlem Document: Photographs 1932–1940.** New York 1981 // **A.S.: Photographs 1932–1978.** Oxford 1979 (cat. Museum of Modern Art) // Jonathan Green: **American Photography: A Critical History 1945 to the Present.** New York 1984 // **Taken by Design: Photographs from the Institute of Design, 1937–1971.** Chicago 2002 // **A.S. 100.** New York 2003 (cat. Stephen Daiter Gallery)

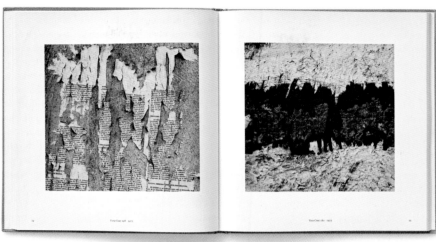

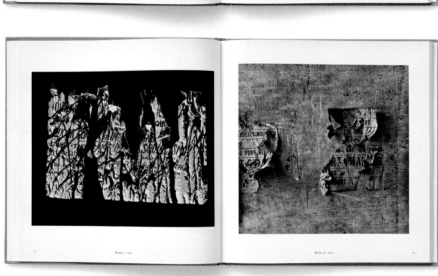

Anatolij *(Vasiljevitch)* Skurichin

15.3.1900 Kotelnich (later Kirow, Russia) — 1989 Moscow (Soviet Union) Pioneer of Soviet photo reportage. Photo reports on industrialization and the world of labor. Son of a teacher from the town of Kotelnich. Volunteers in the Russian Civil War (1919) and serves in elite unit of the Red Army (machine gunners). Plays active role in defending the banks of the Vyatka River against the Czarist army. Together with Red Army units advances as far as Lake Baikal. 1921 trains at the Vkhutemas (Russian State Art and Technical School). 1927 obtains painting degree. Returns to his birthplace and initially works as backdrop painter for the state theater. At the same time (1927–1928) active as landscape painter. Also during this period turns his attention to photography. Self-taught. Strongly influenced by the art photography of Sergei Lobovikov (1870–1941), begins to produce nature photography in the spirit of Pictorialism. 1928 publishes two works (*On the Banks of the Vyatka* and *Water Sports in the Winter*) in the magazines *Pravda* and *Sovetskoe foto*. Soon afterwards wins competition sponsored by *Sovetskoe foto*. Results in being invited by Maria Ulyanova (one of Lenin's sisters and leading editor at *Pravda*) to join the magazine as correspondent for *Komsomolskaya Pravda*. Photo reports on the country's industrialization (the initial Five Year Plan) as well as heroic portraits of workers. From the late 1920s works for numerous publications produced by the publisher Ogonyok and (soon afterwards) the magazine *USSR in Construction*. From 1930 works for the agencies Soyuz Foto and TASS. From 1935 for *Isvestiya*. Creates extensive travelogues (on Karelia, Murmansk, Barents Sea, and the Altai Mountains). Images of fishers and hunters. Photo reports on the country's development and wealth of nature. In his absence his editorial archive is confiscated and the editors Nikolai Bukharin and Karl Radek arrested. Other editorial co-workers exiled (to camps in Norilsk and Vorkuta). A.S. undergoes over four months of intensive interrogations. Finally acquitted, with a ban prohibiting the further publication of his work. Beginning 1938 completes more photo reports, largely on "kolkhoz" collective farming practices in the Lower Volga and Kirov regions. In WW II concentrates on reportages on the Home Front. Until 1980 photo correspondent for *Isvestiya*. Earns title: Honorary Creative Artist of the Russian Federation.

EXHIBITIONS (Selected) — **1935** Moscow (Kuznetsky Most/ Master Soviet Photographic Art) GE // **1937** Moscow (Pushkin Museum/**First All Unions Exhibition of Soviet Photographic Art**) GE // **1989** Moscow (Central Exhibition Hall in Manege) GE // **1999** Washington, DC (Corcoran Gallery of Art) GE // **2000** Columbus (Ohio) (Columbus Museum of Art) GE // New York (International Center of Photography) GE // St Petersburg (Russian Museum) GE // **2004** Brooklyn (New York) (Howard Schickler Gallery/**Pioneers of Soviet Photography IV**) GE

BIBLIOGRAPHY (Selected) — **Masters of Soviet Photographic Art.** Moscow 1935 (cat. Kuznetsky Most) // **20 Soviet Photographers 1917–1940.** Amsterdam 1990 (cat. touring exhibition, Europe)

"His training at the revolutionary Vkhutemas School and his experience as a landscape painter form the basis of Skurichin's photography. His first reportages were completed while traveling throughout the country in the capacity of correspondent for *Pravda*. Already with these – later famous – reports on the construction of the Kuznetsk Combine and Magnitogorsk Plant, Skurichin proved himself to be a talented narrator, conveying the enthusiasm of a society of workers during Russia's first Five-Year Plan. His photographs transcended the known borders of conventional press photography. He created at the same time an iconography of heroic workers and farmers, whose victory poses bring to mind military role models. Bold verticals and dynamic diagonals are typical ingredients in his visual compositions. Reproduced on both sides, the riveting photographs of the Red Army's companies on horseback stand metaphorically, as it were, for earlier victories and those to come. Undoubtedly, images such as these were especially well suited for the posters and photomontages that served Soviet propaganda." — Tatiana Salzirn ✍

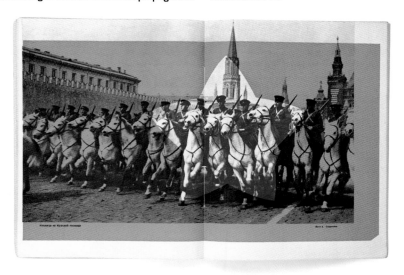

Anatolij Skurichin: **Cavalry in Red Square**, from: **Ogonyok**, Sondernummer, 1935
Anatolij Skurichin: **Kuznetsk under Construction**, from: **Sovetskoe foto**, no. 10, 1931

W. *(illiam)* Eugene Smith

30.12.1918 Wichita (Kansas, USA) — 15.10.1978 Tucson (Arizona, USA) Legendary photographer of the 1940s and 50s. Creator of highly acclaimed photo essays, especially for *Life*. Exponent of a photojournalism schooled in artistic ideals with a (now widely criticized) tendency towards repetition and aestheticizing topics. His father a successful grain merchant, his mother a passionate amateur photographer. Attends school in Wichita. During the same period intensively explores photography. 1934 publishes first photograph in the *Wichita Eagle*. 1936 his father (financially ruined by the economic crisis) commits suicide. 1936–1937 studies at the local university. 1937 moves to New York. Definitively turns his attention toward photography. 1937–1938 works for *Newsweek*. Later freelances at the Black Star agency. 1939–1942 signs first contract with *Life* magazine (completes 170 reportages, 81 published). 1943–1945 war correspondent for the magazine *Flying*. Beginning May 1944 travels to Pacific Front (Pearl Harbor, Iwo Jima) for *Life*. Wounded and requires period of recovery until 1947. 1948–1954 signs second contract with *Life* and during this period also creates his most important photo essays: *Country Doctor* (1948), *Spanish Village* (1951), *Nurse Midwife* (1951), and *Man of Mercy* (1954). April 1955 leaves *Life* after differences of opinion concerning picture selection and layout. 1955 comprehensive photo essay on Pittsburgh. Magnum membership begins the same year (until 1958). Elected one of the world's ten best photographers by *Popular Photography*. Increasing financial difficulties. Also drinking problems. 1969 photographer at the Woodstock Festival. 1971 his last large work: *Minamata* (reportage on the effects of an environmental catastrophe in Japan). Spends his last years in Tucson (Arizona) as professor at the Center for Creative Photography, where the entire Smith Estate is administered. In existence since 1979 the W. Eugene Smith Award for Best Reportage of the Year.

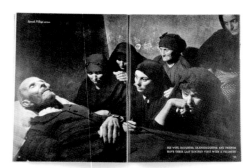

EXHIBITIONS (Selected) — **1944** New York (Museum of Modern Art – 1965) SE/GE // **1970** Rochester (New York) (George Eastman House) SE // **1971** New York (Jewish Museum) SE // **1975** New York (International Center of Photography) SE // **1978** Tucson (Arizona) (Center for Creative Photography – 1980) SE // **1991** Paris (Centre Pompidou) SE // **1999** Winterthur (Switzerland) (Fotomuseum) SE // **2008** Madrid (PHotoEspaña) SE

BIBLIOGRAPHY (Selected) — "Pittsburgh." In: **Photography Annual**, 1958 // **W.E.S.: His Photographs and Notes.** New York 1969 // **Minamata.** New York 1975 // William S. Johnson: **W.E.S.: A Chronological 1934–1980.** 3 vols. Tucson 1980–1984 // William S. Johnson: **W.E.S.: Master of the Photographic Essay.** New York 1981 // Jim Hughes: **W.E.S.: Shadow and Substance. The Life and Work of an American Photographer.** New York 1989 // Gilles Mora and John T. Hill (eds): **W.E.S.: The Camera as Conscience.** London 1998 ✍ // **W.E.S.: Más real que la realidad.** Madrid 2008 (cat. PHotoEspaña)

"Throughout his career, everything Smith produced was conceived in the context of a publication. He never shot or selected a single photograph without having a magazine or book in mind beforehand. With his first photo reportages for *News Week*, whose team he joined in 1937 (shortly before it was renamed *Newsweek*), to 'Minamata' (1971), all his images were conceived in terms of a narrative within an organized framework, and with a continuity which until then had never been a real option for press photographers; this applied equally to his successful series of photographic essays for *Life*, created between 1948 and 1954, the Pittsburgh Saga, and the interminable (unfinished) autobiographical photographic project *The Walk to Paradise Garden*."
— Gilles Mora 🖉

W. Eugene Smith: **Spanish Village,**
from: **Life,** vol. 30, no. 15, 9.4.1951

Lord Snowdon *(Antony Charles Robert Armstrong-Jones)*

7.3.1930 London (England) — 13.1.2017 London Socially committed photography, theater photography, portraits of artists and celebrities, fashion. Regarded as one of the most versatile and internationally well-known English photographers of his generation. Nephew of the famous theater designer Oliver Messel. 1946 contracts polio and spends six months in hospital in Liverpool. After only modestly successful schooling and studies (incl. architecture) 1951 begins a photography apprenticeship under the society photographer 'Baron'. Stops after six months. 1952 opens his own photo studio in Pimlico, London. In the same year, publishes for the first time, in *Picture Post*. 1953 regular contributions to *Tatler* and *Sketch*. 1954 first theater photography. Photographs for *Vogue* (UK and USA), *Harper's Bazaar*, and the *Daily Express*. From 1957 regular contributions to *Queen*. 1958 influential book, *London* (edited by Mark Boxer). 1960 marries Princess Margaret (1968 divorced). From 1962 social topics for *The Sunday Times Magazine*. Also color reportages on India, Japan, and Venice. 1968 first television documentary (on aspects of aging). 1970 begins to work for British *Vogue* again. 1971 TV documentary on people of restricted growth (*Born to be Small*). 1975 *Children behind Bars* for *The Sunday Times Magazine*. 1980 creates the Snowdon Award Scheme to help students with physical disabilities. 1990 photographer for *Telegraph* magazine, 1995 major essay on the English theater for *Vanity Fair*. 1997 official portrait of the Queen and Prince Philip for their golden wedding anniversary. Also active in design and architecture. More than 20 books. Numerous awards, not least for his work to help the handicapped.

EXHIBITIONS (Selected) — **1972** Cologne (photokina) SE // **1989** Bradford (England) (National Museum of Photography, Film and Television – 1998) SE /GE // **1996** London (Royal National Theatre) SE // **2000** London (National Portrait Gallery) SE // **2001** New Haven (Connecticut) (Yale Center for British Art) SE // Vienna (Kunsthaus) SE // **2006** London (Chris Beetles Gallery) SE // **2007** New York (Godel & Co. Fine Art) SE // **2008** London (National Portrait Gallery) GE

BIBLIOGRAPHY (Selected) — **London**. London 1958 // **Private View**. London 1965 // **Assignments**. London 1972 // **Personal View**. London 1979 // **Stills 1983–87.** London 1987 // **Public Appearances 1987–1991.** London 1991 // **Snowdon on Stage.** London 1996 (cat. Royal National Theatre) // Martin Harrison: **Young Meteors: British Photojournalism: 1957– 1965.** London 1998 (cat. National Museum of Photography, Film and Television, Bradford) 🖉 // **Snowdon: A Retrospective.** London 2000 (cat. National Portrait Gallery) // Graydon Carter (ed.): **Vanity Fair Portraits: A Century of Iconic Images.** London 2008 (cat. National Portrait Gallery) // **L.S.** Hamburg 2008 (= **Stern** Portfolio no. 52) 🖉

"There are 23 books by Lord Snowdon. They are a photographic archive of England and the world from the 1950s to the turn of the century. You could flip through them without reading a word and still know the history of England – an England from below, with the workers' pub in the port of London where strippers danced at Sunday lunchtime; with the dingy provincial hospitals where the mentally handicapped are put away and where Lord Snowdon snuck in disguised as a cleaner. But also England from the top, with the royal household and all the portraits of the Queen's family into which Tony married in 1960, becoming the husband of Princess Margaret. Since then he has been Lord Snowdon. It is the ease with which the photographer Snowdon moves in this England from the bottom to the top that gives his photographs their serenity and self-possession. They don't have exclamations marks, don't yell out: Look here! Instead they are like a wandering gaze that takes in what it sees." — Jochen Siemens

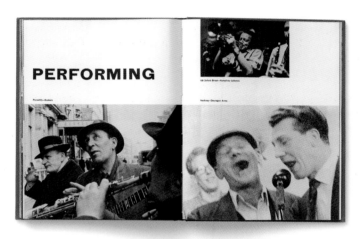

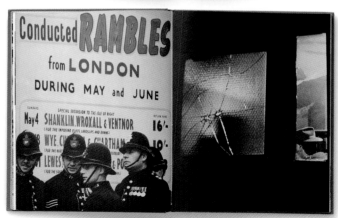

Alec Soth

Alec Soth: **The Last Days of W.**
(Self-published artist book printed on newsprint) 2008

1969 USA — Lives in Minneapolis (Minnesota, USA) Middle-generation Magnum member, an exponent of conceptual documentarism. Explores postmodern reality influenced not least by New Color Photography. Studies at Lawrence College with the intention of becoming a painter. Strongly influenced by a > Sternfeld lecture, abandons the idea and turns his attention toward photography. 1999–2004 makes several road trips along the Mississippi from Minnesota southward to Louisiana equipped with a plate camera for making 8 x 10 negatives. Results in a "precise and likewise highly personal and poetic travelogue" (Felix Hoffmann). Accumulates at the same time source material for his first book publication *Sleeping by the Mississippi*. His second large-scale and highly imaginative project (*Niagara*, 2006) likewise uses this type of travelogue photography. Occasionally compared to > Evans and > Frank when discussed in the context of American social reportage. Magnum membership status: nominated 2004, associate membership since 2006, and full membership beginning 2008. Numerous solo and group exhibitions include participation in *Click Doubleclick* (Haus der Kunst, Munich, 2006), *Picturing Eden* (Museum of Photographic Arts, San Diego, 2007), *Heart Land* (Van Abbemuseum, Einhoven, 2008), and *Portraiture Now* (National Portrait Gallery, Washington, DC, 2008). Receives grants from the McKnight Foundation and Jerome Foundation. 2003 Santa Fe Prize for Photography. *www.alecsoth.com*

EXHIBITIONS (Selected) — **1993** Minneapolis (Minneapolis Photographer's Gallery) SE // **1995** Minneapolis (Icebox Gallery) SE // **1998** Minneapolis (Minnesota Center for Photography) JE (with Joel Sternfeld) // **2001** St Cloud (Minnesota) (Central Lakes College Gallery) SE // **2003** Chicago (The Museum of Contemporary Photography) SE // **2004** New York (Yossi Milo Gallery) SE // San Francisco (Stephen Wirtz Gallery – 2009) SE // Minneapolis (Minnesota) (Weinstein Gallery – 2006, 2007) SE // Berlin (Galerie Wohnmaschine – 2006, 2008) SE // Liverpool (Open Eye Gallery) SE // **2005** Southend-on-Sea (Focal Point Gallery) SE // Santiago (Chile) (Museo de Arte Contemporáneo) SE // Minneapolis (Minneapolis Institute of Arts) SE // **2006** Des Moines (Iowa) (Des Moines Art Center) SE // New York (Gagosian Gallery – 2009) SE // Riverside (California) (California Museum of Photography) SE // **2007** London (HOST Gallery) SE // **2008** Cardiff (Great Britain) (Fotogallery c/o Turner House) SE // Paris (Jeu de Paume – Site Concorde) SE // Berlin (C/O Berlin) SE // Chicago (Daiter Contemporary) SE // Winterthur (Switzerland) (Fotomuseum) SE

BIBLIOGRAPHY (Selected) — **Sleeping by the Mississippi.** Göttingen 2004 // **Niagara.** Göttingen 2006 // **Vitamin Ph: New Perspectives in Photography.** London 2006 // **Fashion Magazine. Photographs by A.S.** Paris 2007 // **Dog Days, Bogotá.** Göttingen 2007 // Uta Grosenick and Thomas Seelig (eds): **Photo Art. Fotografie im 21. Jahrhundert.** Cologne 2007 // **Last Days of W.** (self-published artist book printed on newsprint) 2008 // Brigitte Lardinois (ed.): **Magnum Magnum.** Munich 2008

"With a narrative-documentary background, Soth develops his very own aesthetic and artistic language in his long-term studies. As a member of the Magnum association and agency for photographers (since 2004), he typifies a multidisciplinary expansion that can no longer be categorized as 'applied' or 'artistic' photography." — Felix Hoffmann ✍

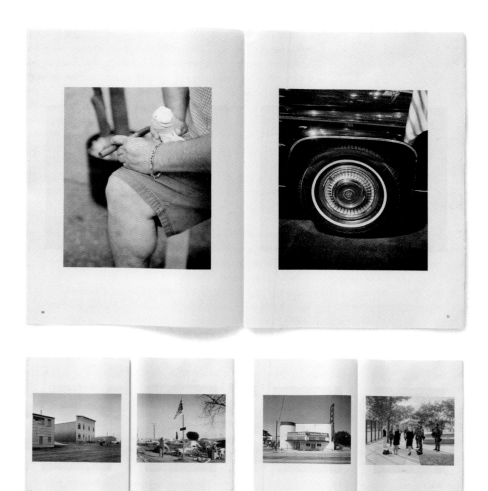

Emmanuel Sougez

Emmanuel Sougez: **Notre-Dame de Paris. 50 Photographies inédites de Sougez.** Paris (Éditions Tel) 1932

16.7.1889 Bordeaux (France) — 24.8.1972 Paris (France) Nude studies, still lifes, and portraits. Also important photo-historian. "Eminence grise" of French photography around 1940. After studying at the École des Beaux-Arts in Bordeaux moves (1911) to Paris. Turns his attention to photography. Student trips to Germany, Austria, and Switzerland. Beginning 1919 works as "photographe illustrateur" in Paris. 1926 sets up new picture editorial staff at the magazine *L'Illustration*. Introduces the color print using the Finlay color process. Explores still lifes, whereby he strives to attain greatest possible definition of surfaces and textures. 1936 founding member of the photographers association Rectangle and (1945) of Groupe des XV. Beginning 1930 numerous exhibitions. Publications include those in the magazines *AMG Photographie*, *L'Art vivant*, and *Jazz*. Significantly participates in Raymond Lécuyer's *Histoire de la photographie*, in the French edition of Peter Pollack's *Picture History of Photography*, and (1968/1969) author of the second popular culture history of photography. 1971 donates 169 works to Bibliothèque nationale (Paris). Estate administered by Musée français de la Photographie (Bièvres near Paris).

"If Sougez succeeds at leaving his mark on the history of French photography, he has to thank his still lifes for this. It might seem astounding to learn that this great studio photographer has photographed in many countries and the most diverse subjects: in Paris, France, Switzerland, Italy, Spain, and Portugal, oceans and mountains, forests and rivers, animals of every species, industrial workers and craftsmen, vaudeville dancers and the liberation of Paris. Nonetheless, among the 160 photographs donated to the National Library of France, only a few portraits and landscapes appear among the completeness of the still lifes, which, as he writes, 'create the essential part of my work' and designate him the leading exponent of pure photography in France." — Sophie Rochard ✍

EXHIBITIONS (Selected) — **1933** Paris (Studion Saint-Jacques) SE // **1936** Paris (**Exposition internationale de la photographie contemporaine**) GE // **1985** Bordeaux (France) (Musée national d'art moderne) SE // **1993** Paris (Palais de Tokyo) SE // **1996** Valencia (Spain) (Sala Parpalló/Centre Cultural Le Beneficència) SE // **2001** Grenoble (France) (Musée de Grenoble) GE // Paris (Galerie Laurent Herschtritt) SE // **2009** Paris (Jeu de Paume – Site Sully/**Collection Christian Bouqueret**) GE

BIBLIOGRAPHY (Selected) — **Alphabet.** Paris 1932 // **Notre-Dame de Paris.** Paris 1932 // **Paris. 100 Photographies.** Paris 1947 // **E.S.: L'éminence grise.** Paris 1993 (cat. Palais de Tokyo) ✍ // **Antológica/Antològica (1889–1972).** Valencia 1996 (cat. Sala Parpalló) // Christian Bouqueret: **Des années folles aux années noires.** Paris 1997 // **Figures parfaites. Hommage à E.S.** Grenoble 2001 (cat. Musée de Grenoble) // **Paris. Capitale photographique. 1920/1940. Collection Christian Bouqueret.** Paris 2009 (cat. Jeu de Paume – Site Sully)

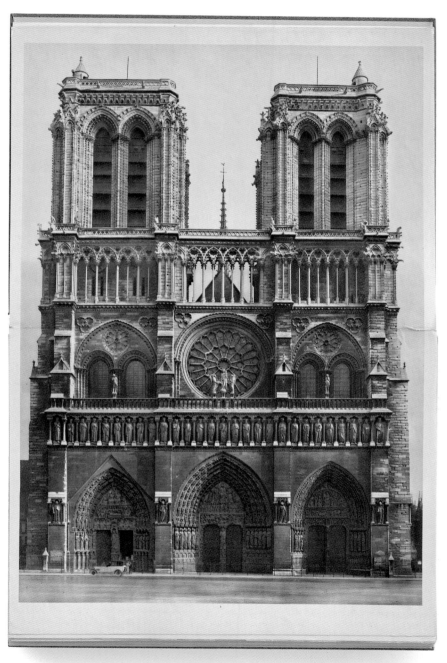

SOUGEZ 549

Alice Springs *(June Browne, June Newton)*

Alice Springs: **Mrs. Newton.**
June Newton a.k.a. Alice Springs.
Cologne (TASCHEN) 2004

3.6.1923 Melbourne (Australia) — Lives in Los Angeles (USA) and Monte Carlo (Monaco) Fashion photography and portraits. Most recently focuses on portraits of prominent contemporaries (exclusively in b/w). Her own career in the art and cultural sector runs parallel to the career of her husband Helmut Newton. Originally actress. First appearances at the "Little Theater" in Melbourne. 1947 meets > Newton in his studio in Melbourne, where he comes to flee the National Socialists. 1948 marries Newton. As June Brunell still active as stage performer. 1956 together with H.N. moves to Europe (London and Paris). Returns to Australia. Beginning 1961 permanently in Paris. 1970 takes first photographs (when H.N. cancels an appointment due to illness and J.N. replaces him). Results in advertising photography (for Parisian coiffeur Jean Louis David) and editorial photography for magazines like *Dépêche Mode*, *Elle*, *Vogue*, *Marie France*, and *Marie Claire*. Later, under the name Alice Springs, concentrates on portraits of prominent artists (including > Álvarez Bravo, > Brassaï, Catherine Deneuve, > Gibson, Peter Hujar, > Lartigue, > Mapplethorpe, > Weber, Wim Wenders, and Billy Wilder). 1978 first solo exhibition, in Amsterdam. 1983 first book publication. Assumes responsibility for the visual appearance of H.N.'s *Us & Them*. Joint A.S. and Helmut Newton retrospective travels to Copenhagen (1998), Odense, Rotterdam, Paris, Milan (1999), São Paulo, Cologne (2000), Berlin, and Melbourne (2005). Since 2004 oversees conception and program of the Helmut Newton Foundation in Berlin, where her estate is to be administered.

EXHIBITIONS (Selected) — **1978** Amsterdam (Canon Gallery) SE // **1983** London (Olympus Gallery) SE // **1985** Poitiers (France) (Musée Sainte-Croix) SE // **1986** Paris (Espace photographique de la Ville de Paris) SE // **1987** Frankfurt am Main (Fotoforum) SE // **1988** London (National Portrait Gallery) SE // Paris (Musée d'art moderne de la Ville de Paris) SE // **1990** Mexico City (Museo Contemporáneo) SE // **1991** Bonn (Rheinisches Landesmuseum) SE // **1992** Los Angeles (Shoshana Wayne Gallery) SE // **1993** Leipzig (Hochschule für Grafik und Buchkunst) SE // **2005** Berlin (Helmut Newton Foundation) JE (with Helmut Newton) // Melbourne (RMIT Gallery) JE (with Helmut Newton) // **2010** Berlin (Helmut Newton Stiftung) SE

BIBLIOGRAPHY (Selected) — **A.S.: Portraits.** Paris 1983 // **A.S.: Portraits.** Poitiers 1985 (cat. Musée Sainte-Croix) // **A.S.** Paris 1986 (cat. Espace photographique de la Ville de Paris) // **A.S.: Portraits.** Pasadena 1986 // **A.S.: Portraits récents.** Paris 1988 (cat. Musée d'art moderne de la Ville de Paris) // **A.S.: Portraits.** Munich 1991 (cat. Rheinisches Landesmuseum, Bonn) // Helmut Newton/A.S.: **Us and Them.** Zurich 1999 // **Mrs. Newton. June Newton a.k.a. Alice Springs.** Cologne 2004 ✍

"While photographic portraitists normally guide and arrange their models by means of sophisticated artistic directions, Alice Springs' art of representation manifests itself in selecting the 'decisive moment'. This selection process makes visible the essentially creative element of her photographic practice, and her many years of experience as an actress and extraordinarily precise powers of observation underscore her decision-making act. Alice Springs manages to create bafflingly direct photographic portraits which establish psychological insights and seem to stem from an intimate knowledge of the models. More often, however, Alice simply relies on a heightened empathy." — Klaus Honnef ✐

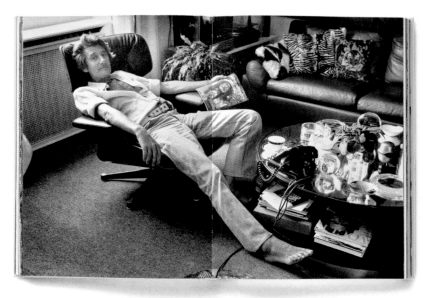

Anton Stankowski

Anton Stankowski: **Photographien.**
Zurich (Kunsthaus Zürich) 1979

18.6.1906 Gelsenkirchen (Germany) — 11.12.1998 Esslingen (Germany) Exponent of the avant-garde after 1920. Object photography, photograms, and multiple exposures serving a graphic design practice schooled in constructivist models. Child of a family of miners. Trains to become a decorative painter. During this period also takes first photographs. 1923 enters the Dortmann & Vietz studio for devotional art in Düsseldorf. Makes contact with the group Junges Rheinland through art dealer Johanna Ey. 1926 accepted at the Folkwang School in Essen and (from 1927) studies under Wilhelm Poetter and Max Burchartz, whose constructivist and De Stijl-oriented design instruction has a lasting influence on him. Begins intensively to explore photography in the sense of a new way of seeing. Creates textural studies, object photography, street scenes, photographs with a reportage character, and politically motivated photomontages welcoming comparisons to > Heartfield. From 1928 works freelance for advertising consultant Johannes Canis in Bochum. Designs information stand for the Cologne *Pressa* exhibitions. In addition, represented at the exhibition *Film und Foto* in Stuttgart. 1929 moves to Zurich to enter the Max Dalang Studio. Effectively explores photography and typography in the sense of a modern constructive graphic design. 1932 participates in the exhibition *New Photography in Switzerland* organized by the Schweizerischen Werkbund. 1936 returns to Germany. Undertakes photo reportages for the *Stuttgarter Illustrierte* in Stuttgart. Beginning 1939 founds his own graphic design studio. 1940–1948 military service and imprisonment. Returns to Stuttgart and initially works as editor-in-chief of the *Stuttgarter Illustrierten*. 1951 founds his own studio again. Clients include IBM, Deutsche Bank, REWE, and SEL. Also further develops his concrete painting. 1962 first exhibition of his advertising artwork. 1983 founds the Stankowski Foundation (to offset the separating of art and design). 1991 Hans Molfenter Prize of the City of Stuttgart.

EXHIBITIONS (Selected) — **1962** Stuttgart (Landesgewerbeamt) SE // **1976** Berlin (Kunstbibliothek) SE // **1979** Zurich (Kunsthaus) SE // **1985** Hamburg (PPS. Galerie) SE // **1991** Stuttgart (Staatsgalerie) SE // **1997** Munich (Vereinte Versicherungen) JE (with Ellen Auerbach) // **2000** Munich (Walter Storms Galerie) SE // **2002** Gelsenkirchen (Kunstverein/**Die Fotoarbeiten**) SE // **2006** Stuttgart (Staatsgalerie/Graphische Sammlung) SE // Zurich (Haus Konstruktiv) SE // **2009** Gelsenkirchen (Germany) (Kunstmuseum/**Der Kreis um Anton Stankowski**) GE // **2010** Göppingen (Germany) (Kunsthalle/**Der Kreis um Anton Stankowski**) GE // **2014** Hamburg (Haus der Photographie/Deichtorhallen) GE

BIBLIOGRAPHY (Selected) — **Photographien.** Zurich 1979 (cat.) // **Fotografien/Photos 1927–1962.** Cologne 1980 // **Das Gesamtwerk.** Stuttgart 1983 // **A.S. Fotografie.** Stuttgart 1991 (cat. Staatsgalerie) // **Frei und Angewandt 1925–1995.** Berlin 1996 ✒ // **Ellen Auerbach – A.S.: Zeitgenossen.** Munich 1997 (cat. Vereinte Versicherungen) // Stankowski-Stiftung: **S.: Photos.** Ostfildern-Ruit 2003 // Ulrike Gauss and Stankowski-Stiftung (eds): **S. 06. Aspekte des Gesamtwerks/Aspects of his Œuvre.** Ostfildern-Ruit 2006 (cat. Staatsgalerie Stuttgart/Graphische Sammlung) // **Augen auf! 100 Jahre Leica.** Heidelberg 2014 (cat. Haus der Photographie/Deichtorhallen Hamburg)

"What distinguished him most from other object photographers such as Albert Renger-Patzsch, or from Hans Finsler, someone primarily active as an instructor, was the scope of his field of activity, which, beside New Objectivity photography, included functional graphic design and rational painting in the area of photography, as well as political photomontages, documentary photography, and reportages for magazines." — Guido Magnaguagno ✍

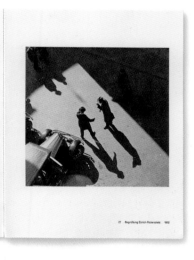

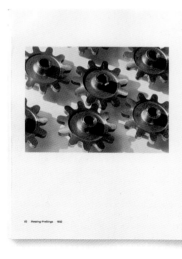

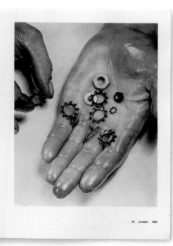

Edward Steichen *(Eduard Jean Steichen)*

Edward Steichen: **A Life in Photography.** New York (Doubleday & Company) 1963

27.3.1879 Luxemburg — 25.3.1973 West Redding (Connecticut, USA) Begins as a painter and celebrated Pictorialist. Later turns his attention to straight photography in fashion and portraiture. As an innovator of the genre, among the best-paid photographers of his time. Also a legendary exhibition curator (e.g. the celebrated Museum of Modern Art, New York, exhibition *The Family of Man*). 1881 arrives in USA with parents. 1894–1898 studies lithography in Milwaukee. Takes first photographs. 1899 attains initial public recognition in conjunction with the Second Philadelphia Salon. 1900 en route to Paris: first meeting with > Stieglitz in New York. Spends four weeks at the Académie Julian in Paris. Participates in the exhibition *The New School of American Photography* in London. 1901 accepts membership of the Linked Ring. 1902 founding member of the Photo Secession. Cover design of *Camera Work* (1903: entire first edition devoted to his work). 1905 coordinates the Photo Secession galleries with Stieglitz. 1904 conducts first experiments with color. 1906 returns to Paris. Establishes contact with Auguste Rodin and Henri Matisse. In 1911 takes first fashion photographs, encouraged by > Vogel. 1914 returns to New York. 1917–1919 goes to France with US army. Abandons painting. From 1922 lives in USA again. 1923–1938 chief photographer at Condé Nast (*Vogue, Vanity Fair*). 1938 breaks with commercial photography. Takes first 35mm photographs (Contax) in Mexico. 1942 becomes lieutenant commander for the US Navy. Organizes the exhibitions *Road to Victory* (1942) and *Power in the Pacific* (1945). 1947–1962 director of the Photography Department of MoMA in New York. Exhibitions include *In and Out of Focus* (1948), *Always the Young Strangers* (1953), *The Family of Man* (1955), and *The Bitter Years* (1962). 1961 critically acclaimed MoMA retrospective on the occasion of his 82nd birthday. 2007 the launch of extensive retrospective shown in Paris, Lausanne, Reggio Emilia, and Madrid.

EXHIBITIONS (Selected) — **1899** Philadelphia (Pennsylvania) (Second Philadelphia Salon) GE // **1902** Paris (Maison des Artistes) SE // **1905** New York (The Photo Secession Galleries – 1906, 1907, 1908, 1909, 1910) GE/SE // **1938** Baltimore (Maryland) (Museum of Art) SE // **1950** Washington, DC (American Institute of Architects Headquarters) SE // **1961** New York (Museum of Modern Art – 1978) SE // **1979** Rochester (New York) (George Eastman House) SE // **2000** New York (Howard Greenberg Gallery – 2009) SE // **2002** Horten (Norway) (Norsk Museum for Fotografi) SE // **2004** Rotterdam (Kunsthal) SE // **2005** Moscow (Moscow House of Photography) SE // **2007** Paris (Jeu de Paume) SE // **2008** Zurich (Kunsthaus) SE // Lausanne (Musée de l'Élysée) SE // Madrid (Museo Nacional Centro de Arte Reina Sofía) SE // Wolfsburg (Kunstmuseum) SE

BIBLIOGRAPHY (Selected) — Carl Sandburg: **S. the Photographer.** New York 1929 // **The First Picture Book: Everyday Things for Babies.** New York 1930 (facsimile reprint: Zurich/New York 1991) // **S. the Photographer.** New York 1961 (cat. Museum of Modern Art) // **E.S. A Life in Photography.** New York 1963 // Dennis Longwell: **S.: The Master Prints, 1895–1914.** New York 1978 (cat. Museum of Modern Art) // Christopher Phillips: **S. at War.** New York 1981 // **E.S.** Paris 1993 ✍ // Patricia Johnston: **Real Fantasies: E.S.'s Advertising Photography.** Berkeley 1997 // Penelope Niven: **S.: A Biography.** New York 1997 // Joel Smith: **S.: The Early Years.** Princeton 1999 // Joanna Steichen: **S.'s Legacy. Photographs 1895–1973.** New York 2000 // **E.S.: Une épopée photographique.** Paris 2007 (cat. Jeu de Paume) // **In High Fashion.** Ostfildern 2008 (cat. Kunsthaus Zürich)

"Edward Steichen's career reached unrivaled heights. It was long and fruitful, and with regard to photography and the unceasing efforts to further its distribution, devoted to the largest possible audience. Yet during its grandiose upswing, this career would involve itself with much more. There was hardly a photographic genre which Steichen had not applied his marvelous talent to without achieving astounding results in that area. From artistic and applied photography, fashion photographs, portraits of famous personalities, cityscapes and nature studies, to nude and choreographic studies – his tremendous legacy is omnipresent."

— William A. Ewing ✍

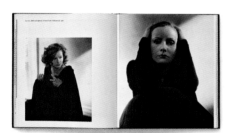
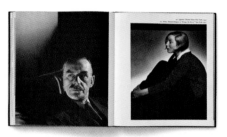
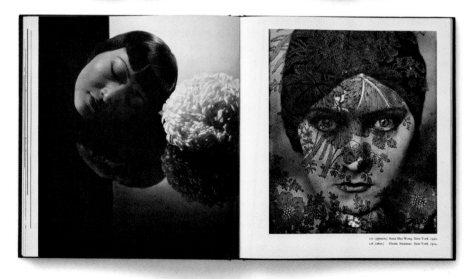

Otto *(Hugo Wilhelm)* Steinert

Otto Steinert: **Otto Steinert und Schüler.** Essen (cat. Museum Folkwang) 1959

12.7.1915 Saarbrücken (Germany) — 3.3.1978 Essen (Germany) As an art photographer, propagandist of a (self-designated) "subjektive fotografie", collector of photographs, exhibition curator, theorist, publicist, and teacher, one of the most influential personalities of German photography after 1945. Originally a physician. Studies in Munich, Marburg, Rostock, and Heidelberg. 1939 obtains Ph.D. 1940–1945 general practitioner later staff surgeon in France and Russia. After the war, initially assistant doctor at the Kiel University Clinic. End of the 1940s definitively turns his attention towards photography, which, self-taught, he produces from the 1930s. 1948 appointed director of the photography class at the Saarland State University of Applied Arts. 1952–1959 university director and beginning 1954 professor. With > Keetman, Siegfried Lauterwasser, Wolfgang Reisewitz, Toni Schneiders, and Ludwig Windstosser establishes the Fotoform group. 1950 first joint appearance during photokina. 1951–1958 conceives and organizes the three important *subjektive fotografie* exhibitions – a first comprehensive attempt "to demonstrate the design-related possibilities of the medium of photography in Germany" (Thilo Koenig). 1959 moves to Essen. Until 1978 instructor, then professor at the Folkwang School in Essen. Artistically outstanding for portraits and darkroom experiments (solarizations, photograms, and negative prints). Numerous awards, including the Kulturpreis of the DGPh (Deutsche Gesellschaft für Photographie: German Photographic Association) (1962), the David Octavius Hill Medal of the GDL (Gesellschaft Deutscher Lichtbildner: German Photographic Academy) (1965), and the Federal Cross of Merit (1974).

EXHIBITIONS (Selected) — **1950** Cologne (photokina – 1951, 1952, 1958, 1980) GE // **1951** Saarbrücken (Germany) (**subjektive fotografie** – 1954) GE **1959** Essen (Museum Folkwang – 1976, 1981) GE/SE // **1986** Frankfurt am Main (Fotografie Forum) SE // **1995** Paris (Galerie Françoise Paviot) SE // **1997** Bonn (Kunst- und Ausstellungshalle der BRD) GE // **1999** Essen (Germany) (Museum Folkwang – 2005, 2008) SE // **2000** Madrid (PHotoEspaña) SE // **2007** Berlin (Kicken Berlin – 2008) SE // **2008** Erfurt (Germany) (Kunsthalle) SE // Saarbrücken (Germany) (Saarlandmuseum Moderne Galerie) SE

BIBLIOGRAPHY (Selected) — **subjektive fotografie.** Bonn 1952 // **subjektive fotografie II.** Munich 1955 // **O.S. und Schüler. Gestalterische Fotografie.** Essen 1959 (cat. Museum Folkwang) // **subjektive fotografie.** Stuttgart 1989 (cat. Institut für Auslandsbeziehungen) // **Die Gruppe 'fotoform'.** Ludwigshafen 1998 (cat. Kunstverein) // Thilo Koenig: **O.S.'s Konzept 'subjektive fotografie 1951–1957'.** Munich 1988 // **Der Fotograf O.S.** Göttingen 1999 (cat. Museum Folkwang, Essen) // Annette and Rudolf Kicken, and Simone Förster (eds): **Points of View. Masterpieces of Photography and Their Stories.** Göttingen 2007 ⌐ // **O.S.: Pariser Formen.** Göttingen 2008 (cat. Museum Folkwang, Essen)

"Otto Steinert's complete works come across as anything but minimalist when compared to the work of his contemporaries, and especially to the work of today's art photographers. Nonetheless, both his own work and that of his students provided indispensable inspiration to others, and successfully advanced the visual language of photography. This was in no small part possible thanks to the groundbreaking exhibitions *subjektive fotografie* (1951) and *subjektive fotografie II* (1954). As a collector and curator, Steinert was guided by the same principles as Steinert the artist and teacher: precision in research and organization, and a continuity in the annual rhythm of his history of photography exhibitions in the Folkwang Museum."

— Erich vom Endt ✍🏻

Bert Stern

Bert Stern: **MM 6/2/62,**
from: **Eros,** Fall 1962

3.10.1929 Brooklyn (New York, USA) — 26.6.2013 New York (USA) Fashion, beauty, and advertising photography. Internationally best-known work is his broadly conceived and comprehensive portrait cycle with Marilyn Monroe. Begins as accountant at Wall Street Bank 1946–1947 and 1947–1948 works for *Look* magazine's postal services. 1948–1951 assistant to *Look* art director Herschel Bramson. 1951 art director of the magazine *Mayfair*. During this period purchases a Contax (also his first camera). 1951–1953 military service in Japan. Acclaimed campaign for Smirnoff (1955) launches his now swift professional ascent. Becomes one of the most sought-after advertising and fashion photographers with his legendary studio on Manhattan's East Side. Clients include Du Pont, Arpège, IBM, Pepsi-Cola, US Steel, and Volkswagen. In addition provides editorials for *Vogue, Esquire, Look, Life, Glamour,* and *Holiday*. 1962 several days of photo shoots with Marilyn Monroe shortly before her death. Also takes remarkable portraits of Louis Armstrong and Eartha Kitt. In the early 1970s abandons commercial photography. 1976 accomplishes comeback as photographer with publications in *Vogue, New York, Condé Nast Traveller,* and campaigns for Polaroid and Pirelli.

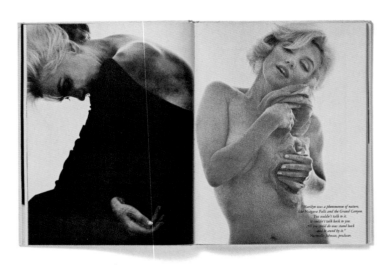

EXHIBITIONS (Selected) — **1958** New York (Limelight Gallery) SE // **1982** New York (Xenon Gallery) SE // **1984** Cologne (Museum Ludwig) GE // **1993** New York (Staley-Wise Gallery – 2007) SE // **2004** Fürth (Germany) (Jüdisches Museum Franken) SE // **2005** Heilbronn (Städtische Museen) SE // **2006** Kuopio (Finland) (Victor Barsokevitsch Photograhic Centre) SE

BIBLIOGRAPHY (Selected) — **The Last Sitting**. New York 1982 // **Sammlung Gruber. Photographie des 20. Jahrhunderts.** Cologne 1984 (cat. Museum Ludwig) // **Marilyn Monroe: The Complete Last Sitting.** Munich 1992 // **Photographie des 20. Jahrhunderts.** Museum Ludwig Köln. Cologne 1996 ⏎ // **Norman Mailer/B. S.: Marilyn Monroe.** Cologne 2011

"Stern was among the first to design color advertisements in a manner that made them barely distinguishable from the photography on editorial pages. His style can be summed up using words like glamour, romance, and delicacy." — Anke Solbrig ✍

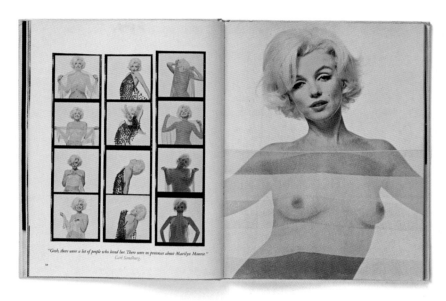

"Gosh, there were a lot of people who loved her. There were no pretenses about Marilyn Monroe."
Carl Sandburg

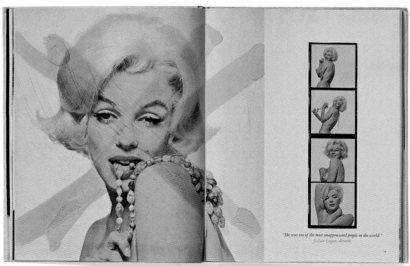

"She was one of the most unappreciated people in the world."
Joshua Logan, director.

Joel *(Peter)* Sternfeld

30.6.1944 New York (USA) — Lives in New York Important exponent of New Color Photography. Known as the choreographer of ironic details. The process of discovery is part of his visual strategy. 1961– 1965 studies at Dartmouth College, Hanover, New Hampshire (B.A.). Self-taught photographer. Initially takes "candid street photographs" (b/w 35mm). Color photography from 1970. Beginning 1978 receives two Guggenheim scholarships (1978, 1982), one NEA grant (1980), and a New York State Council on the Arts grant (1980) allow him to travel in his VW camper van in the sense of embarking on an "American Odyssey". Turns his attention toward large-format photography (8 x 10) and develops a specific type of "landscape photography": "man-altered landscapes" in color and consistently captured from a cool distance. Effectively composed *tableaux vivants* whose narrative aspects (minor events as casually bizarre episodes) are frequently only visible at second glance. Best-known photograph is *Mc Lean, Virginia* (1978): a fireman at a pumpkin sale, while a house burns in the background. Considered a major exponent of a so-called New Color Photography, especially after Sally Eauclaire's critically acclaimed exhibition with Michael Bishop, Jo Ann Callis, William Christenberry, Mark Cohen, John Divola, > Eggleston, Mitch Epstein, Emmet Gowin, Jan Groover, Len Jenshel, Joe Maloney, > Meyerowitz, Olivia Parker, John Pfahl, Lucas Samaras, > Shore, Neal Slavin, and Boyd Webb. Various teaching positions include his 1971–1984 post as associate professor of photography at Stockton State College, Pomona, New Jersey.

"Sternfeld's pictures are not morally neutral. These beautiful, color landscape photos are seductive and pleasing to the eye. On closer inspection, however, one realizes that there is trouble in paradise." — Anne W. Tucker ✍

EXHIBITIONS (Selected) — **1976** Philadelphia (Pennsylvania Academy of Fine Arts) SE // **1977** Arles (Rencontres internationales de la photographie/**La deuxième génération de la photographie en couleurs**) GE // **1981** Syracuse (New York) (Everson Museum of Art/**The New Color**) GE // San Francisco (Museum of Modern Art – 2001) SE // **1984** New York (Museum of Modern Art) JE (with Robert Adams and Jim Goldberg) // **1987** Houston (Texas) (Museum of Fine Arts) SE // **1989** New York (Pace/MacGill Gallery – 1991, 1994) SE // **1997** Paris (Maison européenne de la photographie) SE // **1998** Ulm (Stadthaus) SE // **2000** Berlin (Kicken Berlin/**Aspects of American Color Photography**) GE // **2002** London (The Photographers' Gallery) SE // **2004** New York (Luhring Augustine Gallery – 2005, 2008) SE // **2006** Madrid (Circulo de Bellas Artes) SE // Hamburg (Haus der Photographie/**New Color Photography**) GE

BIBLIOGRAPHY (Selected) — Sally Eauclaire: **The New Color Photography.** New York 1981 (cat. Everson Museum of Art, Syracuse) // Sally Eauclaire: **American Independents: Eighteen Color Photographers.** New York 1987 // **American Prospects: Photographs by J.S.** San Francisco 1987 (cat. Museum of Fine Arts, Houston) ✍ // **Campagna Romana: The Countryside of Ancient Rome.** New York 1992 // **On This Side.** San Francisco 1996 // Melinda Hunt and J.S.: **Hart Island.** Zurich 1998 (cat. Stadthaus Ulm) // **Stranger Passing.** Boston 2001 (cat. MOMASF) // **Walking the High Line.** Göttingen 2001 // **American Prospects.** Göttingen 2004 // **When it changed.** Göttingen 2006 // **Sweet Earth.** Göttingen 2006 // **Oxbow Archive.** Göttingen 2008 // **iDubai.** Göttingen 2009

Joel Sternfeld, from: Sally Eauclaire: **The New Color Photography.** New York (Abbeville Press) 1981

Alfred Stieglitz

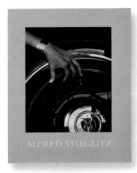

Alfred Stieglitz: **Photographs & Writings.** Washington (National Gallery of Art) 1983

1.1.1864 Hoboken (New Jersey, USA) — 13.7.1946 New York (USA) Gallery owner, collector, theorist, publisher, photographer, and patron (of > Strand and others). Eloquent advocate of photography as art. Principal photographic personality in the USA after 1900. Son of affluent German immigrants. Attends school in New York and Karlsruhe. Studies engineering and later photochemistry at the Technischen Universität in Berlin. 1883 takes first original photographs. 1890 returns to New York and becomes member of the Society of Amateur Photographers. Beginning 1893 editor of the magazine *American Amateur Photographer*. 1897–1902 editor of *Camera Notes*. 1902 founds the Photo Secession (with > Coburn and > Steichen). Following year launches the influential magazine *Camera Work*. 1905 opens the Little Galleries at 291 Fifth Avenue. Beside photography also presents European avant-garde art (Paul Cézanne, Henri Matisse, Pablo Picasso, and Auguste Rodin). 1907 travels to Europe. Meets Heinrich Kühn, Frank Eugene, and Steichen in Igls near Innsbruck, and Tutzing near Munich. 1915 launches the gallery magazine *291*. Discontinues *Camera Work* (1917) and closes the gallery. 1925–1929 manages the Intimate Gallery, where works by his second wife, the painter Georgia O'Keeffe, are also shown. Beginning 1929 up until his death the director of An American Place Gallery. Especially outstanding in his personal oeuvre are the early New York studies (c. 1900) and (much later) the comprehensive series of images and portraits of O'Keeffe. 1942 presents his own collection (*A.S.: His Collection*) at the Museum of Modern Art, New York (now largely owned by the Metropolitan Museum in New York today).

EXHIBITIONS (Selected) — **1899** New York (Camera Club) SE // **1910** New York (Gallery 291) SE // **1934** New York (An American Place) SE // **1942** New York (Museum of Modern Art/**A.S.: His Collection**) SE // **1983** Washington, DC (National Gallery of Art) SE // **1995** Malibu (California) (Getty Museum) SE // **2000** Cologne (Josef-Haubrich-Kunsthalle) SE // **2002** Washington, DC (National Gallery of Art) SE // **2003** London (Victoria and Albert Museum) SE // **2004** Paris (Musée d'Orsay) SE // **2005** Madrid (Museo Nacional Centro de Arte Reina Sofía) SE // **2011** New York (Metropolitan Museum) GE // **2012** Hamburg (Bucerius Kunst Forum) GE

BIBLIOGRAPHY (Selected) — Dorothy Norman: **A.S.: An American Seer.** New York 1973 // **A.S.: Photographs & Writings.** Washington 1983 (cat. National Gallery of Art) // **A.S.** New York 1989 // Benita Eisler: **O'Keeffe & Stieglitz: An American Romance.** New York 1991 // Richard Whelan: **A.S.: A Biography.** New York 1995 // **Camera Work. The Complete Illustrations 1903–1917.** Cologne 1997 // Sarah Greenough: **A.S.: The Key Set 1896–1922/1922–1937.** New York 2002 (cat. National Gallery of Art, Washington, DC) // Katherine Hoffman: **S.: A Beginning Light.** New Haven/London 2004

"Alfred Stieglitz is perhaps the most important figure in the history of the visual arts in America. Who could even begin to rival his multiple credentials? He was, of course, a great photographer, but also a great discoverer and promoter of photographers and of artists in other media, as well as a great publisher, patron, and collector. After his death, it would take his widow, Georgia O'Keeffe, three years to distribute among several American museums his own work and his immense collection, which altogether would probably be valued at over $20 million today."
— Richard Whelan ✍

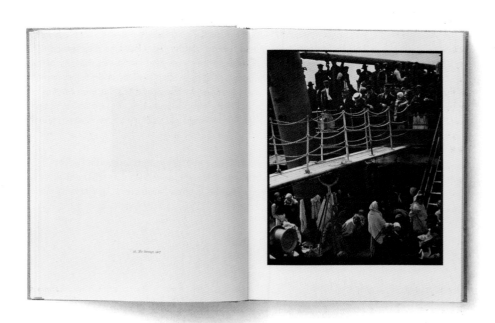

Dennis Stock

Dennis Stock: **California Trip.**
New York (Grossman) 1970

24.7.1928 New York (USA) — 11.1.2010 Sarasota (Florida, USA) Images from the world of jazz and portraits of the actor James Dean are the best-known works of this Magnum photographer. Joins the Navy at 16. He turns his attention to photography after the war. Initially studies at the New School. Afterwards photography course conducted by > Abbott. Assists > Smith for a short period. 1947–1951 trains under *Life* photographer > Mili. For his reportage on the arrival of a refugee boat from Europe (1951) wins first prize in *Life*-sponsored competition for young photographers. Results in meeting > Capa. "Extraordinary" Magnum member. Beginning 1954 full membership. 1954/1955 encouraged by Capa moves to Hollywood, where his numerous stills photography assignments include work for the productions *Oklahoma* and *Bus Stop*. Befriends James Dean. Takes numerous portrait studies of Dean which instantly become cult icons after the film star's premature death. Beginning 1957 intensive (photographic) exploration of the jazz world. 1960 publishes *Jazz Street,* his best known and most important book. 1962 returns to living in the country and — strongly influenced by the work of > Haas — turns his attention toward nature and landscape photography (in color). Renewed exploration of the phenomenon of American everyday culture at the end of the 1960s. Lives for several months on hippie commune in the American Southwest. Book publication: *The Alternative* (1970). Additional important photo essays on Japan and the world of Francis of Assisi. From 1968 conducts several workshops. Numerous picture spreads in international magazines incl. *Life, Look, Geo, Stern, Bunte, Queen,* and *Paris Match.* Increasingly explores working with film and video in recent projects.

"I'm not a photojournalist, and I've never wanted to be one. I'm a photo essayist. I never follow the news of the day; instead, I search out my own line of stories based on what enlightens me, what helps me grow, what gives me spiritual insight – in short, what I love. The intention is the opposite of most photojournalism." — Dennis Stock ✍

EXHIBITIONS (Selected) — **1963** Chicago (Art Institute) SE // **1977** New York (International Center of Photography) SE // **1985** Woodstock (New York) (Photofind Gallery) SE // **1994** Frankfurt am Main (Kunsthalle Schirn) SE // **1999** New York (Staley-Wise Gallery) SE // **2004** London (Hackelbury Fine Art Limited) SE // **2005** Düsseldorf (NRW-Forum Kultur und Wirtschaft) SE // **2008** Amsterdam (Stedelijk Museum Post CS/**MAGNUM Photos 60 years**) GE // **2009** New York (Howard Greenberg Gallery) SE

BIBLIOGRAPHY (Selected) — **James Dean: Portrait of a Young Man.** Tokyo 1956 // **Jazz Street.** London 1960 // **California Trip.** New York 1970 // **James Dean Revisited.** New York 1978 // **Provence Memories.** Boston 1988 // **Made in USA. Photographs 1951–1971.** Stuttgart 1994 // **Magnum Photos.** Paris 1997 // Chris Boot (ed.): **Magnum Stories.** London 2004 ✍

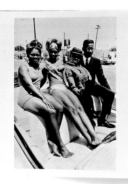

Paul Strand

Cover of **Camera Work.**
A Photographic Quarterly,
Number XLIX, New York 1917

16.10.1890 New York (USA) — 31.3.1976 Orgeval (France) Filmmaker and photographer. North America's most significant propagandist of "straight photography". Parents (Matilda and Jacob Stransky) are Bohemian immigrants. Son's name is changed to Strand at birth. Until 1909 he attends Ethical Culture School. Among his teachers are Charles Caffin, and > Hine. With the latter he regularly visits > Stieglitz's Little Galleries and becomes acquainted with the works of the Photo Secessionists. Until 1911 works in the family business. At the same time explores photography. 1909–1922 membership of the Camera Club. Takes first photos in the spirit of Pictorialism. 1911 travels to Europe. 1915 visits Stieglitz with new works. 1916 first exhibition in Stieglitz's gallery. 1917 entire final issue of *Camera Work* (no. 49/50) dedicated to P.S.'s work. 1917–1918 military service. 1920 works with > Sheeler on the experimental film *Manhatta*. 1922–1932 works primarily as freelance cameraman (for news and sports coverage). 1932–1934 photography and film production in Mexico. 1935, in Moscow. Meets the film director Sergei Eisenstein. 1937–1943 establishes his own production company, Frontier Films. Educational and documentary films. 1943 returns to still photography. 1945 retrospective in MoMA, New York. *Time in New England* is his last photographic project completed on American soil. 1950 settles in France with third wife. 1952–1954 "photographically explores" Italy. 1954 the Hebrides. 1959 Egypt. 1963–1964 Ghana. 1956–1960 predominantly portraiture (Pablo Picasso, André Malraux). During his last years especially focuses on nature studies in the grounds of his house in Orgeval. 1967 David Octavius Hill Medal of the GDL (Gesellschaft Deutscher Lichtbildner: German Photographic Academy).

EXHIBITIONS (Selected) — **1916** New York (Gallery 291) SE // **1929** New York (Intimate Gallery) SE // **1932** New York (An American Place) SE // **1945** New York (Museum of Modern Art) SE // **1971** Philadelphia (Pennsylvania) (Museum of Art) SE // **1973** New York (Metropolitan Museum – 1998) SE // **1976** London (National Portrait Gallery) SE // **1977** Paris (Centre Pompidou) SE // **1990** Washington, DC (National Gallery of Art) SE // **1992** Bonn (Kunst- und Ausstellungshalle der BRD) GE // **1994** Essen (Museum Folkwang) SE // **2003** New York (Howard Greenberg Gallery) SE // **2004** St Petersburg (Florida) (Museum of Fine Arts) SE // **2005** Los Angeles (J. Paul Getty Museum) SE // **2006** Cincinnati (Ohio) (Cincinnati Art Museum) SE // **2007** New York (Pace/MacGill Gallery) SE

BIBLIOGRAPHY (Selected) — Nancy Newhall: **P.S.: Photographs 1915–1945.** New York 1945 (cat. Museum of Modern Art) // **Time in New England.** New York 1950 // **La France de profil.** Lausanne 1952 // **Un Paese.** Turin 1955 // **Tir a'Mhurain. Outer Hebrides.** Dresden/London 1962 // **Living Egypt.** New York 1962 // **P.S.: A Retrospective Monograph. The Years 1915– 1968.** New York 1970 // **Ghana: An African Portrait.** Millerton 1976 // Sarah Greenough: **P.S.: An American Vision.** Aperture 1990 (cat. National Gallery of Art, Washington, DC) // Maren Stange (ed.): **P.S.: Essays on his Life and Work.** New York 1990 // Klaus Honnef: **Pantheon der Photographie im XX. Jahrhundert.** Bonn 1992 (cat. Kunst- und Ausstellungshalle der BRD) 🖉 // **P.S.: Die Welt vor meiner Tür.** New York 1994 (cat. Museum Folkwang, Essen) // **P.S.: Circa 1916.** New York 1998 (cat. Metropolitan Museum) // **Toward a Deeper Understanding. P.S. at Work.** Göttingen 2007

"Like the artists associated with Cubism, Strand too sought an Archimedean point from whose perspective he could depict the world. That he later relativized this position does not point to a break in the aesthetic consistency of his work. He always felt faithful to an inner truth, behind appearances. In this respect, Paul Strand, who also worked intensively with the film medium and served as a cameraman for numerous productions [...] is justifiably considered to be the founder of modern documentary photography." — Klaus Honnef ✍

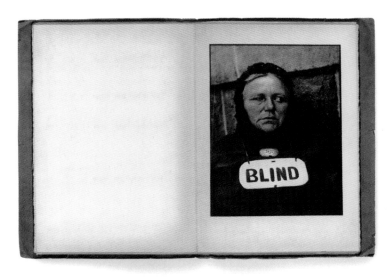

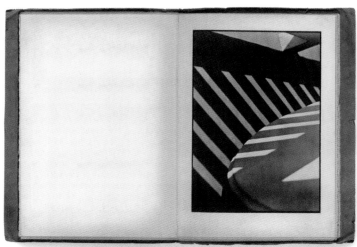

Christer Strömholm

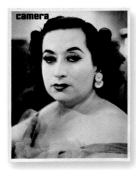

22.7.1918 Stockholm (Sweden) — 11.1.2002 Stockholm Leading Scandinavian camera artist after 1945. Internationally well-known, especially for his early Paris photos in the spirit of Existentialism. Parents divorce 1924. 1934 father commits suicide. 1937 C.S. moves to Dresden. Studies under Prof. Waldemar Winkler. Leaves his art school after disagreements concerning modernism, especially Paul Klee. Moves to Paris. 1938 studies painting in Stockholm. 1939–1945, military service, resistance. 1946 returns to Paris. Studies at the Académie des Beaux Arts. Takes up photography as artistic means of expression. Until 1954 photographer in Paris. At the same time studies at the art academies in Paris, Faenza, and Florence. 1951–1953 member of the fotoform group. 1954–1964 series *Dödsbilder* (Images of Death).

Christer Strömholm: **Indelible images,** from: **Camera,** no. 9, 1980

1956–1962 series on transsexuals in Paris (*Place Blanche*). 1962–1974 head of the Fotoskolen (photography school) at the University of Stockholm (around 1,200 graduates). 1964 *Bilder ur verkligheten* (Images of Reality). 1974–1982 series *Privata Bilder*. 1980 special issue of the magazine *Camera*. 1981 projection at the Rencontres d'Arles. 1982 *Zeichen und Spuren*. 1993 named professor by the Swedish Ministry of Culture. 1998 award from the Hasselblad Foundation.

"Since the 1950s Christer Strömholm has been one of the leading photographers in Scandinavia and after the Second World War he was the first one to establish himself internationally. He joined the German Group Fotoform early in the fifties and during his time spent in Paris at the close of the decade he developed a photographic language analogous to Existentialism. Strömholm's images have since that time contributed strongly to the development of photography as an independent art form in Europe." — Gunilla Knape

EXHIBITIONS (Selected) — **1965** Stockholm (Nordiska Kompanier) SE //**1978** Stockholm (Camera Obscura – 1980, 1982) SE //**1981** Essen (Museum Folkwang) SE //**1986** Stockholm (Moderna Museet) SE //**1990** Porto (Fotoporto/Bienal de Photographie) SE //**1992** Cologne (Galerie Rudolf Kicken) SE // Paris (Mois de la Photo) SE //**1998** Gothenburg (Sweden) (Hasselblad Center) SE //**2001** Lérida (Spain) (Centro Cultural de la Fundación "la Caixa") SE //**2002** Stockholm (Färgfabriken) SE //**2003** Cologne (Forum für Fotografie) SE //**2004** Helsinki (Finnish Museum of Photography) SE //**2006** Paris (Jeu de Paume/Site Sully) SE //**2007** Innsbruck (Austria) (Fotoforum West) SE //**2008** Bolzano (Italy) (Foto-Forum) SE // **2012** Stockholm (Fotografiska) SE // **2013** Paris (Institut Suédois) SE

BIBLIOGRAPHY (Selected) — **Till minnet av mig själv.** Stockholm 1965 // **Poste Restante.** Stockholm 1967 // **Privata Bilder.** Stockholm 1978 (cat. Camera Obscura) // **Vännerna från Place Blanche.** Stockholm 1983 // **C.S.: Fotografias 1930–1990.** Porto 1990 (cat. Biennale) // **Konsten att vara där.** Stockholm 1991 // **Imprints by C.S.: The Hasselblad Award.** Gothenburg 1997 // C.S. Barcelona 2001 (cat. Fundación "la Caixa") // **In memory of himself. C.S. in the eyes of his beholders.** Göttingen 2006 // **The Lido Exhibition.** Göttingen 2008 // **Post Scriptum.** Stockholm 2012 (cat. Fotografiska)

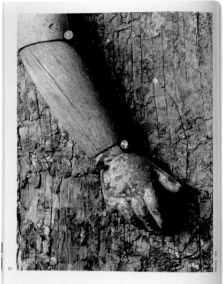

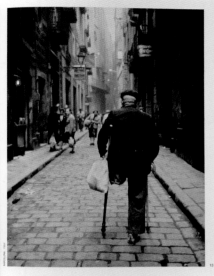

Thomas Struth

11.10.1954 Geldern (Germany) — **Lives in Düsseldorf (Germany)**
Since the late 1970s, three large conceptually-conceived cycles: topographies (in b/w), portraits, and museum interiors; the last of these are his best-known visual creations to date. 1973–1978 studies at the Düsseldorf Art Academy, initially under Peter Kleemann and Gerhard Richter. 1976 changes to class of the newly appointed professor > Bernd Becher. From then concentrates on the medium of photography. Begins photographing (as a rule deserted) cityscapes and street scenes (in New York and Rome); later (color and b/w) portraits undoubtedly in accord with a > Sander-related concept. From 1989 produces large-format "museum photographs" which are "a kind of art trademark for his photography" (Stefan Gronert). 1978 first solo exhibition in New York. 1992 participates in documenta 9, Prospect 96, and programmatic group exhibition *Aus der Distanz* (Bernd Becher and his students, 1991). 1993–1996 professorship at the Karlsruhe Art Academy. 1978 New York grant conferred by the Düsseldorf Art Academy. 1997 Spectrum Photography Prize of the Foundation of Lower Saxony. 2008 under the title *Objectivités. La photographie à Düsseldorf*, comprehensive overview of the Düsseldorf School shown in the Musée d'art moderne de la Ville de Paris.

Thomas Struth.
Milan (Electa) 2008

EXHIBITIONS (Selected) — **1978** New York (P.S.1) SE // **1980** Munich (Galerie Rüdiger Schöttle – 1985, 1988, 2005, 2008) SE // **1987** Cologne/Berlin (Galerie Max Hetzler – 1989, 1992, 1993, 1995, 1997, 2005, 2007) SE // **1988** Frankfurt am Main (Portikus) JE (with Siah Armajani) // **1990** New York (Marian Goodman Gallery) SE // **1991** Düsseldorf (Kunstsammlung NRW) GE // **1992** Washington, DC (Hirshhorn Museum) SE // **1993** Hamburg (Kunsthalle) SE // **1997** Hannover (Sprengel Museum) SE // **1998** Nîmes (France) (Carré d'Art) SE // **1999** Paris (Centre national de la photographie) SE // **2000** Tokyo (National Museum of Modern Art) SE // **2002** Dallas (Texas) (Museum of Art) SE // **2003** New York (The Metropolitan Museum of Art) SE // Chicago (Museum of Contemporara Art) SE // **2004** Berlin (Hamburger Bahnhof) SE // **2008** Cologne (Die Photographische Sammlung/SK Stiftung Kultur) SE // **2010** Zurich (Kunsthaus) SE // **2014** Munich (Pinakothek der Moderne) SE

BIBLIOGRAPHY (Selected) — **Portraits.** New York 1990 (cat. Marian Goodman Gallery) // **Museum Photographs.** Munich 1993 (cat. Hamburger Kunsthalle) // **Portraits.** Munich 1997 (cat. Sprengel Museum Hannover) // **Das Versprechen der Fotografie. Die Sammlung der DG Bank.** Munich 1998 (cat. Sprengel Museum Hannover) ✍ // **My Portrait.** Tokyo 2000 (cat. National Museum of Modern Art) // **Löwenzahnzimmer.** Munich 2001 // **T.S.: Photographien 1977–2001.** Munich 2002 (cat. Dallas Museum of Art) // **New Pictures from Paradise.** Munich 2002 // **Pergamonmuseum.** Munich 2004 (cat. Hamburger Bahnhof, Berlin) // **Museum Photographs.** Munich 2005 // **Making Time.** Munich 2007 // **Familienleben/Family Life.** Munich 2008 (cat. Die Photographische Sammlung/SK Stiftung Kultur) // **Objectivités. La photographie à Düsseldorf.** Paris 2008 (cat. Musée d'art moderne de la Ville de Paris) // **T.S.** Milan 2008 // Stefan Gronert: **Die Düsseldorfer Photoschule. Photographien von 1961–2008.** Munich 2009 // **Texte zum Werk von Thomas Struth.** Munich 2009

"Among Becher's first students at the Düsseldorf Art Academy, Thomas Struth was and remains even today the one who, from the start, evinced the strongest ties to the visual arts – and his experiences with expressive art, meaning his longer periods of working as a painter and draftsman, are reflected in his photographic work. […] Photography as mirroring the achievements of painting could easily be considered the topic of Struth's oeuvre: debating the tradition of painting as a visual form with photographic means." — Wulf Herzogenrath ✎

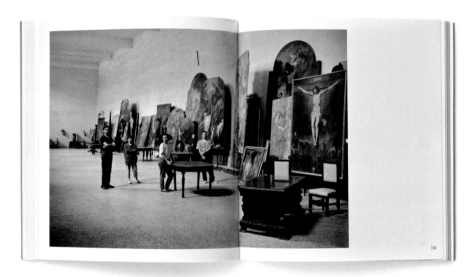

Josef *(Václav František)* Sudek

Josef Sudek: Fotografie.
Prague (Krásné Literatury) 1956

17.3.1896 Kolín (Czechoslovakia) — 15.9.1976 Prague (Czechoslovakia) Landscapes, cityscapes, still lifes, and portraits. Art photographer situated between Pictorialism and New Objectivity. The Czech Republic's internationally best-known 20th-century photographer. Second of three children. His father, a house painter, dies prematurely. Attends grade school in Noví Dvory. 1908–1910 attends the Royal Czech School for Handicrafts in Kutná Hora. Until 1913 does bookbinding in Prague. 1914 budding interest in photography. From 1915 military service. 1917 loss of right arm on the front near Udine, Italy. Returns to Prague. Begins intensive exploration of art photography. 1921 membership in the Czech Club of Amateur Photographers. 1922 accepted at the Graphic Arts Technical College in Prague. Raises the professional standard of his photography influenced by the work of Karel Novák, František Drtikol, and Drahomir Josef Růžičkas. 1923 first travels to other European countries: Belgium, Austria, Switzerland, France, and Germany. 1926 Italy and Yugoslavia. 1927 opens a studio in Prague (Újezd Street). 1928 edition of widely acclaimed album on Saint Vitus (*Svaty Vít*). At the same time completes product and object photography, advertising, landscapes, and portraits. 1936 definitively turns away from Pictorialism and toward a more objective treatment of the medium. 1940 withdraws and keeps to himself due to the war and German occupation: completes cycle *My Studio Windows* (until 1954). 1956 first autonomous monograph. 1959 *Praha panoramatická* expresses his involvement with the panorama camera. 1961 first Czech photographer to receive the title Honorary Artist. 1968 exhibition in Lincoln (Nebraska) launches him in the USA. 1974 experiments with electronic instant images. Estate of over 60,000 negatives now administered by state museums.

EXHIBITIONS (Selected) — **1921** Prague (Club of Amateur Photographers – 1923) GE // **1958** Brno (Czech Republic) (House of Art) SE // **1968** Lincoln (Nebraska) (University of Nebraska) GE // **1974** Rochester (New York) (International Museum of Photography) GE // **1976** Prague (Museum of Applied Arts) SE // **1977** New York (International Center of Photography) SE // **1988** Paris (Centre Pompidou) SE // **1994** Arles (Rencontres internationales de la photographie) SE // **1998** Wolfsburg (German) (Kunstmuseum) SE // **2003** New York (Alan Klotz Gallery – 2004) GE // **2004** Vienna (Galerie Johannes Faber) SE // Boston (Museum of Fine Arts) SE // **2005** New York (Czech Center) SE // **2006** Brno (Czech Republic) (The Moravian Gallery) SE **2007** Berlin (Kicken Berlin) GE // New York (Howard Greenberg Gallery) GE // **2009** Bonn (Kunst- und Ausstellungshalle der BRD) GE

BIBLIOGRAPHY (Selected) — **Svaty Vít** [St Vitus]. Prague 1928 // J.S.: **Fotografie.** Prague 1956 // **Praha panoramatická** [Prague Panorama]. Prague 1959 // **Karluv most ve fotografii** [Photographs of the Charles Bridge]. Prague 1961 // Anna Fárová: J.S. Prague 1995 (Munich 1998) // Anna Fárová: **J.S.: The Pigment Prints 1947–54.** Los Angeles 1995 // **Czech Vision: Avant-Garde Photography in Czechoslovakia.** Ostfildern 2007 (cat. Kicken Berlin/Howard Greenberg Gallery, New York) // Annette and Rudolf Kicken, and Simone Förster (eds): **Points of View. Masterpieces of Photography and Their Stories.** Göttingen/Berlin 2007 (cat. Kicken Berlin) ⬐

"Despite the fact that Josef Sudek embraced a wide variety of artistic impulses and joined different movements, from the beginning he sought his own form of expression. Unusually in the Europe of his day, Sudek understood photography to be an independent means of expression. As early as the 1920s, whilst still a photography student at the Graphic Arts Technical College in Prague, training with the conservative Karel Novák, himself under the influence of the Vienna School, Sudek struck out on his own path. He closely observed developments outside the school, contacted amateur photographers, and, most of all, had many insightful discussions with his friend Jaromír Funke [...]." — Anna Fárová ✍

Hiroshi Sugimoto

Hiroshi Sugimoto: **Architecture.**
Chicago (Museum of Contemporary Art) 2003

23.2.1948 Tokyo (Japan) — Lives in New York (USA) and Tokyo Japanese camera artist living in New York. Representative of a serial photography inspired by minimalist and conceptual art, also in the tradition of Far Eastern simplicity and reduction. Studies at Rikkyō Saint-Paul's University in Tokyo. Graduates in 1970. Moves to the USA in the same year. 1970–1974 studies photography at the Art Center College of Design in Los Angeles. Graduates in 1972. Lives in New York from 1974. Freelance photographer and photo artist. Mainly big cycles influenced by minimalism and concept art. On the whole, a large-scale attempt to explore the boundaries between science and art and religion and history, and to reconcile the rather more contemplative approach of the Eastern World with Western themes. 1976 *Dioramas* series. In the same year he starts his *Wax Museums* cycle. 1978 *Theaters* series (photographs of American movie palaces and drive-ins of the 1920s and 30s using a large-format camera and long exposure times). 1980 he begins his *Seascapes* series (the sky and the sea as elements clearly separating pictorial space) – with this latter series, he creates "pictures of remarkable spiritual depth" (Hasse Persson). From 1997 *Architecture* series. Most recently *Portraits* series, "a fresh departure in the prosecution of his art" (H. P.). Several awards and scholarships, including Guggenheim Fellowship (1980), NEA (National Endowment for the Arts)Fellowship (1982), Mainichi Award (1988), Hasselblad Award (2001).
www.sugimotohiroshi.com

EXHIBITIONS (Selected) — **1977** Tokyo (Minami Gallery) SE // **1979** New York (Museum of Modern Art/**Recent Acquisitions**) GE // **1981** New York (Sonnabend Gallery – 1983, 2000, 2005, 2006) SE // **1988** Tokyo (Zeit Photo Salon) SE // Osaka (Japan) (National Museum of Contemporary Art) SE // **1989** Cleveland (Ohio) (Cleveland Museum of Art) SE // Saint Louis (Saint Louis Art Museum) SE // **1990** Paris (Galerie Urbi et Orbi) SE // **1995** New York (Metropolitan Museum of Art) SE // **1996** Houston (Texas) (Contemporary Arts Museum) SE // **2000** Berlin (Deutsche Guggenheim) SE // **2001** New York (Guggenheim Museum) SE // **2003** Chicago (Museum of Contemporary Art) SE // London (Serpentine Gallery) SE // Houston (The Museum of Fine Arts/**The History of Japanese Photography**) GE // **2004** Frankfurt am Main (Städelsches Kunstinstitut) SE // Paris (Fondation Cartier pour l'art contemporain) SE // **2005** Boston (Museum of Fine Arts) SE // London (Gagosian Gallery – 2006, 2008) SE // Tokyo (Mori Art Museum) SE // **2006** Washington, DC (Smithsonian Institu-tion) SE // Paris (Centre Pompidou) SE // **2007** Osaka (Japan) (National Museum of Art) SE // San Francisco (Fine Arts Museums of San Francisco) SE // Düsseldorf (K20 Kunstsammlung Nordrhein-Westfalen) SE // **2008** Berlin (Neue Nationalgalerie) // **2012** Munich (Museum Brandhorst) SE

BIBLIOGRAPHY (Selected) — **S.** Tokyo 1989 // **Portraits.** Ostfildern-Ruit 2000 (cat. Deutsche Guggenheim, Berlin) ⌁ // **Theaters.** New York 2000 (cat. Sonnabend Gallery) // **Architecture of Time.** Cologne 2002 // **Architecture.** Chicago 2003 (cat. Museum of Contemporary Art) // Anne Wilkes Tucker, Dana Friis-Hansen, Ryūichi Kaneko, and Takeba Joe: **The History of Japanese Photography.** New Haven/London 2003 (cat. The Museum of Fine Arts, Houston) // **Conceptual Forms.** Arles 2004 (cat. Fondation Cartier, Paris) // **Gesamtwerk/ Complete Works.** Ostfildern-Ruit 2005 // **Architecture.** Ostfildern-Ruit 2007 // **Revolution.** Ostfildern 2012 (cat. Museum Brandhorst, Munich)

"For Hiroshi Sugimoto, his major series — *Seascapes*, *Theaters*, *Dioramas* and *Wax Museums* — represent the disciplines of art, science and religion. As techniques of investigation, representation and information, these disciplines attempt to find an explanation for the visible world by tracing their existence in relation to other, invisible forces. This opens up an opportunity to get closer to Sugimoto's photographic practice with its emphatic seriality, its critical analysis of empirical reality, and its penchant for the metaphysical. The elementary concern of his work has to be sought at the intersection between aesthetic desire, close observation, and personal spirituality. In *Portraits*, his new commissioned series, Sugimoto extends the trinity of art, science, and religion to include the historical dimension, revealing how deeply photography is rooted in the past. Sugimoto has rarely abandoned himself to self-reflection to such an extent as in this new group of works exploring the elementary conditions of photographic representation."
— Nancy Spector ✍

Larry Sultan

Larry Sultan: **The Valley.**
Zurich (Scalo) 2004

1946 New York (USA) — 13.12.2009 Greenbrae (California, USA) Critical confrontation with the world of technical images at the center of a conceptually grasped art photography. Known to a broader audience since his well-received cycle *The Valley*. Spends his childhood in California. 1968 studies at the University of California (B.A.). 1973 studies at the San Francisco Art Institute (M.F.A. in Photography) and meets Mike Mandel. L.S. and Mandel jointly study thousands of anonymous consumer images in what were actually the non-public archives of the Stanford Research Institute, the US Government's Department for the Interior, and the Beverly Hills Police Department. Their conceptually oriented picture research culminates in a small edition of a self-published book (*Evidence*, 1977) and some remarkable publications of retrospective 1970s books. 1972 first solo exhibition in Los Angeles (Ohio Silver Gallery). Participation in important group exhibitions includes *The Collection of Sam Wagstaff* (International Center of Photography, New York, 1984), *Pleasures and Terrors, of Domestic Comfort* (Museum of Modern Art, New York, 1991), *Chic Clicks* (Fotomuseum Winterthur, 2002), and *So the Story Goes* (Art Institute of Chicago, 2006). 1978–1988 professor of photography at the San Francisco Art Institute. 1989–1999 professor of visual arts and holds chair at the California College of Arts and Crafts. Meanwhile professor of photography and visual arts at the California College of the Arts. Numerous prizes and grants include NEA (National Endowment for the Arts) Fellowships (1976, 1977, 1980, 1986, 1992), a Guggenheim Fellowship (1983), the Louis Comfort Tiffany Foundation Award (1991), and the Flintridge Foundation Award for Visual Artists (2000).

EXHIBITIONS (Selected) — **1977** San Francisco (San Francisco Museum of Modern Art – 2004) SE // **1978** Cambridge (Massachusetts) (Fogg Art Museum) SE // **1981** Los Angeles (Light Gallery) SE // **1982** Boulder (Colorado) (University of Colorado Art Gallery) SE // **1987** Providence (Rhode Island School of Design) SE // **1989** New York (Janet Borden – 2001, 2004) SE // **1992** San Jose (California) (San Jose Museum, of Art) SE // **1994** Washington, DC (Corcoran Gallery of Art) SE // **1996** New York (Queens Museum of Art) SE // **2000** Rotterdam (Gallery MK) SE // **2002** Dublin (Gallery of Photography) SE // **2004** Cologne (Galerie Thomas Zander – 2009) SE // **2005** London (The Photographers' Gallery) SE // Lausanne (Musée de l'Élysée) SE // **2006** Bremerhaven (Kunsthalle) SE // **2007** Chicago (Museum of Contemporary Art) SE // **2009** Madrid (PHotoEspaña) SE

BIBLIOGRAPHY (Selected) — L.S. and Mike Mandel: **How To Read Music in One Evening. A Clatworthy Catalog** (self-published) 1974 // L.S. and Mike Mandel: **Evidence.** Santa Cruz 1977 (reprint: San Francisco 2003) // **Headlands: The Marin Coast at the Golden Gate.** New Mexico 1989 // **Pictures from Home.** New York 1992 // **The Book of 101 Books.** New York 2001 // David Campany: **Art and Photography.** London 2003 // **The Valley.** Zurich 2004 // Maria Hamburg Kennedy and Ben Stiller: **Looking at Los Angeles.** New York 2005 // **The Everyday.** Madrid 2009 (cat. PHotoEspaña)

"Sultan and Mandel's selection of these photographs undoubtedly obeys their aesthetic motivations. However, what really inspired these authors to self-publish such a book, both strange and innovative for the era in which it was conceived, was more specifically their desire to endow the recorded image with a new logic of meaning by engaging photographs of a scientific and documentary nature taken from different and disparate archives. Both the publishing and the exhibition projects superimpose their internal logic on the complete series and defy any attempt to explain each isolated image. Like any other conceptual work of that era, only the group, gathered in a visual narrative whose code of interpretation has not yet been completely deciphered, is capable of transmitting to us the true dimension and meaning of *Evidence*."
— José Gómez Isla ✍🏻

Karel Teige

Vítězslav Nezval/Karel Teige:
Abeceda. Prague (spol. Nákladem J. Otto) 1926

13.12.1900 Prague (Czechoslovakia) — 1.10.1951 Prague Leading protagonist of Czech photo avant-garde between the wars, and especially prominent with collages. Originally painter in the spirit of late Cubism and Expressionism. First publication in the magazine *Die Aktion* (1917). 1920 founding member of the artist group Devetsil. From about 1922 theoretical head of the group (which also includes Josef Síma, Jindrich Styrsky, Toyen [Marie Čermínová], and Jaroslav Rössler, the only professional photographer). In the same year travels to Paris. There meets Constantin Brancusi, Le Corbusier, Yvan Goll, Fernand Léger, Amédée Ozenfant, among others, as well as > Man Ray, whose album *Les Champs délicieux* impresses him greatly. Conception of the yearbook *Zivot II* (1922) using photo montage for the cover (the first of its kind in Bohemia). 1923 co-organizer of the first Bohemian avant-garde exhibition (*Bazar moderního umení*). 1923 (together with the writer Vítészlav Nezval) founds Poetismus (to "experience and enjoy art" in the sense of an extended Constructivism). In the 1920s especially prominent with collages, book-cover designs and typographical work. 1927–1931 editor of the important Czech avant-garde magazine *ReD*. 1929 curates the Czech contribution to the Werkbund exhibition *Film und Foto* in Stuttgart. In the same year designs Vítězslav Nezval's anthology of poetry, *Abeceda*, with a progressive "synthesis of photo montage and modern typography" (Birgus). From the mid-1930s takes up Surrealism. Beginning of a major series of surreal nude collages. After the Communist takeover (1948) comes under increasing pressure. Heart attack a few days before a police raid of his home and the destruction of countless works and writings. Altogether only about 370 works preserved.

EXHIBITIONS (Selected) — **1929** Stuttgart (**Film und Foto**) GE // **1966** Essen (Germany) (Museum Folkwang – 1984) SE/GE // **1999** Munich (Die Neue Sammlung) GE // **2000** London (Czech Centre) SE // **2005** Prague (Museum of Decorative Arts/**Czech Photography of the 20th Century**) GE // **2007** Washington, DC (National Gallery of Art/**Foto: Modernity in Central Europe**) GE // New York (Guggenheim New York/**Foto: Modernity in Central Europe**) GE // **2009** Bonn (Kunst- und Ausstellungshalle der BRD/**Tschechische Fotografie des 20. Jahrhunderts**) GE // Munich (Stadtmuseum/**Nude Visions**) GE // Ludwigshafen (Germany) (Kunstverein/**Surrealismus Prag – Paris**) GE

BIBLIOGRAPHY (Selected) — Vítězslav Nezval and K.T.: **Abededa**. Prague 1926 // K.T.: **Collagen 1935–1951**. Essen (cat. Museum Folkwang) // Vladimír Birgus: **Tschechische Avant-garde-Fotografie 1918–1948**. Stuttgart/Munich 1999 (cat. Die Neue Sammlung, Munich) // K.T.: **L'enfant Terrible of the Czech Modernist Avant-Garde**. Cambridge (Massachusetts) 1999 // Vladimír Birgus and Jan Mloch: **The Nude in Czech Photography**. Prague 2001 // Vladimír Birgus and Jan Mloch: **Czech Photography of the 20th Century**. Prague 2005 (cat. Museum of Decorative Arts)

"Karel Teige stormed the small but lively cultural stage as a true Jack-of-all-trades: painter, graphic artist, poet, critic, art and architecture theoretician, actor, political agitator, lover, anarchist, Marxist ideologue (although never a Communist Party member) — in short, a dreamer of impossible dreams up until his tragic death, when the 20th century punished him with its magical ability to transform every utopia, even personal ones, into a nightmare."
— Eric Dluhosch

Juergen Teller

28.1.1964 Erlangen (Germany) — Lives in London (England) Fashion, advertising, and album covers. In the 1990s one of the most controversial fashion photographers. Protagonist of a new visualizing language conveying his generation's lifestyle. Child of a family of violin makers. Bowmaker's craft originally his intended professional goal but breaks off training after being diagnosed with a wood allergy. 1984–1986 studies at the Bayerischen Staatslehranstalt für Photographie (Bavarian State Academy of Photography) in Munich. 1986 moves to London to avoid military service. Meets > Knight, who brokers his first portrait assignments for album covers. At the same time takes first fashion photographs. Ascends to trendsetting fashion interpreter of the 1990s. Work includes editorial photography for *i-D*, *The Face*, *Arena*, *Arena Hommes Plus*, *Vogue Hommes*, *Vogue* (France, Italy, Great Britain, USA, Australia), *Dazed & Confused*, *Glamour* (France), *Interview*, *Details*, *Süddeutsche Zeitung Magazin*, *AbeSea*, *Per Lui*, *Marie Claire* (Germany), *Vibe*, *Six Magazine*, *Stern*, *03 Tokyo Calling*, *Jo's Magazine*, *Visionaire*, *W*, *Index*, *Purple*, *Libération*, and *Self Service*. Also campaigns for Blumarine, Anna Molinari, Miu Miu, Comme des Garçons, Helmut Lang, Hugo Boss, Katharine Hamnett, Strenesse, Jigsaw, Yves Saint Laurent, Calvin Klein, Alberto Biani and Alessandro Dell'Aqua, Zucca, Marc Jacobs, Marc, Stussy, Shisedo, Louis Vuitton, Amex, Telecom (Italy), and Ungaro. And album covers for Björk, Elton John, Elastica, Simply Red, Hole, Sinéad O'Connor, Everything but the Girl, Scritti Politti, Stereo MCs, PM Dawn, Terry Hall, Herbert Grönemeyer, Babaa Maal, Richie Rich, Neneh Cherry, Soul II Soul, Texas, Supergrass, and Terranova. 2003 Citibank Photography Prize.

Cornel Windlin: **Juergen Teller.**
Cologne (TASCHEN) 1996

EXHIBITIONS (Selected) — **1998** London (The Photographers' Gallery – 1999) SE/GE // **2000** New York (Lehmann Maupin Gallery) SE // **2001** Winterthur (Switzerland) (Fotomuseum) GE // **2001** London (Tate Modern) GE // **2002** Munich (Fotomuseum im Münchner Stadtmuseum) SE // Essen (Germany) (Museum Folkwang) SE // **2003** Haarlem (De Hallen – 2008) SE // Berlin (Contemporary Fine Arts – 2005) SE // New York (Lehmann Maupin – 2006, 2008, 2009) SE // **2004** Mannheim (Kunsthalle Mannheim) SE // Vienna (Kunsthalle Wien) SE // London (Modern Art) SE // **2006** Munich (Haus der Kunst/ **Click Double Click**) GE // Paris (Fondation Cartier pour l'art contemporain) SE // **2009** New York (International Center of Photography/**Weird Beauty**) GE // Nuremberg (Kunsthalle Nürnberg) SE // **2010** Madrid (Sala Alcalá) SE

BIBLIOGRAPHY (Selected) — Cornel Windlin: J.T. Cologne 1996 // **Fashion: Photography of the Nineties.** Zurich 1996 // Der Verborgene Brecht. Ein Berliner Stadtrundgang. Zurich 1997 // **The Fashion Book.** London 1998 ⏴ // Go-Sees. Zurich 1999 // J.T. Index [special album] Nov/Dec 2000 // Tracht. New York 2001 // **More.** Göttingen 2002 // **Märchenstüberl.** Göttingen SE // Berlin (Contemporary Fine Arts – 2005) SE // New York 2002 [cat. Fotomuseum im Münchner Stadtmuseum] // **Louis XV.** Göttingen 2004 // **Nackig auf dem Fußballplatz.** Göttingen 2004 // **Ich bin vierzig.** Vienna 2004 [cat. Kunsthalle Wien] // **Do You Know What I Mean.** Paris 2006 [cat. Fondation Cartier pour l'art contemporain] // **Nürnberg.** Göttingen 2006 // **Vivienne Westwood.** Göttingen 2008 // **Election Day.** Göttingen 2009 // **Marc Jacobs – Advertising 1998–2009.** Göttingen 2009 // **J.T.** Madrid 2010 [cat. Sala Alcalá]

"[…] Teller photographs clothing as the integral part of an image and not as the center of attention. First and foremost, he is a chronicler who records the everyday existence of those he works and lives with, the result being a sometimes uncomfortable yet true-to-life documentation of people working in the fashion world." — The Fashion Book ✍

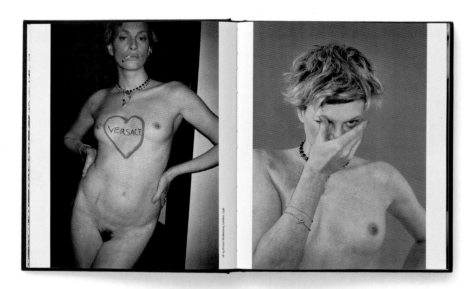

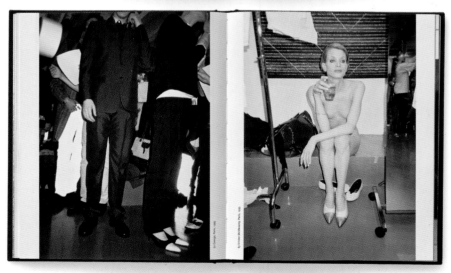

Mario Testino

Mario Testino: **LET ME IN!**
Cologne (TASCHEN) 2007

30.10.1954 Lima (Peru) — Lives in London (England) Fashion photography and portraits. Internationally known since the 1990s. Reception founded on work for editorials and in the art and museum context. Child of a middle-class family. Sister a successful textile designer. 1976 moves to London. Initially compiles portfolios for would-be models. Since then one of the best-known and most sought-after fashion photographers worldwide working for nearly every major label. Works in editorial and advertising. Also campaigns for the fashion (Versace) and consumer goods industries (Campari). 1997 produces what is considered his best-known work, the cover portrait of Lady Diana, Princess of Wales, shortly before her death, for the magazine *Vanity Fair*. 1998 *Any Objections?* is the first of several book publications. Known as the discoverer of models such as Kate Moss and Stella Tennant. At the same time (with portraits of Prince Charles and his sons, William and Harry) an unofficial court photographer of the Windsor family. *www.mariotestino.com*

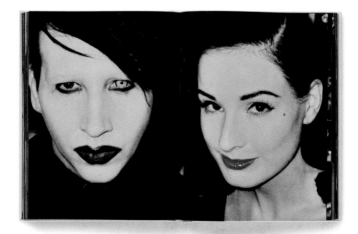

EXHIBITIONS (Selected) — **2002** London (National Portrait Gallery – 2004) SE // Amsterdam (Fotografiemuseum Amsterdam) SE // **2003** Edinburgh (Dean Gallery) SE // **2004** Tokyo (Tokyo Metropolitan Museum of Photography) SE // **2005** London (Kensington Palace/**Diana: Princess of Wales**) SE // **2007** Düsseldorf (NRW-Forum Kultur und Wirtschaft) SE // New York (Yvon Lambert Gallery) SE // **2008** Los Angeles (Los Angeles County Museum of Art/**Vanity Fair Portraits**) GE // **2009** New York (International Center of Photography/**Weird Beauty**) GE

BIBLIOGRAPHY (Selected) — **Any Objections?** London 1998 // **Front Row/Backstage.** New York 1999 📖 // **Party by M.T.** Hamburg 2000 (= **Stern** Portfolio no. 20) // **Alive.** New York 2001 // **Portraits.** New York 2002 // **Any Objections?** London/Berlin 2004 // **Diana, Princess of Wales. Diana by T.** Cologne 2005 // **LET ME IN!** Cologne 2007 // **MaRIO DE JANEIRO Testino.** Cologne 2009 // **Private View.** Cologne 2012 // **In Your Face.** Cologne 2012 // **Kate Moss by M.T.** Cologne 2013 // **M.T.: Sir.** Cologne 2014 // **M.T.: Undressed.** Cologne 2017

"One of Mario's most admirable qualities is that he never overworks his subject. Some photographers are so obsessed with detail that the finished images are in their heads long before looking into the viewfinder — and the result seems at times lifeless or at least one-dimensional. Many surprises are certainly not to be anticipated. Mario is efficient, highly organized, and ready to discuss every photograph in the smallest detail, but consistently remains spontaneous. In addition, Mario never cuts himself off from the world around him. He turns up everywhere. He enjoys life. You see him in restaurants, at parties and events — he always has a great time. This élan, this vitality and love of life, is what you feel in his photographs." — Anna Wintour ✍

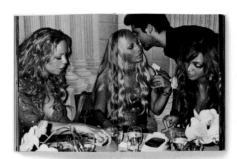
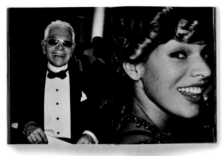

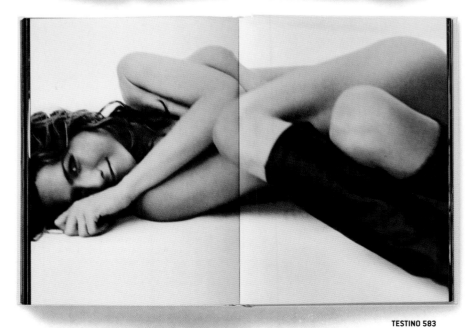

Miroslav Tichý

20.11.1926 Kyjov (Czechoslovakia) — 12.4.2011 Kyjov Painter, drafts-man, photographer opposed to Socialist doctrines on art. Core of his photographic oeuvre between 1970 and 1980. Mostly girls, women, nudes with an aesthetic counteracting craftsmanship. Only child of a tailor, Antonín Tichý. Childhood in Kyjov. Interested in art early on, his drawing attracting especial notice. 1945 moves to Prague and studies at the Academy of Fine Arts (to 1948). There student of Ján Želibský among others. With the Communist takeover (February 1948) end of the short progressive phase at the Academy. Sent down from the school and military service in eastern Slovakia (1948–1950). 1950 returns to Kyjov. Takes up drawing and painting again, influenced by Picasso and Matisse. Together with Richard Fremund, Bohumír Matal, Ida Vacuková, and Vladimír Vašíček forms the artist group Brno Five, which opposes the official doctrine of Socialist Realism. 1956 first group exhibition in the Kyjov hospital, his "coming out" as an artist (risky in spite of Stalin's death in this year). 1957 in the run-up to

Roman Buxbaum: **Tichý.**
Cologne (Verlag der Buchhandlung Walther König) 2008

another group exhibition in a Prague gallery, nervous breakdown and a year's stay in a clinic. Subsequently resolute withdrawal from exhibiting. From the 1960s takes up photography. Photos with primitive, self-built cameras. At the same time an existence as factotum eyed with suspicion, a living antithesis of the new socialist man. Suffers constant surveillance, harassment and repression. 2004 first solo exhibition as part of the Biennale in Seville (BIACS). 2005 major retrospective in the Kunsthaus Zürich marks the beginning of his international recognition.

EXHIBITIONS (Selected) — **1990** Cologne (Die Blaue Kunsthalle DuMont) GE // **2004** Seville (Spain) (Biennale Internacional de Arte Contemporáneo) SE // **2005** Berlin (Galerie Arndt & Partner) SE // Zurich (Kunsthaus) SE // Arles (Rencontres internationales de la photographie) GE // Paris (La maison rouge) GE // **2006** Vancouver (Canada) (Presentation House Gallery) SE // London (Michael Hoppen Gallery) SE // Brno (Czech Republic) (Brno House of Art) SE // Haarlem (Netherlands) (Frans Hals Museum) SE // Shenzhen (China) (5th International Ink Biennale) GE // Salzburg (Salzburger Kunstverein) GE // **2007** Tokyo (Ishii Gallery) SE // Bratislava (Central European House of Photography) GE // New York (Tanya Bonakdar Gallery — 2008) GE/SE // Paris (Centre Pompidou — 2008) GE/SE // **2008** Dublin (Douglas Hyde Gallery) SE // Bregenz (Austria) (Kunsthaus Bregenz) SE // Frankfurt am Main (Museum für Moderne Kunst) SE // Prague (National Gallery of the Czech Republic) GE // Sydney (Biennale of Sydney) GE // Stockholm (Konsthall) GE // **2010** New York (Howard Greenberg Gallery) SE

BIBLIOGRAPHY (Selected) — Tobia Bezzola and Roman Buxbaum (eds): **M.T.** Cologne 2005 // Roman Buxbaum: **M.T.** Zurich 2006 // Roman Buxbaum and Pavel Vancát: **M.T.** Prague 2006 // Roman Buxbaum and Taka Ishii Gallery (eds): **T.** Zurich 2007 // Roman Buxbaum: **T.** Cologne 2008 ✍ // **M.T.** Ostfildern 2008 (cat. Museum für Moderne Kunst, Frankfurt am Main)

"Tichý is a reactionary in the truest sense of the word. While Yuri Gagarin was conquering outer space, Tichý was making cameras out of wood. He put himself into reverse, moving backward against the ideology of progress. A genuine reactionary, and a very effective one; unlike the Five Year Plans, he achieved his aims. The 'Stone Age photographer' was the embodiment of an insult to the small-town communist elite. He became the living antithesis of progressive thought, of the Marxist theory of history moving in a straight line. Tichý may have abandoned the usual social conventions, but he did not become an autistic loner. Unlike the thinking of the masses, he backed the individual; he depended only on himself. He went into internal exile and became an observer on the margins of society." — Roman Buxbaum ✍

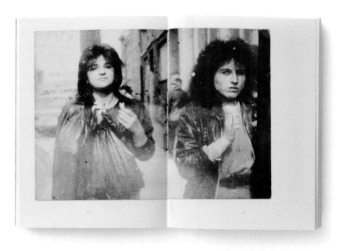

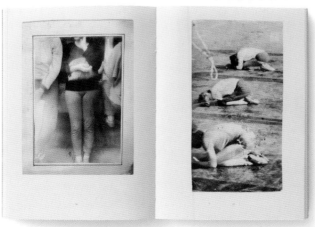

Wolfgang Tillmans

16.8.1968 Remscheid (Germany) — Lives in London (England) and Berlin (Germany) Chronicler of postmodern youth culture. Color works produced with a new "anti-aesthetic" with a claim to directness and authenticity. Sex, fashion, and the globalization of customs and dreams are the primary themes of his internationally admired oeuvre. 1987–1990 Hamburg. 1990 moves to England. Until 1992 studies at the Bournemouth and Poole College of Art. 1992–1994 London. 1994–1995 New York. From 1996 lives in London again. 1998–1999 visiting professorship at the Fine Arts Department of the University of Fine Arts in Hamburg. 1995 Ars Viva art prize of the Cultural Circle of the Federation of German Industries (BDI). 1995 Böttcherstraße art prize in Bremen. 2000 Turner Prize. 2001 honorary fellowship of the Arts Institute at Bournemouth. From 2003 holds an interdisciplinary art professorship at the Städelschule fine arts academy. Important group exhibitions include *Das deutsche Auge* (1996), *Veronica's Revenge/Lambert Collection* (1998), *Im Rausch der Dinge* (2004), and *Click Double Click* (2006). 2006 opens with *Between Bridges*, his own art space in London. 2009 Kulturpreis of the DGPh (Deutsche Gesellschaft für Photographie: German Photographic Association).

Wolfgang Tillmans.
Cologne (TASCHEN) 1995

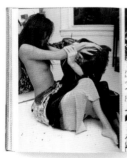

EXHIBITIONS (Selected) — **1992** Hamburg (PPS. Galerie) SE // **1993** Cologne (Galerie Daniel Buchholz — 1994, 1996, 1997, 1999, 2001, 2003, 2007) SE // **1994** New York (Andrea Rosen Gallery — 1996, 1998, 1999, 2001, 2002, 2003, 2007) SE // **1995** Zurich (Kunsthalle) SE // **1996** Wolfsburg (Germany) (Kunstmuseum) SE // **2001** Hamburg (Deichtorhallen) SE // **2003** London (Tate Britain) SE // **2004** Tokyo (Opera City Art Gallery) SE // **2006** New York (P.S.1 Contemporary Art Center/Museum of Modern Art) SE // **2008** Berlin (Hamburger Bahnhof) SE // **2013** Düsseldorf (Kunstsammlung NRW) SE

BIBLIOGRAPHY (Selected) — Burkhard Riemschneider (ed.): W.T. Cologne 1995 // **W.T.** Zurich 1995 (cat. Kunsthalle) // **W.T.** Frankfurt am Main 1995 (cat. Portikus) // **Wer Liebe wagt lebt morgen.** Ostfildern-Ruit 1996 (cat. Kunstmuseum Wolfsburg) // **Concorde.** Cologne 1997 // **W.T.: Burg.** Cologne 1998 // **Soldiers – The Nineties.** Cologne 1999 // **Totale Sonnenfinsternis.** Cologne 1999 (cat. Galerie Daniel Buchholz) // **Aufsicht.** Ostfildern-Ruit 2001 (cat. Deichtorhallen Hamburg) // **if one thing matters, everything matters.** London 2003 (cat. Tate Britain) // **Freischwimmer.** Tokyo 2004 (cat. Tokyo Opera City Gallery) // **Truth Study Center.** Cologne 2005 // **Freedom From The Known.** New York/Göttingen 2006 (cat. P.S.1 Contemporary Art Center/Museum of Modern Art) // **manual.** Cologne 2007 // **Lighter.** Ostfildern 2008 (cat. Hamburger Bahnhof, Berlin) // **Neue Welt.** Cologne 2012

"With his early images of young people casually revealing their identity, cravings, and behavior, but also with his interiors, landscape photographs and still lifes, Wolfgang Tillmans became one of the most influential and innovative photographers of his generation. Since the early 1990s, his work has been shown in numerous exhibitions and published in magazines such as *i-D*, *Interview* and *Index*. For the media, Tillmans's name is almost synonymous with depicting Pop and subculture, stylistically characterized by its improvised fashion, rituals, and self-confidence. The provocation and the excitement captured in many of his images, but also the obvious break with sexual taboos on the one hand, and a pronounced search for beauty in a seemingly 'unaesthetic' reality on the other […] contribute to the fact that these works, widely distributed by the media beyond the borders of the photography and art scenes, have become known to a broader audience." — Zdenek Felix ✍

Shōmei Tōmatsu

Shōmei Tōmatsu: **Japan**.
Tokyo (Shaken) 1967

19.1.1930 Nagoya (Japan) — 14.12.2012 Naha (Japan) Important representative of Japanese camera art in the 1960s and 70s. Departs from conventional documentary photography in particular through books such as *11.02 Nagasaki* (1966) or *Japan* (1967). A self-taught photographer, he studies economics at Aichi University in Nagoya. Graduates in 1954. In the same year he begins to work for the Iwanami Shoten publishing house. From 1956 works as a freelance photographer. From 1957 member of the Japan Professional Photographers' Society. 1959–1961 founder member of the Vivo agency, with Kikuji Kawada, > Narahara, Akira Satō, Akira Tanno). 1961 together with > Domon, published the photobook *Hiroshima-Nagasaki Document 1961*, which was eminently important for postwar Japanese journalism and for coming to terms with the trauma of war. Also regarded as "a clear progression towards truly world-class Japanese photographic expression" (Parr and Badger). *11.02 Nagasaki* (1966) was a further contribution to this topic in book form: the even greater intensity of the visual dramaturgy makes him one of the most prominent Japanese photographers to have rejected conventional documentary photography – "in favour of the allusive and metaphorical as the most appropriate trope for describing the postwar Japanese dilemma" (Parr and Badger). Its influence on the succeeding generation of Japanese camera artists was considerable. 1974 participates in the *New Japanese Photography* exhibition at the Museum of Modern Art (New York). Numerous awards, including the Japanese State Award (1995) and Grand Prix at the Annual Shinchō Awards. 2004 much acclaimed touring exhibition with stopovers in New York, Washington, DC, San Francisco, and Winterthur.

EXHIBITIONS (Selected) — **1956** Tokyo (Matsushima Gallera/**5 Photojournalists**) GE // **1959** Tokyo (Fuji Photo Salon – 1962, 1964) SE // **1968** Milan (Triennale) GE // **1979** New York (International Center of Photography/**Japan: A Self-Portrait**) GE // **1981** (–1984) Touring exhibition in Japan (**Japan through the eyes of S.T.**) SE // **1986** Oxford (Museum of Modern Art/**The Eyes of Four**) GE // **1993** Speyer (Historisches Museum der Pfalz) GE // **1999** Tokyo (Tokyo Metropolitan Museum of Photography – 2007) SE // **2003** Kyoto (National Museum of Modern Art – 2004) SE // Houston (Museum of Fine Arts/**The History of Japanese Photography**) GE // **2004** New York (Japan Society) SE // **2005** Washington, DC (Corcoran Gallery of Art) SE // **2006** San Francisco (San Francisco Museum of Modern Art) SE // Winterthur (Fotomuseum) SE // **2007** Prague (Galerie Rudolfinum) SE // Modena (Galleria Civica Modena) SE // **2008** Cologne (Galerie Priska Pasquer) SE // **2009** San Francisco (Museum of Modern Art/**The Provoke Era**) GE // **2010** New York (Howard Greenberg Gallery) SE //Cologne (Galerie Priska Pasquer) SE

BIBLIOGRAPHY (Selected) — S.T. and Ken Domon: **Hiroshima-Nagasaki Document 1961.** Tokyo 1961 // **11.02 Nagasaki.** Tokyo 1966 // **Japan.** Tokyo 1967 // **OO! Shinjuku.** Tokyo 1969 // **Taiyo no empitsu (The Pencil of the Sun).** Tokyo 1975 // **Japan: A Self-Portrait.** New York 1979 (cat. International Center of Photography) // **S.T.: Japan 1952–1981.** Graz 1984 // Thomas Buchsteiner and Meinrad Maria Grewenig (eds): **Japanische Fotografie der 60er Jahre/Japanese Photography in the 1960s.** Heidelberg 1993 (cat. Historisches Museum der Pfalz, Speyer) ✍ // **Traces: 50 Years of Tomatsu's Works.** Tokyo 1999 (cat. Metropolitan Museum of Photography) // Ian Jeffrey: **S.T.** London 2001 // Anne Wilkes Tucker, Dana Friis-Hansen, Ryūichi Kaneko, and Takeba Joe: **The History of Japanese Photography.** New Haven/London 2003 (cat. The Museum of Fine Arts, Houston) // **Skin of the Nation.** New Haven 2004 (cat. San Francisco Museum of Modern Art) // Ryūichi Kaneko and Ivan Vartanian: **Japanese Photobooks of the 1960s and '70s.** New York 2009

"Shōmei Tōmatsu's photographic career has run parallel to the post war economic boom in Japan. Beginning in the field of photo journalism, Tōmatsu has developed a kind of reportage photography with subjective coloring through which he expresses the problems of society and brings them to the attention of the public. His pictures are in direct opposition to the traditional Japanese aesthetic order. His photo series have been very critical of the destruction of this order, which is something rarely found within Japanese photography. This was first expressed in his work on the consequences of the atomic bomb explosion."
— Thomas Buchsteiner and Meinrad Maria Grewenig ✍🗁

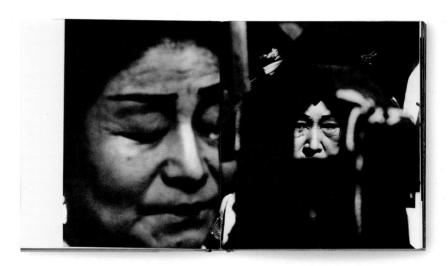

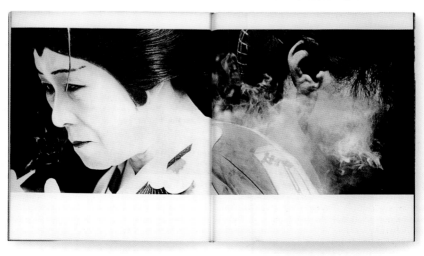

Shōji Ueda

Shōji Ueda: **Dunes – The Great Horizontal. Tokyo** (Parco) 1986

27.3.1913 Sakai (Japan) — 4.7.2000 Yonago (Japan) Still lifes, landscapes, staged images of children, and architectural photography in the sense of a magic realism. B/w photographs influenced by Surrealism and subjective art photography. One of the best-known Japanese photographers in the West. Child of a lower middle-class family in the provinces. 1930 receives first camera (a gift from his father). 1932 studies photography and sets up a modest photo studio in a section of his parents' store. During this period also investigates the European photographic avant-garde. 1933 founds a photography circle (Nihon kaï). 1939 first prize for his photograph *The Four Girls* shown in the exhibition *Nihon shashin bijutsu ten*. 1949 meets > Domon and the same year takes his famous and Surrealism-influenced portrait of Japan's best-known photographer of his generation. 1951 takes his first nude photo studies in sand dunes (recurring background motif).

1957 participates in first group exhibition at the Fuji Photo Salon in Tokyo. 1958 first presents a work at MoMA (New York) as part of a show of selected new acquisitions. 1972 opens spacious photographic store also doubling as a tearoom and gallery. 1974–1985 regular columns (images and texts) in the magazine *Camera Mainichi*. 1978 workshop in Arles. Larger sale of his work through the Bibliothèque nationale in Paris. 1987 night projections at the Rencontres d'Arles. 1992 first color works as dye transfers. Until his death produces about 20 books. 1995 the opening of the Shōji Ueda museum in Kishimoto (now Hoki, near Yonago) dedicated exclusively to S.U.'s art photography.

EXHIBITIONS (Selected) — **1958** New York (Museum of Modern Art, 1960) GE // **1974** Tokyo/Osaka (Nikon Salon) SE // **1980** Cologne (photokina) GE // **1984** Tokyo (Pentax Forum/**Fifty Years of Photography of U.S.**) SE // **1986** Paris (Centre Pompidou) GE // **1987** Frankfurt am Main (Fotografie Forum) SE // **1988** Tokyo (Seibu Art Gallery) SE // **1990** Lausanne (Switzerland) (Musée de l'Élysée – 2006) SE // Paris (Palais de Tokyo) GE // **1994** Toulouse (France) (Galerie municipale du Château d'Eau) SE // **1995** Kishimoto-cho (Japan) (Museum Shōji Ueda) SE // **2002** New York (Howard Greenberg Gallery) SE // **2003** Houston (Texas) (The Museum of Fine Arts/**The History of Japanese Photography**) GE // Paris (Hôtel de Sully) GE // **2005** Tokyo (Metropolitan Museum of Photography) SE // **2008** Paris (Maison européenne de la photographie) SE

BIBLIOGRAPHY (Selected) — **Le Japon des avant-gardes, 1910–1970.** Paris 1986 (cat. Centre Pompidou) // **Dunes – The Great Horizontal.** Tokyo 1986 // Wolfgang Stemmer (ed.): **S.U.: Fotografien 1930–1986.** Bremen 1987 (cat. Forum Böttcherstraße) // **La photographie japonaise de l'entre deux guerres – Du pictorialisme au modernisme.** Paris 1990 (cat. Palais de Tokyo) // Anne Tucker, Dana Friis-Hansen, and Ryūichi Kaneko: **The History of Japanese Photography.** Houston 2003 (cat. The Museum of Fine Arts) // **Japon 1945–1975, un renouveau photographique.** Paris 2003 (cat. Hôtel de Sully) // **Une ligne subtile – S.U. 1913–2001.** Paris 2008 (cat. Maison européenne de la photographie) // **S.U.** Paris 2008 (= Photo Poche no. 117) ✐

"Shōji Ueda was born in 1913, in a small city in Southwest Japan: Sakaiminato [previously Sakai]. He died near there in 2000. He rarely traveled. He was the local photographer, owned a shop, sold film and cameras, and made portraits of his clients. Concealed behind this commonplace professional façade was one of the most inventive and expressive photographers of his generation. Apart from his career as a provincial photographer, he left behind a unique and wonderful body of work, produced for his own enjoyment and out of passion, by a man who would rather go to photography clubs than search out the 'serious' photography circles."
— Didier Brousse ✍

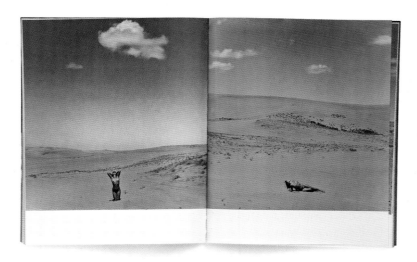

Umbo *(Otto Maximilian Umbehr)*

18.1.1902 Düsseldorf (Germany) — 13.5.1980 Hannover (Germany) Pioneer of portrait photography and reportage. Around 1930 one of the most innovative German photographers. Internationally renowned portrait studies (close-ups) of people evoking a metropolitan presence. Also photograms, photomontages, nude studies, and advertising photography. Son of a middle-class family, the second of six children. Active in the German Wandervogel youth group. 1915 receives his first camera (from his father). Drops out of high school. Wanders throughout northern Germany. 1921–1923 studies at the Bauhaus. Attends course conducted by Johannes Itten. Afterwards enrolls in the metalworking workshop. Following administrative conflicts removed from the list of students. 1923 moves to Berlin and initially works at the private Werkstatten bildender Kunst (Visual Arts Workshop). Later unskilled laborer and public "welfare" recipient. At the end of 1926, inspired by Paul Citroen, U. turns his attention to photography. Begins producing portraits. 1927 portrait *Ruth. die Hand* launches a series of widely acclaimed, revolutionary portrait studies of people evoking a metropolitan presence. Series includes portraits of Valeska Gert, Ruth Landshoff, and Marlene Dietrich. Simultaneously undertakes figure studies and photomontages (for Walter Ruttmann's film *Berlin*), street scenes, object photography, and photograms. 1928 teaches at the Johannes Itten School of Art and Architecture. In the same year founds the agency Dephot with Simon Guttmann. Publishes his reportages in the magazines *Berliner Illustrirte Zeitung* and *Münchner Illustrierte Presse*. Participates in groundbreaking exhibitions in Jena (*Neue Wege der Fotografie*, 1928), Essen (*Fotografie der Gegenwart*, 1929), Stuttgart (*Film und Foto*, 1929), and Munich (*Das Lichtbild*, 1930). 1933 after closing Dephot works as freelance photo reporter. 1938 commissioned photographer for the Ullstein publishing house. 1943–1945 military service. 1943 loss of entire archive (around 60,000 negatives) in an air raid. 1945 returns to Hannover. Produces passport photos, advertising, and reportages for the local press. 1948–1957 in-house photographer for the Kestnergesellschaft (Hannover). 1957 adjunct professor of photography in the schools of applied arts in Bad Pyrmont and Hannover. 1976 exhibition in Chicago (*Photographs from the Julien Levy Collection*) initiates a belated reevaluation.

EXHIBITIONS [Selected] — **1928** Berlin [Kabarett **Im Top-pkeller**] SE // Berlin [Kunstschule Johannes Itten] GE // **1978** Munich [Galleria del Levante] GE // **1979** Hannover [Spectrum Photogalerie] SE // Cologne [Galerie Rudolf Kicken] SE // **1981** Darmstadt [Kunsthalle] SE // **1990** Berlin [Bauhaus Archiv] GE // **1995** Düsseldorf [Kunstverein für die Rheinlande und Westfalen] SE // **2000** Berlin [Galerie Rudolf Kicken] SE // **2005** Berlin [Kunstbibliothek] GE // **2014** Hamburg [Haus der Photographie/Deichtorhallen] GE

BIBLIOGRAPHY [Selected] — Jeannine Fiedler [ed.]: **Fotografie am Bauhaus.** Berlin 1990 [cat. Bauhaus Archiv] // Herbert Molderings: **U.: Vom Bauhaus zum Bildjournalismus.** Düsseldorf 1995 [cat. Kunstverein] ✍ // Herbert Molderings: **U. Otto Umbehr 1902–1980.** Düsseldorf 1995 // **Collection de photographies.** Paris 1996 [cat. Centre Pompidou] // Christine Kühn: **Neues Sehen in Berlin. Fotografie der Zwanziger Jahre.** Berlin 2005 [cat. Kunstbibliothek] // **Augen auf! 100 Jahre Leica.** Heidelberg 2014 [cat. Haus der Photographie/Deichtorhallen Hamburg]

Umbo: **Untitled,** from: **Arts et Métiers
Graphiques Photographie,** 1935

"At the end of the 1920s, Umbo enjoyed the fame of a pioneer of 'New Photography'. His contemporaries considered his innovations to be on the same level as those of Man Ray, El Lissitzky, John Heartfield, and László Moholy-Nagy. However, unlike these photographic masters, Umbo was largely forgotten after World War II. The reason for this was the complete destruction of his oeuvre during the bombing of Berlin in August 1943. Without having a single one of his history-making masterpieces at hand, and without his archive to draw from [...] Umbo was unable to build on his earlier successes." — Herbert Molderings

Ellen von Unwerth

Ellen von Unwerth: **Fräulein.**
Cologne (TASCHEN) 2009

1954 Frankfurt am Main (Germany) — Lives in Paris (France) Fashion, beauty, erotic studies. Known for her fanciful-playful tableaux. Internationally known since the mid 1990s. Childhood and youth in an orphanage in Allgäu. Moves to Munich at age 16. Works for a time as a showgirl in the Zirkus Roncalli. 1975 moves to Paris as photographic model. Mid 1980s burgeoning interest in photography. First (child) photos during a fashion shoot (1986) in Kenya. Publishes the photos in the fashion magazine *Jill.* Takes up photography definitively. Breakthrough with a fashion shoot for French *Elle* with the then 17-year-old Claudia Schiffer as model. Subsequently numerous publications in *Vogue, i-D,* and *Vanity Fair.* 1991 first prize at the International Festival of Fashion Photography. Also music videos for Duran Duran, Salt'N'Pepa, among others, as well as portraits of Rihanna, Christina Aguilera, Britney Spears, and Madonna. A number of books, exhibitions, and group exhibitions.

EXHIBITIONS (Selected) — **2000** New York (Guggenheim Museum) GE // **2002** Rotterdam (Nederlands Fotomuseum) GE // Hamburg (Deichtorhallen) GE // **2003** Berlin (Camera Work) SE // Paris (Galerie Kamel Mennour – 2005) SE // Amsterdam (Galerie Wouter van Leeuwen – 2005) SE // **2004** New York (Museum of Modern Art/**Fashioning Fiction in Photography since 1990**) GE // **2007** London (Michael Hoppen Gallery – 2009) SE // Moscow (POBEDA gallery) SE // **2009** Berlin (Camera Work/**Fashion – 9 decades of fashion photography**) GE // New York (Staley-Wise Gallery) SE

BIBLIOGRAPHY (Selected) — **Snaps.** Santa Fe (New Mexico) 1994 // **Azzedine Alaïa.** Göttingen 1998 // **Couples.** Munich 1998 // **Wicked.** Munich 1999 // Giorgio Armani: **Twenty-Five Photographers**. New York 2000 (cat. Guggenheim Museum) // Marion de Beaupré [ed.]: **Archeology of Elegance. 20 Jahre Modephotographie**. Munich 2002 (cat. Deichtorhallen Hamburg) // **Revenge**. Santa Fe 2003 // **Fräulein.** Cologne 2009 // **The Story of Olga.** Cologne 2012 // **Heimat.** Cologne 2017

"Ellen von Unwerth is the 'shooting star' of the erotic photo scene. Currently the most exciting woman behind the camera, she conquered the world with her refreshingly unconventional fashion and nude photography. The secret fantasies which she draws out of her models and to which she carries them off are paired with a mixture of humor, cheekiness, and playfulness typical of Ellen von Unwerth. Her career began on the catwalk where she was known as the 'the merry model'. Spontaneity is her strength. 'Life offers its best unplanned' is her motto, and so she surprises life with great sensitivity in those telltale moments." — Anonymous/Wicked ✍

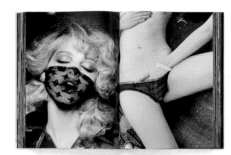

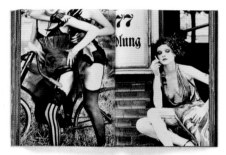

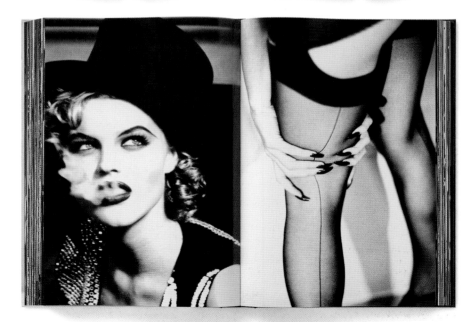

André Vigneau

André Vigneau: **Le château de Versailles.Vues extérieures.** Paris (Éditions Tel) 1935

4.6.1892 Bordeaux (France) — 5.7.1968 Paris (France) Pioneer of applied art (New Objectivity advertising, fashion, film) in France around 1930. Studies art in Bordeaux and Paris (1906–1914). 1917–1920 shares studio with > Sougez in Lausanne. Returns to Paris and takes up film and applied graphics. Art director for the firm of Siegel (mannequins). 1929 opens an advertising studio for Lecram Press. There he teaches > Doisneau among others. Publishes in *Gebrauchs-graphik*, *AMG Photographie*, *La Revue du Médecin*. Advertising for Bugatti, Dunlop, Sandoz, Rodier, Louis Vuitton, among others. Also book illustration, e.g. for the *Encyclopédie photographique de l'art* for Éditions Tel (Ancient Egyptian art, 1936; Mesopotamia, Canaan, Cyprus, and Crete, 1936; Greece and Rome, 1938). Takes part in the important exhibition *La Publicité par la photographie* (1935). 1932–1936 managing director of the production company Camera-Films. 1940–1948 head of state film production in Egypt. Returns to France, where he is substantially involved in the development of French television until 1956. 1963 writes a *Brève Histoire de l'art de Niépce à nos jours*. Estate held in the Bibliothèque historique de la Ville de Paris.

EXHIBITIONS (Selected) — **1931** Paris (Galerie d'Art contemporain) GE // **1932** Paris (Galerie Studio Saint-Jacques – 1934) GE // **1934** Paris (Galerie de la Pléiade) GE // **1936** Paris (Exposition internationale de la photographie contemporaine) GE // **1965** Arles (Musée Réattu) GE // **1986** Paris (Bibliothèque historique de la Ville de Paris) JE (with Pierre Jahan) // **2009** Paris (Jeu de Paume – Site Sully/**Collection Christian Bouqueret**) GE

BIBLIOGRAPHY (Selected) — **La cathédrale de Chartres.** Paris 1934 // **Le château de Versailles.** Paris 1935 // T.M. Gunther and Marie de Thézy: **Pierre Jahan – A.V.: L'Essor de la photographie de l'entre-deux-guerres.** Paris 1986 (Cat. Bibliothèque historique de la Ville de Paris) // Robert Doisneau: **A l'imparfait de l'objectif. Souvenirs et portraits.** Paris 1989 // Christian Bouqueret: **Des années folles aux années noires.** Paris 1997 ✍⌐ // **Paris. Capitale photographique. 1920/1940. Collection Christian Bouqueret.** Paris 2009 (cat. Jeu de Paume – Site Sully)

"But one of the most endearing personalities of professional studio photography and advertising remains Andre Vigneau, who was a pioneer. Art director at Siegel, he invented new types of mannequins for fashion shows at the Exhibition of Decorative Arts in 1925, which were photographed many times by Outerbridge, Jr, Man Ray, and Hoyningen-Huene. By the late twenties, film (then silent) immediately appeared to him as a way of expression that accorded with the times. Correctly judging it to be based on photography, he decided to learn the art first. He worked at the same time at a printer's, where he created the photo studio, Lecram Press, in 1929. He left Siegel in 1930 and opened his own studio, Camera-Films, in 1932. There he worked in fashion, advertising, portraiture and short films. Vigneau was an inveterate experimenter and critic Louis Chéronnet clearly saw in his approach that 'he constantly sought to renew his expression […]." — Christian Bouqueret ✍

Roman Vishniac

Roman Vishniac: **Polish Jews.**
A Pictural Record.
New York (Schocken) 1947

19.8.1897 Pavlovsk (Russia) — 22.1.1990 New York (USA) Important chronicler of Jewish life on the eve of the Holocaust. Extensive series from Eastern Europe bearing witness to a disappearing culture. Also a contribution as natural scientist and philosopher. His father, Solomon Vishniac, a successful umbrella manufacturer. Childhood in Moscow. Interested in biology and photography early on. A microscope, a present from his grandmother for his seventh birthday, is the starting point for an intensive exploration of microscopy and micro-photography. 1914 begins studying in Moscow (zoology, medicine, philosophy). Assistant to the biologist Nikolai Koltzhoff. 1914 – 1917 serves in the White Russian Kerensky army. 1918 meets Luta (Leah) Bagg, from Latvia, who later becomes his first wife. Deserts and flees to Riga. Engagement to Luta and – now a Latvian passport holder – moves to Berlin. There – not very successfully – works as businessman. Takes up microscopy photography definitively. For the Berlin office of the American Jewish Joint Distribution Committee (a relief organization for oppressed Jewish communities) R.V. makes a photographic exploration of impoverished East European ghettos and *shtetls*. Between 1935 and 1938 continual documentation – also at his own initiative – of life in Eastern Europe and Jewish Orthodox culture (incl. in Russia, Poland, Hungary, and Rumania). After Kristallnacht (November 1938) flees to France. Arrested, interned. End of 1940 emigrates to the USA (also on board the SS *Siboney* are Jean Renoir and Antoine de Saint-Exupéry). In the USA, because of his poor English he initially takes portraits under contract, or at his own initiative, of Albert Einstein and Marc Chagall, among others. 1946 divorces Luta. Marries Edith Ernst. Gives up portrait photography to concentrate totally on biology and micro-photography. Pioneering work in the area of time-lapse photography. Teaches (art, philosophy, religion, ecology, and photog-

EXHIBITIONS (Selected) — **1939** Paris (Musée de Louvre) SE // **1941** New York (Teachers College) SE // **1971** New York (Jewish Museum) SE // **1973** London (The Photographers' Gallery) SE // Jerusalem (Israel Museum/**The Concerned Photographer II**) SE // **1977** New York (Witkin Gallery) SE // **1983** New York (International Center of Photography) SE // **1995** Milan (Fondazione Antonio Mazzotta) GE // **1996** Paris (Hôtel de Sully) GE // **1997** Bonn (Rheinisches Landesmuseum) GE // **2004** Petaluma (California) (Barry Singer Gallery) SE // Boca Raton (Florida) (Boca Raton Museum of Art) SE // **2005** Berlin (Jüdisches Museum) SE // **2006** Paris (Musée d'art et d'histoire du judaisme) SE // **2007** New York (Goethe Institut/ **Roman Vishniac's Berlin**) SE // **2008** Munich (Stadtmuseum/ **Streetlife**) GE // **2009** New York (International Center of Photography /**This is Not a Fashion Photographer**) GE

BIBLIOGRAPHY (Selected) — **Polish Jews: A Pictorial Record.** New York 1947 // **The Concerned Photographer 2.** New York 1972 // R.V. New York 1974 // R.V. Tempe 1985 // **A Vanished World.** New York 1991 // **To Give Them Light: The Legacy of R.V.** London 1993 // Colin Westerbeck and Joel Meyerowitz: **Bystander.** Boston 1994 // Giuliana Scimé: **Fotografia della libertà e delle dittature da Sander a Cartier-Bresson 1922– 1946.** Milan 1995 (cat. Fondazione Antonio Mazzotta) // Klaus Honnef and Frank Weyers: **Und sie haben Deutschland verlassen ... müssen.** Bonn 1997 (cat. Rheinisches Landesmuseum) // Julian Rodriguez: R.V. London (cat. Hackelbury Fine Art) // **Children of a Vanished World.** Berkeley 1999 // David Acton: **Keeping Shadows: Photography at the Worcester Art Museum.** Worcester 2004 ✍ // **R.V.'s Berlin.** Berlin 2005 (cat. Jüdisches Museum)

raphy) at the City University of New York and the Case Western Reserve University, among others. Honorary doctorates from the Rhode Island School of Design, Columbia College of Art, and the California College of Art.

FISH SELLER [CRACOW]

"Around 1933 Vishniac began to photograph life in the Jewish communities of Central and Eastern Europe, neighborhoods similar to where he had grown up. He well understood the threat of the political ascendency of Adolf Hitler and the Social Democrats, and felt the growing urgency of his project as the decade progressed. During the years 1935 to 1938, Vishniac traveled in Poland, Russia, Hungary, and Romania with his camera. It was a challenging task, since the commandment against graven images prompted orthodox Jews to avoid having their photographs taken. There was also the danger of his being accused as a government spy, so Vishniac often used a concealed camera. The photographer was arrested eleven times in the mid 1930s and served sentences of hard labor in two concentration camps. Although he took over sixteen thousand photographs, all but two thousand of his negatives were confiscated and destroyed."
— David Acton ✍

Massimo Vitali

Massimo Vitali: **Beach & Disco.**
Göttingen (Steidl Verlag) 2000

1.1.1944 Como (Italy) — Lives in Lucca (Italy) Beach life in northern Italy, bathing scenes, and disco fever: exploration of postmodern leisure culture. Attends school in Milan. Studies at the London College of Printing. 1964–1979 works as freelance photojournalist. Cameraman for feature films and advertising. 1993 turns his attention to personal topics. People on beaches and in swimming pools observed with a large-format camera. Numerous exhibitions of his predominantly 150 x 180 cm printed (intentionally monochromatic) visual inventions. Since the (1998) Rencontres d'Arles also internationally known. Publications include those in *Frankfurter Allgemeine Zeitung*, NRC Handelsblad, *Het Parool*, *Double Take*, *Corriere della Sera*, *Village Voice*, *i-D*, the *Independent* magazine, *Arena*, *Artforum*, *Le Monde*, *Art in America*, *Libération*, *Dazed & Confused*, and *The Face*.

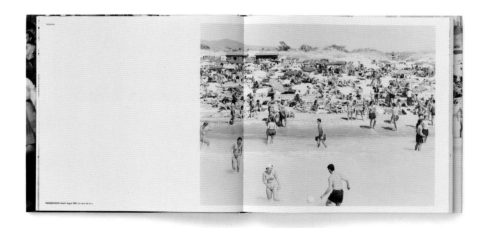

EXHIBITIONS (Selected) — **1994** Cologne (Historisches Archiv der Stadt) SE // **1997** London (The Photographers' Gallery) SE // **1998** Arles (Rencontres internationales de la photographie) SE // **1999** Paris (Galerie du Jour) SE // **2000** Brussels (Crown Gallery) SE // **2001** Gothenburg (Sweden) (Hasselblad Foundation) SE // Amsterdam (Serieuse Zaken) SE // Venice (Biennale) SE // **2004** New York (Bonni Benrubi Gallery – 2005, 2008) SE // **2005** Madrid (La Fábrica Galería) SE // **2006** Rome (Brancolini Grimaldi Arte contemporanea) SE // Seoul (South Korea) (The Columns) SE // **2007** Atlanta (Georgia) (Jackson Fine Art) SE

BIBLIOGRAPHY (Selected) — **Un Nouveau Paysage humain.** Arles 1998 (cat. Rencontres internationales de la photographie) // **Beach & Disco.** Göttingen 2000 // **Pique Nique.** Paris 2000 // **Les pieds dans l'eau.** Toulon 2000 // **Landscape with Figures.** Göttingen 2004 // **Landscape with Figures 2.** Göttingen 2009

"Massimo Vitali's photographs record the rites and rituals of modern leisure time as played out on the beaches and in the nightclubs of northern Italy. He shows us late 20th-century spaces of relaxation, freed from all social restraint. These locations are ideal for chance encounters, but also for the uninhibited pursuit of sensory simulation in either the touristic drive to experience the new and the exotic or the clubber's fantasy full of sexual and auditory excesses. We find ourselves in the phantasmic world of the liminal and the carnivalesque: spaces of ambiguity and ambivalence, which fall between the social spheres of the public and the private."

— Jon Bird

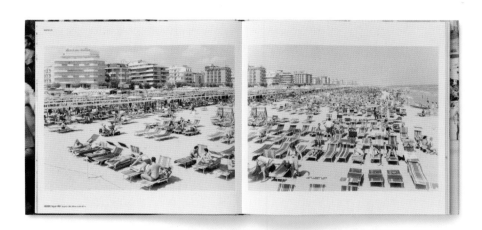

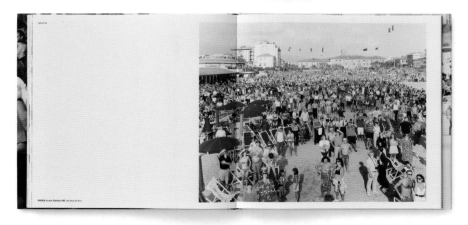

Lucien *(Antoine Hermann)* Vogel

Lucien Vogel: **Au pays des Soviets**
from: **VU**, no. 192, 1931

1886 Paris (France) — 1954 Paris Journalist, publisher, and photographer. Central figure within the French illustrated press during the period between the wars. Son of the draftsman Hermann Vogel. From 1906 art director at *Vie heureuse* and *Fémina*. From 1909 editor-in-chief of *Art et décoration*. 1912 founds *La Gazette du bon ton*. 1914 military service in French Morocco under Marshal Hubert Lyautey and works as photographer in the Service des beaux-arts des monuments historiques et des antiquités. 1915–1917 together with Jean Rhoné is commissioned to complete cityscapes and architectural studies in Meknes, Fez, and Marrakesh as the starting point for several state publications: *Les Monuments mauresques du Maroc* (1921) and the two-volume work *Le jardin et la maison arabes au Maroc* (1926). 1920 founds the magazine *Illustration des modes* (later *Jardin des Modes*). 1922–1925 art director for *Vogue*. 1928 (May/June) member of the Conseil d'administration of the *Arts et Métiers graphique*. Member of the organizational committee of the important first *Salon indépendant de la photographie*. March 1928 first issue of the magazine *VU*, founded by L.V. (with Carlo Rim as editor-in-chief beginning 1930); at the same time editor of the magazine *LU*. His own reportages regularly appear in *VU* (including the comprehensive photo report *La Rue – Les Ouvriers* in the special Russia issue, no. 192, 11 August 1931). After he officially joins the party of the Spanish Loyalists (see *VU*, August 1936) excluded from the Conseil d'administration. 1937 editor of the *Petit Journal* and managing editor at *Messidor*. Emigrates to USA after the German invasion. 1945 returns to France and resumes work as editor of *Jardin des Modes*.

EXHIBITIONS (Selected) — **1982** Woodstock (New York) (Catskill Center for Photography) GE // **2001** Cologne (Museum Ludwig/ Agfa Foto-Historama) GE // **2006** Paris (Maison européenne de la photographie/**Regarder** VU) GE // **2007** Chalon-sur-Saône (France) (Musée Nicéphore Niépce/**Regarder** VU) GE // **2009** Gentilly (France) (Maison Robert Doisneau/**Premiers photographes au Maroc**) GE

BIBLIOGRAPHY (Selected) — Jean Gallotti: "Hommage à Lucien Vogel." In: **Jardin des Modes**, no. 391, July 1954 // **Picture Magazines Before Life.** Woodstock 1982 (cat. Catskill Center for Photography) // Christian Bouqueret: **Des années folles aux années noires.** Paris 1997 // Kim Sichel: **G.K. Avantgarde als Abenteuer.** Munich 1999 (cat. Museum Folkwang, Essen) // **Kiosk. Eine Geschichte der Fotoreportage 1839–1973.** Göttingen 2001 (cat. Agfa Foto-Historama, Cologne) // Michel Frizot and Cédric de Veigy: **VU. Le magazine photographique 1928–1940.** Paris 2009 ✍

"Vogel was himself an active photographer, as recognized in the magazine *VU*, especially on the occasion of his trip to the Soviet Union (1931). He was also in regular contact with the most advanced modern photographers. […] On friendly terms with Coco Chanel and Mayakovsky, Gide and Philippe Soupault, Cendrars and Fernand Léger, he was intrinsically bound to the milieu of the arts out of curiosity as well as for professional reasons, and by no means scorned the avant-garde of the 1920s. One could assume that this committed man, clearly a Republican, had left-wing sympathies. Most of all, he was a pacifist, as verified through his countless articles, published in *VU*, against re-armament and the war, against Fascism and Nazism. During the Spanish Civil War, he put aside his pacifism to commit himself on the side of the Republicans, working as the magazine's editor but also a photo reporter. In early August of 1936, he himself sent Robert Capa and Gerda Taro to Spain." — Michel Frizot and Cécric de Veigy ✍

Jeff Wall

Jeff Wall.
Zurich (Scalo Verlag) 1997

29.9.1946 Vancouver (Canada) — Lives in Vancouver Staged photography since the end of the 1970s. Largely everyday scenes conveying an iconographic link to classical painting, presented as large-format backlit transparencies. Since the 1990s among the most internationally controversial photographers. Also considered one of "contemporary art's most advanced thinkers" (Stefan Gronert). 1964–1970 studies at the University of British Columbia in Vancouver. 1970 M.A. (Art History). 1970–1973 period of research at the Courtauld Institute, University of London. 1974–1975 assistant professor in the Art History Department of the Nova Scotia College of Art and Design in Halifax, Nova Scotia. 1976–1987 associate professor at the Centre for the Arts of Simon Fraser University in Vancouver. 1987–1999 professor in the Fine Arts Department of the University of British Columbia in Vancouver. 1967 takes first photographic images. At the end of the 1970s creates large-format color works conveying an iconographic nearness to classical painting. As a rule stages images with a narrative content, conspicuously presented in the form of oversized light boxes (inspired by contemporary advertising practices). Since the mid 1990s also b/w works on paper. Undoubtedly among the most controversial

EXHIBITIONS (Selected) — **1979** Victoria (Canada) (Art Gallery of Greater Victoria) SE // **1982** Kassel (documenta – 1987, 1997, 2002) GE // **1983** Chicago (Renaissance Society at the University of Chicago) SE // **1984** London (Institute of Contemporary Arts) SE // Basel (Kunsthalle) SE // **1987** Basel (Museum für Gegenwartskunst) SE // **1988** Villeurbanne (France) (Le Nouveau Musée) SE // Münster (Westfälischer Kunstverein) SE // **1990** Vancouver (Vancouver Art Gallery) SE // **1991** Humlebæk (Denmark) (Louisiana Museum of Modern Art) SE // **1992** Frankfurt am Main (Museum für Moderne Kunst) SE // **1993** Lucerne (Switzerland) (Kunstmuseum) SE // **1994** Madrid (Museo Nacional Centro de Arte Reina Sofía) SE // Düsseldorf (Kusthalle Düsseldorf) SE // **1995** Chicago (The Museum of Contemporary Art) SE // Paris (Galerie nationale du Jeu de Paume) SE // **1996** Wolfsburg (Germany) (Kunstmuseum) SE // **1997** Washington, DC (Hirshhorn Museum and Sculpture Garden) SE // Los Angeles (The Museum of Contemporary Art) SE // Munich (Lenbachhaus) SE // Los Angeles (Museum of Contemporary Art) SE // **1999** Cologne (Die Photographische Sammlung/SK Stiftung Kultur) SE // **2001** Frankfurt am Main (Museum für Moderne Kunst) SE // **2003** Vienna (Museum Moderner Kunst/Stiftung Ludwig) SE // **2005** Basel (Schaulager) SE // London (Tate Modern) SE // **2007** London (White Cube) SE // New York (Museum of Modern Art) SE // **2013** Munich (Pinakothek der Moderne) SE

BIBLIOGRAPHY (Selected) — **J.W.** Victoria 1979 (cat. Art Gallery of Greater Victoria) // **J.W. Selected Works.** Chicago 1983 (cat. The Renaissance Society at the University of Chicago) // **J.W.: Transparencies.** London 1984 (cat. Institute of Contemporary Arts) // **J.W.: Transparencies.** Munich 1986 // **J.W.** Villeurbanne 1988 (cat. Le Nouveau Musée) // **J.W.** Münster 1988 (cat. Westfälischer Kunstverein) // **J.W.** Vancouver 1990 (cat. Vancouver Art Gallery) // **J.W.** Humlebæk 1991 (cat. Louisiana Museum of Modern Art) // Jean-Christophe Amman (ed.): **J.W.: The Storyteller.** Frankfurt am Main 1992 // **J.W.: Dead Troops Talk.** Basel 1993 (cat. Kunstmuseum Luzern) // **J.W.: Restoration.** Basel 1994 (cat. Kunsthalle Düsseldorf) // **J.W.** Madrid (cat. Museo Nacional Centro de Arte Reina Sofía) // **J.W.** Chicago 1995 (cat. The Museum of Contemporary Art) // Thierry de Duve, Arielle Pélence, and Boris Groys: **J.W.** London 1996 // **J.W.: Landscapes and Other Pictures.** Wolfsburg 1996 (cat. Kunstmuseum Wolfsburg) // Kerry Brougher: **J.W.** Zurich 1997 (cat. The Museum of Contemporary Art, Los Angeles) // Gregor Stemmrich (ed.): **J.W.: Szenarien im Bildraum der Wirklichkeit. Essays und Interviews.** Dresden 1997 ✎ // **Bilder von Landschaften.** Cologne 1999 (cat. Die Photographische Sammlung/SK Stiftung Kultur) // Rolf Lauter (ed.): **J.W. – Figures & Places.** Munich 2001 (Museum für Moderne Kunst) // **J.W.: Photographs.** Cologne 2003 (cat. Museum Moderner Kunst/Stiftung Ludwig, Vienna) // Theodora Vischer and Heidi Naef (eds): **J.W.: Catalogue Raisonné 1978–2004.** Göttingen 2005 (cat. Schaulager, Basel) // Peter Galassi: **J.W.** New York 2007 (cat. Museum of Modern Art) // **J.W.: Black and White Photographs 1996–2007.** London 2007 (cat. White Cube) // **Jeff Wall in München.** Munich 2013 (cat. Pinakothek der Moderne)

postmodern art photographers. Represented several times at the documenta in Kassel. Numerous honors and prizes incl. the Munich Art Prize (1996), the Hasselblad Award (2002), and the Roswitha Haftmann Award (2003).

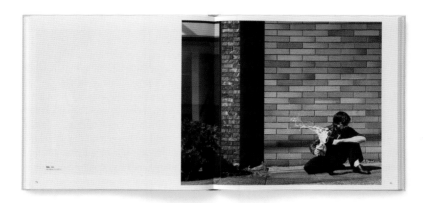

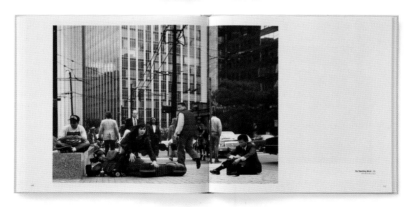

"Towards the end of the 1970s, Jeff Wall became known as an artist through his large-format diapositives presented in light boxes, showing posed scenes in a familiar urban environment. Even though contemporary technology is used, his images bring to mind paintings from the classical art tradition. For that reason, in texts written about his work, they tend to be discussed in the same manner, namely with respect to analyzing their iconography, their compositional principles, their genre affiliation, and their political-ideological content." — Gregor Stemmrich ✍

Chris von Wangenheim

21.2.1942 Brieg (Silesia, today Poland) — 9.3.1981 Caribbean Island of St Martin Erotic and fashion photography in the spirit of > Guy Bourdin and > Helmut Newton. One of the most innovative fashion photographers of the 1970s. Also takes photo essays in b/w. Son of an officer. After fleeing to the West, childhood and youth in Bavaria. First photos at age 11. After school-leaving exam, 1962–1964 attends the Bayerischen Staatslehranstalt für Photographie (Bavarian State School for Photography). Graduates with journeyman's certificate. 1965 moves to New York. There becomes assistant to the successful fashion and advertising photographers David Thorpe and James More. 1968 opens his own studio on Washington Square. At first works for the American edition of *Harper's Bazaar*, from 1970 for the Italian edition. From 1972 works especially for US *Vogue*, but also for its German, French, and Italian editions. Also successful campaigns for Clairol, Christian Dior, Calvin Klein, Revlon, and Helena Rubinstein, as well as publications in *Esquire*, *Playboy*, *Viva*, and *Camera* (there a sensitive essay on life in a Zen monastery near Yokohama, Japan). Dies at 39 in a car accident on the Caribbean island of St Martin.

"Chris von Wangenheim produced a body of work which has continued to fascinate, intrigue and influence the photography world. Combining a dark world of sexuality, violence, and voyeurism in all their perverse implications, with an extreme visual elegance, he achieved a startling synthesis of glamour and terror which is unique to his work." — Staley-Wise ✍

EXHIBITIONS (Selected) — **1990** Vienna (Kunstforum Länderbank) GE //**2000** Munich (Fotomuseum im Münchner Stadtmuseum) GE //**2004** New York (Staley-Wise Gallery – 2007) GE //**2008** Lugano (Switzerland) (Museo d'Arte Moderna/**Photo2Oesimo**) GE //**2010** Wasserburg am Inn (Germany) (Fotogalerie Karin Schneider-Henn) SE

BIBLIOGRAPHY (Selected) — **Camera**, no. 11, November 1970 // Polly Devlin: **Vogue Book of Fashion Photography: The First Sixty Years.** New York 1979 // Carol di Grappa: **Fashion: Theory.** New York 1980 // Ingried Brugger (ed.): **Modefotografie von 1900 bis heute.** Vienna 1990 (cat. Kunstforum Länderbank) // **20 Jahre Vogue 1979 – 1999.** Munich 1999 // **Lehrjahre – Lichtjahre. Die Münchner Fotoschule 1900–2000.** Munich 2000 (cat. Fotomuseum im Münchner Stadtmuseum)

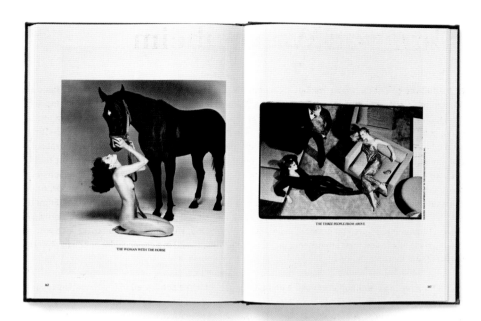

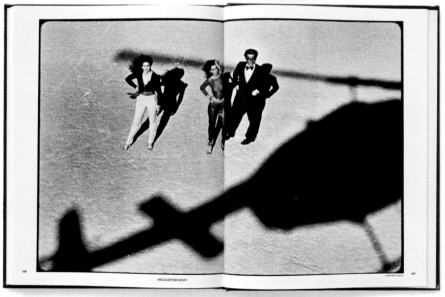

Chris von Wangenheim,
from: **Fashion Theory.**
New York (Lustrum Press) 1980

Nick Waplington

Nick Waplington: **Truth or Consequences: A Personal History of American Photography from the Last Century.** London (Phaidon Press) 2001

25.7.1965 Scunthorpe (England) — Lives in London (England) Internationally acclaimed exponent of a "New British Photography" developed parallel to the Thatcher era. Takes first photographs in the early 1980s. 1985–1986 art foundation course. 1986 begins studying photography at Trent Polytechnic in Nottingham. 1989–1991 at the Royal College of Art in London. With first book publication, *Living Room* (prefaced by John Berger), his breakthrough as exponent of a new documentarism promoting the use of color. Meanwhile focuses in part on staging bizarre situations (see his series with "posed" accident victims, 1995–1996). Numerous solo and important group exhibitions include *Color Work* (The Photographers' Gallery, 1989), *Who's Looking at the Family?* (Barbican Art Gallery), and *On the Bright Side of Life* (Neue Gesellschaft für Bildende Kunst, 1996). Also filmmaking: *England Mine* (La Sept, 1990), *Living Room* (Geo Film, 1994). Numerous prizes, including the Kodak British Award and the Kodak European Award (1990), the E.C. Eurocreation Bursary in Naples (1991), his artist-in-residence status at the Kunsthalle Rotterdam, and the Young Photographer Award of the ICP (1993).

EXHIBITIONS (Selected) — **1990** London (The Photographers' Gallery – 1994) SE // **1991** New York (Burden Gallery – 1994) SE // **1992** Philadelphia (Pennsylvania) (Museum of Art) SE // **1993** Brunswick (Germany) (Museum für Photographie) SE // Bath (Royal Photographic Society) SE // **1994** Palm Beach (Florida) (Norton Museum) SE // **1995** Salzburg (Galerie Fotohof) SE // **1996** Bradford (England) (National Museum of Photography, Film and Television) SE // **1997** New York (Holy Solomon Gallery – 1999) SE // Berlin (Neue Gesellschaft für Bildende Kunst) GE // **1999** London (Lux Gallery) SE // **2000** Genoa (Rebecca Container Gallery) SE // **2005** Paris (Galerie Marion Meyer) SE // **2006** London (Museum 52) SE // **2007** London (Whitechapel Art Gallery) SE

BIBLIOGRAPHY (Selected) — **Living Room.** New York 1991 // **Other Eden.** New York 1994 // **Weddings, Parties, Anything.** London 1996 // **On the Bright Side of Life. Zeitgenössische Britische Fotografie.** Berlin 1997 (cat. Neue Gesellschaft für Bildende Kunst) ⌐ // **Safety in Numbers.** London 1997 // **The Indecisive Memento.** London 1998 // **Smoky Motels for the Baby Jesus.** London 1999 // **Truth or Consequences.** London 2001 // **Learn How To Die The Easy Way.** London 2002 // **You Love Life.** London 2005 // **Double Dactyl.** London 2008

"Approaching the end of this millennium, could anything at all in British photography be thought of as looking 'on the bright side of life'? Indeed, one could recognize in Nick Waplington's images of families from Nottingham a certain degree of optimism. In his two books, *Living Room* (1991) and *The Wedding* (1996), the men, women, and children are shown in their typically furnished low-income homes. They make a raw first impression, but at the same time seem full of a zest for life. They surely gained nothing from the revolution under Mrs. Thatcher. Still, Nick Waplington would insist that they survived this period. Though the work Waplington started in 1995 mainly expresses desperation, one can also decipher a kind of dry humor." — Val Williams ✍

Andy Warhol *(Andrew Warhola)*

Andy Warhol: **Andy Warhol's Exposures.** London/New York (Hutchinson) 1979

6.8.1928 Pittsburgh (Pennsylvania, USA) — 22.2.1987 New York (USA)
Commercial artist, painter, printmaker, filmmaker, and photographer. Internationally best-known exponent of Pop Art in the USA. Child of immigrants from what is now Slovakia, his father a construction worker. 1942 art instruction at Carnegie Institute of Technology. 1945–1949 studies art at the institute (majors in Visual Design). 1949 obtains diploma. In the same year moves to New York. First illustrations for the magazine *Glamour*. Results in drawing assignments for *Vogue*, *Seventeen*, *The New Yorker*, *Harper's Bazaar*, Tiffany & Co., Bergdorf Goodman, Bonwit Teller, and I. Miller. 1952 first solo exhibition in the Hugo Gallery in New York (*Fifteen drawings …*). 1960 turns away from commercial art (to that date has had great success) . Turns his attention towards Pop Art. Produces first Coca-Cola pictures and Campbell's soup cans. Also "disaster" and so-called Do-It-Yourself pictures. Beginning 1962 produces Elvis Presley and Marilyn Monroe portraits. Discovers how to incorporate the silkscreen technique. 1963 purchases 16mm movie camera. Shoots *Sleep* as the first of numerous "Underground" movies. In the same year takes first photo-booth pictures. Moves into a studio at 231 East 47th Street (known as the "Factory"). Takes his first Polaroid photos. Beginning 1966 organizes multimedia events under the heading *The Erupting* (later *Exploding*) *Plastic Inevitable* (together with Nico and the group Velvet Underground). 1968 seriously injured after an assassination attempt by the radical feminist Valerie Solana. 1969 first issue of the magazine *Interview* edited by A.W., Gerard Malanga, Paul Morrissey, and John Wilcock. Beginning 1972 commissioned portraits include those for Truman Capote, Mick Jagger, and Michael Jackson. Dies following routine gall bladder surgery. Since the 1960s represented in practically every major art museum. 1989 first posthumous retrospective, at the Museum of Modern Art (New York). 1999 photographic work exhibited in Hamburg (Kunsthalle) and Pittsburgh (The Andy Warhol Museum).

EXHIBITIONS (Selected) — **1980** Cologne (Museum Ludwig/ A.W.: Fotografien) SE // Amsterdam (Stedelijk Museum/A.W.'s Exposures) SE // London (Lisson Gallery/A.W.: Photographs) SE // **1987** New York (Robert Miller Gallery/A.W.: Photographs) SE // **1989** New York (Museum of Modern Art/A.W.: A Retrospective) SE // **1992** Stuttgart (Württembergischer Kunstverein/ A.W.: Social Disease) SE // **1999** Hamburg (Kunsthalle/ A.W.: Photography) SE // **2004** Hannover (Sprengel Museum) SE // Brunswick (Germany) (Museum für Photographie/Polaroids) SE // **2005** Paris (Maison européenne de la photographie/**Polaroids**) SE // Buenos Aires (Malba Museum — Coleccion Costantini) SE // Washington, DC (Corcoran Gallery of Art) SE // **2007** Amsterdam (Stedelijk Museum Post CS) SE // **2008** Stockholm (Moderna Museet) SE

BIBLIOGRAPHY (Selected) — A.W. and Gerard Malanga: **Screen Tests. A Diary.** New York 1967 // **A.W.'s Exposures.** London/ New York 1979 // **A.W.'s Party Book.** New York 1988 // **A.W.: A Retrospective.** New York 1989 (cat. Museum of Modern Art) // Karl Steinorth and Thomas Buchsteiner (eds): **A.W.: Social Disease. Photographs 1976–1979.** Ostfildern near Stuttgart 1992 (cat. Württembergischer Kunstverein) // **A.W.: Photography.** Thalwil/Zurich 1999 (cat. Hamburger Kunsthalle) ✍ // **A.W.: Giant Size.** London 2006 // **A.W.: Polaroids.** Cologne 2017 // **A.W.: Seven Illustrated Books 1956–1959.** Cologne 2017

"Instead of inventing motifs for his pictures, he extracted them from photographs by other people. Repeatedly, he photographed himself in the cramped cell of the photo-booth; in the studio, he posed himself in front of the Polaroid camera. He communicated with others by photographing, incessantly and everywhere. He collected a huge amount of celebrity and fashion photographs, published his own books of photography, and shot films as though they were time-elongated photographs. To make a portrait of someone, he photographed the person. And he was photographed like no other artist this century: photography and photographing form the center of Andy Warhol's work." — Uwe M. Schneede ✍

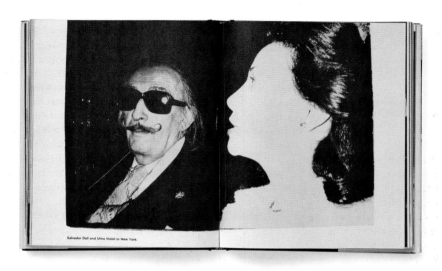

Salvador Dalí and Ultra Violet in New York.

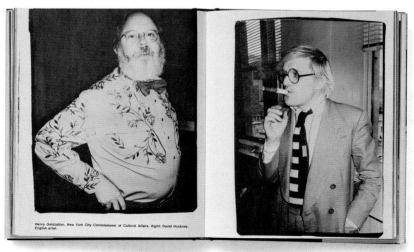

Henry Geldzahler, New York City Commissioner of Cultural Affairs. Right: David Hockney, English artist.

Albert Watson

Albert Watson: **Cyclops.**
New York (Bulfinch Press) 1994

1942 Edinburgh (Scotland) — Lives in New York (USA) Internationally sought-after fashion photographer with roots in graphic design, art, and cinema. Known as "the least-known great photographer". Also nude studies, portraits, still lifes, and landscapes. Studies Film and Television at the Royal College of Art in London. Fellow student of Tony Scott, Richard Loncraine, and cameraman Stephen Goldblatt. Takes his first photographs at the end of the 1960s. Up to today his work crosses the borders between photography, film, and television, suggesting references to > LaChapelle and Perry Ogden. At the same time an innovative fashion photographer influenced by pop culture, the visual arts, and movies, while clearly oriented towards classical ideals and interested in masterly work done by hand in the process. 1971 moves to Los Angeles. Also begins his ascent to being one of the most-contracted fashion and advertising photographers of his generation. To date over 250 *Vogue* titles and more than 600 campaigns for labels such as Gap, Levi's, Chanel, Prada, Revlon, and Christian Dior. Publications in practically every major magazine. Picture spreads in *Harper's Bazaar*, *Rolling Stone*, *The Face*, *Interview*, *i-D*, *Arena*, and *Time*. As "the great unknown" or "the greatest little-known" photographer, frequently somewhat in the shadows of more prominent colleagues. After publishing his acclaimed illustrated book *Cyclops* (with typography by David Carson), A.W. is recognized as a major creative figure straddling art and design. *www.albertwatson.net*

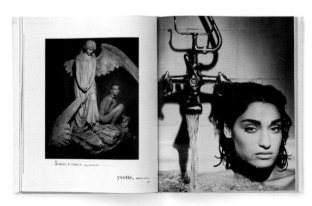

EXHIBITIONS (Selected) — **2002** Rostock (Germany) (Kunsthalle) SE // **2005** Vienna (KunstHaus) SE // **2006** New York (401 Projects) SE // Edinburgh (City Art Centre) SE // **2007** Antwerp (Museum voor Fotografie) SE // **2008** London (Hamiltons) SE // Düsseldorf (NRW-Forum) SE // Berlin (Camera Work) SE // **2012** Hamburg (Haus der Photographie, Deichtorhallen) SE

BIBLIOGRAPHY (Selected) — **Cyclops.** New York 1994 // **Rolling Stone. Gesichter des Rock & Roll.** Zurich 1995 // **Mad Dog.** Munich 1996 // **Maroc.** New York 1998 // **A.W. A.W.** Munich 2002 (cat. Kunsthalle Rostock) // Ingrid Sischy: **A.W.: The Vienna Album.** Munich 2005 // **A.W.** Hamburg 2005 (= **Stern** Portfolio no. 42) // James Crump: **A.W.** London 2007 ✐

"Albert Watson's images have the power to seduce with their pristine beauty and sophistication. In his images, technological mastery serves a rigorous aesthetic program, where genres literally bend and weave together, and subjects defy simple categorization: a Watson nude, for instance, is a still life, is a landscape, is a portrait, is a fashion picture. His pictures lie at the crossroads of sensuality and objectivity; they inhabit a site located between intense and sometimes lurid colors, together with hues of rich sepia, recalling earlier eras when hand-craftsmanship still imbued photographic printmaking. Many of Watson's images are iconic representations meanwhile burned into our collective memory: a nude portrait of supermodel Kate Moss, the back of boxer Mike Tyson's head, a NASA spacesuit, or a group portrait of the band Nine Inch Nails. Together, these images suggest the range of content and representational style in Watson's diverse oeuvre. More importantly, they reveal a forcefully minimal visual language informed by graphic design, filmmaking, the history of painting, and the incredibly broad cultural awareness gained through Watson's travels around the world." — James Crump ✍

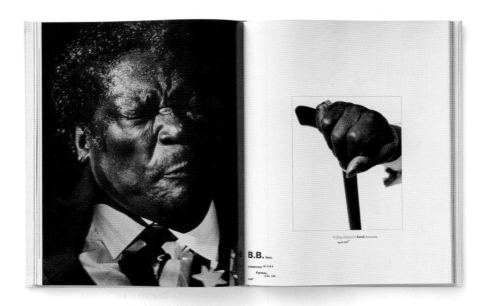

Alex Webb

Alex Webb: **Under a Grudging Sun.**
New York (Thames and Hudson)
1989

5.5.1952 San Francisco (USA) — Lives in Brooklyn (New York, USA)
Magnum member. Known for intensely colorful photo essays and reportages showing life under the Southern sun (in Haiti, along the Amazon River, Florida, and elsewhere). Budding interest in photography in his youth. 1972 attends Apiron Photography Workshop conducted by Charles Harbutt. Studies history and literature at Harvard. 1974 obtains B.A. and begins professional career as photojournalist. Initially captures small-town everyday life in the US American South (b/w photos). From 1979 completes freely developed essays and reportages from the Caribbean, Latin America, and Africa. 1976 associate membership at Magnum. Full membership since 1979. Numerous publications incl. those in *Geo*, *Life*, *The New York Times Magazine*, *Stern*, and *National Geographic*. Numerous exhibitions in USA and abroad. Prizes and honors include the Leopold Godowski Color Photography Award (1988), the NEA (National Endowment for the Arts) Fellowship (1990), Hasselblad Foundation Grant (1998), Leica Medal of Excellence (2000), and David Octavius Hill Medal of the Deutsche Fotografische Akademie (2002).

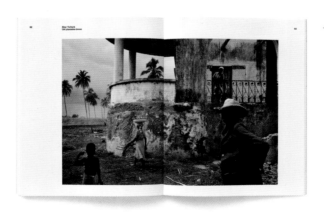

BIBLIOGRAPHY (Selected) — **Hot Light/Half-made World**. New York 1986 // **Under a Grudging Sun**. New York 1989 // Max Kozloff: "Picturing the Killing Fields". In: **Art in America**, June 1990 ✍ // **From the Sunshine State**. New York 1996 // **Amazon**. New York 1997 // **Crossings: Photographs from the U.S.-Mexico Border**. New York 2003 // **A.W. Habla con Max Kozloff**. Madrid 2003 // **Istanbul: City of a Hundred Names**. New York 2007

"Perhaps a new category needs to be established to define pictures as hybrid as Webb's and those of a few other Magnum photographers. As something to look at and as something to incite feelings, these images outdistance any of the photography seen in American galleries in the 1980s. But if they are not so much in an artistic limbo, they exist in a media limbo. This is imagery still very much in search of an audience." — Max Kozloff ✍🏻

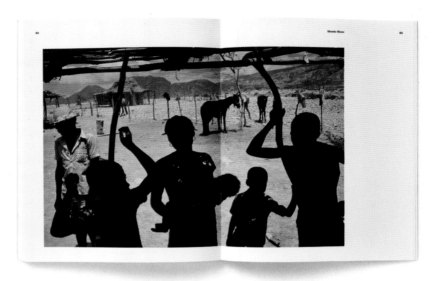

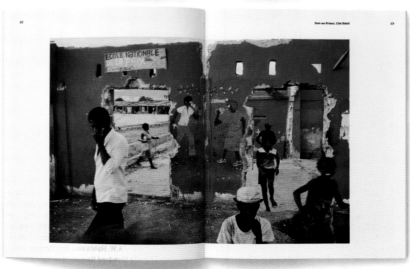

Bruce Weber

Bruce Weber.
New York (Alfred A. Knopf Inc.)
1988

29.3.1946 Greensburg (Pennsylvania, USA) — Lives in New York (USA)
Fashion, beauty, and portrait photography, frequently engaging a charged homoerotic visual language schooled in Hellenistic ideals. Cult photographer of the 1980s and 90s. Studies art and theater at Denison University in Ohio. Studies film at Princeton University in New Jersey. Befriends > Arbus and attends the course by > Model at the New School for Social Research. Changes to photography. 1973 undertakes first works, for *Men's Wear*. Then the catalogue for Jordan Marsh, Boston (hailed as "best catalogue of the year"). 1980 two larger fashion spreads for British *Vogue* (shot in Greece and Australia) as breakthrough for the "most influential figure in fashion photography in the 1980s" (Martin Harrison). 1989 photography for Ralph Lauren's fall catalogue. Additional trendsetting campaigns for Calvin Klein, Valentino, Versace, Lagerfeld, and Comme des Garçons. Editorials for *Interview*, *Details*, and *Per Lui*. 1983 around 250 American participants in the Olympic Games for *Interview* (1984). In the same year voted fashion photographer of the year by American Society of Media Photographers. 1994 Applied Photography Award of the ICP for his Banana Republic and Ralph Lauren campaigns. Designs 1998 Pirelli Calendar (including portraits of Kris Kristofferson, John Malkovich, and Fred Ward). Shoots documentary film on boxing (*Broken Noses*, 1987) and a film homage to jazz trumpeter Chet Baker (*Let's Get Lost*, 1988). The latter screened at the film festival in Cannes (May 2008) as part of the Cannes Classic Series. Since 2003 presents his own fashion label, Weberbilt. Creates music videos with the Pet Shop Boys (*I Get Along*, 2002) and others. Most recent editorial photography includes his work for *W Magazine*, *Vogue* (France and Italy), *L'Uomo Vogue*, and *V Magazine*. *www.bruceweber.com*

EXHIBITIONS (Selected) — **1974** New York (Razor Gallery) SE // **1984** New York (Robert Miller Gallery) SE // London (Olympus Gallery) SE // **1985** London (Victoria and Albert Museum – 1991) GE // **1986** Basel (Kunsthalle) SE // **1988** Arles (Rencontres internationales de la photographie) SE // London (Victoria and Albert Museum/**Photography Now**) GE // **1991** Los Angeles (Fahey/Klein – 2005) SE // **1992** Cahors (France) (Le Printemps de la Photo) SE // **1997** London (National Portrait Gallery – 2008) SE/GE // **2008** Hamburg (Haus der Photographie/Deichtorhallen) GE

BIBLIOGRAPHY (Selected) — **B.W.** Los Angeles 1983 // **O Rio de Janeiro.** New York 1986 // **The Andy Book.** Tokyo 1987 // **Let's** Get Lost: Starring Chet Baker. New York 1988 // **B.W.** New York 1989 // Martin Harrison: **Appearances: Fashion Photography since 1945.** London 1991 (cat. Victoria and Albert Museum) // **Hotel Room with a View.** Washington, DC/London 1992 // **Gentle Giants: A Book of Newfoundlands.** New York 1994 // **A House is Not a Home.** Boston 1996 // **Banded Youth and Other Stories.** Boston/London 1997 (cat. National Portrait Gallery) // **The Chop Suey Club.** Santa Fe 1999 // **Roadside America.** Hamburg 2000 (= **Stern** Portfolio no. 22) // **Blood, Sweat & Tears: Or How I Stopped Worrying and Learned to Love Fashion.** Kempen 2005 // **All-American VII: 'Till I Get It Right.** New York 2007 // **Vanity Fair Portraits. Photographs 1913–2008.** London 2008 (cat. National Portrait Gallery)

"Together with Robert Mapplethorpe, Bruce Weber has changed the terms on which men have been photographed. Both looked at men in a manner which until now was only found acceptable when men gazed at women. In Weber's case, however, while male sexuality might be portrayed as uninhibitedly physical and romantically sensual, it's equally expressed in a spirit of fun or camaraderie." — Martin Harrison ✍

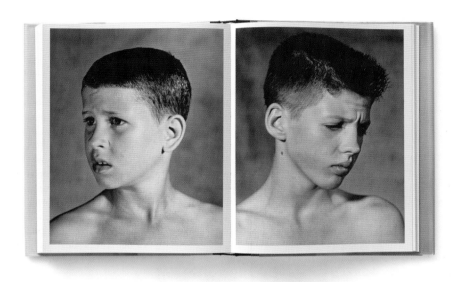

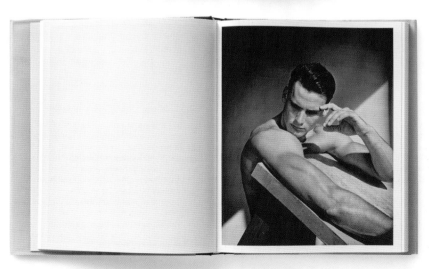

Weegee *(Usher / Arthur H. Fellig)*

Weegee: **Naked City.**
New York (Essential Books) 1945

12.6.1899 Zloczew (Austria, today Poland) — 26.12.1968 New York (USA) Legendary photographer of the 1930s. Chronicler of a violent era and the prototype of the astute photojournalist. 1910 moves with his family to USA. Attends school on the Lower East Side in New York. Leaves school at the age of 14. Works as confectionery salesman, street photographer, and assistant to a photo dealer. Moves out of family apartment at age 18. Unskilled laborer then gets work as passport photographer. 1925–1935 lab assistant at Acme Newspictures. First assignments as photojournalist. 1930 first camera of his own (Speed Graphic). Beginning 1935 freelance press photographer. Specializes in photographing traffic accidents at night, fires, and crimes of violence. Until 1945 produces around 5,000 reportages from the district of the Manhattan Police Headquarters. 1945 publishes his first book, *Naked City.* 1947 film adaptation of book's material. Film advisor in Hollywood, plays smaller roles, and develops concept of the volume *Naked Hollywood.* Also creates photographic caricatures of cultural and political celebrities. In the 1960s commissioned work includes photo reports for the *Daily Mirror* from Europe. Several films by and about W., the last being Howard Franklin's *The Reporter.* 1997 comprehensive retrospective in the International Center of Photography.

"The city was his territory, the night his sphere. Weegee listened in on police communications over the radio and usually reached the crime scene long before the professional reporters. His images illuminate the depths of human existence and the psyche of individuals as much as they do social damnation. His style is characterized by a brutal realism which relies less on compositional precision. Hard contrasts determine his pictures. Even when, on the surface, this is the result of circumstances that had to be reproduced in daily tabloids, it reflects – perhaps involuntarily – his artistic nature." — Klaus Honnef ✍

EXHIBITIONS (Selected) — **1944** New York (Photo League) SE // **1962** Cologne (photokina) SE // **1977** New York (International Center of Photography – 1997) SE // **1979** Zurich (Nikon Fotogalerie) SE // **1984** San Francisco (Museum of Modern Art) SE // **1992** Bonn (Kunst- und Ausstellungshalle der BRD) GE // **1999** Madrid (PHotoEspaña) SE // **2006** New York (International Center of Photography) SE // **2007** Paris (Musée Maillol) SE // **2008** Montpellier (France) (Le Pavillon Populaire) SE // **2013** Salzburg (Museum der Moderne) GE

W.'s Creative Camera. New York 1959 // **W. by W.** New York 1961 // **W.'s Creative Photography.** London 1964 // Louis Stettner: **W.** New York 1977 // **W.'s New York.** Munich 1982 // Jane Livingston: **The New York School.** New York 1992 // Klaus Honnef: **Pantheon der Photographie im XX. Jahrhundert.** Bonn 1992 (cat. Kunst- und Ausstellungshalle der BRD) ✍ // **Unknown Weegee.** Göttingen 2006 (cat. International Center of Photography) // **W. dans la collection Berinson.** Paris 2007 (cat. Musée Maillol) // Anthony W. Lee and Richard Meyer: **W. and the Naked City.** Berkeley/Los Angeles/London 2008 // **Focus on Photography.** Munich 2013 (cat. Museum der Moderne, Salzburg)

BIBLIOGRAPHY (Selected) — **Naked City.** New York 1945 // **W.'s People.** New York 1946 // **Naked Hollywood.** New York 1953 // **W.'s Secrets of Shooting with Photo Flash.** New York 1953 //

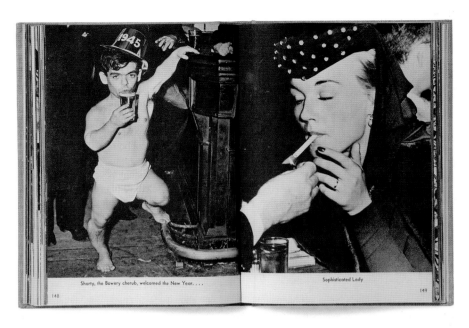

Shorty, the Bowery cherub, welcomed the New Year. . . .

148

Sophisticated Lady

149

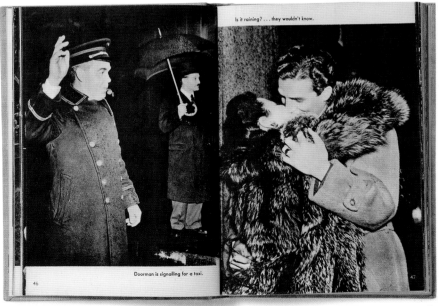

Is it raining? . . . they wouldn't know.

Doorman is signalling for a taxi.

46

47

Brett *(Theodore)* Weston

Brett Weston: **Voyage of the Eye.**
New York (Aperture) 1975

16.12.1911 Los Angeles (USA) — 22.1.1993 Hawaii (USA) Nature stud-
ies and landscapes with an increasing tendency towards abstraction.
Most prominent son of Edward Weston and for many years responsi-
ble for printing his photographs. Second of four sons born to Flora and
Edward Weston. 1925 moves to Mexico to live with his father. Meets
Diego Rivera, José Clemente Orozco, and > Modotti. Takes his first
ambitious photographs, using E.W.'s professional camera (Graflex).
1927 first solo exhibition. 1928 opens a portrait studio with E.W. in
Glendale (California). Results in regularly carrying out darkroom work
for his father. 1929 represented with 18 works at the exhibition *Film
und Foto* in Stuttgart. 1932 participates in first exhibition of the f/64
group (though not a member). 1935 opens another studio with his
father in Santa Monica Canyon (California). 1941–1942 industrial
photography for North American Aviation and Douglas Aircraft. 1943
camera assistant for 20th Century Fox. Completes portfolios of personal work at the same time. 1945
Guggenheim fellowship. 1952 and 1955, supervised by his (already ill) father, works on two of E.W.'s
portfolios documenting his life achievement (in total 7,600 images). 1960 longer stays in Europe.
1966–1967 portfolio of his "hundred best photographs". 1973 receives NEH (National Endowment
for the Humanities) grant for a photography project in Alaska. 1975 *Fifty Years in Photography*: com-
prehensive touring exhibition curated by Beaumont Newhall opens at the University of New Mexico.
Altogether more than 100 solo exhibitions in his lifetime. Numerous publications include those in *U.S.
Camera* (1935, 1936, 1939, 1940, 1942, 1950, 1952, 1953, 1956, 1957, 1960, 1961, and 1962). On
his 80th birthday deliberately destroys all his negatives (to ensure others can't print his photo-
graphs). Spends his last years in Hawaii. *www.brettwestonarchive.com*

EXHIBITIONS (Selected) — **1927** Los Angeles (Jake Zeitlin Gal-
lery – 1930, 1936) SE // **1929** Stuttgart (**Film und Foto**) GE //
1932 San Francisco (M.H. de Young Memorial Museum) SE/GE
(**f/64**) // **1935** New York (Julien Levy Gallery) SE // **1937** San
Francisco (Museum of Art – 1950) SE // **1947** Princeton (New
Jersey) (University Library) SE // **1952** Santa Barbara (Cali-
fornia) (Museum) SE // **1953** Chicago (Illinois) (Art Institute)
SE // **1966** Fort Worth (Texas) (Amon Carter Museum) SE //
1971 Carmel (California) (Friends of Photography) SE // **1983**
San Francisco (San Francisco Museum of Modern Art) SE //
2004 San Francisco (Robert Koch Gallery) SE // Tokyo (Tokyo
Photographic Culture Centre) SE // **2007** Carmel (California)
(Weston Gallery) SE // **2008** San Francisco (Scott Nichols Gal-
lery) SE // Oklahoma City (Oklahoma City Museum of Art) SE //
Washington, DC (The Phillips Collection) SE

BIBLIOGRAPHY (Selected) — **B.W.: Photographs.** Fort Worth (cat.
Amon Carter Museum) // **B.W.: Voyage of the Eye.** New York
1975 // **Landscape: Theory.** New York 1980 // **B.W.: Photo-
graphs From Five Decades.** New York 1980 // **B.W.: A Personal
Selection.** Carmel 1986 // **B.W.: Master Photographer.** Carmel
1989 ✍ // **Hawaii: Fifty Photographs by B.W.** Carmel 1992 //
Dune: Edward & B.W. [no location] 2003 // **San Francisco.**
Revere 2004 // **White Sands.** Revere 2005 // **New York.** Revere
2006 // **Fifteen Photographs.** Revere 2007 // **Out of the
Shadow.** Oklahoma 2008 (cat. Oklahoma City Museum of Art)

"Brett Weston has carried on a love affair with photography since the age of 13. He has given us sensual pleasure with his technical prowess, and assigned heroic qualities to subjects which usually go unnoticed by making minute adjustments in his camera's relationship to thousands of motifs. His sometimes bravura and always fluent pictures encourage us to surrender to his fictionalized world. While sometimes perplexing, the intense emotionality of Brett Weston's photographs often make us draw back from them in order to reflect. This is mainly because there is no sense of visual confinement or the slightest limits to the intuitive levels of imagination in his work." — Van Deren Coke

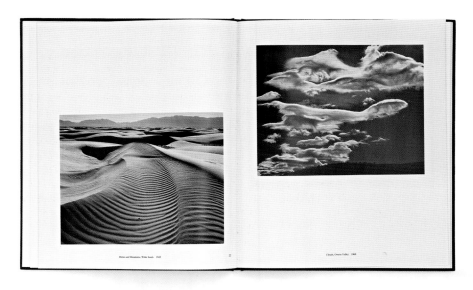

Minor White

9.7.1908 Minneapolis (Minnesota, USA) — 24.6.1976 Boston (Massachusetts, USA) Theoretician and teacher, long-time editor of *Aperture* magazine as well as the author of an oeuvre influenced by Alfred Stieglitz. One of the most influential art figures in America in the 1950s and 60s. Interested in photography early on. First camera already at eight. 1928–1933 studies botany at the University of Minnesota. 1933–1938 various jobs as barman, waiter, night porter. At the same time assistant in a photo studio in Portland (Oregon). 1942–1945 infantryman in the Philippines. 1945–1946 studies art history at Columbia University, New York. Photographer at MoMA (New York) under Beaumont and Nancy Newhall. Meets > Callahan, > Stieglitz, and > Strand. 1947 joins the New York Photo League. 1952 with > Ansel Adams, > Lange, Beaumont Newhall and others founds the magazine *Aperture* in San Francisco. 1953–1957 works at the George Eastman House in Rochester. Editor of the magazine *Image*. 1955–1964 teaches photography and photojournalism at the Rochester Institute of Technology. 1965–1976 professor at the Massachusetts Institute of Technology, Cambridge. Numerous contributions incl. in *Photo Notes*, *American Photography*, *Art in America*, *Image*, *Aperture*. Guggenheim Fellowship 1970. In the same year major retrospective in the Philadelphia Museum of Art.

Minor White: **Mirrors, Messages, Manifestations.** New York (Aperture) 1969

EXHIBITIONS (Selected) — **1942** Portland (Portland Art Museum) SE // **1948** San Francisco (San Francisco Museum of Art – 1950, 1952, 1957) SE // **1950** New York (Photo League) SE // **1954** New York (Limelight Gallery – 1957, 1959) SE // **1955** San Francisco (The Photographers' Gallery) SE // **1964** New York (Underground Gallery) SE // **1965** New York (Gallery 216) SE // **1966** Hillsboro (New Hampshire) (Lotte Jacobi Gallery) SE // **1970** Philadelphia (Philadelphia Museum of Art/**Retrospective**) SE // **1980** London (Visions Gallery) SE // **2000** Salzburg (Austria) (Rupertinum) SE // **2001** Milan (Galleria Gruppo Credito Valtellinese) SE // Modena (Städtische Galerie) SE // **2004** Paris (Galerie Nicole et Léon Herschtritt) GE // Tucson (Arizona) (Center for Creative Photography) GE // Yokohama (Japan) (Museum of Art/**American Photographs from 1900 to 1970**) GE // Santiago de Compostela (Fundación Pedro Barrié de la Maza) GE // **2005** New York (Alan Klotz Gallery/**A Sense of Abstraction**) GE // **2008** New York (Howard Greenberg Gallery) SE // Lugano (Switzerland) (Museo d'Arte/**Photo20esimo**) GE // **2009** Seattle (Washington) (G. Gibson Gallery) GE // **2010** Vienna (Galerie Johannes Faber) GE

BIBLIOGRAPHY (Selected) — Nathan Lyons: **Photographers on Photography.** New York 1966 // **Mirrors, Messages, Manifestations.** New York 1969 // **Octave of Prayer.** New York 1972 // Jonathan Green and M.W.: **Celebrations.** New York/Cambridge 1974 // **Rites & Passages.** New York 1978 // Jonathan Green: **American Photography: A Critical History 1945 to the Present.** New York 1984 ✍ // Filippo Maggia: **M.W./Life is Like a Cinema of Stills.** Salzburg 2000 (cat. Rupertinum) // Nathan Lyons: **Eye Mind Spirit – The Enduring Legacy of M.W.** New York 2009 (cat. Howard Greenberg Gallery)

"White's photographs may be divided into two major categories, both having their basis in the concept of equivalence. [...] In the first category I would place those close-up records and transformations of fragments and details which provided him instant access to metaphors and signs. Here White strove for a mimetic symbolism in which one clearly discernible natural fact is made to allude to another visible reality. In the second category I would place the view and landscape photographs made out of the traditional pictorial vocabulary inherited from Stieglitz, Weston, Adams, and the popular photographer. In these photographs White attempted to convey not only grandeur and perfection but to find moments of personal revelation and psychic correspondence." — Jonathan Green ✐

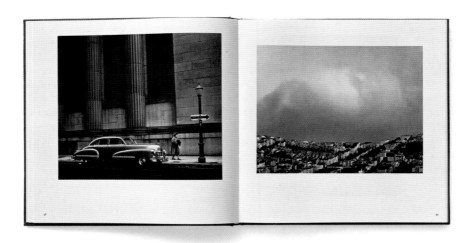

Garry Winogrand

Garry Winogrand: **The Animals**.
New York (The Museum of Modern
Art) 1969/2004

14.1.1928 New York (USA) — 19.3.1984 Tijuana (Mexico) Exploration of American everyday life engaging a clearly radical visual language. Street photography as "art". Since the 1960s, one of the most influential American photographers. 1947–1948 studies at City College, New York. Later studies art at Columbia University in New York. Takes first photographs. 1949 attends course conducted by > Brodovitch at the New School for Social Research. 1951 first assignment from *Harper's Bazaar*. 1952–63 American Society of Media Photographers member. 1964 first of three Guggenheim fellowships. 1967 participates in the group exhibition *New Documents* (curated by John Szarkowski) at MoMA, New York. 1969 publishes *The Animals*, first of three "major books" (Gilles Mora). Further important photo-historical cycles in book form are *Women are Beautiful* and *Public Relations*. 1969 travels to Europe. 1971 teaching post in Chicago (Institute of Design). 1972 returns to New York. Numerous teaching posts to follow include those in Providence (Rhode Island School of Design), Boston (Massachusetts College of Art), and New Haven (Yale University). 1973 professorship at the University of Texas (Austin). 1974 first portfolio: *G.W.* (Double Elephant Press). In the same year begins his cycle *The Great American Rodeo*. 1977 photographs in Greece. 1978 moves from Austin to Los Angeles. 1982 workshop in Arles (Rencontres internationales de la photographie). 1983 Denmark and Sweden. 1984 sudden death from cancer. 1988 retrospective in the Museum of Modern Art travels to Austin (Archer M. Huntington Art Gallery), Chicago (Art Institute), Pittsburgh (Pennsylvania) (Carnegie-Mellon University Art Gallery), Tucson (Center for Creative Photography), and San Francisco (Museum of Modern Art).

EXHIBITIONS (Selected) — **1955** New York (Museum of Modern Art/**The Family of Man**) GE // **1966** Rochester (New York) (George Eastman House/**Toward a Social Landscape**) GE // **1967** New York (Museum of Modern Art/**New Documents**) GE // **1969** New York (Museum of Modern Art – 1977, 1988) SE // **1971** New York (Light Gallery – 1972, 1975, 1977, 1979, 1981, 1984) SE // **1976** Fort Worth (Texas) (Art Museum) SE // **1980** Stockholm (Fotografiska Museet) JE (with Bruce Davidson) // San Francisco (Fraenkel Gallery – 1981, 1983, 1986) SE // **1984** Houston (Texas) (Center for Photography) SE // **1991** Paris (Centre national de la photographie) SE // **2000** Cologne (Galerie Thomas Zander – 2003, 2006) SE // London (The Photographers' Gallery) SE // **2001** Arles (Rencontres internationales de la photographie) SE // **2002** New York (International Center of Photography) SE // **2003** Chicago (The Museum of Contemporary Photography) SE // **2004** Portland (Maine) (Portland Museum of Art) SE // **2007** Phoenix (Arizona) (Phoe-nix Art Museum) SE // **2013** San Francisco (Museum of Modern Art) SE // **2014** Vienna (WestLicht) SE

BIBLIOGRAPHY (Selected) — Nathan Lyons (ed.): **Contemporary Photographers: Toward a Social Landscape**. New York // 1966 (cat. George Eastman House, Rochester) // **The Animals**. New York 1969/2004 (cat. Museum of Modern Art) // **Women Are Beautiful**. New York 1975 // **G.W.** El Cajon 1976 // **Public Relations**. New York 1977 (cat. Museum of Modern Art) // **Stock Photographs: The Fort Worth Fat Stock Show and Rodeo**. Austin 1980 // Jonathan Green: **American Photography. A Critical History 1945 to the Present**. New York 1984 // **The Uneasy Streets of G.W.** San Francisco 1999 (cat. Fraenkel Gallery // Gilles Mora: **The Last Photographic Heroes: American Photographers of the Sixties and Seventies**. New York 2007 ✍ // **G.W.** San Francisco 2013 (cat. San Francisco Museum of Modern Art)

"Aside from the content of his pictures, Winogrand's treatment of form also makes him truly fascinating. Few of his colleagues, with the exception of his friend Lee Friedlander, put so much time and energy into interpreting the true nature of the connection between photography and reality – to the point of reversing the usual relationship between them. For Winogrand, the world only existed after it had been photographed. Therefore, our knowledge of the world was beholden to that responsibility. Awed by the transformation of the real into the photographic, Winogrand found his best expression in street photography and its constant flow of images, through the aggressiveness of picture-taking and its obsessive repetition, but also thanks to the dynamic exchange between the photographer and his subjects." — Gilles Mora

Joel-Peter Witkin

Joel-Peter Witkin.
Madrid (Museo Nacional Centro
de Arte Reina Sofía) 1988

13.9.1939 Brooklyn (New York, USA) — Lives in Albuquerque (New Mexico, USA) Hermaphrodites, dwarfs, victims of AIDS, and amputees are the protagonists in his postmodern tableaux. Since the 1980s, one of the most internationally controversial photographers. Child of a Jewish father and Catholic mother. Takes his first photographs at age 16. 1961–1964 military service as war correspondent. Returns to New York and works freelance in various photo studios. Studies sculpture at the Cooper Union School of Fine Art (B.F.A.). 1969 first solo exhibition at Moore College of Art (Philadelphia). 1974 receives SCAP grant for photography. 1975 moves to Albuquerque. 1976 studies photography at the University of New Mexico. Influenced by > Arbus and > Weegee. 1986 M.F.A. 1984 widely acclaimed solo exhibition at Pace/MacGill in New York. At the same time his international breakthrough. Frequently referred to as "the most controversial photographer working today" (Hal Fischer). Clearly the creator of a much discussed oeuvre equally indebted to religious thinking and the history of painting (referencing Hieronymus Bosch, Velázquez, and Goya). Post-processes photographic work by hand in the darkroom. Numerous prizes. Also editor of several publications on the history of medical photography (*Masterpieces of Medical Photography*, 1987; *Harms Way*, 1994). 1989 participates in the programmatic exhibition *Das konstruierte Bild* at the Munich Kunstverein.

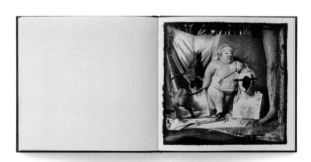

EXHIBITIONS (Selected) — **1982** Paris (Galerie Texbraun) SE // **1983** Amsterdam (Stedelijk Museum) SE // **1984** New York (Pace/MacGill Gallery – 1985, 1987, 1989, 1991, 1993, 1995) SE // **1985** San Francisco (Museum of Modern Art) SE // **1988** Madrid (Museo Nacional Centro de Arte Reina Sofía) SE // **1989** Paris (Centre national de la photographie) SE // **1993** Cahors (France) (Le Printemps de la Photo) SE // **2000** Paris (Hôtel de Sully) SE // Paris (Galerie Baudoin Lebon – 2004, 2007) SE // **2003** Madrid (Circulo de Bellas Artes) SE // **2005** Moscow (Moscow House of Photography) SE // **2007** Seravezza (Italy) (Palazzo Mediceo di Seravezza) SE // **2008** Milan (Padiglione d'Arte Contemporanea) SE

BIBLIOGRAPHY (Selected) — **J.-P.W.** Pasadena 1985 // **J.-P.W.** Madrid 1988 (cat. Museo Nacional Centro de Arte Reina Sofía) // **Gods of Earth and Heaven.** Altadena 1989 // **W.** Paris 1991 (cat. Galerie Baudoin Lebon) // **J.-P.W.** Paris 1991 (= Photo Poche no. 49) // **Fragments.** Cahors 1993 (cat. Le Printemps de la Photo) // **W.** Zurich 1995 // **Disciple et maître.** Paris 2000 (cat. Hôtel de Sully) // **Œuvres récentes 1998–1999.** Paris 2000 (cat. Galerie Baudoin Lebon)

"Witkin's work was first exhibited in 1980 and has since then exerted a great appeal because of its absolute originality and often disturbing overall effect. Witkin shows us a personal universe at the far end of nightmares, a world of silent suffering, which, in his own words, is a prayer directed at God. This work is profoundly religious, and the seemingly monstrous bodies it harbors, the collected human afflictions and deformities, the stray appendages, and grotesque attitudes are meant be understood as a dark but fervent hymn to the beauty of all individuals created by God, even those most unworthy of depiction." — Régis Durand ✍️

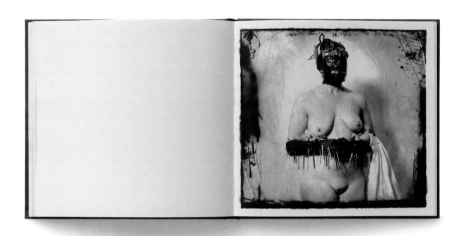

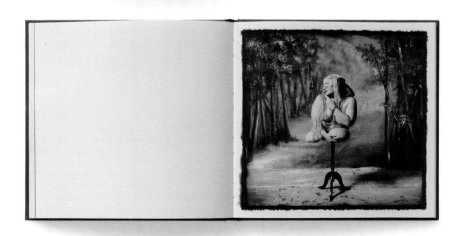

Reinhart Wolf

Reinhart Wolf: **New York.**
Hamburg (Stern Verlag) 1980

1.8.1930 Berlin (Germany) — 10.11.1988 Hamburg (Germany) Doyen of photography design in Germany, specializing in architecture, still lifes, and food photography. 1942–1950 attends school in Bremen. 1950–1951 studies literature, art history, and psychology in the USA. Acquaints himself with the work of Edward Weston and > Penn, both enduring influences on R.W.'s work. 1951–1955 continues his studies in Hamburg and Paris. Work on acclaimed artist portrait series (b/w) includes portraits of Max Ernst, Alberto Giacometti, and Fernand Léger. 1954 appointed to the GDL (German Photographic Academy). Definitively turns his attention toward photography. Attends the A. Schwoerer School of Photography in Hamburg. Postgraduate studies at the Bavarian State Academy of Photography in Munich. 1956 Masters certificate examination. 1956–1957 teaches photography at the fashion-design school Meisterschule für Mode in Hamburg and accepts visiting professorships at various colleges. 1958 founds an advertising agency in Hamburg. Numerous campaigns incl. those for Tchibo, Volkswagen, Reemtsma, and Deutsche Bank. Increasingly undertakes editorial photo assignments (*Stern*, *Geo*, *Schöner Wohnen*, and *Der Feinschmecker*) as well as personal projects. Numerous prizes include the 1982 Kulturpreis of the DGPh (German Photographic Association) and several medals conferred by the ADC (Art Directors Club) of Germany and New York. 1964 founding member of ADC (Art Directors Club) Germany and 1975–1976 its president.

"His life was all work and play. As meticulously as he served the former, he gave in with relish to the latter. Reinhart Wolf was one of Germany's most committed advertising photographers. Yet he was known worldwide on the basis of a different kind of image. […] One remembers him for magazine publications covering expansive topics like New York, the façades of famous buildings, and flower studies. These were subjects he hardly took lightly, but rather prepared with the same care afforded assignments executed in the studio. Reinhart Wolf turned perfectionism into a maxim." — Hans-Eberhard Hess ✏️

EXHIBITIONS (Selected) — **1954** Bremen (Germany) (Amerikahaus) SE // **1972** Hannover (Galerie Spectrum) SE // **1977** Munich (Galerie Lange-Irschl) SE // **1984** Frankfurt am Main (Fotografie Forum) SE // **1987** Düsseldorf (Kunstverein Nordrhein-Westfalen) SE // Munich (Stadtmuseum) SE // **2005** Herford (Germany) (MARTa Herford/**Architektur 1969–1982**) SE // **2008** Paris (Galerie Verdeau/**Portraits d'Artistes**) GE

BIBLIOGRAPHY (Selected) — **Gesichter von Gebäuden.** Bremen 1980 // **New York.** Hamburg 1980 // **Castillos.** Munich 1983 // **China und seine Küche.** Munich 1986 // **Japan. Kultur des Essens.** Munich 1986 // **Einblick/Ausblick.** Munich 1985 (cat. Munich photo symposium) // Hans-Eberhard Hess: **R.W.** Hamburg 1992 ✏️

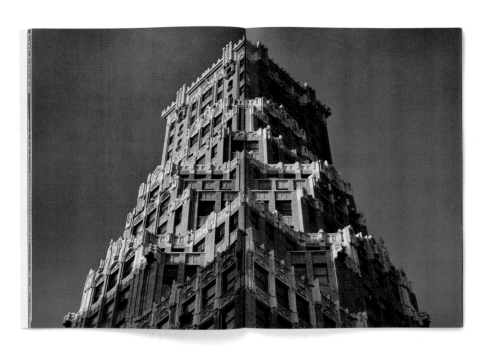

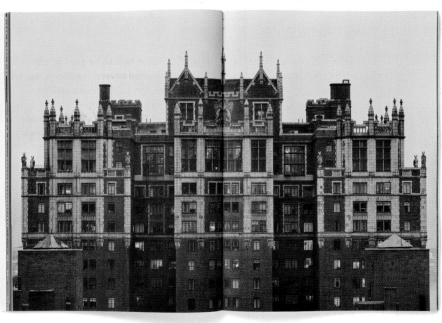

Paul *(Heinrich August)* Wolff

Paul Wolff: **Meine Erfahrungen mit der Leica.** Frankfurt am Main [H. Bechhold] 1934

19.2.1887 Mülhausen (today Mulhouse, France) — 10.4.1951 Frankfurt am Main (Germany) Industrial reportages, nature studies, and cityscapes. Author of successful illustrated volumes and photo advisor. Known for advocating Leica photography. Already a passionate amateur photographer as a student. Studies medicine in Munich and Strasbourg (M.D.). 1914–1918 military service as a regimental doctor in France and Russia. 1919 expelled from Strasbourg and settles in Frankfurt am Main. 1920–1925 works for industrial film production. Also takes his own photographs (largely cityscapes). 1926 purchases first Leica. Intense exploration of 35mm film photography follows. 1927 together with the younger Alfred Tritschler (1905–1970) founds firm of Dr Paul Wolff & Tritschler. Industrial photography, reportages, and topographical images as main focus of the rapidly expanding business (often with as many as 20 employees). 1934 edition of programmatic book *Meine Erfahrungen mit der Leica* (7 printings, 50,000 copies). 1936 accreditation as photographer at the Olympic Games in Berlin. 1939 marries Bertha Marie Beiger, co-worker at Wolff & Tritschler. 1940 first industrial illustrated book in color, *Im Kraftfeld von Rüsselsheim* (Opel). Altogether over 200 illustrated volumes and books of photography. Until 1945 numerous reportages for industrial sector. 1943 included in the official mission to document endangered art treasures in Greater Frankfurt. 1944 bomb attack destroys his house and archive. Resettles in Braunfels (Germany). Turns his attention to nature photography (color). 35mm negatives now located in the "historical photo archive of Dr P.W. & Tritschler" in Offenburg. Larger posthumous publications in *Professional Camera*, no. 2, 1980 (*Dr Paul Wolff im Zwielicht*) and in *Leica World*, no. 1, 2001 (*Der Mann war einfach ein Begriff*).

EXHIBITIONS [Selected] — **1935** USA [touring exhibition: New York, Washington, DC, Philadelphia, Detroit, Chicago, Pittsburgh, and Boston] SE // **1957** Munich [Stadtmuseum] SE // **1980** Frankfurt am Main [Stadtarchiv – 1987] SE // **1991** Tokyo [Bürgergalerie Shinjuku] SE // **1992** Dresden [Johanneum] SE // **1994** Frankfurt am Main [Institut für Stadtgeschichte] SE // **1995** Frankfurt am Main [Historisches Museum] SE // **1997** Bonn [Kunst- und Ausstellungshalle der BRD] GE // **1999** New York [Leica Gallery – 2001] SE // **2000** Berlin [Galerie argus fotokunst – 2004] SE // **2003** Vienna [Albertina/**Das Auge und der Apparat**] GE // Aachen [Suermondt-Ludwig-Museum] GE // 2004 Völklingen [Germany] [Weltkulturerbe Völklinger Hütte] SE // **2006** Berlin [Landesvertretung Hessen] SE // **2007** Vienna [Museum Moderner Kunst/**Laboratorium Moderne**] GE // **2014** Hamburg [Haus der Photographie, Deichtorhallen] GE

BIBLIOGRAPHY [Selected] — **Meine Erfahrungen mit der Leica.** Frankfurt am Main 1934 // **Was ich bei den Olympischen Spielen 1936 sah.** Berlin 1936 // **Arbeit!** Berlin/Frankfurt am Main 1937 // **Im Kraftfeld von Rüsselsheim.** Munich 1940 // **Meine Erfahrungen ... farbig.** Frankfurt am Main 1942 // **Frankfurt in Fotografien von P.W. 1927–1943.** Munich 1991 // **Deutsche Fotografie. Macht eines Mediums 1870–1970.** Bonn 1997 [cat. Kunst- und Ausstellungshalle der BRD] *⌀* // **Les Jeux Olympiques** Berlin 1936. Strasbourg 1999 // Monika Faber and Klaus Albrecht Schröder [eds]: **Das Auge und der Apparat. Die Foto-sammlung der Albertina.** Ostfildern-Ruit 2003 [cat. Albertina, Vienna] // **Augen auf! 100 Jahre Leica.** Heidelberg 2014 [cat. Haus der Photographie, Deichtorhallen Hamburg]

"Wolff's specialty was to link professional and extravagant image production with results suggesting an amateurish first impression; his images gave the appearance that anyone with similar means could experience and imitate them. This was especially true of countless works that Wolff made in settings happened upon while traveling. Photography and traveling are inextricably linked provided the medium and means of transportation exist." — Rolf Sachsse ✍

Wols *(Alfred Otto Wolfgang Schulze)*

Wols Photographs.
Cambridge, Massachussetts
(cat. Busch Reisinger Museum)
1999

27.5.1913 Berlin (Germany) — 1.9.1951 Champigny-sur-Marne (France) Prematurely deceased maverick of the avant-garde around 1930. Painter, draftsman, and photographer. Founder of Art Informel. As art photographer, strongly linked to Surrealism. Son of a high-ranking state official of Saxony. First of three children. Family has strong ties to Dresden's art scene (Otto Dix, > Erfurth, Oskar Kokoschka, Heinrich Tessenow). First camera at age 11. Takes first photographs and creates first montages. Also strong affinity to painting, drawing, and music. High-school training (discontinued). 1932 moves to Berlin. Begins studying under photographer Genja Jonas. In the same year moves to Paris and makes contact with the avant-garde artists around Hans Arp, Alexander Calder, Theo van Doesburg, César Domela, Fernand Léger, Amédée Ozenfant, Tristan Tzara. His photography intensifies: street scenes, vagabonds, rain-drenched cobblestones, walls of buildings covered with poster fragments (anticipating the later art of the *décollage*). 1933–1935 spends period in Spain with Gréty, later his wife. 1937 official photographer for the Pavillon de l'Élégance at the Paris World's Fair: produces photographs of exhibition spaces laden with surreal overtones which are the best-received works in his lifetime. Publications in *Harper's Bazaar*, *Vogue*, *Fémina*, and *Jardin des Modes*. Adopts the abbreviation of his name: Wols. 1937 first solo exhibition in the Galerie de la Pléiade. Internment at the beginning of the war. Spends a period in Southern France. 1945 returns to Paris. Frenzied production of portraits and self-portraits. Minimalist still lifes: vegetables, fruit, slaughtered rabbits. Abandons photography in favor of drawing and painting. 1947 exhibition in the Drouin Gallery (Paris) where he makes his breakthrough as a painter. Drinking problem increases. Dies following a late rehabilitation. 1978 posthumous monograph launches his new reception as photographer.

EXHIBITIONS (Selected) — **1937** Paris (Galerie de la Pléiade) SE // **1961** Freiburg (Germany) (Kunstverein) SE // **1963** Frankfurt am Main (Steinernes Haus) SE // **1973** Berlin (Nationalgalerie) SE // **1979** Paris (Centre Pompidou) SE // **2002** Berlin (Galerie Berinson/**Photographien**) SE // **2003** Tokyo (Il Tempo/**Wols Photographs**) SE // **2004** Zagreb (Croatia) (Museum of Contemporary Art) SE // **2005** Vienna (Albertina) GE // **2006** Monaco (Fondation Corbeau et Renard) GE // Hamburg (Haus der Photographie/Deichtorhallen) GE // **2009** Paris (Jeu de Paume – Site Sully/**Collection Christian Bouqueret**) GE // **2013** Berlin (Martin-Gropius-Bau) SE

BIBLIOGRAPHY (Selected) — Laszlo Glozer: **W. Photograph.** Munich 1978 // **W.: Photographien.** Munich 1986 (cat. Goethe-Institut) ✍ // **Collection de photographies.** Paris 1996 (cat. Centre Pompidou) // Christian Bouqueret: **Des années folles aux années noires.** Paris 1997 // 1999 // **W. Photographs.** Cambridge, Mass. 1999 // Monika Faber and Janos Frecot (eds): **Portrait im Aufbruch. Photographie in Deutschland und Österreich 1900–1938.** Ostfildern-Ruit 2005 (cat. Albertina, Vienna) // **La trajectoire du regard. Une collection de photographies du XXe siècle.** Cologne 2006 (cat. Fondation Corbeau et Renard, Monaco) // **Paris. Capitale photographique. 1920/1940. Collection Christian Bouqueret.** Paris 2009 (cat. Jeu de Paume – Site Sully) // **Der gerettete Blick.** Ostfildern 2013 (cat. Martin-Gropius-Bau)

"The broad palette and diversity of Wols's photographic work – from urban photography in modern-day Paris with vagabonds and an illuminated Eiffel Tower to surrealistically charged objects combined to create still-life studies – could be interpreted as his search for the form of expression that corresponds to him. Initially, Wols does, in fact, practice the gaze of the other in order to simultaneously extract from this way of seeing its certainty, suggested objectivity, and virtuosity, by nullifying the distance upheld by all his role models." — Laszlo Glozer ✍

Yva *(Else Ernestine Simon geb. Neulaender)*

26.1.1900 Berlin (Germany) — 1942 Majdanek concentration camp (Poland) Fashion, advertising, and object photography. Also nude studies and portraits. With her Berlin studio, she is as prominent as she is innovative in the early 1930s. Her father a merchant, her mother a milliner in the family business. The youngest of nine children. 1925 opens a photography studio for fashion and portraits under the name of "Yva" in Berlin (locations: 17 Friedrich-Wilhelm-Strasse, 17 Bleibtreustrasse, and finally 45 Schlüterstrasse). 1926 brief collaboration with > Hajek-Halke. Explores various experimental strategies possibly inspired by Hajek-Halke (see her multiple exposures of the dancer Claire Bauroff). Report on her business appears in *Photofreund* (no. 23, 1926). Beginning 1927 publishes in *Die Dame*. Beginning 1929 regularly publishes in *Uhu*. Further publications include those in *Elegante Welt*, *Berliner Illustrirte Zeitung*, and *Das Deutsche Lichtbild*. Represented at the exhibition *Film und Foto* in Stuttgart. 1934 marries Alfred Hermann Simon (resulting in her taking over the studio's business management). 1936–1938 > Newton as her assistant. Increasingly pressured by the National Socialists. 1936 her business is officially handed over to her friend Charlotte Weidler. 1938 occupational ban. Closure of the firm. Forced to work as a radiographer in the Jewish Hospital. 1942 arrested by the Gestapo on 1 June (with her husband); on 13 June taken to the Majdanek concentration camp near Lublin and murdered there.

"Among those Berlin photographers who started their own studios during the 1920s to primarily satisfy the demand for portraits, Yva was one of the most successful. From the start, she geared her studio's profile toward commercial photography published in the press, meaning that she supplied the illustrated journals and magazines, and saw the 'great possibilities of her chosen path for industrial advertising images and posters, as well as for illustration purposes'."
— Marion Beckers and Elisabeth Moortgat ✍

EXHIBITIONS (Selected) — **1927** Berlin (Galerie Neumann-Nierendorf) SE // **1929** Stuttgart (**Film und Foto**) GE // **1980** San Francisco (Museum of Modern Art) GE // **1993** Berlin (Berlinische Galerie) GE // **1994** Essen (Germany) (Museum Folkwang) GE // **1995** Berlin (Galerie Bodo Niemann) SE // **2005** Berlin (Kunstbibliothek) GE // **2007** Washington, DC (National Gallery of Art) GE

BIBLIOGRAPHY (Selected) — Van Deren Coke: **Avant-Garde Photography in Germany 1919–1939.** San Francisco 1980 (cat. Museum of Modern Art) // Ira Buran: **E.N.-S.: Eine Berliner Fotografin der 20er und 30er Jahre.** Berlin 1992 (unpublished academic paper) // F.C. Gundlach and Uli Richter (eds): **Berlin en vogue. Berliner Mode in der Photographie.** Tübingen/Berlin 1993 (cat. Berlinische Galerie) // **Fotografieren hieß teilnehmen. Fotografinnen der Weimarer Republik.** Düsseldorf 1994 (cat. Museum Folkwang) // **Y.: Photographien 1925–1938.** Tübingen 2001 (cat. Das Verborgene Museum, Berlin) ✍ // Christine Kühn: **Neues Sehen in Berlin. Fotografie der Zwanziger Jahre.** Berlin 2005 (cat. Kunstbibliothek) // Matthew S. Witkovsky: **Foto: Modernity in Central Europe, 1918–1945.** Washington, DC 2007 (cat. National Gallery of Art)

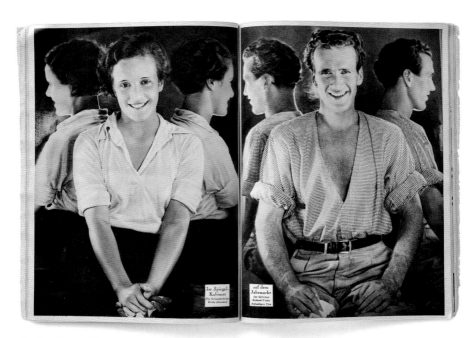

Yva, from: **Uhu,** no. 12,
September 1932

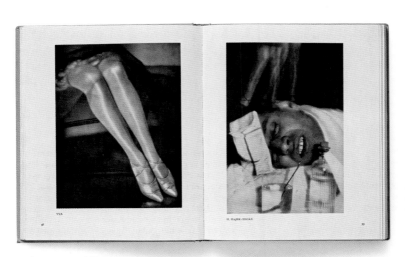

Yva (left-hand page): **Untitled,**
from: **Das Deutsche Lichtbild,** 1931

Alexander *(Solomonovitch)* Zhitomirsky

Alexander Zhitomirsky (design),
from: **Stroim**, no. 19, 1936

1907 Rostov-on-Don (Russia) — 1993 Moscow (Russia) Leading agit-prop artist in the Soviet Union. Pioneer of the photomontage used for ads and political propaganda. Poster artist, book, and magazine designer. Loses his father (pharmacist) in the Russian Civil War (1917–1922). Shows an early interest in the visual arts. First surface used for his "applied" work is the billboard for a local business selling colonial wares. Moves to Moscow at age 17. Studies painting at the art studios of the AHRR (Association of Artists of Revolutionary Russia). Beginning 1925 works for the Soviet Press. Produces illustrations and posters. Beginning 1930 creates caricatures for *ROST* and *Rabochaya Gazeta* ("newspaper for the working class"). 1930–1931 continues his training in the Favorskij Studio. 1931–1932 attends course conducted by > Heartfield (whom A.Z. considers his essential instructor during his lifetime), later a close friend of the artist. 1967 essay by Heartfield on A.Z. appears ("Against Fascism, Against the War") in which the author expresses his esteem for his Russian colleague. In the 1930s works as commercial artist for *Sotsialisticheskaya Industriya* (Industry in Socialism) and *Illustrirovannaya Gazeta* (Illustrated Newspaper). Beginning 1936 responsible for the appearance of the magazine *Stroim*. Numerous montages and covers for the magazine. Professional collaborations include those with > Debabov, Anatoly Garanin, > Markov (Grinberg), Ivan Schagin, Arkadi Schaichet, and Georgi Zelma. 1941–1945 designs the front newspapers, including the legendary *Front Illustrierte* addressing German soldiers. Designs flyers using documentary photo material with accompanying pacifist texts by Bertolt Brecht and Erich Weinert. Designs at the same time the photography newspaper *Photo Gazeta* and flyers for Soviet soldiers. From 1945 to the late 1970s works as art director of the magazine *Soviet Union* (fomerly *USSR in Construction*). Publications in *Pravda, Izvestia, Literaturnaya Gazeta* (Literary Magazine), *Krasny Flot* (Red Fleet), *Smena* (Departure), and *Krokodil*. 1947–1975 cycle of photomontages entitled *For Peace, Against War*. During Cold War period

EXHIBITIONS (Selected) — **1961** Berlin (Deutsches Historisches Museum) JE (with John Heartfield) // **1975** Moscow (Central House of Artists) GE // Moscow (Central House of the Workers in Arts) SE // **1987** Prague (Exhibition Hall) SE // **1992** Boston (Massachusetts) (ICA) GE // **2000** Columbus (Ohio) (Columbus Museum of Art) GE // Moscow (Novy Manege) GE // **2004** Moscow (Moscow House of Photography/**Photomontage in the USSR**) GE // **2005** Barcelona (Kowasa Gallery/**Fotografía Soviética: 1920–1960**) GE // New York (Nailya Alexander/**Phototmontages 1931–1973**) SE

BIBLIOGRAPHY (Selected) — "Photomontages of A.Z." (text by Solomon Telingater). In: **Iskusstvo**, no. 9, 1963 // **Die Collage.** Cologne 1963 // **Bez Maski** [Without masks]. **Political Photomontages of A.Z.** Moscow 1964 // John Heartfield: "Against Fascism, Against the War. " In: **A.Z.** Moscow 1967 // **A.Z.** Moscow 1975

repeatedly makes visual appeals for disarmament, against the war, against capitalism, etc. Also undertakes book illustrations (for Boris Polevoy and Sergei Belyaev). Between the 1960s and 1970s several trips abroad (South Africa, Italy, Great Britain, France, Algeria, Tunisia, Czech Republic, Romania, German Democratic Republic, and Vietnam). Essays on A.Z. appear in *Ogonyok* (Moscow, 1963), *Tvorchestvo* (Moscow, 1963), *Revue Fotografie* (Prague, 1973), and *Interpressgrafik* (no. 4, 1973).

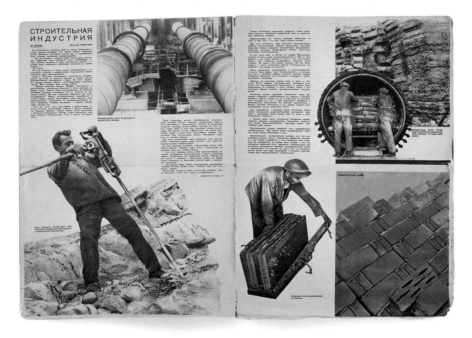

"Zhitomirsky was undoubtedly inspired by Meyerhold's work in the theater. The art of his photomontages, founded on strong contrasts, resulted from a skillful combination of scenic elements and various documentary images whose combined effect defies every one-dimensional reading. At the same time, his compositions seem extremely spatial. Nonetheless, his allegories, his political montages – laden with sarcasm and concealed incisiveness – were easily understood by the majority of the people and, like only a few creations of their kind, found their way into the collective consciousness. Though his photography-incorporating design work can hardly be separated from Russian Constructivism, it stands closer to Berlin Dadaism (Hannah Höch and George Grosz). Heartfield's photomontages for the *AIZ* [*Arbeiter Illustrierte Zeitung*] and *Die Rote Fahne* exercised a considerable influence on Zhitomirsky." — Tatiana Salzirn

A History of
Photography

Photographers A–Z

20th Century
Photography

Karl Blossfeldt

Stieglitz.
Camera Work

Eugène Atget.
Paris

Curtis. The North
American Indian

Burton Holmes.
Travelogues

New Deal
Photography

André de Dienes.
Marilyn Monroe

Lewis W. Hine

Bookworm's delight:
never bore, always excite!

TASCHEN
Bibliotheca Universalis

The Dog in
Photography

Julius Shulman

Eadweard Muybridge

Norman Mailer.
MoonFire

Frédéric Chaubin.
CCCP

Film Posters of the
Russian Avant-Garde

100 All-Time
Favorite Movies

Movies of the 50s

Movies of the 70s

Movies of the 80s

Movies of the 2000s

Horror Cinema

Film Noir

The Stanley Kubrick Archives

David Bowie. The Man Who Fell to Earth

Steinweiss

Extraordinary Records

1000 Record Covers

Jazz Covers

Funk & Soul Covers

100 Contemporary Fashion Designers

Industrial Design

Design of the 20th Century

Scandinavian Design

1000 Chairs

1000 Lights

100 Interiors around the World

100 Contemporary Houses

Small Architecture

The Grand Tour

Tree Houses

Modern Art

Interiors Now!

Living in Japan

Living in Bali

Living in Tuscany

Imprint

EACH AND EVERY TASCHEN BOOK PLANTS A SEED!
TASCHEN is a carbon neutral publisher. Each year, we offset our annual carbon emissions with carbon credits at the Instituto Terra, a reforestation program in Minas Gerais, Brazil, founded by Lélia and Sebastião Salgado.
To find out more about this ecological partnership, please check:
www.taschen.com/zerocarbon
Inspiration: unlimited.
Carbon footprint: zero.

To stay informed about TASCHEN and our upcoming titles, please subscribe to our free magazine at www.taschen.com/magazine, follow us on Twitter, Instagram, and Facebook, or e-mail your questions to contact@taschen.com.

© 2019 TASCHEN GmbH
Hohenzollernring 53, D-50672 Köln
www.taschen.com

Original edition: © 2011 TASCHEN GmbH
Project management: Simone Philippi & Jascha Kempe, Cologne; Chris Murray, Chester, Cheshire
Design: Birgit Eichwede, Cologne
English translation: Hilary Heltay, Whitney-on-Wye; David Higgins, Paris; Karl Edward Johnson, Berlin; David Smith, Weimar-Roth
Reproductions: Hans Döring, Munich; Rheinisches Bildarchiv/Britta Schlier, Cologne
Production: Horst Neuzner, Cologne

Printed in China
ISBN 978-3-8365-5436-7

Most of the books and periodicals reproduced in this volume come from the library of Hans-Michael Koetzle. Exceptions are from the following:

Hans Christian Adam — pp. 106–107, 284–285, 392–393, 434–435
Roland Angst — pp. 425, 588–589
Norbert Bunge/argus fotokunst — pp. 258–259, 282–283, 306–307
Frank Goerhardt — pp. 506–507
Renate Gruber — pp. 180–181, 198–199, 266–267, 296–297, 336–337, 450–451, 618–619
F. C. Gundlach — pp. 104–105, 174–175, 236–237, 268–269, 344–345, 374–375
Dieter Hinrichs — pp. 10–11, 12–13
Klaus Kinold — pp. 252–253, 500–501
Helmut Kummer — pp. 636–637
Kunst- und Museumsbibliothek Köln/ Rheinisches Bildarchiv — pp. 98–99, 112–113, 134–135, 142–143, 322–323, 334–345, 406–407, 420–421, 444–445, 482–483, 514–515, 564–565, 590–591, 598–599, 620–621, 622–623
Robert Lebeck — pp. 72–73, 92–93, 96–97, 176–177, 244–245, 316–317, 342–343, 352–353, 378–379, 416–417, 481, 542–543
Andreas and Simone Philippi — pp. 114–115, 216–217, 340–341, 624–625
Tatiana Salzirn — pp. 140–141, 540–541, 638–639
Markus Schaden — pp. 530–531
Max Scheler Estate/Peer-Olaf Richter — pp. 364–365
Fotogalerie Karin Schneider-Henn — pp. 606–607
Dietmar Siegert — pp. 118–119
TASCHEN — pp. 6–7, 16–17, 18–19, 34–35, 44–45, 54–55, 66–67, 148–149, 212–213, 218–219, 220–221, 222–223, 232–233, 256–257, 286–287, 298–299, 312–313, 318–319, 326–327, 328–329, 338–339, 368–369, 436–437, 456–457, 502–503, 526–527, 528–529, 532–533, 586–587, 594–595, 630–631, 634–635
Thomas Wiegand — pp. 384–385, 524–525, 576–577

Endpapers (front) — Kishin Shinoyama, Nan Goldin, Man Ray, Karel Teige, Norman Parkinson, Harry Callahan, David LaChapelle, Andreas Feininger, David Douglas Duncan, Henri Cartier-Bresson, Brassaï, Edward Steichen, Robert Frank, Jaromír Funke, Rudolf Koppitz, Irina Ionesco, Richard Avedon
Page 1 — Nobuyoshi Araki, Rineke Dijkstra, William Klein, Peter Keetman, Alexey Brodovitch, F. C. Gundlach, Pierre et Gilles
Pages 2/3 — Bob Richardson, David Hockney, Ihei Kimura, Bruce Weber, Martin Parr, Clifford Coffin, Yousuf Karsh, Lillian Bassman, Hans Bellmer, Juergen Teller, Paul Outerbridge
Endpapers (end) — Robert Polidori, Cecil Beaton, David Douglas Duncan, Jean-Paul Goude, Inez van Lamsweerde/ Vinoodh Matadin, John Bulmer, Lee Miller, René Burri, Henri Cartier-Bresson, Bruce Gilden, Alice Springs, Robert Mapplethorpe, Jean-Paul Goude (Detail), Thomas Ruff, Cecil Beaton, Sam Haskins, Mario Testino, Chargesheimer, Massimo Vitali

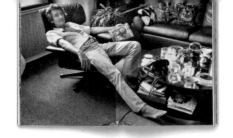

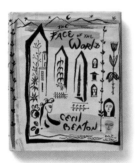

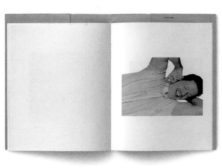